ALSO BY WILLIAM FEAVER

The Lives of Lucian Freud: Volume I

Frank Auerbach

Pitmen Painters

Masters of Caricature

When We Were Young

The Art of John Martin

The Lives of Lucian Freud

THE LIVES OF
LUCIAN FREUD

Fame,

1968–2011

William Feaver

ALFRED A. KNOPF NEW YORK 2021

THIS IS A BORZOI BOOK
PUBLISHED BY ALFRED A. KNOPF

Copyright © 2020 by William Feaver

www.aaknopf.com

Knopf, Borzoi Books, and the colophon are
registered trademarks of Penguin Random House LLC.

Library of Congress Cataloging-in-Publication Data

Names: Feaver, William, author.
Title: The lives of Lucian Freud / by William Feaver.
Other titles: Life of Lucian Freud
Description: First American edition. | New York : Knopf, 2019. |
"Originally published in Great Britain by Bloomsbury Publishing Plc,
London, in 2019." | Includes bibliographical references and index.
Contents: [volume 1]. The restless years, 1922–1968
Identifiers: LCCN 2019016659| ISBN 9780525657521 (v. 1 : hardback) |
ISBN 9780525657668 (v. 2 : hardback)
Subjects: LCSH: Freud, Lucian. | Painters—England—Biography. | BISAC:
BIOGRAPHY & AUTOBIOGRAPHY / Artists, Architects, Photographers. | ART /
Individual Artists / General. | ART / History / Contemporary (1945–).
Classification: LCC ND497.F75 F39 2019 | DDC 759.2 [B]—dc23
LC record available at https://lccn.loc.gov/2019016659

Front-of-jacket photograph (detail) by Bruce Bernard, 2000.
Courtesy of Virginia Verran for the Estate of Bruce Bernard.
Spine-of-jacket photograph by Jane Bown / Camera Press / Redux

Jacket design by Carol Devine Carson and Joan Wong

Manufactured in the United States of America
First American Edition

For Andrea Rose

CONTENTS

Preface xi

PART V

The Painter Surprised, Final Years 2003–11

PREFACE

Notebook entry for Wednesday, 28 November 1973, the day I began to get to know Lucian Freud:

> A bed in each room, empty canvases ready. A painting: nude sprawled, leg cocked across, painting stool edging into the bottom of the picture. The front room has a brass bedstead, tables covered with letters, telegrams, The Listener, paint tubes bent and worried. A small surprisingly bright palette.

Lucian talked, I remember, about how, early on, he had taken to showing up at the Ritz Bar and other wartime haunts in a fez and postman's trousers. That was then. And now with his fiftieth birthday in prospect and a retrospective to follow, such stunts were blips in a distant past. Things were getting ever more serious in terms of ambition: paintings accomplished and those he hoped might yet be done.

His "mid-career show" was an occasion for taking stock, an Arts Council man had told him without going as far as to explain that it was in fact a stopgap: somebody else's proposed exhibition had fallen through, hence this sudden late addition to the Hayward Gallery winter schedule. Freud wasn't bothered about being second choice since he had never been associated with any innovative tendency and thus had no date-stamped reputation to lose. He wasn't even as celebrated an anomaly as his friend Francis Bacon. To be exceptional was good enough.

The *Sunday Times Magazine* hadn't specified what sort of article I should produce to coincide with the opening of the exhibition, but it had been put to me that an arresting character study was needed, as revelatory as I could make it. Freud's life and works had become wreathed in rumour. Waiting in that cluttered upstairs room in Maida Vale while he changed for lunch, discarding the paint-smeared trousers, I began jotting down potential quotes and observations.

Where to start? Briefly: Lucian Michael Freud, born in Berlin on 8 December 1922, the second (middle) son of Ernst Freud (architect and youngest son of Sigmund Freud), was named after his mother, Lucie Brasch. In September 1933, not long after the Nazis had seized power, the family moved to England where in successive schools Lucian became fluent in English but evasive when faced with academic demands and institutional procedures. A term or two at the Central School of Art was followed by spells at the more congenial East Anglian School of Painting and Drawing interrupted by three traumatic months, March to May 1941, during which he served incompetently as an ordinary seaman in two North Atlantic convoys: Nova Scotia and back. Invalided out and exempted from conscription he swung into an opportunistic way of life in London. The emblematic centrepiece of his first one-man show, in 1944, was *The Painter's Room*, featuring a red-striped zebra head (a gift from his femme fatale Lorna Wishart) intruding upon a space furnished with attributes: sofa, scarf, top hat and scruffy palm.

Post-war, Freud made his way as soon as he could to Paris, then—in the autumn of 1946—to Greece where he spent several months with fellow painter John Craxton on the isle of Poros. Soon afterwards, having returned to London, he became involved with Kitty Garman (daughter of Jacob Epstein and niece of Lorna Wishart) whom he married in 1948. She sat for *Girl with Roses* (1947–8), and more resignedly as *Girl with a White Dog* (1950–1). Freud did not take to domesticity. His *Interior in Paddington* (1951), featuring a resentful young man squaring up to the even more unkempt palm in its alien setting (the painter's room in Delamere Terrace, London W2), secured an Arts Council Festival of Britain purchase prize. Divorce was followed by marriage to Caroline Blackwood in December 1953. The subsequent *Hotel Bedroom* (1954) was a disaffected view of the relationship, which formally ended in 1957.

Emboldened paintings ("making the paint do what you want it to do") were more than a match for the distractions—gambling, betting and amorous pursuits—of the sixties, a period in which the artist achieved a degree of accomplishment bordering on virtuosity. Living still (squatting virtually) in various council properties scheduled for demolition, he fitted phenomenal stretches of activity into each day: a compartmented life in which sittings had unquestionable priority. He aimed throughout, he said, for "greater ruthlessness." As his celebrity swelled he became increasingly conscious of time running out.

This second volume begins when Freud had just over forty years of studio life ahead of him: years that in terms of ambition and relentless application were to prove extraordinarily productive. It combines his words and my recollections together with the reminiscences of many others whose relationships with him differed widely.

Sometimes, when he stepped back to take a fresh look at a painting as it neared what could be declared completion, he would murmur, as though taunting himself: "How far can you go?"

Initially this book was to have been a brief account of Freud the artist, but in the late 1990s, as the tapes accumulated and reminiscences flowed, we agreed that what Lucian had taken to referring to as "The First Funny Art Book" was outgrowing its prospectus, so it was shelved for the time being, Lucian half-heartedly assuring me that he would have no objection to "a novel" appearing once he was dead. Working with him on a number of exhibitions made the oeuvre ever more familiar to me and we went on talking, primarily on the phone, almost daily. The notes I took from the countless conversations ("How old am I now?" he would ask me or, less specifically, "How goes it?") are the chief source of these two volumes of biography.

Jacquetta Eliot, the Death of Ernst Freud, Leaving the Marlborough for James Kirkman
1968–81

"The point is the forehead"

British *Vogue*'s fiftieth-anniversary issue for October 1966 lauded the "New Plastic Age" and featured prominently the young Lady Eliot, looking not best pleased at being photographed by the pushy David Bailey as a "Janus Face" whose daytime look (boyish hairdo and a nine-guinea golden-yellow sweater) flips into nightlife glamourpuss. "Transformed by Pablo [the hairdresser] into a modern Cleopatra. He uses a long black wig, fine black lashes and liner painted as lashes on the lower lid."[1]

Later to pose intimately, dedicatedly so, for Lucian Freud, Jacquetta Eliot, daughter of the wartime British Ambassador to Egypt, Sir Miles Lampson, was a friend of Penelope Cuthbertson, whom she replaced as his prime sitter. "I didn't know her well in the first few months," Freud said. "She was twenty-four, had married pretty young. Her father was the person who kicked Farouk out of Egypt [that is, was overseer of King Farouk's abdication]. She seemed brilliant and wrote marvellous poems and was friendly with people." He met her shortly before his 1968 Marlborough show, at a time when, he rather felt, his relationship with Penelope Cuthbertson was becoming irksome. "I was just doing what I wanted; it didn't seem like a complicated transition at the time. They were all in a set. I went down to stay at Perry's." Perry was Jacquetta's husband, Peregrine Eliot (later 10th

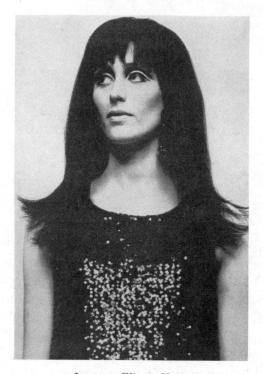

Jacquetta Eliot in *Vogue*

Earl of St. Germans), who lived at Port Eliot, a great Gothic mansion in Cornwall. "It was a very odd place. Sleepy atmosphere, land below sea level, wine cellar by John Soane. I was terribly impressed: in the morning the butler came in and lit the fire quietly and said what the weather was like. And they ate off solid silver plates, even shepherd's pie."

Most impressive, most pleasurable, was Jacquetta, whom he pursued with letters, several a day (many never sent), and trunk calls to Cornwall. ("You know when I get angry it's only from waiting and waiting . . .") He stood in the rain outside their London house in Chepstow Place two nights running and then shinned up a wonky drainpipe to reach her balcony, scrabbling until, as she said, she relented. "Finally, I had to say, 'This is ridiculous. OK: better come in and have coffee or something and get dry.' That was very typical of him: to focus on his prey. I remember him watching me at parties.[2]

"Once he came to Cornwall when Perry was away and I was having a house party; he arrived and I was horrified. 'You must go,' I said. He said, 'I've come all this way,' and so I let him have a bath and drove him to the station in Plymouth and he jumped out and disappeared. He acted on rushes of adrenalin: he would crash in on dinner parties and make me leave with him. He loved a drama and me saying fuck off. And he would get things wrong: when I had my wisdom teeth out, he brought me a pineapple. It took two years to realise I was hooked, a terrible realisation."[3]

As for Freud, he thought he'd met his match. Or so he told Frank Auerbach. Both took a pride in being quick to act in the heat of the moment. "The thing I had with Lucian was very difficult of course and intensified by the fact that I was married—and happily married—when it began. Terribly fraught and a lot of it was to do with going back to Cornwall. That used to infuriate him. And I used to feel strongly that he wanted to break up the marriage; he once said, when we were going down Charlotte Street to get a kebab and the kebab shop was shut, 'Damn, I want it *even more*,' and went into a whole number. The whole thing was break-ups and make-ups.[4]

"He was funny and clever, ardent, urgent and fantastically intimate. Just the way he walked into the room, the way he breathed, like an animal, very feral. He did exactly what he wanted. He electrified my senses and it was fine, I didn't mind."[5] She accepted that she liked a man to have an obsession and that sitting for Lucian was the one reliable way of seeing him. All else followed on from that. She put it to him that there were three great attractions for him in a woman: that she be married, be pretty and have an independent spirit. "Right on the last two," he said. "But not sure on the first."[6]

"I was terribly in love with him, completely hooked, a dreadful drug and couldn't get off it and I tried and I tried. We had an awful lot of fun together."[7]

The notes he sent switched from blunt to cajoling. Mercilessly direct, every sentiment cut to the quick, he told her off for overdone self-expression ("Stick to talking about your hard little heart") and drew reproachful thumbnail faces staring out from mid-sentence. He wrote from his bed, substituting for words a sketch of the brass bed-knob at his feet and the room beyond; he drew bottles on a shelf labelled "telephone tricks, poisonous letters, bitter aloes, evil tele-

grams Not To Be Taken." There were mentions of hearings ("Got to spend tomorrow in cells and court") and excitements in prospect. Letters came with red dabs around the margins ("Are you really so hard and brittle; I feel completely old and lost without your love"), letters overwritten "Moan" "Moan" "Moan." He demanded photographs so that he could paint her in a Cornish pastoral, a Giorgione figure with attendant cow.

"We had a row in Ireland, staying at the Devonshires'. He said he hadn't been there before but I saw Penelope's name in the visitor's book." Best, though even more likely to throw up reasons for jealousy, was being in London. "His flat in Camden Road, very plush: but the lure was studio life: champagne there on dirty floorboards."[8]

Once when they went to Paris they stayed in Jean-Pierre Lacloche's basement apartment, draped in dust sheets with monkeys and parrots, Jacquetta remembered, and sat on the bed while their host "made up an opium spliff" for them to share.

Jacquetta came to see the relationship as a drama, a two-hander of many acts. "We would be Tom and Jerry."[9] To be volatile, it seemed, was to be fully alive. Freud, who couldn't bear frustrations not of his own devising, was racked with impatience. "Mean and shallow little tyrant," he raged.

"The first phone I had was in my secret flat in Camden Road, quite a lot to do with Jacquetta as she was supposed to ring me up. A man at the Colony Room who worked on the telephone lines fixed me up and so I didn't have to pay and be in the phone book; and when she didn't ring I might have pulled it out."

Self-Portrait with Black Eye (1969) was not the product of a spat with Jacquetta but, Freud said, it could well have been. "Someone hit me through the window of a car coming out of the park. And I thought, what can I do with this?" The bruising was briefly fascinating to paint before it faded.

Almost invisible in *Large Interior, Paddington* (1968–9) is what looks like a marble lying below Freud's jacket as though dropped to the floor from a torn pocket. It was a trinket, a gobstopper-sized purple ball with a note inside, planted there for private reminder: a love token from (and now, in its painted form, for) Jacquetta.

· · ·

Though he liked to think that he only worked from people he felt like painting, Freud found it advantageous at times to paint those who had the means and inclination to pay for what he made of them. Never more so than after his 1968 Marlborough show when his prospects with the gallery dimmed.

The Rev. Tim Beaumont, who was also Lord Beaumont, wanted a portrait of his wife Mary Rose. "Friend of Princess Margaret, famously. He had money, huge house in Hampstead, Henry Moore drawings and everything, bought the *Spectator* [in fact *Time and Tide*]. I was commissioned to do this picture of her." Before agreeing to it he said he had to see a photograph of her, liked her white skin; that decided him.

"I started off in a high-necked black sweater," Mary Rose Beaumont said. "But that didn't last long. I became naked, upper half, because of the white skin and blue veins and all that; if I turned up after having sat in the sun he sent me away. I enjoyed the sittings. Lucian continually borrowed small sums of money." He gave her in part repayment a cheque for £1,200. "Which of course bounced!"[10]

The Beaumonts had bought *Naked Girl Asleep I* and they also had a fragment, *The Sisters*, of Caroline Blackwood and her sister Perdita (eyes only), slipped to Mary Rose as recompense for money owing, Freud explained. "I must have cut the heads out and given it to Mary Rose. She told me everything and was game and decent. She had an affair with Clement. I said to her, 'What was he like?' 'Punctual.' Slightly racy conversation, slightly mocking."

"He said how he loathed Clement," Mary Rose remembered. "And he used the wonderful word—given his rolling r's—that he was 'meretricious.'"[11]

"He had a key of the flat below because they had a television. We went down if there was a race and sat solemnly side by side. Once, when there was a marvellous race at Kempton, he got me to go with him in my little yellow Mini, with him driving. I've never been more frightened, whizzing in and out, ignoring the white lines."[12] *Woman with Bare Breast* (1970–2) was unsatisfactory, Freud eventually decided. "I actively dislike it. It's strained. 'Tim thought you'd do a nude,' she said, so I took one of her breasts and put it down. It adds." Mary Rose was inclined to agree. "He said it wasn't a good picture and the best part was Sigmund Freud's raincoat draped over me, revealing one

breast. He said I was 'accurate,' meaning that I wasn't a fantasist. It's a gloomy picture. I was rather sad at the time. What was missing from my portrait was sex!"[13]

A more productive connection was revived when, having painted the Duchess and her son Lord Hartington a decade before, Freud resumed painting the Devonshires. "It wasn't relentless. From first to last I painted them over twenty-five years. She said would I paint Andrew and I said, 'I can't: he moves around too much.' Andrew asked me to do his daughter, very nice and pretty, but I couldn't, I said, and so he said, 'How about my mother?' He was very generous to me. He guaranteed my overdraft."

Portrait of a Woman (1969) is remarkable for the Dowager Duchess's quizzical look. Tom Monnington, a painter who taught at the Slade and had taken to austere abstraction, was impressed. "Andrew said Monnington had been to see the picture and thought the white behind the mother was very good: seeing it from an abstract point of view." Darker in tone and torpid in mood, *Portrait of a Man* (1971–2) was of the Duke nodding off in afternoon sittings with slithery comb-over and tie askew. "All Cavendishes are lazy by nature and my entire life has been a battle against indolence," the Duke confided. "Snoozing is another great Cavendish characteristic. When you consider my advantages—there probably isn't anybody more fortunate in the world—I've achieved absolutely nothing. It's quite shaming.[14]

"It was really luck that led me to sit for Lucian Freud," he said. "I doubt if I would have commissioned him if he had not been a friend as well. The results are not flattering, but I like them." There were thirty-six sittings, two hours each, at Gloucester Terrace. "It took over one's life. There were complications: he wasn't on the telephone [there]; it was awkward to get in touch. A great and fascinating experience because he is, of course, a highly intelligent man. Very interested in horse racing at that time. He rang up. 'I haven't got the silk of your shirt right. Rembrandt would have done it and I'm damn well going to do it, too.'" Initially Freud posed the Duke with a hat on (the racing man), then bareheaded and vulnerable. The former Minister of State for Commonwealth Relations in his uncle Harold Macmillan's government in the early sixties ("the greatest act of nepotism ever. I think we'd given him some good shooting") sat rumpled, depressed,

squiffy, despondently middle-aged. By his account, he was worrying over "a tax situation" at the time.[15]

"Andrew was in a very bad state, an alcoholic phase, cold sweats running down his face. Mauve and yellow round his cheeks, which helped a lot." Freud left under-painting exposed on the forehead. "The point is the forehead."

Conversations ranged over mutual interests: the Jockey Club and the paintings now formally owned by the Chatsworth Settlement. "I loved sitting for him, it was a very great treat, because he's such a clever man, such an intellectual stimulus." Was Rembrandt's *The Philosopher* a true Rembrandt? ("I always wonder about the Devonshire man deep in thought [painting]: if not a Rembrandt it's as good as.") They agreed that Freud's *Who's Who* entry should be beefed up amusingly with "Cyclamen Mural, the Thornhill Bathroom, Chatsworth House, 1962" and "Prize Winner *Daily Express* Young Painters Exhibition, 1954."

During one of the sittings a bailiff arrived and having gained entry refused to go away. "You can't turn them out—anyway he was a huge man—and I introduced them. Andrew was a junior minister then and he asked, 'Would you mind leaving? We both work for the same people.'"

Though collaborating as painter and sitter, Freud and the Duke were conscious of differences between them. Things not to be mentioned ("Slightly crushed by being married, Debo was"). Things that exceeded mere disagreements. During a stay at Lismore Castle there had been a quite dramatic falling out. "A row over South Africa, which I knew about from Francis [Bacon], how appallingly blacks were treated. Francis said that when he stayed with his mother there she poured Lysol [disinfectant] into the rubbish bin and when he asked her why she said, 'Negroes come round and pick through the bin.' 'How *can* you?' 'Everybody does it.'

"This made Andrew savage; I think he wasn't saying what a fuss about nothing; my dumping Debo was what the row in Ireland was about. Andrew liked whores." When a newspaper revealed that he had been involved with a prostitute the Duke said how lucky he was to be able to afford such treats.

"When I was painting him the sergeant major in the downstairs

flat came up for something and said, 'He wants to put his tie straight, doesn't he?'"

With such a neighbour there was what Freud took to be social awareness, aspiration even, to some degree. "His wife worked for the Queen Mother as a cleaner. She used to get quite drunk. Once, when I was pulling up in my car, she said: 'Take me to Clarence House.' I did, I think. 'Don't let her—Kerrie—order you about,' he said. When I moved in there she said, 'Oh how exciting: a *celebrity*.' The sergeant major showed me things he had: a photo of a public hanging in Egypt and trophies. 'What I really like about these things is that everybody likes them,' he said. 'And wants them.' It was a sort of real collecting instinct." He also had the television to which Freud had access for the racing.

"I used to give them amazingly good tips which won at very long odds. Years later she [the sergeant major's wife] wrote a list of them all to me in a letter. All the names and odds."

By the late sixties Freud had become used to being the older man involved with people around the same age as his eldest daughters. Among them were roving spirits, a clique of young successors to the Romany-style caravanners of the Edwardian age, as depicted by Augustus John, and forerunners of the New Age travellers of the 1980s, resolved to lead, with modest discomfort, the simple life by way of the open road.

Penelope Cuthbertson had acquired a caravan pulled by a mare named Lily and joined a convoy trailing through the rural Midlands, the Scottish Borders and the West Country, resting for months on end between spurts of five miles a day and led by Mark Palmer, baronet, one-time owner of a model agency called English Boy. They set off one morning in 1968 after a concert and roamed on and off for five years. One of their resting places was on the estuary at St. Germans, below Port Eliot.

Freud—and Jacquetta—went along for the occasional weekend. "They were Etonians. They called them 'The Carts' and they moved around; they would go to a horse fair and park in the parks of people they knew in big houses—Mick Jagger's Stargrove—and make enormous detours to buy red neckerchiefs. Mark would do anything to be friendly to gypsies and they, of course, had none of that.

"I'd drive up to Wales—Welshpool—where Mark Palmer bought

a farm, The Grove. One place, a town called Montgomery, was absolutely marvellous, like a cowboy set going into the hills. I never went for long. For a day or two, I'd go. I'd ride. I was a sort of townie guest and I remember lots of good-natured argument. Their terrible tolerance made me bolshie. It was fairly fancy dress. Some were Irish. There were Mark Palmer, who married Catherine Tennant, Julian Ormsby Gore, who killed himself, David Mlinaric, Nicholas Gormanston, who was an Irish peer, a sort of thug." For Freud the companionship of horses was more of an attraction than most human company, though there was added pleasure in being able to take a daughter or two with him. Bella stayed for a while in Penelope's caravan and rather appreciated being told by the former nanny to go to bed at nine o'clock.

"Bella wanted to go with Penelope when she was with the caravans; it was very much her way out. She loves animals. 'You know what I'd like to do to people who are cruel to animals?' she'd say, and invent terrible tortures for them. She was a bit crazy when she was at school, thirteen, and she wanted shoes with high heels and they made her take them back. It's difficult to enter into a conspiracy with children when you are on no terms with their mother. Bernardine [Coverley] had an awful man living with her, a US schoolmaster-type who she had a son by, and he had some children already. As a hippy, Bernardine said, 'Never say no to a child.' 'Why not let Bella go?' I asked. 'Because I want to go myself,' she said." Bella did go for a while.

In a cart of her own for part of this sporadic trek was Henrietta Moraes, recently emerged from a cat-burglar phase (with Caryl Chance her accomplice) and a prison spell, according to Freud. "Henrietta was the cook. She was Old Mother Moraes in the caravans. Penelope told me she wandered into her caravan one day and saw the first page of her book and it said: 'Ever since I can remember, I've always loved fucking; something I've always liked better than anything.'[16] She was nice with Bella. She was nice with everyone, looking after them."

Freud was stimulated by the horse-trading that went on around him when he dropped in on the travellers. "I bought a filly from Mark Palmer who was breeding them. She was bred from an Arab stallion and from a piebald pony." For want of anywhere suitable in London he stabled her 400 miles away at Glenartney. "I did quite an elaborate

drawing of her in my painting room in Scotland. I made it into more of a stable." He then painted her, initially with Ali Boyt posed like a Stubbs stable boy, holding the bridle, but decided against having him in. So the filly stood unbridled, in profile, preternaturally obedient. "Then, in the winter, Jane [Willoughby] sent it to the south, to Suzy Boyt's sister, to train to be broken. There was something uneasy about it; it got fever in the kidneys and died, aged three, in Wiltshire." Eventually Penelope Cuthbertson went off to Ireland where she married Desmond Guinness, son of Bryan Guinness and Diana Mitford (later to become Diana Mosley). During the 1990s she got Freud to go halves with her in a horse: an eight-year-old called Miller King that never quite made it. "It was second a lot," Freud conceded. "Always faded after a hurdle. People say that when you buy a horse it's so much cheaper than betting: it isn't, because after the race you have to transport it and stable it and feed it and train it."

Several of his fantasy drawings of horses gambolling and nipping in an affectionate manner were published in Alan Ross's *London Magazine* for January 1970. They came from the publisher's dummy given to him by Stephen Spender and turned into the joint "Freud–Schuster Sketchbook" during their winter evenings in the Capel Curig parlour in 1940. Thirty years on, the redacted sketchbook— drawings only—was passed into safe keeping, and who better for this than Jane Willoughby, whose portrait he had first painted in the early 1960s. On his advice and at his urging, she was acquiring paintings by Bacon, Auerbach and Michael Andrews as well as paintings old and new by himself. When Tim Willoughby, who was in line to become Earl of Ancaster, was lost at sea in 1963, she had become heir to the family lands and fortune. Her hunting lodge on her Glenartney estate was a ready if faraway resort and her mews house in Belgravia was a handy retreat sometimes violently resented by Jacquetta Eliot. "He always used to say it was just where he kept his clothes and she was often abroad." Looking back she recognised that the role Jane Willoughby assumed in Freud's life was enduringly sustaining. "Now, of course, I'd perfectly understand: people have a quite different life at fifty than they do at twenty; I hadn't understood the thing of how real friendship comes in."

He liked to have keys to several addresses at any one time, places to which summonses and overdue bills were routinely sent since the

better the address, he mistakenly thought, the more likely it was the bailiffs would go easy on him. "The only time I was ever really ill was when I was staying at Wilton Row. Jane was away and I had pancreatitis. I couldn't eat. Francis moved in and I remember Miss Beston [Bacon's handler at the Marlborough] writing me a note: 'I envy you your nurse.' He nursed me for a week or so and got me books and got me Dr. Brass with lots of medicines. Pancreatitis is absolutely horrible. The pancreas is a filter. It filters the fat, and when it malfunctions it discharges fat into the blood and I went on being sick and sick and when I couldn't be sick any more I felt my insides coming out. I'm almost entirely carnivorous, so it was probably dietary. Not caused by drink." Bacon's doctor Paul Brass said that this could have been something he was prone to, adding that actually the "butler/housekeeper" was the person who nursed him.[17] Jane Willoughby agreed that Bacon might well have visited him but certainly no more than that.

The friendship with Bacon was still close—but what had once been daily companionship was now, usually, more a set occasion. Besides, George Dyer, Bacon's lover and sometime failed getaway driver, hanging around all the time was exasperating and Bacon couldn't just shake him off. "Francis was quite different having him there," said Alice Weldon. "I saw a lot of him with George. Francis and Lucian had a dialogue, philosophy, etc., and George and I didn't. When they talked about Cocteau I thought, 'I can say something,' but they actually *knew* him. Francis talked about being used to envy. 'Alice is too sensible to fall in love,' he said."[18]

Freud learnt that, possibly out of envy but more likely simply wanting to belittle his recent paintings (*Buttercups*, for example), Bacon had been exercising characteristic disloyalty. "I fell out with Francis. He did the dirty: advised the Marlborough that my things were overpriced. He said—it was a queer treacherous thing—'they don't know if they can sell your things and David [Somerset] quite agrees.' So I wrote to David that Montherlant quotation which I often use: 'It is one of the classical instincts of the human creature to take a single bone and construct a complete skeleton from it.' And he wrote back saying, 'If you behave excessively you end up apologising, always.' For the Ib picture [*Large Interior, Paddington*—Ib being his infant daughter Isobel Boyt] I wanted £1,200—I'd never had more than £1,000—so they gave me an advance of £600, which I spent, and

when I'd done it they didn't give me any more, so I went to see Lloyd at the Marlborough." But hardly had he begun complaining than a phone call interrupted him. "Some charity thing came in and Lloyd said, 'Give them two thousand,' and then he said to me, 'The stock market is wrong: no more money.'"

Given the gambling (which only occasionally proved profitable) and his habit of requisitioning cash from anyone available with which to gamble further, Freud moved beyond being penniless to financial desperation. "When I had absolutely no money of any kind, because I had this cold war with the Marlborough—the Marlborough refused to release me or give me more money—I wrote to [Wynne] Godley [the children's stepfather] saying that I might have to have some of the [Sigmund Freud] royalties money. With the Labour government I had made it over to the children, tax being 19/6 in the pound. Could I discuss it with him? Three months, no reply. Monstrous Godley. I talked to my father about it and he said OK. He was sensible. The reason royalties money fluctuated was there was different money from different countries: for example, suddenly a lot out of Russia. For tax reasons, when asked, I used to put 'company director.' So I stopped it and wasn't allowed to see the children at all."

Fastidious about what he wore, always at pains to appear discreetly distinctive, faintly raffish, in July 1969 Freud had a suit made by Huntsman, Savile Row tailors to clients ranging from Winston Churchill to Dirk Bogarde, Gregory Peck, Ronald Reagan and Cecil Beaton. Huntsman supplied him with suits every few years: 1973, 1978, 1993 and 1995. His attitude to finances was that risks should be ridden and responsibilities left trailing behind. Insouciance appealed: B. J. Thomas singing "Raindrops Keep Fallin' on My Head" over a bumpy freewheeling sequence in *Butch Cassidy and the Sundance Kid* was his favourite song of 1969, as "Hey Jude" had been the year before.

In 1973 the Penguin Freud Library was launched and Sigmund Freud's reputation peaked, as measured in paperback sales. "Royalties were a lot. I divided mine into eight parts to include the other children as well. Then it was a few thousand each a year. After fifty years royalties ran out, though some later translations went on. A trickle."

. . .

Ernst Freud died in April 1970. He was seventy-eight. "He'd had a stroke—no, a heart attack—he lost his way in the mountains and came back completely exhausted; they were out in the South of France with Jimmy and Tanya Stern and he had a heart attack after dinner. When he got ill they didn't go to [the holiday house at] Walberswick much, because he couldn't do fishing and gardening because of his heart condition."

Recognising that his father had done all he could to help him get started and to be businesslike and precautionary in all matters, Freud had been apt to regard him as a natural obstacle, irredeemably paternal, quaintly set in his ways. As a father figure he had some appeal, severely tested. "I didn't paint him. He wouldn't sort of let me. I would have done, oh yes, but my mother said he'd be upset. When he looked in the mirror he pulled amazing faces as he put on his pork-pie hat. He'd got an idea he must have looked odd." Usually when he had gone to see him in his study it had been to collect money or get his help in making a place habitable, inserting baize doors for quietness and strip lighting. "I did want to draw him but being sort of bossy he'd have wanted to change it. There are some ink drawings I did, a bit cartoonish, done ten, fifteen years before then." It was different after the heart attack; the old man, as he saw him, lost that testy look and just sat there, hand to cheek, lank hair dishevelled in a drawing he gave to Jacquetta Eliot. And then, sitting at the bedside watching over him in his final illness, he closed in on him. "I drew him when dying. He's in a pretty bad way." He did a watercolour: pencil filled in with pillowing washes, the presence seeping away, no longer quizzical, no longer presuming to criticise, face deflating into mask. Stephen Freud came to own it for a while. "He hung it opposite a window in the sunlight and it disappeared. One ear lobe left." An exaggeration, but then Freud had always regarded his father as something of a Cheshire cat. A looming then fading authority.

"He was mild and stubborn—it was my mother who I avoided; she was very strong—and he was deliberately modest in things. 'All my shares are going up, it's rather disgusting,' he said. Any sort of extravagance made him panic. He was very cautious; I think if it hadn't been for his father he'd have been a practitioner of order, ritual and some mysticism, but he was filial, I think."

Ernst and Lucie Freud had worked together on an edition of the

Geheim Chronik or "Secret Chronicle" compiled by Sigmund Freud and Martha Bernays during their engagement in the 1880s. Lucie, ever conscientious, was disturbed to find that Ernst had committed an unscholarly act. "My father had destroyed one of my grandfather's letters, a letter that was jealous and violent. My grandmother came from a well-off family and her sisters had young men coming for tea during this painfully long engagement, and according to my mother, there was one of them that he was jealous of and my father was shocked and destroyed it. 'How could you?' my mother said. He was so easily shocked."

More recently they had collaborated on *Sigmund Freud: His Life in Pictures and Words*, a pictorial biography that was to be published in German in 1978. Their researches had involved checking on the fate of the great-aunts in the death camps. To Lucian it all seemed remote. "I never knew them. I had the opposite of an interest in anything to do with my family. I would have had to have known them when they had been alive in order to be aware of them dead. Just ghostly photographs. Half-sisters, I think, from that first marriage of my great-grandmother. Half-great-aunts." This did not inhibit him in later years from rebuffing all invitations to exhibit in Austria.

All three sons reacted to Ernst Freud's inhibitions by flouting them, Lucian and Clement especially. How Germanic their father had remained even after thirty years in London yet how philosophically he had adapted. "He was very much not disorganised. He had a sensible, huge life policy: enough to look after my mother." His prudence and resolution had brought them to England in good time and his practicality had moral weight.

"He said I should have a nail on the wall to put my bills on. Sixty thousand pounds I got when he died."

Freud had hoped to draw his father dead but the undertakers were too quick for him. "'Oh,' my mother said, 'I did think you'd want to draw him, but for an extra £33 they said they'd take the body right away.' There was no funeral; he didn't want one and his body was taken away immediately." Looking back, Freud thought that some ceremony might have been worth having. "The catharsis to do with a funeral would have helped my mother. When he died she was fine. But there being no funeral might have added to her state of pain. She was in hospital for some months."

A living connection with Germany was briefly restored. Linde the governess—Fräulein Per Lindemeyer—wrote from her nunnery. "When my father died she wrote to me as my mother didn't respond. I gave her a book of drawings of Snow White when we left Germany and she wrote that if I did a new one for her she'd give me back the book. In the letter she said that she remembered me as 'very lively but not affectionate' as a child. Which I was very pleased about. I wrote to her, in German, that I didn't want to do a swap."

Going through his father's things in the garage behind St. John's Wood Terrace, he came across, and destroyed, some early paintings. "It's quite an instinct."

"I notice that it is when I am unhappy that I find myself painting still lifes.

"Painting out of the window: I think I've generally done it when my life has been very strained. Not as a result but thinking about it afterward. Periods of strain when working on my own seemed easier for me because I couldn't have thought with the same concentration about the people I was working from. Concentration's one of the most important things there is for painting."

In the summer months between 1970 and 1972 Freud worked on *Wasteground, Paddington* and *Wasteground with Houses, Paddington*, two takes on the view from the rear of 227 Gloucester Terrace facing the back of Orsett Terrace. Convincingly thorough, "not neglected in any part," as Constable said of his large Stour Valley pictures, they are nonetheless views with selective aspects, less factual than they look. In the smaller of the two there are railings on flat roofs but few windows and no garage doors. Walls of London brick enclose the squalid little wilderness and fill the left-hand side, creating a similar overlooked space to that of Van Gogh's *Prison Courtyard*, itself based on Gustave Doré's image of the Newgate exercise yard in his *London* published exactly a century earlier. In the taller and more open *Wasteground with Houses* there are no railings, garage doors and windows have been reinstated and, rising behind, the windows of Orsett Terrace look on blankly beneath a dull sky. Between pictures the rust on the corrugated-iron sheeting reddened and the buddleia grew.

The wastegrounds were day paintings occupying hours when

the ever truculent Harry Diamond (seated this time with bath and washbasin edged in behind him) or Jacquetta Eliot were unavailable. A preoccupation deeper and more extended than when he drew the Great Glen from his Drumnadrochit hotel window thirty or so years before: more like the lovelorn detail of Constable's two views over the flower garden and kitchen garden at the back of his father's house in East Bergholt. Where Constable trained his eyes on bright acres of rural Suffolk, Freud surveyed chimneypots of every variety and recorded the failing windowbox, the leak stains and botched repairs, the small differences, the neglect. He scraped striated paint layers to give the impression of sooted bricks and mortar.

"My grandfather was adamant that to be an analyst you had to be a fully qualified medical doctor, and whenever he examined any of his patients—whatever desperate state they were in—he gave them a complete and thorough physical examination. That seems to me right and proper." While not obliged to set down everything to be seen he did have to be precise with what he chose to linger over. "Have you ever noticed," Giorgio de Chirico wrote, "the singular effect of beds, wardrobes, armchairs, divans, tables, when one suddenly sees them in the street, in the midst of unaccustomed surroundings? We see then the furniture grouped in a new light, clothed in a strange solitude, in the midst of the city's ardent life."[19]

Boarded off as it was from the mews, the refuse festering below the painter's window should have been secure from outside interference but tramps took to dossing there and he had to bribe them to leave it alone. "When my father died I started remaking it. I just felt that the rubbish must be more exact in the way that the actual mattresses related to each other so much. Also I wanted it to be *more* what it was." The armchairs nestling on a cramped flat roof looked safely lodged but one push and they would be down there with the rest. Earthly remains: Stanley Spencer had loved picking through such stuff. "When I see something thrown away I am all eyes to know what it is," Spencer wrote. "These things were little bits of the lives of people to whom they belonged."[20]

Through each summer the buddleia grew, bursting through the acrid litter and squirming upwards. "I was very conscious as I looked out of the window that more and more people were leaving and that it got emptier and emptier. Windows got empty and the garages were

hardly being used and the mews houses were being vacated and some-how the rubbish was the life in the picture." There could have been a zebra head down among the rags and paint cans and soggy rose-patterned carpets of this noisome paradise garden.

Esther, then eight or nine, was brought up from the country by her mother to visit her father. She remembered noticing that a bicycle had disappeared from the picture.[21] "Too easy on the eye," was Freud's explanation. "I thought I didn't want the garage doors to look like abstract art—like Ben Nicholson—so I had someone cycling through there but it didn't work as I can never do people without showing how important they are. That's what I really like about Constable so much: even though it's only a tiny person—*is* it a person?—you do really believe in it."

The back windows of Orsett Terrace could frame domestic scenes as in Hitchcock's *Rear Window*, but without Grace Kelly to hand and no plot resolution to follow they declare only emptiness or anonym-ity. At the time Freud was reminded of another movie, closer to home: *A Window in London*, made in 1940 and starring Michael Redgrave. "He's going on the tube and he sees a man throttling a woman in a window, and his whole life is changed. But really it's just an actor rehearsing. The film ends very poignantly: he's on the tube again and he looks up and the man's doing it again and he smiles, but he actually *is* killing her this time.

"If you look you see it's not lived in. It's why the plants show up so well: they're the only live thing. It's about somebody gone who I was missing."

Once the residents were moved out the terraces were renovated; the mews houses were demolished, replaced with a broad strip of turf and paving; the rubbish site was cleared and a lock-up garage built across it.

2

"I cut such a lot down then"

In the July/August 1971 number of the *London Magazine* I published an article, "Stranded Dinosaurs," singling out several painters whom I thought exciting and overlooked. These, I suggested, were nonconformists in an age of conformity to a lauded variety of formalistic criteria. "In the end perhaps the uncertainty, hence the honesty of Auerbach, Andrews, Freud rests on their avoidance of the current preoccupation with third-hand imagery; with transcriptions of travelogue material rather than landscapes, passport photos rather than the live man, with mass imagery rather than individual perception."[1] For Freud especially, the detailing of a view was a homing in on an absence, what's left in that absence, what still remains and, by virtue of the painting, gets to be remembered.

When, in 1972, the wasteground pictures were first exhibited they prompted talk of Freud inclining towards Photo-realism, then a trend. This he denied. His chimneypots were observed, not traced and plotted. His outlook was unfiltered, unmediated, whereas Photo-realists generally worked from 35mm colour slides projected on to the canvas; for best results clear skies and shiny surfaces were standard, as were drugstore, parking lot, arid backyard and the glazed smiles of family snaps. Initially (the manner palled) there was a kick to be had from seeing the shopping mall in Canaletto cinemascope, everything in ostentatious focus. Photo-realism dominated *New Realism*, a volume compiled by Udo Kultermann and published in 1972, superseding his *The New Painting* of 1969; for this pictorial bandwidth was

elastic enough to include Warhol, who abstracted photographs rather than replicating them, Chuck Close, painter of spectacular replicant pores-and-all mug shots, and Philip Pearlstein, whose sallow nudes were apt to be cited as akin to Freud's naked portraits. Pearlstein situated himself between Painterly Expressionism and Photo-realism, denying any involvement with the latter. "I've never worked from photographs simply because I thought it would be very uninteresting," he explained. "I'm far more fascinated by my elaborate process of measuring. It keeps me going; it keeps me excited."[2]

Freud was insufficiently well known internationally to be included in either Kultermann survey; besides, he was difficult to place, more so than Pearlstein whose elaborate process measured low on any scale of excitement. Freud had the distinction of being peculiarly definite, not that this was noticed much. Told in his early days that his work was neo-Neue Sachlichkeit—updated George Grosz and Otto Dix— now he was repeatedly informed that, Germanic influences apart, he was obviously indebted to Stanley Spencer.

In 1946 Michael Ayrton had likened Freud to Spencer in terms of detail and delineation; David Sylvester had done so in similar vein, talking of "meticulous detail and sharply defined forms";[3] however from 1972 onwards recurrent comparisons between the two tended to focus on superficial similarities between Freudian nakedness and Spencerian nakedness with particular emphasis on *Double Nude with Stove*, a painting Spencer reclaimed from his dealer, Dudley Tooth, and kept under his bed for two years until he died. Painted in 1937, "The Leg of Mutton Nude" (as it was renamed by Tooth) was one of a number of celebrations of his involvement with Patricia Preece, whom he was to marry later that year only to be ousted in favour of her girlfriend. Spencer took to explaining that the painting prefigured the way things had turned out. He had been duped, he insisted, and the exposure of raw meat and pallid skin to the glare of the oil stove was expressive of "the intensity and fear of things going wrong."[4] When painting Preece (who had appealed to him as being more glamorous and worldly than his then wife Hilda Carline) Spencer had hit on the idea of a paean to the flesh with himself bared, gloating over the nakedness of his mistress, not forgetting the joint of mutton destined to be roasted for lunch, after which, he was minded to reveal, the two of them would retire upstairs for a lie-down. So nudist an

ode to corporeality was more Neue Sachlichkeit than anything Freud ever conceived. "There is in it male, female and animal flesh," Spencer wrote. "None of my usual imagination in the thing. It is direct from nature and my imagination never works faced by objects and landscape."[5] Rumours of the painting's existence circulated for some years, prompting Sir Alfred Munnings to denounce Spencer to the police as a pornographer.

The painting changed hands several times after Spencer died in 1959 and was exhibited in 1972 before going to auction in 1974, at which point the Tate bought it. In the decade or so leading up to that, years when it passed from one private owner to another, word went around that it was just the sort of picture that would appeal to Freud or indeed show him up as an imitator.

"Someone I hardly knew—a villain—tried to sell it to me. He wasn't an art person, not Charlie [Thomas] and not the Killer. He rang me up, came round to Gloucester Terrace and put a letter through the door offering it because it was a dirty picture. It was 'Dear Sir, I thought you might be interested in this . . .' And I looked at it and thought no more about it. He wrote twice. There was a threat: 'Dear Sir, unless you give back the photograph immediately there's going to be serious . . .' I think 'Dear Sir' means the person is completely uneducated; I didn't meet him, but I was slightly stimulated. People always thought I had some money, which got me out of quite a few scrapes when I hadn't."

Spencer had been a prize student trained in Slade draughtsmanship and well-rehearsed composition. To Freud such skills—clean lines, busy arrangements—were handicaps. Spencer chattered and his more fanciful paintings tended towards garrulity. "The fact that everything is so busy spoils it slightly for me. You just notice about them their amazing twitches, the colour of the tie, the amount of heat they generate, not only the path, but the garden on top of it, and the larder as well, and the cupboard, everything in it, and his wife with all her clothes on. And off." Spencer dismissed as potboilers the landscapes that Dudley Tooth urged him to supply. He was obliged to do them, he complained, to pay for his daughters' education and the upkeep of Patricia Preece; they were a waste of time for an artist itching to exercise his imagination. Yet the ordinary, he well knew,

could be poetic; indeed, constraint brought out the best in him. "Art is a kind of searching for home," he once said.[6]

Freud's response to Spencer's *Heimat* instinct was not entirely dismissive. "There is a joke saying love is homesickness. I'm always irritated by Stanley Spencer: by being compared to him. (I want to be beyond compare.) I thought his paintings were suburban as, of course, they are. But I'm more drawn to him than I thought." Both were anti-Romantic: Spencer rummaging joyously in dustbins, Freud loathing the "Realist" verbosity of Zola. There's a sense that he and Spencer had little positively in common but instinctually much to rail against.

"I think that the liberties that Spencer takes with the human frame cost him no effort, and that, to me, is what makes his pictures impossible to look at. If it looked like torture, distortion, disease or anything, it would be bearable, but the fact that this is licence based on nothing to do with form, based on whimsy and on literary concepts . . . You never feel with Spencer that this can be made better, or that it's something completely alive and is singular in itself. He's like someone who keeps on talking all the time, not listening. It avoids humourless grandeur, but it also avoids the possibility of what I think of as affecting behaviour."

Freud, who remembered seeing Spencer once scuttling down Tottenham Court Road, found the paintings a bit dotty, often—given his handling of tweedy rumps and bulging cotton frocks—literally so. "There's no standing on ceremony, he just goes in there. His strange, awkward thing to do with love and intimacy: you can't mock him for it, nor can you dismiss those things, the charged silliness of things. The large compositions are unsatisfactory because it's the boredom of people telling you their dreams; but there is truth telling in the good ones. The paintings get so extraordinary, rather brave, Blakean in a funny way. He writes about the different things, the hands and stomachs, moving in the paintings: it's like someone packing a suitcase and not getting everything in. He embarrassed people. I got a feeling that he never disliked anyone. And Christ: no standing on ceremony with him."

Years later Freud took a shine to Spencer's little painting of soapsuds on floorboards, a study for one of his Burghclere memorial

chapel paintings; indeed, he bought it at the 1998 studio sale. Soon, though, he tired of it and passed it on.

Spencer never saw, save possibly in reproduction, Courbet's *Origin of the World*, his painting of a woman's genitals, a privately commissioned potboiler considerably more "truth telling" in its singularity than Patricia Preece with her clothes off. Generations later André Masson devised a shutter for it, Surrealism masking Realism. Later still it belonged for a while to the psychoanalyst Jacques Lacan.

"If often happens that neurotic men declare they feel there is something uncanny about the female genital organs," Sigmund Freud wrote. "This *unheimlich* place, however, is the entrance to the former *Heim* [home] of all human beings."[7] His grandson was not siding with the neurotics when, in 1971, he started on what became *Portrait Fragment*; nor, despite obvious similarities, was he emulating Courbet. "Some people find faces embarrassing to do, more embarrassing than genitals. Faces are genitalia."

A painting consisting of neck, pudenda, a foreshortened torso and inner thighs was stopped short when it became impossible to continue. "That was the beginning in fact of a portrait and then the person changed and I couldn't go on." That person had misgivings about the whole thing. "I found it difficult to do that, exposed; it was someone using a love situation unnecessarily. He knew I was in love. 'Only for the two of us,' he said, but I decided not to and I stopped it."

A further painting, *Head on a Brown Blanket* (1972) with bared shoulders, was larger originally: more horizontal. "I just cut her head off; I cut such a lot down then." Jacquetta remembered it as being edited down because her breasts were getting bigger with pregnancy.

Freud had urged her to stop using contraception. "He said, 'You are mine and I want a child.' Women were always taking children off him, he'd say: 'Nothing to do with me that they're having children.' An outrageous thing to say. I decided to have a child on his birthday, so then I got pregnant and I said to Peregrine in Cornwall, 'I am so sorry, am in love with Lucian'—it was two years after I had been seeing him—a terribly difficult time."[8]

Freud appreciated her anticipatory calculation. "She was trying to give me a birthday present and missed it by two days." In fact she missed it by three weeks. He remembered the birth, on 16 November 1971, as exceptionally dramatic.

For Jacquetta the birth passed in a haze of joy and apprehension, "blissful on pethidine,"[9] her memory blanking out that she had wanted Freud to be there. She noticed only the concerned faces around the bed. She called the baby Francis, after Bacon and her sister-in-law Frances, and Michael after Freud; however he became known as Freddy, the name given him by Peregrine Eliot, his registered father, who agreed to accept him provided the matter was not referred to again. Later Freddy learnt who had sired him, a father who after spending a whole day with him once said, "I could have spent the whole of my life with him." Or so he told Frank Auerbach, who felt that the remark was heartfelt. "He liked babies, whereas Francis [Bacon] said that when his sister had a baby she had a little pink bonehead and while she was screaming, he said, he just couldn't understand why his sister didn't open the window and fling her out."[10] Anyway Jacquetta asked him to write a letter telling the baby that he had been wanted.[11] He did as she demanded, but after their break-up he asked for it back.

"I'd wished that I had a child absolutely identical to Lucian and I got it."[12]

The paintings of Jacquetta, when sittings resumed, were intense. Nothing grasping or supercilious about her: for a while she sat four nights a week, tensed and fuming in *Small Naked Portrait* (1974), one leg braced, the other readied as though to kick. Three versions of the *Small Naked Portrait* pose survive and at least eight or nine were worked on, paintings primed with the stresses in the relationship. Her wilfulness and quick anger unnerved Freud and often brought out the worst in him. "He could be so demanding, unaware or uncaring that I needed to be with the children."[13]

The intensity, and a fond attention to the thickness of an ankle and the mole on the neck, differentiates these exquisite paintings both from those of Penelope Cuthbertson and from the more imposing Bindy Lambton. Jacquetta wouldn't become passive. In *Naked Portrait* (1972–3), she clenches a fist, draws one leg up to her chest and extends the other down between mattress and bed frame while ignoring the stool on which brushes and palette knife are displayed like a batch of surgical instruments. Of all his paintings of her, this, Freud said, was "the least like. She's in a kind of trance." This she denied. She was, she said, just thinking of other things. "Asleep most of the

Lucian Freud and Jacquetta Eliot

night, dead tired from looking after the children all day, not having a proper nanny. Why was I doing it? I didn't start for ages. It was difficult fitting the sittings in, terrible stress and strain. It did make me somebody basically I'm not."[14]

They tried living together. She and baby Freddy joined him in the Camden Road flat, but she soon had enough of that. Freud also stayed with her and the children where, as she explained, there was more room. Polaroids survive of him romping with the boys and fooling around in the bath. "We had moved to Lansdowne Crescent and I used to rent out the basement, Arabs from Qatar rented it for what then was a lot of money.[15]

"Lucian never helped out. Never. Not even then. It didn't work out because he hadn't got the help he had with Jane Willoughby, and so he went back rather quickly. My life was either in Cornwall or with the

children and if I wasn't going to be his model we wouldn't have been together. I was with the children and he with his pictures. Then he'd go off with some girl and I'd retaliate. I'd drive round the block and there would be his car, nestling and hidden, and I'd get furious."[16]

Freud of course, having prompted the rage, was the prime target. "She bit me through the shoulder—broke her tooth—and I was banned from a swimming bath because of it. And there was a scene, rather like a tragi-comic film, when Perry was in the house when we were having a really violent fight. She was shouting and Perry said, 'I think perhaps she doesn't want to see you now. There'll be other opportunities . . .' Jacquetta said, 'I've never been like that with anyone else.' I think she didn't know herself very well. I've never had such times both good and bad with anyone, that's why I can't pretend or overlook things that would be 'trivial if I didn't love you so.' She's

always been very good about scope within which to play up. Which is very feminine. I've always been interested in the limitations people put on their conduct (leaving absolute desperation out of it)."

"On the inside the real Lucian was very loving, hugely supportive and kind." But, Jacquetta added, "he would come fighting in like a mad cat; the minute he'd seen me he'd wind me right up and he'd see me getting rickety and he'd love that and really tear into me. I was just addicted."[17]

Freud admired her spirit. At times, he felt, it was like being beset by a classical Fury. "Francis said, 'Do you think her treachery's a kind of hysteria?' Her vicious side: she smashed everything. She'd got incredibly strong legs and kicked me in the head when I was driving, saying I'd looked at a girl. It was like the Andy Capp cartoon of a man lying on the ground and the policeman looking on and Andy saying, 'I hit him back first.' "

"Lucian loved a drama and me saying 'Fuck off,' " said Jacquetta. "He was helpful though. I felt loved. I did have fantasies of a domestic life in wheelchairs in Brighton. Fantasies of myself working in one part of the house and him in another part.

"I'd write letters and they would ricochet back. He would come crashing round. He'd send letters scrawled in red blood or something. 'I'm going to kill you.' I used to call myself '227,' as in 227 Gloucester Terrace, as being the 227th."[18]

Such a number was, Freud stated, poetic exaggeration. "At Gloucester Terrace the ex-sergeant major in the ground-floor flat put up a notice: 'Please don't throw Rubbish in the Basement as it will attract Rats.' Jacquetta wrote: 'You're too late: there's one living upstairs already.'

" 'Got one of your love notes there,' he said."

When I first met Freud, in 1973, he assured me that Bacon, now in his early sixties, was fit and young and inventive and destined for a grand old age, though his portraits, he added, now needed to go in threes, for mutual support. He had been to Paris, with him, Sonia Orwell and her friend Julia Strachey for the opening of his first Paris exhibition, at the Galerie Maeght in November 1966, but not for his 1971 retrospective at the Grand Palais, which was unprecedented recognition

for a British artist. Bacon's international reputation now far exceeded Sutherland's and even threatened to eclipse Henry Moore's; and as the pressures of success and the twinklings of fame increased they became seductive. Besides the swish triple portrait heads there were bigger paintings, ominously so. Ones that Bacon himself described as "important," notably *Three Studies of Lucian Freud* (1969), in which Deakin's shots from 1958 of Freud fidgeting on his brass bed became interrogatory images of a victimised figure seated in a mustard-coloured showground. The expansive output represented an upgrade: being in pole position Bacon could not but be moved to spread himself more. Celebrity became hard to ignore and impossible to repudiate. Freud still saw him fairly regularly but on more than one occasion found him deranged, hounded by delusions founded on real fears.

"I used to go round quite often to Reece Mews [Bacon's studio] at 5:30 or 6 and have some early dinner. One afternoon he came down in a terribly agitated state and said, 'You can't come in, you can't come in: there are people here.' I thought he was being roughed up or something so I said, 'Shall I get them out?' He said, 'You can't come in.' 'Who are these people?' I asked. 'Well, they are victims of my tongue.' And then he went, 'Oh I'm sorry. I'm stupid, I'm stupid,' and shook himself. I said, 'We'll say no more about it.'

"I thought it was such an extraordinary phrase: 'victims of my tongue.' To do with turning on people: he'd been drinking all morning and afternoon and he'd been half asleep and got agitated. It was sort of DTs, I suppose.

"But bad things did happen. There were windows, starting at a height of about nine feet. He had blankets nailed across them—they were like an old dog that had been in a really dirty river—and he heard a noise outside the window, tore away the blanket, and there was a man standing, absolutely quiet, on the windowsill. Real Eumenides. I was sure it was real; otherwise he'd have woken up. He said things were getting out of hand. It's not that he drank so much but that he drank so consistently. It was to do with going round Soho and being incredibly wild and generous and saying the most extravagant things and people saying even more extravagant things about him and what he may or may not give them and it was obviously blackmail. They were just waiting. He said he really was frightened and went to France the next day."

George Dyer was more hopeless than ever, dependent on Bacon, who outfitted him in smart suit and tie, yet a threat to him and a drag on him, albeit a pathetic one. "It's very hard to behave well," Freud pointed out. "Francis was more and more horrible to him but he told me that George had put a rag soaked in turps or meths through the letter box, to put a light to, and was desperate." He also planted cannabis in the studio and told the police. Bacon's successful defence, handled by Lord Goodman, was that, being asthmatic, he never smoked anything.

Something had to be done about George. Sonia Orwell, the former "Madonna of the Euston Road," who had reverted to being the Widow Orwell after her marriage to Michael Pitt-Rivers ended and who now fancied herself as an organiser of Bacon's affairs, even proposed bumping him off, arguing that this was common gangster practice. Freud (who had taken her to Glenartney once: "a broken-down, drunk nuisance") was outraged at this nonsense and wrote to her, he said, about her "bossy, infatuated, mad interference," ending: "With friends like you I really don't need enemies." Unabashed, she told Freud that he didn't understand drunkards. "Took one to know one. She was tiresome through drink, destroying herself through drink." She took it upon herself to be an unofficial *patronne* of Bacon's show at the Grand Palais, deeming it an event worth boasting of as a *projet* of hers—given her French intellectual connections—if it proved a success. Which it was, except that in ghastly circumstances immediately before the official opening George Dyer died. He had brought an Algerian boy back to their hotel room and, discovering this, Bacon had moved out, to Terry Miles' room. The following morning Miles and Valerie Beston found Dyer dead in the lavatory. The cause of death was an aneurism brought on by drink and pills.

"His heart was weak. Francis made him suicidal," Freud concluded. The suicide of Bacon's previous lover, weepy Peter Lacy, in Tangier immediately before Bacon's Tate retrospective in 1962, was so close a precedent that some saw in it the symmetry of Greek tragedy where others saw squalid and melodramatic coincidence.

"The gang said he must have a proper funeral, meaning a gangland one, and they'd give money. So Francis paid for everything: he didn't want to fall out with them. To George's villainous mates—he was a mascot for them—it was vitally important to have a proper

funeral. They went because they were interested in the ritual, the show: otherwise you're nothing. George had no family that I ever heard of. I knew him very well, a sweet man. I had these desperate messages from Valerie Beston saying I must come to Paris and look after him. But I knew Denis [Wirth-Miller] was there so I didn't."

For the Marlborough, Bacon's success in Paris and subsequently the great sequence of paintings harping on George Dyer's wretched death, collapsed over washbasin and toilet bowl, was spectacular vindication of their promotional strategy. Freud on the other hand came to be considered a liability. "The Marlborough didn't like buying things from me. I had this feud with them." His paintings were small and few compared to Bacon's, and there seemed no likelihood that he would ever attain that level of recognition.

3

"Pictures haven't got to do with reason"

In 1972 Freud left the Marlborough.

"The Marlborough were horrible. I wanted them to buy things and Harry Fischer said, 'You might do a lot and we'd have to buy them all.' I had a contract but it was hard to get any money. Because of [Frank] Lloyd's divorce, all contracts were cancelled and so then no one had an arrangement. I wrote and said when can I have a show? They wouldn't give me one and so I then wrote to Miss Beston and said, 'I've got no money at all and had a show cancelled. I've got no alternative but to go.' And she wrote saying she wished she could come with me. They asked me to lunch, pleading and threatening. Lloyd said, 'You've been here longer than most marriages.' 'Glad I'm not leaving you a sinking ship,' I said. 'I'm offering you a speedboat,' he said."

Though he used to wince slightly at the suggestion that he was interested in the business of selling his work, Freud did more than merely keep an eye on prospects and promotion. "Lucian was keen on that business life," Frank Auerbach said. "He knew exactly how to operate, he was very good at all that and he had a sort of awareness of the art market."[1] He reacted bitterly to what he regarded as the Marlborough's failure to back him with advance payments, as he liked to think his father would have done, reminding them of what he took to be their obligations. "David Somerset said, when I had this meeting—Lloyd, Fischer and him—that he was sorry business dealings are unpleasant. I said, 'Look, you were all here when Frank

[Lloyd] said he would go on buying the pictures to the next show,' and Lloyd said: 'Have you got it in writing?'

"I once took trouble to show my dislike. I was sort of rude to them and Francis said, 'When I dislike people I'm always *specially* nice to them. You'd get on so much better with the Marlborough if you didn't show scorn for them.'

"Mrs. Drue Heinz went to buy a picture of mine and they did everything to put her off." They had taken on the Australian Sidney Nolan and they pressed her to buy something by him instead. "In the end she bought the profile of Charlie [Lumley]. And Lloyd said to her: 'Oh well, that's the last good picture he did.' They refused to release me or give me more money. They were furious, as I wouldn't do prints. I said I could do etchings. They said no. I wasn't prolific enough and the things were too small a deal for them. They were high powered in a way that wasn't much use for me: they kept on getting me commissions which I didn't do."

James Kirkman, son of a general on Montgomery's staff, had been at the Marlborough since Freud's second show. He had been aware of Freud's work before he joined the Marlborough in 1960 and had always admired it. "Probably more than my colleagues," he said, and Freud had noticed this. "When he arrived he showed interest. Then he said, 'I'm going and would you like to come? You'll get more than if you stayed as I've been looking after you for ten or twelve years. And you'd get the money on time.' [Kirkman's recollection was that Freud said, when he left in 1972, "What will happen to me? I'm not staying with those bastards."] Gilbert Lloyd [son of Frank Lloyd] said, 'I suppose you want to leave and be a big fish in a little pond. You've got a long way to go.' I was a very small fish at the Marlborough; James was a very small fish too. Once, when he sold several million pounds for them, they said, 'Which would you like?' (he had just pulled off a deal involving an early Henry Moore) and he chose one of mine." This was *Girl on a Sofa* from 1966, Kirkman said. "Worth £350," he remembered. "I said I'll take that, and Fischer said, 'Are you mad? You could have had a Ceri Richards.'[2] Then Francis said to one of the remaining directors: 'You've lost the best artist you're ever going to have.'" According to Freud, Bacon was equally determined to dis-

suade him from leaving. "Francis said to me, 'You're mad going with James, he'll never get any bigger.'" Then the Marlborough offered what Freud described as a "gangsterish" deal, but Freud had made his mind up: he went with Kirkman.

"The suggestion that I should represent LF came from him," Kirkman said. "I was his 'contact man' at Marlborough and at the time he did not like the directors there and no one else took much interest in him—it's hard to remember how unpopular figurative art was in those days. If Freud did have an international reputation it was as a grandson still, as an adjunct to Bacon, and as the winner of long-ago, local, competitions."[3]

Kirkman did well for Freud, working devotedly and efficiently on his behalf. "James was good for a very long time. It was a very good gentlemanly arrangement: he wouldn't advance me money, he reserved the right to buy the pictures, which he always exercised." Not having a gallery, however, he needed to have an arrangement whereby he could exhibit the work. Accordingly he fell in with Anthony d'Offay's suggestion that they should share the responsibility for Freud, a proposition that Kirkman represented to Freud as using d'Offay "as a shop window."

"Anthony did a good job," said Kirkman. "At that stage neither of us had much money and it certainly was a concern that LF was permanently overdrawn on our account with him. As I remember it the workload was not initially particularly heavy as critical interest in his work, proposed exhibitions, etc., was minimal. His production was considerably less than recently. There were no etchings, very few demands for photographs or interviews and no need for overseas travel."[4]

"Then d'Offay started selling," Freud said. "He put the prices up. They hadn't changed for twenty years: £400. Anthony pushed them up. 'I didn't realise you charged Academy prices,' he said to James. Suddenly they cost several thousand pounds."

In the early seventies Anthony d'Offay, who was to become for some years the leading London dealer in contemporary art, had modest premises, first as the D'Offay Cooper Gallery behind the Burlington Arcade, then as Anthony d'Offay in a small shop in Dering Street off New Bond Street. He specialised in the English art of two or three generations before: Decadents, Vorticists, the Camden Town Group

and, especially, the Bloomsbury painters and decorators. Bloomsbury was his chief interest initially, with Vanessa Bell and Duncan Grant foremost. To show Freud and Michael Andrews, who also decided to go with Kirkman, was a bold move for him. Caroline Cuthbert, d'Offay's assistant, remembered him as being solicitous and sensitive on Freud's behalf in the early days. As Freud had no phone (he didn't get one until the late 1970s) he would send telegrams saying "Please call Anthony at the gallery" and they would have long conversations, d'Offay wooing Freud. He later made the mistake, as Freud saw it, of enlarging his stable of artists to include the leading Germans—most prominently Georg Baselitz and Joseph Beuys—and thereby no longer devoting himself all that much to him. At the start of the relationship, however, d'Offay was, he decided, useful to him. And of some interest personally speaking. "Cyril Connolly told me that when d'Offay was at school he got letters from him—he thought him a book dealer—offering Ezra Pound manuscripts. He bought them. D'Offay was a great friend of Omar Pound. Then he had this long analysis: his upbringing was so horrible, his sadistic father humiliated him and he loathed his mother, who hadn't been a mother at all (she had an antique shop in Leicester), so the woman he was most intimate with, Angelica Garnett [daughter of Vanessa Bell and Duncan Grant], he said to her, 'Angelica, I want you to do something for me.' 'Yes, what is it?' 'Will you be my mother?'

"He was twisted up with unhappiness. When I first knew him, every few weeks he couldn't go out and was in a darkened state. Then he had this idea of being in a group or gang and going to boxing matches." On 30 October 1974 d'Offay took Freud and Coldstream and Frank Auerbach to a screening of *The Rumble in the Jungle*. "'These are my memories,' he said. 'No need to have them,' I said. It seemed like a kind of sexual thing. At one boxing match, a terrifically violent fight, Anthony reached out in his excitement and said, 'Isn't it marvellous!' and the man in front said, 'Take your hand off me, you filthy poof.'"

D'Offay was meticulous. For Freud's first exhibition at the gallery, in October 1972, he produced a trim little catalogue, designed by Gordon House, with *Lucian Freud* on a tipped-in label on a blue sugar-

paper cover and a frontispiece photograph by Harry Diamond of the artist perched on a stool in his chef's trousers, backed up against closed shutters.

The most recent painting in the show, *Factory in North London* (1972), was done from Ib's bedroom window in Suzy Boyt's house in Islington. Ib had to move out while he painted. Freud would arrive, go to the bedroom and the children would notice the smell of oil paint; they took for granted the interruption. By then they were going to the local school in clothes made by her mother, Rose remembered. Dad, she knew, was a painter, which suggested to her school friends that he was a house painter. The view from Victorian house to dilapi-dated modernistic industrial premises featured Crittall windows such as Ernst Freud had favoured, a rusty power plant, fire escape and air vent. "It was an asbestos factory. Very dangerous. They looked pretty ill, the people who worked there. There used to be a woman on the iron steps and I got Ali to photograph her and she was absolutely furious and I felt badly: like cruelty to animals. I thought of putting her in to inhabit the painting: like Constable's little people." Ali took the photographs, black-and-white Polaroid. The figure emerging to have a smoke on the fire escape was omitted, mainly because it gave the scene the air of something happening, which Freud did not want. "I only wanted it to inhabit the factory and make it a working place. But the person being in it suddenly threw everything out." So he put two nearly empty milk bottles on an upstairs window ledge as indica-tions of employees while the glass shards cemented along the top of the perimeter wall were a glinting deterrent to intruders. After being photographed for the catalogue, brickwork was filled in along the bottom of the painting, creating an extra layer of detachment.

Such reviews as there were tended to be positive. In the *Finan-cial Times* Marina Vaizey said how pleasing it was, in an art world of "video-tapes, recordings, statements, films, books, happenings and the like . . . to find a *painter* with something to say and the means to say it."[5] Between *Large Interior, Paddington* and *Factory in North Lon-don* there had been a change of outlook to open air; between *A Filly* and *Head on a Brown Blanket* there had been an equivalent enrich-ment. In the small rooms of the d'Offay Gallery each painting looked newly minted and particular. It was in effect a show of confidence.

The exhibition was toured, in that it went to Hartlepool in

County Durham. The keeper of the municipal art gallery there, John McCracken, a former student at the Slade who had stayed with Freud a few times—"drunken, ended up very badly," Freud recalled—had bought an unfinished portrait of Charlie Thomas' sister for Hartlepool and when he asked if he could show the other paintings too, Freud thought why not?

I reviewed this, the first array of Freuds that I had ever seen, for my local newspaper, the *Newcastle Journal* ("His sitters are not flattered. They are shown shifty-eyed and evasive. Their faces are ageing visibly . . .")[6] and went on to describe, in the *London Magazine*, how it was to light upon such paintings in so unexpected a place.[7] Their appearance in a Victorian villa (formerly The Willows, now the Gray Museum and Art Gallery) in so decrepit a seaport was incongruous, I wrote. "German battleships bombarded West Hartlepool in 1914 and shell fragments still take pride of place in the Gray Museum and Art Gallery. The paintings hung in a perplexing decor of yellow hessian and floral-damasked walls and fruity stained glass with inset hand-painted views of waterfalls. Despite all this Freud's paintings held their own, as they have done for years."[8] Here was a new Realism, a renaissance indeed in indifferent surroundings. I didn't realise then that this was Freud's first one-man show outside London.

He did not go north to see it. There was no question of that, preoccupied as he was with working from Jacquetta and, increasingly, his mother, whom he referred to when I first met him in London some months later as his "main day subject." He told me then about his father having died three years before, leaving his mother unable to cope. "My mother tried suicide, she took all the remaining medicines and then virtually completely wrote herself off. She left a note saying, 'I've gone to join Ernst.' Her neighbour [her sister in fact] stopped her; she was taken to hospital unconscious and brought to life again, very slowly and much against her will. And then she couldn't walk and later she went home absolutely miserable. She gradually moved away from it but was as good as dead. (My brother Stephen said, 'As far as I'm concerned she's dead.') It was bad for her because this was her will and she suffered a lot, but lucky for me from a selfish point of view. I started working from my mother because of my father's death."

Certainly bereavement felled Lucie Freud; reports of a living death however were exaggerated. She needed a minder and her sis-

ter ("Aunt Mosse") took over, only to complain shortly afterwards how demanding and exhausting this role was, so much so that Freud arranged for someone to call in at St. John's Wood Terrace every day for a week to give his aunt a bit of a holiday. That someone, Alice Weldon, expected to find Mrs. Freud catatonic but to her surprise found herself being soundly beaten—repeatedly—at Scrabble by a formidable opponent, perked up, severity intact. She took the lettuces Alice brought her and boiled them up in her pressure cooker. Fretting at being away, Aunt Mosse decided to return sooner than planned. Shortly afterwards the painting sessions began.

"A man who has been the undisputed favourite of his mother keeps for life the feeling of a conqueror," Sigmund Freud had written.[9] Equally, such a man could be in thrall. Frank Auerbach remembered Freud saying to him under his breath—as he used to do when imparting something he felt he had only just admitted to himself— that because of his mother he couldn't have a lasting relationship with any woman. Not that he blamed her. He had always appreciated, while often resenting it, that he was her favoured one, her *Wunderkind*, the child she had once asked to teach her to draw. In that his affairs were not for her to pry into and his behaviour in almost every respect was a worry, she had remained—so long as Ernst was alive— vexed but accepting or, rather, not wanting to know. Yet the adoration was admonitory, he felt.

Among the illustrations in the *Balladenbuch* that the infant Freud had often looked at with his mother was Dürer's study of his own sixty-three-year-old mother, scraggy, wary and, maybe, piously censorious. "The paintings are so horrible, a lot of them, but the drawing of his mother is marvellous." Freud had drawn his mother a fair number of times when he was at the Central School of Art and again early in the war and now, after a thirty-year gap, he was seeing her almost every day. This would have been unthinkable had she remained attentive like Frau Dürer; as it was, she just sat.

"She barely noticed. I think it was *me* more: I had to overcome a lifetime of avoiding her. From very early on she treated me in a way as an only child. It seemed unhealthy; I resented her interest; I felt it was threatening. She liked forgiving me. She forgave me for things I never even did. Curiously, when I asked her for something it came out: 'Why not? I have given you so much already.' But there wasn't

a lot of that. I remembered once when she cut herself and left the blood in the basin and I thought that was bad, a side of her exhibited. But no, she was admirable. She saw me as this heroic figure, to some degree." Many years and many paintings of his mother later, he talked about the good fortune of having had her at his convenience or disposal for so long. "If my father hadn't died I'd never have painted her. I started working from her because she lost interest in me; I couldn't have if she had been interested. One morning when I went to collect her she said, 'I'm all right,' and from then on she was better."

Sitting for one painting after another, Lucie Freud settled into being there for her supremely accomplished son without worrying about him any more. He became her devoted and considerate escort. Once he took her to Auerbach's studio near Mornington Crescent. She sat silent and unresponsive throughout the visit except when it was mentioned that in Berlin days she had seen, more than once, *Rise and Fall of the City of Mahagonny*. Or was it *The Threepenny Opera*? Whichever, whatever: it stirred a memory and she murmured: "Fifteen, sixteen times."

What became a series of paintings over the following decade began gently with signs of mental disturbance—the eyes successively apprehensive and downcast—and acute vulnerability. "The first were the tiny heads, exceptionally small even for me; then one quite in profile and one of her reading. They were pictures of a person who had physically survived but not really. I don't know that she looked at the paintings. But my Aunt Mosse certainly hated them. She was pretty nasty, showing superiority and disapproval with a smile, which made it worse. She said, 'You've made her look absolutely horrible, like your father.' My aunt hated my father because she came to England very late and my father gave her a house and subbed her, which she didn't like. My mother adored her. My aunt destroyed my father's plans and scale models, before my mother died, to clear the garage and let it."

Four or five days a week, on and off for upwards of fifteen years, until the mid-eighties, Freud collected his mother in the mornings and took her for four-hour painting sessions to 19 Thorngate Road, a cul-de-sac in Maida Vale where he moved after the council began renovating the top end of Gloucester Terrace. By the end of 1972 he had completed three small paintings of her there. Test pieces, though not tentatively so, they satisfied him that, unhappy though she remained,

there was a point in the two of them being alone together, regularly, hours on end, she holding his attention, "actually being alive and being there and sitting there."

Large Interior, W9 (1973), painted in the back room of the flat in Thorngate Road, is a study of separateness and proximity. Two people are ignoring one another though not necessarily unaware of being foisted on each other; certainly in the artist's view they enact a tensed situation. Mother holds the floor, commanding respect, and the woman behind her is out of sight, out of mind, as far as she's concerned.

Enthroned in the armchair from Gloucester Terrace, she has her back to the hearthstone and blank bedroom wall where, in earlier years, an open fireplace had graced the room. Jacquetta Eliot on a divan stares at the ceiling, her arms locked behind her head, her legs hunched under the brown blanket.

"Pictures haven't got to do with reason." But one assumes that the painter has brought the two sitters together purposefully, that they are in some way related, he being the reason they are there. They are a contrast: the one subdued, the other so ardent; they are looking in different directions, as though refusing to recognise what has brought them to this. If the painting is a "Two Ages of Woman," lover and mother—the passionately imagined and the peacefully resigned—then it qualifies not as a "problem picture" but as a conflict of interest, in stage terms a two-hander: binary stereotypes, the maternal and the seductive.

His mother did not know about Jacquetta, Freud believed, though she did hear her once or twice banging around in the front room. Jacquetta disputed this. "She must have known. We did meet." When living with Jacquetta a year or so earlier in Lansdowne Crescent Freud would drive with her and Francis (Freddy) to pick his mother up in the mornings after dropping her two elder sons at their school in Loudoun Road. "Several times I went in the car to St. John's Terrace," Jacquetta remembered. "First take the children to Arnold House. Then to his mother's house to pick her up, four of us in the car, then to [Maison] Sagne's for breakfast, then going to Gloucester Terrace, when Francis and I would walk home and he'd work. We walked her down the path to the car. She seemed rather preoccupied, not in a mood to be convivial. She said, 'Nice-looking child': I didn't

know if she knew. But she gave me a photograph of her three boys. I had three boys too."[10]

"Living people interest me far more than anything else," Freud told me shortly after finishing *Large Interior, W9*, having reworked Jacquetta lying there many times to get a slight disproportion evident yet unobtrusive. He acknowledged that the situation here is a re-enactment or re-echo. Not of a Sickert as one might have expected, given such a room (and if the fireplace hadn't been removed), but of Giorgione. "The *Tempesta* idea. That's how I thought of it. It came to mind." In *La Tempesta* the woman breast-feeding on a riverbank ignores the man looking across at her, yet a crack of lightning between the trees completes a triangle and sparks a connection. Not that there is any mystery to be solved in *Large Interior, W9*, Freud insisted. "It's only the idea of the complete unaware, or ignoring. They are not necessarily unknown to each other, not like Brueghel's *Icarus* where the ploughman ignores Icarus in the sea. It's to do with odd things happening like in pre-war French films: *La Bête Humaine*."

The pestle and mortar smeared with crushed charcoal and placed by the armchair is not symbolic. (An audience of Los Angeles psycho-analysts chorused professional disagreement with me when I asserted this once in a lecture.) It serves, rather, as an odd but apposite insertion without which the two figures would lose their bearings a little: it's pivotal in the picture. Freud often mixed charcoal dust into his paint to give it a Paddington tinge. "Ingres used to tell his students: 'Gentlemen, always put a little black in your white.'"

Strangers in the waiting room, the two figures form an arrangement. Like a conjuror's assistant revealed under the blanket Jacquetta is the element or agent of surprise. Could she be a phantom presence? Freud had a photograph of her top half to refer to when she was not available.

"Mother was never there at the same time. She didn't register anything much. She was so detached. I used to get her in the morning and take her to Sagne's in Marylebone High Street for breakfast. 'There was a burglar here last night,' she said one morning. 'A man standing in the doorway of my bedroom and he rushed out.' 'Did you mind?' 'Not at all.'

"She said—not to me—'Every morning when I wake up I'm disappointed.'"

In May 1972 John Deakin died in the Ship Hotel in Brighton where Bacon had sent him to lodge while Deakin was convalescing from a cancer operation. The plan had been for him to go to Greece: to Poros in fact. Dan Farson was to go there and meet up with him, which he did, only to be stood up, he thought. Returning home he went straight to the Colony Room and there discovered that Deakin had been buried that very morning. He had named Bacon as his next of kin; Bacon, grumbling, went down to Brighton to identify the body. "It was the last dirty trick he played on me," Bacon told Farson. "They lifted up the sheet and there she was, her trap shut for the first time in her life."[11]

That October, just a year before he died, W. H. Auden left New York. In London, before going to Oxford where he intended to reside as a Fellow of Christ Church, he appeared on the Michael Parkinson chat show on BBC television and took the opportunity to talk, as was increasingly and repeatedly his habit, about the need for rules in poetry. "The subject looks for the right form, the form looks for the right subject." He capped that with an all-weather aphorism. "The arts are a chief means of communication with the dead. Without communication with the dead a fully human life is not possible."[12]

Geoffrey Grigson rounded off his Auden obituary with a salute: "As he celebrates, investigates, discards, adds, re-attempts, we find in him explicit recipes for being human."[13] Coming from the waspish Grigson this was oddly sententious. Auden's death prompted recycled recollections of "the Thirties poets," a gang apart. Stephen Spender found himself much in demand in both England and America as a period survivor. Coincidentally Freud, while not a "Thirties" painter, was associated with that older generation. A prodigy who had redeveloped, a prodigy made good, he was offered a retrospective at the Hayward Gallery on the South Bank, the new citadel of Arts Council exhibition organisation. "The first time I heard anything about it the obscene sculptor Hubert Dalwood said that 'on the Arts Council we were talking and I said why not have a big show?' I thought fucking hell, never. It was not what I required. And then something happened to put it into focus." Rapidly put together, it was to be Freud's first show in a public gallery since Venice in 1954, apart from West Hartlepool.

While engaged in writing the introduction for the Hayward catalogue John Russell had lunch with Freud. Jacquetta Eliot came too and sat silently, he remembered, her hand cupped, looking into her palm with a radiant smile, and in the end as they left the restaurant she held it out and showed a conker. "Isn't it beautiful?"

4

"The portraits are all personal and the nudes especially demand it"

I met Freud for the first time in November 1973 when I was commissioned to write an article about him for the *Sunday Times Magazine* to coincide with the forthcoming exhibition. As John Russell was to point out in his review, in thirty years there had been only one magazine article devoted to Freud: the profile by David Sylvester published in *Art News and Review* in 1955. Mark Boxer the caricaturist, then an assistant editor on the magazine, briefed me. It was obvious that he longed to interrogate Freud himself but for some reason this was not possible. Instead he jotted down a list of questions that, he impressed on me, needed asking:

> *Pictures not in show: why*
> *Stephen Spender photo—has he found it????*
> *Is this 1st interview?*
> *What is it like to be painted by you—Do you mind my talking to, say,*
> *Jane Willoughby?*
> *What do you want to do in the next ten years.*
> *How English is your work.*
> *The nude*
> *Paintings he owns.*

Boxer did not tell me that he and Francis Wyndham, who also worked on the magazine, had previously engaged the journalist James Fox to write the article but that this had fallen through. Years later

Freud told me that he had suspected that Fox had been asked by Boxer ("disgusting, insidious") to deliver an exposé. "Trying to write about me, he went up to Suzy and the children, when very young, and Jane, and other people I saw, and started asking questions, which worried me a bit. James Fox had just done the Lord Lucan [murder] case for them, and he treated Veronica Lucan so horribly." He was anxious to control his privacy. "I said please would he not mention some things: certain areas where I'm rather fragile, like my address. I didn't care for myself, but others might be affected. A girl I hardly knew, and people I knew like the Krays. 'Would you mind showing me what you've done?' I said to him." Fox had said he could not undertake to do this: journalistic principle. So Freud told Wyndham, whom he had known a bit since early in the war, that it was no good: it was dangerous for him and so he would not give reproduction rights. To placate him, Boxer said that they would get someone else to write the article.

Down from Newcastle, where I then lived, I was staying in Canonbury with the painter Sean Scully when Freud called round. It was late on a November evening. He appeared suddenly at the door asking for me. No, he wouldn't come in. He looked pale and tense, itching to be off. We would meet the next day, he told me. At noon. Having given me directions to where he lived—a cul-de-sac off Marylands Road, just off the Harrow Road—he paused on the step as though deciding what further to say then turned and vanished into the dark.

Number 19 Thorngate Road, a late Victorian terrace house with spindly columns flanking the front door, had a Bentley parked outside and a cramped adventure playground opposite. Smiling a faintly wolfish welcome Freud hurried me upstairs two steps at a time. The rooms had been knocked about a bit; the council, he explained, had removed the fireplaces and installed radiators and "slightly illicitly," as he put it, he himself had taken out a wall or two, as was his habit. There was a bed in each room. In the bathroom, lurking behind a bead curtain—one he had bought in Nice in 1948, he told me—was a bossy bronze figure: Rodin's naked Balzac standing with arms folded as though affronted. In the back bedroom, where he worked in the daytime, *Large Interior, W9* was on the easel and the blackened pestle and mortar were still in position by the chair: "A chair I use a great deal which I very much like."

"Bed, radiator, armchair, easel," I noted. "Sheaves of brushes,

stacks of primed canvases. Flecks and dabs of thrush-coloured paint beside the window: Naples yellow, raw sienna, off-whites. Paddington colours." Having already decided, a day or two before, not to try the Mark Boxer questionnaire on him, I said that I really wasn't interested in his private affairs. "Hooray," he replied. I looked out of the window: nothing much there. "Dishevelled gardens, derelict lilacs. A swing hangs idle. Mattress slumped against a wall."

"I'm fascinated with the haphazard way it's come about, with the poignancy of the impermanency of it," Freud said, his voice drifting a little, faintly Germanic. He told me that there was a parrot in a downstairs room in one of the houses opposite and that an old woman used to go to the outside lavatory and not shut the door. Unprompted, he began talking about his mother, saying that she had money, that when his father died she'd tried suicide and that her sister stopped her and that at ten, when they left Germany, he had been conscious of being a little bit "non-Austrian" and yet not being a practising Jew.

He made a rapid move into the larger front room. There on a table beside the brass bed were telegrams and opened letters and copies of the *Listener*. No phone. This was where he worked at night, he said: seven o'clock to three or four in the morning, then a bath. "I very much like the idea of a painting room, rather than a studio, which is a cage for an artist animal to work in; I'd always rather have a nice Victorian first floor.

"It's a half-inhabited street with only one side." That meant he wasn't overlooked. "A street with only one side has a sort of tension about it." And extra light, of course, same as in the days when he had lived next to the canal, though actually it was the light in Greece that had really started him drawing: all objects there were so clearly defined by light. Byzantine formality had appealed to him too.

On the easel he had a painting of a woman sprawled on the brass bed with brushes, palette knife and pot of turps set on a stool in front of her as though in tribute to her. It was to be called *Naked Portrait* (1972–3) and, exquisitely contained though it was, it too had a sort of tension: an uncomfortable position maintained under protest.

"The portraits are all personal and the nudes especially demand it."

Lunchtime. He changed out of his chef's trousers behind a chair and emerged in a green cord suit. We left Maida Vale in the Bentley at violent speed and talk turned to Chardin without any appre-

ciable effect on his driving. Chardin yes, for him—Morandi no—and he particularly liked *The Young Schoolmistress* in the National Gallery, talking of which, at one time he often used to go there just to see *The Battle of San Romano*. Outside L'Etoile in Charlotte Street he parked unhesitatingly on a double yellow line and sidled into the restaurant not so unobtrusively as to avoid having the waiters say, "Good morning, Mr. Freud," one after another. He ordered Perrier water and a slice of lemon.

During lunch—he hardly ate—we discussed Sonia Orwell, a mutual acquaintance, and his having written a letter to her, which had meant no more relationship. John Craxton? Trouble there too. Craxton, he said, had been passing off his early work with Freud signatures and had also pinched things of his. Solicitors had suggested a meeting to sort things out.

Whitney Straight, who ran Rolls-Royce, he said, and whose mother, Dorothy Elmhirst, had run Dartington, passed the table and said hullo. Freud winced. He knew him from Dartington days. "Just likes to get drunk with lots of girls." Rather like the Duke of Devonshire, who had been very generous to him: he too was a drunk, dried out, and had proved a staunch sitter. He had such difficulties getting people to sit. "I'm quite tyrannical though."

At one stage, he added, he himself had gone in for attention-seeking evening wear. He mentioned the fez and postman's trousers. "It was initially a way of overcoming my shyness."

Talking of artists' images in films, he brought up Ken Russell's *Savage Messiah*, his burlesque film about Henri Gaudier-Brzeska: judging by that, he thought, he'd be good on Henry Moore ("Wouldn't you agree?"). One could so easily picture the stone-bashing bits. He liked the idea of *Last Tango in Paris*—recently screened—and the Bacons shown behind the titles, but he disliked the film. Self-indulgent. Preferred Buñuel.

He still went to the cinema. Sometimes twice a day, he said, but less than he used to. "That thing of coming out: all the people on the pavements having proper lives and you're all full of what's been on the screen."

I slipped in just one of the Mark Boxer questions: what would he want to be doing in ten years' time? The nudes he thought were his most important work. I suggested they may look post-coital, some of

them, and he bristled at that. He wanted them as people. He didn't
want to excite anyone else by them. "They are naked people with
whom one is intimate."

By the time we had finished lunch it was beginning to snow. Hav-
ing thrown away the parking tickets tucked under his windscreen
wipers Freud drove quickly to a street corner where a young woman
stood waiting. She got into the car without a word and we weren't
introduced (many years later she revealed herself to me as Alice Wel-
don); he then drove to a bank and stopped outside while she went
in and, within minutes, came out with a bulging shopping bag. He
talked softly to her, arranged a date for that Friday, dropped her, took
me back to Thorngate Road, nipped upstairs with the bag and stuffed
bundles of banknotes into a cupboard. Why? "Oh, I'm going bank-
rupt."

Sprawling on the brass bed he went through the list of paint-
ings to be shown at the Hayward, pointing out a few changes. *The
Procurer* was to become *Man in a Headscarf*. He mentioned that this
man, David Litvinoff, used to put margarine on his hair and that he
had resented him planting girls on him but that he had in fact taken
up with one of them behind his back.

Time to go out again. First to a garage where he bought eight
gallons of petrol, remarking that there seemed to be no lack of petrol
despite talk of rationing as a consequence of the recent "Yom Kip-
pur" War. Then we drove up Maida Vale to a house near Carlton Hill
where a fault in the car was to be fixed by a mechanic working for Guy
Harte, a jockey turned trainer, antique dealer, gambler, etc., who, he
said, owned *Michael Andrews and June*. As we sat in the car waiting
for the mechanic to appear, schoolboys ran shouting in the dusk. He
talked about gambling, about disliking gambling against people, say-
ing that baccarat was OK "as it is against the bank"; he was doing it
less now, being conscious of limited time at his disposal. He felt, he
said, "less need to rush round the streets. I don't go off now except a
night in Brighton, maybe: rarely leave London."

The mechanic arrived, drove round for a while listening for an
almost inaudible fault and pointed out to Freud—perturbing him
slightly—that there was a "de-mister" on the rear window; he dropped
us at the end of Thorngate Road and took the car off to mend it. The
snow had now begun to settle. Veering from talk of painting people

"according to availability," Freud suddenly started telling me what he felt about domestic ties. He liked the idea of coming and going and mentioned "a house where there are children: a house in Islington. I visit the children, but the mothers can cope, earn and control them; I see the children for a while, like the noise for a while." But time was short, always.

That being so, when I proposed taping our further conversation he suggested going to see a private collection where recording would be possible and bolted across the street to stop a taxi, heedless of traffic. As we rounded Hyde Park Corner into Grosvenor Place he murmured that he found he had more stamina nowadays. In a Belgravia mews he took out a key and let himself into a house, dark downstairs, with glass cases of boxed butterflies on one wall and an early nineteenth-century painting of dogs killing rats. Also a number of Freuds, among them the baleful *Village Boys*, a self-portrait drawing *Man at Night* ("I used myself but I would as soon have used somebody else"), a painting and a drawing of Lorna Wishart whom he identified as "Someone I did portraits of and drew from a lot, 1943–5," *Cyclamens* ("the head becomes absolutely wet and bows down, drowning") and *Sleeping Head* ("One of the few I did very fast: I couldn't work now if I hadn't worked in that way"). He talked about the frustrations attendant on not being a dab hand. "I've always felt that I long to have what I imagine natural talent felt like. I can't tell: maybe this is a common cry. I don't know."

Upstairs he drew my attention to two grand Auerbachs and a splendidly crabby Bacon pope, also—a surprise to me, given its size and an outlook unprecedented in his work—*Wasteground with Houses, Paddington*. "A June-to-autumn painting," he said. "I felt the idea of recording or, rather, portraying the buildings while I was still there. Scheduled for demolition by the council. The rubbish dump was the feeling of not using a person. Like taking a very deep breath." Talking of landscape, he offered to introduce me to Michael Andrews, and extolled his ability to absorb so many considerations into such allusive, often literary-minded, scenes. Talking of books, he read less than he used to, he thought; liked V. S. Pritchett's *Balzac*—liked Balzac— the Russians, Montherlant (*The Girls*), Raymond Chandler (*Trouble Is My Business*). Talking of paintings, yes, he disliked Morandi and Piero della Francesca too. Rather liked early de Chirico. He himself had

Bacons and a very early Augustus John, "like a Cotman," which he had bought on impulse at Agnews for £80. "Impulse is important," he said and I asked him whether he liked having his own paintings around him.

"Oh no. I don't want to live with them, but I want to have them there to look at when I've forgotten my involvement to some degree with them. Sometimes things go backwards with me as well as forwards and often I like to let the paint dry for me to work on it again so that if it goes wrong I've still got something left.

"I tell you what it is: when I've just finished them, my hopes for them distort my dispassionate and critical view of them, but when my hopes are, to an extent, on what I'm already working on—the next one and the next one—then I'm in a stronger position to be able to see weaknesses in them. The very fact of having finished gives me a curious feeling of discontent."

"Is this a bit like finishing with people?"

"No. Pictures and relationships are not directly related because, however much you might be steeped in your own nature, you still have your own relationship: you're living and your relationships grow and mature or decay."

"Is there then a see-sawing between painting and relationships?"

"I don't think of them as in any way competitive. I sometimes think of the time I spend with someone when I'm not working as time in which I might well have worked . . . But you make it sound as though my work's going well/my life's going badly: as if they're in some way rival activities. Whereas you can't stop living unless you literally stop it."

Time to go. Maybe soon, he told me, he would do a Thorngate Road rear-window view, but really there wasn't much for him there. The parrot and the old woman using the lavatory would be anecdotal: no good therefore. The adventure playground across the street was more promising. Its barriers and gangways reminded him a bit of the boyhood elation in Constable's *Leaping Horse*: the low towpath obstacle so triumphantly cleared by inches. ("Such a great painting, don't you agree?") Soon he would be moving on. There were drawbacks to living in a cul-de-sac. He said that he took care not to be on census forms or electoral registers or in the phone book. If you tore up the census form it was only a £250 fine. Worth it surely?

I stood up and he came downstairs with me. "I do keep on the move because I'm strengthened by continuity. I like working from the people I really know because I can then blend them into my rhythm. I very much don't want to force them into my rhythm, but I like to adjust them to my rhythm. You are bound to be selfish as a result of being concerned with this activity. People, whatever their behaviour, can only behave as they themselves can.

"I find, for instance, a bath makes a punctuation for me often stronger than a night, or what remains of one, and often it has a stronger moralising effect—by which I mean a strengthening of my moral fibre—than sleeping might have."

We left the house. Having fixed times when he could phone me (before seven or else very late), as he was anxious to do, he sallied out into Wilton Place to catch a taxi. The sprinkling of snow meant that none came. "Wild!" he cried, nipped on to a bus and disappeared off to the d'Offay Gallery to check on the show of early drawings that was to coincide with the Hayward exhibition.

A fortnight later and back in Newcastle by then, I finished writing the article and sent it to Freud as agreed. The next day he rang and went through it line by line. Rather to my surprise he demanded nothing but the readjustment of some of his more convoluted speech patterns. The call lasted well over an hour, Anne Dunn remembered, because he used her phone, not having one himself. "I recollect that it was then that you and Lucian had a very long telephone conversation, from Argyll Road, because I remember Rodrigo asking about this very long telephone call! Was this the beginning of your association with him?"[1]

During what proved to be just the first of thousands of phone calls from him over more than thirty-five years I asked him what he hoped for from the exhibition. He saw it as something of a test of judgement. "There are some things in the show I've decided to show even though they didn't seem to work and I knew the weaknesses in them; I've had them in and left out the *less honest . . .*" I had already questioned him, in the taped conversation, about how he expected to react on seeing works that he hadn't set eyes on for decades lined up for review. "I hope to be able to gauge what, if any, advances I've made, if I've in

fact developed. And if I *have*, and if I see in what direction, I hope to be able to steer more clearly in the future." This he amended over the phone to: "When I've just finished a painting I look at it and think: so this is the sum total of all those decisions." He left as transcribed—he was rather pleased with it—what I quoted as his final remark: "I feel a bit hopeful about my work at the moment—but then it varies terribly from day to day. I felt much more hopeful two days ago."

John Russell began his catalogue introduction with a crisp pronounce-ment: "In the paintings of Lucian Freud there has been developed over more than thirty years a particular kind of steadfast scrutiny." Char-acteristically, he qualified this with a potentially dismissive remark: "That scrutiny involves a long, slow stalking of the thing seen; but as much could be said, as we know, of a lot of work which in its final effect is pedestrian and unillumined." Then came a quizzical recap: "In Freud's case there is the stalking *and something else* . . ."[2]

"My work is purely autobiographical," Freud was quoted as say-ing later in the essay. "It is about myself and my surroundings. It is an attempt at a record. I work from the people that interest me, and that I care about and think about, in rooms that I live in and know. I use the people to invent my pictures with, and I can work more freely when they are there."[3]

In the *Sunday Times* three days after the opening Russell, who was about to become art critic for the *New York Times*, waxed vale-dictory: "Veterans of the Forties remember him as an unquestioned Kohoutek, a new comet that blazed in first youth across the dreariest of skies . . ." He went on to say that Freud tended "until quite lately to be known either very well or not at all. His activity was not secret, but it was private."[4]

The invitation card for the private view on 24 January carried the 1970 drawing *The Artist's Father*, a drawing indicating bemuse-ment rather than paternal pride, implying perhaps that, had he been around still, Ernst Freud would have recognised how far his way-ward son had come and, all things considered, how well he had done since his first show thirty years before. Beginning with *Box of Apples in Wales* and breaking off with *Naked Portrait* and *Large Interior, W9*

("an old woman and a young one, in the same room, each walled up in her thoughts," John Russell observed),[5] the exhibition paraded his changes in manner and disclosed what a phenomenal painter of modern times he had become.

"With the hanging, I felt quite stimulated putting all the nudes together," he told me during a further phone call; though he had avoided the opening he was keen to be given attendance figures. "What was nice was that it started very quietly and by the end was really full: a thousand people a day." More than 100,000 saw the exhibition in London, among them Bella and Esther Freud who had become used to going with their mother to Gloucester Terrace or Thorngate Road and seeing paintings on the go; consequently ten-year-old Esther was not so much impressed by the art as excited by the distinction of having him usher them in past the queue. Not that the Freuds were an unrivalled attraction. The Arts Council, which at that period organised all Hayward exhibitions (beginning with Matisse in 1968), installed "Edvard Munch" in the lower galleries: an exhibition that opened a fortnight ahead of the Freuds and for which Lord Clark wrote a catalogue foreword, drawing attention to "the frontality which for Munch symbolised virility" and declaring that "no painter had based his art more completely on an intense concern for human relationships."[6] His reaction to works he had first seen more than thirty years before over tea in Abercorn Place is not known.

The exhibition, which went on tour to Bristol, Birmingham and Leeds until June 1974, was greeted on the whole with mild surprise. Young Freud kept being reintroduced and compared to older Freud: the "sophisticated primitivism," as Robert Melville described it in the *New Statesman*, of the period when Melville knew Freud best, was assumed to be more acceptable than the recent paintings with their curious, possibly misguided or even excessive concern for human relationships.[7] In *The Times* for example the critic Paul Overy speculated about the circumstances that might have led to *Portrait Fragment*, the painting of a pose "similar to that favoured recently in semi-pornographic men's magazines," not being worked to completion. "Was it that he had doubts about the painting of a portrait that is full frontal rather than full face? I think that doubt adds to Freud's stature; reveals the nature of his sensibility." He thought that Freud

was better on men than women. "These girls hold something back within which Freud's male sitters give up to him," he argued. "One learns more about the men."[8]

The *Sunday Times Magazine* article appeared on 4 February, just over a week after the show opened. It didn't make the cover: not even that ideal cover picture of Kitty Garman as *Girl with Kitten* could compete with the dashing topicality of an oil sketch by Terence Cuneo, *Incident on the Bar-Lev Line: the last hours of an Israeli bunker*, a scene from the Yom Kippur War. "Lucian Freud: the analytical eye" was inserted between "Molls of the moment: the cinema's changing attitudes to gangsters' women" and "What's new in the Bloomsbury Industry." This was however the first time that more than two or three paintings by Freud had been reproduced together in a newspaper. Colour reproduction, moreover. Freud, at fifty, was making his debut in the mass media. "Whatever the subject matter, all Freud's finest work has an air of finality," I wrote.[9] This, essentially, was what set it apart. He was conscious of his work being grudgingly received by critics who preferred to champion workers in the new media. As he later said to me: "It was at a time of 'easel painting is an anachronism.'"

Nowhere more so than in the brutalist concrete Hayward Gallery where, two years before, "The New Art," selected by Anne Seymour of the Tate, had included stone circles by Richard Long and gigantic charcoal drawings by Gilbert & George of themselves in rural settings. The "New" was anything but painting and anything but the provisional. The pressure was on to juggle formalist and intellectual notions, to cultivate the concept rather than hand and eye; consequently the "New Art" look was predominantly austere. The Art & Language group, for example, exhibited filing cabinets filled with uninformative filing cards.

Coinciding with the Hayward exhibition, "Pages from a Sketchbook of 1941" was shown at the d'Offay Gallery. Among the drawings dismounted and framed were the exquisite little patch of North Atlantic, the friendly "Naval Gunner" and subsequent drawings of Felicity Hellaby, Tony Hyndman at Benton End, Peter Watson in a fur hat, David Gascoyne and an unnamed "Old Man with a Stick." Some were coloured: oil paint rubbed in like rouge into sallow cheeks. Wordlessly, unintentionally and altogether out of keeping with the

conceits and correctives of the "New Art," these were, from thirty years before, Freud's "Songs of Experience."

"At the time of the Hayward show the bailiff's wife was keen on art and asked me to sign my catalogue. Like in [George Orwell's] *Coming Up for Air* when the wife is keen on the Left Book Club. Bailiffs came round and one of them said, 'I was supposed to take things away to the value of the debt; but books, paintings: I don't suppose these will do.' They were always nice. Unlike the police.

"I was as pleasant to them as possible. Also, it was very obvious I wasn't on the floor: I wasn't near that. They were impressed by the sums involved. '£149 only?' Very snobbish. After you'd been done for bills not paid you were gazetted, and not allowed into the Royal Enclosure at Ascot. I went racing quite a bit then, and I had to go into the Adulterers' Bar, because they too weren't allowed in if divorced."

With his retrospective Freud felt himself to be propelled forward a generation. He told me that he liked to leave paintings in a coherent state after each session so that if he "dropped off the perch in the night," as he put it, they would still be presentable, or stand up for themselves. "Francis [Bacon]," he added, "is fascinated with the effect of time on his image. But then his images are very extreme." (Bacon, a generation ahead of him, said in 1973: "My life is almost over and all the people I've loved are dead . . . I'm always surprised when I wake up in the morning.")[10]

"I've never wanted to go back anywhere. It's the sentiment of going back that I don't like. 'How Things Have Changed.' Very lowering. People talk about going back. It's when life has stopped for them and they want to look at what was. I don't."

One day Freud bumped into his Cousin Walter. "The last time I had talked to him was about twenty-five years ago. I saw him on top of a bus. 'Why don't we meet?' he said. 'I don't see anyone,' I said. 'No decision but that no decision is how it is. After we met, what would we do?' 'You could borrow small sums of money from me and then I could try and get some back,' he said. I think he was serious. He was longing to retire."

Walter Freud maintained that until he arrived in England with his father in 1938 he had never been into a non-Jewish home. After his period in SOE, which qualified him for automatic naturalisation, he read chemical engineering at Cambridge.

"Walter had been, like his father Martin, a sort of dud inventor; he invented a set of perfumes where they were all in bottles and you mixed your own scent: DIY perfume kit. It failed. (I loathe perfume.) His failure was mad, psychologically: feminine women want to enhance their charms; they don't want to mix chemical cocktails of scent for themselves, like a homemade bomb-making kit. People were terrified of it.

"Anyway, when I saw him on the bus I thought how odd. Here we are, same age, he was in the army—war hero—and my few months at sea were outlandish, and yet I'm a sort of an Englishman and he's a sort of refugee."

"I don't use things unless they are of use to me"

In March 1974 the magazine *Private Eye*, to which the gossip columnist Nigel Dempster was a regular contributor, reported Freud bursting into Wiltons in Jermyn Street and taking a swipe at Dempster for naming Jacquetta Eliot in his paintings. Jacquetta was with him. According to Dempster, Freud wrestled him to the ground, then ran to his car and locked himself in. Cornered, or making space on a dance floor, Freud's habit when threatened in any way was to lash out. "I used to feel if I thought I was insulted: best to do something." He particularly objected to people like Dempster who had made it their business to be snide about other people's private lives. "I think people in Chelsea are worse behaved than elsewhere. The Chelsea Arts Club: bitter arses."

What he thought of as "a tight rein" Jacquetta Eliot took to be a compulsive desire to have the upper hand: "Not wanting to be seen down or out in any way, he behaved like a rat in a corner if you caught him out in anything. We had terrible rows because I'd confront him and say, 'Have you been with . . . ?' I never minded his staying at Wilton Row because he always used to say it was just where he kept his clothes. And 'be generous,' he'd say. 'People have quite a different life at fifty than they do at twenty.'"[1] For her when roused the immediate procedure was to stage a showdown. "Lucian was absolutely outrageous. He'd hide behind the curtains and say he wasn't there and I'd smash the window and see him."[2]

"At Thorngate she smashed a door and window and—as she was

smashing pictures—was then pushed out by me and she went to the police and nearly got them to come and arrest me; it being quite a working-class district, with violence connected with poverty and drunkenness, they didn't." Though she admitted to putting her foot through a painting at Thorngate Road when provoked, she had no recollection of calling the police.[3]

Anne Dunn had returned to London and agreed to be painted once again. "I was posing in 1973 for a night painting from which I escaped, due to Jacquetta beating on the door. I'd got very brown in Canada, he was interested in colour and, being down in the dumps, at least I was being useful, so I said OK. He was still working very slowly. It was a torture, and I was losing the whole of my life.

"There was nothing to be jealous of, nothing sexual by then, and, anyway, I was in love with Jean-Pierre Lacloche. But she manifested herself: she gave a birthday party for Lucian when I should have been sitting and I was so fed up, having given up yet another evening, now cancelled, that I said that's it, I just couldn't bear it any more. And I also realised that it was going to be a full frontal and I got really frightened. Only a tiny bit got done: hand and breast. He must have been furious. After that there's never been any interest in meeting again."[4]

"Jealousy is love's thermometer," as the 2nd Earl of Rochester said, and when the mercury ran high Freud used to try talking Jacquetta round with fervent letters. ("I've never had such times both good and bad with anyone, that's why I can't pretend or overlook things that would be trivial if I didn't love you so.")[5] He suggested—rich coming from him—that she might see a psychoanalyst about her "tantrums vicious snaps fears and trys to smash things up."[6] He also resorted to communicating legalistically through James Kirkman about damage effected. Defacing the Bentley, for example, was done on impulse and she saw that this was too petty a move. "So pathetic to write 'FART' on the back of his car. He was livid and said he had to have the whole of the car resprayed and sent me the bill."[7]

For Freud the strains of the relationship became increasingly intolerable. Not so much the tit-for-tat violence as the wearisome routine of threat and counter-threat and the loss of control over what most affected him day by day: as he saw it his ability to work without distraction.

"Jacquetta was living in London, not much down in Cornwall. I remember going into her house and there was someone on the bed in her room reading Algernon Swinburne. I said, 'I'll just wait till he gets out.' I was terrifically indulgent in some ways and I was pulled around. She wouldn't do what she said. Her saying, 'I'll be back in a minute,' and eight and a half hours later . . . If there was a fight she'd say, 'What are *you* doing in our room?' Then there was spite and 'I picked him when I was with you.' It's hard to think in a detached way, so many things drove her absolutely wild. The way I left would drive her absolutely mad. Lots of things I can be said to have done in a way I didn't avoid. I didn't treat her like a patient.

"Jacquetta wasn't the only violent one, she was the most extreme, tremendously competitive. If you really like someone you don't isolate things very much; I had sort of taken her on." Another letter was sent through James Kirkman, this one saying that, having run him over, would she please send £68 so that he could buy another bicycle from Harrods. Unabashed, she kept on at him. "He started to grab and push, snatched my bag. He then rammed my car twice and drove off saying, 'Lucky I've still got that gun (don't forget it).'"[8] When things became too much for her she took refuge with her sister, Roxana "Bunty" Lampson, in Ladbroke Grove. Neighbours there noticed Freud in the Bentley sitting day after day on the other side of the road and occasionally crossing over to kick the front door. He threw out things of hers that she had left at the Camden Road flat. "He used to take the whole drawer and throw it into a bin bag. 'I've dumped your things round at Bunty's,' he'd tell me and she would ring up. 'Another bag,' she would say. And black bags would arrive on my doorstep, rubbish bags: I'm sure if I'd opened them a whole bunch of snakes would have come rolling out, or dire fruit, or nests rotting in there."[9]

In *Last Portrait* (1975–7) Jacquetta was left isolated on blank canvas, head and shoulders realised like a fixated memory, the mole on her neck touched in, eyelids veined, tears welling. "I was endlessly crying. It's not dispiritedness; it's the pain of the break-up, of my complete life . . . I was able to extricate myself from Lucian in a way. Perry pulled me out of it and we managed to lead a totally different life. Lucian pursued me and pursued me but I put him out of focus from then on."[10] In the summer of 1975 she went to Greece. "When I came

back from Greece, Lucian still tried to come round, so he did see us until Freddy was about four, but that was when we really broke up. For four years we didn't see each other."[11]

There were, from Freud's point of view, excruciating recriminations. "There were some years after when I dreaded seeing her." The relationship persisted on and off.[12]

Some entries in the Goncourt brothers' journal, Freud felt, struck a chord: he picked out for example a summing up from 24 November 1886: "That violent-tempered woman makes one forgive her incivilities and even love her again with her strange and charming demonstrations of affection."[13]

"When I was with Lucian it was close," Alice Weldon said. "He talked to me and I related to him; I found him to be straight and honest. The thing I really valued was his profound intelligence."[14] And so she behaved as philosophically as she could in the circumstances. "There were ten women he saw regularly—it was clear I was going to be a bit peripheral—and I made no demands on him. Every two weeks, over sixteen years, I'd wait for a phone call. Would it be the last time I'd see him?[15]

Jacquetta Eliot

"I visited my mother in New York. At MoMA 'English Beauties' were on show and there was a huge photo of Jacquetta. Not fair I thought."[16]

From time to time, when he felt most threatened—Wilton Row too exposed and the cul-de-sac of Thorngate Road a trap—Freud took himself off to an upstairs room in Leman Street, Whitechapel. "Leman Street was a bolt-hole. I never used it except when things got terribly, terribly bad with Jacquetta. I used to escape there, but I never really stayed there." The disadvantage of Leman Street was an unwanted lodger, Harry Diamond, who, true to form, refused to be budged. "The big room that really suited me I'd let Harry Diamond have, and he'd moved in. He paid no rent and wouldn't move as he said the radiator was in my part and he had his heating cut off, so I broke with Harry." The landlord, a tailor called Alfred Mawn, told the painter Tony Eyton that he'd been offered "a considerable amount" by Freud to use the weaver's loft on the top floor as a studio. "From the window the view would have been sufficiently grotty and decayed to interest Lucian," Eyton said. "Colin MacInnes lived there and maybe that's how Lucian heard about it."[17]

The various addresses provided room for manoeuvre; like those used by Sickert and Matthew Smith before him, Freud's retreats were alternatives that cost him next to nothing and gave him overnight security. They also served as places to entertain outside working hours. Brian Sayers, for example, a student at the Slade, was shown three of them—two plus the Wilton Row pied-à-terre—in the early seventies. Sayers had been impressed by the *Paddington Interior* paintings featuring Harry Diamond reproduced in my *Sunday Times* article and so, when Professor Coldstream asked his Slade students to name any artists they would like to meet, he said Bacon, if possible, or Freud. "A week or so later he came up to me and said Freud had agreed to come in and that I was to have work ready to show him." He showed him, he remembered, "a truly dreadful copy of his small Bacon portrait which he generously complimented. 'I think yours is an improvement on mine.'" Sayers then ("rather cheekily, being young") asked if he could visit his studio and, surprisingly, Freud agreed and made a date for 4 p.m. the following Sunday at 19 Thorngate Road.[18]

"Tube to Royal Oak and walked up the Harrow Road, turned right at the Neeld Arms as instructed. He was outside emptying something in his bin, dressed in chef's trousers and a yellow V-necked jumper. Up a short flight of stairs past a small kitchen and then a landing with a bookcase with the complete works of Sigmund Freud, then two rooms off, one large front room and a smaller back room." Freud showed him the painting of Ali Boyt near completion ("painted in sections from a central point around the eyes and nose, cascading downwards towards the throat in beautiful 'strands' of cool grey/blues, Naples yellows and umbers"); hinted that he too might care to sit for him (he never mentioned it again); "got out a huge pair of binoculars with which, he said, he liked looking into the rooms opposite" and "grabbed a bottle of champagne from a box by the front door, not drinking it himself as he was about to paint." When he left he gave him "a handful of canvases to use as he said he didn't want them, being 'superstitious' about them for some reason. There were no remains on any of them, sadly, of a painting being started.[19]

"A short time later, walking through Belgravia to Victoria coach station one early Saturday afternoon with a friend, I saw his Bentley coming towards us. He stopped and said would we like to come for a drink? He drove us to a mews flat near by which he said belonged to a friend of his. The small entrance room was covered in box-framed pinned butterflies. Upstairs we drank whisky and chatted. On the wall were a Bacon and early Freud [*Girl in a Dark Jacket*]."[20] On another occasion, again accompanied by a friend from the Slade, Sayers went with Freud "to a small flat in Camden on the Brecknock Road. After picking up the *Evening Standard* 'for the racing' we went up the stairs to the top like something out of *The Lady Killers*, an elderly woman opened her door on the way up and called 'Is that you, Mr. Freud?' Clearly keeping an eye on his flat for him. Inside, a small front room with a round table in the middle on which was a small Rodin, a female black bronze figure, legs truncated and apart, with implications, I thought, for some of his nudes where the legs are similar. Bacon's *Two Figures on a Bed* (1952), in its heavy gilt frame, dominated one wall. He said he wanted the room to look 'nineteenth-century Parisian' with its large, dark, gilt-framed mirrors and elegant leather sofas. The bedroom was smaller, with a brass bed with a patchwork quilt cover and a giant plant hanging over it. On the walls a series of Auerbach

drawings. On the mantelpiece was a print of Paganini and a water-colour/drawing by Bacon."[21]

Around this time, in 1975, David Sylvester chaired a discussion at the Slade on "Likeness" involving Freud, William Coldstream and Euan Uglow. Addressing Freud, Sylvester mentioned that Bacon thrived on images in the mind's eye. That being so, he asked, why did he not work from memory too?

"I have worked from memory, but I find that I'm much freer with the model there. And I find that, working from memory, I'm inclined to be literary and relate back to memory whereas with the person there, I'm much freer. I can make rearrangements of form. I become, in my own limited way, much more inventive. I'm liberated by the presence of the model, whereas memory is slavish and passive . . ."[22]

Freud remembered the discussion as "quite stimulating," leading on as it did from practicalities to aspirations. With his usual imposing solemnity Sylvester asked him to define the difference between resemblance and representation and he reacted snappily.

"Well, the resemblance is something *like* them and representation *is* them. For instance, a resemblance reminds you of them, but a likeness makes you think about the actual." Shown the transcript, twenty-five years later, he corrected himself. "That's not how I meant it. If you think of like-ness literally it's that thing *later*. William Burroughs said something good: 'I woke up in the middle of the night and someone was holding my hand and it was my other hand.'" Likeness is a sort of core, he argued, without which nothing can come about. "You've got a central thing in your head and you make amendments and even surgical changes within it."[23]

Sylvester then decided to push his notion of the possibility of being a "born painter." Which was more important: the talent or the intensity of the effort?

"The intensity of the effort could be to do with trying extremely hard, which is finally of absolutely no importance at all. It's private," Freud replied. "Finally, somebody innately talented, without concentrating too much, could do something of extraordinary interest and subtlety, where somebody concentrating terribly hard could do something of no interest to anyone except possibly their mother."[24]

Lucie Freud, hoarder of his child art, had oppressed him, Lux—Lucian—often said, with her persistent maternal concern. He saw this

as an innate trait (not unlike being a "born" painter perhaps) passed on from one generation to another. "While my mother didn't like her mother, I certainly didn't like my own mother as she was so affectionately, insistently, maternal. And because she preferred me: if it had been equal I wouldn't have minded." She had always singled him out. "It made me feel sick." Anne Dunn was struck by his certainty about this. "He used to tell me how much he hated her and then, when he did that series of portraits, I was astonished."[25]

Previously, while his father was still alive, Freud had regarded his parents as domestic elders living not far from him—primarily never more than a mile or so away—but in a changeless little enclave of stilted English and residual Berlin style. Left on her own his mother became amenable and from then on the pressure was off. Except that her unyielding devotion rendered it impossible for him to have so unconditional a relationship with any other woman. Or so he murmured to me more than once, as though conceding that, to his surprise, she meant more to him than he had ever admitted. He used her, of course, and the portraits declared a sort of subjection to her.

Breakfast with her at Maison Sagne's in Marylebone High Street was followed by four-hour sittings, well over a thousand of them from 1972 until the late eighties, interrupted briefly "having been out of touch rather" in 1974, and arguably the longest time ever spent by any mother's painter son on any painter son's mother. Nine paintings were completed over the years, among them *The Painter's Mother Reading* (1975) in which he gave her his copy of Breasted's *Geschichte Ägyptens*—"physically such a nice book"—to hold; she may have stared at it but in the event he left the pages blank. There were two versions of *The Painter's Mother Resting*, *I* and *II* (1976 and 1977) flat on her back, hands beside her head. The resemblance to the lolling of her granddaughter Bella in 1961 as *Baby on a Green Sofa* was maybe unconscious, probably not fortuitous.

Whistler introduced his painting of his mother to the Paris Salon public of 1872 as *Arrangement in Grey and Black*; Freud's mother— significantly *The Painter's Mother* rather than Lucie Freud in her own right—was not to any such degree abstracted: in painting after painting, and in drawings, her expression changes from bewildered to apprehensive to the stoical reserve of an effigy. Frank Auerbach

(who, as Freud put it, was "kid-napped" from his parents when, in 1939, they consigned him to safety in England) observed that Freud had been so loved by his mother, had been so much the favourite, that he had lifelong self-confidence. "To have unconditional support like that sets you up for life."[26]

Freud liked what D. H. Lawrence (another recipient of persistent maternal solicitude) wrote about Cézanne saying to his models, "Be an apple! Be an apple!" To Lawrence the idea of the sitter being the apple, so to speak, of the artist's eye was spot-on. "It is the appleyness of the portrait of Cézanne's wife that makes it so permanently interesting." Cézanne, he argued, "knew per-

Painter's Mother Reading, 1975

fectly well that the moment the model began to intrude her personality and her 'mind,' it would be cliché and moral, and he would have to paint cliché."

As the cliché has it, Lux's mother was there for him. Inching away in successive paintings at the paisley pattern on her dress Freud was conscious of how "really wrought up and feeling desperate" he became, accomplishing the precise curvature and foreshortening involved in making the patterning sit. "Doing the different paisleys on her dress, I was afraid that my mood would enter into the paisleys and disrupt the dress and the calm of it. Thinking of Walt Whitman who, in later life, suffered horribly from constipation and really worried that his poetry would suffer. I don't want my involuntary moods to interfere with my control."

Where Stanley Spencer would have diligently transcribed the paisleys, Freud varied them. Between *The Painter's Mother Resting I*

and *The Painter's Mother Resting II*, he thinned them out, simplifying them progressively until, in *The Painter's Mother III* (1977), they became a light scattering, like fallen leaves. He said at the time: "I don't want it to look as if disparate elements have been woven into a whole; I want my feeling about the visible flesh to show against the covering clothes. When I paint clothes I'm really painting naked people who are covered in clothes. (That's what I like so much about Ingres.)" Ingres-like he was selective but at the same time never one to skimp. "If the person you are fond of had got one wrinkle missing it would be absolutely terrible; I mean a terrible blow to one's trust; but I don't use things unless they are of use to me." It was a matter of determining what would be essential to the picture as a whole. The brown blotch between ear and eye, a liver spot that could be interpreted as a tear stain, was a useful fact, a necessary intimation: the stigma of old age. Devoting his attention one morning to some such detail, momentarily he took his eye off his sitter and when he looked round found that she had given him the slip. "The door was open and she wandered off down the road and I had to run after her and get her back. Naturally I was more aware of observing than of her state."

"No human face," said Giacometti, "is as strange to me as a countenance which, the more one looks at it, the more it closes itself off and escapes by the steps of unknown stairways."[27]

Ali Boyt, a painting begun in the summer of 1974, names and delights in the very image of would-be stylish youth, long haired, cheesecloth shirt straining at the buttons, thumbs tucked into the waistband of his check trousers and seated in the armchair his grandmother usually occupied. Ali had been at Alleyn's School, in south London, had taken up skateboarding and had lived at Lansdowne Crescent for a while when Freud was with Jacquetta. In the painting he stares blankly past his father's head, his mind elsewhere. He hated sitting, he told me, decades later. "Ali was always trying to get copyright money. Worked for d'Offay a bit, and a building firm—friends of Suzy's—went to the pub a lot." Working for d'Offay hadn't been a success, for Ali would appear unsuitably dressed and undisposed to tackle gallery practicalities. He complained to his sisters of being dropped from favour or attention when holidays in Glenartney ceased. Freud saw the problem: "I used to go up all the time to Jane's; when I went less, I hadn't anywhere to take them."

A common grievance or understanding among Freud's children was that he only saw them—and of them only those whom he recognised—when it suited him and sporadically at that. He used to say that when they were babies or infants, and indeed so long as they needed an upbringing, mothers were the ones to cope. He might be around a bit, but domesticity wasn't for him. Being answerable to anyone was best avoided and most certainly so in the clinging stages. "As a child my expectations were few," Esther Freud said. "We were in East Grinstead and it would have been a bit much to go up to London. It helped a bit that our parents were never involved as far as we knew. It helped not having an angry mother. And as he got older he became more reliable. Perfect for us as teenagers."[28]

As four generations of children grew up he provided practical help and treats from time to time. "I didn't want the situation to arise where it seems to them I'm not interested. If you're not there when they are in the nest, you can be more there later." Being there as they advanced through adolescence involved lunching them, working from them, paying fees, backing ventures, getting them places to live. "I've bought specific things—house, flats and doctors' fees—not so much allowances as I used to get into such trouble." Given that he had no certain income and was apt to incur sudden drastic debts, regular payments were unsustainable. "One thing I don't want to do is be unclear or mess about." He liked to be free with whatever cash he had and to be supportive without obligation. In this he disagreed with his cousin Jo Mosse, now living in Queens, New York, who told him how important it was not to give one's children money. "That Jewish thing: make them stick up for themselves. I feel the opposite."

Annie and Alice (1975) is a painting of Alice Weldon lying cautiously behind a pregnant and strained Annie Freud, a naked arrangement akin to Courbet's *The Sleepers* and *Young Ladies on the Banks of the Seine*. "Two on the bed, done in Thorngate," Freud said. "Annie was pregnant with May: had that spark in her. Annie and Alice were very friendly—Annie was sort of in love with Alice—and Alice did a mural in Annie's bathroom. Alice has very small bones. Delicate."

"Lucian was working from me first with Annie," Alice remembered. "It was difficult sitting because there we would be, lying there, and he and she would be having jokes at my expense. I went off in a sulk and Lucian came round with a sketch of Annie to give me. Next

day I came in a very bad mood, imagining that I was a lizard on a rock in the sun (one of those vivid images one gets) and straight away Lucian said: 'You look like a malevolent lizard.' Uncanny that was."[29]

Alice's relationship with Freud was sustained over many years partly because she was undemanding. "Lucian asked me to look after Annabel. She had been to university—Leeds—earlier and, highly intelligent, was making up for lost time and partying. Winnicott [the psychoanalyst and paediatrician] said that anorexia didn't mean she was suicidal and that her state wasn't his [Lucian's] fault. Lucian was pleased about that. He's used to that: had psychological nous. I was very nervous. He might ring, at two in the morning." She took up drawing. "My drawings: done very slowly and painstakingly from middle outwards building up: Lucian took them to Harry Fischer who didn't want drawings so he took them to d'Offay, who said yes, seeing thirteen childish drawings, "but she must do thirteen more in six weeks," which I did. He showed them at 9 D'Arblay Street and Kirkman afterwards took my drawings too. Then me getting married in 1987 ended it. I couldn't and wouldn't keep on with him."[30] She married a paediatric neurosurgeon.

For Annie the difficulty of achieving and retaining any closeness to her father was complicated by her growing self-awareness. "I cheered myself up thinking whatever the nature of our attachment it was unique. Dad during all my childhood was always there. Incredible hols. We did things, ate marvellous food, met people who had pet tigers."[31] Alice Weldon saw her as casting around for validity. "She went through a period of 'meeting' his girlfriends and becoming besotted with them. She fantasised, while being extraordinarily able: acting, embroidering, writing, plumbing."[32] She read English and European Literature at Warwick University. Freud remembered going to see her there and her begging him not to speak to her tutor, Germaine Greer. "She said, 'Please, please don't talk to that woman.' I once saw her afterwards and she said, 'How's Annie?' 'Married,' I said. 'How awful,' she said. 'Don't be so silly,' I said."

Annie married a French photographer, Jean-Loup Cornet, whom she had met in Saintes-Maries-de-la-Mer. "They met on a bench from which Van Gogh painted the boats. Shared their lunch," said Freud. He took his mother to the wedding in France. "In the champagne country. Mother was in a dreamy state." Naturally, being the eldest

daughter, Annie was the first to resent lack of attention and this, to her father, was exasperating. "If I asked her what she was doing, she said, 'My book of poems . . . this show of prints.' It was terribly hard to ask about it and, obviously, be asked for comment. Things started fizzing inside my brain. She had a girlfriend for ages. Anna[bel] said: 'It's awful: Annie's become a lesbian plumber. It's so embarrassing.'" She worked at d'Offay's for a while and for Heinemann the publisher.

On Christmas Day in 1977 or 1978, Freud went to Annie's for lunch—her marriage was over by then—and made a sketch of wine bottles on the table and his mother behind with Annie's daughter May, "more talkable to than her mother," he later said. Previously, for several years, he had opted to have Christmas lunch with Mike and June Andrews and their infant daughter Mel. He enjoyed, he said, "a friendly feud with Mel" and remembered her saying to him one year as she sat down beside him, "I'm going to be very nice to you because one's got to be very nice to lonely old people at Christmas time."

"Lucian came to us at Pembroke Studios as he didn't have to make a decision over women," June Andrews said. "He would bring flowers, huge amounts, narcissi from Covent Garden. Mel got to hate *The Wizard of Oz*, as he always wanted to watch it after lunch. One time he took sleeping pills instead of uppers and Mike took Mel for a walk to get her out of the way, both with paper hats on, while Lucian slept all afternoon on the sofa. Out like a light. Then Jacquetta on the phone . . ."[33]

6

"Things never look as bad as they do under a skylight"

The Arts Council's "British Painting '74" at the Hayward Gallery in the autumn of 1974 involved, under the direction of Andrew Forge, artists choosing fellow artists to exhibit, a project that resulted in a textural gala laced with examples of Hard Edge or Post-Painterly Abstraction. "There are names absent from the list which I greatly regret," Forge—a former Slade stalwart, by then Associate Dean at the New York Studio School—conceded in his catalogue introduction. Among those "absent for a variety of reasons"[1]—such as a "dislike of the idea of being seen in 'a telephone directory show'"—were Andrews and Auerbach, Bacon, Coldstream and Freud. Two years later "Arte Inglese Oggi," a British Council survey show spread over dozens of echoing rooms in the Palazzo Reale in Milan, repeated the omissions. In a catalogue essay Norbert Lynton of the Arts Council offered a sweeping explanation. "We have been forced to exclude certain maverick artists, detached from nameable trends, though," he conceded, "their work is of great interest and character." The overriding reason for what was in effect a boycott was, he argued, that such work "represents the extending of traditions established well before 1960." With these words this leading arts bureaucrat dismissed continuity and all notion of lasting or renewable achievement. For the painter of portraits apparently, indeed for the direct painting of almost anything, there could be no place and no excuse.[2]

. . .

Freud's painting of Frank Auerbach, begun in 1975, was a second attempt. The first, as Auerbach remembered it, had gone awry. "He started—as was his wont—around the eyes and it sort of grew downwards and the coefficient of error, of unconnected proportions, grew too, and Lucian eventually junked it; then at some point he asked me whether he could start again and I was as usual obsessed and focused with my own work and so I said 'possibly,' leaving it for a bit, and there was an interval of some years. And then he caught me at, for me, a good moment: a moment when for about two or three years I went down to Hereford for two or three days a week and my life in London was far more irregular and I left the studio in trepidation three days at a time. And then I did agree to it.

"I was a conscientious sitter and Lucian was extremely considerate. I mean he always warmed the place, which wasn't naturally warm. I sat for about three hours or so and as often as not he would take me for a meal afterwards, which is something I've never done for anybody who's sat for me. (I take three-quarters of an hour to clear up.) Occasionally, just to assert my independence, I'd take him for a meal and Lucian would say, 'Oh I wouldn't have taken you to this ridiculous clip joint if I knew you were asking me.' (It would be the Neal Street restaurant.) And I sat, I think, in silence because that was what I was used to with people at the time and Lucian painted with the concentration you would expect and I didn't count the sittings. It seemed a long time but it may not have been more than thirty-six or thirty-eight sittings. The thing is that the reputation Lucian acquired, if not quite as a bohemian, seemed to be casual: as a sort of adventurer. When he was painting he was the most focused and unshowy and concentrated painter that you could possibly imagine."[3]

Auerbach's habit of painting from start to impasse every session for as long as it took was more all-or-nothing than Freud's gradual build-up of achieved detail—interminable scraping away and reassertion. But for both there was, primarily, the fierce desire to work the subject, to see it through. They admired one another's work unreservedly and, besides, though born eight years apart, the two of them had been born Berliners. "Aged six, seven, eight, nine, we both had a favourite book, about a stowaway who lives in a packing case," Auerbach said. "Having a similar background, with governesses and so on, the idea of being entirely dependent on yourself was appealing.

And finally it goes deeper than that: these are the dreams of someone who's secure and cared for. It's to do with being, if not suffocated, certainly oppressed by concern and affection, with quite a lot of fear in it." The book was Wolf Durian's *Kai aus der Kiste*, published in 1926. "About a German boy who stowed away in a wooden box for America. He had a great success in the States by devising ever more amazing advertising stunts."[4]

Auerbach had arrived in England in April 1939, when he was eight, beneficiary of a Quaker scheme to send Jewish children to safety. His parents died in one of the camps. "I didn't in fact see anybody who I had seen before, that I remembered."[5] His immediate ambition on leaving school had been to become an actor or stage designer but he gravitated to painting not as the "born painter" but as one who adopted it. Freud remembered that the two of them were sitting one day outside a Soho pub when some girls went by. Auerbach suddenly shouted how he wanted to be tucked up in bed. Freud took this to be a cry from the heart. "Like people only blurt out the real truth in the middle of a family quarrel. I remember once that Frank said, 'My father was a tubby man.'"

> *Dear Frank Just in case you thought the pale pink highlight on my nose this morning had been placed there out of deference for the new Bacons—It was an "unharnessed" accident brought about by the carefree use of a toothbrush, overloaded with Sensodyne toothpaste. Love Lucian*

Auerbach's reply on the back of the note was:

> *Dear Lucian*
> *I thought you had been using foot-ointment on your nose again.*
> *Love Frank*[6]

Freud's friendship with Auerbach and admiration for his work grew as his relations with Bacon soured and waned. In a foreword to the catalogue of Auerbach's "Working After the Masters" at the National Gallery in 1995, he wrote that his touch was like perfect timing or perfect pitch. "The space is always the size of the idea while

the composition is as right as walking down the street . . . The mood is one of high-spirited drama. In fact his work is brimming with information conveyed with an underlying delicacy and humour that puts me in mind of the last days of Socrates."[7]

That mood, one of patience barely contained, clinches the portrait. "That purposeful forehead," as Bruce Bernard remarked.[8] Auerbach pinned up a reproduction of it in his studio next to photographs of Rembrandts, a Matisse and a Picasso, not as a trophy but as a prompt. He regarded Freud as having an extraordinary intuitive unreservedness. "Like everybody else, I suspect, I was struck by the fact that he was more nervous and alive than other people; later I discovered that he was also more simple, generous and (in his own way) honest than most."[9]

The painting was recognition of the friendship, its closeness similar to that of the head of Bacon two decades earlier. Auerbach, his head bowed as though anticipating a laying on of hands, saw it as a useful sacrifice of time. "I found the process strenuous, but was convinced it was worthwhile in the sense that something was being made. I don't think that I would have sat for anyone else by then. And given that sitting is inevitably a sort of chore I cannot imagine working with—for—a more interesting person. I was a good but reluctant sitter, always conscious that time and energy were leaking away."[10]

I asked Freud once—shortly before his seventieth birthday—what he would do if he had to stop painting. A good terminal use for himself, he said, would be to sit for Frank. At least that way he would be instrumental in the making of memorable paintings. And, he added, it would have been preferable to sitting for Bill Coldstream, as he did in the summer of 1976.

Anthony d'Offay pressed him to do so. "He said that Bill really wanted to do it and didn't want to ask me, so I did, as Bill had had to put up a lot with me." It later emerged that the request came not from Coldstream himself (who having recently retired from the Slade was set on painting full-time once again) but from Rodrigo Moynihan, who d'Offay, being Coldstream's dealer, knew would buy the picture. Freud sat from June to October: thirty-three early morning sessions at the Slade, during which the painting developed a stitched look. "The portrait of Lucian is going well," d'Offay reported to me on a postcard at the end of the summer. But it was not. Coldstream sharp-

Lucian Freud by William Coldstream

ened the chin and contoured the hairline, giving his sitter a hefty wid-
ow's peak. The portrait was not a success partly, no doubt, because of
the mutual, if unspoken, reluctance. "Neither of us wanted to do it."
Freud was insufficiently amenable and his impatience agitated Cold-
stream, causing his fine deliberation to stall. Freud's face, plotted as
though for some surgical procedure, was classic: a reassertion of the
formal exactitude that Bacon, working from Deakin photographs, so
extravagantly shunned.

That year, 1976, the distractions were such that Freud decided
he would have to effect a move, if only to protect his one out-and-
out concern, the ability to work. "My life became very difficult at
Thorngate Road through being caught up with Jacquetta. I just had

to have more privacy. I thought it would be nice to have somewhere more substantial. More secure. Also I did want to have somewhere with a skylight.

"Things never look as bad as they do under a skylight."

A top-floor flat in 36 Holland Park, near the Greek Embassy, appealed as being potentially secure and adaptable to his requirements. "I really moved to be less vulnerable with Jacquetta. I thought what a lovely hideout: all those rooms, but not one room with a high ceiling. So I thought I'd get it and change it.

"It took a long time as so much needed doing as it was an ordinary flat and needed studio rooms and windows made. But because I was still at Thorngate I wanted to do it gradually. I was feeling very nervous about it." It was, he said, like the hesitancy he felt about wearing suits straight from the tailor's. "I've got some clothes made five or six years ago, the last time I was at the tailor's, that I still haven't worn. It's exactly like that, moving into a new place.

"I was very cautious about new places and used to sleep on a mattress on the floor. And I'd go there sometimes with Katy McEwen. A French woman on the floor below said she had heard strange noises, a busy rattling, on the floor: she said could she come up and show me? 'No, no,' I said: I didn't want her to see the mattress. She said, 'You are looking so terribly pale.' Slightly forward: she knew what was going on; she had a big handsome husband who was away." He already knew the theatrical producer who lived on the first floor. "Johnny Gilbert: his father was a well-known impresario and he was rather less well known, had a Rolls and was terribly nervous; I knew him before through gambling, private gambling parties, and he was a great friend of that comedian who ran a club, the Establishment Club, where I went sometimes: Peter Cook, who I quite liked. Amazingly uncharitable, amazingly vicious: Johnny Gilbert used to go out drinking with him once a week. He wanted me to make a staircase from my flat down to his."

Four flights of stairs, fifty-four steps, no lift. "Built 1888, servants' quarters." It suited him. "I was very conscious, after Thorngate, that I wanted somewhere fortified. That's why I made two doors on to the landing, opening different ways." These double doors, inner

and outer, sealed him off from intrusion. "If I opened the outer one suddenly it would sweep someone off the landing." Double-locked, double-soundproof, the doors—and, later on, a security camera on the downstairs entrance—were a more than adequate defence. Rewiring, reroofing and replastering took months. New windows were inserted, front and back. "The building was Grade II listed so I couldn't have a skylight at the angle I wanted as it could be seen from the road." An approved skylight was installed by crane.

"Some of the floors were useless—I always liked old boards—but I had to have quite a lot of new boards in the studio room." The studio could not be carpeted of course so, to meet the terms of the lease, the floors had to be soundproofed under the floorboards with felt and steel wool. He wanted a roof terrace, opening off what was to be the studio: a shady enclosure, "shrubs with mirror glass behind," inspired by the de Noailles garden in the Place des États-Unis where, during lunches, he had seen Charles de Noailles entertaining female guests. He was not allowed to have it fenced so he grew bamboo in tubs instead. "It was a new terrace and the horrible woman underneath me sunbathed and said that it cast a shadow on her terrace."

Before the move from Thorngate Road there were paintings to finish, among them the view across the road from the first-floor front. "It was done long distance, through the window, fairly soon before I left. I was always going to do the back view and didn't." The cranky steps and exits of *Children's Playground* (1975) reflected the dismantling involved in his move from W9 to W11, the sheets of corrugated iron forming a wonky barricade between grass and concrete, hidey-holes exposed and a walkway tacked together from planks. It was a contrast to the spreading elegance of *Acacia* (1975), an unfinished painting of bare, whiplash branches seen from Alice Weldon's first-floor window in her flat in Alma Square, near Abercorn Place. Several square inches in one corner of what would have become grass stayed blank.

Rather than give up 19 Thorngate Road altogether, Freud passed the flat on to Ib. "I tried to get it (for £10,000) but the council wouldn't let me; they said, 'We gave you six months' option to buy, which lapsed,' so I paid the rent. Ib was at Thorngate a good many years." Freud left behind there the brass bed, "the Napoleonic bed," as he called it, and Jane Willoughby provided a replacement,

an Empire bed from Grimsthorpe Castle. That wasn't all. As Frank Auerbach put it, "Jane made Lucian one of her projects, mothering him in a way, not trying the spiritual stuff she enjoyed discussing with Mike [Andrews]. She loved Lucian as well."[11]

"Jane bought the Holland Park place," Freud explained, his thinking being that property was liability. "Don't own anything," he used to recommend. "Then the bailiffs can't get it." That said, he hadn't the money anyway, whereas she would inherit 75,000 acres of Perthshire and Lincolnshire. "We got it down very much: it was £38,000 down to £24,000 or £22,000. Public school spivs owned it and we got another twenty-five years for £2,000, so it was pretty modest." Having helped him out to that degree, not for the first time or by any means the last, she was distressed to learn of Freud's further attachment to a much younger woman: Katy McEwen.

She told June Andrews, who remembered her reaction on learning that Lucian wanted to go off and live with Katy. "'How are you going to live?' she asked. He said it would be all right."[12]

The involvement with Katy McEwen dated from 1975. June Andrews liked her. "A sweetie. Used to come round and I'd open the door and there'd be Katy in boxing boots. Gothic black she used to wear. Never without a drawing pad."[13] "When I took up with Katy, Jacquetta said Katy looked like a man," Freud remembered. He got to know her through his three younger daughters who were around the same age as her. "Rose and Bella knew Katy. When Bella and Esther were hippies with Penelope [Cuthbertson] they used to camp in the grounds at Marchmont where the McEwens lived and then Helena, her sister, was Esther's best friend. And she made a great friend of Rose, who was engaged to her brother, who shot himself." She and Rose pursued a boxer, the light-welterweight Dave "Boy" Green, Tiger of the Fens, who twice challenged Sugar Ray Leonard; they were fans, which perplexed him. One night they went to a fight and he gave them a lift to the station afterwards. Him in a green velvet suit. Katy drew him, held between two stewards.

Freud appreciated Katy. "I thought she was amazing; also I thought she looked so marvellous. Funny and a terrific sense of ridicule and, if people were genuine in a pure-in-heart way, that appealed. Though she minded her legs being rather thin and did exercises to fatten them. And she learnt Chinese. The one person who really shared

with her was her younger brother, Johnny. Katy went to enormous trouble to divest Helena of religious belief." She also went to considerable trouble to bring together Freud's various broods.

"Katy had this idea in her head that they should all know each other but, being naturally rather private and secretive—though always trying to avoid lying—I didn't think they should know each other. Katy introduced them to each other. I watched with interest. I didn't think they shouldn't, but obviously it's something that's stimulating for younger children and not very for older ones. What I mean is, the youngish children were delighted to find that they'd got brothers and sisters whereas old ones, who thought they were rather unique, were slightly annoyed."

Katy's wildness was troubling, even more so than Jacquetta's. "Katy would lose her temper and kick him," Esther remembered. "He seemed pretty desperate, very unhappy. It seemed to go on for years, but it didn't really." It was a perplexing relationship. "How would you like it," one of the sisters said, "if you were Katy and going out with an old man?" For Esther, her father having a girlfriend practically her own age was less disturbing than Katy's actual behaviour. She had a compulsion to play "Happy Families," so to speak. "Shocking when I look back. Katy always wanted Bella around and she suggested that he visited us. Suddenly Dad was capable of being gleefully childish, like the McEwens were." He took them up to Marchmont on the Scottish borders. "We drove so far we found ourselves in Wales and had to turn round and head up to Scotland. A policeman stopped us. 'I've been trying to follow you,' he said, 'for the past one and a half hours.' We'd been going at over a hundred miles an hour."[14]

Freud took a shine to Marchmont, a fine flat-fronted country house, and to Katy's father. "Robin was a lawyer but he inherited Marchmont and he hadn't got enough money to run it. His wife, Brigid, was the daughter of James Laver the costume historian and was heartless. Esther and Helena were playing hide and seek once at Marchmont and found Robin in a cupboard. He'd been there for hours."

Six years his junior, Robert "Robin" McEwen died in 1980, "a sort of suicide," Freud said. He had a brother, or half brother—"probably by another father: some Scottish lord brighter than his

father. David, 'Gummer,' he was called—gummed up his eyes—was very eccentric, extravagant and generous, lots of romances with girls. He shared a flat with a Master of Fox Hounds in Notting Hill. I used to go to breakfast. He would say, 'What sort of champagne shall we have for breakfast?' I never saw him the worse for drink but often the better for it. Had a passion for crème de menthe. I didn't draw him, as—like leisurely people—he would be 'busy.' 'Got a meeting,' he would say. Under forty when he died of a clot on the brain." Nearing death (in June 1976) he had a surprise visitor. "Only close relatives were allowed in at the end," said his nephew, the art critic John McEwen. "So this nun appeared and this nun was Lucian. David loved it."[15] Freud, when I asked him about it, demurred as best he could. "I think I was dressed up as a nun for work; or I might have been in a strange gown because of his being a Catholic: a bit more suitable."

When he first knew her, Katy, aged sixteen, was living by herself in her father's house in Paulton Square, Chelsea and working for Michael Parkin in his gallery in Motcomb Street, Knightsbridge. "I asked her, 'What do you do?' 'I sit at the desk. A man with a split-arse jacket comes in and looks at me and says, "Is the old sod in?"'"

The Katy whom Freud painted—*Head of a Girl* (1975-6)— resembled a bedraggled Epstein angel, hair lank on her shoulders. "Pretty desperate, very very desperate," he said. "She was at art school at Chelsea. She tried to slash herself with razor blades. She was ashamed of me being so old and she thought I was rich. There were things I could do nothing about." She cringed when, knowing he would find her at a coffee stall that she liked, by Chelsea Bridge, he picked her up in the Bentley, showing her up in front of others more her age. One night he asked her who would she like to have dinner with. What about some dukes? He arranged it: a Dukes Dinner at Annabel's. Party of five.

"Then I got her into the Slade, perhaps a mistake." There Katy painted palm trees all over the women's lavatories including the sanitary waste bins, an initiative that vexed Lawrence Gowing, who had just taken over from William Coldstream, because the firm that owned the bins had to be compensated. One of her admirers, Danny Miller, said that she slept her way around ardently and chaotically. She left the Slade. Freud tried settling her. "I got her this place on the

Head of a Girl, 1975–76

canal. She worked and had powers of concentration. And I got her a flat in an Air & Space studio in Shaftesbury Avenue. Then something happened and she fucked up her work."

Her impulses were generous. She gave Freud a rat, a Japanese laboratory rat such as she had bred as a child when she used to go around with one under her blouse; this one, Auerbach remembered, roamed the kitchen table during meals at Holland Park and nibbled at the butter. Freud reciprocated by giving Katy a monkey, Bimba, and drew her with it on her head. "She didn't want it and took it up to Scotland to her parents and I saw it up there. It was fine there. Her next passion was eels, which she kept in the bath; I bought her gold-fish for them to eat." She painted him asleep under a blanket, a small painting à la Freud in style.

"Katy liked going away. I remember in a sleeping car returning from Marseilles, she said everything was fine, but things hardly ever were all right. She was strangely controlled but so unhappy. The future to her was a ludicrous sham, a sort of insult."

They went to Marseilles to see Bacon's most recent work at the Musée Cantini in the late summer of 1976 and the following January they, plus Rose Boyt, saw a further exhibition at the Galerie Claude Bernard in the rue des Beaux Arts. Freud was photographed by Rose examining a triptych, Katy standing back. One night they bundled into a Metro station photo booth for a two-headed mug shot; later, in 1982, he would make an etching from the image calling it *A Couple*: the two of them with biting grins, like medieval grotesques.

"I complained to Francis that Katy said, 'I'm half-heartedly in love with you.' I don't know about half-hearts, I hate qualification, I hate it when people say, 'I like her legs, not her breasts.' There were some years when I dreaded seeing her. When we broke up, she kept coming round. She'd say, 'I want to look at such and such a picture.'" To be casually neurotic was, he felt, improper.

"I'm not an idealist, but I want things to be rather all-or-nothing-ish. Katy was half-hearted about life."

"Katy took up with a famous lesbian, or group of lesbians," June Andrews said. "That affected her. She had already had another affair: Lucian found out, and smashed her flat up. (He held keys for all flats.)"[16] She could be terribly persuasive, Freud said. "She tried to get me to have a car crash with her. 'Couldn't we have a real crash?'"

In August 1983 she returned to Marchmont and a month later went off to Kenya with two friends and the next day was found washed up on a beach. Local police didn't investigate: possibly drowned, though she never swam, maybe suicide. There was a week of funeral "celebrations" at Marchmont, lots of diversions, football and dancing. Marchmont was sold in 1989 and became a Sue Ryder Home for the sick and disabled.

"I don't like mementos and gave some of her things, things of real quality, a beautiful one of the walled garden at Marchmont, to John McEwen. I gave a drawing to her mother." McEwen disconcerted Freud by laughing a lot—defensively—when he called to collect these relics.

Several times when coming to see Katy in the Shaftesbury Avenue

flat, Freud had lingered downstairs and talked to the manager of the Air Gallery, a recent art-school graduate, Moira Kelly. Consequently he took Moira to the Playboy Club one evening and suddenly, as they arrived, tested her nerve. "Will you do absolutely anything I ask?" She said she would. He then demanded a cheque for £200, which was more than all she had. Gamely she obliged and, despite her protests that she knew nothing about blackjack, he set her to play. By the end of the evening she had nothing left and they drove back to his house where he got out, hugged her and disappeared, leaving her angry and dismayed. But then, driving away up Holland Park Avenue, she felt a lump in a pocket and found he had planted on her a wad of notes: £3,500. With this she set up her own gallery in the Essex Road.[17]

"I don't want a painting to appear as a device of some sort"

The poet Robert Lowell, who had married Caroline Blackwood in 1973, included in *The Dolphin*—which proved to be his final collection—"Mermaid," a poem that, seemingly, apostrophised her ("warm-hearted with an undercoat of ice") as she who "kills more bottles than the ocean sinks."[1] The marriage foundered as Lowell's manic phases became ever more extreme. Freud rather warmed, he said, to Lowell's craziness. "I saw her and Lowell. I liked him, I thought, though he rather shocked me by being wonderful and then, within minutes, not remembering anything. We were going out to a restaurant and he said: 'Do drive carefully. Caroline's been in an accident recently.'

"Lowell had mental breakdowns in their house in Fitzroy Square. He thought he was Hitler. (In my grandmother's day it was Napoleon that people thought they were.) Then he went off and died in the taxi with my picture in the boot. He'd just taken it."

The death occurred between Central Park and West 57th Street in September 1977. Lowell had with him, wrapped in brown paper, one of Freud's paintings of Caroline; he had brought it to New York to be valued, had a heart attack and was dead on arrival at the apartment of Elizabeth Hardwick, his ex-wife.

Caroline asked Lucian to go to the memorial service; he did not: he always felt that all such occasions, funerals too, were to be avoided. Her novel *Great Granny Webster*, published that year, was nominated for the Booker Prize; Philip Larkin (who cast the vote that finally

told against what he described as this "deceptively concise" novel in favour of Paul Scott's *Staying On*) reported her at the dinner, "pissed as arseholes."[2] Her novels were, Freud thought, "just on the right side of journalism. Mostly." The previous year he had become briefly acquainted with Natalya, her straying sixteen-year-old daughter by Israel Citkowitz. Where Michael Wishart and Kitty Garman had been, in a sense, proxies of Lorna Wishart, their mother and aunt respectively, Natalya Citkowitz was a sort of reconnection. To see her was to review a past, to sniff a trail. She died of a heroin overdose in June 1978.

Having agreed to be filmed by Tristram Powell for the BBC in the late 1970s, Freud found the busy set-up involved—this was when he was still in Thorngate Road—oppressive and alarming, particularly the microphone taking in everything he said. "Tiny room at Thorngate with technicians and lights. I was nervous, so I took twenty aspirin tablets, because they make me feel different. A transcript girl wrote it all down not knowing what lots of the words were. I read the transcripts and I was talking such rubbish I just thought I must do everything to stop it. Saying stupid things doesn't matter; being recorded does," he insisted. His disquiet at being subjected to attentive questioning provoked him into glum responses. ("If something works very well in a picture it's often best to take it out.") The process felt like entrapment. "I never saw the film, but Tristram told people he was pleased with it and some years after I panicked and said could he do something to make it more difficult to be seen? Take it to some dump? He was slightly irritated." Powell had no option but to agree. He remembered only two rolls of film being shot, twenty minutes' worth maybe. "The print was junked, but there's a negative lurking somewhere, probably." In fact, though he had handed over the rough-cut footage to Freud for him to destroy, it survived as an unidentified spool.

Many years later, in 1995, Freud suggested Tristram might sit for him and a portrait head resulted: the elder son of the novelist Anthony Powell, sharp-eyed, observant, faintly questioning. Would he care to pose for a full-length painting? No, he said.

The condition of privacy, hard to sustain if fame or notoriety

were in any way involved, struck Freud as being his to demand. "It's why not interviews." He did all he could to preserve it yet liked the idea of controlled exposure from time to time when he wanted paintings publicised. Being ex-directory and not giving out his (frequently changed) Holland Park phone number to more than the most essential few—lawyer, a girlfriend possibly, later on a daughter or two—minimised the risk of intrusion. He avoided being on electoral lists. "Why vote? I'd vote anarchist." By the late 1970s he was keenly aware of the repercussions, desirable or otherwise, of being in the news for he had become a byword: Freud the elusive, Freud the uninterviewable, Freud the flâneur whom Mark Boxer might caricature (a roué head on squared shoulders) and whom not every journalist still felt it necessary to reveal to be a grandson of Sigmund Freud. Every newspaper's cuttings library now had its well-thumbed Freud file. There was a time—"a marriage, a car accident"—when his face was often in the papers, he said. Which was why his instinct had been to kick Nigel Dempster.

Gossip columnists needled him increasingly, more so than ever they had done in the Beaverbrook era; for unlike then, when he occasionally leaked incidents concerning himself, his violent disinclination to be available for the doorstep photographer now prompted the popular press to assume that his was a newsworthy life and lifestyle. Bacon—that Faustian, Proustian, bacchanalian soul—was ready-tagged and young David Hockney, whose *David Hockney by David Hockney* was a Christmas bestseller in 1976, was always eye-catching and good for a quote. Not so Freud who, though happy to update from time to time his entry in *Who's Who*, was notoriously unwilling to be in the public eye.

"The police *accuse* you of not being listed," he said. He liked to think that he, and he alone, could determine whether anybody noticed him. "It's not self-importance exactly. Something I really hate is carrying materials—canvas or frame or picture—down the road." He flinched at the idea of exhibiting himself alongside his work. "I don't see people who buy pictures," he used to say. "Only four people I showed pictures to, and you were one." (This was from the late 1970s onwards.) He shunned his own private views.

In the newly internationalised art world of the time, a network now served by jumbo jet, celebrity overtook reputation. To be per-

ceived as legendary became a requirement. During a discourse on the subject in 1974 Joseph Beuys, whose image was incorrigibly shamanistic, remarked to me that fame validates. "Everybody has to become famous, because famous means no other thing than to come to a special ability." To Beuys the glow of fame was a spiritual dimension, not to say a marketable aura.[3] Freud considered this a sort of preening. "I feel anything that incorporates mystification isn't good. It's exciting when your brain is tested with ambiguity and scholarship. But the thing of it being done in order to make you wonder about the maker—Derrida is so ghastly—it's irrevocably linked to vanity. Beuys wrote to me once or twice. Anthony [d'Offay] said we should be friends." Josef Beuys and John Ruskin, he thought, had something in common: talking art up, attuning it to piety. "Ruskin doesn't seem visual. I like the idea of very strong moral attitudes: anarchic feelings are moral attitudes, surely, like in Baudelaire, but people think of morals as puritanical. That somebody completely damp could influence some very intelligent people—K. Clark thought he was marvellous—is interesting."

Ruskin's exhortation to the Modern Painter of the 1840s to "go to nature in all singleness of heart . . . rejecting nothing, selecting nothing and scorning nothing; believing all things to be right and good, and rejoicing always in the truth" was preachy yet sensible. Painters do well to concentrate on actuality, for fantasy needs roots and the imagination cannot stimulate itself in a vacuum. Freud, who had little time for theory, still less for the theorising intellectual, backed the idea of the interdependence of sight and touch: "Bishop Berkeley and the notion that you only learn to see by touch, to relate sight to the physical world. I look and look at the model all the time to find something new, to see something new which will help me . . ." The model serves, in classic Freudian terms, as the source material, the stuff of transference, meaning that the painting takes on the identity of the sitter: appearance, image and aura, if any. It also has its own accrued work-of-art identity.

"[Jacques-Louis] David's portrait of Napoleon in the study: it's a surrealist idea, but if, when David was painting it, Napoleon had wandered in, he'd have said, 'Don't get in my way,' wouldn't he? He didn't want this little man; he wanted this you-don't-know-how-big-he-is in that picture. The wonderful grandeur of it." David's Napoleon,

in this full-length portrait informed by the setting (rumpled green carpet, guttering candle) is the tireless and unsleeping shaper of destiny, seen alone in his palace at 4 a.m. (as the ormolu clock indicates), engaged in drawing up the Code Napoléon. The portrait pleased the Emperor, as it was designed to. "You have found me out, my dear David," he wrote. "At night I work for my subjects' happiness, and by day I work for their glory."

Living with each painting, devoting the hours to it, the model being there for him at whatever time of day or night could be arranged, Freud was a man possessed. When a picture worked it became permanently immediate; once it worked, the sitter was disposable: his or her identity yielded to the furthered identity of the painting itself. That, logically, rendered the naming of names unnecessary. "I think it's quite nice, seeing how [with David] it's so often Napoleon. But one doesn't *need* to know." His constant pursuit—the urge to perpetuate appearances, people and places—stimulated relationships and stifled them too. "I've always—not in a thought-out way—allowed myself to be very attracted by the people I worked from so that it put me in a stronger way to making them part of the whole process. Like to do with their colours, their movements and all that, their utterances and so on. I'm certainly affected by the people, the life in them and the way they are made, their physical, farmyard behaviour.

"I'm drawn to certain things, rather like Eliot said 'I am moved by fancies that are curled . . .'[4] The insides and the undersides of things; and I use things that would actually be visible from another position. That thing, people on the roads, they had very red necks and when it got very hot and they took their jackets off and there was their vest and there was a white piece. That is the sort of revelation that I like very much. I don't want a painting to appear as a device of some sort."

John Singer Sargent's celebrated remark that a portrait is "a likeness in which there was something wrong about the mouth"[5] came to mind one day when we were looking at *An Interior in Venice*, Sargent's portrait of Mr. and Mrs. Daniel Curtis and family in the grand salon of the Palazzo Barbaro, a painting rejected by Curtis on the grounds that Mrs. Curtis appeared too old and their son "a slouch." Time had rendered the objections sillier than ever, Freud said, given the spacious handling, the airy ease. The painting seemed to him so masterly: such dramatic potential so contained and so complete.

"The goal of all art is the human face," Cézanne said.[6] Portrait heads collectively (in Giacometti's phrase, "heads frozen in the void")[7] tend to meet the head-hunter's remit: bags of characters hung out to dry. Aware of the insidious lures of over-identification, Freud had to try for objective individuality from one face to the next, each face an isolated instance. "I wanted to do a person in a more dispassionate way than I was actually capable of; I was very conscious that I just didn't want to leave lots and lots of faces because that's what I was naturally drawn to, very much." Unlike Rembrandt's portrait of his son Titus in the Wallace Collection, a painting smitten, as Freud said, with the infectious affection of "Titusitis," *Portrait of Ali* (1974) conveyed not so much paternal pride or tolerance, more a sense of patience wearing thin and, meanwhile, determined engagement with the straggly hair, the veins on the backs of the hands, arms akimbo and the thick check trousers. In comparison to that, *Head of a Girl* (1975–6) was all the better for being so resolutely a dispassionate account of Katy McEwen's consuming despair.

"Think of Augustus John, who was painting rather bad paintings, some of them, and he went to Jamaica and obviously played around with the natives to a great degree and have you seen those pictures of Jamaican girls? The fact that art is a filter might have remained a mystery when you look at those. They're sort of after-dinner stories of someone who's having a lovely time. They're really awful." However, as he said to Lawrence Gowing around this time, sitters impose terms. They compose themselves; they assert themselves. "The way they sit, move and talk about themselves affects the picture. The speed of movements. I can't think of it like a transformation scene in a panto. There are lots of jokes and suggestions made from people I know well when they sit."[8]

Being alive to the sitter's presence and moods was not something that Bacon bothered himself with, or so it now seemed. Freud came to regard his old friend and idol as an ebbing talent, whose methods were becoming routine and whose derision, directed at all possible rivals, seemed compulsive. Typically, Bacon impressed on him that he had no time for Auerbach. "He said, 'You know I made the mistake of saying how do you do that? And since then, Frank has kept coming round to the studio to show me.' Francis went on about how good looking he was."

Bacon's generosity or profligacy with cash and champagne was laced with a towering disdain and a taste for the put-down. June Andrews particularly remembered the dinner Freud gave to mark the opening of his show at d'Offay in 1978. "At Wheeler's, with some of the children and Frank and Mike and I. And I was next to Francis and he was getting more and more drunk. 'Can you change places with Mike?' he said. I saw Mike's face: it was when Lucian had done Frank and he knew that Francis couldn't wait to rubbish the painting. Frank was sitting next to Mike and Francis said to Mike, quite loudly, '*Look* at that great *forehead*,' and Mike sat there squirming; and then he said—knowing Lawrence well—'Who's the Professor?' 'It's Lawrence Gowing,' Mike said. 'Oh, is *that* him?' And then he said a funny and hurtful thing: '*Look* at his hand. It's like a shovel. It's the size of a shovel.' Francis drank more and more."[9]

In earlier years Bacon had seen Freud most days, and Auerbach almost as frequently; if paintings were a tally of affinity, it was significant that he had done more paintings, nominally, of Freud than of anyone else, apart from those of himself. But since his Grand Palais retrospective he had worked his way into sequel after formulaic sequel. "In Francis's case—it's so easy to say after the event—it was losing its bite."

Having dwelt on George Dyer's death in a number of rueful triptychs, the outbursts of bafflement and gut-wrenching abandon lost impetus, Freud felt, and left Bacon threshing around. "He got obsessed with really funny things. He had a studio in Narrow Street, pretty marvellous, never worked there, but he had this absolute terror that Fischer would bring Kokoschka there and he would do a view of the river from his place. That was partly why he sold it. 'I know he's going to bring him.' Kokoschka used to paint the rivers wherever there was a convenient hotel."

Inevitably Freud too came in for the dismissive treatment because, following his Hayward show, he was increasingly recognised as a remarkable painter of indisputable achievement. "When I started getting on a bit, he resented it. Francis made a great thing about the sensuality of treachery." When he mentioned to Bacon that some critic had written about him being an immigrant, Bacon just said, "That critic needs an immigrant to write about him," a careless jibe with nasty undertones. "To give him his due," Freud said,

"I don't think he ever liked my things much." And, as ever, money talked: *Naked Portrait*, of Jacquetta Eliot on the brass bed, was sold in 1975 for £5,000 when Hockney's *Doll Boy* fetched £22,000 and an average Bacon £38,000. Freud's prices would have to more than quadruple before it could be said that he qualified, in art-market terms, as Bacon's equal. Meanwhile there were taunts. "How much do you get for your work now?" he would say.

"Funny thing: a Sickert that Francis had, of two people in a room, Hubby and Marie in a doorway [*Granby Street*]. Some years later he said, 'Would you like it?' I had it when I first moved to Holland Park. I heard from a number of people that he regretted giving me the picture. I think all that giving things back is like asking for the ring back." The critic Angus Stewart remembered asking Bacon about this Sickert and where was it now? Bacon said that he'd been a fool: he'd lent it to Lucian so that was the end of it.

Fundamentally the divergence was to do with differences of approach: for one supposedly the assault and for the other sheer laborious ascertainment. "One of the things that excited Francis most was to do with the way he worked. Things went down which he had no idea might. He talked about harnessing the accident; that was a terribly bad idea, I think, if you think of Degas saying 'I don't know the meaning of inspiration: everything in my work is manipulated, is to do with awareness and artistry and tricks.' Francis felt that these things were sent to him, somehow. He made some amazing liberties with the faces. But he wasn't au fait enough with the bodies to remake them in any way: the bodies were generally stock ankles and feet. I noticed, for instance, he always gave me his legs when he painted me. He had those wonderful calves and those funny gym shoes.

"I only noticed when it wasn't all right. I think that I questioned things, not necessarily verbally. I suppose he got very used to my admiring things and when I stopped . . . When I saw him most days for a very very long time—when he was in London, obviously—I hardly ever saw a painting that I couldn't really admire or be surprised by. And then it grew less so. When he was repeating himself, when they became hollow and lost their meaning, obviously, I couldn't say anything, and he must have noticed.

"Frank's view was that he should have gone back to being a mysterious gentleman of leisure, like when we first met him, to the wit and

generosity and marvellous manners of being understanding, ridiculing people and being affectionate, in a way. I was surprised how late he went on. Same old photos."

David Sylvester's interviews with Bacon, published in book form in 1975, after Bacon himself had extensively edited and rephrased them, formalised his already celebrated flows of remarks about the body being meat, and about opening the valves of feeling.[10] Freud had heard it all before, often enough. "They are interesting because they are an interesting person talking, but they aren't actually radical. The first one's interesting, the second is less so and then the others completely tail off. 'The beauty of the wound': the wound to the point of chi-chi.

"Suddenly it looks unnecessary. There's something about his line on 'the accident,' which is against the whole nature of the accident. I like the idea that you create your own accidents, even when people slip and fall and so on. In Francis's case you thought the first was exciting, of course, and then when there was another splodge . . . I remember in one picture, a self-portrait, Francis tried something in the corner that didn't work and he painted it out in a violent way with dark-blue paint and it looked like a horse and cart, a bit. This excited him no end (very understandably), but that sort of thing can't happen twice. He couldn't work at it. They were hit or miss. Inspired or dud. After that they looked as if someone who didn't understand his work had tried to do them. The paintings were depressing—that awful one of Denis Wirth-Miller by the washbasin. Him in an airport lounge. But Francis had marvellous courage and human concern. He didn't know that the work was so terrible. He believed in the triptychs."

Bacon's shock devices—swastikas, hypodermic syringes, scattered Letraset—should have been discarded, on second thoughts, but instead he reused them. "Arrows were left behind like the scissors of a lazy surgeon in the stomach after an operation," Freud said. He felt that delusion had set in. Bacon began to talk like an auctioneer, referring to one or other of his big, plush, three-piece suites of squished figures as "one of my more important triptychs."

"OK, it's a quiet little complaining remark, but it's so ludicrous—or maybe I'm just quibbling—but the word 'important' followed by the word 'triptych' . . . I mean, one can't make recipes for other people, but if he reduced the scale enormously so that, instead of these

things being rather hollow demonstrations, they were somehow over-packed . . . With a lot of painters one of the things you want is *more*, you know."

Lazily, or from lack of interest, Bacon laced his conversation with dismissive prejudice. "His opinions seemed no longer tested by look-ing at the things he was slagging off. It seemed like policy, a complete policy: liking bad art. When he first used to say that nothing was any good, except perhaps some Michelangelo sketches and one or two things, though it seemed to me so extreme and strange, I thought, well, the work is so extraordinary, if you do things like that you might think that. But the work deteriorated and these things ossified." It occurred to Freud that Yeats had similarly disparaged or ignored those who, he felt, offered competition to his unique distinction. "Yeats saying Lady Dorothy Wellesley was the best poet and the person Yeats hated more than anyone was Sean O'Casey and, marvellous as he was, Yeats couldn't really write a good play and O'Casey could hardly write a bad one." Bacon's blistering remarks were not meant to be taken as pre-cepts, he added. Many, however, were preserved, notably in Dan Far-son's *The Gilded Gutter Life of Francis Bacon*: "things said when drunk: now framed like samplers in a cottage." But there is little doubt that, like the arrows jabbing at lumps of cushion-flesh in so many of the pictures, Bacon talked as he felt, prodding and jibing and to hell with it; the more he let out of his studio, triptychs especially, the bigger the stacks of cash and the more reassuring the numbers in the Swiss bank account. There was, Freud thought, petulance masking hope-lessness. "The hollowness of money with approaching death. There is this marvellous petrol in the tank but you can't put your foot down any more, it will go through the bottom of the car. I feel it's deeply linked to memory loss. The depression is lack of programme, lack of ideas, lack of clarity. Also, the thing of going into Soho: it's almost impossible not to have hangers-on trailing after you, especially if you like it and are stimulated by it, and they seemed to be the only people round Francis then. Gay exploitation: is it fundamentally different from girls? This sounds terribly one-sided, but I can't help feeling girls are more deserving. The boys are all sharks, in it together, and also gays like Bacon, they're hedgehogs: when their parasites leave them that shows they are ill. It's part of the healthy organism to have a few crawling around."

Besides being the pride of the Marlborough stable Bacon was indisputably the doyen of the School of London, a grouping nominated by Lawrence Gowing and promoted by R. B. Kitaj in his "The Human Clay," a selection of figure drawings exhibited at the Hayward in 1976. Kitaj had regarded Anne Seymour's "The New Art" and other such professedly landmark survey shows of that period as epitomising "a malaise as pervasive and worth questioning as the academic malaise which a heroic modernism had to deal with seventy years ago."[11] To him "The Human Clay" was the right stuff and this touring exhibition was his opportunity to propagate what he saw as the flowering of a very special school of art in what had been Eliot's Wasteland.

"I think there is a School of London. A School of real London in England, in Europe . . . with potent art lessons for foreigners emerging from this odd old, put-upon, very singular place."[12]

Writing as an American in London, casting himself as another Ezra Pound, or a more graphic Whistler, Kitaj called for the advancement of painters, figurative painters especially, as the instinctive accomplices of novelists and poets. "Dickens and Tom Eliot knew this place and how I wish for a London art that would body forth at those levels of quality."[13] Naturally he praised Bacon, though he could find no drawings by him to feature in "The Human Clay"; he extolled David Hockney—"the most intelligent, thoughtful, meticulous and tireless draughtsman in the world"—and he singled out Frank Auerbach as "one of the very moving painters of Europe (with Balthus and some of the other artists in this exhibition)." Freud was represented by a head of Alice Weldon (Kitaj secured this for the Arts Council collection), the *Ill in Paris* etching, *Boy on a Bed* from 1943, of Nigel Macdonald wanking (which Hockney lent) and one of the three drawings of Francis Bacon with his waistband undone, which Kitaj himself owned.

Eager to proselytise, Lawrence Gowing, writing in the *Sunday Times* in 1980 on "Painters of Fact and Feeling," extended and elaborated the School of London membership to include Jeffery Camp, Patrick Caulfield, Patrick George, Howard Hodgkin and Euan Uglow. Senior luminaries of the Slade and the Royal College, they had also been included in "The Human Clay." But the term became exclusively associated with Bacon, Freud, Andrews, Frank Auerbach

and Leon Kossoff. And Kitaj was identified with it closely enough to count as also being on the strength. He was, after all, a Marlborough artist. "You never know where the sun is going to shine. Suddenly," Kitaj said to me, "the sun was shining on London. What I mean is, the sun shone on Paris like nowhere else for a hundred years; there was nothing like it since sixteenth-century Florence, and the same conditions apply: why should ten world-class painters occur in Siena at a certain point, or in Florence or in Paris or in New York for twenty years?"[14]

The following year the Yale Center for British Art in New Haven showed "Eight Figurative Painters," a British Council exhibition selected by Andrew Forge (by then Dean of the Yale School of Art) involving Andrews, Auerbach, Bacon, Freud and Kossoff together with Coldstream, Patrick George and Euan Uglow. Gowing wrote an introduction in the course of which he described Freud's *Large Interior, W9* as "a visionary experience of sexuality" and ended by quoting Auerbach as saying he hoped the exhibition wouldn't "look like dreary nineteenth-century revival" but instead "have to do with a strenuousness in getting grand forms that are not artificial or sculptural or wilful or arbitrary."[15]

When in 1946 Michael Ayrton talked about a School of London he associated Freud with it despite his being, as he put it, "not British." The term was not new even then. It had been used before the war in connection with the London Group, involving the pre–First World War avant garde and Roger Fry and relating to Hogarth, Sickert and Bomberg. This time round it was confined to painters who (with the exception of Kossoff) came to London from abroad or, in Michael Andrews' case, from provincial Norwich. Just as, indeed, most of the leading figures of the School of Paris and the School of New York came from elsewhere. When, twenty years later, Kitaj left England, he took his departure to be the end of an era. "The School of London is closed," he declared.[16]

"Hooray," said Freud.

"Good painters have courage; that makes them good painters and of course the fact that they prefer painting to anything else. I always think there's a deep core in painters: they always know when things are good or not."

Bacon became testy on matters that in earlier years would have

amused him and accordingly was outraged when he found that the Lefevre Gallery was pricing a Balthus higher than anything of his. He hated being no longer the youngish painter sweeping all before him, the Beau Brummel of outré behaviour, the authority on how to cook even, how to entertain, how best to spurn convention. Freud saw this as pique.

"At one of the corners of Holland Park Avenue/Bayswater Road there's rather an ugly modern hotel. And we were walking along and Francis said, 'Let's have some tea.' We went in and it was no worse than many—a bit tasteless, brash, phoney, darkly luxurious and hideous—and he said, 'You know, that's why I can't bear London.' And if you think of Paris! I thought it wasn't remotely any aesthetic thing: I think he had terrific adventures in Paris. 'Good jumping ground,' he said. The French only wear berets; they can't do art any more."

When, in October 1982, he took Bacon to see what proved to be his last show at the d'Offay Gallery his new protégé Celia Paul was with them and she remembered one particularly tart remark. "Bacon said, 'Do you mind if I say something bitchy?' Lucian said no and so he said, 'There's something very Euston Road about them.'"[17] Scorn was one thing—virulent banter—but Freud regarded it as cheap malevolence. "I saw Francis less. I used to take him to Annabel's a bit and then he became a member and then didn't like being a member and stopped that."

Bacon's comment on the fadeout of their friendship was as bitchy as could be. "She's left me after all this time," he said. "And she's had all these children just to prove she's not homosexual." John Richardson had relayed this to Freud, who grinned in the retelling to me. It had taken great dedication, he said. Bacon had been a powerful and lasting influence on him, not least in his discreet habit of working longer hours and with greater sober application than he liked to let on about. He had also impressed on him the importance of being lordly in one's attitude to spending—"he taught me a lot about roulette"—and how right it was to disdain anything other than the best in wine, food and tailoring. Money was to be treated as small change whatever the sum.

"Clearly money has something to do with life. My economics weren't straightforward in the ordinary way; when I finished a painting I generally wanted money, so I got it to spend. I made *such* an

effort not to mind about debt." He told me he tried not to think about it. "My conscience worked in other ways. The income [from the Sigmund Freud royalties] became a tenth of what it was because of a lot of things. Nine children get it. I didn't really have it much."

"Gambling has made me very tough about money, about not caring a bit if it's not there at all. I so guard against that pressure. I don't mind not gambling whereas the idea of not painting is absolutely unthinkable, it would be embarrassment to a degree that causes blindness. Gambling is completely meaningless, unless the money's not there and the only thing wrong about money is if it's not there."

The parallels between gambling and painting do not extend far, but there is the common factor of wilful risk and the beguiling possibility of a winning streak. The appeal of gambling lay in the exposure to a whole set of calculable yet finally uncontrollable circumstances; to win was less important than being caught up, for a while, in headlong drama. "If I can't win, I think, 'OK, let's see how much I can lose.' I want a result of some sort. I'm inclined to go race by race—as most people do—and what I bet depends on how they fared in previous races. For instance, if there's a short-price horse that I fancy a lot, if I lost on the previous races, if what still seems to me a horse that has a better chance, and also has a full price, comes along, I'm very unlikely to back that one because, even though it won, I couldn't break level. So I'd rather back another horse in that race that I would have thought was the danger and if it wins at least win. So the most important thing is ratio. If you have six bets and one of them wins and if you come out on top, then your ratio's right. So I'm not *sporting* in that way at all.

"Gambling must be all-out. It must alter the balance of life."

Auerbach thought that Freud's sporting life was, to him, something of a privileged and deliberately endangering release. "Lucian may have felt that he himself was simply too good looking, too extraordinary, athletic too, really clever; he may have felt he was just too lucky. Géricault was the same: had a lot of money and gave it all away to put himself in a situation where he thought he might paint better. The funny thing is, once people have been a bit spoilt they have a sort of freedom the rest of their lives, they're not as cautious as people who have been very poor from childhood. Francis had that famous thing of a tiny, tiny allowance; Lucian had—until he gave it away—his

allowance [from the Freud copyrights]. He gave far more away and spent far more and gambled far more. It must have helped."[18]

Gambling had less kick when knowledge of form could not be applied and, equally, when potential losses were too easily recovered. Michael Tree's brother, the trainer Jeremy Tree, said as much, Freud remembered. "Not long before he died I saw him and he said, 'You betting much these days?' I said, 'You know, I rather retired when you did.' And he said, 'Not so much fun when you can afford it, is it?' I thought that was good. It's so difficult winning because there's only one law: 'Thou shalt not win.' So when you do, you never think about the difficulty of actually getting paid. You have to believe in the betting shops being really rich; which doesn't happen, actually, with the small bookmakers. They go bust. If you start with a limited amount of money then send all the dangerous betting away, then you get caught if you've got a winning punter who's obviously got good info. But a really good bookmaker, even if all the favourites win, will still make a lot.

"I've been banned from betting shops when I was doing well. Banned from the thing that Woodrow Wyatt ran, the Tote, and I saw him somewhere and said, 'Woodrow, you're absolutely mad: I've been *banned*,' and he said, 'Well, you know you've been doing rather well in that Harrow Road shop.' He *knew* it! I didn't *believe* it: I was warned off.

"I loved the risk but on the other hand it was only money."

In the general election of 1973 Clement Freud stood as Liberal candidate for the Isle of Ely constituency, placed a £100 bet on himself to win the seat and made £33,000.

One dodge for the banned gambler was to place bets through middlemen. A more beneficial one in the longer term, Freud found, was to befriend the bookie and in effect cut out all go-betweens. Among such middlemen Guy Harte was handy and useful too in that he sat well for him, as did Speck, his terrier.

"The dog makes him more interesting. A jockey, the man who owned the place where I got my car cleaned in Maida Vale, did everything." He had done time in prison. "I used to bet through Guy and he'd forget to place the bets and it didn't work. They were always wrong, the pictures he bought: he was one of those people who'd rather have something crooked than expensive. I'd always known

him, through Charlie Thomas, and when I did pictures he sold them on. He was at some race meeting and Clement said to him, 'I've seen the latest things,' and Guy said, 'You ignorant cunt, you don't even know where his studio is.' He was a friend of mine for a time."

The first painting of the pair he abandoned: their heads were too high on the canvas, leaving what would have been too much trouser space, a mistake resolved in *Guy and Speck* (1980–1), completed in May 1981, in which Speck, basically a bull terrier, is alert to any untoward move by the painter and Guy, the aspiring connoisseur, a florid dresser with polka-dotted handkerchief, chunky watch and signet ring, looks confident that before too long he'll close the deal. Subsequently in *Guy Half Asleep* (1981–2), he sat back, sagging a little, business well in hand.

Several bookies became involved as patrons, creditors and sitters. There was the one who agreed to be painted by Freud to settle a debt. He was *Man in a Sports Shirt* (1982–3). When the painting came to be shown at the Hayward Gallery in 1988, the sitter went to have a look and saw himself, his heavy moustache and rolls of fat under the chins, and was aghast: not so much at that but at being told that the picture, which he had sold on for under £2,000, was worth a quarter of a million.

Ulster's pre-eminent bookie, also the manager of Barry McGuigan when in 1985 he became the world featherweight champion, was Barney Eastwood. "If you had what I owe," he told an interviewer once, "you'd be a wealthy man." He too liked acquiring pictures. "Barney gave Charlie Thomas a terrible time, nearly buying things—*Man in a Blue Shirt* (1965), and a nude—and he wanted me to paint his daughter." He bought the painting of Ali. Eastwood (a Catholic) owned horses with another bookie, Alfie McLean (a Protestant) of Ballymena. "They had a fight in the Ritz Hotel and Alfie had a black eye. I heard about the fight and met Alfie as I wanted to paint the black eye, but the eye got better." Guy Harte introduced them. Freud, he said, took him into a corner and said that he must paint him for, besides the black eye, there was a marvellous bulkiness to the man, a polite, benign and genial quality. He had begun as a greyhound trainer and racer on the Northern Ireland tracks in the 1950s and 1960s, went into on-course betting with Barney Eastwood for a while, and when betting shops became legal in Ulster in 1962—before the mainland

UK—his business grew until there were sixty shops with the "A. McLean" sign and 300 staff.

"Alfie started from nothing. Was interested a bit in paintings, through Guy [Harte]; he bought things occasionally. The things he had of any quality were Tissot and Munnings (actually I like Munnings); I got him Jack Yeats, a really very good Géricault, which I bought in a sale, a marvellous Degas of young girls bathing by the sea. I've never been to Alfie's house, but there's a certain consistency, I feel, about what he's bought. If you are sort of advising someone on collecting, one important thing is not to diversify too much. I've got one rule if I really like something, which is: would it look all right if it hung in the National Gallery?

"This Degas, which was hung near the ceiling in a bad dirty state and was amazingly modest at £110,000, he left with me for a year or so. I said, 'What do you think of the Degas?' and he said, 'Um, well, I wasn't fussy about it, but if it's your nap choice then that's good enough for me.' Now it's in all the books (as *Peasant Girls Bathing by the Sea at Dusk, c.* 1875). Such an extraordinary picture."

Alfie McLean proved to be an admirable sitter. "He'd sit and sit, six or seven hours at a stretch. He wouldn't even rest and have a stretch, he'd say, 'I'm fine.' I asked him once how it seemed no trouble and he said, 'You see, when I was young—seventeen—I was very ill and I had to be in a sanatorium for a year or more and ever since then walking down a road, sitting in a chair has been a pleasure to me.' He's got a philosophical nature, a very lively mind."

The ruddy face of *Head of the Big Man* (1975) is set into relief by light strokes of grey background around the temples and down the sideburns. Each feature is an aspect of character: the chin a gleaming bump, the mouth lopsidedly accented, sharp blue eyes resolutely averted. "Alfie's got such a very good character; obviously he let me bet there—we are friends—but he said he really didn't like telephone accounts very much because people said numbers and didn't *feel* how much money they were putting on." The neck balloons over the blue shirt collar. ("I like to do very thick necks.") On the back of the painting—*pace* Bacon, about as far from Euston Road School norms as could be—Freud wrote: "1st portrait of Alfie McLean painted by his friend Lucian Freud November 1975."

"When I met Alfie the first thing that impressed me was his con-

versation. We didn't talk much when I worked. So amazing; so Irish. He was yarning on about people in Ireland and he said that one night in a bar it got very late and a man he met said to him, 'I'm probably the only person in this room who has been on a jury for a man being tried for murder, when I did it.' The man did the right thing, Alfie said. He did get him off."

The following year Freud started on *The Big Man* (1976–7), Alfie squarely seated as though facing interrogation, fingers interlaced and thumbs pressed together. Mirrored behind him the floorboards rise; he and his reflected self are clamped together back to back, comb-over yielding to bald patch.

The Big Man II, completed in 1982, is formidably self-possessed. Again head and hands declare a steadfast readiness to be there for six or seven hours at a stretch. Body, arms and legs spread the pose and nudge the radiator. Hands or fists, whichever suits: either way he is prepared, as before, to face up to the trial and sit it out. "He's not greedy. He's peculiar in that."

That year, the Ulster connection brought Freud into dispute with the betting authorities.

"I used to have rather a lot of Ulster cash: red hundred-pound notes, rather big piles of these, through Alfie and Barney. Ulster notes are sterling, not like the money from the South, which is worth less. It was two or three weeks before the National: I went into the local Ladbrokes in Holland Park Avenue and I said, 'Can I have so and so much on this horse at sixteen to one?' 'Certainly, sir,' said the fellow I spoke with. I gave him the money. 'So sorry, sir, I'll just phone up head office and check.' 'You'll find it's sterling,' I said. 'I'm sorry, sir, I've been instructed by head office that we can't take this money.' 'Look I'm not saying what you're doing is actually illegal. But you are refusing a transaction, which you accept under one condition, under another condition which you've invented, which is in fact illegal. I'd like to remind you—not that I blame you personally—I consider myself on.' This meant I had the bet. So naturally I went round the corner to Corals who were only too pleased to take it. The horse subsequently won. At that time I had an account with Ladbrokes, so then I'd have won roughly £3,000. I owed something like £15,000 and I cancelled

it out because I knew that morally I had won that money from them but they would get the people in the betting shop to swear they'd never seen me before. (I knew this from a friend who was on the committee adjudicating betting disputes.) So then I had a letter from the board responsible. Betting losses are not recoverable by law—that's why the whole thing about gambler's honour is so strong—and they said unless I paid this by such and such a time I'd be warned off every race course in the country. (Well, I hardly ever went anyway.) So I was warned off. I did go when I was warned off, but then my face was hardly known at all, really." He was put on the "forfeit list" in February 1983 for not paying a debt of £19,045. Escorted by a bookie, Vic Chandler, he flouted the ban at least once, gatecrashing a racecourse disguised in a beanie and dark glasses; and he thereafter placed his bets with Irish bookmakers, principally Alfie.

The lust to bet on the racing was to do with greed, of course, but more for love of the straight run. For Freud never veered from his childhood notion of himself as a jockey, a role that seemed to him to be sensationally ideal: that fierce concentration of effort and skill, balance and drive; that hold on the reins—no horrible "Black Beauty" bearing-reins for him—and the delirium of powering over the fences or on the flat, man and beast as one. He used to joke that Lester Piggott was his true love object. Jockeys appealed as a select and perfected breed. The tough little figure in racing colours carrying whip and saddle to the enclosure was the hero afoot and once mounted, rising from the saddle, carrying the weight of bets placed on him as he risked his neck at reckless speed, he was—momentarily—the utter artist.

The Quest for Sitters, Betting, Etching, the Death of Lucie Freud 1981–9

8

"I don't think paintings have come about emotionally"

When in 1977 Freud moved to 36 Holland Park he admitted to being in a nervous state, anxious to shut himself off from those he didn't want to see. His flat was to be a working eyrie with a studio to suit ambitious needs.

In May that year Mentmore Towers in Buckinghamshire, designed by Joseph Paxton in the 1850s for Baron Meyer de Rothschild as the ultimate in baronial mansions, was sold and its contents auctioned off. Over three days, in what Sotheby's described as "The Sale of the Century," a mighty assortment of elaborate furniture and fittings— among them the black and white marble fireplace designed by Rubens for his house in Antwerp—was catalogued and dispersed. Attracted by the ballyhoo, Freud attended and came away with an iron-frame bed, "a servant's bed: £7. Not ornate enough for Chrissie Gibbs" (Christopher Gibbs was a socially prominent dealer-decorator), an acquisition that was to appear in a number of pictures for, unlike the brass bedstead, it was unshowy: ideal for the studio.

The large mirror salvaged from Delamere Terrace went into one of the front rooms, which he turned into a kitchen, the sink and cooker across one end and a long table for the telephone and tidal accumulations of magazines and newspapers. In the hallway stood Rodin's *Balzac*. "I got Jane to buy it. I had some Rodin bronzes very early on, got them for £100 and £200, including the one out of Michelangelo, thorn out of a foot, and sold some to Jane. She got Balzac; I bought a

nude." A few years later a spectacular Auerbach joined the Rodin in the hall, a blustery winter evening on Primrose Hill with gulls swooping, so powerful Freud decided that the Sickert that Bacon had given him would have to go. "I gave it to Jane because I don't think that it stood up to the Frank."

The front room on the right was formal and little used, a transposition from the Viennese, with heavy furniture, a round table, buttoned sofa, his *Dracaena deremensis* in its big earthenware pot and a bookcase full of Pound, Eliot, Balzac, Auden and other preferred writers. "It was a bit like a parlour: the front parlour. It just didn't work as a sitting room. I had some things in there that didn't work; I did like to buy things irrespective of what they were for." Michael Andrews' *Lights VII: A Shadow* (1974), the silhouette of a balloon soaked into an empty beach, dominated the room. "I saw it before it was shown: so marvellous." When it was borrowed for Andrews' exhibition at the Hayward in 1980 he summoned Mike and June for a drink and showed them the empty wall. On it he had drawn himself in outline weeping over his temporary loss.

The bedroom, painted brown and soon stained with damp seeping in from the eaves, was dominated by Bacon's *Two Men on a Bed* ("The Buggers"). Besides the Empire bed borrowed from Grimsthorpe he had Empire chairs with gilt swans' heads capping the arms. "I bought them for £400 each, covered them in velvet: I used to have grand things as I like having no money and gold things."

A small room to one side, cluttered with books and cupboards, became his cubbyhole for watching TV, mainly the racing, which was how he came to buy a television in the first place. "I had a huge bet and I badly wanted to watch and so I went down Westbourne Park Road and looked at the televisions in a shop and saw them just lining up for the race. I watched it and the man switched through the various stations and I said, 'I rather want to see this station—the one with the race on—it's such a good picture.' The horse won and I was so relieved I bought the television, though I'd had no intention of getting it. Ali fixed it in. A 'telly lounge': I never use it really."

Along the hallway beyond the "front parlour" there had been three poky rooms, one of them windowless, another a dismal kitchen. Keeping only the sink, and the pipework exposed around it, he had the internal walls removed to create a good-sized studio. Once the

skylight had been lowered in and the remaining walls and ceilings plastered he got Kai Boyt to tone down the bare plaster. ("I always get other people to rub dirt on the walls.") To do it himself would have been arty, he thought: a contrived studio decor, and he was at pains to avoid that. Every bit of furniture was there for a practical reason; everything was to be of use in paintings. "The black screen and plan chest were in pictures very early. And I changed sofas, as I absolutely didn't want to continue with them too much. I change chairs."

A door opened on to the roof terrace and views westwards to Shepherd's Bush, northwards towards Holland Park Avenue. Below him he could sweepingly indicate the whereabouts of the studios of Glyn Philpott and Russell Flint, long-gone specialists in slinky nudes, male and female respectively. Beyond Holland Park to the south lay the grandest of all studio residences: Lord Leighton's Moorish Leighton House and, in Melbury Road, Woodland House: a conspicuous Queen Anne–style indication of the success of Luke Fildes, Victorian painter of lowly genre scenes and society portraits. Not for Freud the baronial studio. He just wanted more elbow room and better light. "I increasingly felt, looking at Dutch pictures, that I wanted to work with a skylight. Top-lighting on heads. Looking at humans with the light streaming down is something that I terribly liked; it's one of the things that's in Rembrandt. That awful phrase 'spiritual grandeur': you can't say what gives it, but if you are going to use a device, a skylight's not going to come amiss. It's got spiritual value, that skylight.[1]

"When I put the skylight in I rather panicked; I was afraid of it at first, under the window where the bed was, working towards the mews. My mother was done there."

Part day room, under the skylight, and part night room, it was bigger than anywhere he had had before, spacious enough to keep two or three set-ups in place at any one time: bed with grey blanket for his mother to lie on, the formerly green, now camel-coloured sofa and armchair from Thorngate Road. Easels stood around. It took time to acclimatise himself. "I'd never had a studio before. It was really lovely." He even had a telephone installed, not that he let the number be known to more than a few. (D'Offay, notably, still had to communicate by telegram.) Paint scrapings and phone numbers accumulated on the walls next to where he stood to work.

"The subject matter's always been dictated by the way my life's

gone and I noticed that I switched away from people when I was under a particular strain: I didn't feel so like staring at people or bodies all day. I preferred working in complete isolation often. Feelings of desperation were bypassed by work. Misery, compared to work, is unreal. Because if you're really miserable one telephone call can change everything, but if you've got a brush in your hand it's so different in atmosphere. I think that you work to keep all those things at bay. Death especially." He quoted Lewis Carroll's *The Hunting of the Snark*: "the Bellman, who 'kept some jokes for a season of woe—But the crew would do nothing but groan.'"

"*Two Plants* I did to test out the skylight, the 'Flemish' skylight." Five foot by four, on fine thin canvas, made in Switzerland: in 1982 it was a large trial piece, exhaustively so, a bewilderment of minute particulars: foliage, glossy, frizzled, entangled, in plain daylight engaging him on and off for three years. "You think of other things while you work. The harder you concentrate the more the things that are really in your head start coming out."

"If one's eye was like a magnifying glass," Delacroix wrote, "it would be impossible to look at photographs. We should see every leaf on a tree, every tile on a roof, even the moss and insects on the tiles."[2] The accomplishment of *Two Plants* (1977–80) wasn't the same as Stanley Spencer's virtuoso clumps of Michaelmas daisies in a Cookham garden and foaming may blossom on Cookham Moor, subjects that, Spencer said, absorbed every bit of his energy and concentration; to work from them was to reaffirm his love of Cookham in fulsome detail. Freud's *Helichrysum petiolatum* and *Aspidistra elatior* are not hymned or lauded; the leaves crowd into the light, their twists and creases even-handedly realised, so much so that after all that effort they appear dulled slightly.

"They are lots of little portraits of leaves, lots and lots of them, starting with them rather robust in the middle—greeny-blue and cream—and getting more yellow and broken. Then the aspidistra in the middle started shrivelling. And then I had a huge leaf from the aspidistra going across the little leaves and that was ruinous to the picture and it went again: psychologically the picture went completely wrong. I wanted it to have a really biological feeling of things growing and fading and leaves coming up and others dying."

Why the aspidistra?

"Partly that was to do with a bit of poison that has to go in; I wanted it to be quiet but not as quiet as that. I felt that through restraint I could learn as much as possible about the light and when the aspidistra started dictating a kind of really dramatic composition it worked against the quietness I wanted the picture to have." He intended the painting to be detailed enough to fox the eye yet not fanatically so: not like the torrid filigree undergrowth generated by the criminal lunatic painter Richard Dadd. The aspidistra fronds slash across the lower half of the picture, fresh against the dried-out sprays of countless smaller heart-shaped leaves. He had a Swiss canvas, the same as for *Last Portrait*, too lightweight to take the Cremnitz white that he now favoured. He deliberately chose instead to use zinc white, "which is nice and silvery."

"I didn't realise what I had taken on. Not quite. It was slightly before the enlargement days, which started about 1980. I was not enlarging but ensmalling." Less circumscribed than Dürer's clump of grasses and, at the same time, less amenable to précis than the paisley patternings on his mother's dress, the leaves proliferated to become as uncountable as heads in a mass demonstration. "One tiny leaf affected whole areas of it." Below the leafage he planned to place a dead bat (dead ones had been available to paint at Glenartney); failing that he thought of putting in an electric fire on a stretch of floor but thought better of it: the plants needed to be serried, not put behind.

There were personal undertones. "I'm doing a You-scape," he told Alice Weldon, whose plant drawings were modest and unbewildering in comparison. The painting, so peculiarly self-contained, was an odd one to put a price on, James Kirkman felt. "'What should we ask for it?' James asked. '£12,000.' James thought that meant £24,000, because of the fifty/fifty split, so he asked for that from the Tate and got it." A letter came from the conservation department asking him to provide technical details such as could prove useful to them in future years. His response was "I cannot talk about it. It is PAINTED."

"When it hung at the Tate I went there once and stood near it and I saw people looking at the painting and going past it and then looking at the one after it, as if there had been a sign saying This Way to the Next Picture; and I thought I wanted it to be quiet but not as

quiet as all that." What had begun as a test piece proved to be more a feat of persistence. "Like the telegram getting through the difficult mountainous district. The theme itself carries you on."

Once settled into the Holland Park studio, Freud found himself so much better accommodated that, working longer hours—less inclined to drift and dart around town in the afternoons—insistent on punctuality, instinct feeding appetite, he could now, he told himself, keep going more or less round the clock provided those he was engaged on showed up. Initially he began the day with his mother, still mornings mainly, but rather less often than before; others might sit through into late afternoon and then there were the night paintings. Two or three sessions were likely therefore every twenty-four hours, depending on the willingness and availability of sitters. For them, as press reports invariably reiterated, the situation of being painted by the living Freud was spookily akin to the subjection of Professor Freud's patients on the sofa in the study at Berggasse 19. There could be nine paintings or more on the go at any one time: a full diary.

In *Night Portrait* (1977–8), a woman lies on a bedspread, her arms limply extended, as in a "Deposition" by Manet after Velázquez, with the quilted coverlet dimpling and yielding beneath her. "I started painting quilts when I was doing my mother. I've never done decorations. It was a girl who I got by post: she wrote, friendly immediately, and I started working two days after we met. I did this lengthy picture, the only picture I did of her; I worked right through the night. She married this very nice man, a schoolteacher, who lived in Norfolk, made palettes. They had children. I certainly didn't want to continue. She had some drawings and letters of mine and locked them away and was going to sell them. Then James [Kirkman] wanted to buy the drawings and she wouldn't sell them. Her husband said to me what an appalling thing it was to sell letters. 'I'd just get hold of them, if I were you,' I said. Then her family came down from the North and said that they were her property and tied him up. Then they split up. She'd had three affairs, he said. He was very friendly: to him I was a sort of stalwart figure from the past." He went on sending Freud palettes made especially for him. As for the woman, she wrote to Freud asking to see him again. "I thought it wasn't a very good idea. I gave the coverlet away." It went to Susanna Chancellor, whom he had first drawn

in the 1960s, and—mark of what was becoming a key relationship—it ended up in her house in Italy. "It wasn't ordinary and plain enough." D'Offay sold the painting cheaply to Jane Willoughby. Female nudes, he told her, were hard to shift.

The quest for sitters was a constant preoccupation. These people had to be prepared to give up considerable amounts of time to the process. Fledgling artists might be attracted, their willingness—eagerness in some cases—to be painted a disposition that had to be tested. Freud never quite grasped that those who approached him, putting themselves forward as ideal sitters, were correspondingly likely to prove unsuitable. Always on the lookout for faces of interest, he came to recognise that the best sitters, for him, were likely to be people graced with inner resources and reserve.

Harriet Vyner was one such discovery, an eighteen-year-old schoolgirl, still doing A levels, in 1977 when she first sighted Freud. "Craigie Aitchison and I had gone for a night out at Zanzibar, a very popular bar in Covent Garden at the time. He was different from my teenage imaginings—stranger and more secretive—and I was mesmerised . . . He made it clear from the first that he was interested in me. I was nervous and talked too much and he didn't talk at all. He just stared at me with those hawkish eyes and then asked for my phone number." She was to realise that any relationship took second place. "He would paint to the exclusion of almost everything else in his life. If you minded, then there was no place for you."[3]

Blue veins skein her forehead in *Sleeping Head* (1979–80) and an eyelid is slightly raised, suggesting not sleep but stupor. Freud saw in her a lost soul. "She was awfully nice and on drugs when I knew her; she was really exciting, in and out of jail completely unfairly, and never the same after. It's then a question of hoping they'll be OK. Jollying them along, not giving them a drink." Her autobiographical novel *Among Ruins*, published in 2006, involved Freud in all but name ("Christopher Kovel"). She served time in Holloway once for drug dealing. Freud told Frank Auerbach that, worse than any such misdemeanour, once when she was out with him she was unforgivably rude to a waiter. "After we split up Lucian and I remained good friends. I used to live around the corner from him in West London and, because he didn't have a television, he would often pop round to watch a race or something. He was funny though, which redeemed

him; the smallest thing could make his shoulders hunch and he would get breathless with laughter."[4]

Freud thought it obvious that, while a painting may evoke and—better still—stimulate mood, there is no formal connection between an emotional state and the emotional charge achievable in a picture. Work takes over. The processes of painting, long drawn out and intermittently frustrating, temporarily supersede all other concerns; all else is absorbed in working the leaves of a plant, the paisley patterns on a dress, the veins running blue and red under skin, the white whiskers on a rat.

"I don't think paintings have come about emotionally—only because I am so conscious that that is a recipe for bad art."

In painting, as in writing, understatement—antithetical to Expressionism—is a telling reserve. "We must feel as a brute beast, filled with nerves, feels, and knows that it has felt, and knows that each feeling shakes it like an earthquake," Maupassant wrote. "But we must not say, we must not write—for the public—that we have been so shaken."[5] Reticence absorbs the strain and, ideally, the more substantial the painting becomes the greater its lucidity.

"Fancy," Dryden said, is "moving the Sleeping Images of things towards the Light."[6] For the painter the sleeper is more a convenient object of contemplation; the poetry is the unconscious stirring.

"Katy McEwen had a rat which she kept on her. It looked so nice suddenly appearing under her jumper and I thought lucky rat. She gave me one. I had it at least eighteen months. I taught it to jump off the table into my lap. But in the end it got bored with me, and I with it, and I took it out to Holland Park."

Over many months before its release into the landscaped wild of the park just down the road, the rat came in handy. In *Naked Man with Rat* (1977–8), it is hand-held, whiskers awry, its limp tail draped over a thigh complementing the lolling penis. The arrangement, Freud insisted, was not a device. Could it, I asked him, relate to Sigmund Freud's "Notes upon a Case of Obsessional Neurosis," concerning the "Rat Man," a young man, tortured by rats or the thought of rats, viz. the anal erotic source?

"It could be, but isn't, I wasn't even aware of it. I'd been longing to use the rat in a picture because I use everything I like and this was my first opportunity, and this boy I was painting liked the rat; he liked

holding it. No other model would wear it. This was a warm unslithery tail. And since the rat was tame, its proximity to people was very different from a dangerous and wild rat that people like to imagine in order to give themselves the creeps. It was a Japanese laboratory rat, on the cleanish side." Freud tranquillised it before sittings with champagne and sleeping pills.

The sitter, whom Freud had known since the sixties, and who here became the first naked male he painted, was Raymond Hall. "Raymond referred to himself as 'Raymonde,' he got my address through Charlie Thomas, then he cleaned the flat in Camden Road, looked after that for a bit. Raymond was sort of ambitious, an artist as well—life-size sculptures—and had rages. He did painting and decorating: his great thing was climbing and falling off ladders. He had no money at all, but an extraordinary sort of eye; he sort of understood. He bought things and I gave him some things. He dealt a bit and had things of Frank." He had *Man in a Blue Shirt*, the portrait of George Dyer, before it went to the bookie Barney Eastwood. He worked for Kirkman and for d'Offay. "Raymond used to cause a lot of trouble. There were threats—I'm not sure about what. He lived with this man John Favell, a pelmet queen, who had been left a house in Ebury Street by a friend, where d'Offay took refuge when he walked out on Dagmar (his first wife): went out to work and never came back. Raymond's mother was a cleaning woman and he lived with her in one room, Raymond and John sleeping in the same bed, same room as mother. A very nice room, which Charlie Thomas had."

"John finally came into his own a bit," June Andrews remembered. "An old lover died and left him furniture. A nice old queen he was, at a butch queen's mercy. Raymond worked on a building site. Had a love of art: he used to go in work clothes to the Marlborough and pay off a Lucian painting and a Mike. They found him rather marvellous. He offered to lend Lucian and Mike money and they said yes. Mike repaid him with little works of art but apparently Lucian didn't pay Raymond back and Raymond went round to sit one day, with John, and had been drinking or drugging and looked very wild-eyed and Lucian thought Raymond was going to smash up the place."[7]

Freud was never one to spurn a loan. "I think maybe he gave me £2,000 or something, small amounts of money, as often I hadn't got any. And then when I did a picture of him he wanted to buy it

and I gave him a small head looking down. I gave him drawings and a picture, even some money. He was very generous." He got Rose to photograph him and a naked Raymond, the two of them larking around in the studio with the rat as plaything. One shot from the roll of thirty-six was used as the frontispiece of the catalogue for his imminent show at d'Offay: the only one of Freud alone, without Raymond or rat.

In 1978 Freud began a painting of Raymond and John together. "When I was doing *Naked Man and Friend* I had a telegram saying 'you have systematically cheated us for a year therefore no more sitting from Raymond and John. Yours sincerely John & Raymond.' Raymond hadn't told John about this gunshot; John, the old curtain-maker, was a bit of a blackmailer: he sent me a letter signed 'John & Raymond' but didn't tell Raymond. So I went on with Raymond." But Raymond then told Freud that his friend was very ill. "So I repainted him to accommodate this fact, making it more of an obituary. Having succeeded in fucking that up I found out that he wasn't dying and so I changed the painting of him again."[8]

Holidays at Glenartney were still offered as a treat for long-serving sitters. "Raymond and John used to come up to Scotland. On the way to Glenartney, or on the [roundabout] way back to Edinburgh for the train, they went to Glen [House, near Peebles]." Colin Tennant, by now Lord Glenconner, was at his Scottish seat. Tennant, Freud said, was "a bit of a Raymond and they loved him being a laird and lord and so precious. Colin loved a charade, as did they." In the gardens they showed off their pose for *Naked Man with his Friend* (1978–80) and photographs were taken, Raymond naked except for a silk scarf. "That sort of thing stimulated them very much."

The naked man's left leg, sticking up between thighs, looks like his friend's penis, a later sitter, Angus Cook, remarked. Freud did not intend anything more than the pressure of limb on limb, maintaining as he did that to be suggestive is almost as bad as being symbolical. "And there's nothing I want to have less truck with than symbolism." To him the conjunction of the couple was an advance on the solitary pose of *Naked Man with Rat*. Same sofa, same sitter, only this time, instead of the rat loosely held, Raymond's hand rests affectionately on his friend's ankle as the two of them doze. In sleep they fit in with each other, one right foot pushed beneath the mat giving pause on

the picture margin: a foreground hitch like that of the rucked carpet in *Interior in Paddington* thirty years before but now sensually composed. "More many-sided. I become more interested. Queers are so brave . . ." Freud said. When I asked him, shortly before he completed the painting, whether he felt there was any difference between painting men and women naked he hesitated. "The difference is only the difference in life between men and women. It's something very marked. Does my brush behave differently? It may do, but it's not something I'm consciously aware of, though I'm very conscious, very aware, I've got a naked man or woman in front of me."

Some years later a further question—equally disingenuous—was whether painting somebody extraordinarily famous would affect his handling. He hesitated then launched into a roundabout disquisition.

"When I was with d'Offay—they thought it was a joke—someone rang up asking me to do the Pope. The Pope before last: John. Smiled a lot. There are different Catholic lobbies who have a call on being able to do the Pope and this was an American group and they were allowed to commission a portrait, and they asked me and I initially regarded it as a stimulating challenge, because there have been such marvellous pictures of popes. But as they said more and more, it put me off. In the beginning I thought, well, this is actually a chance: I don't know him, I haven't seen pictures of him; I haven't been put off. But obviously I'd have had to have gone there; I couldn't be alone with him, and then I thought of being in Rome . . . It's like being in your fancy-dress clothes all the time wherever you go."

In the summer of 1977 Anthony d'Offay married Anne Seymour, a respected Tate curator. Freud did the honours. "I gave the wedding lunch because he asked me to be best man. My Rose [Boyt] and I gave them lunch, caviar and everything, at Holland Park." The marriage marked a change of course for the gallery from dealing with old-fashioned Modern British—Bloomsbury, Gwen John, Stanley Spencer—to promoting "The New Art," as had been selected by Seymour for the exhibition of that name at the Hayward in 1971. The press releases she wrote for the d'Offay Gallery were remarkable for their far-reaching assertions, relating Richard Long's stone circles for example to Michelangelo's *Tondo*. It was soon apparent that Freud and Andrews were no longer uppermost in d'Offay's estimation. Besides Long, Gilbert & George were taken on and Joseph Beuys became for

d'Offay an imposing and lucrative guru. In 1980 extra premises were acquired at 23 Dering Street.

Freud's dealings with the gallery revolved around financial concerns. "D'Offay was so funny about money. He didn't realise I was very stimulated by being in debt; it had a slightly liberating effect. Once he said, 'Do you know how much I owe you? You'd better sit down.' It was £6,000 or something. 'That's completely outrageous,' I said. 'Can you find out exactly what I'm owed? Can you recheck?' He sent out one of the girls to find out how much and she came back with some sum: £14,000. I questioned it and she went back and got some more. I got £8,000 more." Normally it was the other way round: d'Offay telling him how much he was owed. Freud had thought that when d'Offay put prices up that meant it would be easier to get money off him. "But d'Offay would only give me money to get me into debt. Horrible for Mike [Andrews], who loved paying tax."

Mike Andrews was in an artists' materials shop one day with Freud and was amazed to see him pick a handful of sable brushes and say, "Charge it to Anthony d'Offay." To Freud the one sensible reaction to feeling exploited was to exploit back.

9

"The one thing more important than the person in the painting is the picture"

Lucie and Lucian Freud at Sagne's in Marylebone

The Peterborough column in the *Daily Telegraph* reported that during the three days Freud spent hanging the eighteen paintings for his second exhibition at 9 Dering Street in February 1978 one person who "stayed a long while and enthused" was Francis Bacon and that David Hockney did not. This was an intense display, including as it did three variations on *The Painter's Mother Resting* and the head of Auerbach. In the *Observer*, for which in 1975 I had become the art critic, I talked of Mrs. Freud being "a wary effigy" compared to the more showy *Naked Man with Rat* and *Night Portrait*: "blue veins snaking across a haunch like the after-shadow of a rat's tail."[1] John McEwen, Katy McEwen's uncle, wrote in the *Spectator* that Freud, "can strip bare a character, even review and preview a past and a future,"[2] an observation that chimed in with the theme of Lawrence Gowing's article "Mother, by Lucian Freud," published in the *Sunday Times Magazine* three days in advance of the opening, for which Bruce Bernard, the *Magazine* picture editor, commissioned the photographer David Montgomery to take a picture of mother and son at Maison Sagne, a place of fine mirrors and fake marble tabletops, the Marylebone High Street's equivalent of the Café Royal. Freud cocked one leg over the other under the table. His mother, in pearls and sandals, sat behind a basket of croissants. For her this simulated breakfast photo session was no more an occasion than any everyday studio sitting. The passivity was affecting. Annie Freud remembered her grandmother not so long before as someone lavish with food, loading the dining table, even cooking midnight feasts just for her (thereby missing the point of midnight feasts), conscientious in the running of the household, actively presiding. Now she just sat there.

"To make painting like people, in ways that it was never like them before, may not be the most serene of imaginative triumphs, but it is in a mysterious way incontrovertible," Gowing wrote in 1981, in his introduction to the catalogue for *Eight Figurative Painters* at the Yale Center for British Art in New Haven.[3] Effusive though Gowing so often was—he talked about the "visionary idealism" of Freud's paintings of his mother—his panegyrics were persuasive. "To use likeness as a measure of discernment, a means of exceeding mere description, is to engage with the most pressing demand of all: that of isolating who and what we are."[4]

Sometimes, when his mother had been to visit her sister-in-law

Anna, Freud would call at Maresfield Gardens to collect her, which meant having a word or two with his detested aunt. "I waited while they had tea and then my mother came out and my aunt said, 'It must be nice to have a free model.' I can't say anything about her as a doctor, as a scientist, and she looked very good.

"My mother said, 'You know, Anna was in love with Rilke.' 'How do you know?' I said. 'They met once.' 'But how do you know?' 'I know. I was there,' she said."

Freud became confident that his mother would never again voice disapproval of what he did. He had kept his involvements compartmented and had seen no reason to go out of his way to acquaint her with many of the children to whom she was a grandmother. "She didn't meet them mostly. Rose she met; Rose was pretty good with her. She met some ones that I don't see. And others she knew about." Bella met her only when she was in her teens and she hardly regarded her as her grandmother: more as a grand old lady who, she knew, had once been most affectionate and lively and was now withdrawn.

"The only time my mother said anything was at Wilton Row, when Anna[bel] lived there, next door to Jane. Various daughters lived there. Esther did. Gave a party and my mother was there."

Esther remembered that it was a tea party, not at Wilton Row, and that it was for her a mortifying occasion. In 1980, aged seventeen, she was sharing a flat with Helena McEwen. "I had this fantasy that I looked like her." Her grandmother, whom she had never met, came into the room. "She ignored me and insisted on Helena." Then, turning to him, Freud said, she indicated that she knew one when she saw one. "She saw Helena McEwen, Katy's younger sister. 'That one, I can tell, definitely, is yours,' she said."

"I got fed up when Bella was sixteen and drugging very much. Colin Glenconner said, 'Look, I'm staying in St. Lucia. Bella could come along. There are animals and she likes them. Marvellous time. No drugs.' Then Princess Margaret said, 'We've got to go to Mustique,' so Bella went there. Obviously I paid for her to go. Mick Jagger and Jerry Hall were there then and Jerry made her a birthday cake, but the royal nanny took against her. She was made to change where she lived six or seven times and made to feel bad, so she went to St. Vincent and moved in with the local pusher who treated her like a lady. She said that Colin was like a snake in the Garden of Eden

on Mustique, so I didn't see him for years after that. Colin was fairly fragile. The 'quarrel' with him was *nothing* to do with him selling my pictures."

So Freud said. But he was dismayed at what he saw as a betrayal of friendship. In 1978, Tennant sold most of the paintings he had amassed—thirteen or fourteen out of around twenty—to James Kirkman for £100,000. Kirkman paid his utmost. "When Colin Tennant wanted to raise £150,000, I and d'Offay couldn't possibly [meet that]."[5] Tennant needed the money for his Caribbean commitments, having bought Mustique in 1959. What particularly rankled with Freud was, he said, that in effect this wholesale deal devalued his work and, besides, furnished Kirkman with stock, the proceeds from which would not directly benefit him. The paintings included the laboured *contre-jour* portrait of Henrietta Moraes at Delamere Terrace, which went to Eric Rothschild, and one of Caroline in bed from 1952. It was no reassurance that the deal more or less coincided with his debut exhibition in New York ("Recent Paintings," transferred from d'Offay in April 1978) at Davis & Langdale, a small Madison Avenue gallery run by Roy Langdale and Cecily Davis, specialists in Gwen John. It made little impact. "Americans confused him with Philip Pearlstein," Anne Dunn reported. "Such a ridiculous idea: they are such different painters. But they had shown at the same time and, of course, everything about Pearlstein was wonderful—'support our boys in New York'—and everything about Lucian was terrible."[6] In Tokyo, where he showed at the Nishimura Gallery in 1979 and 1984, reaction was not muddled by dubious comparisons. The Nishimuras were an affable couple and, Kirkman was pleased to report, prompt payers. In their gallery, a small square windowless room, the early drawings that crowded the walls included several from the convoy sketchbook and Charlie Lumley as *Boy in Red and Blue Jacket* together with six paintings, among them *Father and Daughter* (the 1949 double portrait with bead curtain) and, from 1967, *Girl in a Fur Coat*. It was, fairly obviously, an assortment selected from stock.

Each such venture overseas raised questions of origins and derivations, touchy matters in that denials had little effect, the assumption still being that Freud's outlook was somehow, innately, Germanic. In November 1978, the Arts Council staged at the Hayward "Neue Sachlichkeit and German Realism of the Twenties" with George

Grosz, Otto Dix, Christian Schad and Käthe Kollwitz exhibiting angst and disaffection in graphic manners: as slinky as Cranach, as gleefully callous as Wilhelm Busch. Otto Dix, Freud accepted, related distantly to Cedric Morris, thence marginally to him in late adolescence; but to identify as his precedents, not to say inspirations, Schad's glamourised freaks—*Agosta, the Pigeon-Chested Man, and Rasha, the Black Dove* and *Two Girls*, casually fingering themselves on a bed—was, he protested, categorically wrong. He objected even more to being told that his work was Viennese and, specifically, reminiscent of Egon Schiele's reddened extremities and empurpled cavities. ("They are all these organs and sexual parts, and yet you just jolly well *don't* know what gender they are.") Surely his corporeal painting—those taut kneecaps—was the absolute opposite of Schiele's scrawny draughtsmanship. Those he was now working from, everyone from his mother to a number of new sitters, several daughters included, invariably people with minds of their own, were substantial rather than histrionic presences. It mattered remarkably little how they presented themselves, clothed or naked.

Being used to engaging with sitters one at a time by appointment, Freud had come to operate professionally rather like a doctor (or analyst). Basically, each relationship was vital only so long as each painting required and while, often enough, further paintings came into play with the more sustainable sitters, there was a constant itch to secure replacements. People were drawn in, made to feel indispensable and, when his attention moved on, grievously put out at being no longer functional, no longer needed. It was, Anne Dunn said, "Like being flung out of the Garden of Eden."[7]

Celia Paul, a Slade student, was befriended by Freud in the autumn term of 1978. "Lucian said that he had come to the Slade to find a girl, and that girl was me."[8] She had been to a boarding school in rural Devon and had hated it but a sympathetic art teacher got in touch with Lawrence Gowing at the Slade who bent the rules to admit her when still just sixteen. Initially she had felt inept there and at a loss, mainly because of the regimen of Euan Uglow and Patrick George, especially the latter who talked of painting as a process of "getting it right" and even said to her once with mock severity: "Why can't you paint like everybody else?"[9] For her [a missionary's—later bishop's—daughter with four elder sisters] Freud was a liberator. "I

first saw him in early October 1978, when he was invited by Lawrence Gowing to be a visiting tutor at the Slade. There was a general air of excitement because he was visiting for the first time that day and he was in great demand so that I only got a chance to speak to him late in the afternoon. He came into the studio (the basement life-class), he was smoking a French cigarette and was very white-faced and wearing a beautiful grey suit. I went up to him and asked if he was busy. He gave a half-laugh as if to say how could he be busy wandering round the Slade when the only way to be busy was to work. I showed him my things and he particularly liked the drawings of my mother. I went back to his studio afterwards and he showed me the *Two Plants* picture that he had started. I saw him quite regularly after that."[10] Impressively, he took her to stay at Justin de Blank's hotel, Shipdham Place, in Norfolk; the courting phase however was essentially a process of accustoming her to his dominant needs. She would sleep, or pretend to be asleep, in bed while he worked on from the plants until, from two o'clock to six, he too would sleep.

The relationship admitted no interference by others. In 1982, for example, according to Anne Dunn, her son Danny Moynihan fell foul of it. "Danny was a student at the Slade and arranged for a students' show at Acquavella in New York. One of them was Celia Paul. Lucian came round, walked straight in, took the work away and that was that." The show opened as just "Three English Artists" instead of four. "Danny was mortified at setting all this up, and such a slap in the face. Lucian would get a better gallery for her and he wanted control."[11] That was not quite how Freud remembered it. "Danny Moynihan got Celia's paintings from the Slade and she said she wanted them back. He said, 'Sorry, they've gone to America.' So I walked round to Redcliffe Road [where the Moynihans lived] and took them."

Wholly at his disposal, Celia arranged herself on a grey bedcover averting her eyes from the halved hardboiled egg lifted from Velázquez's *An Old Woman Cooking Eggs* (in the Scottish National Gallery) and redeployed as a suggestive footnote. She remembered how self-conscious she was lying there for what became *Naked Girl with Egg* (1980–1). "I felt excruciated at how like it was, a very pitiless painting."[12] She was often crying. Neither she nor Freud was happy with the result; if for her it was the pitilessness, for him it was the

rather too obvious contrivance: breasts and halved egg. Auerbach was struck by how disconcerted Freud was by Celia's unhappiness. "I remember him saying that because Celia gradually found out that she wasn't his only girlfriend she very often wept while she was sitting and she had no self-esteem at all because he preferred other people on occasion to her. And Lucian was really distressed and asked me what could he do to make her feel better about herself."[13]

By the late seventies Freud had a range of younger daughters grown up enough to sit regularly for him. Their willingness and readiness to do so could be interpreted as subjection to a Miltonic degree:

> *Therefore God's universal Law*
> *Gave to the man despotic power*
> *Over his female in due awe . . .*

The blind Milton had his daughters read for him and take dictation; Freud employed his to be there for what he could make of them. His reliance on them individually was also involvement, and such awe or resentment as there may have been was dispelled on growing acquaintance. In mock-paternal mood he would quote at them the opening lines of Kipling's rollicking narrative poem "The *Mary Gloster*":

> *I've paid for your sickest fancies; I've humoured your crackedest whim.*
> *Dick, it's your daddy, dying; you've got to listen to him!*

"The effect of people naked is that they are more vulnerable, which makes you inclined to be chivalrous and considerate. Of course vulnerability would not be an issue if I used professional models."

The relationship of painter to sitter, innately exploitative ("I'm not beautifully behaved"), with an intimacy born out of seclusion and closeness and mutual concern, evolved as work proceeded and altered once the portrait asserted itself as the prime concern. For Freud, the regular use of his children, daughters especially, was convenient in that paternity, not to say sibling rivalry, gave him more pull than he could otherwise enjoy, even with a lover. Several affectionate relationships developed and, of course, his interests were served. "It's nice when you breed your own models," he said.

Annie and Annabel had sat often enough over the years, so why not those others with whom he felt involved? "They were all pretty good." Ali Boyt had become impatient, but his sisters, Rose, Ib and Susie a while later, also their half-sisters Bella and Esther, proved cooperative. Painting them naked was not a problem. "They make it all right for me to paint them. My naked daughters have nothing to be ashamed of." *Portrait of Ib* (1977–8) leaks self-consciousness, Ib undressed, shrinking back into the buttoned bulges of the sofa as though remembering what it was like ten years before, parked in her vest under the Zimmerlinde for *Large Interior, Paddington*; the painting that had just changed hands, from Colin Tennant to Baron Thyssen-Bornemisza. "On the move. It's very like. She was very pre-occupied at the time, about eighteen, at University College London, doing philosophy. She said, 'The more I study philosophy the more interested I get in interior design.'" Rose Boyt—who also went to UCL and read English—assumed a testing pose for *Portrait of Rose* (1978–9), lying back with a thumb laid across one eye warding off merciless studio lighting, a cloth snagged around a leg and toes (her suggestion, she remembered) as though restraining her a little. She was, Freud said, "always in the state of just waking up."

Rose had left home at fifteen and had moved into a flat in Elgin Avenue, in the block where Winston, Freud's cleaner, lived. Her father paid half the £12 a week rent. "I can do that for you," he told her. A builder boyfriend, he understood, paid the rest. Rose cut her hair short and, given the punk scene, felt that this was a good aggressive image to have. Psychotherapy was her resort ("made me sensible").[14] She was full of aggression, she remembered, partly wanting to be noticed by her dad, partly wanting to shout, "Where were you when I needed you, you bastard?" She sat for him because she had the time and, being adolescent, would do anything. She took her clothes off because that was the obvious thing to do: partly it was to prove that she was not going to be fazed by it. "I don't know if my dad got a big surprise; I remember saying I don't want my hairy legs in this picture." The painting was a surprise to her ("quite a lot of muscles clenched") in that she did not see it while it was in progress. As for the cloth wrapped around her leg and foot, that, Freud said, was his idea. "The pose was hers." Right leg up, calf pressed against thigh, not quite realising the overtness of the pose until some time later. "Not

that comfortable over two hours at a time." Anyway, she liked the idea of herself being assertive. "I didn't want to feel floppy and soggy. I wanted to feel I'm just about to spring into action. I could have been extremely, extremely, extremely angry. And I wasn't. And I felt that there was a potential for me to suddenly get up and say, 'Look, fuck off! I'm not doing this any more!' Or: 'Where were you when I needed you, you bastard?' And I think that maybe he was a little bit concerned in case I was actually going to spring up and protest." She would often sleep in the studio until morning and then go off to her lectures.[15]

There was, she thought, "a certain amount of combat under the surface. It was very tough and hard work and long hours and very intense. I woke up on that sofa in the morning with a blanket over me, quite often. I'd go shooting out of there. Nietzsche I was reading." So was he, she guessed. "Full of ideas and thoughts and feelings and feeling energised."[16] Or as Frank Auerbach once said, in another connection: "It's a question of rendering the object raw and newly perceived."[17]

When the painting was exhibited at the Tate in Freud's 2002 retrospective she steered her children past it. "I'm very proud of it," she said. "I didn't suggest I'd do it again however. If I was still nineteen maybe."[18]

Bella too posed from the age of sixteen when, having left school, she came to London. "Pretty consistently," Freud said. "It was by no means sit or you will not be paid." First it was head only and then head and shoulders, arms folded, crossed hands rested on the sleeves of a favourite dress with floral embroidery on collar and cuffs. Being, as she described herself, a "turbulent teenager," she enjoyed sitting and before long was happy for him to paint her naked. "Once you've got your clothes off it's fine. He made it very nice in a way that was special for each person. Nice atmosphere, lots of lovely food. However troubled I was, I left it at the door." That said, not having been brought up with him around much, she felt restrained as he worked away on what became, in terms of painting, a lustrous whole. "I've never had that familiarity thing. He seemed strong and invincible."[19]

Esther, who moved to London in 1979 to train as an actress and also started sitting, regarded the stints as akin to auditioning but more positive. "It was the first time I'd spent that much time with him, a

Rose, 1978–79

really lovely way to get to know him." Right away she took her clothes off thinking it was expected. "The first painting I did I felt kind of 'I'm going to prove I can sit terribly well, very still and unblinking'; he said, 'You can blink if you like.'" Eager to please, she tried difficult poses. "If I sat in an uncomfortable position, I thought, that would be good. But it isn't. I sat in quite a self-conscious way. My father often talked about someone who sat well and I wanted to be someone who 'sat well.' But I also wanted to look like some of the beautiful nudes that he'd painted earlier in a much more unnaturalistic style. So when I finally saw the finished painting I felt a bit despondent that I looked very much like myself." Herself, as *Esther* (1980), was very much the

ingénue, uncertain of herself, shrinking back, willing her body to be svelte. "I wanted to be beautiful."[20]

Freud saw potential in the way she held that pose, nakedness no problem. "I asked and it seemed natural." Not having much grasp of what went on in the daughters' lives he rather assumed that the routine of sitting would put paid to any lack of confidence in him that there might be. His preoccupations had rarely touched on them or concerned them and now he greeted them as new recruits, fresh arrivals, fully formed and suddenly appreciable. Where Gainsborough's paintings of his two daughters hymned the ephemerality of childhood, his were forthright accounts of young women asserting themselves simply by being there. Esther realised that resentments were out of place. "You get the good bit if you want to accept what he's like. An intelligent choice you can make."[21] She did not sit naked for him again but the experience was reassuring enough for Freud to propose, suddenly—as though casually—a trip abroad for just the two of them.

"Around 1980 I went with Esther to stay with Ann Fleming in Italy. She took a house on Tony Lambton's land when she was dying."

For Esther, then seventeen, it was a revelatory fortnight. "We didn't know each other very well before this painting and at the end of the year we went on holiday together, which is the only time in my life that I've known him to go on holiday and we had the most wonderful time." So memorable was it that she relived it in her novel *Love Falls* published in 2007, transposing names, swapping identities round, introducing her father as one Lambert Gold, historian, a man not given to travelling lightly. As it was, the journey to Tuscany turned out to be quite an ordeal. "There was the physical closeness of being on trains for hours and hours," she remembered. "We assumed it to be so grand to go all the way by train and that we would eat in the restaurant car. We took apples and bottles of water. Thirty-six hours later we were almost dead." There had been no restaurant car. "During the drive from Pisa to the hills we bought peaches and he said, 'Don't eat them so fast, they'll upset your stomach.' "[22]

Esther was unaware of the significance for her father of staying on the Lambton estate or for that matter why he particularly wanted to see their hostess. "It was goodbye to Ann Fleming but I was so

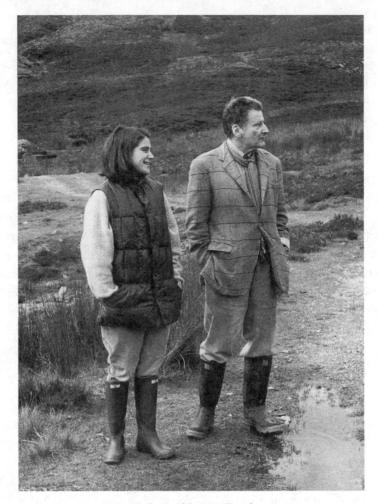

Esther and Lucian Freud

involved with myself, being seventeen, I never guessed that she was ill. She swam every day; there were good meals. One night I woke up, I had a bad dream. He was in the room next door with a spare bed and I crept in there and then I realised in the morning how odd it was. I was embarrassed. I remember at one point feeling how naked my father seemed without his work. Though he managed to conceal it pretty well. We went on a walk. Too hot."

Towards the end of the holiday, after spending a night or two at Susanna Chancellor's house elsewhere in Tuscany (precisely what

part Susanna played in her father's life was another poser for Esther; initially she had just dropped in for tea), they went to Florence, where Esther had arranged to meet her friend Helena McEwen, with whom she then stayed for a few days in Perugia.

Florence got Freud down. "Horrible place: should be twinned with Ipswich. I used my Italian swearword from very long ago: the word was 'porcum misere' [actually 'porca miseria']; then they told me it should be 'Porca Madonna.' I used it in a restaurant when we ordered and they said they were going to close in ten minutes. 'Porca Madonna.' Had terrific success in one go." And then the figures of *Day* and *Night* on the Medici tomb in San Lorenzo made Florence worthwhile. He marvelled at Michelangelo's touch.

"The pleasure, for him, of knowing how stomach muscles move. He could show every expression in the body. It must be like knowing how to play a very extraordinary instrument. Can't think of anyone else ever having done it. He makes it absolutely clear they are men. Even women. The fact he was like a marvellous writer: still telling you, in spite of censorship, what he was really up to. In spite of amazing abandon, and their being men-and-women-mixed sort of thing, you do get a feeling of them [the Medici tomb figures] being done under pressure. Of 'I haven't broken the rules, but I haven't kept to one of them,' and yet . . . It may be how they've been looked after: I did get a sort of feeling that they are made out of soap. And the odd thing is, when I looked at them, the reproductions came into my head. The fact that there were two hundred and eighty German tourists in there, none of them less than about eighteen stone of water displacement, perhaps did affect me as well. It was what a travel writer would call 'inauspicious.' I thought why aren't they grander? And yet . . . when you get up to them, they are miraculous."

They stocked up lavishly for the train back to London. "We were eating the entire journey," Esther remembered. The holiday had been a success. "We would go away together a few times, just me and him, as I was—he thought—his most reliable daughter." They went to Glenartney and to Badminton and, in 1985, to Heini Thyssen's fifth wedding.

Ann Fleming died in July 1981. "The funeral was awful," Debo Devonshire wrote to Paddy Leigh Fermor, going on to say: "Lucian sort of wouldn't be there, would he."[23]

The rips in the seat of the sofa unravelled, exposing the stuffing when Freud went on from *Naked Portrait with Reflection* (1980) to *Naked Portrait II* (1980–1). Both paintings were of Rose Jackson, whose mother, Janetta Woolley, had been the girlfriend on whom, forty years before, he had lavished his pay from the SS *Baltrover* and whose father was Derek Jackson, former amateur jockey (rode twice in the Grand National), war hero (RAF navigator) and Professor of Spectroscopy at Oxford. He had been engaged to a daughter of Augustus John and married successively Janetta Woolley, Pamela Mitford and, briefly, Barbara Skelton. Soho legend had it that he had even paid for a three-in-a-bed session involving himself, Isabel Rawsthorne and Francis Bacon, who remarked afterwards that, having now been to bed with a woman for once, he was pleased to say she was uniquely beautiful.

"Derek Jackson was very interesting," Freud remarked. He was for a while part-owner of the *News of the World*. "I knew him very early, after marriage to Debo's sister Pam. Reactionary. Friend of Mosley. A twin. (The head of the other twin came off in a bobsleigh accident.)" Rose's birth had unmanned him, he added. "When Derek saw it was a girl he ran away because he was a queer, he said. 'I'm very fond of blondes of either sex, I don't mind.'"

Naked Portrait with Reflection (1980) has Rose Jackson sprawled on the couch as though flung down after disporting herself. In the top right-hand corner the reflection of Freud's feet and lower legs tilts the action: a hint of intrusion to tip the balance between passive and active. "I took off my boots to make it more dancelike; I had to look over the top on tiptoe; I wanted movement there."

Belly swollen, "forms repeating right through the body"—as Freud saw it—*Naked Portrait II* mirrors *Naked Girl with Egg*. Worked on concurrently over a number of months, it was originally called "Pregnant Nude." Where Celia Paul lay awake in desperate unease, Rose Jackson was now torpid, her slumber scrutinised from above, lips set to drool, lines and creases stretched taut on the burst upholstery, a ripe specimen come to term and, coincidentally, the truthful alternative to Bacon's renditions of female nudity: Henrietta Moraes done over like a slab of uncooked veal. This was, quite plainly, flesh made flesh by painterly means. "I'm so fond of navels. She looks as old as me. I stopped the night before the baby was born." Freud maintained

that Rose had said the baby wasn't his but rather wished it had been and that earlier she had been involved with Anne Dunn's son. "She was sort of engaged to him. I couldn't hear a word she said."

Anne Dunn was convinced that Freud moved in on Rose Jackson deliberately, exercising a compulsion. "He always tried to seduce Francis's girlfriends. And did, one or two. That interested me. It was not wanting my sons to have anything that he didn't have: the complete ruthlessness of having to own what he's created. His creation is what intensifies the painting."[24] Freud denied any such urge. "I think of people as free." But this, Anne Dunn thought, was bluff. "I think Rose Jackson suffered very badly. I think it—the posing for Lucian—cut her off from progressing with her life in some way. According to Janetta [Woolley], she suffered some form of ocular nervous breakdown when she saw the painting. And he was very strange, because I think he almost hated her at that point. It's a wonderful painting."[25]

The whole episode, Janetta Woolley thought, could have been retaliatory. Anne Dunn quoted her as saying, "Lucian kicked me in the bottom at the Gargoyle [Club] and Derek knocked Lucian out. Was it revenge thirty years later?"[26] The child was a boy. "A boy called Cosmo," Freud said. "Never had any connection." (The boy was in fact called Rollo.) Concerning relations between him and the sitter he had little to add—"I was the one endangered there"—but *Naked Portrait II* is a consummately aware painting, suffused—satiated—as it is with the warmth of living flesh, "every expression in the body," knuckles to navel, realised in full, substantiality merged with feeling.

Metaphysical talk about the atmosphere of a painting and, for that matter, metamorphic talk about transformative powers is baloney, Freud maintained. "Talk about the equation of flesh with paint—transubstantiation—makes me uneasy. I want to give the different chemical constituents, because of their having different functions, different lives. Most of all: different importances. I don't want the person to be more important than the corner of the picture. The one thing more important than the person in the painting is the picture."

Katy McEwen had told Freud about her friend Danny Miller using "an amazing white." This was Cremnitz white, which has twice the lead carbonate content of flake white, sufficient to make it an illicit substance. Agitated at news that this endangered white would become unavailable he ordered a hundred tubes and then, when a

ban was imposed in the early eighties, bought up all he could from surviving stocks and, subsequently, from beyond Europe. Without it, he felt, he would be deprived of an essential resource, for the density of Cremnitz enabled him to work the features more. Cremnitz had body in the sense of malleable bodyweight. It was, he said, a leitmotif of flesh. "The build-up is the result of what happens when I go on. I don't mean that it's like the cookery analogy: you stir and let it thicken and stir again. In order to cut down on certain dangers I like the rest of the paint to be dry. And that's where my patience, which I always think I haven't got, comes in. It's to do with not going the whole way, so that there is some leeway for the sort of apotheosis. Goya did everything in all the portraits in one go."

Talking of Goya: Frank Auerbach remarked that, like Goya, Freud started with the head and—also like Goya—ran out of space for the legs so made them smaller or—increasingly from the late eighties—had the canvas enlarged to fit in the necessary extremities. Speed of attack came into it also. While Van Gogh could do a painting in three-quarters of an hour and Auerbach himself took to scraping down and reworking the painting each session, Freud progressed by accretion, working outwards from the area of the picture initially secured. Thus, though every part of the picture was of equal worth, some were more so than others. "The bits that really count, I'm not saying that they are more important, all I'm saying is that I treat them differently in my pictures, as being of living organic matter. There's a key, as it were, and the key may be in my head because (say I'm painting very lightly, which I hardly ever do) it would still be the same but I wouldn't show it. I'd use Cremnitz, some turps. When it builds up it seems to do it in a way which I can equate with flesh.

"I don't look at a tube and think there's half a face in that tube. I oblige myself to think: this *is* flesh. I use it for hair as well. I use it actually for anything that is organically innate, animals or people. Never for clothes or anything else. It's a code. Wrist going into a cuff: Cremnitz stops with the wrist and other paint takes over. In a sense it's convenient because, if I thought about it in a different way, I'd think I can't use it for hair but then I'd have to think: under a microscope everything is covered in hair; and what about the hair on clothes? I've often had to ask if the spot or birthmark or line are as a result of temporary pressures or the lines where the brassiere is, or is

it a line where the breast is used to making a mark? Things like that, which my intelligence should tell me; but I'm not going to risk it."

Freud talked about "dull" colour, the sparrow colours, tabby colours that he used. They were "as Londony as possible," he said. "I want the colours to be *not* beautiful." Two favourites, besides Cremnitz white, were terre verte, which he had used from *Girl on the Quay* (1941) onwards, and Naples yellow, purportedly unstable but not so, in his experience.

"My staple colour is Naples yellow (pale)."

"It was quite an urgent situation"

"A New Spirit in Painting," staged at the Royal Academy in the winter of 1981 by Christos Joachimedes and Norman Rosenthal (the RA Exhibitions Secretary) together with Nicholas Serota of the Whitechapel, was posited as a bold manifestation of renewed confidence in painting, big paintings mainly. Picasso featured as the imitable forebear in whose late works—four examples of which were shown—there was, the curators averred, "a freedom of expression which allies them to the youngest painters of this exhibition." Other "old painters," they added—such as Balthus, Hélion, de Kooning, Guston, Matta and Bacon—had "real affinities with the younger painters we have selected."[1] Freud too was told that he could rest assured of his newly assumed relevance.

"That horrible German Christos Joachimedes used to write to me all the time. It was curiously political. 'We want to press these things. You are one of the three things it's based around,' they said." An unspoken objective behind the talk of "a new sensibility" and "a new understanding" (one that also took in Auerbach, Hockney, Cy Twombly, Philip Guston, Howard Hodgkin and Andy Warhol) was the inclusion of a startling number of then lesser-known German painters, prominent among them Markus Lüpertz, Georg Baselitz, Rainer Fetting, K. H. Hödicke, Anselm Kiefer and Sigmar Polke. There was also an ostentatious late arrival on the scene: thirty-year-old Julian Schnabel, whose use of broken plates mounted on board as a destabilising work surface provoked comment. Here was Expressionism

in smithereens provoking curatorial small talk of "new relationships between art and reality." It was no wonder that in this context *The Big Man*, *The Artist's Mother Resting*, *Naked Man with Rat* and *Naked Man with his Friend* looked reserved. Such singularity was not amenable to team building or conducive to generalisation about art trends.

Soon after "A New Spirit" opened, to a chorus of complaints (particularly from Royal Academicians, none of whom was included among the thirty-eight selected), Raymond Hall, of *Naked Man with Rat*, went to the Royal Academy Secretary, Piers Rogers, introduced himself as Freud's personal secretary and told him that Freud was furious with the Academy. Puzzled, Rogers sounded Freud out about this. "He said to me, 'I'm sorry you were so furious.' Completely untrue. D'Offay nearly made Raymond a partner but I never saw him again. Saw him hanging around the house once or twice, and he cycled all the way to Norfolk once, to see Mike [Andrews], and Mike saw him walking towards his door and said, 'Oh God,' and Raymond turned round and cycled all the way back to London. 'Oh, I saw Mike last weekend,' he said to me."

One day later that year Freud arranged to meet Cedric Morris at Brown's Hotel in Albemarle Street. He was hoping, he told Auerbach, to get him painting again after decades spent mainly gardening, cultivating his irises. They met. Morris looked at him blankly. "You know, there's a waiter here called Lucian Freud," he said. Obviously he was past it: mind gone, no more paintings, no more abandon. Richard Morphet organised a posthumous Cedric Morris show at the Tate the following year. Freud went round it with him, looked quickly and carefully, swung through, didn't say much but was keen to express his appreciation of his teacher. Cedric had been the first to direct him into immediate expression: painting without qualms or hesitation.

Reflection (Self-Portrait) (1981–2) could have been—but no doubt wasn't—Freud's passing salute in profile to Sir Cedric Morris's quizzical attitudes. It is a brusque sighting: the self squinted at, left shoulder and bared chest, harsh highlights on chin, nose and forehead. Catching his eye, memorising himself, he made of himself a double take: not unlike the fix that H. G. Wells' *Invisible Man* found himself in when he attempted to reify his vanished person. ("I had thought of painting and powdering my face and all that there was to show of me to render myself visible.")[2] Freud could not ignore the distor-

tion. Also—double discrepancy—the lapse between seeing himself reflected and re-creating the reflected facts had to be squared; it was more of a challenge than any face-to-face portrait and, at the time, it represented his recoil from the idea of being written about between hard covers.

A book on his work would be welcome, Freud's dealers and at least one publisher assured him. As for himself, he always liked seeing how the paintings looked in reproduction. A book had become necessary for, as things were—with no catalogues to proffer except the slender Hayward one—Kirkman had been obliged to assemble a dozen or so paintings to acquaint potential buyers with the evidence that this was an artist of great achievement. A book could corral his work to advantage, irrespective of any so-called "New Spirit in Painting." So Lawrence Gowing was commissioned by Thames & Hudson to write a short monograph, its publication timed to coincide with the artist's sixtieth birthday in December 1982. Nikos Stangos of Thames & Hudson suggested that, to enable them to produce the book at a reasonable price, Freud should consider including a print with each copy of a deluxe edition. Not wanting to issue a hundred copies of a single etching—the quality of the impressions would tail off—Freud eventually decided to issue four in editions of twenty-five.

Gowing and Freud were on friendly terms. They had known each other for more than forty years. "He wanted to do the book. I said that I didn't think he liked my things. 'Well, they put my teeth on edge,' he said. Because of his stutter and humble origins he was ridiculed by the art-antiquary-grand side. But he was brave, standing up to them at meetings. His *Vermeer* book was what made me agree to the book."

C. Day Lewis had sat for Gowing in 1945 and wrote a poem about being given the treatment:

> *With hieratic gestures*
> *He the suppliant, priest, interpreter, subtly*
> *Wooing my virtue, officiates by the throne.*[3]

Gowing's zeal to shine as a painter had been compromised by his full-time employment in teaching and administration; he was all too conscious that being Slade Professor was a handicap to any painter

with persisting ambitions. Thus, when in 1980 he was commissioned to produce a portrait of the orderly and unassuming Norman Reid to mark his retirement as Director of the Tate, he aimed to startle by producing a head fragmented as though reflected in a broken shaving mirror. He talked of "duplication underlining what escaped a single image," in this instance a reflection of Reid's unyielding solicitude for what he regarded as progressive abstraction in contrast to the figurative preferences of his predecessor John Rothenstein. At the same time Gowing ventured into grandiose body painting, telling himself that "to get away from the arbitrary choices and the routine of distinguished sitters and attractive models, I had better use the body I was stuck with, my own." With the assistance of compliant female students he went through a phase of stringing himself up, employing himself as a template for silhouettes of the artist spread-eagled like a flayed target. "I felt a ribald impulse," he wrote, "to put the body back into the painting that exiled it."[4] He told Freud that if it hadn't been for the freedom he, Freud, had given him by setting such an example he wouldn't have ventured so quixotic, not to say ludicrous, a batch of pictures. "Does not painting always satisfy more impulses than the painter had in mind?"[5] Freud sympathised. "I thought he was a heroic person. Lawrence in his terribly nice way always misunderstood everything."

Gowing on Freud did not have the authority of Gowing on Matisse or Gowing on Vermeer, for in praise of the masters he could relax into whole-hearted eloquence, whereas with Freud he was too close to the source, too conscious of this painter having achieved what he himself had failed to accomplish. The essay, edited down to twenty-six pages of text, pleased its subject to the extent that its aphorisms and circumlocutions spared him embarrassments.

"In his way, with a loud whisper, Lawrence was sort of tactful."

Disarmingly, Gowing talked about his habitual "ramparts of verbosity" and, eager to reproach himself for running on, stammered frantically, spraying spittle with a wavering half-smile, subjecting students and others to homilies that could veer in the course of a single sentence from brilliance to fog. "A condition of private liveliness," he said, was associated with Freud. "In the past art was full of such people," he added.[6] Young men of the Renaissance, "their eyes on anatomy and the main chance, on the street corners at evening when the

botteghe came out and the virgins were hurried indoors." He talked about the "miraculous lack of anything approaching mellowness one had thought endemic to *mahlerisch* figuration." The praise, at times, sounded reproachful. He had been unable, he confessed, to get confirmation even of the "relevant" details of Freud's childhood and his own memories were burdened with generalisations. He insisted that he could not identify most of Freud's sitters and that it was unnecessary to do so. "The name is nobody's business, nothing to do with the pictures." Instead he tagged the unnamed with descriptive labels. There was "the sitter with heavy-lidded eyes" whose "visionary idealism" was manifested in *Large Interior, W9* and who, in *Last Portrait*, provoked him into rhetorical twirls. "If I had managed to gratify my curiosity, then I should have cheated myself of the essence of that picture, that quite specific, definite, unmysterious thing, which lacks nothing, that lovely masterpiece of love. Suppose I sentimentally misread the picture. Does it matter so long as there is such a picture?"[7]

Gowing went round to 36 Holland Park several times while working on his essay but was bashful about asking questions so Freud decided that, while he was there and since there had been this talk of his doing a print to go with the book, he might as well get him to sit for an etching. Gowing was delighted. "My appointment to be drawn on his etching plate was at dawn. I had to control my eagerness to talk while I sat." The excited Gowing became, in the first of two studies, a gentle caricature: pendulous lips, jaw askew, wispy hair. In the second the head was more imposing. "Printed three or four; liked it in a funny way. I used the plate to paint on or scrapped it." This was the meditative Gowing, about to deliver one of his testy retorts. "I said to him, 'I like Manet.' He said, 'You're being affected. Do you really? I can't believe you.'"

The book opened with a photograph of the Bryanston sandstone horse, scarred with old injuries and presented like an archaeological find. "At the outset," Gowing began, "there is always a mystery. We cannot know what a painter brought to painting or what drew him to it. Yet everything he paints throughout his life adds to our understanding of one or both these things." He referred to what he considered to be the tactical aspects of Freud's painting. He cited achievements as though conferring on Freud an honorary degree. "A sense of the entirety of a person, and the principle that moulds him, is

Freud's longest-lasting, most original theme," he wrote. "The viable, sure-footed, impenetrability of his persona is intended."[8]

Gowing's essay tiptoed where names were to be avoided. Gnomic phrases ("the great ages of trust in the truthfulness of art") were scattered on the swirling waters of overflowing analogies. "Talking about a figurative painter who is not only living but alive, as only one or two painters are at any time, I feel a desperate duty to shake the critical language till it gasps, massage and kiss the prostrate faculties until with a shudder they draw a groaning breath . . ."

Picking through the manuscript Freud pronounced himself horrified. "I always think that mystification is ghastly; just as spelling things out is equally ghastly." The blurb stressed his editorial interventions. "He has supervised the reproduction closely and the arrangement is his; not only the work but the view of it here is his own." He stipulated that the book should be printed in Holland and sold for not too high a price, that the illustrations were to be numbered but not identified on the page and that there should not be a figure on the cover but a detail from *Two Plants*. "Dolmades: leaves wrapped round meat," he explained: leaves outside, flesh inside. And the title was to appear not on the binding but on a transparent wrapper so as not to intrude on the foliage. During the discussions in a meeting at Thames & Hudson, Nikos Stangos, the publisher, was treated to a sudden demonstration of agility. Freud performed a headstand on the table. Unsurprisingly he was in two minds about the book. "I like things to be embarrassing in a good way. Gowing's strange hints made me boil. He said a funny thing to me: 'I realise that no good pictures have brown in them,' and I thought, hold on, all my pictures have brown in. And what about Rembrandt? He's respectful in a 'tread carefully, it's Art' way which I don't like."

Several reviewers picked on this allusive elaboration. "The most peculiar salute to a contemporary artist to have appeared in years," Richard Shone wrote in the *Spectator*. It was, he said, "hagiography at its best"; apart from certain "passages of brilliant concision," Gowing's writing was "serpentine, advancing by qualifications and asides with brisk, almost demotic, sentences varying the pace of his plenipotential prose." Shone, at that time known as the leading young expert on the Bloomsbury Group, took Freud to be an "establishment black sheep darling (with all the confidence that that implies)." Gowing, he

suggested, was addressing the toffiest of elites. "The book seems to be speaking to the minority who have always held Freud in esteem. And few of them surely can be bothered with this kind of sustained exegesis; they buy the pictures instead."

One admirer, Angela Dyer, who wrote to Gowing in raptures over the book, received a glowing reply. "I don't think I have ever had such a totally rewarding and transporting fan letter. I sent it straight on to Lucian as of course the achievement is far more his than mine and he was equally delighted by it."[9] Freud then wrote to her too. "Lawrence Gowing sent me a copy of your letter to him. I don't know if he's had any letters about the book but I certainly have not. Though I am rather immune to abuse and praise I had a feeling of excitement on reading what you wrote that I've only felt on suddenly coming across someone I really like the look of. So, right in the middle of painting my mother's stomach this morning, I read it again."[10]

Nonetheless when the possibility was raised he vetoed a second edition.

Auerbach took up etching in 1980 for the first time since his student years; he was moved to do so when staying with Joe and Jos Tilson in Wiltshire where, one weekend, "everyone was etching" and he gave himself three-quarters of an hour to produce a head of Joe. A suite of portrait heads followed; back in London Kitaj and Kossoff sat for him, followed by Freud, who was struck by how swiftly he worked on plate after "ruined" plate. Terry Wilson of Palm Tree Studios then produced a composite image by printing from four plates to form a single impression. Freud marvelled at it. "The speed of movement: Frank moves in an incisive way. The etching went on and on. My neck was very scrawny in it, and I remember looking in the mirror and thinking, God . . ."

Thus prompted, he decided to try it again himself, got hold of etching equipment and, in September 1981, made a start. "I went to see Hockney about etching when I restarted as he was the only one I knew who I thought knew all about it and he said he absolutely didn't but put me on to the man who did." This was Terry Wilson. ("His wife, Maudie Marks, was the granddaughter of Lord Marks of Marks and Spencer's, who used to wander round M&S serving people.")

To coincide with publication some twenty paintings were shown at the d'Offay Gallery from 8 October 1982 for four weeks only.

There was no catalogue: just a list of works on the announcement card, among them *Two Plants*, *Rose*, *Naked Man with his Friend*, *Naked Portrait II*, *Guy and Speck* and *Guy Half Asleep*. These, at Freud's insistence, were hung by Auerbach who placed *Naked Portrait II* (the painting of Rose Jackson pregnant) right opposite the door of the gallery's new upstairs premises at 23 Dering Street. D'Offay objected to this, Auerbach remembered, preferring to give prominence to one of the few paintings not on loan from private collections and, in the case of *Two Plants*, from the Tate. But there was more to it than hanging saleable pictures to advantage.

The d'Offay Gallery had narrowed in scope to the new internationalism, the premises expanding in fulfilment of what d'Offay said had been his boyhood ambition: to represent the world's top five artists. Eventually he was to secure working relationships with Joseph Beuys and Andy Warhol while also exhibiting the leading figures of the *mahlerische* ascendancy in German painting: Gerhard Richter, Georg Baselitz and Anselm Kiefer. To showcase them, and others besides, he had taken on the new space just up the street from number 9, transforming it into an elegant white showplace, grand by the standards then prevailing in London, comparable to Madison Avenue's finest and suitable for the installations he envisaged there, things such as the laggings of felt and lashings of fat magicked up by Joseph Beuys and the impeccable stone circles of Richard Long.

Freud sensed demotion. "The new gallery was opened. D'Offay persuaded me to go there, it was all prepared and then, two or three months before the show, he said, 'If you really want the old gallery [number 9], you can,' because he gave the big gallery to Baselitz." Worse, Anne Seymour was heard to remark that the Freud show would be a good curtain raiser for Baselitz, whose reputation (boosted by the rising tide of "A New Spirit in Painting") was founded on an all but patented procedure of painting and presenting images upside down for added detachment. This, Freud decided, was intolerable. "What I really minded was making an arrangement and then d'Offay changed the show: two or three weeks off the end. 'In future,' he said, 'we've got a policy of 28 days, no more, instead of a month and a half.'"

Publicity was needed, Freud was told, and he agreed to answer questions from Henry Porter, a *Sunday Times* journalist, provided

they were submitted in writing. "It's not that I'm trying to be Garbo-esque and it's not that I don't like being interviewed," he told him. "It's simply that I have nothing to say. I don't talk about my life because it's still going on."[11] Guy Harte was questioned about him but had little to say. "He loves good food and often goes to lunch with Francis Bacon. He is interested in all forms of art, even antique furniture. He is still very fit and rides a bit and swims a lot."[12]

"He's simply a very elusive character, that's all," d'Offay explained, not mentioning (possibly because he had not yet realised it) that Freud was about to elude him for good. The arrangement between Kirkman and himself had been coming unstuck. "Kirkman didn't know that d'Offay was easing him out," Freud reckoned. "And things got worse. He had more or less got me away from Kirkman, who was three-quarters out of it when I left."

It wasn't just the snub. For Freud, who liked to have informants, d'Offay's behaviour was a peculiar compound of sly if not snakelike urges, evidence of which he was eager to learn from people working at the gallery. It was always good, he said, to have "a spy in the enemy camp." He had become friendly with Judy Adam, in her early twenties and fresh from Deeside, who worked for d'Offay on exhibitions and publications. She had arrived by bus from Aberdeen to be interviewed for a post at the Royal Academy but noticed an advertisement in *The Times* ("calm, efficient secretary required" at the d'Offay Gallery), went there (*Naked Man with Rat* was in the narrow hallway) and was offered the job. Being penniless and impressed she accepted it the next day and stayed with the gallery for ten and a half years. Freud took to her partly, at least, because she was so refreshing a presence in the gallery with, as d'Offay liked to say, "the best art in the world in London."

"There was something robust and bucolic about her, and she was nice," Freud said. "She used to stand up to d'Offay." She also, in the summer of 1981, began a standing-up pose for him at Holland Park, a stance related in her mind's eye with Manet's *Boy with Fife*, naked though and with her hands behind her back. He took her one evening to the National Gallery (using his recently issued twenty-four-hour pass) to look at their new Degas: *Hélène Rouart in her Father's Study*, a similarly red-haired figure standing propped against a chair in a confined space. She invited him to tea with cucumber sandwiches at

her digs to meet her parents when they came down on a visit; he arrived in the Bentley and her father—who was around the same age as Freud—struck up conversation, saying they had something in common: they were both interested in horses, weren't they?

"D'Offay barred her from a meeting to decide my fate when I wanted to go during that show. They desperately didn't want me to go. I got Lord Goodman to say I didn't want to stay. The thing is: nature, you think, is somehow going to improve people and then there are people who *go on* being half dead."

The break with d'Offay was not cleanly achieved. Rumour had it that a dog turd was put through the gallery letterbox; others such as the critic Brian Sewell—Freud's name for whom was "Brian Arsewell"—had it that verbal abuse ("d'Offay is a cunt") was daubed on the window of 9 Dering Street. When I asked him about all this, twenty years later, Freud demurred. "Sending the cock's head [in Dublin in 1951], yes, but posting dog turds, or human turds, through someone's front door? It's very hard. I can't say. I can't think how it originated. It's something I'd remember . . ." Certainly an abusive handwritten note on brown paper was posted through the door and shuffled into the morning post.

Freud's contempt for what he regarded as a failure to honour obligations and a crass lack of perception did not subside. Michael Andrews sympathised but, with characteristic misgivings, decided that it would be wrong to leave d'Offay simply out of solidarity.

For nearly a decade following the split Kirkman was Freud's sole dealer, operating without a gallery in which to show the work. This, he found, did not prove much of a drawback. Diligent and shrewd, he did all he could to meet the—often urgent—financial demands, arranging exhibitions, securing sales, tracking down and securing works from earlier years and gathering material for a projected catalogue raisonné. The arrangement benefited from having developed over the years; never formally contractual, it was open ended.

The day after the opening on 8 October 1982 of what turned out to be his best-received show for years ("magnificent pictures," the critic Marina Vaizey concluded in the *Sunday Times*: "magnificent in all their desolation and grandeur"),[13] Freud learnt that his Aunt Anna had died. This was not, for him, grounds for sorrow. Ever since she had refused to pay for the framing of the flower picture he gave her

in 1938 he had disliked her, loathed her even. Convinced of his incorrigibility Anna Freud saw him always as Lux the teenage thief filching from the gold reserve in Ernst's desk and, she claimed, stealing books from her father's library. This he denied. She was, he assured me, a classic repressive, mean and nosy. "I don't think she was a monster but she was absolutely horrible to me, I thought, and superior. Superiority and disapproval with a smile, which made it worse.

"When my aunt died, Paula, the servant they had since she was fourteen, went back to Austria. The only reason I ever went to the house was to see Paula the maid. Paula Fichtl. I was talking once about my grandmother and my mother told me—one clings to these things—that Paula the maid was pregnant once and my grandmother was appalled and arranged for an abortion and kept it from my grandfather who would have loved it. That was in Vienna. Paula hated Anna but lived in the house. She got odd and the house wasn't small and she polished everything and wouldn't have any help. She admired my grandfather and went back to Vienna. Couldn't speak English or German by then. Tragic Viennese dialect with English sound."

The house in Maresfield Gardens with the blue plaque over the front door opened in 1986 as the Freud Museum. Inside, visitors were kept at arm's length from the couch and desk in the study on the ground floor and from the loom in the corner of Anna Freud's living room upstairs. "Her horrible weaving and no books except thrillers." Lux's palm-tree drawing was there, though for many years not on public display; other members of the family, a number of his children among them, looked in there occasionally but he himself never went near the place.

Freud had given *Last Portrait*, his unfinished painting of Jacquetta Eliot, to Katy McEwen. "As a gesture," he explained. "And then it got completely out of hand." In the bottom left-hand corner it bears the initials "DG" and "omega wk," a near-invisible reference to the d'Offay Gallery's one-time zealous exaltation of the Bloomsbury Group, involving Duncan Grant and the Omega Workshop. The painting having been abandoned, Freud's graffiti survived. As a love token the gift was, he admitted, "slightly odd" and Katy tried to pass it on to Bella. "She liked giving things and I think she wanted to forge links: a bit mad, as Bella was with a gang of crooks and I was trying to keep some control over her. Then Robin McEwen had it—he said it

was his most precious thing—and she wanted to sell it. I told her that I didn't give it to her to sell but that I'd give her some money instead so I got it back." He then sold it to David Somerset who, delighted with his prize, stopped off at the Marlborough Gallery on his way home with it only to find, sitting in a back room, Baron Thyssen who asked him what he had there and when he unwrapped it made him an offer that, much to his regret, he couldn't refuse given that, technically, once it had passed over the Marlborough threshold it counted as gallery stock. The accomplished incompletion of *Last Portrait* rendered it enigmatic.

Baron Hans Heinrich Thyssen-Bornemisza, the greater part of whose collection came to be housed ten years later in Madrid, had become as committed an accumulator of Old Masters as his father, whose Hals *Family Group* had been coveted, Freud said, by the Mauritshuis in The Hague. ("They said, 'Baron, if you let us have this picture you can choose anything in the museum for yourself,' and he said, 'Very well, I'll have the Vermeer *View of Delft*.'") Being less ambitious, but not less keen a collector, the younger Thyssen developed a taste for more recent paintings starting, in the early sixties, with German Expressionists, then the new Masters: Braque, Picasso, Mondrian, Hopper, Pollock and, among living artists, Michael Andrews and Freud. David Somerset introduced Freud to Thyssen at a time when he owed the bookies frightening amounts. ("It was quite an urgent situation.") They had lunch. Thyssen said to Freud, "I understand you are interested in doing my picture," and invited him for the weekend to Daylesford, his house in Gloucestershire.

"I thought him very polite. Went on Friday night and by Sunday evening I felt I could say: 'Can I make a rather unusual request?' I told him that I had an urgent situation, a rather serious racing debt." Would it be possible to have an advance of the money for the portrait? "That would be a pleasure," Thyssen replied. "Of course I understand. My assistant's a terrible gambler." He began sitting for him in July 1981.

Two security men accompanied him to the studio and checked it out. They admired the double door at the top of the stairs. "'Sensible precaution,' one remarked. 'Good thinking.' The detectives sat in the kitchen to stop him being murdered, which was annoying, but I got used to them. They said, 'We can stop him being kidnapped; we can't

stop him being shot.'" He gave them a Raymond Chandler to read while they were there: *Trouble Is My Business*.

Behind Thyssen's head Freud pinned up an enlarged image of a Watteau, *Les Jaloux, or Pierrot Content* (1712), which Thyssen had acquired a few years before. "Thyssen gave me his catalogue and got me a photograph and I got someone [Judy Adam at d'Offay] to blow it up; I didn't see the picture till years later; it's a lovely little picture."

One of Watteau's first *fêtes galantes*, a diminutive tableau of parody courtly love, it has Pierrot embarrassed at the attentions of the women around him, one strumming a guitar and singing, another putting fan to chin, doubtless to snub a potential lover lounging beside her. "Apart from *Gilles* I don't generally like Watteau, hardly ever. *The Departure* [*for Cythera*] is magical but I'm not drawn to it. But I got interested in Watteau: he's the only really good painter ever who's been terribly tired. With TB obviously. In the tired ones in the Wallace Collection—not the best ones by any means—the leaves are not like Gainsborough, who could do a whole lot of leaves just like that, but his arm is so weary. Sufferers from TB are amorous always, and elated."

In Freud's transcription the Watteau becomes Thyssen's realm of fancy with a garden bust of Pan adumbrated above his head, also a barely visible suppliant head, positioned for a word in one ear, and two flirting characters perched behind one shoulder of the dogtooth jacket, itself as busy as a Van Gogh harvest field. "Bright colours, well French made," Freud pointed out to me. "The French have an idea of English clothes for middle-aged men." With his dented shirt collar reiterating the crumpled volley of cloud showing between Watteau's trees, the Baron seems cast, unawares, as the ageing, preoccupied and possibly forlorn Pierrot. He happened to be situated halfway between his fourth and fifth marriages. One topic of conversation he raised as he sat was Frederick the Great.

Portrait of a Man ("if people are remarkable enough, they are anonymous") was completed just in time to be included in the last d'Offay show. Then, having warmed to Thyssen's "angular, funny behaviour," Freud began another, as he also did with Guy Harte: another sitter to whom he warmed. "I didn't have to do the second painting of Thyssen. I got fond of him. The second one goes much deeper." Here the Baron was no longer a courted Pierrot. The painter stepped back and

the sitter became the meditative tycoon installed in one of Freud's gilded Empire chairs beside a heap of paint rags. Jacket buttoned up, legs braced, elbows akimbo, he held on in there, his back protected by the grey screen, his fingers splayed on his knees like those of Monsieur Bertin, Ingres' newspaper proprietor ("I think about him a lot, though more in other things"), their spread and grip matching the swan-neck arms and ball-and-claw feet of the chair. The painting was completed fairly quickly despite Thyssen not being available to sit often enough (there were about a dozen sittings) and then sometimes being too talkative. Kirkman sat in for him a few times, serving as a presence in a jacket slightly too big for him.

The rags smudged with flesh colours could be taken to represent a befuddled brain. "He had a terrific hangover: he was still drunk in the morning and kept on. 'Heini,' I said, 'you seem rather sleepy, would you like some coffee?' 'No: it sends me to sleep.' Asleep and woken up: and hardly any difference. His wife Denise was furious with him—they weren't quite divorced then—and we went with Tito [Carmen "Tita" Cervera], the wife-to-be, to have lunch. I suggested Harry's Bar and he said, 'Yes, very well, but if Denise comes in, Tito is with you.' Heini's got this gift of turning commonplace women into complete fiends. Tito loathed the picture. She said she could see a rat in the rags and wouldn't have it in the house. I looked and looked and there *was* one: you can always see one if people tell you so."

"Like all mild people he was stubborn."

Some years later Freud asked Simon de Pury, keeper of the Thyssen Collection, whether the paintings were on the A list or the B list and was told that, the new Baroness having taken charge ("Heini became a vegetable"), the small one was on the A list and that the other was not on any list at all. Unsurprisingly, given that the sitter was just a year older than him and that both, passing sixty, were concerned about diminishing capabilities, the two paintings radiate anxiety. Thyssen sitting was at leisure of course whereas Freud, exercising control, had to stand and deliver. His eyesight was sharp enough, his health in general was good apart from bouts of asthma or hay fever, but—while admitting that he suffered intermittently from hypochondria—he became anxious about his ability to produce large pictures from then onwards.

"Such an intimate grandeur"

The frontispiece of Gowing's book, *Detail of Work in Progress 1981–82*, was a head of Suzy Boyt set against hefty foliage, a preliminary glimpse of what was to become *Large Interior, W11 (after Watteau)*, the work that preoccupied Freud from mid-May 1981 to the summer of 1983, six months after publication. "What was astonishing," Gowing wrote, "was that the canvas on the easel measured more than two metres in both directions." This six-footer, the same size as some of his favourite Constables, was to be exceptionally demanding, Freud reckoned. "I hadn't done anything like it at all before." Now or never, he thought, convinced as he was that soon he would become incapable of raising his left arm—the painting arm—because already he had arthritic pains in one shoulder (for which he had cortisone injections from time to time) and these, he feared, might worsen. He had a special rest made for his palette and ordered a fine Dutch canvas.

The precedents for the elaborate composition he envisaged went way back. When staying at Marchmont with Katy McEwen, he had often gone into Edinburgh to see in the Scottish National Gallery *Diana and Calisto* and *Diana and Actaeon*, the two great Titians on loan from the Duke of Sutherland's collection—surely, he was apt to say, the two most beautiful pictures in the world. (When I observed that he had said the same about other paintings, for example Constable's *The Leaping Horse*, he agreed. "If you say it, you'd say it more than once. Like saying, 'You're the most beautiful girl in the world.'") "I went to the gallery every day and stood in front of them and the

attendants got rather suspicious. Titian's women in this marvellous airy place: the more I looked at the pictures the more I saw in them. I found more and more dogs in them. Why is it as effortless as Matisse and yet it affects you more than any tragedy? It hardly matters what is going on. The people, though involved with others, are there to pleasure us. The nymphs' toes. There's such an intimate grandeur. The woman leaning back to the right has an amazing deep navel. I was painting Rose [Boyt] nude then, so when I came back I repainted her navel. I then saw the Titian catalogue raisonné—you can't know enough about these pictures—and I found that these pictures, during a war, were taken away in case of damage and dragged through the Tiber. Damage was done to the navel: so a fish was in there." Energy harmonises as the drama unfurls, arms upraised, dogs yapping, trees and clouds and temple fragments splendidly arrayed; gestures prompt counter-gestures, details reciprocating one another, myth refurbished as magnificent charade. "Titian is incredible happiness, the beauty of everything. He painted completely out of his head and he gives the action an inevitability. The pictures are so intimate. Which of the two do I prefer? *Diana and Actaeon* over *Diana and Calisto*. Edinburgh also has that Rembrandt of the woman and bed curtains [*A Woman in Bed*]: you can *smell* the bed."

The notion behind redoing a Watteau on a relatively huge, indeed Titian-masterpiece, scale was that it should be a *fête champêtre* adjourned indoors or, rather, removed from Watteau's studio to his. He pulled down the blinds on two windows and the door opening on to the roof terrace, leaving little view of the outside world and yet, under the skylight, a sense of being virtually in the open air, in a semblance of the glade where Watteau's players idle.

"I took a while setting it up. It took quite a lot of staging. I'd been making drawings with the idea of doing a group painting, which I'd never done." He had the canvas ready, waiting, and he told Celia Paul that he felt it was mocking him and his inability to get started. It was partly, she thought, a matter of coping with the intrusion. There could be anything up to five people in the studio all at once. "With every strand of his life so very separate it was an exciting challenge."[1]

The sittings were irregular, augmented person to person after assembling his cast one Sunday. "They started together, in drawings: them together, then in threes and twos, then ones, and then three

Balzac (naked) by Rodin

quite a lot, with Suzy's son Kai Boyt (substituting, from July, for Ali who dropped out after the first week or so, as did Esther), the Pierrot figure, in the middle, with people each side, and then chiefly in ones." The bed they sat on was the one Freud had bought in 1977 at the Mentmore sale. "An iron bedstead, £7, from the servants' quarters. It broke, but I used it. (In the actual Watteau they are sitting on a kind of woodland seat.)" There the characters perch, four in a row, the light incubating them, the atmosphere charged, the scent of the verbena mingling, we may deduce, with the whiff of paint. The pose is just that: no action, no narrative as yet. "Like the artless shots in Buñuel, which are necessary to set up the rest."

That verbena, sweet smelling and unruly, straining upward, falling back and reaching out towards the floral-patterned dresses, also shrivels. "It grew and took the whole skylight over and I had to chop it down. I used the remains of the plant to surround the group, in a way, on one side. The clothes were old clothes, on the whole. Slightly costumey. I wanted the setting to be a slightly *deliberate* setting. It's the nearest thing I have ever come to casting people rather than painting them, but they're still portraits, really. They are also characters.

A slight bit of role playing they are doing, but I didn't try and forget who they were. In the end they are just there."

Bella became Watteau's Columbine. "Bella had a mandolin because I wanted to use the instrument. I liked the thing of a person with an instrument. It was a kicking-off point." Bella's thumb, poised over the strings, holds the centre of the picture. Under her thumb is the black hole in the body of the mandolin. Beyond her hand are other hands, different in feel and differently disposed. As in the Watteau, as in a Titian, the differences are part of the patterns. Bella became tired of posing in the dress: it was dusty, it was hot, she sat mainly with Celia; and it was an odd situation, this assembly, where normally it was only herself and her father. Celia sat only with Bella. "Never with Suzy or Kai. I didn't want to make too much about the unity, the fact that people are sitting next to each other, know each other very well, not at all, or slightly. I'm interested in all that aspect of things: the people and to what degree they are affected by being near each other—that's one reason I like Hals so much—not cold-shouldered but each wrapped up in themselves." Freud showed them his photograph of the Watteau and told them that he wanted something similar. "I wanted variety in the clothes, and they did dress up a little bit." The acting was perfunctory, their presence being the main requirement, and their willingness to act like those (Baudelaire among them) who had gathered together in Courbet's studio in 1855 for his great allegory of the modern painter's life; and they resembled also those who had been brides and philosophers for Rembrandt, who had been Diana and her troupe for Titian and who, as members of the Infanta's household—maids in waiting, a nun, a dwarf—had attended on Velázquez. Freud stuck them in front of him in much the same way as he had handled the Hadleigh scruffs in *The Village Boys* of 1942, glowering like reluctant conscripts into the church choir; only this time the cast were almost all intimates of his. That August he read Evelyn Waugh's *Decline and Fall*, that tale of emblematic misfortune, finding it "very poignant."[2]

Celia Paul who, Gowing said, he and Freud thought to be "one of the best painters of her generation," sat on the left, one hand propping herself upright, the other placed hesitantly on Bella's thigh, making no effort to match the coquettishness of her counterpart in the Watteau. She was particularly aware of Freud's desire to assemble dif-

ferent people with separate bearings on his life. Her father had said, after meeting Freud for the first time, that he was "the most selfish man he'd ever met";[3] he died in 1983, the year she moved into the flat Freud bought for her, high in a building opposite the British Museum. After his death and following *After Watteau*, she painted her mother and sisters adrift on a bed: the remaining family lovingly nestled. Her son Frank was born on 10 December 1984. She took three weeks off in Cambridge after the birth at the Portland Hospital (which Freud paid for) before leaving the baby with her mother and returning to London. In *After Watteau* she sat with Bella, because of having to rest her hand on her knee, but not with the others. Bella, in high heels such as she had coveted as a child and still too big for her, wore a vaguely *commedia dell'arte* striped dress. Suzy Boyt, on the right, perching on the edge of the bed, showed not the jealousy manifested in the Watteau but patient compliance, the fan she holds extended like a sheaf of playing cards. Her son Kai played Pierrot. "He's the subject," Freud explained to me when I first saw the painting, before much more than the four figures had been established. "Not Suzy, not Bella, certainly not Celia. I was a bit conscious he felt lost—a form of dreaminess—in certain respects; Kai was not neglected by Suzy, but Kai's father, the German, had ghastly ideas about children."

The child in the foreground was to have been Freud's grand-daughter, May. "I wanted Annie's daughter but it didn't work out." Annie refused. "That upset me because I wanted to get to know her." He had not been getting on with Annie. "The Watteau was a bust-up, a very deep misunderstanding. There was a thing in the paper: 'someone close to the artist says . . .' and she said, 'Why can't I be the person close to you?' I wrote and said, 'Suddenly I get this emotional letter out of the blue.' It was almost impossible to be in the same room; she made me feel crazy, wanting to meet, then not; and chang-ing her name; and then not hearing from her for years." He sent her a postcard ending with "Do you see I'm stimulated by conflict." She was distressed. "I'd lost my way with him. It was terrible."[4] During an awkward reconciliatory lunch with him at Wheeler's two years later a youth came up to her and, to her astonishment, introduced himself as her baby brother.

The substitute for May, it so happened, was the little sister of the girlfriend of that brother: Ali Boyt. In the picture she is the only

participant not dressed up specially and the only one unselfconscious enough to watch what Freud is doing. "Star, she was called. Her mother, a hippie living off Regent's Park, sat with her: she loved a drop of champagne to settle her. She said to Star, 'You are lying by the beach, sun shining and fish in the sea and little waves curling, you can feel them . . .' 'No. I'm bored,' she said. She's a very strong feminist now. Star was borrowed and bored. Little Frank [his son by Celia Paul] didn't exist then."

Star apart, everyone in the painting was dependable. "They were—same as always—people I knew, and would sit, and I liked working from." Sessions could be anything up to six hours. When Suzy Boyt was unavailable their daughter Susie sat, wearing the flowery dress. Freud wanted to achieve, as Courbet did in his *Painter's Studio*, a look of convincing pretence, though, unlike Courbet, his intentions were absolutely non-allegorical. "Intimate but humdrum. I'm the connection: the link is me." At one point early on he thought of having a figure under the bed. Lorna Wishart would have been good, he mused. Impossible of course, but Courbet could have managed it.

The demands of the picture absorbed him. As he inched it into being and then, month after month, towards completion, he found himself regarding it with builder's pride. Structurally it called for darting concern and relentless attention to everything from thumbs to power socket. Should he bother with the white tiles around the sink? In the end he decided to do away with them, showing instead patchy skimmed plaster. Celia remembered that once the windows were done the painting came together into an entirety. "Then it suddenly seemed like an interior with a spatial quality, consciously worked, keeping the light subdued. Such extraordinary patience, over two or more years, working towards exactly what he wanted."[5]

My first reaction early one afternoon in March 1983, when he ushered me past the bronze cast of Rodin's naked Balzac, positioned in the hallway like a philosophical club bouncer, and into the studio to see what he had been so quiet about for so long, was astonishment at the scale of it. Even without stretches of floorboard and wall space still to be done, the painting stood free of the room around it. Already the mottled plaster and tangling leafage, the shining blinds, the characters perched on the bed and the child dumped at their feet

like a sulky foundling, had an emphatic cohesion. Three months later the background amounted to more and there was incidental pleasure in the way the flawed glass of the one window without a blind made the view over stuccoed Holland Park shimmer and bulge. The floorboards held their own now, running smoothly. (He had enjoyed doing the way they flowed, he remarked.) Bella's head was perhaps too dark; he had wanted it to be more *contre-jour* but it might need redoing. He liked the tousled verbena but decided to cut it back; it had become too much, he said. The running tap was maybe a distraction. "A busy painting on this scale, you see one bit and another. A lot more happens. Also it's like conducting an orchestra: reading one bit and another. Is the water of the taps too loud?"

Celia Paul thought the wobbly view through the back window, there as a reminder of the patch of distant landscape in the Watteau, a distraction from the intensity of the real theme as she saw it: namely jealousy.[6] But the traits embodied or enacted on the bed—submissiveness, carelessness, nonchalance and forbearance, say—are insistent: moods and attitudes transfixed in a place where nothing moves unless you count the cold water spouting from the left-hand tap.

Having seen the finished painting, I asked Freud if he would care to put it in a group exhibition that I was assembling for the Walker Art Gallery in Liverpool in the autumn of 1983. He liked the idea. It would be like trying out a new play before bringing it to town, he fancied. The painting would have to be hoisted out through the skylight, he told me. He was eager to get it seen.

"There's something very nice about canvases being shown as canvases when they've just been done, but otherwise it's a little bit like old nudists." The frame was to be unobtrusive. "Like the supposedly well-dressed man: you don't notice his dress at all."

When I proposed showing works by him, Mike Andrews and Frank Auerbach in one room he offered to lend Auerbach's blustery view of Primrose Hill. That too would have to be taken through the skylight to join *The Big Man*, *Naked Portrait II* (the painting of Rose Jackson pregnant) and *Naked Girl with Egg*, together with Michael Andrews' paintings of the lane that ran past his Norfolk farmhouse.

"Peter Moores Liverpool Project 7: As of Now," one of a biennial series, was to feature photographs by my *Observer* colleague Jane Bown of the artists involved, among whom were the sculptors Barry

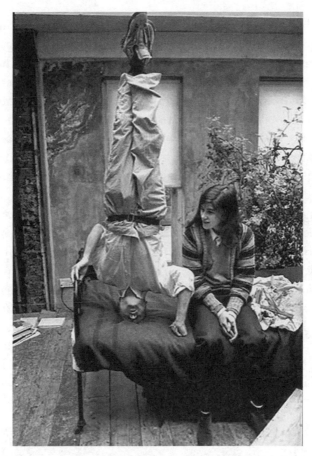

Lucian and Bella Freud

Flanagan, Dhruva Mistry and Bill Woodrow, together with Hamish Fulton, Peter Kinley and Graham Crowley. Freud baulked at this. He hated being photographed. He would not be photographed. Recently his aversion had prompted him to kick a photographer outside Drue Heinz's house following a dinner party there, only to find that the privacy threatened was that of the Foreign Secretary, Lord Carrington, caught dining out with Mrs. Heinz at the height of the Falklands crisis. Not that he was invariably camera shy. Bruce Bernard, for one, had photographed him recently in the studio, doing a headstand on the bed—with Bella beside him giving him a smile—and posed in his chef's trousers and laceless boots as an imitation Henry Moore falling-warrior sculpture. He suggested using one of these, arguing

that anything taken by anyone else could be published anywhere, beyond his reach and control. "Once it exists it will be used." Despite the fact that the list of those who had photographed him when occasion demanded, usually for publication, was already long (Beaton, Clifford Coffin, Brassaï, Deakin, Snowdon and David Montgomery) he remained obdurate. "It destroys privacy. You can't go into the street. Think what it's like for Hockney." However he did agree that when Mike and June Andrews came up from Norfolk, on the day the Andrews photograph was to be taken, he would join us for lunch and, incidentally, see Jane Bown using her camera.

Sitting with his back to the window in the upstairs room at Wheeler's, he spotted one diner worth talking about: the *Daily Mirror* agony aunt, Marjorie Proops. He had often written to her, he said, but never sent the letter except for once. "I said 'Not for publication,' but she never replied. A girl wrote about the elaborate ins and outs of sleeping with two men in a car, being engaged to one and both married and Marje said the men were Evil. But they weren't. A woman said that she was worried she'd got these smoked-salmon stretch marks and Marje replied, 'I should say if you like someone you like their stretch marks.' So I wrote to her: 'If you didn't like someone, you would still

Freud pretending to be a Henry Moore sculpture

like her stretch marks.' Do you know that Johnny Cash song, 'My first wife died of stretch marks . . . ?' "[7]

A sudden thump and commotion in the street below interrupted his recitation and he turned to see what was happening. "A taxi," he reported, craning his neck to get a good look. "I hoped there'd be arms and legs lying around: I need that for something." Nobody hurt, it appeared, just a cab shunting a car, and he sank back into his seat. Over coffee Jane took out her camera and began clicking away at Mike (who was, unprecedentedly, about to go off to Australia to see Ayers Rock—then beginning to be better known as Uluru—with a view to painting it), which prompted Lucian, in what could have been a burst of pique, to dash to the stairs and disappear. That evening he rang me and said that it was all right for her to photograph him. She went to Holland Park the next day to find him awaiting her in a fine Huntsman grey flannel suit quite prepared, she told me, to cooperate—with fists clenched—for longer than she actually needed. He disliked the results. His nervousness looked baleful. "Strained," he said.

Before *Large Interior, W11 (after Watteau)* went off to Liverpool, Kirkman arranged for it to be shown at Agnews in Bond Street, a gallery that Freud liked: its shallow stairs and faded flock wall coverings gave it an air of plummy seclusion. Besides, the two entrances, Bond Street at the front and Albemarle Street at the back, made it easier, he said, to escape from people there he did not want to see. Kirkman paid for the Watteau. "Had to be round with a cheque and, I thought, it would be possible to show one picture like *The Raft of the Medusa* was shown in London in 1820. I was friendly with Ags." He also showed a number of drawings to make some money, shared with Agnews. The painting went into a viewing room where more than one reviewer, associating floorboards and unpainted plaster with slum conditions, took it to be a study of hippy folk living in squalor. "A sordid room . . . peeling walls, a nasty sink and the sort of all-too-visible plumbing the English are prone to accept," Terence Mullaly harrumphed in the *Daily Telegraph*. "Lucian Freud has always seemed to me grossly overrated and this picture confirms my opinion."[8] And Richard Cork, in the *Evening Standard*, waxed lurid about a "doomed house . . . ramshackle space . . . condemned playground . . . seedy modern interior." Despite the "bleakness of their environment," he added, Freud's models were surprisingly tranquil. "No breast-

beating or hectoring disturbs the prevailing calm."[9] Such verdicts, strong on misapprehension, were perhaps more indicative of a desire to see drawing-room potential in a studio setting than to examine or question Freud's concern with that perennial challenge, the painting of modern life. Others damned the paint handling. Tim Hilton, in the *Observer*, was thoroughly displeased. "Latterly his application has loosened into unctuous pigment: but flesh and hair, in his Elastoplast-to-raw-umber palette, retain the hardness of his earlier more enamelled work . . ."[10] In both London and Liverpool the painting came under attack for what was widely regarded as its misconceived or miscegenated incongruity. Besides getting the setting wrong several of the most dismissive criticisms were to the effect that Freud had no business monkeying around with a nice little Watteau. As Hilton put it: "The Watteau copy is mistaken. Too much of the picture dully describes its setting; the five figures have been separately studied, thus precluding unity; and Watteau's atmosphere and elegant poses are not transferable to the terms of Freud's art." Later, in 1984, part of the Liverpool exhibition, including *After Watteau*, was shown in Ireland at the Douglas Hyde Gallery in Trinity College Dublin. There again comment on this tacit homage to Rembrandt and Hals focused on perceived discrepancies between Freud's handling and Watteau's.

Kirkman offered *After Watteau* to the Tate for £250,000 and, when the trustees turned it down, let it be known that this masterpiece was not for sale. The *Evening Standard* reported him as pleased to keep it for himself. "I shall be glad to have it in my house. I have always said that if you haven't space for a painting you should make room for it." Freud was insistent on Kirkman taking it off his hands. "I needed some debt money rather badly."

Bacon looked in to see the painting at Agnews and told Dan Farson, a gleeful listener, that it was awful. This verdict went the rounds. For him the awfulness was aggravated by the disturbing news a few months earlier that *Pregnant Girl* (the 1960 painting of Bernardine Coverley) had been sold at auction for £44,000, four times the estimate. Worse, the buyer was Gilbert de Botton, Bacon's personal banker-collector. "It was instinctive when Francis suddenly turned against someone," Freud said. If he was now doing rather too well, in auction-room terms, then *After Watteau* practically invited swatting comment. How could Bacon tolerate the exposure the picture

represented, all that indoor foliage and the come-as-you-are cast sitting there doing nothing much and not a cut-throat razor between them? As he had said in one of his conversations with David Sylvester: "The moment there are several figures—at any rate several figures on the same canvas—the story begins to be elaborated. And the moment the story is elaborated the boredom sets in; the story talks louder than the paint." He did not, however, go into the difference between elaboration and complexity or, for that matter, between simplicity and vacuity. He himself was at that time working on paintings of sawn-off torsos kitted out in cricket pads.

"He didn't know it, that the work was so terrible," Freud countered. "He *believed* in the triptychs. It's hardly worth going on about the worst: the cricket pads with pricks. 'I particularly like these ones,' he said. 'The French wouldn't have them.' His feeling was that they were too strong, like Joyce. That the French couldn't take it. I said, 'Will they refuse the willies because they are too small?' and he didn't answer. We were not on good terms by then. I read he disapproved of my getting an honour."

Freud had been named a Companion of Honour in the 1983 Birthday Honours List. Bacon crowed with scorn at this. He pooh-poohed all awards, telling people that he had refused them for himself and that Queen Victoria had proposed giving his grandfather the revived title of Earl of Oxford and that therefore, as his brother Harley had died of lockjaw in Rhodesia, he could claim to be a rightful earl *manqué*.

Lord Goodman (with whom Freud had a ten-year bill unpaid at the time and who himself had become a CH a decade earlier) told him that the order was referred to as "Central Heating" by the senior civil servants presumed to care about it most and that the gold medallion was worth £2,000 and worn on a nice ribbon. "Good people have it," he said. "Besides, you get to see the Queen." And, he assured him, he would not have to "queue up for it with Africans and have his photo taken."

Freud saw no virtue in disingenuity such as that of Herbert Read who, though a declared anarchist, had been gratified to be knighted, explaining that he did not feel important enough to refuse. The clincher for him was that it represented discreet recognition, as distinct from being given a handle to one's name. (Clement, for example,

on ceasing to be an MP in 1987, was to get a knighthood.) "The reason I accepted is because I'm a naturalised British subject and if my country of adoption gives me an honour I can't refuse it." Also he recalled Freddie Ashton's attitude. "He had everything. He said, 'My dear, I'd accept a bottle of gin.'" However he remained uneasy and as Thyssen was sitting for him again he mentioned it to him. "I was oppressed because of having to wear a dark suit and having to go to Buckingham Palace by tube. I was a bit worried. 'I will send my car for you,' he said. 'My chauffeur knows the way.' Heini was so considerate."

The worries proved groundless, for on the appointed day he had a private audience and two courtiers to tell him what to do. He thought the Queen nervous and shy. "Does stamina mean you're good?" she asked him. "It can mean you're pig-headed," he replied and she laughed. He told her about having once photographed her father at the boys' camp at Southwold. Afterwards he felt dispirited. The award prompted Nigel Dempster into having another go at him in the *Daily Mail*. "Very strange to know this person who's behaved so dishonourably on the race course should become a Companion of Honour. Did the Queen know?" This was a reference to the bet placed, unacceptably, with Ulster money. By then, Freud considered it a matter well in the past. "It was indicated that I could come back but I hardly ever go. I did go when I was warned off, but then my face wasn't known at all really."

"I gave £5,000, a hugely handsome sum, to get them back"

Among the Titians in the exhibition "The Genius of Venice" at the Royal Academy in the winter of 1983–4 was *The Flaying of Marsyas*, borrowed from a monastery at Kroměříš in Czechoslovakia: a great painting little seen for well over a century. Its re-emergence created excitement, especially among painters. "All these months," Lawrence Gowing wrote, "London has been half under the spell of this masterpiece, in which the tragic sense that overtook Titian's *poesie* in his seventies reached its cruel and solemn extreme."[1]

Apollo looks on as an impious worldling hung up by the hooves is stripped of his skin: punishment for daring to emulate his divine musicianship. Pain and terror and lingering cruelty transmuted into grandeur—torture as sacrament, as last rite—was all that Bacon had hankered to achieve and all the more wonderful to behold at a time when fashion favoured the Neo-Expressionism of Georg Baselitz, whose paintings of inverted motifs were being promoted then by Anthony d'Offay as a thrilling post-modern procedure. For Freud the curious intimacy of the Titian appealed, and the absorption: every jarring element bedded down, abstracted, caulked with meaning.

Christopher Bramham, son of a newsagent and former student at Bradford and Kingston art schools and subsequently a formidably distinguished painter, was teaching two days a week in a prep school when Freud first met him in 1983. "I ran a church youth club and in an early Van Gogh way my whole life revolved round church and helping these young people." Through church he encountered a bene-

factor. "A sort of antique dealer who used to install and repair Lu's chandeliers. He was a churchwarden, liked something I was doing, felt sorry for Ruth and kids in poverty and said he'd mention me to Lu. Of course I never expected anything to come of it, but Lucian gave this fella his address, so I wrote and miraculously Lu wrote back inviting me round. I was so excited."[2]

16-11-83

 Dear Mr. Bramham Could you come here on Tuesday the 22nd as suggested? I would be pleased to look at any work you care to bring along. Between 4 and 4:30 pm yours sincerely Lucian Freud[3]

"I couldn't make a picture at all. I really just did not know what to do, making a picture was quite beyond me, subject matter, everything," Chris Bramham told me in the first letter of a long-running correspondence.

 When I met Lucian I was making some progress in resolving this problem: I was bored with stuffed animals but had then begun to draw trees a lot. Lucian encouraged me to paint at a point I really felt I would never be able to. So I would paint and report back to Lu every six months. Lucian would visit and I would think long and hard about where it was going right and wrong. I remember slashing a whole summer's work once after a visit. Not that he ever said anything harsh, I was just left with a feeling that I had been sloppy.

 I learnt from Lucian how to persist with a picture. To do that you have to love the subject.

 Lucian actually bought one of my pictures on our first meeting, can you imagine!

 Neither of us could phone at the time so usually letters would be sent.[4]

In December 1983 R. B. Kitaj and Sandra Fisher were married at the Sephardic Synagogue of Bevis Marks in the City of London. Freud, Auerbach and Kossoff were mustered to represent the *minyan*—ten Jewish men—and David Hockney (to Kitaj "an honorary Jew") was

best man. As Kitaj explained to me: "The Sephardic Synagogue was founded by a friend of Rembrandt's in 1700. We needed all these Jewish men—a *minyan*—Lucian and Frank and Kossoff and Hockney and my two children, and Lucian said he'd never been in a synagogue in his life and Hockney with his blond dyed hair . . . and I thought these rabbis would go crazy."[5] Freud felt friendly but uninvolved. "It was obviously not an orthodox service. Being Kitaj, it was more a showbiz thing; the rabbi said things like 'I hope they'll paint marvellous pictures.' That's like the Catholic priest saying to the couple 'I hope you'll commit incest' almost. I saw Leon [Kossoff] looking askance as if to say they don't even know how to do it. That was my only visit to the synagogue." He refused to get into the coach that was to take them all to the Neal Street Restaurant for the wedding feast. "Too many Jews for safety in one vehicle," he said.

Kitaj decided to produce a painting to commemorate the union of two painters in the presence of so illustrious a *minyan*. "I knew I had to paint it," he told me, "so I worked on it and worked on it and worked on it. Most of them saw it and gave me advice about it through the years and I had no idea how to finish it. It seems over-laboured to me and I finally just gave it to the Tate. I tell you: the main aura that hangs over it is the *Demoiselles* [*d'Avignon*]. The idea of a clump of figures: well, at one point Frank said that I should differentiate the forms more. I kept taking everyone's advice . . ."[6]

The writer David Plante who, with his partner the Thames & Hudson publisher Nikos Stangos, attended the ceremony, remarked on Freud's paper skullcap being too big for his head and how he stood nervously on the edge of the dais just outside the fringes of the canopy, stepping from side to side, reaching out as if to steady himself in trousers that appeared several sizes too big. Stephen Spender was present. "Stephen whispered to me, 'I can't stand being in the same place with Lucian. He is an evil man.' "[7]

Another grouping, less exclusive, was "Traditional Method and Subject in Recent British Art," the theme of "The Hard-Won Image" at the Tate in the summer of 1984, a trawl of the unfashionable and non-fashionable, differing from "A New Spirit in Painting" in that it was localised, though extending to painters beyond the School of London. The Tate curator, Richard Morphet, assembled works by painters associated with the Slade (William Coldstream, Lawrence

Gowing, Craigie Aitchison, Euan Uglow, Patrick George, Richard Hamilton) and the Royal College (Rodrigo Moynihan, David Hockney), the Beaux Arts Gallery (Helen Lessore, John Lessore, Raymond Mason) and the Royal Academy, and many others besides. Next to the Howard Hodgkins and opposite the Leon Kossoffs were five paintings by Freud: *Wasteground, Naked Portrait* and *Naked Portrait II, Two Plants* and *Large Interior, W11 (after Watteau)*. "For some reason an 'either/or' mentality seems deeply engrained in this country," Morphet wrote, anticipating what he described as "negative contributions" from commentators who thought him indiscriminately catholic in his tastes.[8] As it happened a British Council survey, "The Proper Study," shown in India in the autumn of 1984 at the Lalit Kala Akademi in New Delhi and in Bombay, overlapped with "The Hard-Won Image" and coincided with the assassination by her bodyguards of the Prime Minister Indira Gandhi. Armed guards were posted in the galleries for reassurance. In dazzling Indian sunlight the colour leached out of the Freuds—*Girl with Roses, Naked Girl with Egg, Guy and Speck*—and their validity was questioned by a number of Indian artists inclined to presume condescension and detect passé ways.

The art market had soared in the early eighties, globally so with a bubble of Japanese involvement. Prices rose dramatically. In 1980 the Whitney Museum paid a million dollars for a Jasper Johns and in 1988 his *Three Flags* sold for $17 million. A new generation of voracious collectors emerged, the most prominent in Britain being the advertising man Charles Saatchi, who bought in quantity, acquiring in the late eighties all the Freuds he could lay his hands on.

Neo-Expressionism became an almost universal trend with figuration, symbolical and otherwise, adopting heavy historic guises. It was a period of stylistic bodybuilding. Already, in the seventies, Philip Guston had switched from abstract tone poems to a redneck look involving images of himself, bug-eyed, chain smoking and painting furiously with outsize brushes. He became a widely imitated model.

"There's one thing dealers hate more than anything else: it's people buying their things from a dealer and then putting them in auctions to get more. Well, there was a danger of this happening with the bank manager, who was also Francis's, who behaved terribly well. Francis gave him a William Blake head and I gave him a few pictures of mine, and a very early self-portrait with marbled face which I had

kept, and when he died it went for about three or four thousand and that caused a bit of a stir. Things started going up."

Freud became restless. High prices at auction coincided with an entrepreneurial boom or bull market in art collecting.

"Picasso's periods really linked to the women he was with; they were not entirely stylistic changes." For Freud, now in his sixties and undeniably—inescapably—cast as the older man, the scrutiny he brought to bear on those he painted was ever more affecting. Age gave him assurance: he could now expect people to want to sit for him beyond the several daughters prepared to be available and of course his mother. All sitters, all intimate to some degree whatever their involvement, demanded an unwavering concentration each appointed time. And time, as he often said, was dwindling. He watched his mother with unease as she struggled up the five flights of stairs to the studio.

The Painter's Mother, begun in 1982 and completed in the winter of 1984, had qualities that Bacon professed to despise: lucidity and a guarded calm. Previous portraits had hinted that the eyes just might light up. But here, withdrawn beyond any such possibility, graced with a harmony of blacks and whites and flesh tones, "Mutti," as Freud still called her, became an incipient memory. The bed on which, at other times, the Watteau characters sat was pushed close to the wall; the blinds remained down. Decorous on the bed, she lay with one leg raised, the other extended, the hand with the wedding ring flat on her stomach. Above her, framed in the skylight, she could see clouds and birds perhaps or even a plane every so often droning towards Heathrow. Not that she cared. He was to paint her once again there, an upright composition (he used the canvas on which he had begun his painting of Judy Adam), bamboo shoots crowded behind her, jostling her bewilderment. "Where am I?" she used to ask. After more than twelve years, this proved to be the final painting. It was his decision. "More me than her really. I think (maybe in retrospect) I didn't like the picture with the bamboo."

There were several recurrent sitters besides his mother and the daughters at Holland Park, notably—in daylight hours—Susanna Chancellor, who sat for *Woman in Profile* (1980–1), head on elbow, a confiding look imparted. The paintings of her were to be the most intimate he would do. She had become, and was to remain, a lasting

presence, there not primarily to be painted but to be a reassurance, there to approve cloth and cut when the tailor called. She arranged for her cleaner to be his daily too. For years there had been fallow spells, during which the day-to-day relationship lapsed, and there were to be periods of reproach, each ending with the resumption of sittings and paintings of unparalleled warmth and liveliness. She it was who introduced the whippet motif and she who recommended her doctor, Michael Gormley, as someone who could be relied upon to be sensible. ("OK: you're not well but things will sort themselves out.") Dr. Gorm, as Freud referred to him—though not to his face—was eminently reliable. "A bit alternative: give patients the choice." Let there be homeopathy if wanted, Freud understood. And acupuncture or masseurs or cranial osteopaths.

To sit was to serve, more often than not in more than one capacity. Celia Paul sat regularly into the late eighties, as did Sophie de Stempel, granddaughter of a White Russian aristocrat, who met Freud in a Soho pub when she was nineteen. "He asked me to model for him and I agreed. At first I was a bit nervous—I had never stripped off like that before—but I soon got used to it."[9] This was in 1981. Freud talked of her fondly but patronisingly: she was even younger than Celia. "Started, then bust up, then—two years later—went on. I remember I used to say something rather sultanish when we stopped: 'You can stay if you like.' A good thing about her was that she knew better than to talk as she posed. Never said anything." She sat for him eight years on and off, nights primarily. "He often paid me in £50 notes. Which, at that time, were impossible to change. His fortunes were up and down."[10] *Blond Girl, Night Portrait*, painted over five years from 1980 with a two-year gap, had her slumped against the arm of the buttoned sofa, red-faced and risking a crick in one shoulder. He impressed her with his intensity of effort, such that he would at times work through the night and continue the next day without a break. He was gentle and kind, she found, as well as being "a bit of a bully."[11]

Sitters aside, Freud reckoned, there was nothing in animal creation to match the responsive docility of a good horse and the one place in central London where exceptionally good ones were always to be found was the Knightsbridge barracks. Seeking access, he asked Michael Tree if there was any possibility of working from the wealth of horseflesh there. Obligingly, Tree introduced him to his friend

Andrew Parker Bowles. "He was Colonel of the Blues and Royals and had a flat over the barracks and he came by and asked me to go riding." So, for a while, between seven and nine in the mornings in the mid-eighties Freud rode with Parker Bowles in Rotten Row, as he had wanted to ever since the *Black Beauty* days fifty years earlier. Parker Bowles was nervous about his refusal to wear a hard hat. "He was a good rider, a bit too brave." Soon the question arose of gaining access to the stables in order to paint. "Can't do that in London normally. I was to paint the two hundred and fifty horses, no less." That proved impractical but, given a pass authorising him to draw, he sat on a campstool at night and watched troopers bringing girls back to their quarters, a subject off-limits to him, he was told, but he did work from two horses, Success and Pegasus, drawing their heads in profile, strikingly similar to his own alerted *Reflection (Self-Portrait)* of a year or so earlier. "I got him the doziest trooper I could find to stand with the horse," Parker Bowles recollected. "He gave the trooper a sketch and said, 'Go and see Kirkman if you want money.' This he did, got a reasonable sum for it, the result being he could buy his first house."[12] This and other studies in crayon and charcoal were added to the display at Agnews, together with drawings derived from the *After Watteau* and, Freud conceded, done "slightly with an eye on Agnews, but not much." For him they were re-examinations of the painting, significantly different in outlook and handling from those surviving from when he was half the age he had now reached.

Some such early drawings became the subject of a chronic dispute between himself and Johnny Craxton, one that had been brewing for well over a decade. Freud resented what he regarded as poached, filched, tarted-up or negligible works loosely attributed to him being exhibited for sale. Especially so when the person who stood to profit from them was Craxton. This was intolerable: a sly move too far.

"Lucian was constantly in debt," Kirkman explained when discussing the reasons why, for Freud, this became such an issue. "I'd go to him and say, 'Haven't you got a few drawings in the plan chest?' We'd look through the plan chest: nothing. Scraps. Nothing decent. That's when he put drawings by Craxton in a sale (they had been in his mother's house) with no reserve and Craxton—reasonably enough—was annoyed and sold one or two sketchbooks they'd shared. Lucian got in a terrific state. Had to buy them: £6,000. I then said to him

more than once, 'Why don't we go through these sketchbooks, and chuck out some of them?' Lucian would vaguely say yes. There were lots of lousy drawings. 'You should get rid of them,' I said, but he didn't."[13]

In February 1984 the Christopher Hull Gallery in the Fulham Road announced an exhibition of drawings by Craxton and Freud, to open that April. The press release alluded disingenuously to the questionable attributions. "It is our purpose to offer the Visitor and Critic alike an opportunity to compare the formative years of endeavours by the two artists before they went their separate ways." Guesswork would be involved. "Some 60 drawings will be shown and (as a tease) it is not our intention to identify which drawing is by which artist."[14]

Indubitably a number of the drawings were by Craxton; some were possibly by Freud and maybe coloured in a little by Craxton. Freud dismissed the lot as "things not by me and things I would have destroyed." Craxton however claimed that they had "shared" sketchbooks. The extent of sharing was contentious and the implications even more so. "It was more Craxton continually adducing a close relationship which, if it had existed—which I suspect it did—didn't last for more than six to eight months," Frank Auerbach said.[15] Since the late forties their activities and achievements had diverged entirely. The promise that initially Craxton had showed settled into Grecian mannerism; in his 1967 Whitechapel retrospective "elaborate compositions heaped thin and high" predominated, as John Russell wrote with his usual waspish elegance.[16] And in Greece, following the Colonels' coup, Craxton faced accusations of looting or, as he saw it, "salvaging of antiquities" such as icons from derelict churches. By then he and Freud were far apart. This distancing in itself constituted grounds for a feud.[17] Freud, always quick to strike when threatened in any way, had been eager to tell me, as early as 1973, that Craxton had helped himself to maybe as many as a hundred drawings, some scavenged from Abercorn Place, some from E. Q. Nicholson's in Dorset and elsewhere: the litter of idle moments. He said, relentlessly, that he considered the "rather light-fingered" Craxton vicious and pathetic. "I sometimes took him out. Once—feeling sorry for him—I took him to Annabel's and he started talking to the waiter, a handsome waiter, in Greek, and started making up to him: 'Don't you think the people here are ghastly? New vulgar rich,' and the waiter said, 'I don't under-

stand.' He didn't know Johnny's demotic Cretan Greek. How like him, I thought, to make up to an Italian waiter in Greek.

"When I got *really* angry was when he was selling some stolen things. The Killer, who had a gang, was always trying to do things for me (though there was nothing I wanted doing) so I said that there was this man who *stole* things a long time ago. 'I know roughly where they are, but I don't want to get anything back except *my* things.' 'Look,' he said, 'I can't send anyone in to *choose*.' So obviously I couldn't do it. Anyway, at every auction there were these things: over a hundred things from the rubbish drawerful. I had assumed—wrongly, as things got worse—that he was running out of things to sell. But he kept very nice things. Which is very like him." One resort, he added, had been to send people to bid at Christie's. "Get Charlie Thomas or someone to bid them up and leave a false name and address (can't try that again) and then scarper."

Anne Dunn regarded the hounding of Craxton as an example of "Lucian's viciousness towards people."[18] Certainly his malice expressed itself in a taste for the vendetta and a reflex kicking out at perceived obstacles and threats. As he saw it, once Craxton started attempting to take advantage of him there was nothing for it but to retaliate. A meeting between solicitors—Freud's being Lord Goodman—was arranged to put an end to the matter. "Johnny didn't come and I said to his solicitor, Mr. Rubens, about the icons and he said, 'How can you make such terrible allegations?' 'Because it was true; because I was there, keeping a lookout.'"

Freud assumed that drawings by Craxton inscribed to him were thereafter his to sell. ("Went into Kalman's. Something for the 2:30.") Naturally this disposal of Craxtons for quick cash offended Craxton. But what enraged Freud was Craxton's notion of value added: the alteration of someone else's work, juvenile ephemera at that. While Craxton had the initial grievance, Freud had the serious accusation. And he was unforgiving, proudly so.

"On the back of one drawing it said, 'done by Lucian Freud in my presence,' signed John Craxton. 'Is a cunt,' I added, and his solicitor said, 'a superb drawing defiled by your client.' But Goodman stood up for me. He said, 'It has no doubt significantly added to its value.' Some Craxton stole, some are Craxton; some he coloured up: things not by me and things I would have destroyed. In law anything that

is 'improved' is altered; if you translate the concept into humans it means people in make-up can't be introduced as they aren't the same person."

It was obvious, wrote Oswell Blakeston in *Arts Review*, that the show in the Fulham Road mainly consisted of leftovers from parlour games: "the cross-pollination of domestic evenings. One can pick out characters drawn by one or the other in mutual fantasies, remark sympathetic criticisms of other painters' styles, count the long noses (perhaps another Freud comes in here) . . ."[19] In the downstairs gallery, for purposes of comparison, were "*corps exquises*": surrealistic mixed heads, bodies and legs drawn in similar circumstances by John Minton and Michael Ayrton.

"I gave £5,000, a hugely handsome sum, to get them back. We had a bash-up at Jamie Astor's and destroyed them." They were fed into a bonfire in a garden in Ladbroke Grove and that put paid, Freud thought, to the matter. He was, he told me many years later, "awfully tired of Johnny Craxton, tired of hearing that I didn't want to admit to something. He claimed we shared a studio. We had rooms at Abercorn, we were in the same house in the Scillies, but we never shared a studio. We never did. MacBryde and Colquhoun shared a studio: is Craxton implying this? His saying all my works are influenced by him, and that we were very friendly: he doesn't make things up so much as twist them.

"At Goodman's, when our solicitors were talking, Craxton said to me, 'I wouldn't have done this if *you* hadn't sold them.' But I always *did*. Fionn O'Neill [Ann Fleming's daughter] said to me: 'What Johnny can't forgive you for is being so treacherous by betraying the homosexual cause.'

"He doesn't need grounds. We are all queer; if you say you're not, that means you really are; you're outed. It's just that I don't want to go down as having shared a studio. I was friendly. In Greece I was the lookout. (Otherwise I wouldn't know about the icons.) Why do people have to be grouped or typed?"

"It was a direct jump from paintings to etchings"

A Couple (1982), Freud's etching of himself and Katy McEwen clinched in a photo booth, has the squiffy look of a late-night snapshot: the two of them caught out, surprised by the flash, he leering over her shoulder into the mirror like a Dutch droll pestering his scold. In this instance the three-minute wait before the damp strip of prints landed in the tray outside anticipated the longer interval between scratching the image on the etching plate and having it dipped and proofed. It was a one-off. Usually, from then onwards, paintings prompted comparable follow-up etchings. "It was a direct jump from paintings to etchings, not from the early etchings. What I learnt was how to use my painting; it was all to do with painting and willpower."

Etching—drawing with bite—made a change from painting, the procedures involved being more committed, virtually irreversibly so. For although the image might be modified, transformed even, at the dipping and proofing stages there was still a level of risk akin to gambling. "The exciting thing is the time you go along and—hooray!—it worked! And then I got going and gradually more confident." Feeling his way he produced fifteen etchings in 1982, nine of which were published. Three were of his mother, in effect a triptych when all three plates were printed alongside one another. Besides reworking some proofs in pastel and charcoal he took to using varnish to create highlights. By the mid-eighties he was on to large portrait heads, which is where his printmaking originality developed.

Most of the prints from the forties had been small, dipped in

one go in the hotel washbasin, printed in ones and twos and if not passed over to the dealer E. L. T. Mesens, given to anyone he thought might like them. Now, however, he had ambitions for them, as both multiple—saleable—items and expansive efforts. With little regard for craft technicalities, he sought to coax fine line into the fleshiness and weightiness more readily achievable in oil paint. The graininess of Cremnitz white translated now into abrasive cross-hatching, contours were feathered out, muscles were plumped in sweeps and grazes. "At first I was doing drawings on copper really, but then they became related more; I *could* do aquatint and lots of things but I don't want to get into it that deep." From the mid-eighties onwards the etchings held their own successively. *Blond Girl* and *Girl Holding her Foot*, for example, followed on from paintings of Sophie de Stempel. In these the sofa, so necessary to the paintings, played no part; the body was couched with minimal shadowing in the void of the unworked plate from which the printer wiped all but a faint bloom of ink. Then for *Man Posing* he worked the plate edge to edge, filling it with sofa, walls and floorboards. The sprawling figure resting one foot on a pile of books was Angus Cook—a fellow student of Rose Boyt at University College London—set down and laid out in due proportion and contrast: kneecap to forehead and forehead to scrotum, contrasting muscle and padding, hairy legs and wood graining, pubic hair, horse hair and worn leather binding. This etching, for once, preceded the related painting.

During the printing of *Man Posing* in 1986 Freud fell out with Terry Wilson, who had been recommended to him by David Hockney. "Gifted. Drove a red Aston Martin. He took some plates, locked them away and I arranged to smash the doors. I saw Lord Sieff in Harry's Bar, or somewhere, and said, 'Your niece's husband is causing me trouble.' 'Sounds like drugs or something,' Sieff said. Finally I got the things back."

The last full edition printed by Terry Wilson was *Head of Bruce Bernard* (1985). Bernard, the former picture editor on the *Sunday Times Magazine*, a man with a doleful countenance and a varied employment history, had set out to be a painter, was props master for Sadler's Wells touring company in the late sixties and had proved to have a good eye for an image when employed gathering illustrations for history part-works. He had retrieved John Deakin's photo archive,

heaps of it, from under his bed after he died in 1972 and, like Deakin, took up photography himself. Freud had known him since the day during the war when he went with Lorna Wishart to see her son Michael at Bedales. "Bruce was Michael's friend and Lorna said we must take cigarettes for Bruce. He looked pretty sullen, he certainly wasn't a smiling friendly boy."

In 1985, nearly forty years later, Freud drew him: receding hairline and faint suggestion of morose resolve. "A drawing on brown paper. It didn't work and then the etching did and I looked at the drawing again and cut it a bit and it then did." In the etching parts of the forehead were stopped out with brushfuls of varnish. "I worked in a very free way with that; it was more of a portrait." Knowing Bruce and his moods, he lingered over the twisty mouth and glint of amusement in the eyes. This was the archetypical Soho man (brother to the equally archetypical Oliver and Jeff) who, only half jokingly, adopted a pseudonym for Soho use: Deirdre Clough. "He has got that almost arrogant look. There's something grand about him: he's got a very lovely smile. Mischievous. Slightly rueful. Bruce in the army was a land girl and as he was digging on the land in the Border country some people came along. 'Poley Poo,' they said. 'Hello. Jiggy-jig: yes-no?' From the shape of Bruce's head, and as he was digging, they thought he was a Pole. Everyone knew Poles had round heads and dug and liked jiggy-jig."

Another massive male head, good to draw and to be incisive with on etching plates, was that of Arnold Goodman, Lord Goodman CH, Master of University College Oxford, founder of the firm of solicitors Goodman Derrick, former Chairman of the Newspaper Publishers Association, of the Arts Council, of the Royal Shakespeare Company, the Royal Opera House, the Housing Corporation, the *Observer* and Jack Baer's gallery, Hazlitt, Gooden & Fox, averter of scandals—such as Lord Boothby falling in with the Krays—and pre-eminent fixer of deals, leading libel lawyer and power broker, a man of fabled common sense and discretion, the most celebrated *éminence grise* of the age.

Freud had long admired Goodman's professional guile and curious unworldliness. "I think I met him at Ann Fleming's as Goodman wanted to marry her much later, having first met her in 1964. She remembered at a party sitting leaning against his legs: they were all muscle. He was a stranger to jiggy-jig." Ann Fleming, who was in a

position to know, told Freud that Goodman was sort of innocent. "He doesn't remember when he last did it; I don't think he's ever done it." Occasionally around then Freud had taken advantage of Goodman's hospitality, not that Goodman necessarily knew it. "In the fifties I went out with Suna Portman, as many people did, and she'd say, 'Let's stay at Goody's flat.' I got his advice about some things, which made me realise how nice he was. He had no knowledge of people sometimes. He said to me about George Wigg [Labour Party Chief Whip and then head of the Horserace Betting Levy Board], 'He has to have women *all the time*, it's *very* odd.' And I said nothing. I was amazed at how naive he was. I went to dinner there. He loved entertaining: sometimes ridiculous, sometimes interesting people. I hadn't realised to what degree he based himself on Dr. Johnson."

In 1985 Freud drew Goodman in bed, propped up on the pillows, readied for consultation. "Early-morning sittings. He lived in a hideous 1930s block off Upper Regent Street. I went round to breakfast. I didn't paint him: didn't like the idea of bringing paints round there. I took an easel and left it there. He was ill. Invalidish." Having placed the easel between the bed and the window, he stood to draw while Goodman looked through the newspapers preparing to face the day. He published a diary in the *London Review of Books* recording the experience of being drawn by Freud. "He would arrive at eight o'clock and leave at nine, coming on most mornings. He would occasionally accept an invitation to breakfast and would certainly do so if I was able to offer his favourite—woodcock.

"Lucian Freud is not one of those artists whose speech is frozen when he is at work. One sits in whatever posture he directs and immediately engages in an exciting conversation on a great variety of topics, on which he possesses an amazing amount of information . . . If one says something he responds intelligently, often amusingly, and with a nice touch of malice. One has a feeling that his work is directed by total confidence."[1]

Graham Sutherland had painted Goodman in the early seventies, a portrait—tight suit, frizzy black hair heading backwards—that left the sitter unmoved. "Sutherland was a conventional man, whereas Lucian is a completely unconventional person. He was much more penetrating than anyone who had painted me previously. One had a feeling that here was a man with a mind and this could be a cerebral picture."[2]

Freud enjoyed Goodman's lumbering knowledgeability. "The twinkle in his eye side of him" when, for instance, he told him about a prize-giving at a girls' school and being interrogated afterwards about what he got up to as adviser to the Labour Prime Minister. 'What do you do with that dreadful Mr. Wilson?' the headmistress asked. 'Oh, we spend much of our time signing death warrants.'"

First proofs of the etching that became *Lord Goodman in his Yellow Pyjamas*, published in 1987, were a bit lacklustre. "Something's missing," Freud conceded and added the yellow wash, brightening the presence. Goodman was not altogether impressed, detecting maybe a slight hint of *contre-hauteur*. During these sessions, Freud said, he was reminded of the Auden line: "Private faces in public places / Are wiser and nicer / Than public faces in private places."[3]

"That 'wiser and nicer' applies to portraits. Touching things: I took my daughter Susie, she was eighteen, to see Goodman. He said, 'Why don't you pour your husband another cup of tea?'

"He was hard to pay: everything was to do with exchange and barter; he lived a life of bartering. Francis gave him a self-portrait. (I put him on to Francis over the cannabis planted by George Dyer in Reece Mews.) He wouldn't take any money for his legal services so I gave him a drawing. The pastel I then did was more benign, so he said would I swap? But then James told him the pastel was worth more than the drawing and he was dismayed: he liked the pastel so much better. "Do you like port? Let me give you a case of port." Two cases came. One I gave to Frank. Probably they really belonged to the college." Goodman had not long retired from being Master of University College, Oxford.

More than once the possibility was discussed of painting Princess Diana. Goodman, naturally, became involved. He said to her secretary: "A great, great, wonderful idea. But I shouldn't leave her in the room with Lucian."

The tinting of the pyjamas was a single instance, but also occasionally Freud used proof etchings as preliminaries to be tinkered with and worked over in pastel. Pigment applied like makeup to portrait heads clogged the bitten lines. There was quick stimulus in working dry on dry, feeding one medium into another, seeing what more could be done. "I want to familiarise myself with my materials to such an extent that, having them to hand, I can use them. My quarrel with

acrylic paint is *my* inability and not it. I think that these things are terribly private; I know that going from one medium to another, from drawing to painting, say, does refresh."

Further refreshment was to be had from intermixing cultures. For example, Freud was partial to Reg Smythe's comic-strip figure Andy Capp, the cocky bottle-nosed County Durham pub regular who forever strutted and lounged in the *Daily Mirror* and, with few words and fewer gestures, left the opposition, principally his wife, spitting asterisks in pointless fury. A squat figure in an immovable cloth cap, he was descended from the terrible juveniles of Wilhelm Busch and was as bouncy as the nippers drawn by Fougasse or Walter Trier. What particularly appealed to Lucian (and, he said, to Bacon) was the lack of complication: the startling ways economy of line cuts to the quick. The cartoonist Nicholas Garland, who drew an ineffably improper Barry McKenzie strip (with Barry Humphries) for *Private Eye* and whose son had been friendly with Ali Boyt, was another whose work Freud particularly admired, so much so that he made a point of introducing him to Mark Birley, owner of Annabel's and Mark's Club and grandson of the swish society portrait painter Sir Oswald Birley. The three of them had lunch one day, Garland remembered. "I listened to them talking about what a great draughtsman Peter Arno was. Lucian mentioned several artists, including Matisse, in the same breath with Arno without making the slightest distinction between comic art and fine art, which pleased me very much. He came up once when I was drawing in the club [Annabel's] and asked, incredulously, how could I possibly draw in public like that? He couldn't do it to save his life. He shook his head as if to say wonders will never cease and said, 'Come and have a drink.' I didn't because I was working. But I wish I had. I liked him so much. You hear all sorts of stories about him being so disagreeable, but he can be terrific. Lucian was quite different then, or I was."[4]

In 1985, a couple of years before he became political cartoonist for the *Daily Telegraph*, Garland produced a set of linocuts of Annabel's. These Mark Birley published privately and Freud contributed a crisp introduction—one that, incidentally, evoked something of what he was up to in his own work. "When I noticed Nicholas Garland at Annabel's earlier this year drawing unobserved—first in one corner then in another like a sparrow in the Zoo—I knew this could

have serious consequences. Some of his people are invented, some are composite portraits but we recognise them at once by their behaviour. We know what each is thinking or saying. They display such particular feelings with a disarming clarity. We watch four couples dancing, lost to the world, strange attitudes of accelerated courtship."[5]

"I want portraiture which portrays them, not here's another of mine"

By the mid-eighties and following on from *After Watteau* Freud was keen to keep at least one large painting on the go at any one time. This held him to working longer hours. What he had in hand summoned him and preoccupied him fascinatedly day in, day out; the outcomes, consistently and regardless of size, were more substantial now, both literally and expressively so, avid impulse fusing into long-drawn-out execution. Being over sixty bothered him, his great fear being loss of capability. Urgency, he felt, could be stronger motivation than the attractions of subjects in plain sight. "The thing of things happening as if some structure had no human element, e.g. if I was to read that the *reason* Napoleon conquered all those countries was that he had scabies and that kept him in his tent: I like facts, but I do like *reasons* very much. If *fact*, they are completely shorn, they are more *abstract* really." Such thoughts prompted a greater than ever preoccupation with undertones (or overtones): those elements or aspects of a painting that present, for example, the appearance of latent feelings. It was what distinguished a true portrait from a mere likeness. In terms of painting it was incalculable but you knew it when you saw it. "These things to do with fate and biology and condition and the future, everything, coming in."

In one of his sketchbooks—an old accounts book—he drafted a statement. "Abstract by its exclusion of Human or representational Object cannot ever move the senses but can still at best have an escetic [*sic*] appeal only."

There were also the formal challenges, perennial and unchanging. "You would hardly believe how difficult it is to place a figure alone on a canvas, and to concentrate all the interest on this single and unique figure and still keep it living and real," Manet told his friend Antonin Proust. "To paint two figures which get their interest from the duality of the two personalities is child's play in comparison."[1] Freud thought otherwise. "Two people are harder because I'm outnumbered. You want them to sit as you wish . . . Twice as much control to be exercised, like two circus animals. Takes more time somehow, like on a beach getting lots of children into the sea takes more time. I like to think that they don't mind being there and I quite like the idea of their posing for me being a specific part of something they are doing for me. I want them to be themselves. I want to do *them*, and even identical twins wouldn't do if I didn't know *them*. I don't want to put anyone in my mould. I want portraiture which portrays them, not here's another of mine."

Irving Tindle (*Man in a Sports Shirt*, 1982–3) was subject enough on his own, given the smack of polish on his forehead, the coarse brushwork of the moustache and the rolls of fat swelling the neck lodged within a golfer's open collar. Tindle was a bookie and took payment in kind. "A sort of dodgy businessman who had to live in Spain later. I gave it to him for £45,000 I owed him and he sold it for £280,000 and left the country." Compared to him Alfie McLean was friendliness and goodwill personified. Alfie had already proved himself to be an exemplary sitter ("particular feelings . . . disarming clarity") when he posed with his nineteen-year-old son Paul, for *Two Irishmen in W11* (1984–5), the self-made man sitting there with seasoned confidence, massive hands relaxed on the armrests, signet ring glinting. Thinking what? He had his growing business empire to give thought to as the hours passed and family concerns back home in Ballymena; but there was also, surely, the matter of what he was now doing, exposing Paul to this absorbing other life. Squeezed into the chair recently vacated by Irving Tindle and with Paul stationed behind him, a sharp dresser awkwardly placed, Alfie submitted to being made over into Freud's image of him: an image of variance not confined to the differences between one style of city suit and another. Paul, gripping the back of the chair, was, he told me long afterwards, bored, bored, bored: itching to be out and about in livelier parts of

London. "A very quiet boy," Freud said in the autumn of 1985 when he first showed me the painting. "He'll take over the business but he's as opposite as you could think of to a gambler. He's interested in making and keeping money." He found the pair of them captivating. "Paul said that Alfie's tactfulness is a lack of warmth. He wouldn't tell Paul what he thought about things and Paul took that to be a lack of warmth."

In the ten years since he'd been first painted Alfie had come to rely on Freud for advice on pictures to buy at auction and elsewhere but, Freuds or whatever, he and his wife were chary of having paintings involving nakedness in the house, though there were at least two outstanding exceptions. He gave him open credit. Consequently Freud, who told me that he had not had a bet since Ascot that summer and that he had asked Alfie if he had any nephews for him to paint to pay off debt, came to be under a huge obligation to him. Whereupon the completion of this picture became timely.[2]

He had been at pains not to make too much of the view over Shepherd's Bush towards a red-clad tower block alien among the chimney pots, lest it become illustrative, like a neat patch of view behind a Memling Madonna. This was, he said, one of the problems with larger paintings: the intrusiveness of ill-adjusted parts. He had dimmed the blind to make the rest brighter, thickened the paint on the window ledge and inserted at skirting-board level two mousetrap-size self-portraits left off just past the cheekbones ("I often started these, I did a lot and scrapped them"), telling himself that they would serve as footnotes almost. "I wanted a point of life and I was there to point up the fact that the sitters were not where they belonged, that they were strangers in town. More poignant: 'the story of the picture,' if you like." For Freud this was reason supplanting mere fact. Plus the fact that the two faces hinted at his favourite double spread in one of his favourite books: plates 120 and 121 in Breasted's *Geschichte Ägyptens*. He was pleased with the floorboards—they had come right first time.

Alfie McLean acquired the bare-shouldered *Reflection (Self-Portrait)*, also completed in 1985, a painting that I suggested to him, on first seeing it, looked a touch heroic, reminiscent of the photographs of Yousuf Karsh—"Karsh of Ottawa"—best known for his growling Churchill and pores-and-whiskers Papa Hemingway. "Freud,"

I wrote, "has cultivated a remorseless sort of portraiture. Avidly, it seems, he watches sweat breaking out on the sitter's forehead, veins surfacing and swelling."[3] He bridled at the implication that he had burnished himself. "That horrible remark you made. Not having clothes on was to make it more immediate." He had wanted to avoid the business of shirt collars, not quasi-Karsh but à la Rodin. He did however concede that I wasn't the only one to remark on the lavishly exercised look of it. "Alfie's daughter Kathy in Ballymena (where women aren't thought too much of—in Ireland and Greece—women are doubly observant) said, 'He's treated himself rather better than he's treated us, hasn't he?'"

While working, intermittently, by day on *Two Irishmen*, *The Painter's Mother* and the second Thyssen portrait, at night Freud was preoccupied with the paintings of himself and of Sophie de Stempel (*Blond Girl, Night Portrait*) and Celia Paul (*Girl in a Striped Nightshirt*). This, for its searching, indeed tender, intimacy, was the painting of her that Celia liked best. After the birth of their son Frank, Freud asked her what she would like. Paints, she said, and he complied lavishly. Another birth: Christabel McEwen (cousin of Katy McEwen), married to Ned Lambton, had a baby—Fred—in February 1985 and within a week Freud painted him, much as he had painted Ned nearly twenty-five years before. He said he would give them the little painting once he had found the right Venetian frame for it but cancelled when, he said, an urgent debt intervened. Predictably, the painting ended up in Ballymena.

Sitters now ranged daily from intimates—progeny included—to people who just happened to be suitably disposed. Ib Boyt sat again, as an adult now, the agreement being that he gave her money for the taxi fare from Islington to Holland Park and she would save by going home by bus. She found the whole process trying: there and back and in between the passive hours she spent at his disposal. She didn't feel then that the paintings were revealing; she liked the attention however. Chris, an Australian, posed for *Naked Woman on a Sofa* (1984–5) and *Night Portrait* (1985–6), oozing dissatisfaction. "I met her early on, in a pub in Chelsea, a girl I liked in every way, but I realised something very depressing and psychological: I could do everything with her and I really liked her company but I could not work with her in the room. I thought, 'I'll try again,' but it didn't work. She was a baby

minder when I went out with her a bit, then she went to Australia (she had some family there), became very religious and married an Australian Jewish neurotic man—she was a kind of mother figure to this man—and she came back and I did the pictures of her."

The sitters varied, naturally, some affecting nonchalance or indifference and others doing their utmost to be complicit. Yet they all became inventions to some degree, made over into the specific qualities of worked paint. There was also the matter of eyes open or closed: conscious or unconscious, or consciously unconscious, or consciously unselfconscious. Janey Longman, who sat for *Naked Girl* (1985–6) and the exquisite *Girl with Closed Eyes* (1986–7), had indirect connections with Freud stretching decades back. "When very young, she took up with Bobby Newton and Natalie Newton's son—full of hates and fears—and she was with Tim Behrens, and with James Fox for a long time. She's certainly vulnerable and she had a pretty bad time, but she's got a very strong character." In *Naked Girl* she burrows into sleep, her head pushing at the pillow, her thin arm shoved under. Where bone tightens the skin the paint was rubbed to a marmoreal sheen.

Woman and dog rest together in the congenial abandonment of the daytime snooze. Susanna Chancellor, a reluctant sitter, shielding her eyes from the skylight, serves as foil to Joshua her whippet, she resigned to holding the pose, he lying as though felled, legs lankily outstretched. The two of them overlap, shrouded flank cushioning curved spine. *Double Portrait* (1985–6) celebrated intimacy: the mottling of the pelt, the pink underbelly where blood-heat is exposed, the fine hairs around the claws and soft dark pads. Gently, snugly, the interconnections of animality and human nature impinge. Two qualities of confidence are asserted: the dog flaked out, the woman, knowing what's needed of her, keeping still. Joshua's forelegs encompass Susanna's arm; the muzzle resting in the palm of her hand exhales the warm breath of animal contentment. Both are conscious of being watched. "She didn't like pictures of herself being in exhibitions," James Kirkman found. Whenever Freud painted her he exercised discretion.

The role of whippet as surrogate, literally underlying, is intimated in *Double Portrait*, an attachment, smouldering at times, that proved enduring. "There was some sort of sense of kindred spirits about

them," Frank Auerbach thought. He remembered "Susanna driving us, Lucian and me, to what turned out to be a very good restaurant near Camden Road station which only opened at eleven o'clock at night and was run by a former croupier whom Lucian had become friendly with. Susanna was at the top of Parkway in her very fast car and simply put her foot down and went like a bullet and Lucian said, 'I've never noticed this before but you're a *really* good driver.'"[4] In *Triple Portrait* (1986–7), she sat guardedly while Joshua and Lily, her slumbering intimates, graced the picture. By their presence they stimulate and reassure. "We are drawn to great work by involuntary chemistry, like a hound getting a scent," he told Robert Hughes. "The dog isn't free, it can't do otherwise, it gets the scent and instinct does the rest."[5]

Given that instinct determines behaviour and—naturally—predominates in every species, Freud liked to think that primal instinct was the vital nudge that brings into play what others might call inspiration. "Only insofar as wearing clothes and sitting, it's still an animal dressed that you are.

"I am so aware of Velázquez's dogs. The dog in *Las Meninas*: a dog may look at a king." He quoted his grandfather on how dogs are "the beauty of an existence complete in itself."

But what about human characteristics such as guilt, maybe, or blame? What price consanguinity and inherited traits? In September 1985 Freud told me that he'd been thinking it might be an idea to paint his brother Stephen. How odd it was that they differed so. "Father bought him this doorknob shop in Marylebone. Not often open: he'd be at golf or in the basement, watching racing. 'What do you do?' he was asked. 'Ironmonger.' And Mother said, 'I wish you wouldn't say that.'" Odder still, earlier on, in the fifties, besides packing books at the publisher Max Parrish, he had been the editor, briefly, of Geoffrey Willans and Ronald Searle's purposefully ill-spelt and scratchily illustrated Molesworth books: farcical chronicles of a Dotheboys Hall for the eleven-plus era.

"I thought it might be interesting to get to know Stephen, whom I hadn't really known since childhood. I used to borrow money from him—he wasn't absolutely sure he'd get it back. Seeing him in the morning at Sagne's, when I took my mother there, I realised I needed money for gambling, loans of £400, £500, never more than one or

two thousand, short term. But he made it so difficult where it should be a pleasure. I gave him post-dated cheques with 25 per cent added. He took the cheques. He deluded himself. He is conventional to the point of eccentricity. *Golf.*

"I got rather intrigued because I was interested in his appearance. To do with my father and odd things, like he forgets to shave under his chin. I saw some old photographs and saw certain resemblances; therefore I was pleased when he said, 'Was it the dentist or the barber you bit?' To make the sittings more attractive I worked from him on his way to work in the morning. He would sit 8 to 10. We went out at night sometimes. I was going with Harriet Vyner at the time and she had an absolute passion for him. We'd go to Annabel's and so on, and Ann his wife came once or twice. She was the daughter of a blind bank manager at Southwold and was the only one of them I ever had Christmas cards from and when I stopped seeing Stephen she wrote a plaintive card. But what is the point of seeing someone when you had nothing to say to them?" Having owned the painting of Kitty (*Girl with Kitten*) for many years Stephen sold it to James Kirkman for £75,000, a tidy profit but a sale that he regretted, he said. Ann added that Kirkman had kindly supplied him with a colour photograph of it to dilute the loss.

In his portrait Stephen appears to have been rudely awoken to a disagreeable world. He said that Lucian had made him look like Lord Goodman and that the picture was prophetic. A second portrait was scrapped when a quarrel blew up. Stephen said that Lucian had lent him money, just the once, to pay an income tax bill. Two thousand, he thought. "A small money matter." And he suddenly, eleven years later, remembered this and wondered if he'd paid it back. As he was looking after their mother's financial affairs at the time he couldn't tell whether cheques to "L. Freud" were to her or Lucian. It was, he maintained, a genuine slip on his part.

Lucian thought differently. "One day at Sagne's Stephen said, 'Could you lend me some money?' £2,000. I said, 'Of course,' and gave him a cheque and forgot about it. And then some years later his wife Ann said, 'Stephen is thinking of returning money.' I was in a really tight spot. So, marvellous, I thought. I waited a week or two. Saw Stephen. 'Oh, Ann tells me you are thinking of paying back the money: it would be extremely useful.' 'Oh hang on: drugs or some-

thing? Oh come on. How much?' 'It's for you to say,' I said. It was a lot for then. A great deal more than I ever borrowed from him. 'Will you check?' I said in a letter. 'Statements will say how much, and I'll be very obliged.' He wrote back and said, 'I've checked the time and I've noticed every sum is identical. I think we'd best forget about it.' I wrote back and said, 'Very well, I will forget, but I'd like to say I'll never lend or give you anything again.'

"By that time my mother was old and ill and she said, 'I'll leave you your pictures in my will.' I discussed this with my brother Stephen and said that tax will eat up the money left from the insurance policy. 'Get these out of the will,' I said, but he didn't do it and didn't do it. 'There'll be no money left for you,' I said, 'and I'll give you a picture.' And then he actually did do it. So I got 'Drumnadrochit,' the drawing of Juliet Moore asleep I got left to Annie, and a little painting of Anna[bel] in bed—I think a bit soppy—I was going to give that to Stephen. But then he did something so horrible I haven't seen him since. Therefore no 'Anna in Bed' for him. I sold it. Then he panicked and sent a cheque for £1,000. So I said, 'Thank you for your cheque: it's not the amount that I lent you but, on your form lines, I think I'm lucky to have got it at all.' Another cheque came, which I tore up. He said, 'D'you think I'm dishonest?' I said, 'I'm not saying that, but you are the prize wanker with a pocketful of red herrings.' 'That was the most insulting letter in my life,' he said. Ann wrote saying he was terribly upset. Then Stephen nearly got me into trouble with Alfie: he mentioned to a friend on the *Mail*, a journalist, about settling bills with pictures and he put it in the paper. I said how absolutely mad. That was the real reason for the row. Serious trouble.

"He's got this nervous twitch and when my mother tried to kill herself he twitched and said: 'As far as I'm concerned she's dead.' I think my mother saw him as first-born and that he was therefore responsible in some way, though only eighteen months older than me. He's very very nervous. Once, walking down the street with me—before the war—when I wore corduroys, he was embarrassed."

Meeting Stephen Freud in the Freud Museum one evening, I asked him whether he knew about the gold that went missing from his father's desk. He shrugged. "I don't blame him for getting it."

"What do I ask of a painting? I ask it to astonish, disturb, seduce, convince"

A retrospective to be shown internationally had been mooted since 1983, initially at the urging of James Kirkman. The British Council's art department took up the idea, which was greeted enthusiastically by Gérard Régnier, then a curator at the Musée d'Art Moderne in the Centre Pompidou, yet it wasn't until September 1985 that his wish to meet Freud was fulfilled when Kirkman took him to the studio. Freud said that he would like him to write a catalogue essay. Régnier (nom de plume Jean Clair) was delighted. But there were further delays. The suggestion that the exhibition might be shown in London was rebuffed by the Director of the Tate, Alan Bowness, who wrote to the organisers: "Though one day clearly a major Tate retrospective for Lucian should be considered, I do not think that time has arrived."[1] Then Dominique Bozo, Director of the Pompidou, decided that the time was not right for him either. Régnier, who did not get on with Bozo, told him that to cancel was reprehensible. Attempts meanwhile to place the exhibition in New York were unsuccessful. The Metropolitan Museum and the Museum of Modern Art declined it on the grounds they were fully programmed to the end of the decade. "Freud's work is not my personal dish of tea but I admire and respect it," said Bill Rubin of MoMA, adding, "nor could there be found any consensus for this project by the museum staff now."[2] Diane Waldman at the Guggenheim gave it the brush-off, remarking witheringly: "the project is a worthwhile endeavour."[3] Only Jim Demetrion of the Hirshhorn Museum in Washington, a noted individualist among

American museum directors at that time, more prepared than most to entertain the idea of exhibitions of non-American or non-canonical origin, was unwaveringly enthusiastic. He bought *Night Portrait* (1985–6) for the collection, confirming his belief in the work.

Corner of Freud's studio

Eventually Bozo found he could, after all, accommodate the exhibition, albeit tucked away at the bottom right-hand corner of the Centre Pompidou, a far from prime position. And Dr. Honisch at the Neue Nationalgalerie in Berlin also took it on, reluctantly, remarking that the showing would coincide with the 750th anniversary of the city.

Ostensibly these negotiations were of no great concern to Freud, but he kept himself incessantly well informed on the phone to Kirkman. And the prospect of this second retrospective stimulated him into pushing ahead ever more determinedly with paintings in hand. He became anxious, I found (the phone calls grew more frequent), to have works in hand—paintings that he thought viable already—looked at with other eyes than his: seen in rehearsal so to speak.

Visits to the studio, morning, afternoon or evening, followed a pattern. Press the "Top Flat" bell push at the front door for a quick-responding buzz and, halfway up the stairs, there would be a rattling of keys as inner and outer baize-lagged doors were opened far above and Lucian stepped out on to the attic landing, usually in painting trousers and with a twitch of a grin. He liked to keep callers separate, for general conversation could be trying and there was nothing to be gained by being outnumbered. One late afternoon in March 1986 was typical. He showed me into the kitchen, enabling someone else to brush past and head downstairs, leaving a whippet sprawled alongside the *Evening Standard* on the studio bed. This time I had come to see a picture he had been engaged with for three years so far, off and on, in the absence of sitters. He was thinking of calling it "Two Japanese Wrestlers," featuring as it did an image torn from a magazine ("Pho-

tograph by that marvellous photographer Robert Capa, 1954, *Life* magazine. Aged colour, fading yellowish sepia, consciously ambiguous") and lodged behind the brass taps in the studio sink—as seen in *After Watteau*—in such a way that the stout little naked men could be thought to be peeing hot and cold.

"Not using a person is very much like taking a deep breath. There is no bad subject."

Besides being a lustrous study of white tiles, grouting, plughole and stains, *Two Japanese Wrestlers by a Sink* (1983–7)—sold by Kirkman to the Art Institute of Chicago—was a play on the convention of interiors-with-figures. Also on the go was the portrait of brother Stephen—then little more than an expression of resentment—and one of a skinny girl jabbing head and arm into a pillow. There had been a disaster the day before, Lucian said. An etching had failed: man flung across the sofa, head too small, spine awry. But another one, a portrait head, had been anointed with stopping-out varnish on the forehead and thereby made good. He went to the plan chest and brought it out: Bruce Bernard, our mutual friend, his face clenched into a characteristic near leer. Another thing: the bursting horsehair sofa had become rather too sensationally decrepit so he had passed it on to Celia. Bella arrived and made coffee: she was due to sit.

A fortnight later I and my wife, Andrea Rose of the British Council who was the exhibition's curator, went to the studio one evening for champagne before dinner. We sat in the residually Biedermeyer front room where white lilies in a white enamel jug were posed opposite Mike Andrews' lone balloon shadow staining the beach. Preparations for the show were now well advanced. But David Beaufort (the former David Somerset and since 1984 Duke of Beaufort) had told him, speaking less as an owner than as a director of the Marlborough, that he couldn't, or wouldn't, lend *Buttercups* (the jug of wildflowers in the Gloucester Terrace sink) because Lucian had refused to lend his Bacon, "The Buggers," to the Tate the year before. The deadline for loans to Washington was approaching. Consequently the most recent painting there would be the bare-shouldered *Reflection (Self-Portrait)*. Others surely, he said, could be added at the Hayward, which was where, staged by the Arts Council, the exhibition was now to have its London showing, given that the Tate and Royal Academy were unavailable. That was where he would be seeing it. Not in Paris

and certainly not in Berlin where the tour would end. These days, he stressed, he had no inclination to travel or to mingle. His seclusion, he added, was privacy, quoting Philip Larkin: "It's not people I dislike, it's company." He brought out *Double Portrait* (Susanna and Joshua the whippet) and the beginnings of a large painting of Celia Paul and Angus Cook posed together as painter and model. It grew dark and the scent of the white lilies thickened the air. He turned to Andrea and fell to talking about love. "When you fall in love with somebody you show heightened interest in them and in everything about them. For most people that's what happens. But for an artist—for me—that heightened interest is a continuous and sustained interest, and that is what my art is about."

We went off to dinner. I drove. He, in his immaculate grey flannel suit, twitched beside me all the way, giving directions to Mark's Club off Berkeley Square. Celia joined us there. She seemed silenced. Sitting with her beneath the ornately framed Victorian hunting scenes that set the tone of the decor, he touched her leg and she reached for his arm, peeking sidelong at him as he talked. The female part of him, he said, looking down the menu, saw that women seek to get men to themselves. "Married: a whole future." He ordered a lobster. "Celia reads Dickens," he said. "*Our Mutual Friend*," he added. "*Little Dorrit*," she said. Talking about Mike Andrews and the narrow difference between a good and a bad painting, he argued that where his balloon shadow on the beach was faultless his big new paintings of Ayers Rock, soon to be shown at d'Offay, were ("Wouldn't you agree?") very *nearly* bad. "There are no bad *subjects*. (Not even Dalí-type ones are really bad.)" His grandfather once said there were two elements of happiness: "to love and to work." His own remark, "A happy life doesn't have art in it," had been misquoted by the "horrible" Dan Farson as: "You can't lead a happy life if there's no art in it."

"It's not reason that affects my decisions but impulse. Intentions have no place when a person looks at a finished thing."

Anxiety kept him awake at night, he said.

Bill Coldstream was ill in hospital. "When Frank and I saw him we opened the door and went in and he said, 'Oh my God.' He had a pretty dashing way with him. 'I never really forgave Stephen [Spender],' Bill told me. 'I painted Inez [then married to Stephen Spender], and I made such an effort not to make up to her, and Stephen said, years

after, 'Did you go with her?' in a friendly way, as if he expected it. If only I'd known.' " Coldstream died in February 1987.

The Hirshhorn sent a cardboard-box model of their galleries to London together with thumbnail images of the exhibits, the assumption being that Freud would be interested in the hang. But apart from checking on loans he stayed clear. (Jocelyn Stevens, Rector of the Royal College, refused to lend the portrait of Johnny Minton, explaining that the tempera was flaking; Freud, incensed, pointed out that it was an oil painting. The loan was then agreed.) He wanted low lighting. And having dismissed Jean Clair's catalogue essay as woefully abstruse, he agreed that Robert Hughes, the flamboyantly no-nonsense *Time* magazine critic, should be commissioned instead.

An even more immediate concern in the summer of 1986 was the need to find a reliable printer. In May Marc Balakjian, who with his wife Dorothea Wight ran Studio Prints in Kentish Town, had a phone call followed shortly afterwards by clamour on the doorbell. There on the step stood Freud with an etching plate wrapped in white cloth: *Man Posing*, half editioned already by the Palm Tree Press. Would he—he'd been recommended by Celia Paul—take it on? Of course he would. Freud's requirements were Balakjian's opportunity to extend his skills and ambitions. Freud found him prepared to experiment while giving him the benefit of experience. "When I first went to Marc Balakjian, Frank said there were some plates of his that he left in all night. 'Couldn't we do that?' I asked. 'Look, you stick to the way we're biting,' he said." The consistent quality of the proofs he produced, every seemingly casual wipe enriching line and enhancing tone, convinced Freud that here was a resourceful craftsman who could see his efforts through whatever the scale of the etching or the complications involved. Having coped with the sweeping textures of sofa and floorboards presented in *Man Posing* he operated skilfully on *Head of a Man* (Angus Cook) animated with a variety of marks largely achieved by lavish stopping out (that is, varnish applied to prevent further bite when the plate is dunked in the acid bath). From then onwards etchings complemented paintings, once or twice anticipating them, and proved a ready and fairly reliable source of income. The strain of anticipating the unforeseeable in an etching was also

the kick of the hazard and the tension of letting someone else get on with it. "So dependent on the printer (Marc). He's really good but there's a certain amount of 'look no hands' about it: I'm in a state but the etching isn't."

Drastic amendments came to be viable, thanks to the Balakjian touch. *Pluto* (1988), for example, was originally a double portrait, Susanna and whippet, but Susanna's face became so heavily worked it looked threatening and—Frank Auerbach's suggestion—the plate was cut down leaving Pluto sleeping backed by Susanna's lower body, an arm and a leg. To chop appealed to Freud: irreversible editing enabling the choice bit to flourish. And with practice he learnt what worked. "First I was doing drawings on the copper really, but they are more related now," he told me in 1990. Balakjian could be counted on to ameliorate, sometimes miraculously so. Freud acknowledged this. "When I've finished I take it to him and then bring the scratched plate home and then bring it back to him. It needs things like scratching out, touching out, then dip it in an acid bath for—it depends— anything up to one and three-quarter hours, the difference between giving someone breakfast and giving them a five-course meal. Then quite often, at the etchers, I do a certain amount of drypoint: scratch actually into the copper."

He wore his glasses when working on a plate, as he did when scanning the small print of racing pages in newspapers. Not for painting. "It's focus. I can't see very close to and have to draw in a way I draw in charcoal on canvas."

Bacon's second Tate retrospective, held in the summer of 1985, was introduced by Alan Bowness, the Director, with a gush of superlatives. "His own work sets the standard for our time, for he is surely the greatest living painter; no artist in our century has presented the human predicament with such insight and feeling."[4] Bacon granted interviews, signed catalogues and allowed himself to be caught unawares by photographers, pausing with shopping bags on the doorstep at Reece Mews and strap-hanging on the tube like any ordinary Londoner.

All this had the effect of strengthening Freud's feeling that he had done the right thing in refusing to lend *Two Figures* (aka "The Buggers") despite appeals from the Tate. "For the first twenty years I had it it was travelling round the world; it came back from one of the

tours hanging out of the frame so I said to Francis, 'Would you mind my not lending it any more? I'm really rather worried.' He said, 'I understand. I've got a show at the Grand Palais, please lend and never again after that.' So when I was asked, and threatened, by one of the bogus roughs of his at the Tate I didn't lend as I took him at his word. If *Francis* had asked I'd have lent it," he added. "And then Frank said, 'There's no exhibition without a missing masterpiece.'"

The retrospective transferred to Stuttgart in the autumn of 1985 and, coincidentally, Bacon's selection of his favourite National Gallery paintings went on show at the National Gallery as his contribution to a series called "The Artist's Eye." David Sylvester exercised himself over the choices and supervised the hang. Velázquez's *Rokeby Venus* went next to a Degas pastel of a woman sponging her back and Van Gogh's chair was placed beside Michelangelo's *The Entombment*.

Freud thought the selection perfunctory, based more on great names than on great paintings and, in the case of *The Entombment*, a misguided reverence. "It made no sense; it's not by him."

By contrast, two years later, when it was his turn to be the "Eye," he treated the project as a test of loyalties and acumen. Much of his shortlist seemed obvious to him: the autumnal melancholia of Constable's *Cenotaph*, the flawless pomp of Ingres' *Madame Moitessier* and the painterly attack of Cézanne's *The Painter's Father*. But selection also involved rejection; his haul would have to be both striking and telling. As he said more than once, a good museum had to be didactic. "I mean: I go to the National Gallery like going to see the doctor."

For the catalogue cover he drew, on heavy grey Japanese paper, a detail from Turner's *Sun Rising through Vapour*: a catch of skate and sole exquisitely strewn across a foreshore and about to be gutted. He talked about the "ambiguity" of Turner's figures: "people having such a good time in red caps. Turner can't draw his people. They are studied nothings. His fish though are wonderful."

As it happened Freud's catch matched Bacon's in one or two places. *Bathers at Asnières* was prominent again and the *Rokeby Venus*, which he hung between Rubens' *Samson and Delilah* and Degas' *Young Spartans*. It made for a fine array of body types: the dimpling softness of Venus beside Samson's opulent muscularity, the taunting Spartan adolescents and Seurat's bathers airing their monumental pallor. In the course of many phone calls, twice daily or more as the pressure

to edit his choices became urgent, he kept telling me how surprised he was at the way things were panning out. Daumier's *Don Quixote*, Degas' *Hélène Rouart* and Monet's *The Beach at Trouville* redirected him from what he had initially supposed. "Most of the paintings in the National Gallery are Italian and I was made more conscious of the fact that they weren't the things that I felt were essential to me. I think it's the openness that puts me off. The 'Renaissance Spirit.' I love Michelangelo—the sculpture and drawings—but it seems to me that the *paintings* are marvellous exercises in 'How to Do the Best Painting in the World.'"

He responded mainly to paintings of people. Individual rather than iconic people redolent of their times yet not stuck in them. Apart from the small Rembrandt *Deposition* he avoided the non-secular. No Piero della Francesca. ("I always prided myself on loathing Piero: paintings rhymed.") And very much not Sargent. ("In a great many Sargents, he draws your attention to something that doesn't necessarily tell you any more.") But, yes, Whistler's *Miss Cicely Alexander*, ethereally unsure of herself, and for sheer, wanton, drawing-room-charade quality Vuillard's *Madame Wormser and her Children*, a choice questioned by the Director Neil MacGregor who, Freud remarked, didn't appreciate the attractions of tea gown, bare knees and parquet.

The frequency of the phone calls peaked when it came to placing Chardin's *The Young Schoolmistress*, a particular favourite, between two six-footer Constables. Maybe this was too pushy a contrast. Or were all three not quite up to it, really? "I was made more conscious of the fact that they weren't things that I felt were essential." He had surprised himself, he acknowledged, by going a bundle on Rembrandts. "Seven Rembrandts on one wall in natural light. They had to be included."

Besides being asked to add *Double Portrait* and *The Painter's Brother Stephen* as necessary credentials, Freud was expected to contribute a statement underwriting his rationale, if any. Insisting that it be inserted inconspicuously, halfway through the catalogue, he laboured away at what little he felt should be said and kept checking it with me over the phone. Adjectives were excised.

I have been asked to give the reason for my choice of paintings. The paintings themselves are the reasons. Just as the language of art

is silent, so it is the beauty of a painting that renders the spectator speechless. The uneasy silence of a man faced by a work of art is unlike any other.

What do I ask of a painting? I ask it to astonish, disturb, seduce, convince. One quality these paintings share is that they all make me want to go back to work.

Back to work. The roster of sitters was headed for a while in the late eighties by Angus Cook and Cerith Wyn Evans, younger-generation males whose social activities intrigued Freud. Cook, a writer, knew Celia Paul and Rose Boyt, and as *Man Posing*, he presented himself much as Rose had done seven years earlier: same sofa, similar sprawl, though in his case no sense of defiance or abandon. His companion Cerith Wyn Evans struck Freud as more the chancer. He had been an assistant to the filmmaker Derek Jarman and in 1986 made a short film featuring Freud, momentarily, as Louis XIV in a grand wig. "Cerith was lent facilities at the Royal College Film School some afternoons and in a few hours it was done," Freud explained. "In the film I'm laughing, an amazing sound. He called it *Look at Me*, but

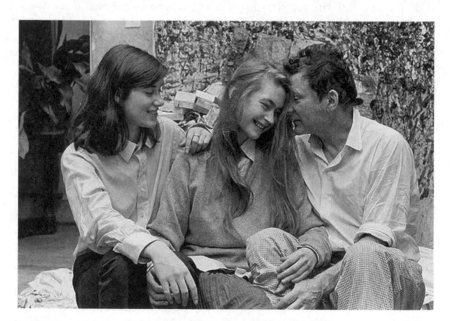

Bella Freud, Celia Paul and Lucian Freud

he got sponsors and they called it *Degrees of Blindness*. He got a blind footballer from the Blind School, an eleven-year-old boy. Went to his parents to get him. Very, very clever, getting the boy to be in it.

"Cerith," he noted, "wears £400 trousers."

Such trousers featured in *Two Men* (1987–8): Angus and Cerith, lying facedown and faceup, respectively, Angus naked, one leg flexed on the bedding as though scaling a tilted floor, and Cerith, wearing the trousers, dreamily complacent, Freud suspected. "When I started working from Cerith I was pleased because it went rather fast. I did this very queeny head and I thought I'd got him; but as I got to know him I realised that was the very least of it, a superficial thing, which I mistook as being an innate side. So I didn't use it.

"When you are working from someone, things like that go through your head. I'm suspicious of them going too well but that's because I think of the time element as helping me." Cook said that sometimes during the sessions Freud came close and fondled bone and muscle.[5] Getting the feel of the sitter was a reflex, much the same as being a trainer in a racing stable running a hand idly over brisket and withers.

Angus and Cerith, Celia Paul, Sophie de Stempel, Susanna Chancellor, Bella and Esther were recurrent sitters, and (featuring for the first time) Susie, the youngest Boyt daughter. Also, through James Kirkman and essentially as a commission, there was a portrait of Simon Sainsbury, businessman, collector and member of the supermarket family who were paying for the Sainsbury Wing at the National Gallery, then under construction. Given to anonymous philanthropy, widespread and varied, Sainsbury of the Monument Trust is presented as a diffident melancholic. *Red Haired Man with Glasses* (1987–8) was, Freud saw, self-effacing and resignedly so. "Caught," he said, "in his unhappy role."

Gossipy Michael Tree sat for two portraits. The first was abandoned in 1985 as little more than a mask of amiable character. The second, *Man Smoking* (1986–7), made features of his striped shirt, his stripy hair brushed back across baldness, the pipe jutting at an angle from the corner of his mouth and white smoke rising like an anecdotal speech pattern. "He was sort of sporting in an Edwardian way, painted, drew, golfed and a snob, as well as being a valuer at Christie's. Went to Dr. Hoffer. He looked very vaguely like my father. Perhaps

that's why I painted him." He had done amateurish pen-and-ink studies for the illustrated edition of John Betjeman's *Summoned by Bells*. Freud liked him and quoted him. For example, his thumbnail dismissal of an unnamed Cork Street dealer: "He's like someone who's being buggered by his bank manager, and rather pleased to be."

Painting Celia Paul was a more intimate concern. She herself was driven. "There is pathos in the feeling that maximum life is being bought at the expense of lovely rendering," Freud said of her devotion to painting which, initially, owed much to his example. "She homed in on art and gave her life to it," her mother said. "She is obsessed by it."

"I must try to find a straight way of painting the mysterious," Celia told me when still, determinedly, eradicating all trace of Freud's influence upon her. "I wanted to get away from a sort of dull English duty, like having to finish all the food on your plate."[6]

Ahead of the Hirshhorn show, *Architectural Digest* published an "artist's dialogue" in which I didn't so much engage in dialogue with Freud as talk around him, describing the painting that had been preoccupying him. "A young man reclines on a bed in a place barely indicated. A young woman, painting him, faces the bed. There is as yet no tension, no completeness."[7]

For *Painter and Model* (1985–7) Celia Paul was posed as if considering painting Angus Cook and, lost in thought, stepping with premeditation on a squelching tube of terre verte. That this lies underfoot, planted together with four brushes and other paints like the makings of an offering on the otherwise spotless studio floor, prompts speculation. "When I paint I wipe my brushes on my dress and Lucian was keen to paint me in this strange outfit," Celia explained. "I had also been drawing my friend Angus Cook, so Lucian thought of painting us together. There are plenty of clues in the picture: the bare foot standing on the paint tube and the angled brush and the sort of unusual role reversals male and female: I think it's about power and desire."[8] It was also about rearrangement.

Freud baulked at such implications. "There was the easel there in the initial plan. I realised it would work better without: too many verticals. The easel made the fact she's stepping on the tube unnecessary. A painter's someone with a brush . . . how nice. It's set up, unlike 'she's doing a job.'" He wanted there to be an air of expectancy maybe and nothing doing. "What had a strong effect was a Van Gogh I saw

at Wildenstein [in the late fifties] of a person at a loom. Just because I could get so fascinated with something as boring as weaving it opened my eyes to something: the fact one could read something exciting added to the quality of the picture. It was enlightening, being told about the whole quiet activity. It's fine to do simple time-consuming things. I like ironing. Everyone does. [This from someone who had rarely, if ever, used an ironing board.] I just thought how extraordinary to be so affected by something so boring. The balance there." He had been reading the writings of Duchamp and was taken with the thought of not adding unnecessarily to the excess of art in the world. A painting of a painter meditating on the act of painting: unrealised art represented by the bedaubed practitioner. "It isn't possible to detach oneself from one's aesthetic sense. But," he added, "it would be wonderful if you could do."

"Lucian was very aware of the fact that Celia wanted to paint and actually went out of his way to encourage her," Auerbach commented. "That elaborate and, to me, not entirely successful picture of her and Angus and she stepping on the colours was partly done, I think, in order to make her feel better."[9] Certainly he was concerned to keep his two sitters to hand for as long as he needed. The painting was completed in the autumn of 1987. And that proved to be the end of the intimacy.

"I officially split up with LF in February 1988 (when I was twenty-eight!)," Celia said. "But obviously the relationship carried on for the rest of his life (and beyond) because of Frank and Love and Art," she wrote. Her Frank—Frank Paul—was then three.[10]

"Lucian Freud Paintings" had been worked on for a number of years—such shows taking considerable time to put together—primarily by James Kirkman and Andrea Rose of the British Council's art department, and had developed into a good-size retrospective. It opened at the Hirshhorn in Washington DC on 13 September 1987. The American press release stressed that, if not in New York then further afield, the artist was celebrated. "Although perhaps not as widely known as his friend Francis Bacon, Freud has gained a strong international following."[11] Among sympathetic critics the obvious conclusion to be drawn was that the Hirshhorn had scored where all other leading art institutions had not only missed out but had shown wilful disregard. Andrea Rose had met with rejection after rejection while

attempting to place the show, each museum saying in effect that the idea of a Freud exhibition just wouldn't have occurred to them and therefore couldn't be entertained as a possibility let alone a scheduled priority. "Are the curators there blind?" asked Paul Richard in the *Washington Post*. "No Englishman has shown us human beings so well as Lucian Freud."[12] Alex Katz, Pearlstein and David Salle, he wrote, "seem effortlessly demolished the way a swinging wrecking ball destroys sheets of plasterboard." Jack Flam in the *Wall Street Journal* talked of "one of the most accomplished painters alive, precisely in the way he handles paint."[13] Robert Taylor of the *Boston Globe* went even further: "A show that restores one's faith in the power of figure painting."[14]

Robert Hughes' characteristically forceful catalogue essay ended with the tag line "the greatest living realist painter,"[15] which was to be much quoted, and it was seconded by John Russell in the *New York Times*: "A glorious risk" had been taken by the Hirshhorn. Freud was, he said, "the only living realist painter and the one who has given back to realism an element of risk and revelation that had long been forfeited."[16] Even by Russell's standards—he was renowned for his genial way with words—this was a resounding call for day trips to Washington from a New York art world attuned to dogmatic formalism and fad on fad. "The dimensions of the known are redefined, until we come out of the show feeling that we can never again look at another human being in quite the same way.[17]

"Anybody who cares about painting would have to be crazy to miss it."[18]

The launch of the exhibition at the Centre Pompidou, in a set of rooms looking out on an immobile Tinguely fountain, was dispiriting. Andrea Rose reported the opening to the relevant British Council committee as "a very poor show of officials and bureaucrats huddled around a tray of sandwiches."[19] Attendances were relatively sparse by Pompidou standards. Where in Washington nearly 150,000 people had seen the exhibition in ten weeks, in Paris over five weeks (Christmas included) there were 46,000 only, despite which Jean de Loisy of the Ministry of Culture deemed it "a critical failure, a great public success."[20] The critics were mostly disposed to stress Freud's, to them, unpleasing body count. Hervé Gauville of *Libération* thought the exhibition "one of the most testing experiences painting can offer

today" and talked of "des peaux blanchâtres, des veines bleutées, des chairs translucides et gonflées." Philippe Dagen in *Le Monde*, under a mocking headline ("Le Pompier de la Couperose"), described Freud as "un dandy tragique," adding that after seeing the paintings he felt he needed to have a Turkish bath, a dismissal that Freud took to be visceral. "I find that," he said, *"really* stimulating."

The critic John Berger, by then living a rural life in the Haute Savoie, got in touch, rather to Freud's surprise. "He wrote about the pictures of my mother and sent me this thing about his mother. I wrote back—I've never minded him—I said—'unmanned (for a moment) with noble emotion'—I *am* the Bellman and 'This amply repays all the wearisome days / We have spent on the billowy ocean.'"

"My world is fairly floorboardish"

The British Council/Hirshhorn exhibition arrived at the Hayward in February 1988 enlarged by seventeen paintings and a few drawings and ending with newly completed work, most prominently *Painter and Model*. Unlike in 1974 when Edvard Munch had been the prime attraction, Freud being then something of an oddity, now Roger Fenton's photographs of treeless Crimean War battlefields and bosky English landscapes filled one half of the lower galleries. Little competition there, so Lucian was better placed to make demands. He wanted gauze on the windows of the partially day-lit upper galleries to diffuse glare and screen out the London skyline. This they allowed him, but not the lining paper that, he suggested, could tone down the walls throughout. Frank Auerbach came in to help with the hang, relieving him of the "hopeless fatigue" that he said he felt when faced with the task of sorting paintings and drawings into sequences. Having put together a roomful of naked portraits—creating thereby what he referred to as a Turkish bath—they decided that it would be good to interpose *Buttercups* between bodies. "Parsley with the pork," Lucian explained as he went round with Jane Willoughby and me. He flinched at *Sleeping Nude* (1950), not having seen it for nearly forty years. Back then he'd been pleased, he said, with the sense of space he'd achieved between the dark of the fireplace and pallid Zoe Hicks, but now . . . well, it looked too composed. And he disliked Harry Diamond's NHS wire-framed specs in the 1958 *Man in a Mackintosh*. They looked unfitting, he said. Like felt-tip defacement. The little

paintings on copper, such as the Tate's head of Bacon, held up well. And how big the pictures of Kitty had once seemed, whereas now . . . No, his mother wouldn't be coming: too infirm at ninety-three. They had arranged the paintings of her in chronological order, which meant starting with the smallest. He told me he was reminded of the packets of postage stamps that he used to send off for in Berlin days.

On the Saturday before the opening there was a celebratory dinner at Green's Oyster Bar in Duke Street, St. James's. As we sat down Lucian slipped me a photograph of a painting of Susanna and her whippets sprawled on a green and white striped mattress, the implication being that this, given its keepsake size, was more immediately his concern than the taxing business of setting up the retrospective. It struck me later that its rumpled intimacy was a declared contrast to the chill detailing of *Girl with a White Dog* an age ago: again the mattress but this time a sense of ease. A further dinner, involving lenders and others, was staged the following Tuesday at James Kirkman's house in Brompton Square. Having avoided the preceding private view the artist arrived late and picked his way among the circular tables with the intention, as he repeatedly said, of not staying to eat. Yet he did, settling down circumspectly as though the idea of doing so had only just occurred to him.

The previous day Jake Auerbach had filmed, for the BBC's Sunday tea-time programme *Review*, his father and Lucian checking the installation, moving from room to room, Frank taking the lead, Lucian listening closely. I had been brought in to interview Lucian ("makes his TV debut," the programme notes boasted) and provide commentary. ("He has taken the immemorial tradition of painting and has extended it. That's his great achievement.")[1] Was he concerned at all, we asked, about reactions to the exhibition? Lucian responded with a shrug. "There are very few people where what they would think would count for me." The *Review* editor proposed stretching this footage to make a half-hour special but Lucian himself suggested that another interview altogether would be preferable; this was done and Jake edited it into a forty-five-minute *Omnibus* programme.

Squeamish in the presence of the camera, he responded cautiously to Jake's prompts, lowering his voice to near inaudibility towards the end of each reply. "I'm self-questioning, but only up to a point. It's to

do with days going by. I never think about technique: it holds you up. It clogs you up."

The hesitancy quickened a little once the sitter began to sense himself being listened to. "I think many people are astonished that people would sacrifice a possibility of comfort and what's thought to be an agreeable life to a life of uncertainty and loneliness." Prompted, he cited Charles Laughton in Korda's *Rembrandt* and Tony Hancock in *The Rebel* as his favourite cinematic impersonations of artists' lives, adding that Laughton in *Rembrandt* was too conscious of being Laughton. As for the experience of encountering so many of his paintings again, he said that he felt conscious of his privacy being paraded. "I feel fairly demoralised at the whole thing," he said. "I think of all the trouble they've given me over many years and now brought out. Unlike fifteen years ago, when it was just a matter of arranging them. It's a kind of elation, and more than that. It's a kind of indulgence. But then indulgence is perhaps a kind of elation.

"It's to do with hope and memory and sensuality and involvement really."

Asked about doing self-portraits he ventured a smile. "It's very tempting because of your permanent availability, but I do start more self-portraits and destroy more than any other picture because in my case they tend to go wrong so very very often and I haven't found a way of doing them. Not that I've found a way of doing anything . . ." His eyes twitched and refocused, seeking exits. "I think," he resumed, "upon seeing their work people make certain assumptions about their [artists'] lives. They don't realise it's a life of self-discipline. People assume the art that is produced comes out by mistake as a kind of by-product of this anarchic, idyllic, undisciplined way of life. I've never heard of anyone working like this."

There was then the question of the function of the studio and the use of beyond: a boundless outside world. "I think that if you had a landscape of your own in the way you have a room of your own you could then people it at your discretion. I'm perfectly happy working behind closed doors. You can't know a place well enough. There's something very suspect about a new place even if you don't think of it when you move. Having to break in a new place." He paused. "The door and windows and ceiling and skirting: they are all things to be considered. They're waiting there . . . should you need them.

"I try to keep as calm as I can always."

The film came close to being little more than a muttered soliloquy. "I was sort of concentrating on the serious and poignant at the expense of the fun and humour," Jake Auerbach explained. "I don't regret not cutting him down: I like seeing him think."[2]

The Times television reviewer was unmoved. Freud on TV was, William Holmes wrote, "a man whose pictures look at the human form with an unflinching gaze, without a trace of sentimentality, being rather banal and sentimental about the process of creating those pictures. His only assertiveness was in his silence."[3] Freud, deeming himself "fairly immune from praise and abuse" but at the same time disturbed by encountering himself on screen as what he could only regard as "a stammering foreigner," had put the film behind him by the time it was transmitted the following May. By then he knew that the exhibition had attracted the Hayward's third biggest attendance to date, after Dalí and Picasso. Reviews were positive, mostly, though for some every picture still spelt misery. In *Time Out*, the listings magazine, Sarah Kent talked of Freud's "bleak vision" casting "a deadening pall of anxiety over everything he portrays." She exercised her imagination on the settings shown: "Paint peels off stucco walls, taps leek [sic], the stuffing emerges from ageing armchairs, flesh appears mouldy and putrid, breasts droop, stomachs sag and hands are withered with age or deformed by arthritis. The nudes are not models posing so much as bodies that lie prone, sapped of all energy and willpower. Legs are often splayed to expose the genitals in a dog-like gesture of total submission—for these paintings seem more a statement of mastery than of love or desire."[4]

Bacon took a look too and went round with Dan Farson, telling him, not for the first time, that the paintings were "*realistic* without being real," adding: "everything Lucian does is so careful."[5] Freud responded (to me) by saying of the most recent Bacons: "They looked as if someone who didn't understand his work had tried to do them."[6]

When *Children's Playground* from 1975 sold at Sotheby's the previous year for £58,000 there had been talk of a "more realistic balance" being set between Freud's prices and Bacon's. That rankled with both.[7] By then the differences between the two were irreconcilable, as Mike Andrews tacitly acknowledged when I invited him to name for the *Observer* the painters he most admired and he tried

even-handedness. "To Bacon we owe an enormous debt, which is that he regenerated the realism of palpable presence, that sense of someone being in the room with you, that you can touch or feel them." Freud on the other hand, he added, was more sympathetic. "I can think of no other contemporary painter capable of conveying such a tragic sense of mortality. As a result of the Hayward retrospective, the pictures, particularly the late ones, have become so poignantly intimate that the fact of being mortal seems tragic. I owe a great deal to both of them."[8]

In May 1988 the South Bank Board (successor to the Arts Council in organising touring shows) arranged "Lucian Freud: Works on Paper," comprising almost all the prints to date and sixty or so drawings, some of which had been in the Hayward retrospective. The exhibition was toured to Oxford, Edinburgh, Hull, Liverpool and Exeter, then to the Palace of the Legion of Honour in San Francisco, to Minneapolis, to St. Louis and to one commercial gallery, Brook Alexander in New York, where, James Kirkman reported, people queued round the block. Meanwhile the British Council exhibition went to Berlin. Freud particularly wanted it taken there rather than anywhere else in Germany. After the war Gabriel Ullstein, his childhood neighbour, had been back there and found that of all the buildings in Regentenstrasse only the modernist Shell-Haus had survived. The rest was a wasteground occupied by lethargic rabbits. Now, forty years later, on Matthäikirchstrasse, just west of the Berlin Wall, there stood Mies van der Rohe's Neue Nationalgalerie, that landmark glass box and basement beneath which, it could be supposed, lay buried the site of young Lux Freud's long-jump pit.

The Neue Nationalgalerie was reluctant to take the retrospective—Freud, Professor Dieter Honisch the Director pointed out, was not known in Germany—and nobody from the gallery went to see it in Paris or London, let alone Washington. Although partition walls were eventually built in the basement Grafikgalerie and further galleries were given over to it, a number of paintings, among them *Sleeping Nude*, *Buttercups*, *A Filly* and *Factory in North London*, were withdrawn for want of space. To the evident surprise of Director Honisch and his staff there was an attendance of around 38,000 in the first three weeks and the catalogue sold out.

During the morning of Friday 27 May installation photographs

were taken for the Neue Nationalgalerie archives. Then, during the afternoon, the 1952 Bacon portrait, lent by the Tate, went missing. It emerged that seven of the guards had called in sick and nine were on holiday, and that instead of the requisite three guards only one— a cloakroom attendant—had been posted in the part of the gallery where the painting hung. That guard, from the security firm Berolina, spotted a gap beside the label at the same time as one of the visitors, another of whom had noticed that gap shortly after midday, two hours earlier. Dr. Honisch ordered the main doors of the gallery closed and the police arrived shortly afterwards to check the identities of a hundred visitors detained in the building and set a search going. The thief would have found the security screws on that conveniently pocketable painting—the smallest there—not too tricky to dislodge provided he or she was left undisturbed. The walls of the "graphic area" of the gallery, where the painting had hung, were not covered by the proximity alarm system.

The Tate had set indemnity (risk covered by the Treasury) at £75,000. After the loss a more sensible estimate was £1.4 million. Not that compensation came into it. This being the iconic Freud of the iconic Bacon it was grand theft, devastatingly so, and the almost immediate decision from the British Council, acting for the artist and the two prime lenders, was to insist on closing down the exhibition a week before it was due to end. Reaction from the Neue Nationalgalerie was plaintive, defensive and abject. On further inspection one of the screws on *Interior with Hand Mirror* (not quite so small or covetable as the stolen picture) was found to be missing. A reward of 25,000 deutschmarks was offered for information leading to recovery and the installation of some reassuringly heavyweight works by Richard Serra went ahead in another part of the building. As for Freud, he could only think that the theft was the culminating slight upon him in what had once been his very own part of Berlin. "Lucian called me in a state of botheration," said Robert Hughes who, having described the painting in his catalogue essay as "that smooth pallid pear of a face like a hand grenade on the point of detonation," had lobbed it into play as, he asserted, "one of the key images of modernity." The phone call had ended with him remarking that at least there was someone out there who was really fanatical about his work. To which Lucian, he said, replied: "Oh, d'you think so? I don't think whoever it was

took it because he liked me. Not a bit of it. He must have been crazy about Francis. That would have justified the risk."[9] This he repeated to me. I told him I thought that the postcard size of the painting must have made it all the more tempting. Assuming that the theft had been unplanned, indeed opportunistic, the police recommended maximum publicity, yet the incident was reported with little comment on local television and in some newspapers. Were any attempt to be made to take it through customs or East–West border controls, they said, the copper plate would show up on scanners. They looked into the theft diligently until, some months later, the Neue Nationalgalerie urged them to desist. Theories abounded. Wolfgang Fischer, formerly of the Marlborough, for example, had a meeting with Professor Honisch on the Saturday after the theft and told him that he should look into the psychology of the affair, given that Freud wasn't well known locally. It also struck him that Freud might consider offering the Tate a work in lieu.[10]

That suggestion went no further and when Lucian poured con-solatory champagne a few days afterwards for Andrea Rose and me he recited "Our Albert," Stanley Holloway's monologue relating the righteous indignation of Mr. and Mrs. Ramsbottom when—their lit-tle Albert having been eaten by a lion—the magistrate said he hoped they'd "have further sons to their name":

> *At that Mother got proper blazing,*
> *And "Thank you, sir, kindly," said she.*
> *"What, waste all our lives raising children*
> *To feed ruddy Lions? Not me!"*[11]

He felt the same, he said. Recriminations were futile and he was pretty certain that the picture would be returned. However, there was no trail to follow and no ransom demand came. He brought out his head of Simon Sainsbury, small and hapless-looking in itself yet, he pointed out, three times bigger than the missing picture. He then said, pointedly casual, that the Keeper of the Queen's Pictures had asked if he'd like to paint the Queen. Another modest-size picture it should be, he'd thought; but whatever the size there was the question of how many sittings. And where she might sit. Ideally she would come to him . . . Naturally it helped, he conceded, that he knew her

Private Secretary, Robert Fellowes ("I've seen him dancing around in Annabel's. A great friend of Jacquetta's brother"), and had been able to discuss these matters with him.

"I said, 'I live very high up.' 'That wouldn't be a difficulty.' 'I mind about my privacy; I wouldn't want attention to arise.' 'I think we can manage that.' 'But I don't want the sittings to be limited.' He said, 'I don't think we can do that.'"

So that was that, he added with a shrug. For the time being anyway. Meanwhile—that afternoon, in fact—he had been at the Fine Art Society in Bond Street, hanging young Christopher Bramham's paintings. Someone he'd been keeping an eye on for quite a while, he reminded me. He had real promise, he felt, and so he had alerted dealers and collectors about him. This was to be his first one-man show.

"Lucian's help with galleries was fantastic," Chris Bramham acknowledged. "Of course they would see my stuff: it is all about confidence. At the time I was very timid about my work and it is only looking back, at the evidence, that I can see how much he believed I could do something. I learnt so much from him. 'Don't put the big one in the centre like a queen bee,' etc."[12]

[23 April 1988 postmark]
Dear Chris Alfie is sending All the paintings to the fine Arts today or tomorrow. So they should be there Monday or Tuesday. Could we do the Selecting next Friday (the 29) at 5pm? Let me know if this is O.K. and I'll meet you at the F.A. Go to the early Cezannes. Lucian

"Cézanne: The Early Years" on the top floor of the Royal Academy was, said Lucian that Saturday evening as we left, the best exhibition he'd seen in ages; he had already been fourteen times, out of hours. Where Lawrence Gowing (whose selection it was) talked of Cézanne's "ribald delight in scabrous, sprawling indulgence"[13] in those, his often disregarded formative years, he, Lucian, saw not ribaldry but the doggedness of the venturesome artist doing his best to make substantial pictures. Such as *Scipion* (*Le Nègre Scipion* from the Museu de Arte, São Paulo), that hefty life model pressed into a great white bale of unyielding material. The density of the picture, its slumped look, sacrificial almost, particularly affected him in that

it had come to London just as his preoccupation with the big night painting of Sophie de Stempel, *Standing by the Rags* (1988–9), was ending. Besides which a depiction of the latter (an image of the image) featured in the current day painting, *Two Men in the Studio* (1987–90), for which he had stood a naked Angus Cook—no Scipio he—on the bed braced against the roof beam under the skylight through which, eventually, all the bigger completed paintings, such as these, had to be manhandled out into the world.

"Just try and make the pictures look believable," was a precept to be dandled and followed through for here, protruding from under the far side of the bed, lay the sleeping head of Cerith Wyn Evans, his face tinged with Prussian blue to tone in with the floorboards, his role that of the lurking understudy with *Standing by the Rags* positioned behind him as though dreamt up right there. As Wyn Evans said: "The painting becomes the only thing that is left and the real reason why you are doing it."[14]

"The following (like a cartoon character's thought-bubble) is based on things which came into my head while modelling for Lucian Freud," wrote Angus Cook by way of preamble to his catalogue essay for Freud's projected 1991 exhibition in Rome and Milan. Here he stands, deeming himself to be supportive. "Can painting matter?" he continued. "The feelings of antipathy aroused in me when I look at my favourite Lucian Freud paintings are a necessary response."[15] Such contrariness made him quite the St. Sebastian of *Two Men in the Studio*, standing to the fore subjecting himself to intense attention, statuesque in a realm of tumbled rags. ("Lucian thinks of their presence in the pictures as a kind of water: 'Their watery and wavy aspects.'")[16] Equally, and more convincingly as the essay proceeds, he could have believed himself to be a latter-day Gilles: Watteau's clown, that disheartened leading man stripped bare. Then again, posed there as though thinking of taking a shower, he was obviously acting obedient. So too Sophie in *Standing by the Rags* for she, settled on her compacted perch of paint-smirched bed linen, blood draining from her upper body and suffusing thighs to toes, could be considered victimised: an Andromeda pressed against the rock awaiting rescue. Rock bound or rag bound, whatever, she also served as a splendidly corporeal washed-up Venus.

Lucian wouldn't admit to any such interpretations. "My world

is fairly floorboardish," he said, which made the set-ups essentially theatrical in that each one was a prospect to be worked from directly and unreservedly without any promptings other than those of the moment. "I hate mystification; I think it's an unpleasant form of aggressiveness. Take Pavel Tchelitchew, who painted Edith Sitwell. They had a passionate correspondence and when they actually met they loathed each other. His huge *Hide and Seek* in the Museum of Modern Art: people were taken in by it. Lots of mystification there. Where Gustave Moreau is *interestingly* bad (like B. R. Haydon who did his *absolute* best but was terrible), Tchelitchew was a try-on. What good and bad have in common is shamelessness.

"It was rather like when you meet someone and they tell you something and they think (because of ordinary human idiocy) that this is typical and you don't realise that it is something that you noticed or you were alive to or that you exaggerated (or he exaggerated). I want to get to be *of* the person, rather than 'Oh, that's like so and so, did you have them in mind?'" Derivations, particularly the trails of presumed influences and thematic concerns that so delight teleological art historians, were of little account in circumstances where only immediacy really mattered. Once completed and eased through the skylight out into Greater London and beyond, painting after painting went on to be exposed, of course, to reaction on every level: academic, monetary, associative, instinctive. "Put straw on the floor," Lucian said, "and the mice will come." In a "fairly floorboardish" world, he maintained, every floorboard has individuality. "One of my preoccupations has been treating them differently. I want the feel of them being boards but I don't generally do the lines." Shine and feel were accomplished with consummate panache in *Lying by the Rags* (1989–90). There lay Sophie de Stempel, rags to the right of her, boards to the left of her, interposed between white cotton turbulence and shiny planks as though floated ashore and stranded. "Slightly from Donald McGill," Lucian mockingly acknowledged. "Cedric Morris admired him: 'Move over, Bessie, and let the tide come in,' a coastguard says." But besides being reminded of the robust visions of obstructive corpulence in saucy seaside postcards he liked to think that the decking in Gustave Doré's illustrations for *The Rime of the Ancient Mariner* had become involved. He had been mightily impressed by those frosty planks in his Dartington Eurhythmic Players days.

Lying by the Rags was however primarily and most extraordinarily an ode to—a "Rime" about—glint, gleam and absorbency. It was the last picture to involve Sophie the aspiring painter. There had been one long break some years before. "She then sat well for a very long time. Then I did a picture and it wasn't good and I then realised I couldn't work from her any more. She was a bit emotional about it. She was always pressed. I quite like being a press. Once, when I was doing *Lying by the Rags*, I kicked her. Things were going badly and I kicked her by mistake. 'This is it': she got up and I laughed. 'I promise you I'm not . . . I don't kick naked girls by mistake.' She's one of those people who imagines things that are not so. Everyone has a slant on things. It's not necessarily untrue." His slant was that her usefulness to him was over, her sentence served, her chagrin her affair only; not that she saw it that way. "I walked out on him," she said.[17] He was also, he told me, considering no longer using rags as a feature. "Some," he said, "I know too well by now." As for Sophie, he added, "Her father and her stepmother were had up for embezzlement of an aunt's money: prison for both.

"Rimbaud's 'I took Beauty on my knee / I found her bitter so I injured her.'[18] Frightfully good, wouldn't you agree?"

"In a conspiratorial way she kept all my drawings"

The roster of sitters, all temporarily indispensable, altered according to the needs of the paintings, those envisaged as well as those in hand, so the need to recruit remained a continual concern. Typically, when in Edinburgh in the summer of 1988 to see a selection of his work (predominantly belonging to Jane Willoughby) at the Scottish Gallery of Modern Art and "Early Works on Paper" at the Fruitmarket Gallery, Lucian encountered Anne, a green-eyed, redheaded teacher, phoned her at work and became so exhilarated when she gave him a lift—saying "I'm going to drive as fast as I can; I feel I can just go anywhere"—that he asked if she would care to help him find the train ticket that he'd mislaid in his hotel room. Weeks later, following an exchange of letters, she called on him in Holland Park. He asked her if she'd sit for him naked, but she decided not to because she had her sons to consider and anyway, he said, they would have to be night sessions, which would have been impractical. Chris the Australian on the other hand was to prove, over several paintings culminating in *Seated Nude* (1991), a singular and effective presence, given her air of assertive disdain.

Courbet's *Young Ladies on the Bank of the Seine*, a National Gallery painting that Freud had always liked for its taunting show of spent dalliance, prompted him to get Bella and Esther to arrange themselves on the red-buttoned sofa, shoes off, settled in for the familiar process, his two bohemian daughters outnumbering him but companionably so. They enjoyed posing for what became *Bella and Esther*

(1988), given that there were plenty of laughs and restaurants afterwards. Esther remarked how well organised he now was, the pace steady, stints interspersed with pauses to glance through the newspapers and make phone calls. "Third Floor Ladies' Underwear," he said when he first showed it to me in a presentable state. After that Bella went to Rome to study fashion while Esther became an actor though, beyond being an alien once in *Doctor Who*, she found it unrewarding and turned to writing, whereupon sittings (nine in the evening until midnight or later) became too much for her. "I found it hard once I started writing. It's almost unbearable if you're busy. There you are. Nothing you can do." Besides, she said, "as an actress it was dangerous: I might have my hair cut or coloured or turn up too brown. In the last painting I had my hair cut very dramatically and he had to go blotting out my hair." An etching from 1991 and a painting from 1992 showed her thirtyish and poised: the author now of *Hideous Kinky*, the lightly fictionalised account of her spell in Morocco with mother and sister for which her father provided a dust-jacket drawing taken from a photo of her at that time, her hair in bunches, a singularly level-headed ten-year-old. Having been very much at her father's beck and call, Esther was now more fruitfully preoccupied. "I suffered in my early twenties. He would ring up. 'Would you like to come to dinner?' and I'd have already made dinner for myself but I binned it and rushed out to it. There was a time when everything was like that. I just wanted to be there." Later, she said, "I feel I can see myself becoming more confident."[1]

Another daughter available to sit from time to time was Annabel. A bus ride from Brixton to Notting Hill was the routine and she settled herself on the mattress in a pale-blue bathrobe for *Annabel Sleeping* (1987–8), ankles exposed, heels pressed together, the soles of her feet touchingly grubby from the studio floor. With *Annabel* of 1990, a naked portrait half the size of *Annabel Sleeping*, he compressed what he saw—and how he saw her—into a blurted truth.

The attention warmed her: "Dad said he used to paint people to get them well."[2] Annie, her sister, agreed. "A person's back is as important as their front. The way the hair is drawn makes you see the whole face." The canvas was extended a couple of inches to accommodate the toes. Where *Standing by the Rags* may be thought to recall classical poses (Leda possibly, pressed against a breastwork of tum-

bled whiteness), *Annabel Sleeping* bears no trace of derivation. Nor do the heads of Ib and Susie Boyt from 1990, freighted with anxiety. Sitting meant extended contact. "I went from seeing him a handful of times a year to three or four times a week," Susie Boyt said. "We talked all the time." For the first portrait she arrayed herself in "a grey dress, 1940s, quite dressing-up box, black velvet, wing thing off the side. The second one I did was very much about things I was thinking about at the time. On balance it was very satisfying. Surprisingly unfraught, the whole thing."[3] Her first novel, *The Normal Man*, was published in 1995.

"I can't help it: even when quiet I have to produce my 'magic,' where there is 'heightened presence,' which is really a kind of signature tune a bit," Lucian assured me with the mock solemnity he favoured when mocking declamatory received opinion. "It's an aspect of what I like to think of as Truth Telling. Which has a slightly 'Let-There-Be-Sculpture-ish' sound but I don't mean it at all like that." He meant, he added, not "rhyming and soothing" but sustained accretion, never just settling for the satisfactory. His persistence made him scrape off into rag-wipe every dab that he felt at a glance was gratuitously seemly. "I'm always making sacrifices. (Do I mean sacrifices? Yes.) When the paint goes down well I'm pleased, but I nearly always score it out if there's a form that I can use to make it more like a person. By 'like' I mean so that there's a relation between the paint and the form of the subject. Which is again something I see, or think I see, in the picture's 'really like.'" Enlargements often proved necessary in the realisation of "really like," relieving pressure and enabling forms to stretch out and spread themselves. Having extended he could re-emphasise and redispose. His preferred method of achieving this switched from extra strips zigzag-sewn on enlarged stretchers to areas of canvas on supplementary stretchers bolted into place. Owners might worry about cracks developing along the joins but he, thinking of how Brueghel, Rubens and so many others had made do perfectly well with composite wooden panels, said he really wasn't bothered. Indeed he liked the rejigging involved. "My discipline was controlling scale and the composition. So I have to enlarge. Oh God yes: the idea of surgery is really exciting now."

Extensions affected balance. "It's like stepping back over the edge because you know the terrace, in your absence, has been built a lit-

tle bit further. It's to do with a diabolical liberty rather than a terrible risk."

"I could never put anything into a picture that wasn't actually there in front of me," he told Robert Hughes. "That would be a pointless lie, a mere bit of artfulness."[4] His impulse on spotting someone who might suit him was to see if they were agreeable to sitting for him and, more important, whether he could stand being in the room with them. Punctuality and stamina were crucial, of course, and a proper awareness of the nature of their role. " 'Good' models would have an idea about posing in itself, which is exactly what I'm trying *not* to do; I want them to be themselves. I don't want to use them for an idea I've got where I must use a figure, 'let's have that one.' I actually want to DO them."

There was usually a stack of kicked and slashed rejects by the door. "They all make me want to go back to work."

Man in a String Chair (1988–9) was Victor Chandler, credit bookmaker and friend of Alfie McLean. Lucian had known him since 1984 when they were introduced over a meal at Wheeler's and he had started laying bets with him. In 1988 it was agreed that he should sit for a small head-and-shoulders painting but then it was decided it should be full length. Three nights a week for around eighteen months, starting at six or seven, Chandler sat; afterwards, some nights, they would go to the River Café or Annabel's or the Cuckoo Club (where the Stork Room had previously been, off Piccadilly) and even to the National Gallery a couple of times. Chandler denied that this was a commission; it was however done with an eye to a probable sale and they came to what he described as "an arrangement" and, as Lucian put it, "A spectacular enlargement." Extended top, bottom and side to make space for headroom, feet and armrest, the painting became a polite account of the sitter, relaxed in cashmere cardigan and deck shoes worn without socks (an outfit mutually agreed upon) on the creaky Lloyd Loom chair bought in the Harrow Road. This was an ex–public schoolboy with the air of a lordly Charlie Lumley. "I used to know his father. His mother wrote that it was a terribly nice picture." Nice but truculent, more like, in that Chandler was used to taking bets on tick and making deals to secure what, more often than not, Lucian subsequently owed. The painting became a sort of surety against ultimate loss. "It took eighteen months and probably well over a hundred

sittings to do," Chandler remembered. "I paid most of the money for the picture up front and in the end I reckon I paid £250,000 for it."[5]

Debt was a barometer in that it denoted degrees of vulnerability or satiated risk, settlement being part of the drama with paintings used as negotiable assets. "Vic Chandler had a bad run. He pawned pictures. Vic said he'd just pawned them for six weeks: in book-making you don't run out of money for very long." As a gentleman bookmaker, racehorse owner and gambling magnate who, ahead of the game, in 1998 transferred his business to tax-free Gibraltar, he appealed to Lucian as a paragon of buccaneering enterprise. As for himself, the gambler, his winnings, Lucian half persuaded himself, were best put into making time for painting risk. And commissions could be put to good purpose. "You can use them selfishly for your own ends, as Grünewald must have done at Isenheim."

Lord Rothschild—Jacob Rothschild—whom Lucian painted twice between 1989 and 1991 ("I did always want to paint Jacob: extraordinary presence"), first half-length and then head only, was another admirer of his work ("I think only when I got on a bit, or was taken a bit more seriously") who, it was understood, wouldn't nec-essarily commission any painting in hand but would quite certainly acquire it. Seated in plain daylight he became *Man in a Chair* (1989), donnishly stooped, concentrating on the near passivity of being worked from and upon, enlargements down each side giving him barely enough room in which to settle himself. Lucian liked the way he talked, referring to certain people of his acquaintance as "comfort-ably off," meaning that they were worth many, but not that many, millions. Gangling, bony, emphatic, he had taken charge of the family bank, N. M. Rothschild, in 1967 and transformed it before setting up on his own account, with phenomenal success. The refurbishment of the National Gallery in the 1980s and 1990s was just one of his more conspicuous ventures in art philanthropy.

Telemessage: 10 April 1989
 DEAR CHRIS
 JACOB LIKES YOUR PICTURE VERY MUCH AND IS BUYING IT. WILL YOU FRAME IT SOON? WOULD IT SUIT YOU IF WE STARTED YOUR PORTRAIT ON THE 1ST OF MAY AT DUSK? LUCIAN

The portrait *Chris Bramham* (1989) was so titled because, Lucian maintained, being an artist he needed his name out there. Bramham proved to be a self-conscious sitter, forefinger cocked against the side of his head, eyes studiously averted from what was going on at the easel. He had been told he was very good mannered. "Which was based on the fact that I had not gone for a pee throughout the day's modelling. I was always so nervous in those days. I always drove up early to Holland Park, to sit, and once too early and went for a coffee in the high street. Lu and Susanna walked in, all very friendly; they talked more to each other over a *Vanity Fair* or *Tatler* about mutually known celebs. This was part of knowing Lu. You did know your place! I hate that sort of thing—being a working-class northerner—but I think it was entirely natural to them. When he was taking me to the National Gallery at midnight we called in at the Zanzibar. He ordered a bottle of champs. I was such a timid little bore. I remember the champs cost a fortune and was corked—badly. He looked around at the ladies & after a couple of sips—and me being so wet—we left. He hated bores, didn't he? It surely didn't matter what class you were from."[6]

After a while the canvas was extended by an inch or so above the receding hairline. ("Twice asked me to get my hair cut for this.") This was a painting of someone still dazed somewhat at being in this position, sitting there. "It is funny, before I met Lu, how mysterious his work was. It was good one didn't know the sitters' names and yet once you got to know Lucian a bit . . . well, for me it was still pretty secretive in those days and I never dreamt of digging too much— always more interested to learn more as a painter. I like his 'putting a little poison in the pictures' (as he said). That is the difference. I paint to make myself calm."[7] Once, to his despair, some months before, a painting of the view in winter from the back of his Richmond council flat seized up on him. "I had a real problem of not knowing how to deal with the bottom part, which was a new, brick garden wall. So I left an SOS in Lu's letterbox. Some time after midnight, we're all tucked up in bed, and there's this persistent ring on the doorbell. Lucian called up. Looking out: 'Fuck, it's Lucian.' Pyjama-ed and bleary I took him to the problem picture. I was told not to be embarrassed at the wall etc. Brick by brick the problem was solved. Susanna

was his taxi driver. Just a wave and smile from her little Renault and off to some club probably. Looking back: how wonderfully kind."[8]

Further encouragement had followed:

I hope you are feeling ready to start on some very ambitious projects. Though I doubt if there will be any need for it, the ambulance is at your disposal—Dusk till dawn. Lucian[9]

That said, it wasn't long before Lucian lost patience with making himself available as a dispenser of guidance. Bramham appreciated this. "I was amazed and intrigued by his style, but thank God never tempted to take a leaf out of his book. He saw everything from a different angle. I used to like Wordsworth; he hated Wordsworth. He liked the Earl of Rochester. I sent him a verse by Masefield, cheekily, and he was absolutely delighted with it as he liked Masefield and could quote from 'The Dauber.'" And so, although ruthlessness dictated that distractions were to be avoided, there remained benevolence. "He sent me some money: 'A horse had won.' The generous side, which was so hugely there. He was pretty private in those days and I never really asked questions, respecting that.[10]

"An artist who feels such passion for, let's say, flesh and veins on a breast. The joy in form and weight. The genius of making floorboards into water."[11]

1-3-90
Dear Chris. Please come to T on Sunday. "If there is to be art, if there is to be any aesthetic doing and seeing, one physiological condition is indispensable: Frenzy. Frenzy must first have enhanced the excitability of the whole machine; else there is no art." "Twilight of the Idols," Nietsche [sic]
Put that in your pipe and Smoke It. About 4:30 L.[12]

Art, in Nietzschean parlance—which Lucian relished for its hectoring qualities—needs triggering and springing and purposeful abandon; to this end, sitters need to excite attention. Their presence is both the prompt and the spur, each a prospect to be stimulated by and worked over. "They'll have done different things, talked to differ-

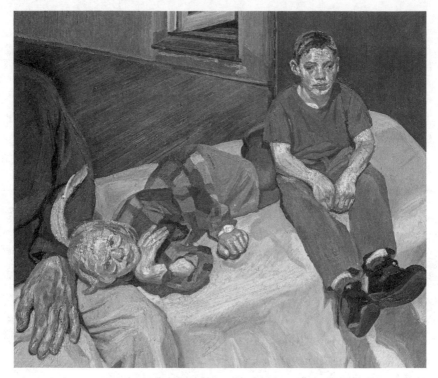

Polly, Barney and Christopher Bramham, 1990–91

ent people, maybe woken up next to a different person in a different bed. All these things affect me and so affect the painting. Degas said: 'There are certain kinds of success indistinguishable from hysteria.' He said that in 1880. I doubt if he had read my grandfather's book? Could he have?"

He could not have. Not that it mattered. Intensity wells wherever, regardless of theory. Particularly, for Lucian, in the light of his grandfather's celebrated observation that love and work is all there is. This he addressed in *Polly, Barney and Christopher Bramham* (1990–1), involving two of the five Bramham children, Barney aged twelve, a future mathematician (who brought Gussy his magpie to a number of sittings), and ten-year-old Polly, already a fiercely dedicated animal lover, posed beside their father on the studio bed on Thursday afternoons (they were home-schooled) and in evenings often until past midnight. "It was a night-time painting and staying up late was excit-

ing," Barney later wrote. Recitations of *The Rime of the Ancient Mariner* and, equally well remembered, *The Hunting of the Snark* eased the monotony of eighty sittings. "Like a clock hand, you could hardly see the painting grow."[13]

Chris, edged to one side on a radiator—almost out of the picture—and thus more in a position to watch, described the method of application. "Did it with his back to us. Holding the palette knife up he mixed paint very slowly. It took him twenty minutes getting the tone of the plaid right on Polly's dress. Then loaded up a brush with a lot of it, placed it on. Curious, tedious method of painting. Placed the paint on, then wiped the paint off, scraped it off onto the wall. He'd get impatient." He remembered David Beaufort remarking once how amazing it was that his—Chris's—works "bore no resemblance to Lu's. Lu just smiled, I think I knew they were very much from Lu's."[14]

In the painting Barney slumps a little, acting disengaged; Polly lies beside him with her ponytail draped across her father's left arm; she happens to be interested in what's going on and stares at the wielding of the painter's brush as though studying animal behaviour. For Freud the three of them together was a strangely, maybe enviably, cohesive combination, the children being dependants, both of them displaying traits rather than manners and, he told me admiringly, an ability to concentrate. "He brings them round, they come on the tube, with a magpie, which shat on me." The impeccable American painter Ellsworth Kelly, whose work Freud admired, remarked to him that the paint (handling) on each of the children was different. Freud said he was jolly pleased to think it should be.

"I was always with adults," he pointed out to me, making that the explanation for his lack of affinity with the young. "A baby is only an animal. It's terribly interesting, but it's to do with actually having an interest. Speaking as one of the great absentee fathers of the age." The children presented him with a little battery-operated plastic ghost in a hanky shroud, its attraction being that it would react frenziedly to sudden sound. One morning, dropping into sonorous Nietzschean tones, he told Frank Auerbach that he thought the studio was haunted and then clapped to make it go "ooh ooh." Nothing happened. He'd forgotten that it needed to be switched on. After that the ghost was relegated to the kitchen cupboard.[15]

During the breaks the children were allowed to look at a book

of human freaks. "They pored over it with great excitement," Chris remembered. The book interested him, Lucian explained, because it took abnormality for real, categorising it as enhanced physiology. "It's very genteel: two books abridged into one. Fascinating. Biological. Some of them from Tod Browning's film *Freaks* are in there. A very odd book, *Very Special People* it's called, and there's an extraordinary preface: 'Dedicated to very special people and to try and show there's a place for them in the world.'"[16]

He was to paint the two young Bramhams again four years later: older, more interestingly unsure of themselves and their situation, holding a pair of ducks.

Woman in a Grey Sweater (1988), one arm crooked over her head, the other pillowing her, looking quizzically at the painter as he worked at achieving the look of spontaneity, was Susanna Chancellor. "The coy picture," she called it. "It went on for years." Begun in the Holland Park flat, it was finished elsewhere, a short car ride away, in a final session lasting no more than half an hour. "I could remember what I was thinking about," she said. Far from coy, the painting affirms an emotional and practical reliance. Susanna was with Lucian when, acting with what seemed—to her—staggering promptitude, and advised by Duncan Davidson of Persimmon Homes, he bought—for £65,000—what was to be the only home he ever owned (Coombe Priory had been more Caroline's than his), a Grade II listed late eighteenth-century house in Kensington Church Street, off Notting Hill Gate. Gradually he accustomed himself to going there and working there and staying there; it was reassuring that *Woman in a Grey Sweater* could be so quickly completed in the new place.

Susanna was seen as supportive while still essentially independent. "I didn't know her that well," Chris Bramham said. "She was always a smiling presence in background and sideground, always very friendly. I remember Lucian saying she wanted to scrub the nicotine off her finger. Lucian's lifestyle was clearly attractive. You imagine how dull lives are cheered up and excited by trotting off hither and thither and meeting everybody. Pure Balzac. L adored her and I think wanted to marry. But her family was hugely important to her. She wouldn't pose nude. And she did not like Lucian going off the lead when she went off for months to her big house in Tuscany. Lucian said she wanted him to be monogamous. Well, tell a dog to be vegan."[17] When she

was away in Italy Lucian would phone her as often as four times a day. And when she was at home and he rang her, he told me, he became angry when she said that she was making a cup of tea for normally he saw her in the afternoons and this suggested to him that she couldn't be bothered. What he took to be an "important" call would turn out to be her saying she couldn't come round as she had workmen in. He admitted that he was unreasonable in being so infuriated.

One afternoon in April 1989, the usual brisk ushering in when I arrived at the top of the stairs was suddenly interrupted by a whippet pushing forward like a practised hostess, quivering expectantly. This was Pluto. Lucian had bought her for Bella from the breeder Jan Banyard, a neighbour of Susanna's mother in Dorset, who impressed him with her passion for whippets (and for Elvis Presley, whom she had once known), describing them as "supremely affectionate, cleanly built and fastidious by nature." Quick too. "Take a whippet into a field and watch him fly over the grass with heartstopping beauty, a perfect running machine . . ."[18] But Bella began working for Vivienne Westwood, who refused to allow Pluto in her workshop so, with initial reluctance, Lucian took her on. "I didn't so much like dogs; it wouldn't be much of a life in London. They like habit, I don't." His grandfather, who had owned an Alsatian in the early twenties and chows thereafter, had appreciated canine wholeheartedness, their innate innocence. For Lucian a whippet was manageable, more so than the larger breeds he had favoured in his married phases.

Pluto shadowing him was akin to Charlie Lumley dogging his footsteps in Delamere Terrace days, yet less of a liability. There were no emotional demands to speak of or misdemeanours to cope with. Her needs were simple. Her rattling energy when stirred, her readiness to doze off and her dark-eyed elegance charmed him. "She knows I don't like being welcomed when I come into the flat. Other people she makes more fuss of: with children she dances round." While he worked she slept. Practical demands, to be fed and exercised, were easily met; no tap water for her: she had Evian, same as him. He would reach into the fridge for prime minced beef (from Lidgate's in Holland Park Avenue) and toss handfuls of it to the kitchen floor for her to wolf down. Her impatience matched his. "Pluto trying to eat a hot sausage: she doesn't realise that it will cool down in a minute." Pause. "Neither do I for that matter."[19]

She kept pace with him, frantically tackling the long climb to the top floor. Going out she would skitter downstairs, leap into the car and ready herself for the swerve as the car swooped into Holland Park Avenue regardless of traffic. Her whippet instinct was to sniff for what she wanted to know; then, curiosity sated, she would return to her basket. Asleep she served as a model. A small painting of her was begun, head and haunches dealt with, scrapes below the ribcage where she liked to be scratched, paws unrealised. He quoted Walt Whitman, partly for the sentiment but more for the exactitude.

> *I think I could turn and live with animals,*
> *They are so placid and self-contain'd.*
> *I stand and look at them long and long.*
> *They do not sweat and whine about their condition;*
> *They do not lie awake at night and weep for their sins.*[20]

"I had rather see the portrait of a dog that I know than all the allegorical paintings they can show me," said Dr. Johnson.[21]

The River Café, which opened in 1987, became for a while Lucian's favourite place to lunch. The drive from Holland Park to Fulham was always terrifying because the route there took him through narrow streets lined with parked cars. Pluto would sit on the back seat swaying as the G-force kicked in. When we arrived she used to sit on the lawn outside enjoying the attention from the many who took her to be an exceptionally fine stray.

The day I first encountered Pluto, Bella arrived for a sitting and made coffee, adding rum to her cup; she was about to set up her own fashion company with Lucian's backing; her clothes were, Lucian told me proudly, "for someone who doesn't want to blend into the background." She now wanted a distinctive trademark. "I asked him if he would write my name so that I could use it as a logo of sorts. He sat at the kitchen table and took out a drawing book and worked intently for 20 minutes. 'Would this work?'"[22] His design was a grinning Pluto with lolling tongue. It served perfectly as both label and motif, as skittish as any Fougasse *Punch* cartoon recalled from Bryanston days.

When I asked him a week or so later how he and Pluto were getting on together his answer came pat: "A dog makes life nicer."

. . .

On 16 August 1989 Lucie Freud died. Lucian had worked from her from 1971 onwards, though latterly the sessions had tailed off. "I thought a gap was dangerous. At over ninety she got up the stairs: her minder person said she went up like a mountain goat. 'I'm glad it's not further,' mother said." Stephen considered this typical of his brother's thoughtlessness. "He even made our elderly mother climb the stairs."[23] Her death brought resentments to a head.

"My aunt Gerda did horrible things. Like my brother Stephen who in an imaginative gesture (no doubt it must have been a bargain) said, 'I've found a wonderful flower service. For so and so much money this flower service sends the recipient [Lucie Freud] an order of flowers every week. Will you go halves?' I said yes, what a good idea. After two or three months my aunt cancelled this without telling Stephen or me and when asked why she'd done it she said: 'The flowers were unsatisfactory.' She was very nasty really, in a small sort of way. Her expertise was opening letters. Other people's."

A companion-nurse had been engaged. "The minder was an ex–chorus girl married to a famous comedian never been heard of. We got her through Stephen my brother's wife. (She had a way with her: I got a bill from a roadhouse in Devon, lots of bottles of wine, champagne. 'Don't milk this elderly delinquent,' I said.) This companion person was terribly drunken—quite rough in an appealing way—and I was asking: 'Mum, don't you *mind* her doing that?' 'I do rather,' she said."

The stoicism that Lucian admired in her persisted to the end. "When she was dying Stephen had her put in the Royal Free Hospital. People were screaming, no privacy: all cubicles and curtains. I said to my mother, 'Don't you mind?' 'I don't really.' 'Not really? Wouldn't you like to be in St. John's and St. Elizabeth's? It's near home.' And she said yes. She was in there one and a half days, then died."

The eighteenth-century Scottish portrait painter Allan Ramsay admitted that when his infant son died and, instinctively, he recorded how he looked in death he found that the task absorbed him. Grief employed, mourning becomes productive. "While thoroughly occupied thus, I felt no more concern than if the subject had been an indifferent one."[24] Lucian, similarly moved to do one final drawing of

his mother (as he had done with his father), phoned the hospital to let them know. "I rang up about drawing her. You aren't allowed to be alone with a corpse so an Irish boy was posted in the room. The boy was a fashion student in Connemara—it was a holiday job—and knew of my work; I wondered why he was looking at me and then realised it was being alive; I was doing a drawing, and another. I kept looking at him too: *he* was *alive*."

There she rested, eyes closed, teeth removed, sunken. He noted the lack of resilience, the impersonality. What Lucian drew—*The Painter's Mother Dead* (1989)—was the detail of lifelessness: the combed hair, the dark inside the mouth. "Well," he said to me, "I liked my mother. I was close to my mother, especially after my father died."

"Sex and death," W. B. Yeats said and Lucian quoted, "are the only things that can interest a serious artist."[25]

"Cousin Wolfi [Dick Mosse], a trustee, arranged mother's burial. There was a memorial service. I didn't go to it: too many people I didn't want to see. The girls went, some of them."

Going through his mother's things at St. John's Wood Terrace, Lucian was perturbed to find letters that he had written to Angie Jeans some fifty years before. How had she come to have them? This was more than motherly hoarding or proactive archival zeal. It was prying. And then there were the bundled drawings, postcard size, some by his father, some by his brothers maybe, but mostly his. "In a conspiratorial way she kept all my drawings: literally about 1,500 of them. Because of my dodgy brother I went through them when she died simply because there might be danger to my privacy. There's one from when I was seven or eight of a group of houses on fire, all the smoke from them came out and joined up. I suddenly felt oh yes: a kind of link! I kept a couple of hundred and destroyed the rest."[26]

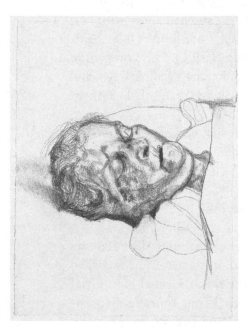

The Painter's Mother Dead, 1989

Some years earlier Bernardine had asked for a small painting of Lucian with baby Esther in his arms, one that he had agreed was hers, but not to be relinquished for the time being because, he explained, "It's hanging in my mother's house still."[27] When Lucie died the time came, she felt, to claim it again so she asked tentatively and then, getting no response, had a lawyer's letter sent. Lucian was furious but the painting was handed over and she proceeded to sell it through a dealer for very little, though enough with which to buy herself a cottage.

Following the funeral a row developed with "Wolfi" Mosse. "It was quite ridiculous," Lucian insisted. "Cousin Wolf did this thing, which was really psychological. Psycho. My mother left £40,000–£50,000 to us each from my father's life insurance; Wolf was trustee of father and mother's estate and he wrote and said such money as remained was being split in three and I should give up my share as I had removed some paintings from the estate. He said that it was wrong that I should benefit. It was very unfair of my cousin. OK, I thought, let it be. I wrote: 'from the point of view of equality you are probably right, but from the point of view of justice you'd better pay what's left.' But then he put in a letter that 'You'd be very unwise to press the matter; it would stir up a hornet's nest, and Stephen is in need.' I won't be threatened, so I wrote: 'Dear Wolf, I'm sure you're right about Stephen. Yes I'd like the money and money should go to Stephen: such money left to me by my mother, perhaps. And some of *your* trust fund money, surely, could go to Stephen?' He advised me not to look into it. Little bits of money and bits of property: scrabbling for it is so disgusting. So I took it to Diana Rawstron [at Goodman Derrick] and she said, 'Unless I'm crazy, he's supplied the evidence against what he says.' Then came a grovelling letter from him saying 'terribly sorry.' He even called round once: I saw him through the viewfinder on the front door and didn't answer.

"It arose out of violent disapproval as I used to borrow money from anyone when gambling. And from him, which he loathed. I would give him a post-dated cheque and it disturbed his sense of decorum: not treating money with the respect it deserves. (His father the doctor, at Bubbling Well Road, sent me a backscratcher from Shanghai once and I thought of him in a friendly way. "He's awfully vulgar," my mother said.) I didn't terribly mind. It was slightly on the

lines of the Hilaire Belloc rhyme—'since the damages were small, / He gave them to a Hospital'[28]—but I didn't like the *threat* element.

"Stephen is not malevolent; he is bonkers actually, he really is. My brothers think I'm illegitimate. Rather stupidly, Stephen asked me if I thought I was. I said, 'You know my parents, why do you ask?' He said, 'Cle and I are rather stout and rather bald and you're not very fat and you've got some hair, you know.' What could I answer?"

Jane McAdam went to the memorial for her grandmother. "She died when I was in Rome. They said, 'You were closest.' I was upset, not distraught. I felt a whole past gone. Lucian was not there." They drank coffee at St. John's Wood Terrace. Acquaintances among the half-brothers and half-sisters had developed through odd encounters. Jane first met Bella in Rome. "Bella was at Babington's Tea Rooms in Rome and a fashion college. She phoned me saying, 'You don't know me.' A strange girl: a weirdo she seemed. 'I'm your half-sister.' She made bags and shoes." Jane herself was in Rome on a scholarship at the Scuola dell'Arte della Medaglia. "I'd met an Italian when I was fifteen in Bulgaria, was with him for ten years and grew up. A father figure he was." Her brother David had met Matthew Freud (son of Clement) working together, as had Paul, in Tokyo. ("We were in a lift and he flashed a telegram at me saying, "Your grandmother is dead.") "Matthew introduced David to Bella then Esther. They met regularly. I used to go to see Rose at the British Museum, in her Little Russell Street flat."[29]

"Me and Susie," Esther remembered, "were desperate for a holiday and David McAdam was in the travel business; worked for Virgin. We asked where to go and he suggested a free holiday with him (and Mother, as it turned out) to Jamaica and the Bahamas. When there was a relationship for a year or two. We got to know them through Matthew Freud. It's an extraordinary situation. Those four children."

Coincidentally, Jane said, Rose Boyt knew Paul McAdam by sight from a club she ran, where he had been a bouncer and they had all been at the launch of Rose's first novel, *Sexual Intercourse*, in 1989. Paul had left home at twenty-one and lived in Las Vegas for a year hoping to become a croupier. "I grew up early, got wise," he told me in 1998. "I went to art school and used to have visions of Lucian on a windsurf board; I needed a picture of him. When we met, around 1989, we got on really well. He bought me lunch, put his arm round

me, was encouraging about my paintings. I sent him some pictures that I did to get rid of childhood anger. He kept one. Bella said that he said I painted really well. I said, 'I'd like to meet you regularly,' meaning occasionally. It's been ten years."[30]

Kirkman remembered Freud saying to him one day, "I've got four more children." Relations were limited, but he did see something of Jane. "Genuinely interesting," he said, "she's got a talent. Worked for the Mint in Italy and England. She's fairly normal. In Rome Bella rang her up. In London she'd got freedom of the Goldsmiths' Company and City of London and she had to have a proper birth certificate, for arcane reasons, with both parents on it." ("Mum said the birth certificate had been stolen, and a picture, in Paddington," Jane explained.) "Had to be certified non-bankrupt too. So she finally went to Bella." Eventually, in 1990, she got her certificate. "Goodman did it, a piece of paper, illegible script, biro pen running out."

She began a bust of her father. He used to send her telegrams when she was working at the Royal Mint in Cardiff arranging times. "He said, 'You know, I knew a girl who wanted her thighs to be thin.'"[31] That would have been Katy McEwen. He was tempted to make sculpture himself. "It was her [Jane's] idea to do it when Esther had a flat in Golborne Road. There was a bin of clay outside the front door and in a basement flat. I went there two or three times." She said that they faced each other and he shielded his work with his arm. In the second week she did a green wax figurine of him, legs crossed. They worked once a month for a few months and then the sessions stopped. "It got me down," he told me. "I found her oddly pressurising. I left in the middle. I wasn't behaving very well. I tried a few things but it began to hurt my fingers. If I went blind like Degas I'd take to doing it." Jane left the beginnings of her bust of him in a cupboard at Esther's flat and it disappeared. Later, in 1995, when she did a bust of Annabel their father helped pay for the casting.

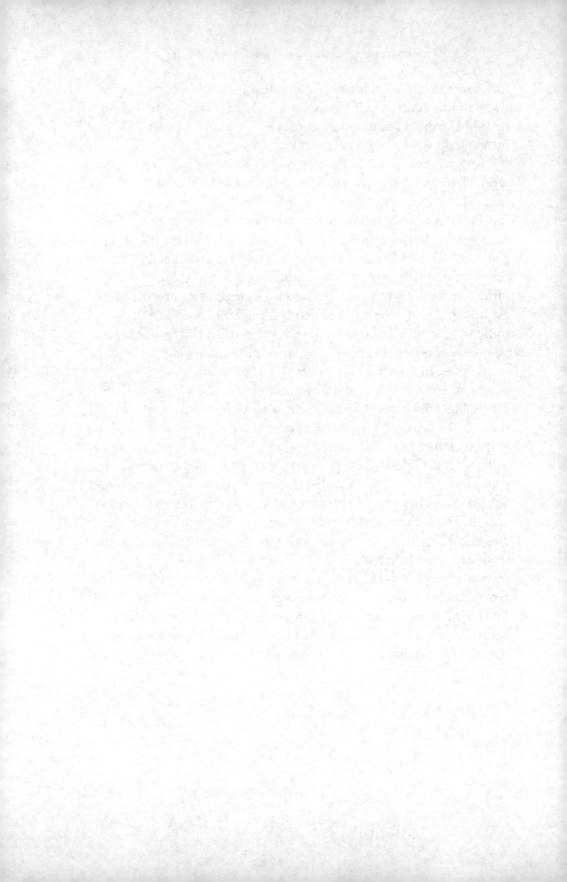

Painting Leigh Bowery, Leaving James Kirkman, Finding William Acquavella

1990–7

"Nothing tentative"

My studio visits became more frequent, keeping up with Lucian's extended working hours and the increase in paintings on the go since the group painting *After Watteau*. There would be the phone call, usually late afternoon when he took a break. "Hello, William [pronounced *Villiam*]. How goes it?" He would then pitch into whatever was vexing or amusing him. Some days he led with the suggestion that I might care to come round for a look at what he had in hand. Each picture became familiar over the months through the extended process of approaching completion, repeatedly brought out and placed on the easel after which, backing off, he would look at it with a trainer's air. There was no need to say anything much. Grunts and gestures would do. Sometimes, cycling in the early morning through Kensington Gardens, I'd be stopped by the Parks Police who would cut across the grass in their Range Rover and demand to know what I was up to. I could have told them that I'd been summoned to check progress on a picture and that I anticipated a breakfast of baked parsnips or partridge or woodcock or—a brief passion—deep-fried parsley. But I realised after a while that their real concern was the proximity of Kensington Palace.

The Turner Prize, organised by the Tate and first awarded in 1984, was thought up as a stimulant, aimed at exciting public awareness of contemporary art through a process of nominations, shortlist and award. Initially there was no age limit. Accordingly Freud was eligible for citation as "considered" and subsequently "commended" in

1988 alongside Tony Cragg, Richard Hamilton, Richard Long, David Mach, Boyd Webb, Alison Wilding and Richard Wilson. Tony Cragg then won. The following year Freud was again listed, as was Richard Long, along with Gillian Ayres, Giuseppe Penone, Paula Rego, Sean Scully and Richard Wilson. Second time round Kirkman was convinced that Freud would not be passed over. "James said, 'You're going to get it, but you must come to the dinner.' 'Why must I? I won't.' 'Then you won't get it, I have very good information.' 'If I do, will you give the money to the Injured Jockeys Fund?' 'It will do you no good. It will make people connect you with gambling again.'" This disagreement came to nothing, for Richard Long won. Freud was not surprised. "One thing I learnt about the Turner Prize: it's agenda-ed."

This also applied to the activities of Charles Saatchi, advertising man, who with his first wife, Doris Lockhart (they divorced in 1990), created a stir in the mid-eighties by buying art in such quantity that their collection became an art-world spectacle. Saatchi's acquisitiveness ranged over whatever struck his fancy on two continents; there were by 1984 thirteen prime Warhols to his name, extensive Donald Judds and upwards of two dozen Anselm Kiefers. By 1987 he and his brother Maurice, co-founders of the advertising firm Saatchi & Saatchi, were entertaining the idea of acquiring the Midland Bank. Buying in bulk as he did, with voracious yet fickle enthusiasms, Saatchi became a trailblazer for moneyed collectors courting the new. Almost inevitably his roving attention alighted, briefly, on Freud. Having amassed whatever he could lay his hands on, in March 1990 he displayed most of his haul—together with his Auerbachs and several Richard Deacon sculptures—in the long white spaces of his gallery in Boundary Road, St. John's Wood, round the corner from Clifton Hill.

Auerbach hung the paintings. Saatchi rehung them. "Saatchi was useless," Freud concluded. "Frank changed things and the room made less sense when Saatchi went and did what he himself wanted: ones that didn't work next to each other for reasons of scale." Sitting next to him at a dinner Saatchi told him that he'd got rid of the dreadful frames the etchings had come in. "Really?" Freud responded, adding so quietly as to be almost inaudible that those happened to be the ones he'd chosen. And then, he said, there was the nuisance of Saatchi man-talk in his left ear. "'How do you do it? Just go to a girl at a table

and go off with her?' I said that this isn't true even in my experience. 'I have been in love with one woman for some years and she has not allowed sex.'"

Not long afterwards Saatchi took to trawling a generation labelled the "Young British Artists" and thereupon disposed of most of his Freuds, among them *Two Men in the Studio* for which he had paid $2 million, a record price; several—*Two Men in the Studio* among them—went to another impulsive enthusiast, the self-made and overwhelmingly successful financier Joe Lewis. In 1991 Saatchi paid for the realisation of a Damien Hirst project, the procurement and installation at Boundary Road of a tiger shark from Australia: a toothy predator looming in the greenish murk of a tank of formaldehyde. Freud thought Saatchi none the worse for being impulsive. As for the preserved shark: "That was OK."

Rapid acquisition and rapid dispersal being his practice, Saatchi's turnover in what was effectively stock in trade made dealers anxious, particularly so in the early nineties, a period of slump and recession during which Freud, regardless of sales potential, became preoccupied with large paintings of a phenomenal new model.

15 Oct 1990
Sunday
 Dear Chris [Bramham] *Panick not. The big picture is still on the go and will be for another 5 or 6 weeks? Because the Subject is slipping off to Japan for 2 weeks in a week.*[1]

That "Subject" was by then Freud's prime sitter: Leigh Bowery, introduced to him in 1986 by Angus Cook. Since arriving in London in 1981, Bowery, son of sometime administrators for the Salvation Army in Melbourne, had grown up to be a performance artist, designer-cum-nightclub-operator, the most eye-catching Australian in town. He entered the Alternative Miss World 1985 contest as "Miss Fuck It."

"I was in a queue outside Olympia, there for horses, I think," Freud remembered. "I was very struck. It was only the first or second time I ever saw him. He was walking by a queue I was standing in and I noticed his legs and his feet—he was wearing clogs—and they were unforgettable partly because his calves went down to his feet almost

avoiding the whole business of ankles altogether. I was fascinated by his physique." In October 1988 Bowery performed at the d'Offay Gallery with a two-way mirror installed so that he could admire himself without seeing what audience he attracted. "Lucian came and watched," Judy Adam said. "Stood at the back watching Leigh posing, different costumes every night for a week."[2] Dazzled, not to say overexcited, d'Offay himself wrote of his performance, comparing him to a Hindu deity. "He allowed you to feel real. It's a very curious thing," he added, "that part of yourself was in Leigh. He unlocked a key in you, you would see this shiny mirror, it was an amazing thing."[3]

Leigh, squeezing himself into night-life character like a hermit crab into an alien shell to become Fairy Liquidator or Wehrmacht Funkadelic, was an ideal life model in that he could not but be stimulating. "I'm in this odd area," he explained, "between fashion and art."[4] Shaven head to foot, he contrived to be a neutral body to which anything might be fitted to dramatic effect. More Babar than Elephant Man, he contrived to be cumbersome yet light on his feet. Where Bacon had conjured up apparitions from swipes and sponging, he improvised with costumier skill from whatever struck him as suitably gross and ludicrous. A Hasidic greatcoat from Brick Lane market might be teamed with a sequinned tea gown, giant red spots and squirts of glitter. Using a special bra he would squeeze his flabby man-breasts together for a six-inch cleavage and tuck away penis and testicles, securing the lot with gaffer tape. He had "Mum" tattooed inside his lower lip.

Scenting possibilities, Freud arranged to meet this cocky phenomenon for lunch at Harry's Bar in South Audley Street, only to have him turn up without jacket and tie. No worries: Freud being a valued patron, Leigh was allowed to get away with borrowing a waiter's jacket and his host's own grey silk scarf. "I was hoping he'd ask me to sit for a picture, and I wanted to please him. I was nervous and Lucian is always nervous." He described the climax of a show he had recently done in Amsterdam that ended with his squirting an enema at the audience. Freud then put it to him that he might care to sit and he eagerly agreed. Two days later he was in the studio and seated on the red armchair. "I assumed he was going to paint me naked so I just started taking my clothes off and that's how the first picture really started."[5]

Soon after that I encountered Leigh one afternoon as I left the flat. He was hurrying upstairs, wide-eyed, panting, anxious at being almost two minutes late; his anorak and moptop wig gave him what the singer Boy George described as his "Benny Hill child-molester look."[6] The second time I saw him he was in the same outfit, anonymity personified, refuelling on beans on toast in a Whitechapel café. When, much later, we talked on the phone he was eager to impress on me that getting to sit for Lucian had been the big break he had so much needed. It offered cultural permanence, potentially at least. "Nice having that level of attention, and a tension. The bonus is the quietness. You get a different sense of yourself. Sometimes I fall asleep."[7]

"Very aware," Freud stressed, "and curiously encouraging in the way that physical presence can be." He found Leigh audacious. "The way he edits his body is amazingly aware and amazingly abandoned." Stripped of pretences he proved capable of maintaining poses for anything up to seven hours a day, on and off, and five days a week. "Someone who wasn't a dancer couldn't move and relax as he does. I've increasingly tried to get movement into my figures and he's helped me very much." A stepped box was built to enable Freud to reach to the top of this eight-foot-tall painting, so large that to view it whole one November evening before the light went we had to go out on to the balcony and look back in.

From Leigh's point of view *Leigh Bowery (Seated)*, completed in 1990, was an audition, testing stamina and commitment. "In the first picture I was amazed, I even had to be in position when he was working on a huge expanse of floor."[8] Sitting there, left leg cocked over left chair arm, the disarming yet coolly appraising young man from down under proved singularly adept. Freud had had no sitter like him before (except himself maybe) in that Leigh presented himself as a brazen object of fascination, one who won audiences by serving as the clowning hub of Michael Clark stage productions, outrageously dolled up amid milling dancers. His costumes were ingenious carapaces; essentially, much as Freud's own swanky get-ups (tartan trousers, joke fez) had been in his social-climbing days. "I used to like fancy clothes, certain ones. I think it was initially a way of overcoming my shyness. I had a sort of exhibitionist streak which was a way of creating a kind of attention."

The second painting of Leigh centred on a narrow shadow cast by the confluence of buttocks on white chair cover. Back turned (not unlike Cézanne's voluminous *Le Nègre Scipion*), Leigh becomes submissive, all six foot two of him monumentally unwieldy. Freud saw *Naked Man, Back View* (1991–2) as a picture of someone not bothering to play a part. Here he was thinking of Velázquez's *Mars*, in the Prado: that muscle-bound life model, well past his prime, seated in a clutter of discarded martial kit; he loved the disillusion, every touch softly stated. "He's so tired and fed up but obviously very deliberate isn't it? 'The God of War.' The pointlessness of his strength."

In both of these Leigh paintings a castor was removed from the nearest chair leg, effecting imbalance, a tilt towards the painter, the possibility of capsize and maybe just a hint of insecurity. "Things that used to embarrass me," Leigh assured me in 1993, "like nudity and gender confusion, don't any more." He saw Freud outperforming him in that he saw to it that the huge expanse of torso hogged the picture. "He always lets the figures find their own proportion. We are just elements in a picture. I'm so aware of how he manipulates things. That's what artworks are: elements being manipulated."[9]

In January 1992 Bruce Bernard photographed the set-up for *Back View* with Lucian assuming the title role in a charade homage to Courbet's *Painter's Studio* and Leigh stationed naked behind him posing as Courbet's female muse. The artist poking his brush at the as yet unresolved curvature of Bowery's bum was, Bruce observed, a double bluff. "This involved Freud, who is left-handed, pretending to paint with his right hand. The lordly gesture."[10] Freud himself later explained why he, Leigh and Bruce contrived such a tableau. "When I see photographs of painters staring into the distance I always think what complete cunts. I don't want to be one of those."[11]

When, some years later, the Metropolitan Museum acquired the painting, one of the ladies on the board was horrified, so much so that Brooke Astor, philanthropist and a fellow trustee, was moved to remonstrate. "But it's nothing but paint!" she reminded her. In retrospect Lucian was dissatisfied with *Naked Man, Back View*. "Doesn't work, I don't think." Overall it lacked feel. The paint made flesh was, he decided, a bit inert. It needed a heavy frame, he said.

Over a period of three years the Holland Park sessions were for Leigh a priority. Often he would sit five or six days a week from dawn

to mid-afternoon with a break every hour or so during which he could play with Pluto. "Or we'd be in the kitchen shelling peas for dinner. (He likes the idea of fortifying us.) Night pictures didn't take so much time: 9 p.m. to 2 a.m. You always get a bit of cash."[12] The model became an accomplice whose youthfulness, charm and barefaced candour ("I do a tuck and glue job to effect a hairy pussy") struck Lucian for quite some time as refreshing. He showed him off here and there, took him to dinner with Frank and Julia Auerbach one Christmas Eve and also introduced him to Bindy Lambton who, thirty years on, was sitting for him once again.

Woman in a Butterfly Jersey (1990–1) was as much a complement to the Leigh paintings as a catching up. "My idea. She liked doing it. I've always been friendly with Bindy and thought I'd do another but didn't." Downright as ever she sat in one corner of the Moroccan-leather sofa sporting shocking pink nail varnish and a white sweater adorned with machine-knit flowers and butterflies arrayed like chorus-line celebrations of her will to live and her lifelong love of butterflies. She was now a survivor of car and go-kart crashes. Arthritic and with eyesight failing, she nonetheless remained formidable. Which was why Lucian introduced her to Leigh. Who in turn introduced Lucian to Nicola Bateman, his dressmaker and greatest admirer (she paid for the "Mum" tattoo) and occasional co-performer, as in *Useless Man*, which climaxed in Leigh giving birth to her along with a cow's liver and a string of sausages. ("It became dangerous to be inside Leigh upside down strapped in," she pointed out. "Especially when he drank too much before going on stage.")[13] They went for a preliminary coffee near Holland Park tube station. Lucian was nervous and twitchy and immediately popped the question. "When can you start?" She needed no prompting. "Leigh brought me in to relieve him a little bit. I think he needed a break and I was a quite handy break to have. First sat for him about three days after meeting him."[14]

For *Nude with Leg Up* (1992), Leigh made as if he'd tumbled from bed to floor: a sprawled pose athwart the studio rags reminiscent of the scene in Beatrix Potter's *The Tale of Samuel Whiskers* when Tom Kitten suffers the attentions of a pair of rats intent on cooking him in their under-floor lair. "All at once he fell head over heels in the dark, down a hole, and landed on a heap of very dirty rags." Lucian had given Leigh a set of the Beatrix Potter storybooks and *Nude with Leg*

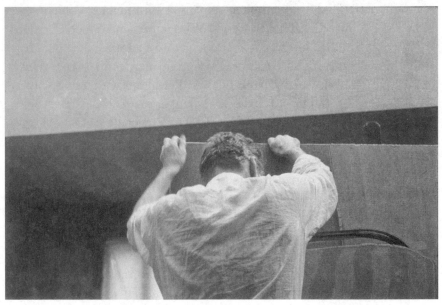

Lucian Freud in front of *Nude with Leg Up* (unfinished) in studio, 1992

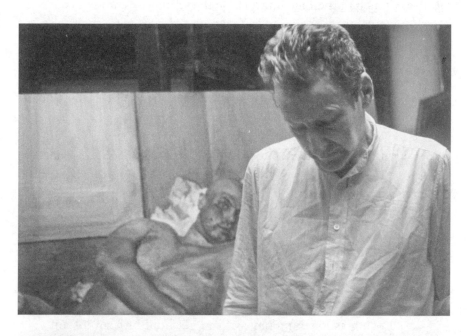

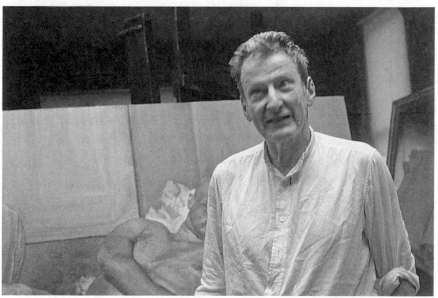

Up has a touch of their laconic quality: the pretend victim with cocked eyebrow outstaring the painter. Genuine risk was something else, a devouring instinct. Leigh used to cruise wigless in Russell Square on the way home from Holland Park, laying himself open to trouble with the law. In 1991 Lucian engaged Lord Goodman to get him off a cottaging charge at Liverpool Street Station, arguing that he would have lost his model had he been deported. And it was he who paid the £400 fine. He decided that he enjoyed humouring Leigh, and in 1991 agreed to be interrogated by him for *Lovely Jobly*, an impressively small-circulation fanzine; the liveliness of the result led to the interview being reprinted in the *Independent*. Leigh's questions were disarmingly provocative.

> *You have been called a misogynist. Do you know why?*
> One of the classical instincts of the human idiot is to take a single bone and to reconstruct the whole animal from it.
> *How does gambling affect things?*
> Losing as much money as I can get hold of is an instant solution to my economic problem.
> *When did you get the idea of working from your naked grown-up daughters?*
> When I started painting naked people.[15]

One of the quotes scribbled on the studio wall was Isaac Newton's apocryphal precept: "All systems tend towards disorder." Order turned disorder. That could be said of painting and the tug of circumstances altering perception. Or the onset of studio mess. Although he wasn't on the lookout for an assistant, Lucian came upon David Dawson, a Royal College of Art painting graduate who had been working part time for James Kirkman and, as he admitted, had hardly heard of Freud before Kirkman sent him one day on an errand to Holland Park. Finding him amiable and spry, Lucian took to ringing him in the mornings. ("Any news?") Initially, for Dawson, the contact was fortuitous. "I lived in Talbot Road near by and he liked having me round. That's how it started." Soon he progressed beyond sitting at the newspaper-strewn kitchen table to being shown into the studio. "The most remarkable room I had ever stepped into," he said. There, besides the paint encrustations and phone numbers

scribbled on the walls, he saw to his astonishment *Nude with Leg Up* and the newly completed *Woman in a Butterfly Jersey*, which he helped wrap in hospital sheeting and take downstairs to the car, off to Riccardo Giaccherini, the framers in Newman Street, Soho. After that he began working four mornings a week, buying materials such as the linen rags (from a place in Brick Lane), generally helping out and walking Pluto. Though no handyman ("I'm not practical, I'm rubbish at that"), he planted the garden at 138 Kensington Church Street. What struck him initially most of all was Lucian's manner, firm and attentive. "Grandness not pomposity of any sort." He was incredibly busy, he saw, which impressed him. He was not required in the afternoons. "I left him to it." Afternoons were for affairs requiring privacy, to varying degrees, one door opening, another closing from time to time as visiting women came and went. "He packed an awful lot into a day."[16] And he paid him well, a salary set up through the bank. To employ an assistant wasn't a major step at the time though in retrospect it indicated a significant shift in the day-to-day operation of the studio; there was the convenience of having somebody there to run errands (paintings to Riccardo's, urgent notes to whomsoever), to buy paint and prime canvases (five coats minimum, rubbed down between layers); relishing David's friendliness and reliability, he took to referring to him on occasion as "Slave."

Another indication of advancing years and the trail of past accomplishment catching up with Freud was James Kirkman's proposal that a catalogue raisonné of the paintings should be compiled. I was to write an introduction and notes while the systematic records that Kirkman had amassed over the previous thirty years were to have provided an orderly basis. That data alone was enough to set Lucian's pulses hammering and so, in June 1991, he and I had lunch at the River Café to celebrate cancellation of what he said would be a premature tombstone. For he still thought of himself as untrammelled: a continuing beginner in the lifelong pursuit. "I would like to do a picture that makes all my other pictures look like fakes by somebody who didn't understand just how good a painter I actually was." Besides, any purportedly complete catalogue would amount to a misleading register of derivations, influences and effects.

"I like to have nothing there so I felt they came from nowhere."

The previous week a Constable exhibition had opened at the Tate,

the second there in fifteen years, and one afternoon shortly before the private-view day I met Lucian there. He was with Angus Cook and Chris Bramham, going from room to room slowly, intently, remarking on the lack of portraits and rounding on a catalogue statement to the effect that Constable had experienced difficulty with foregrounds. How senseless that was considering the erotic nature of his painting: the slap and gurgle of water, the upsurge of cloud on hill and the exhilaration of *The Leaping Horse*: the bargee lad triumphantly clearing so low an obstacle on life's well-trodden towpath. "The greatest painting in the world, but of course I like horses. It isn't Expressionist: it's fast but it all reads." We agreed that a great Constable exhibition covering all aspects, portraits included, would have to be mounted some time and that we should do it. "Nothing tentative."

When Angus Cook put him on to Georg Christoph Lichtenberg's *Aphorisms* Lucian rang me to recite the saying that touched him most: "Where moderation is error, indifference is crime." He admired Cook's literary knowledge and skill but felt that any relationship exercised over many sittings was lapsing into indifference. *Man's Head with Arm* (1988) had shown Cook lying back, eyes shielded, sock dangling from his left foot. Was this unarousal? Who cared? Once Leigh Bowery began sitting for him the sessions with Cook dwindled. "For two and a half years I was working on an unusual number of things. Big Leighs. Leigh was such a marvellous sitter. Leigh Bowery was a friend of Angus who, after three and a half years, couldn't sit any more. I was working from him so much he felt strained. He does pop videos and writes. Remarkable."

Cook's deft catalogue essay for the show in Rome and Milan in the autumn of 1991 was liveliest where Freud himself spoke. "Freshly felt emotions can't be used in art without a filter. It's like people thinking manure is just shit, so they shit in a field and they think the plant will grow and in fact it half-kills it."[17] And the statement he had made for *Cambridge Opinion* in 1964 was reworded a little for translation into Italian. It was an improvement. "The invention of the atom bomb brought the end of human life into focus; (the end suddenly became nearer). It made things more potential for the artist; the act of self-indulgence acquired a poignancy, with the end in sight, as opposed to working in a void."[18]

In Henry James's *The Tragic Muse*, which he had first read in 1946

on George Millar's boat off Poros, Lucian found a remark that struck him, he told me, as absolutely to the point. "The painter Gabriel says to the brilliant young man he's painting, 'I wonder what you are going to do when you are old?' and he never comes back after that session. It puts so well the situation between the painter and the model and it's amazing because one doesn't think of Henry James as being visual in that way. He's saying that only in painting do you get that kind of scrutiny. I felt, when I read that, how did he know this? He's voicing the absolute condition of a painter looking at another person, and these things to do with fate and biology and condition and the future: everything coming in. It's so good because when you are working from someone things like that go through your head. The eyes give the messages to the brain and not all of those come out in the form of speech. (I mean the information gathered, and the subsequent ideas.) The painter looking at a person thinks things that the other person jolly well doesn't want thought about them, and makes guesses, which are really impertinent. It's to do with the inherent life in people. He [Gabriel] was thinking about the brilliant young man and about death and everything. He was just wondering in a way that you think and— unless your friendship is very thick with the person—you wouldn't really say."

By 1992 Cook and Wyn Evans were no longer sitters. "I thought Angus might be a bit of an artist. Maybe I got on his nerves a bit. I remember I was going off once, I was going to stay somewhere and I said, 'Do you want to stay?' and as I went off I took Pluto and he said, 'Are you going to deprive me of her too?' Like a playback of mar- riages, Angus always got money, Cerith's not good at money." Their association with him lapsed chiefly because they no longer had time for him. Cook moved to New York, Wyn Evans proceeded to become identified as one of the more senior Young British Artists and Lucian had his reasons for complaining about them. Frank Auerbach thought they went too far. "Lucian said, 'I've got a drinks table and I'm begin- ning to think twice about it because every time Angus comes he emp- ties all the bottles.'"[19] His grievances about the two of them bordered on the pernickety but there were breaches of what he regarded as honour or etiquette. "I gave them etchings knowing they'd sell them. They tried to sell to James, and then Matthew Marks (who was then at d'Offay's) gave them good prices." Not that he minded about that,

he added, after all he himself had sold paintings that Bacon had given him. That said, as ever Lucian tended to consider a gift, retrospectively, a loan or pawn. This partly stemmed from his reluctance to encumber himself with objects liable to be seized by bailiffs so he was apt to disown them temporarily. And basically he resented anyone questioning his right to repossess what had once been his.

"Father's library at St. John's Wood Terrace I bought out of the estate. I could have installed it at the top of the house [Kensington Church Street], but that would have been a slight shrine so the fitted bits were refitted in a room off Great Russell Street, Cerith's flat, which Angus used. I got someone to install it: a present to Cerith. There was a sofa and three chairs designed by my father, which I let Cerith have too. 'Until I need them,' I said. Rose then got a house. Could he let me have them back for Rose? I asked. And then came these incredibly rude letters. It was a gift, he said, and he wanted to sell for £48,000. So I got this man in—Mick, who I painted—to get it for me." Mick Tobin and David Dawson collected the furniture. "And after the furniture had gone he said he'd spent lots of money having it done up so I sent him a cheque saying, 'you stink.' A sofa done up in Berlin wool work: Angus took that from Cerith and I gave it to Rose, same time as I gave him the library. Angus took it and charged an enormous amount for copies made and I gave them to Rose. I've got not a single piece of furniture from the family. Chairs which father designed I'd lent to Stephen [Spender] when he moved in to Maresfield Gardens. Which Natasha got: amazing, her behaviour. Her daughter Lizzie, wife of Barry Humphries, 'Hellllow' manner, said to me in a restaurant: 'I don't know why you don't talk to me, you were my father's best friend.' 'I have nothing to say,' I said."

Mick Tobin, guileful in a rakish tweed cap, was an ex-Navy boxing champion and a former chief carpenter at Sadler's Wells. He had always lived with his mother. When he died, in 1997, Bruce Bernard's brother Jeff described him in his "Low Life" column in the *Spectator* as "an awesomely good street-fighter and a very nice bloke." That said, Lucian (whom he originally knew as "Lu the Painter") liked the way he kept his end up. "He's like these tough people, he's pretty shy and touchy, quite a short fuse but jokey about himself. And so he's not a 'type.' I'm not interested in 'types'; indeed the idea of 'types' is to do with sentimental vulgarisation or to do with out of focus. A

sort of Popeye the Sailor Man, not really dashing, not like Charlie [Thomas]." He had had a secret affair with Elizabeth Smart, Auerbach remembered. "In the old working-class sense he thought she was a 'real lady.' He was known as 'Covent Garden Mick.' He had this idea of river tours of London for tourists, hired a barge, showed them round."[20] Auerbach had taken his son Jake, when young, on one of these trips and made the mistake of venturing to correct Mick's running commentary where he said that some bas-reliefs they were passing on the South Bank were by Epstein when actually they were the work of Frank Dobson. "At that Mick became irate and violent. Another time as the boat passed the Houses of Parliament he said, 'Here's the Westminster gasworks' and someone from there heard and the boat tour was disbanded. After that he sold newspapers."[21]

Lucian had tried getting the newspaper seller outside Holland Park tube station to sit for him but he wasn't having any, which was why he turned to Mick Tobin, having in mind the ghoulish figure in that early painting *Memory of London* fifty years on: a newspaper seller being in effect street furniture. Covent Garden Mick was, for him, a lost soul of garrulous character blown in from Soho past.

"In friendship, as in art, agreement one does not seek; it is valueless and suspect."

"Shows I do are punctuations"

"Shows I do are punctuations. I've never worked for a show like Francis worked very quickly for: an 'African' show and 'Van Gogh' show. It seems amazing to work for a show as if the paintings have something to do with each other." Those that qualified as full retrospectives imposed a sense of order on works conceived with no such end in mind.

Kirkman, once again collaborating with the British Council, organised a fair-sized retrospective that toured for more than a year, from October 1991 to Rome and Milan, the following February to the Tate Liverpool, then to Japan and Australia. "When I had my show in Rome—went with Susanna—I remember being pleased so many people were seeing it and the poster: Susanna and the dogs, seeing that in funny places. The show was in a bit of a Ruspoli palace. They had several. (Bella was with Prince [Dado] Ruspoli—nice enough but childlike—woke up beside him one morning and decided that he was old. They were together some years.) Glamorous style: all these palaces and titles."

Man Smoking, the painting of Charlie Lumley that had been bought by a reluctant Ian Fleming as an investment to benefit his son Caspar, was sold at auction for £650,000 in 1988, by which time both had died, Caspar a suicide. The following year *Girl in a White Dress* from 1947 fetched £308,000, a world record then for a drawing. Such sums, being well above his dealer's prices, were upsetting, so much so that by 1990 Freud was pretty well convinced that Kirkman could no

longer be his dealer, not so much because of the sale prices, though these stung a little as they didn't benefit him directly, but because in a time of recession and what was proving to be—for him—a singularly productive spell, Kirkman kept telling him that he couldn't continue to buy paintings from him on completion for he hadn't the available capital and so he could only take each one off him on consignment— that is, pay him once he had succeeded in selling it. Freud expected him to buy paintings from him immediately, regardless of whether a buyer was to hand or when there had been a fall in market values of something like a third, as he was told, in the slump of 1989–90, when the stock market fell and interest rates were high.

"Over the years," Kirkman told me, "I think that basically I had brought LF good news, higher prices, etc., every time I saw him. But I well remember in 1989 warning him that I thought the art world was due for a considerable downturn and for the first time a noticeable chill entered our relationship. Over the following two years he told me that he considered his work 'recession proof,' and it is true that his paintings continued to do remarkably well at auction, partly because I tried to support the market, but general demand for this work fell off dramatically."[1]

Kirkman was not ineffectual, Freud acknowledged. "James was fastidious about whom he sold to, which was surely good, but in the recession he panicked." Not only that, he was conscientious over financial affairs, insofar as he was privy to them, and, as Freud admitted, sorted out his tax. "Everyone's guilty from some point of view. He put me on the straight and narrow rather, to do with accountants. He used to say, 'I've had my grubby little fingers on this picture.'"

In 1990 Kirkman succeeded in selling *Standing by the Rags* to the Tate for £920,000, half their acquisition budget for the year. "The painting stresses palpable reality," the Tate press release claimed. "Its subject is not only the portrayal of a naked figure in repose, but also the act of painting itself."[2] Freud took exception to that. "It is not remotely symbolical. That is what must be stressed. It can be read into it, as I can't stop anyone doing so. But it was not intended. Rags are a by-product." They were also, he decided, outstaying their usefulness as studio set dressings. Only two more paintings were to feature them. Kirkman too was discarded. His explanations (rather than excuses) were to the effect that times were hard and sales slow.

"Interest rates were high, the Tate didn't pay (delays in payment coming through) and I lost over this deal. Lucian wanted these huge sums of money, always immediately. I pointed out several times: would he consign and he'd benefit. He was always overdrawn and then there was tax and VAT. 'What you must consider,' he said, 'is that every artist resents his dealer.' He'd be better off, I told him, with another dealer. 'We can't keep up this arrangement,' I said to him. 'Consign them. You'll be all right won't you?'" It was, Kirkman added, like a marriage that went wrong: first one thing, then an accumulation of grievances and plaints and a parting. Minor irritations exacerbated the basic resentments. "He wasn't a generous man in any way. For example, Lucian always expected me to pay for meals."[3]

For his part Freud decided that Kirkman was presumptuous in telling him which charity to favour. "I got one of those prizes, like the Turner Prize. I said it should go to the Injured Jockeys Fund and he said I'd got to give it to the Artists' General Benevolent Fund. It was my business, private, not his . . ."

Frank Auerbach suggested that as a mollifying gesture Lucian might try doing a painting of Kirkman. Good idea: he came and posed, collar unbuttoned, leisure shirt, fist to cheek as though awaiting some response to a perfectly reasonable final offer; but that was as far as it went: head and shoulders, nebulous background, nothing resolved. "When things were going rather badly, when he felt terrible about not buying things from me, I did the portrait of James. He's sort of smiling. It worked really well as far as I wanted to take it." *Unfinished Head* (1991) vanished. "I've got it secretly hidden away," Freud said. It went off to Northern Ireland. "Some pictures went to Alfie," Kirkman commented. "I liked him; but it was slightly galling when pictures went to him. For the first pictures of Leigh, Lucian wanted a million [dollars] each. £750,000."

On 11 October, 1991, Sotheby's Monaco sold Boris Kochno's collection, which included the etching of a rose from 1948 inscribed "For Bebe from Lucian Christmas 1948" and possibly the only proof to exist. Kirkman alerted him to the sale. "There was the etching I gave to Bérard, *Rose*, and I said to James I'd like it. 'You can't buy that: I want it,' he said. 'We can't compete. We must agree, otherwise it's ridiculous.' 'How much?' he asked should he bid. 'It's very small; just get it,' I said. Then he rang. 'Do you want the good news or the bad

news?': then 'Yes, *I've* got it.' I laughed. 'You are mad,' I said. He'd left a bid for £38,000 and got it. So I paid £40,000, just under. I had the money, so it was possible. Poor Susanna, she was so upset that I'd spent so much on it." Kirkman's account differed significantly: "Lucian wanted to buy it for Susanna—a complete collection of his etchings was being assembled—in a Saturday-afternoon sale. Lucian said, 'I want to buy it, I've told Susanna I'm giving it to her.' I sat there bidding and bought it for £35,000. 'Good news and bad news,' I said to Lucian. 'Good, I've got it. And bad, the cost: £35,000.' "[4]

Too bad, Freud decided, and other matters also rankled such as a plan for a show of drawings in Germany and maybe elsewhere about which he said he hadn't been consulted. There was also the cancelled catalogue raisonné, which exasperated Kirkman, as did Freud's financial demands. "As LF would never consider consigning his work or etchings to me, and as he was producing more and larger paintings he clearly needed an infinitely richer dealer than I could ever be. I well recall trying to discuss this with him several times between 1989 and 1991 and suggesting that he find someone else. I would say that Lucian and I had a close business relationship. Particularly after d'Offay was out of the picture. As interest in the work grew I probably spoke to him most days and went to the studio once a week or so, but it was never a 'social' relationship and we rarely ate together or discussed personal matters."[5]

As Freud saw it, Kirkman was "obsessionally" buying up whatever works he could find either on the secondary market or stray early items, such as the drawing of Lorna Wishart in the ocelot coat from 1944, owned by her and, he maintained, retouched by her, thereby effecting that cliché complaint of those dissatisfied with the look of their portraits: "something wrong about the mouth." He insisted that any drawings he considered substandard needed destroying and there was Kirkman buying scraps and persistently compiling data on him. This led Freud to attribute to him psychological tics dating from childhood. "His father was Monty's favourite general which was why he had no friends as they moved around all the time and never settled." Yet, for all the grudges raked into a heap of obloquy, Freud couldn't deny that Kirkman had served him well. Nevertheless, the resentments accumulated and grew in the telling. "He gave Colin Tennant money for my pictures, which he sold to his friend

Simon Sainsbury: an anteroomful. A shrine." This Kirkman denied. "I bought them in half shares with d'Offay and amongst others Simon Sainsbury may have bought one of them." Freud: "He [Tennant] kept the portrait of him and then, awful, *painful*, for me, I gave him *Bottles on a Shelf*—which I did at Dedham—as a wedding present and he had it *badly cleaned*."

Essentially, Kirkman hadn't the resources to keep Freud contented, though Freud himself said, not wholly convincingly, that he had enough to get by on. "For the first time I got £100,000. Because I remember James saying 'keep it down' (the price) and I remember saying I *really* needed some debt money, *rather badly*, and I actually said, 'I want rather more.' 'You're right,' he said, and after that it went up. James's profits were very odd. They varied enormously between some things at least double and some between 25 and 50 per cent. Actually, he was good for a very long time. Took great care." Not selling indiscriminately to Saatchi for one thing. "For eighteen years James Kirkman was the best dealer that any artist could have had. He was Talleyrand and Jeeves. Alas his morale collapsed with the art market [collapse] and when I discovered he had arranged a travelling exhibition in Germany and Austria consisting chiefly of scraps that I would have destroyed had they been in my possession, I gave him the boot.

"I got Goodman to write to him as he was telling other people I was under obligations with him. Sold nothing for a while. 'I can freewheel till things change,' I told him. Goodman sent a letter saying I didn't want to do anything with him, i.e. no deals, and that I wanted nothing more to do with him. He was my dealer, not my counsellor (which I may need); also, after all, we were on friendly terms but not friends." James disputes receiving a letter.

Etchings, besides being a stimulating alternative to painting, were an important source of ready cash. Lucian liked the business of selling his artist's proofs—"APs"—informally to dealers. Partly because—as on a successful day at the races—it was satisfying to come away with wads of cash in the back pocket. Kirkman, whom he expected to buy up entire editions of every etching, resented being bypassed and, quite often, left with stock unsold while Lucian was enjoying the easeful peeling off of twenty- or fifty-pound notes in betting shops, restaurants and clubs. However, there was a young dealer happy to relieve

him of the whole business. "Matthew Marks was the cause of my first and final row with Lucian. He came to see me and I was indiscreet and he said something to Lucian and when Lucian fell out Matthew took to publishing the prints himself." Marks had approached Kirkman to put him in touch with Freud years before when still a student in New York and, unaware that just dropping in was not usual practice in England, least of all with Lucian, he had come to the studio late one evening straight off the plane. They got on well and a friendly connection developed. Then, for three years from 1984, he worked for d'Offay before opening his own gallery in New York in 1991, whereupon he took over as print publisher. Kirkman, Freud said, pretty well abdicated once he declined to buy more than four prints out of the edition of a formidable etching of Kai Boyt. "Which is a good one," Kirkman acknowledged, angered though he was at the cash transactions with other dealers.[6] But who else, Freud countered, could he sell them to? "Some blue rinse? Bring her round to see them?"

"James was an extremely hardnosed professional dealer and outside his dealing generous and kind," Frank Auerbach emphasised. "I think he was torn, realised what he was doing, and was extremely vulnerable. He said to me: 'When I go and see Lucian now he doesn't seem pleased to see me.' He was a very perceptive dealer with a pretty good eye. Suddenly there was a chill. It was basically due to the recession and Lucian found it inconvenient. He put Kirkman in a very difficult position. He was just a normal dealer, and then times got bad."[7]

"Arnold Goodman was rather on my side," Freud maintained. "A good lawyer tries to bring things together." Certainly his summing-up, when asked to conciliate, was characteristically pithy. "Huge paintings of the drag artist Leigh Bowery sitting on the lavatory: Kirkman didn't want to put down three-quarters of a million to pay for them." That said, the split happened and the rest was aftershock. "Once I fell out with Lucian I didn't want to speak to him," Kirkman said. "I did say to Desmond Corcoran [of the Lefevre Gallery], 'By the way, if this goes on I'll let the shit loose.'"[8] Freud continued to seethe and marshal his grudges. Having once remarked to Kirkman that the telephone could be used as a weapon he demonstrated this by subjecting him to silent phone calls in the small hours. That was unnerving enough but furthermore, infuriatingly, the mystery caller sometimes left the phone off the hook so that the Kirkmans'

line remained engaged. Lucian shrugged and winced when I asked about this. "Is it likely? The last time I called him I said, 'Please tell me where the German show is,' and then Susanna rang him (the only time ever) saying, 'I think it's quite unfair. Why can't you tell him?' The thing is, I don't get my hanky out. He has these phobias, I could get phobias, I could get the phone people and say I have been accused of ringing these people. There are two possibilities: 1) He's making it up, or 2) He's not."

What disturbed Kirkman most was the vindictive egocentricity. "Freud has never been an artist to underestimate his own worth—in terms of cash or reputation," he said a decade later, the hurt still rankling. He mentioned that he had often seen him at the kitchen table in Holland Park going through the financial pages with as keen an interest as he showed in racing form. "I still," he added, "think of him as a great painter."[9]

After the rift with Kirkman, Diana Rawstron, since 1986 a partner at Goodman Derrick, fielded all daytime phone calls to Freud. Being, as she put it, his telephonist (a phenomenally expensive one, she used to remind him) her discretion and judgement were invaluable to him from then onwards, also her ability to deal knowledgeably and tactfully with all sorts of concerns, particularly any threat to his privacy. A red light over the studio door alerted him when he was working to calls from her or the few others who had his number, one that he changed whenever anyone to whom he had given it threatened to be troublesome. Another advance: the landlord installed an intercom with a closed-circuit camera at the street entrance, which meant that now he could tell at a glance, without having to speak, whether or not the visitor was admissible.

On the afternoon of 10 December 1991, Lucian and I recorded an interview for BBC *Third Ear*. I arrived at Broadcasting House in good time to find him already there, waiting for me twitchily in the foyer with the producer Judith Bumpus. "I'm psychosomatically early for things," he said, wary of the lift and after that the dulled hush of the studio. We started slowly, talking about childhood, his grandfather's visits to Berlin and the memory he had of Brueghel's lumbering cattle herded down a lane. That led on to the nature of painting from life,

nakedness and exposure and people's "Oh How Could He?" reactions.

"The people who think like that want to dramatise their lives in some way. People who want to give themselves the creeps. And to think there's something appalling going on is a stimulant to them, perhaps. Finally, I can't oblige someone to sit or lie or stand for me unless they are prepared to do it and also, even though they are inclined to be friends and people I like very much and that I admire or interest me (or both), I still don't delude myself that this is going to be what they really love doing. But they also realise it's difficult for me to do it and on the whole they are very indulgent about spending long hours in this pursuit or lack of pursuit."[10]

At this point Judith left the control room, edged into the studio and slipped me a note telling me to get him to be more precise and please ask him to stop letting his voice fade at the end of sentences. Both instructions I found impossible to enforce.

"I think the thing about working all the time is that you are spared from what could be a dodgy therapeutic aspect. You know: 'Unhappy? Join a cycling club.' If you work as I do, slowly, always being in the middle of things, the theme itself carries you on.

"You've got a central thing in your head and you make amendments and even surgical things within it. I'm conscious of having certain faces and heads, features and proportions in my head, of not transferring one to another. That's one reason I try and curb my obsessional side as far as subject matter's concerned, because I don't want to have a type; I don't want to be drawn in any direction. I have perhaps a predilection towards people of unusual or strange proportions, which I don't want to over-indulge. There's a boy who delivers fish at weekends who I really think I'll work from. He's so extraordinary in his proportions, his appearance, he's simply another species really.

"I'm very conscious of, as it were, Titus disease: that Rembrandt loved [his son] Titus so much he couldn't do him quite straight. I mean I love the Titus pictures but they aren't terribly good, are they? There's a sort of Titusitis.

"I don't think that I'm drawn to oddities themselves, but I'm drawn to *people* and their oddities may be part of their attraction and interest; but in the end their oddities are secondary to the nature of

the person; the stimulant of the oddities is not what it is to me at all; that Diane Arbus side—a collection of freaks—is not what I'm interested in; I'm *really* interested in them as animals and part of liking to work from them naked is for that reason, because I can see more; and it's also exciting to see the forms repeating right through the body and often in the head as well so that you see certain rhythms set up: I've increasingly tried to get movement into my figures."[11]

Lengthy sentences like that, Judith Bumpus told me sadly the next day, meant a big editing job.

Afterwards, much relieved, Lucian offered to drop me off at the Serpentine Gallery in Kensington Gardens where there was a Leonora Carrington exhibition that I needed to see. We sat in the taxi for a while eating macaroons from a paper bag as he talked about Carrington and her one-time husband, that passing influence on him so many years earlier: Max Ernst, who had been arch with him the one time they met, denying that he ever worked hard at all. It grew dark in the wintry park and with the Broadcasting House experience still playing in his head he thought aloud about what he had to show for all those years of preoccupation.

"When people forget about themselves. Human, tired, they are the thing which they themselves feel is essential to them, which is the effect they have by their presence, which is relegated to actually being alive and being there and sitting there."

Much of what he had said in the interview had been to do with insistence. And the bloodlines of personality. "To dismiss what in fact often remains right through (when your character manifests itself) what are inherited features, inherited proportions, to make judgements on them to do with behaviour, seems to me very flawed. You know you say, 'Chinless people have no will.' Well, does the will reside in the chin?

"Incidentally," he said, nibbling the last macaroon as I got out of the taxi, "I'm thinking of making a new will."

Cut off from commerce for the time being in that he had no dealer, Freud had a growing stack of unsold paintings. "The only time I've ever had a group that I owned." These he stored under dust sheets at the back of the studio. Besides what he used to refer to as the Leighscapes there were other largish ones such as *Naked Portrait on a Red Sofa* (1989–91), with Bella draped on the chapped

and perished leather, features—face, shoulders, elbows, fingers—lingered over and exacerbated with skin-toned Cremnitz white. Also, notably, there was *Two Women* (1992), involving Janey Longman and India Jane Birley, daughter of Mark Birley, of Annabel's and Mark's Club (and granddaughter of portrait painter Sir Oswald Birley). Whereas the Leighscapes were unlikely to find a ready buyer, *Two Women*, Freud contended, was more the tempting and intriguing classical two-hander, given the two Janes lying there, playing indolent, arms and legs lolling and extending beyond the confines of the bed. "Such a marvellous subject: girls together is more exciting than boys. Courbet's *Women by the Riverbank* [*Young Ladies on the Banks of the Seine* (before 1857)] is so mysterious . . . I've always been thinking about Courbet. Desmond Corcoran and others came to buy it—I was offered £700,000." That, he felt, was encouraging. "I saw my only chance was having a group of works at my disposal. I also did a drawing on canvas, six foot by four, and the drawing went down so well I left it at that. Very elegant. Matthew Marks bought and sold it." Marks, in Madison Avenue, was a reliable source of payment: the consignment to him of three etchings—heads of Leigh Bowery and a version of *The Egyptian Book* (1994)—were the start of what promised to be a mutually beneficial works-on-paper relationship.

A girl was coming once a month to take care of tax and VAT; important, Lucian told me, and in the same breath he announced that the wins at gambling had kept him for more than a year: eleven wins, one loss, which was the same as the second or third win, so he was well ahead and had a cheque from the bookie.

"In art you take a risk. Like Russian roulette with cars."

Besides the likelihood of failure with each painting as it inched into being there was the risk of dependence on others, not so much on any dealer but on every sitter. Mere attendance was not enough. There had to be rapport or, failing that, reliability; but naturally the necessary engagement was liable to fluctuate over the months, urges being primed and stimulated. As, for example, Chris Bramham said: "Janey was young and utterly devoted to Lu, she would never take money from him; she did the odd secretive errand for him. He painted Janey with India Jane as a way of changing gear in the relationship."[12] After one session he gave her a drawing he'd just done of her: life-size, nose only.

Willingness and readiness to sit was one thing; quite another was the process of vetting those who brought themselves to his attention. "People wanting to be painted because they are black, or peculiar. A man wrote to me and said, 'I'm sure you'd like to paint me because I have no ears, despite which I'm a vicar.' And also—it would probably add to the interest—one of his eyebrows had fallen off. He had assumed something, which is very much not the case I think if you know anyone has oddities, anybody could be fascinating. The stimulus of the oddities is not what it is at all." Because the need to find and retain sitters for as long as it took had become the dominant concern, Freud was constantly on the lookout for recruits in one capacity or the other. He had applicants, eager to meet demands. One, unnamed, fluttered her availability. "She's like a chicken. Free range some nights." Another woman wrote to him saying she admired him above all men and would he paint her? Rising to the bait he took her to lunch. She was a trainee nurse—promising—but talked wildly and uncontrollably and that was enough to put him off. Soon afterwards she sent an identical letter to Frank Auerbach. Almost always the desire to be painted was a disqualification.

Occasionally—rarely—Freud worked from secondary sources. In 1991, for example, he had made a drawing from an old snapshot of Esther beaming, her hair in bunches; it was for the dust jacket of her first novel, *Hideous Kinky*, based on childhood memories of the Moroccan escapade with her sister and mother. Afterwards he kept it from being sold, explaining that its artistic life existed solely as a book cover. When I questioned him on this and other instances when, surely, he had used photographs, he admitted as much. "Yes, I have done, but only to do with people I know so well that their presence in photographs was a reminder of them rather than an introductory thing. I realise why it doesn't help me, it's because photographic information is almost entirely to do with light and you recognise people in photographs through how they catch the light. I'm more interested in what's inside their heads."

The two heads reproduced in mellow rotogravure as plates 120 and 121 in J. H. Breasted's *Geschichte Ägyptens*, the book that Freud had kept by him for fifty years and which fell open through frequent reference at that double spread, appealed to him as being profoundly remote yet hauntingly present. Captioned as "plaster masks from the

studio of the sculptor Thutmose at El Amarna, Eighteenth Dynasty, about 1400 BC, Berlin, Ägyptisches Museum," they were nameless but it was possible, arguable anyway, that the face on the left could be that of Akhenaten the pharaoh (and father of Tutankhamen) who had decreed there to be monotheism in religion and naturalism in art. His reign was brief but his singular long-nosed portrait image survived and, whomsoever they represented, the El Amarna heads seemed to Freud wonderfully personal and immediate. He did two paintings from them—*Still Life with Book* (1991–2 and 1993)—and an etching, well aware that Bacon had worked similarly from a photograph of the death mask of William Blake; but far from toying with the iconic, let alone the Baconic, he saw in them a poetic closeness anticipating by well over 3,000 years something of the acuity that he was to achieve soon afterwards in his naked self-portrait *Painter Working, Reflection* (1992–3).

The sombre detachment of the El Amarna faces happened to resemble Bruce Bernard's habitual expression when bored or obdurate. Lucian was working from him at the time. Despite or perhaps because of having achieved distinction as picture editor on the *Sunday*

Painter Working—Reflection (work in progress), 1992

Times Magazine and subsequently on the *Independent Magazine*, Bruce nursed a complex about being a failed painter, Lucian felt. "There was a place across the landing at Leman Street which Bruce had when he was trying to be a painter still: lots of things he had left behind, laboured still lives. It was painful." He still saw in him something of the awkward schoolboy whom he had met when visiting Michael Wishart at Bedales with Lorna fifty years before. "Looking as if his clothes weren't right, as is very often the case with boys, especially when their mother's interested in other things. He was too big for them somehow, like when you come out of prison. He has still got that look." This same Bruce was now renowned in and beyond Soho for having salvaged a pile of Deakin's photographs from under his bed after he died and for having rescued a multitude of past photographers from anonymity and oblivion with his splendid compilation *Photodiscovery*, published in 1980. But he was diffident about his own ability with the camera, particularly when photographing Lucian. And he was even more nervous about being painted by him. Lucian did all he could to settle him into the role, short of plying him with drink prematurely. "In sessions nine o'clock to quarter to twelve, not too long," he told me. "Talks a bit because he isn't quite used to it. Bruce has a bad leg and needs rests. Stands under the light. That head: a doctor said to him 'has your head grown?'" Bruce on the other hand said that he was always anxious not to say anything that might hinder or endanger the painting. There he stood, thinking to himself, thinking back.

His father, Oliver Bernard (1881–1939), had been a scene painter and stage designer, a wartime pioneer of camouflage devices (fake hollow trees as observation posts on the Western Front) and, in the late twenties, designer of the jazzy mirrored-glass foyer of the Strand Palace Hotel. In his autobiography, *Cock Sparrow: A True Chronicle*, published in 1936 and written in the third person (referred to as "Bunny"), the key moment comes in May 1915 when Bunny finds himself to be probably the last man off the torpedoed *Lusitania*. "His rubber-soled boots gripped the sloping boards," he wrote, "as he steadied himself to turn round and face what might be the final plunge."[13] Lucian had read *Cock Sparrow* and, aware of how Bruce revered his many-talented father, he evoked something of that scene: Bunny or Bruce, stocky, dogged yet truculent, the rags tumbled behind him like sea

foaming on to the boat deck. That said, what may have been a studio re-enactment was Bruce's habitual foursquare stance in club or pub or private view. Determined not to falter through two hours or more he stood at his post waiting to be relieved with a drink, his usefulness over with. "Hey . . ." he would say, and relax into a confiding smile.

"I was very amused," Freud remarked, "to read Bruce saying that he kept his hands in his pockets because it would make it quicker. What he doesn't realise is that hands in pockets is just as much a problem as hands."

Bruce Bernard's *Vincent by Himself*, a Van Gogh anthology in words and pictures, published in 1985 (dedicated to his brothers Oliver and Jeffrey) had given him the idea for a similar volume on Bacon, primarily illustrations plus a text compiled from published articles and reviews. On seeing the dummy, however, Bacon took against the project. He objected to the mingling of source photographs and pictures and as he liked it to be believed that he had been unrelievedly disparaged in print in the early years he didn't want to see this disproved. But the worst offence—an act of unforgivable folly, Colony Room commentators agreed—was that Bruce, seeking approval, had gone and shown the paste-ups to Lucian.

On 28 April 1992, Bacon died in Madrid where he had gone to stay with his lover and haunt the Prado. The obituaries were copious, concentrating mostly on his power to astound.

There had never been a formal falling out with Freud but such relations as there were had become little more than sniping. Bacon had exhibited at the Hirshhorn in October 1989, following on from Freud, and though he still had the greater reputation, even that order of success and succession had been enough to trigger droning sarcasm. His need for admiration had rendered him impossible, that and alcohol, Freud maintained, adding: "He really minded my getting rather high prices." Yet his death shook him nonetheless. "If he'd *seen* that the work wasn't what it had been, he'd have done something about it, because the one thing he didn't lack was daring; but then he had certain ideas, which made it impossible for the work to free itself. I feel also the hollowness of the money with the approaching death."

On a hot June Sunday afternoon a month or so later I arrived at 36 Holland Park to find Lucian watching an England v. Pakistan test match on his old table-top television in the junk room of the flat. He

remarked that the Pakistanis wanted to win more than the English. "They have the *need* to win." I noticed in the studio, scrawled on the bare plaster, what could have been parting words:

"Art is Escape from Personality."

The need to go all out. Regardless. Kirkman had this to add: "The moment Francis died Lucian said to Gilbert de Botton, 'I'll paint you.' Within a week." De Botton, working with Jacob Rothschild, had set up Global Asset Management from which both Bacon (who described him to Lucian once as looking like an "Ancient Egyptian") and Lucian benefited. He was good company. "He wanted conversation to be on a very high abstract plane. I like philosophy to be things you can incorporate in your life: an Elizabeth David recipe of philosophy. Gilbert's furniture was so elaborate—ormolu—you had to use your brain to decide if it was a table or what. I think as he grew richer the distinguishing element wasn't quite so horrible." Having put his foot through a first attempt he completed a smaller portrait described wryly by the sitter himself as having a "deeply meditative expression."[14]

Opportune paintings (not to be described as commissions exactly) were offset by those embarked upon by way of refreshing contrast. Lucian told me that he was about to paint foliage and had "got the use of somebody's back garden to paint in, to get back to green." Besides there were etchings, most notably *Kai*—that is, Kai Boyt a decade on from his role in *After Watteau*, a monumental head, still somewhat bemused, docile, equine almost. "He got a music group he managed and a nice girlfriend, went to Mauritius, did very well there, said he'd been bitten by a rare fish, actually a hysterical paralysis." Kai helped around the studio quite a bit. His half-sister Ib reappeared too: the small head *Ib* (1990), determinedly yet uneasily seeing it through; on a larger scale, *Ib and her Husband* (1992), in which Pat the New Zealander husband is sandwiched between his third-time-pregnant wife and the radiator, his protective (or restrictive) arm and fist a bolt of rigidity down the middle of the picture. Separate dreams, shared pillow and, overhead, a welter of scrapings from previous works. "It was quite a tough time for me in my life," Ib said some years later. "Dad was very sweet and kind. Me with the children's father, which was a different situation. We were very close. It was more like those family portraits. It's always something I'll never do again and then I do. I

guess 'cos it's a way of having a relationship with my Dad and there's a part of me quite flattered." He would talk her into sitting for an etching. "Then I nod off. And then there's a canvas on the easel."[15]

Louise Liddell, a former nurse, had become by the time Freud painted her—*Woman Holding her Thumb* (1992)—the mainstay of Riccardo the framer in Newman Street. Lucian appreciated her enthusiasm and practicality. "Very emotional. Her emotions are proper emotions. She can carve frames." She in turn talked about him as "dishy" and sat for four to six hours a night for six months, three or four nights a week, downright and unfussy, an Ingres odalisque made sturdy, seen from above as though in free fall. "She cursed God for her fat ankles or something," Chris Bramham recalled, "and Lucian said, 'I thank God for them.'"[16]

Asked by Stuart Jeffries of the *Guardian* if Freud was a monster to work with, getting her posed in difficult positions and all that, she responded enthusiastically. "God, yes. He's an absolute beast. You arrive at the studio and get plied with champagne. He's a great cook and usually prepares something lovely to eat in the break, like lobster or game . . . You see that stomach? It was often rumbling. I mean, what a monster."[17]

"To be with him is like putting your fingers into an electric socket," she told me. "You come out spiritually uplifted. He's exciting company." Uplifted and not disillusioned. "Painting comes first and that's been a problem with the women in his life who like to fight it."[18]

"Could you make your belly a bit more interesting?" he asked her once and she did her best to oblige. A third big painting of Leigh Bowery failed to thrive and so he had it cut down. *Parts of Leigh Bowery* (1992) was a full-length sprawl reduced to two hands, a penis and a pair of thighs. Unsaleable surely, he presumed. Choice excerpt though it was, it remained a blatant offcut. "But then someone will come along and buy it." That took time. Eventually—in 1999—Matthew Marks was to sell it for what he described as "a modest price."[19]

"Lucian Freud's paintings are extraordinarily direct and therefore disconcerting," I wrote in the essay for the Japanese and Australian editions of the previously Italian exhibition catalogue, and I quoted lines he had recited from T. S. Eliot's *Preludes* during our radio session the previous year: "The notion of some infinitely gentle / Infinitely suffering thing."

This, I argued, was key. "Everything stems from how he regards what he has decided to work from. As he stands at the easel he usually sees his subject from a superior angle. Whether seated or lying down, whoever is posing occupies the picture space like fruit on a dish."[20]

Through the spring and summer of 1992 the exhibition "Lucian Freud Paintings" went from Tochigi Prefectural Museum to Otani Memorial Art Museum, Nishinomiya, and the Setagaya Art Museum, Tokyo. Then, with a few alterations, it proceeded to Sydney. The catalogue acknowledgements had needed amending. Since Kirkman could no longer be described as "friend and agent" he was afforded instead "special thanks . . . for his generous help." Lucian said that he liked the idea of his work being shown in the homeland of Leigh (for the Liverpool showing onwards he had added *Head of Leigh Bowery*, stigmatic cheek piercings featured) and appreciated that *Naked Man with Rat* had been a bold purchase by the Art Gallery of Western Australia in Perth, where the tour was to end. I was to go to Australia to deliver a lecture and, to make it up to date, I decided to photograph Lucian and the studio. A first session was a failure (my incompetence) so we had a second go a few days later. Lucian, assisted by Kai, moved the easel, shifted the bed and brought out the new full length of Leigh as I set up my tripod to secure shots of him obligingly frowning and grimacing. I also photographed the *Bruce Bernard* (1992), just completed, wedged between the first picture of Leigh and the sure beginnings of the naked self-portrait. There were now many pictures stored under sheets at the back of the room. "The collection is growing," he said. He hadn't had such an accumulation of new and unsold work to hand since 1944.

In Australia, where vampiric fruit bats circled every evening over the lush Botanic Gardens beside the Art Gallery of New South Wales, the paintings looked powerful but dispossessed, their intensity wilting a little in the shimmering daylight. Press reactions were mostly offhand or muted. What to make of such intimacies as these? Jacques Delaruelle in the *Sydney Review* talked confidently of "the anguished nakedness of his models and the haunting expression of their reticent stare." Elwyn Lynn, in the *Australian*, detected "various degrees of mesmeric repugnancy," singling out "a facially unbecoming woman" and deploring what he took to be a bad case of urban squalor: "crowding four people on to a shabby bed in a shabby, paint-peeling room,

though two have flowers floating on their frocks." Finally he ventured a dismissive thumbs-up. "There is much that is enjoyably instructive in this well-culled exhibition."[21]

In another paper readers learnt that Bruce, the brother of the more famous Jeff of the play *Jeffrey Bernard is Unwell*, who had been impersonated on stage by Peter O'Toole in London and in Sydney more recently by Dennis Waterman, was himself making an appearance at the Art Gallery of New South Wales, in an etching.

"Art," said Sigmund Freud, "is a way back to reality."

In reality Freud was concerned to attract a suitable dealer while pressing on with work in hand, urgently so. "I'm vulnerable to how things are going. I don't mean, someone saying, 'Need you give me such a big nose?' You see if I listen to them (to do with painting) that would be useless. And if they *did* know (e.g. Frank) they'd be quiet. Your dependence is really on your art. Working from a living person: it's a prejudice I certainly adhere to because it helps me; but even there you can't say it's better to work from a person; I know it's better for me, but is it better? It's not reason that affects my decisions but impulse. Intentions have no place when a person looks at the finished thing."

A number of small heads were worked to a degree unparalleled in any late Bacon or indeed in any earlier twentieth-century British portraits. They included *Head of a Woman* (a confiding Susanna), Ib Boyt preoccupied (next day's teaching maybe or lingering resentment) and a twelve-inch by twelve-inch self-portrait built up stubbornly: paint worked way beyond mirror likeness into the very nature of the concentrating face. These, and the smaller etchings also, were all the more compelling for being such a contrast to the larger paintings.

"Trying to make something that's never been seen before"

Following the split with Kirkman various dealers approached Freud with propositions. "When we fell out I thought [Thomas] Gibson, Lefevre or Marlborough would take Lucian up the next day," Kirkman said. "I was amazed he wasn't."[1] There were speculative postcards from Anthony d'Offay ("I replied, 'I'm giving it careful consideration': it was the rudest thing I could think of saying"), and letters from others. "Desmond [Corcoran] came and tried to make an arrangement," Freud recollected. "Thomas Gibson was also involved and possibly David Beaufort. I had a lot of big pictures, and James said they were too big to sell." There was a vague possibility of several dealers forming a consortium. "Nothing improper. Their arrangements were that James would be in it and that there would be huge sums for individual pictures. I was offered £700,000 by Desmond for the *Two Janes*. It wouldn't have worked." Kirkman said, "After we split I had no dealings with LF at all and no dealings with other dealers re him."[2]

As Freud saw it the unfeasibility of the situation was exacerbated by what he regarded as misconceived schemes to patch things up. "Kirkman [for necessarily obscure reasons] sold *Woman with Tulip* to Jane for £40,000 after the Australian tour. Slightly mad." As for him, he needed to survive and it took courage to persist without having any buyers. Particularly as regarding the Leigh Bowery paintings—he was in the middle of a fourth one—for these he felt were best kept back anyway for his proposed exhibition at the Whitechapel the following year. "Lucky I had all those paintings.

"I made some [by gambling: the horses] and was quite cautious, not having a definite outlet. For six months I sold nothing. It was OK. Acquavella writing to me was a great stroke of luck." The overture was prompted by David Beaufort, Beaufort claimed.

William Acquavella, a specialist in Impressionist and Post-Impressionist works, whose father had founded the gallery in 1921, had the previous year bought the entire stock of the Pierre Matisse Gallery: 4,700 works for $153 million; eighteen months later he'd made $300 million from them, selling them in packages. "It's good to be nervous," he said. "It keeps you sharp. It keeps you working."[3] His gallery on East 79th Street, close to the Metropolitan Museum, had been the premises of the once notoriously pre-eminent trans-atlantic British dealer Joseph Duveen. As Acquavella saw it Freud approached him, not the other way round. "I was more into Picasso, Matisse, Miró. And I'd heard that Lucian was difficult."[4] Anyway, they had lunch.

Later that afternoon Kai let me into the flat and Lucian darted out to say hello and that he had visitors in the studio so I sat in the kitchen while Kai made tea. David Dawson, who was reading the *Independent*, looked up and remarked that Sidney Nolan—Lucian's long-resented nemesis at the Marlborough—had died. Then there was muttering and cordiality in the hall, a glimpse of handshake and the visitors left, the door thudded shut and Lucian came into the kitchen elated. He had secured an arrangement: money for two years plus, a show next May with a dealer who, John Richardson had assured him, was as good as he could get. Having sold only one picture in the past year (and that to Jane Willoughby) he was now well set with plenty of paintings ready for sale. "It was odd. Acquavella said when he came he was embarrassed how to get it out—asking me—and then he *had* to have things of Leigh. He said he was frightened of taking me on." Acquavella's account of the deal was more businesslike. "We met and I went to his studio, saw all those huge Leigh Bowery paintings he'd been working on, I was knocked out and bought them all. We never had a piece of paper between us." Within half an hour it was agreed: "I would represent him worldwide. He said 'fine,' we shook hands and that was the end of it."[5]

"Bill gave me a two-year advance as I hadn't sold anything for well over two years and said if they didn't sell he'd keep the pictures.

If he sold them he'd even it up, and if more . . . He just needs to sell two or three a year. Apart from Anthony Caro, in the early eighties, he never had any contract. I've a sort of contract."

There would be some sorting out to do. "Acquavella was concerned about 'things that might come out of the woodwork' such as scrappy early works." Freud had reassured him over this, telling him he'd always been careful to thin out as he went along. But besides that there was a matter of some urgency. "I've got a bookie and I've got a problem with him." Besides buying in the ordinary way Alfie McLean had taken paintings to cover betting losses. Alfie was owed $3.5 million (c. £2.8 million). Acquavella, after initially thinking any debt would surely be less than that (£100,000, say), settled that and was assured that the problem would not recur. He didn't gamble any more, Freud said. Though this proved not strictly true, he did find the thrill of the bet less compelling once regular infusions of wealth dulled the risk. He himself was now set to become a New York and New World—not to say global—front runner. His prospects had shifted for, shown the three large Leigh Bowery paintings, Acquavella made it clear that these were paintings with which he could do business, whereas the smaller early work would not have suited him. Size was critical. So much so, he averred, that no way would Lucian ("Looshian" as he pronounced his name) have gone on to become a global phenomenon without producing works large enough to command "serious" interest. "We were able to open up an American market to him in 1993. Prior to that he didn't have much access to the international market. That made a big difference."[6] In addition, Lucian said, "Charles Saatchi, such a stupid man, did me a good turn later: just because I wouldn't sell him *Nicola in the Attic Doorway* he was so angry he put them all for sale. Acquavella bought them."

Naked Man, Back View went to the Met for over a million dollars. That sale was notable enough in itself but the queue of valued clients responsive to Acquavella's assured manner when it came to completing a sale was what impressed Lucian most. "That blind man who was in Las Vegas—Steve Wynn from Hungary—spent $150 million with him. I'd say to Bill, 'I'd much rather not have pictures there, in Las Vegas,' but, as Bill said, '$17 million: a good buy.'" Acquavella, he added, was "painfully pessimistic always. Has a marvellous eye. He's

got a sort of real feeling and liking. He dances. Dancing and ice skating are skills it's hard to lose."

David Dawson summed it up: "Acquavella could afford him. And enrich him."

On 8 December 1992 Freud was seventy. We recorded a conversation for the *Observer* to coincide and celebrate. "Oh yes: Feast of the Immaculate Conception. You've got to pass that barrier: three score years and ten. I've ordered a huge canvas seven by five." He went through the edited transcript with me, trimming phrases and adding intriguing bits about Princess Marie Bonaparte and how he "stole a lot of gold," wanting this published, he said, to see if his brothers would now kick up a fuss. (They didn't.)

We had talked at some length about his grandfather.

Do you read him?

I've read certain things. I've read the case histories he did with Breuer. And there's a volume Humour and Mania: I went through that looking for jokes and there were lots of really good ones.

My grandfather was forced into neurology because he wanted to be a surgeon but anti-Semitism had closed those ranks and surgeons had already established themselves to the point where they kept Jews out. This science, which he invented, was after all to do with extreme cases. My grandfather was adamant that to be an analyst you had to be a fully qualified medical doctor, and whenever he examined any of his patients—whatever desperate state they were in—he gave them a complete and thorough physical examination. That seems to me right and proper.

What would you do if you didn't paint, do you think?

Well that's why I can't celebrate my seventieth birthday! I wouldn't mind sitting for people I really admire, so I could help bring something about. I use up all my patience working.

Bringing a painting to completion. Would that be in the end like steering a boat, or horse riding?

Except that the horse riding or steering: when you do either you can have a lovely boat or riding holiday but the

difficulty if you're trying to make art isn't any fun at all. Trying to make something that's never been seen before. And personal. And being fearless.[7]

At the *Observer* there was some concern about putting a naked Leigh Bowery on the front page of the "Review" section. Eventually it was decided that the painting of him spreading his legs between bed and floor should be put near the bottom of the page so as not to be overly conspicuous. That did nothing to stem a flurry of letters from readers complaining that flagrant (male) nakedness was not what people wanted to see over breakfast. "This pollution of our Sunday reading," as someone from South Glamorgan put it. And from a Mrs. Savage came: "After viewing the 'portrait' of a fat ugly ageing poseur exhibiting his genitalia and arsehole in the name of 'Art' on your front pages you may forget any future purchase of your paper by this family." Acquavella sold *Nude with Leg Up* to Jim Demetrion at the Hirshhorn where it was well received.

"Though I hope to strain the onlooker's sensibilities, what I'm really interested in is outraging my own one," Lucian commented. Leigh, he added, was of course provocative but it wasn't just that. "Someone who wasn't a dancer couldn't move in the way Leigh does, couldn't be relaxed in the positions in which he lies." They had mutual stamina, competitively so. "I've increasingly tried to get movement into my figures and he's helped me very much."

That sense of movement and the charged effect of two people interacting became the concern in *Ib and her Husband* completed in 1992 and on a grander—indeed, Prado-worthy—scale *And the Bridegroom* of 1993: paintings in which Ib Boyt and Nicola Bateman were similarly posed (though Nicola was naked and Ib clothed) while their respective partners lay behind them, Pat Costelloe with one arm clamping his pregnant wife while the sprawling Leigh faced away from Nicola, lavishly relaxed.

> *Lovers lying two and two*
> *Ask not whom they sleep beside,*
> *And the bridegroom all night through*
> *Never turns him to the bride.*[8]

Freud remembered Auden telling him that he particularly liked that verse. "The fact that 'nothing happened.'"

While Leigh told people that the working title for their big picture was "A Fag and his Hag," Nicola, playing Titania to his Oberon (or Bottom), took the painting to be a celebration of their relationship, an idyll no less. "We were very close when it was painted as well as physically close. Totally at peace with one another," she said. "And I've always liked the picture because my leg's on Leigh's and it shows the intimacy that we did have, not in a sexual way necessarily but just very intimate." Leigh, she added, relished the role play. "I think he was quite pleased with the way his willy falls."[9] As for Lucian, he said he was surprised at the relative ease with which the painting had progressed and resolved. So much so that he decided he preferred it to his naked self-portrait, though Acquavella paid him more for that. One afternoon a week or so later, as we speeded down Star Road into Greyhound Road to lunch at the River Café (where he banged into a parked car reversing and drove quickly away) he crooned the ballad from *High Noon*: "Do not forsake me, oh my darlin," on this our wedding day." That chimed in nicely with the Thomas Hardyesque disposition of *And the Bridegroom*.

"The only point of titles on the whole is to distinguish one picture from another, rather like Fugue in C Major (Moonlight). The title roles are generally passive, or ostensibly so. The sitters may be alert or they may doze. I just want them to accept the fact that I want to go on until I've finished. They make it all right to paint them. I don't feel I'm under pressure from them. *And the Bridegroom*: I quite liked that title. That 'How Young They Were' kind of look."

That look, that dispassion, presented with such lucidity between black screen (a hint of Hispanic triptych) and grey dustcover (as swish as any Velázquez drape) came about after one false start and toying with the idea of including a mirror image. (He later gave the abandoned canvas to Nicola.) For Nicola the painting was elegiac: a show of easeful compatibility. "I could take whatever Leigh dished out, which could be cruel, or horrible or fantastic, because I chose to love him." The following year, in May 1994, they got married, an event that Leigh passed off as "a little private art performance, just between ourselves," though a more serious motive was soon to emerge.[10]

By then the relationship between painter and sitter had run its course from provocation into something approaching over-familiarity. "Picking his brains is something I like doing," Leigh had told me. "I didn't feel vulnerable, except early on. There are days when very little happens. 'Today's gone backward,' he'll say. If Lucian seems to be annoyed it's difficult to locate the cause. Ten minutes late? He's never said, 'I'm in the most rotten mood.'"[11] Leigh was often the irritant, no longer always available now that he found himself in demand for celebrity appearances. He wasn't above getting up to tricks when Lucian left the room for a phone call or whatever, even going so far as to add an undetectable dab to the painting in order to be able to boast later about literally having done his bit. Busy as a dung beetle hurrying with his spoils, he took bundles of smirched paint rags home to fashion for himself a scratch portrait of Hitler. It later emerged that, as a lark, he also filched a painting or two. Leigh liked the turnover in images of him but the process was getting to be too demanding. Boring possibly. "The pictures leave the studio. You don't have time to reflect. He's structured his life so that he can work, no distractions except the occasional sore shoulder, good at check-ups with the doctor, acupuncture and weekly masseur."[12] This health-conscious, not to say hypochondriac, Freud completed four etchings of Leigh in 1993 and paintings too, including one of him on the sofa, head to the fore and a stripy taffeta skirt to the rear cutting in like a swatch of Toulouse-Lautrec. The larger the better, Leigh thought. "I think he figured that very quickly and I like them the most. The first picture kept getting bigger: four extra feet on it."

Then came the idea of a large composition as elaborate as *After Watteau* and practically the same dimensions. Leigh would feature together with Nicola, Cerith maybe and Pluto possibly. Though slightly smaller than *And the Bridegroom* (which, predictably, was rejected by London Underground as the Whitechapel exhibition poster: "Tube wouldn't wear it"), this painting would be more freighted with contrasts. It was to be called *Evening in the Studio*.

"I can never say that it's finished"

Evidently there had been some incident in the distant past of the war years when Lucian and Francis Wyndham, novelist and littérateur, had not got on; both of them however remembered having become better acquainted when staying in Ireland in the fifties with the Devonshires at Lismore. Francis had been given a narrow bedroom in the bachelor quarters and Lucian had dropped in on him, "talking about books and so on and being brilliant."[1] Previously Francis had seen him every so often but had always felt that Lucian operated on another social plane. "We were acquaintances and contemporaries and never had a quarrel."[2] The proposal to sit, put forward by Janey Longman, came as a surprise.

"He rang me once or twice, asked me to lunch. I was very pleased. Then he came round, arrived almost at once, and seemed rather self-conscious. We drove off in a marvellous car to the River Café (frightening), he didn't say anything, seemed very nervous and troubled. Suddenly in the middle of lunch he said, 'Can you sit?' And the whole thing was easier once it was out and fixed. After lunch he came back with me and looked at my wardrobe, such as it was, and chose that sort of pink shirt."

The plan was for him to sit early two or three times a week, starting at 5:30 a.m. and ending at 10.

"I just sat there," Francis Wyndham said. "There is a great sense of intensity. He consciously tries to last longer than the sitter."[3]

"I've known him an awful long time," Lucian said, explaining why

the idea of painting him so appealed. "He had a passion for a huge café in Marble Arch above the cinema. He'd take me there to see people. He lived with his mother." She was Violet Leverson (daughter and biographer of Ada Leverson, friend of Oscar Wilde and, as a short-story writer, apt to be compared to Saki). His father, Colonel Sir Guy Wyndham, brother of Dick Wyndham, was in his eighties when Francis was born. A softly bulky figure with a semi-open-plan cell of his own on the *Magazine* floor at the *Sunday Times*, where he worked in the seventies, Wyndham had written with elegant asperity on the Krays and Gilbert & George; he had helped Caroline Blackwood set up as a novelist; he had retrieved Jean Rhys from impoverished obscurity, getting her to complete *Wide Sargasso Sea*, and he did much to encourage Edward St. Aubyn (married to Janey Longman) with his Patrick Melrose sequence of novels, greatly admired by Lucian, extending as they did in lacerating style through episodes of incestuous buggery, drug addiction and Princess Margaret's ludicrously imperious conduct at a country-house weekend. Talking to me at that time and for *Lucian Freud: Portraits*, a film Jake Auerbach and I made in 2002–4, he remarked on the turbulent nature of art circles as described by Lucian. "This art world seems to be full of these tremendous rows: classic row with Bacon. The *passion* that goes into these non-sexual relations: 'I like violent theatre,' he says." Being a particular friend of Anne Dunn, Caroline Blackwood and Janey Longman, among others, Wyndham was perturbed by the way Freud talked about certain friends of his, some of whom he may not even have known but nonetheless were, he said, ghastly. Bruce Chatwin for example, and David Sylvester. "Lucian lives in a world of deep loyalties and friendships and antagonisms. It always interests me when he dislikes people. He does very brilliant, elaborate, slightly dotty explanations as to why. Sometimes really wild, unconvincing, and wouldn't stand up in court. Can do a brilliant demolition job. ('Sylv always gets into the winner's enclosure . . .') He has a tremendous sensitivity to his interlocutor. He's so interested in feeling and emotion, perhaps he's interested in that rather than what they really are. It makes everything very dramatic. A lot of people would be accused of being 'genteel.' He'd say 'squalid' a lot. He told me that when he paints on his own he makes a most terrible din."[4]

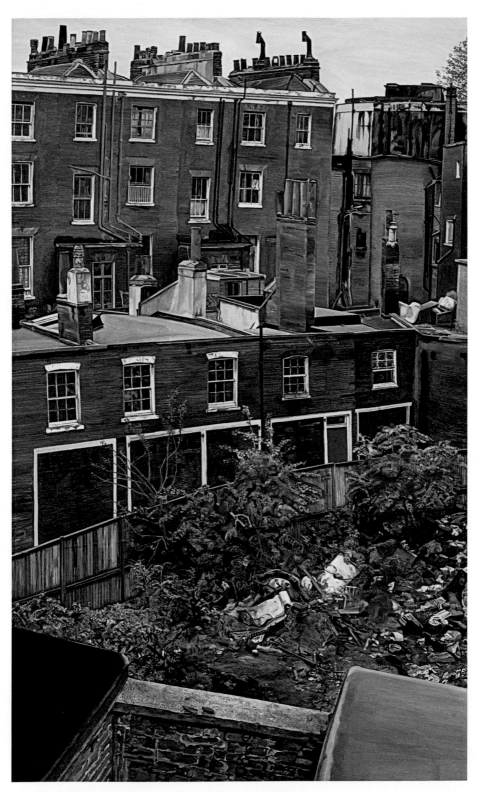

Wasteground with Houses, Paddington, 1970–72

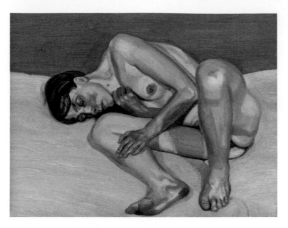

Small Naked Portrait, 1973–74

Last Portrait, 1974–75

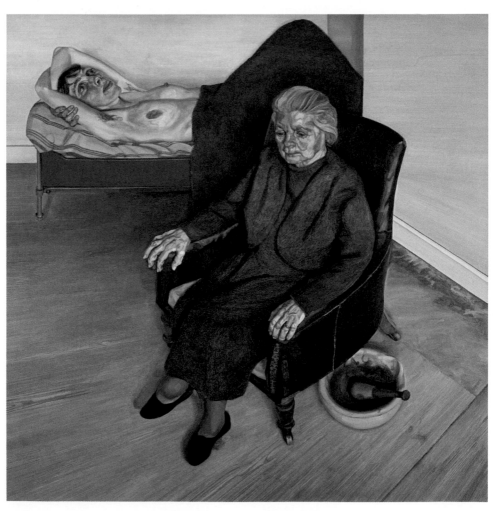

Large Interior, London W.9., 1973

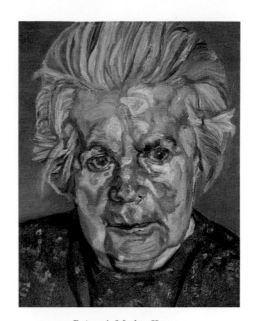

Painter's Mother II, 1972

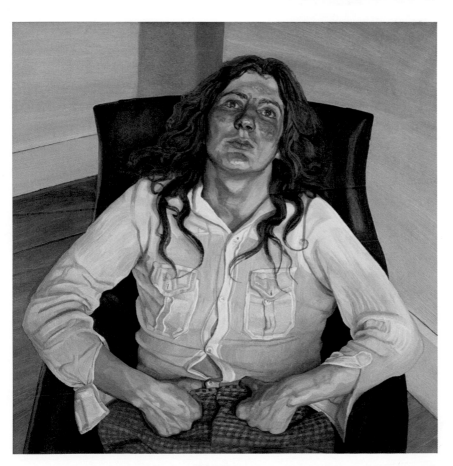

Ali, 1974

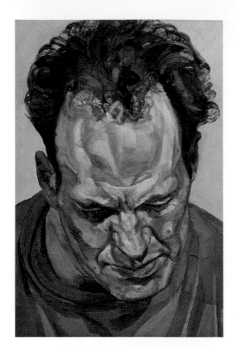

Frank Auerbach, 1975–76

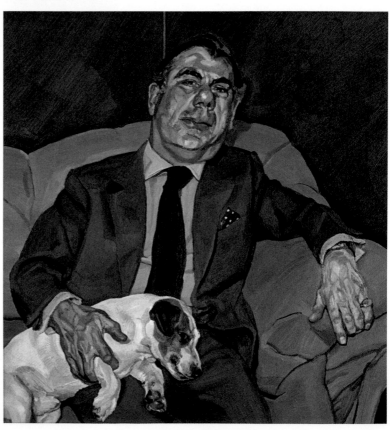

Guy and Speck, 1980–81

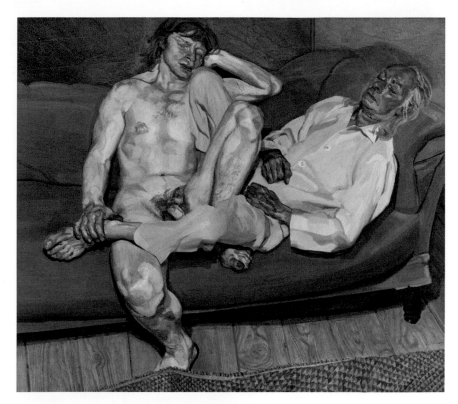

Naked Man with His Friend, 1978–80

Two Plants, 1977–80

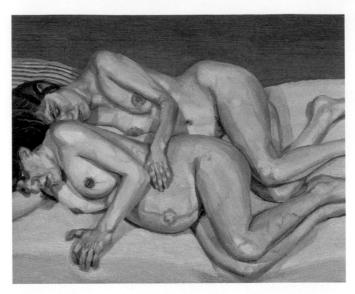

Annie and Alice, 1975

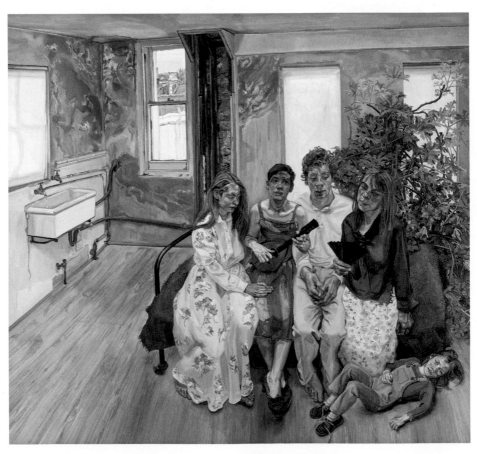

Large Interior W11 (after Watteau), 1981–83

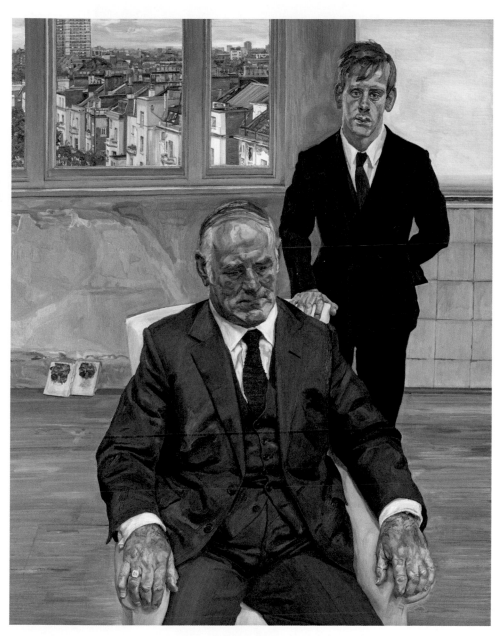

Two Irishmen in W11, 1984–85

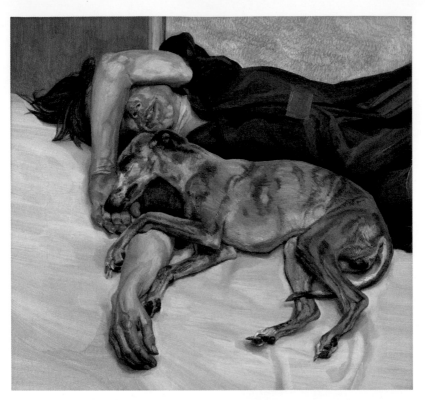

Double Portrait, 1985–86

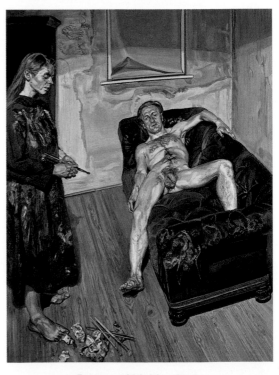

Painter and Model, 1986–87

Having been painted by both Robert Buhler and Lawrence Gowing, Wyndham knew what was called for. "I just sat there. He marked in green chalk for the kitchen chair—we kept on losing the marks—and the mirror he put a blanket over so it was blinded."[5]

The sittings were congenial, never more than twice a week. "On the whole the sessions were a great treat and great fun. He'd sometimes offer me tea, boiling Evian water, and there'd be a lovely cake or macaroons, greedily accepted. He couldn't have been more considerate and polite. There was almost too much for us to talk about, and we both sort of remember wartime, same sort of people, and would remember friends in common, and he is so interesting about books. He'd get absorbed and I'd stop talking; I was frightened something would go wrong.[6]

"I was wearing a rather hideous sort of reddish shirt—'the rhubarb-coloured shirt'—terrified something would happen to it in the launderette. When the phone rang—a red light goes on in the studio when the phone goes—he'd vanish for quite a long time and I'd stroke the dog. The whole thing took nine months to a day—August to May—and suddenly he put the brush aside and said, 'It's finished.' He didn't walk me to the door as he was looking at it. He's famous for being unflattering but I think he has rather flattered me. Anyway, he's made me look interesting."[7]

Freud's Wyndham ended up quite decisively meditative ("I had worries but worries weren't my main mood"), part way to becoming something of a soulmate to the ancient Egyptians from Breasted's *Geschichte Ägyptens* poignantly depicted that same year in *Still Life with Book*, his eyes being aware, whereas theirs look sightless. "My idea of myself is unlike how I appear; it's a wonderful painting of someone. I don't feel exactly flattered; I don't feel in any way exploited or caricatured; it seems to me a picture I'm very interested in and can forget it's me."[8]

"Did you see the *Naked Self-Portrait* in the studio?" Lucian asked me towards the end of November 1992. "Suddenly that's going. There's an end in sight for that." That end receded. Adopting the same stance as Bruce in his *Bruce Bernard* he worked his way down from head to feet at a fixed distance from the mirror reflection. Six feet or so: just far enough to secure his image full height yet objecti-

fied, diminished slightly and contained. "You've got to try and paint yourself as another person." This was to be, he hoped, the painting with which to conclude his forthcoming Whitechapel exhibition, a sort of salute, left hand raised with palette knife readied to scrape, right hand gripping the daubed palette. Having begun it in January 1992, he worked on it until the end of August the following year up to, and beyond, the curatorial deadlines.

Behind the image of scrutiny and salutation lay more than self-esteem; old rivalries were being addressed, for this was ultimately Freud's riposte to other presences: Bacon's spongiform solitaries and Balthus' showcased Humberts and Lolitas. In October 1989 there had been a Balthus show at the Lefevre; Bacon had looked in and was incensed, Lucian said, at the prices he fetched. "He was shouting, sneering, furious. I went to see Balthus, we had dinner at Desmond Corcoran's, and I asked if I could draw him. He was in the Hyde Park Hotel. I drew him there one afternoon." No longer the "petit rat" of Marie-Laure de Noailles' salon, he was now a pensive valetudinarian, eyes averted. Lucian remarked that his late work had that look of "a kind of murderous book illustration."

It so happened that five years previously James Lord, biographer of Giacometti, had written an article for Hilton Kramer's *New Criterion* in which he talked of Balthus' "ongoing dalliance with the make-believe."[9] Freud had written to Kramer saying that it was "a sneering article" and, were he to decide not to publish his letter, would he please forward it to Lord, whom he had always disliked. "I'd just been reading Flaubert's letters and I wrote, 'With all the trouble you've taken, there's not one point where I'm reminded of Balthus in what you say and, for those who care about art and love, the only conclusion to draw is that the writer is a poisonous cunt.' Sylv was friendly with James Lord and he saw the letter on his desk and said, 'I'm sorry Lucian feels like that about it.' Then, when Balthus attacked me for being German and Jewish, Lord wrote about how sad it was that I was 'a famous cultivator of enemies.' What I don't want to have is false friends."

And now, it so happened, Balthus and a neighbour of his in Switzerland, the rock star David Bowie, recorded a conversation for publication in the Autumn 1994 edition of *Modern Painters* during which Balthus waxed querulous.

For instance I have a horror for dear little Freud who, I was shocked to hear, that he is seventy now. He was a charming young man, which I knew when he came to Paris about 30 years ago, or 20—I don't remember now—I was really shocked by the last thing I saw. So Berlin painting.

That's the influence of Francis. As though some cancer is forming on the skin [Bowie explained]. *There's a shocking feeling to his work.*

Well I haven't seen the paintings themselves.

They're very odd. The use of paint is most strange. It resembles a growth of some kind.[10]

Cynical in the presence of so cultivated a Living Master, Bowie was nonetheless right about the "strange" use of paint and the "growth" involved. Not that to be producing a full-length naked self-portrait at seventy made Freud a claimant assuming the role of "England's greatest painter," a nonsensical accolade. All it stood for was the recognition that there he was, resolute and intent, there in the workaday studio, behind him a rumpled bed. It brought *King Lear* to mind. "Is man no more than this? Consider him well."[11]

"I did three small canvases getting gradually larger and scrapped them, as very often happens. Got another canvas and restarted it and then, when I started it again, it looked clear to me. It was something I had always wanted to do: something that didn't look specially like one of my pictures." Compared to, say, his *Interior with Plant, Reflection Listening* twenty-five years back, this was not only full exposure, it was a stripping down to the painter's essentials: him alone. The fourth attempt worked eventually. He had had to do it, he said, quoting *Les Fleurs du Mal* ("Oh Lord, give me the strength and the courage / To contemplate my heart and my body without disgust") and reciting—humming mainly—the Tex Ritter ballad from *High Noon*, "I do not know what fate awaits me / I only know I must be brave / And I must face the man who hates me / . . . / Or lie a coward in my grave."

"When I do stare, see how the subject quakes," quoth Lear. Lucian himself said: "I don't accept the information that I get when I look at myself and that's where the trouble starts.

"Likeness becomes a different thing—partly it's the reflection—I have to do what I feel like without being an Expressionist." The fol-

lowing morning he rang up to tell me that he'd become headless. He admitted that the daily confrontation was, at times, unnerving. "It's more difficult than painting people, I find. Increasingly so. The psychological element is more difficult. I think that the way you present yourself you've got to try and paint yourself as another person. The difficulty comes from there.

"I like what that painter—James Pryde—said: 'One foot in the grave and another on a banana-skin.' My self-portrait got so bad it ought to have been one of the nastiest things that have ever been done. It just looked so horrible." Inches were added to the top of the canvas to relieve what had become stifling.

In late July he took a few days' break, Saturday to Thursday, from his portrait incubus, having worked on it up to the last minute before leaving to catch the plane to Italy. "Near Arezzo, by the motorway. Bella's going to be there." He travelled with David Beaufort who stayed with Tony Lambton while he went off with Susanna who was waiting for him at Pisa airport. He reported that he'd bought denim shirts at the airport shop and at Susanna's house he'd had a swim. "Actually a paddle in the pool."

Faced once again with the painting on his return he despaired a little at the ageing evident in it. "I've been working on it in the dark. It's like scratching the head. The first day I reworked it, it turned out to be my father." He then became tentatively optimistic. "It's got a better body and remade from the neck up. I put lots of different expressions in and obscure them. I don't want to make a Schnabel of myself," he added, punning the German for beak (or schnozzle) with a peck at the ever-assertive Julian Schnabel. "I can't pretend there's a method. The neck has to be a bit different. It thickened (very Giacometti) the getting it by the throat. It's a result of going on and on. I don't set out to use thick paint." The neck became encrusted, the build-up of paint cupping his chin thereby reflecting (not to say labouring) the concern about scrawniness that had led him to muffling his actual neck with a silk scarf when out and about. "Especially when I'm feeling ill," he explained. "I'm very *dancing around* rather. Rather muted greenish background. Subdued: that's the word. Colours as Londony as possible.

"The naked body has done some quite good modelling," he added. "You see the thing is I can't scrap it because then I'd be doing

away with myself. Leigh's body is his instrument—he's a dancer—and my body is . . . Well, all those things are private."

Exercised about the Whitechapel show, now imminent, he phoned me daily through the late summer reporting on the state of the self-portrait and his annoyance over the lengthy catalogue essay by the Director of the Whitechapel, Catherine Lampert. "Personal, inaccurate, feminism bits, split infinitives." What particularly riled him, he said, was her suggestion that Manet's remark about Degas ("He lacks spontaneity, he isn't capable of loving a woman") was applicable to him. "It rings true then when the comment is repeated," she wrote. Francis Wyndham had gone through the whole piece with him—four hours it had taken—suggesting amendments but there remained what Lucian regarded as an impertinent slur. "She irritates me rather, talks about me in a rather presumptuous way in the catalogue. Thinks my things are loveless." This, he said, was fundamentally objectionable.

"I think there *are* people who are loveless. Michael Ayrton." The offence wasn't just personal, he maintained. Implicitly it degraded the work. "Something I really dislike in some art is German art with 'love' in. Landseer has got a lot of hate in his: the sentiment in his pictures reads as panic. Terrible the way he made highlights-in-the-eye appeal. Dogs playing chess: rather well drawn, but if you poor pets didn't give Landseer a 'human' look you were for it."

By mid-August the self-portrait was advanced enough to be photographed for the catalogue and listed as "work in progress." But shortly afterwards he rang me to say that Frank had seen it and thought the head "a bit postage-stampish." There was no denying it. "I couldn't say I can't be bothered. Titian keeps your attention by making heads slightly too large or too small: one of his ways of keeping us on our toes. The head is a limb of course but . . ." This one seemed not only smallish but also inexplicably deferential. "Sometimes things that go wrong with me are through concentration, like when you forget to put your trousers on."

Then came a turn for the better. He sounded relieved. "It's happier. I never like things to have a specific expression. I doubt that you can say about it, like people do say, 'Cheer up, it may never happen.' Except about the body perhaps." The following day, 29 August 1993, the painting was reproduced on the *Observer Magazine* cover. "Perhaps it will be done with, definitive, by the time the exhibition opens,"

I wrote. Lucian suggested that a note should be inserted under the photograph. "For final version refer to painting."

"After a certain point the picture itself takes over. And on the other hand the more that goes down the more everything affects everything else, which means that I can never say that it's finished."

The laceless boots with which he shod himself when working were to arouse comment. That cloven-hoofed look: was it diabolic or animalistic? Neither. "Didn't want to get splinters in my feet."

Acquavella paid a million dollars for *Painter Working, Reflection*. "It's a bit special," he explained, and promptly sold it to Si Newhouse of Condé Nast, a deal that happened to coincide with the publication in Condé Nast's American *Vogue* of an article on Freud by Kennedy Fraser talking of "small bare buttocks, hands slid between thighs . . ." and "a suggestion of recent sex," wrongly identifying the posing child, Ib in *Large Interior, Paddington*, as Rose. That is, the writer was seemingly unaware, or maybe not, that Rose was a daughter. Not only that, she was also referred to as the subject of "his most erotic portrait of all, lying in open surrender . . . perspective of a lover."[12] Lucian had been worried about it since hearing of it in May: "a silly article." He said that it couldn't affect him but it did affect the girls, so he went to the notoriously aggressive lawyer Peter Carter-Ruck who told him that he couldn't sue in the United States, where the libel laws don't apply to public figures of which, he understood, he was one; so writs were served in London. "Rose was rather pleased to be co-plaintiff." Significant damages had been mentioned for each party, money that he would divide among those daughters specifically defamed. They won: full retraction plus costs (and an undertaking from named daughters that they wouldn't sue).

"Si Newhouse wanted a Leigh picture, a small head [*Leigh Bowery*, 1991], but I couldn't have it sold to him while the case was on. The best way out was to give it to the Tate."

The installation process at the Whitechapel was of no great concern to him, Lucian maintained. "Frank's hanging them again. I had the idea of leaving a blank on the long wall upstairs. One of them, of Rose—my Rose—I was quite pleased it wasn't hung. They need hanging low because they are painted from on high." Trust Frank, he repeatedly said. Not to be trusted was William S. Lieberman, chair of twentieth-century art at the Met, who had removed the glass from the

back view of Leigh despite Lucian's insistence that glazing protects oil paintings and is preferable to varnish. That wasn't his only complaint. Lieberman informed him that he had already mixed an "old library white" for the walls and would hang the paintings only very slightly lower than was his usual practice. "Lieberman is barmy, saying 'Do you trust me? Do you trust me?' repeatedly.

"He asked what music I would like for the preview. I said I'd like the pictures hung low: *that* would be music to my ears. I'd have 'The Flight of the Bumble Bee' very loud, non-stop. I'm completely unmusical." True: when singing Lucian was apt to start on a low note and fail to get lower. Then it was suggested that he might care to view the hang on the final day of installation. That, he grumbled, would be like being asked whether for your last meal you wanted butter on your peas or olive oil. The idea had been that he would fly to New York for the opening but now he jibbed at the prospect. "No point my going to New York—haven't been for forty-one years—unless I have something to do with it; artists may be dud at everything else but one thing they do know is how their work looks. Bill [Lieberman] was a hysterical queen. Remember the woman in *L'Âge d'Or* making love to the statue and starts sucking its feet? That's him. Self-important. He makes these dramas and it's a question of keeping him calm." In the end Lieberman conceded a little, to Lucian's relief. He decided that the Edward G. Robinson role in *Brother Orchid* (a film he'd seen in Dedham in 1940) was more his line: this gangster who finds himself in a monastery and, having taken the name Brother Orchid, sorts out his co-star rival Humphrey Bogart. By July he was talking of stopping the show, knowing of course that this was something he didn't really want and his dealer wouldn't wear. "My spectacular thing of cancelling it. Can't do that because of Acquavella." Instead, he said, he would like to be driven blind, straight into New York, well after the opening. He accepted however, more readily than he liked it to be known, that some advance promotion was desirable as well as necessary. Philippe de Montebello, the Met's Director and, Lucian was pleased to know, a half-nephew of Marie-Laure de Noailles, assured him that "just a few interviews" were all that was required of him. A lengthy feature in the November issue of *Vanity Fair* resulted: "The Naked and the Id" by Martin Filler, who lingered over the hazards of encountering one whose "antipathy to journalists, critics, and historians is famous

in the art world" and added that "members of Freud's inner circle risk banishment if they speak to the press about him." Happily, following a midnight phone call ("For some reason my friend Jacob Rothschild wants me to speak with you"), a breakfast meeting took place at the Connaught Hotel ("Man with a recording machine came to see me from *Vanity Fair*"), enabling the writer to expand on the concept of "Lucifer Freud" being "an avid womanizer, absentee father, inveterate gambler, rival sibling, phobic non-flier, and bearer of a curious persecution complex." He quoted Charles Saatchi as saying, "I find him completely beguiling. Bewitching in fact."[13]

Lynn Barber, reputed to be the most incisive profile writer in the British press, who for ages had been attempting to secure a Freud interview, got his address off Bruce Bernard and tried again. "She said, 'Surely you must go out to eat or to the dentist?' I wrote saying, 'Your letter makes the assumption that there's some need to read or write about it. I do eat and therefore go to the dentist; but that is some way from being shat on by a stranger." That dealt with her; she framed the letter and hung it in her downstairs lavatory. Subsequently he agreed to talk to John McEwen of the *Sunday Telegraph* over breakfast one day; skittishly it transpired. Eight, he revealed, was his favourite number. "When I see an eight I'm like a little old lady whose ship has suddenly come in. My birthday's on the eighth, I always back eight at roulette and if I think of telephone numbers, I usually squeeze out an eight, one way or another. I've never painted an eight directly but I quite often use canvases that measure in eights or divisions of eight and I'll sometimes round up, say, 26.5 inches to 28 to include an eight. I used to like a motorcar in my youth called a Ford V8, which was presumably called that as a result of market research to attract people like me. I'm probably just one of a huge banal group of eight-suckers."[14]

Following that twinkling stream of consciousness he came up with a well-founded aphorism. "I think in good pictures there isn't such a thing as 'background.'"[15]

On the same day, 5 September, the *Independent on Sunday* published several photographs that Lucian had found at his mother's ("she kept everything") and stuffed into his plan chest. "Plus one of Francis and me outside the French Pub that's been used before. I'm in danger of being rather near to *My Hundred Favourite Photographs of*

Myself by Rudolf Nureyev." In the accompanying article Bruce Bernard speculated on the importance of family background. "His mordant power depends, I think, on having been a refugee and continuing to be one, unpleasant as that word used to sound from the mouths of polite middle-class anti-Semites before and after the War."[16] Andrew Graham-Dixon, in the *Independent*, was enthusiastically dismissive. "Freud's art seems increasingly full of pictorial devices designed to mask or compensate for the ways in which he fails as a traditional painter of the figure." Without elaborating on what he meant by "traditional" he proceeded to draw the reader's attention to what he took to be physiological faux pas. "Freud's recent paintings are uneven and often almost cack-handed. They are full of anxiety and uncertainty." And the extremities he painted came off badly too: "He makes ankles thicker than they really are and he places massive emphasis on splayed feet."[17] A fortnight later, in the same paper, Tim Hilton pronounced on the self-portrait. "He looks like an exhausted but still dangerous wolf."[18]

In similar vein "Parks have flashers, art has Freud," wrote Waldemar Januszczak in the *Sunday Times*. "And to make matters better—or worse, depending on your own orientation—he does not even appear to have a true gender preference. Men, women, dogs, the painter himself, his friends, his daughters, they all strip naked in Lucian Freud's art and show us their genitals."[19] Leafing through the newspapers, Lucian marvelled at such stomping harangue. "It's where enormous publicity and complete loopiness meet. He thinks of something and contradicts it. The only thing he says derogatory is that the group of Leighs is doubtful. But am I doing with giants what Velázquez did with dwarfs?" As for the ever-supercilious Brian Sewell in the *Evening Standard*: "He said I was the worst: another Fujita. How bad it would be to be praised by him. He's an arsehole with a bit of rouge on it." And, he reported, an equally splenetic article had appeared in the *Daily Mail*. "Paul Johnson wrote that the painting of Lord Goodman was worse than the drawing. But I haven't painted Lord Goodman. 'Smell of Belsen,' he said too. Should be a health warning, I think. Is it a new policy to mock pensioners? How cruel can they get?"[20]

After the private view at the Whitechapel there was a smallish celebratory gathering at 2 Brydges Place, a designer-fusty club premises in a smelly alley next to the London Coliseum—home of the

English National Opera—in St. Martin's Lane. The Auerbachs, Mike Andrews, Kitaj and several Freud daughters were there, also a number of new acquaintances, such as the Texan model Jerry Hall, but Lucian absented himself. "I didn't go to the party because I was working on Big Sue (she's going to India) and I didn't want to be talking about the exhibition all night." (He even postponed seeing the completed hang until a day or two later.) I asked him why he had decided to have the party there. "I went about six months ago, took Susanna and as we turned into the alleyway less than two yards away there was a body on the ground. I skipped over it." "Dead was it?" "He wasn't very well. Susanna was so disconcerted she hit me."

The "Big Sue" about to go off to India was Sue Tilley, a friend of Leigh, one-time cashier at his nightclub Taboo and, by day, a benefits supervisor in a Jobcentre; Leigh had suggested some time before that Lucian might try using her instead of him and had even drilled her in studio manners. "He said I should expand my mind and learn more." Basically, he told her, she was not to be argumentative. "Bit nervous about taking my clothes off; Leigh made me take my clothes off to practise; I used to get a bit embarrassed."[21] Eventually she was told that she had a part to play in his next big picture.

Evening in the Studio, referred to early on as "the orgy painting," turned out to be no such thing. As with *Large Interior, W11 (after Watteau)* a decade earlier, those involved appeared to have been positioned regardless of one another and, while the original idea had been possibly to include Cerith Wyn Evans (standing) and Leigh (sleeping), neither of them was up for it so in the event a relaxed Pluto took to the bed. Lucian explained to me that the set-up was mostly substitutions. "Pluto instead of Leigh. Big Sue, she's playing Leigh. It was a bit Barnum & Baileyish and I wanted it to be ordinary." Pluto dormant, Nicola Bateman seated in the shell-like Lloyd Loom chair sewing sequins on a Klimt-style robe for Leigh to swan around in somewhere. And then, like an obstructive afterthought, came this corporeal surprise ("Fat crab," said Leigh; "A fat toad," more like, said Sue), landed smack bang in the foreground as though dumped from some galumphing floorshow. "It was Lucian's image of me rather than me myself," she told me. "He put me in this most excruciating position: there was a cold draught under the door and I was lying on bare wooden floorboards."[22]

The painting shaped up to be a display of contrasting states of mind and body settling into an assortment of forms and textures, a feast of virtuosity accentuated by the glare of the 500-watt lightbulb overhead. Two or three times a week for nine months, with evening shifts from six-thirty to about one in the morning, work proceeded, strong shadow accentuating the elaborate play of curve and fold throughout. Mid-November 1993: a phone call and I went round to see how it was going. Pluto as usual hurtled downstairs to greet me and Nicola emerged in a floral wrap to make tea. One of Big Sue's hands had been painted out and lowered a little to exert pressure on the bottom edge of the picture.

"Leigh was curiously very fit in his way. His body was an instrument. Hers sits. Just hung in there. She's in her way very feminine and, as she said, luckily she's got a sensible gene. Initially, being aware of all kinds of spectacular things to do with her size, like amazing craters and things one's never seen before, my eye was naturally drawn round to the sores made by weight and heat."[23]

Between 1993 and 1996 Freud was to paint Big Sue four times, each of them one in the eye for those whose idea of a body beautiful was slinky or demure. "She rolls and you think of Courbet girls on the riverbank." Lodged in the sagging sofa she became a marvel of physique lit upon in the spirit of John Donne:

> Before, behind, between, above, below.
> O my America! my new-found-land.[24]

"He just loves women," Sue said. "He just paints them as he sees them. Loves paint. Loves it. Has to do it. It was *me*, the whole personality, that interested him. He asked my mum and dad to the studio and said to them, 'Had to see where this extraordinary creature came from.'"

"When there were the three of us," she later wrote, "there was a lot of gossiping going on. Leigh would phone me to find out what had happened."[25]

What did emerge was that the painting gelled, becoming boldly harmonious. "It was getting a bit sweet," he murmured shortly before he declared it complete, every square inch delectable, from blunt toenails to exuberantly mottled wall plaster. It was added to the White-

chapel show in its final week—not so much a postscript, more a *coup de théâtre*. Come to think of it, Titian's *Perseus and Andromeda*, the painting that he sometimes said was his favourite in the Wallace Collection, operates similarly: the role play of the Freud studio three-some rehearses the clash of the Titian trio: the female captive, the moiling sea monster and, swooping earthwards with limbs extended, a godlike Perseus/Pluto.

"You can't imagine Hals people without clothes," Lucian observed, talking one day about *Evening in the Studio*. "The only ones I almost can are that dressed-up couple on the edge of the wood who look like two insects: that absolutely marvellous one with elaborate hats. But it couldn't be more disturbing even if they were naked . . .

"I want the fact that the people I paint are alive to be the subject of my pictures."

"In real life," Sue pointed out, "I look a bit better."[26]

The Whitechapel had a record attendance: 70,000. The Met show attracted 83,321 people in its first three weeks, Freud learnt, just before going to New York with Susanna for a long weekend, Saturday to Tuesday, to see for himself what the *Baltimore Sun* had rated as "the hottest ticket in town."[27] Having avoided the opening (though Leigh attended in floral gown teamed with *Pickelhaube* helmet), Freud landed in America for the first time in forty-one years to face the customary sceptical encounter at immigration. "An Oprah Winfrey type (double-fronted) on the desk said, 'What you here for? Business or pleasure?' 'Pleasure.' 'Are you thinking what I'm thinking?' she said. Susanna wasn't too pleased."

For pleasure they took in *Guys and Dolls* ("Boy, it was great") and for displeasure he only had to look at the way Lieberman had hung the exhibition. The arrangement was in smaller rooms than at the Whitechapel, thus more broken up yet arbitrary, and his naked self-portrait at the far end looked, he said, as though it wanted to escape. Kirkman had withdrawn his pictures, most notably *After Watteau*, explaining, Lucian said, that he needed them for his guests to see. A pity, but attendances at the Met had been persistently good nonetheless: 9,000 on one Sunday alone.

The gallery had booked him under a pseudonym into the Carlyle Hotel on Madison Avenue for the weekend and, once installed, he got in touch with his cousin Jo Mosse. "We asked Jo over. The drawing

room of the Carlyle suite had flowers in it. 'I've never been anywhere like this,' Jo said. Not very badly off, could always manage. Worked: something to do with cartoons, publishing. When money came in it was almost too late. Jo had been with the brother of a man, Walter Kaufmann, who wrote a book about Freud and Nietzsche. He seemed ghastly: a Jewish Paddy Leigh-Fermor. I never saw him. He didn't come to England: kind of 'men are men and women are glad of it' kind of man." Lucian had no time either for Jo's sister Carola. "Lives in Muswell Hill. She's very genteel and whatever you say, whatever you tell her, she says: 'Oh I'm so sorry.'" Jo was different, he added. "Now an elderly Yiddisher momma living in Brooklyn. We'd always been friendly. In New York and when she came over here I used to telephone her quite a lot and she was terrified about the spending even though she knew that I had made some money. 'We mustn't talk for too long, it's so expensive,' she said. 'I never pay phone bills,' I said. 'It's someone else's phone.' 'Bless you,' she said.

"Jo said, 'It's terribly important not to give your children money': that Jewish thing, make them stick up for themselves. I feel the opposite . . ."

The details and scope of the will Freud had made in 1992 were now a concern. Which children were to be beneficiaries? With serious money in prospect and already made he became increasingly exercised about potential demands from claimants who could appear and either bother him directly or, after his death, affect the interests of those he was closest to. A will made things official. "Fairness is a disaster. You have to go by what's needed at the time." In 1993, for instance, Jane McAdam got a bursary at the Royal College but needed a bit more to pay her way so she asked him to help out and he sent her a cheque for £20,000. That, he felt, was good and uncomplicated. He had developed no familiarity with the McAdams. "I felt I didn't want to so I said, fairly lightheartedly: 'I've done much worse than you have done but I think I've done it better.' They feel I have a tight-knit family and that they all have been bought houses except them. I try and be fair. I couldn't just see one of them."

The "tight-knit" costs, regardless of any future claims or arrangements, included paying for flats, school fees and, in the case of Bella, the large sums needed to get her fashion label going. And then there were grandchildren. Money was not a problem provided he was not

expected to stump up regularly, for he continued to think in terms of a wad of readies in the back pocket and sums hidden around the flat rather than income in the abstract, better spent on impulse. Commitment to liabilities was still to be avoided because, above all, one had to suppress any temptation to maybe ease up a little when deciding whether a work was fit to leave the studio or not.

Secluded by day, prowling by night, running on like an overheated engine, as he described it, Lucian pursued not relaxation but immediate requirements.

"I sleep not much. Always looking at the clock."

"Britain had taken me in"

"Don't you find it hard to get in the mood?" asked the Queen as she handed him his OM. "Did Guardi have to get in the mood?" she added, swaying on her feet, memories of Glenn Miller doubtless in mind. There were two huge Guardis on the wall behind her. "No," Lucian replied. "Guardi had assistants."

The enamelled badge of the Order of Merit, bestowed in 1993, came in a battered case, the recipient being given to understand that this one had previously belonged to Thomas Hardy, that it would have to be handed back when he died and insured meanwhile. It was the most exclusive Order in the Sovereign's gift. Henry Moore had been an OM, and Graham Sutherland, but not Bacon, who let it be known that he had spurned it, saying, "I don't want anything for myself." Surprisingly perhaps for a philosopher, Isaiah Berlin OM took a more than academic interest in the Who's Who of public honours and while he approved of Freud as an artist he considered his private life unmeritorious.[1] Lucian himself was averse to some of those with whom he had now come to be associated. "Mother Theresa is one. Not someone to sit next to at lunch." And there were irksome stipulations. The palace required a drawing of him for the Royal Collection—plus a large glossy photo for their files—and when he offered a self-portrait they demurred, thinking apparently that he was pulling a fast one.

The Queen remarked that there had been some difficulty getting in touch with him; her people had eventually done so through Lord

Goodman CH. That prompted the (unspoken) question: why accept honours? "I told her that Marie Bonaparte had made it possible to stay in England and not get sent to Australia in the war. It was good to accept; after all, Britain had taken me in." As he further explained to Nick Serota, the new Director of the Tate, when he noticed that they were printing out on display labels the letters after his name: "I'm not ashamed of the honours I've got, but I'd like to take them off my pictures. Please take them off."

Towards the end of his audience with the Queen he mentioned his offer of a self-portrait drawing. "She thought it was something dodgy and got flustered. I'd been given a list of people selected by Philip and Charles who might do it [his portrait]. I chose Peter Blake. Then I thought: I can't. 'How about a self-portrait?' I suggested. She panicked. Then they explained to her and said it was a good idea if I did it myself. I then got various letters (every year) reminding me." Finally, it was agreed that his self-portrait etching of 1996 would be acceptable. "The librarian from Windsor came to see me, we got the etching out and I asked Robert Fellowes [Queen's Private Secretary and registrar of the Order of Merit] what to put. 'Is it "To Her Majesty"?' ' "To Her Majesty," and if you could put your name in full, not initials.' I lunched with Fellowes again and he said, 'She was very struck by your print, she really was.' And when Isaiah Berlin went to an OMs' lunch there he said it was up and it caused a certain amount of notice. E. H. Gombrich asked Isaiah why wasn't I there; was I ill or something? Apparently it's a command attendance.

"They also wanted a photograph, no more than so and so in size and on special paper 'For our archives.' And I wrote a rather rude postcard saying I don't possess a photograph of such and such a size." That was not all. One afternoon, having shown me the badge and ribbon of the Order, Lucian fished out a letter he'd just received. "Take a look at this: from St. James's Palace." Four pages long and handwritten in bright-blue ink, it expressed delight at that "magnificent show" at the Whitechapel in which a small painting of a woman in a blue dressing gown (that is, *Annabel Sleeping*) had particularly caught the writer's eye. A masterpiece and if not already sold could it perhaps be swapped for "one of my rotten old watercolours"? A PS offered congratulations on the OM. Lucian folded the letter and stuffed it away. Should he reply by postcard with "I refer you to my agent" or

words to that effect? He paused. "Hang on a sec. I've recently given a picture to the Tate." (This was a small head of Leigh, added as bonus following the purchase of *Standing by the Rags*.) "How many more am I going to be asked for?" Narked but tickled, he gave differing accounts of what he had actually said or now thought of saying. Colin Wiggins of the National Gallery said that when Lucian showed him the letter he asked how he was going to respond. "Tell him to fuck off of course." Then he told Andrew Parker Bowles that he didn't reply at all. "What was there to say?" It was some months before the exchange became rumoured enough to get into the papers. John Ezard in the *Guardian* commented: "His method of refusal—as first reported—would have been a mode of address from subject to royal rare except perhaps in 1789."[2]

Lucian later learnt that the over-enthusiastic Debo Devonshire had put the Prince of Wales up to it. "Surrounds himself with third-rate people. That's mildly putting-off. My postcard couldn't have got through."

Distinctions and seniority (and the good fortune of having his work internationally sought after) stimulated in Freud, more than at any time since Coombe Priory days, spasms of home making. By 1993 he had become used to being a householder, one who acquired pieces of furniture without necessarily putting them to studio use. Number 138 Kensington Church Street filled and the Holland Park flat emptied until little remained there but works in hand and the necessary materials plus bed and table, plan chest and cupboard.

The house, formerly the offices of the Prep School Association, needed attention but the renovation was minimal. David Dawson rubbed a blending dirtying tone on to the walls to season the plaster; buff-coloured carpeting was laid, and lino on the creaky ground floor. And there were acquisitions. "Got Degas head, Degas horse, Franks [Auerbach] for the house, to make it more inviting, and I had a winning run, which paid for all the doing up: a winning run for three or four months—I got cheques every fortnight. I wasn't trying that hard. Many people say, 'Don't you own things?' Not much. It's to do with privacy and ownership: the reason is that bailiffs can't seize things I don't have." Possessions were liabilities. Yet he bought good brown

furniture and French table chandeliers with cut-glass pendants. "Real stuff," he pointed out. "Not Italian." He agreed, he added, with William Morris: "In a house have only what is useful or beautiful." The Rodin naked Balzac stood on a table beside Pluto's basket, arms folded as though minding the shop.

Soon the hallway and stairs were lined with Auerbachs—and (briefly, until it came to irritate him) he also hung there a Stanley Spencer study for one of the predellas in his war memorial chapel at Burghclere: a close-up of streaking soapsuds on a tilted floor, soon replaced, successively, with Sickert's etching of a leggy chorus line grinning and a little painting of Susanna turning her head away. The first floor, primarily one room divided by folding doors, became the studio. Above that was the drawing room with his bedroom beyond, where he placed Degas bronzes, Auerbach drawings and his favourite Bacon—"The Buggers." The top floor was his "library" with dark blue bookshelves, two gilt Empire chairs and a second plan chest for prints.

The far corner of the ground-floor room was fitted out for minor cooking, "dish of tea" mainly. ("Villiam, did you ever do *vashing up?*" he once asked me. He had done so just the once, he claimed: washing glasses in the Shoulder of Mutton pub, Hadleigh, as a punishment for breaking blackout regulations.) The French windows at the back opened on to decking and a narrow wilderness soon so heavily overgrown that, to Susanna, it seemed underground, carpeted with leaf mould, planted with bamboos and framed with lattices on the sidewalls. They bought bay pillars from Clifton Nurseries that, to her despair, he wouldn't trim, so they lost their form and horticultural status. Also from Clifton Nurseries came an apple tree and a pear tree, while trailing nasturtiums and rampant buddleia appeared from nowhere. "I've put a lot of dandelions in and things so I may do that some time: treat it as a huge landscape." At the far end there was a sixteen-foot drop into gardens beyond. The view beyond from the upstairs windows took in a lavish array of aerials and satellite dishes on the roof of the Russian Embassy.

The Holland Park studio remained Lucian's base for quite a while until, that is, he became comfortable with the house. Slightly wider than 32 St. John's Wood Terrace, 138 Kensington Church Street was an improvement on what his father had settled for and it proved to

be, all in all, a well-appointed workplace dedicated to his needs alone. "It's a house for a single person," he told me firmly as we drove away after he had shown me round for the first time. "Of course, I live a self-indulgent life." Although he entertained visions of falling in with domestic routine ("I like to go into houses where there are lots of beds made up and a smell of cooking"), he knew that such goings on were not for him. Initially he slept at the house perhaps one night a month but once he had begun painting there he realised that sooner or later he would transfer wholly. He wasn't, he said, thinking of giving the flat up until he was a really old man and incapable of getting up the stairs. Then, he added, he would do Monets in the garden.

Almost fifty years on from the day Freud returned to Delamere Terrace just after a V-1 flying bomb had struck near by and found the picture of his few showy possessions—top hat and scarf, potted palm, tatty sofa and mute zebra head—intact on the easel, *The Painter's Room* came up for sale at Sotheby's and went for £507,500 to Paula Cussi, a prominent Mexican collector. Her export-licence application in August 1994 had the date of the work down as 1943, which made it just over fifty years old, and this meant that the Tate (also the Duke of Devonshire, who wanted it for Chatsworth) had the chance to match the auction price and thereby, maybe under joint ownership, keep the painting from leaving the country. Freud was annoyed at this. He suggested that the new owner could well retaliate by depositing the picture in a London bank vault until the export ban ran out in 2005 or even go so far as to buy herself a London house to put it in. But his real objection was that a painting of his was being placed under restraint. "Any artist who is alive should not have his work clamped." It then occurred to him that, hang on, actually he hadn't completed it until shortly before he exhibited it at the Lefevre Gallery in November 1944. Indeed, come to think of it, he well remembered seeing it on the easel, wet yet intact, that September afternoon when the doodlebug exploded near by. This clinched it at the export-licence committee hearing. *The Painter's Room* was slightly too new to be subject to the fifty-year rule.

Another concern in the summer of 1994 was R. B. Kitaj or, rather, how to react to Kitaj's reaction to being subjected to what he considered a vicious array of dismissive reviews of his Tate retrospective. "He thinks no one has any bad reviews," Lucian remarked. Colin

St. John (Sandy) Wilson, architect and collector, a man of persistent loyalties, urged him and others to rally in counter-attack and Kitaj himself joined in with blasts of hurt and pained relish. I had found plenty to admire in the show but others had reacted scornfully to his confessional traits and, most of all, to the elucidatory paragraphs that he had posted alongside many of the exhibits. Just who did he think he was, cutting in on the expertise of the seasoned art critic? For Kitaj this was tauntingly provocative. In one of his occasional letters to me, neatly handwritten on yellow lined paper, he let rip. "The lynch-mob alliance between conservative reactionaries like Sewer et al and modernist reactionaries like Hilton has been quite a lesson in old-fashioned hatred for me," he wrote, adding: "You're a real Mensch!" and a mock-self-deprecating afterthought:

> PS: I wd not be "Kitaj" if I didn't end upon a pretentious, literary quote, would I? "It seems that you have the honor of inspiring hatred."—Baudelaire to Manet. The scumbags haven't chang'd![3]

Freud's response to Sandy Wilson's rallying letter a fortnight before had been uncooperative yet not unsympathetic:

> 2-7-94
> Dear Sandy though it's often a good idea to write to someone in order to object, agree, question or ridicule anything they may have said or done (or even to challenge them to a duel or ask them to lunch) I feel it is pointless to gang up on a third rate critic when you don't consider him seriously. As they so wisely say in Ireland: What do you expect from a pig but a grunt?
> Regards Lucian[4]

Lucian used to say that Sandy Wilson irritated him because every time they met he'd bang on about 1922 having been such a good year in that, besides being the year of *The Waste Land* and the English edition of Wittgenstein's *Tractatus Logico-Philosophicus*, it was moreover the year they themselves were born. As for Kitaj, he also was much too concerned with his place in art history. Indeed, Kitaj himself told me, shortly before his retrospective opened, that he was about to sit for Lucian and this, he guessed, promised to be a most memorable,

indeed historic, experience. "He is going to start to paint me this summer. I don't know that I can cut it. How long do you think I'll have to sit? (5 to 9?) I don't mind the time but, I mean, how long will it take?" At least forty sessions, I suggested. "I wonder if Frank sat forty times for that beautiful forehead. Beautiful. That's what I want. I could have bought that, I could just kill myself for not getting that: I could have done then: it was within my grasp. It was very stupid. I've always loved to be with Lucian, except we keep such different hours. I go to bed at ten o'clock."[5]

Kitaj liked to look back at his younger self and see a fervent inno-cent abroad, a voyager after knowledge disembarked in Britain, Lon-don rather, lusting to assimilate all that was great in the local culture. He told me that he had seen *The Red Shoes* many a time in a little cinema off Times Square. "I mean Moira Shearer in ballet tights: this vision of half her ass. And I thought My God, this was what I want: I want to go to Europe and be an artist.[6]

"The thing that is very seductive (and because it is so seductive won't happen to me like it's happened to Lucian) is *old-age style*. See this man who was a wonderful painter become a *great* painter between the ages of sixty and seventy, and with that name hanging round his neck. One *dreams* of an old-age style—that's Kenneth Clark's term. The best painters of all, the finest painters, did their greatest work in old age. And painterly painting is in marvellous hands: Auerbach and Freud and Kossoff and a hundred other people, failing in many cases. And myself."[7]

Suddenly, in the aftermath of the dismissive reviews, Sandra Fisher died, her brain aneurism brought on, Kitaj insisted, as the con-sequence of London's art critics crucifying him. Some of them any-way. That the stress Sandra experienced was partly due to his distress at having been written off compounded his grief. Lucian telephoned him and listened to him, there being little he could say. To him Kitaj in his misery seemed childish. "Sandra has left two babies: one of eight, the other seven," he told me. Kitaj, crying, had struggled to spell out what widowerhood was doing to him. "It means a complete change in the regime. I've got to take Max to school now." Max was his and Sandra's eight-year-old son.

Thinking to be supportive Lucian decided to go to the funeral. "Max said, 'Why has there got to be a service if there is no God?' And

Kitaj said, 'Perhaps there is but he's out to lunch.'" David Hockney, "looking ancient," he reported, turned round like an angry old man when he came in late. Kitaj had told him [Lucian] to go to Rutland Gate when the synagogue was in Rutland Gardens. The singing was marvellous, he said. "Man and piano, several songs. Incidentally," he added, "I went the other night to see my favourite singer at the Shepherd's Bush Empire. Johnny Cash. Anyway, back to the house [Kitaj's house in Elm Park Gardens] lots arrived so I said bits of 'The Ancient Mariner' to myself in the kitchen." That, Lucian had found, was an effective way of coping with unnerving social situations but there were too many people commiserating so he slipped away. "They were all weeping, but Max was good handing round the drinks."

He was sorry for Kitaj and to paint him, he felt, was to be supportive and considerate. "The act of sitting, which takes a long time in my case, constitutes a connection, obviously." But his "old-age style" failed to kick in. A first attempt was quickly abandoned; the second one dulled. "I tried things and failed. Both the Kitaj paintings went very fast, but his gushing and going on put me off in a way it shouldn't have as I liked him and felt protective towards him because of his awful predicament. But he kept saying, 'It's great.' Like someone coming to you and saying, 'How do you manage to breathe?' He asked my opinion of a picture and I gave it rather conscientiously and he said: 'Now I will tell you what Hockney said.'"

Lucian's favourite handbook was Max Doerner's *Malmaterial und seine Verwendung im Bilde* (*Materials of the Artist and Their Use in Painting*), 1921, a supremely practical manual. "It says that it's no use expecting a book to teach you how to paint. That's like learning to swim by going on the sofa." Kitaj's expectations were similarly misplaced. He was, Lucian decided, one of those people who couldn't but be exasperating when required simply to sit. "Because they were agitated or they stopped me from working I'm just put off my stroke: I can't work with someone like this in the room. I think his interest in my picture put me off. It sounds awfully feeble, but when he was talking about it in glowing terms it was as if he was admiring some masterpiece from the past when in fact it had only just got going. I found it, oddly enough, inhibiting. I hate being watched really."

Kitaj, ever wry, had anticipated the lapse of the painting when, months earlier, he talked to me about incompletion. "I don't know

why you have to finish a picture. You don't finish friendship. Friendships can go wrong, pictures can go wrong, oh sure. But you don't have to."[8]

The abandoned portrait, the very image of a fraught man, a diminished man, was set aside. Occasionally it was put by the front door with other cancelled pictures only to be retrieved, its pinched and vulnerable look—a failure to quite grasp so ingenuous yet so fanciful a character—causing it to survive. "If something goes wrong it's a great temptation to blame the sitter."

The sitter had only this to learn: be prompt, be present and avoid butting in. "Art is a very inorganic habit so it's nice having someone completely uninterested in a bovine way. Lots of girls are like that and some men: passive, not in a half-alive way. I don't want to put anyone in my mould. I want portraiture that portrays *them*. Not 'Here's another one of mine but different.'" He should have known that having Kitaj sit for him wouldn't work out. "A weakness on my part. I've never had anyone be so interested."

In 1997 Kitaj moved—with Max—to Los Angeles.

"With girls I've said: 'Please don't look at it while it is on the easel,' but that's only an excuse." Good sitters knew their worth as occupants of chair, bed or sofa, the two prime examples in the mid-nineties being Leigh's nominated successors: one, Nicola, characteristically alert and the other, Sue, reliably somnolent after a day's work at the Charing Cross Jobcentre.

"It's clear that a benefit supervisor—I'd never heard of them—spreads benefit. Every civil servant, a hundred thousand of them—no, more, with policemen—would know what that means. Somehow the fact that she's naked makes it more rather than less interesting: she has made herself available. It's not who is playing Hamlet this week, it's *them* I try and get. I want to get it to be *of* the person, rather than 'Oh, that's like so and so, did you have them in mind?' The painting says it all. She's all there. She sure is." Voluptuously lodged, hogging the comfy corner of the sofa, head thrown back, open arms, left knee pivotal, her thigh a taut ellipse, *Benefits Supervisor Resting* (1994) celebrated a fleshiness set against floral upholstery and black screen.

"The problem with painting a nude of course is that it deepens

the transaction. You can scrap a painting of someone's face and it imperils the sitter's self-esteem less than scrapping a painting of the whole naked body."

The paintings of Big Sue risked, indeed invited, comparisons with Rubens on the one hand and, on the other, with the Brobdingnagian maids of honour described with gawping amazement by Jonathan Swift's cowering little Lemuel Gulliver: "Their skins appeared so coarse and uneven, so variously coloured, when I saw them near, with a mole here and there as broad as a trencher."[9] Ultimately though the Big Sue of *Benefits Supervisor Resting* was more a Molly Bloom ("I was a Flower of the mountain yes . . ."), the soft splendours of a copious body yielding to sleep and dream.

Lucian relished the challenge Big Sue presented. One after another—*Benefits Supervisor Sleeping* (1995) followed—his paintings of her weighed up character and substantiality. "In her quiet way, she's quite sensible. Somehow the fact that she's naked makes it more rather than less interesting . . . She does after all look contented.

"Isn't it true that, for instance when you see a dwarf in the street that you don't know, you are taken by the fact that the dwarf is a dwarf, but if you *knew* him, you'd notice that he'd be wearing a new tie and, what's more, rather a special tie." In other words familiarity stirred particularity and, furthermore, these forays across shoulder and breast, these spectacular helpings of body weight and disposition, complemented *Leigh Under the Skylight* (1994), the painting that proved to be Leigh's last stand, a salute to the statuesque performer and former Burger King assistant manager, raised up and cast as a caryatid or (given the daredevil glint in his eye) a Samson readying himself to bring the house down.

"If you've got AIDS it doesn't mean you've lost your sense of humour, does it?"[10] Leigh had known since 1988 that he was HIV positive. Nicola was not aware of this when she married him. "He wanted to be known as a person of ideas not AIDS," she said later.[11] As *Naked Girl Perched on a Chair* (1994), she reverted to the foetal pose (as she said, "Like in a womb of sorts")[12] of her role in Leigh's burlesque birthing act only now she was herself alone and, as Freud insisted, cleansed of makeup. "You get to feel as if you are put in this different kind of universe," she remembered. There was something of the "infinitely gentle, infinitely suffering" about her, stemming, Lucian

suggested, from her physical state. "Because of her spina bifida, which I have used a lot because it's so somehow native to her. This sounds a bit far-fetched, but I feel there's something specially for me that I can use, understand and assimilate in a way that affects her. It slows her up in some ways but makes her unique and beautiful in another way." He said he hoped the spina bifida didn't show unless you happened to know about it.

One day towards the end of November 1994 Nicola returned home after a sitting to find a note from Leigh saying that he had gone into hospital. There she found him with an oxygen mask and morphine drip. What he referred to as "our little secret" was blown.

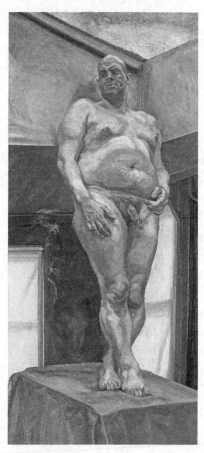

Leigh Under the Skylight, 1994

He knew he was dying. He got Sue to tell people that he had gone to farm pigs in Bolivia or on holiday to Papua New Guinea and let Lucian know that he had meningitis. Didn't look like it, Freud thought. "When Leigh was dying I went in to the hospital and asked for 'Leigh' and he was known there as John Waters." (John Waters being his favourite director.)

"They said are you his father?"

Matthew Marks, established in New York, now published Freud's etchings and exhibited them, drawings too from time to time.

October 1994 to Matthew Marks:

Your offer of £30,000 for the edition of 25 I find too Skinny. I suggest £40,000 though I raise no objection [if you] pay a small sum in three instalments, the first post dated by 2 months, then at monthly intervals, [it] does not make a good impression—if only from a point of Style. I hope you don't think this letter too unfriendly Lucian

4 Nov 1994
Dear Matthew did you get my letter? If so Im sorry not to have heard from you. IF my suggestion is not acceptable to you—so be it. Yours ever Lucian

What Matthew Marks was prepared—or able—to pay for each edition and what Freud was apt to demand could only become contentious for, besides being an increasingly ambitious sideline, the etchings were currency with quantitative-easing potential. That being so it suited him to have his print dealer on Madison Avenue, far from Cork Street and elsewhere in Mayfair where he could peddle his APs (the artist's proofs of each etching) and thereby harvest handsome amounts of ready cash. Etchings were relatively affordable. Each new one could be exhibited simultaneously on both sides of the Atlantic.

Paintings were another matter. Following the Whitechapel exhibition Lucian had been fretting over the need to have somewhere to show new paintings before they disappeared overseas. "I've got an American dealer so the pictures are going to America and I just like

the idea of them being seen here . . . Megalomania if you like. Neil [MacGregor, Director of the National Gallery] said, 'When will you show?' Rather difficult for me because of my otherwise very satisfactory American arrangement and I'm a Londoner. Pressure, even though not tight or strict, means I can't now show in a commercial gallery here. Neil said, 'I know where: Dulwich.' And so he laid it on." The Director of the Dulwich Picture Gallery, Giles Waterfield, welcomed the proposal. "Four paintings," it was announced, "for a brief period over Christmas." Sir John Soane's building—the oldest purpose-built public art gallery in Britain—was ideal, Lucian decided, for what would be a stimulating encounter. "The wall colours are right and the light's wonderful." The installation went without a hitch: *Leigh Under the Skylight* counterbalancing Rubens' *Venus, Mars and Cupid* and, incidentally, showing up the degree of reheated Baroque in Leigh's catwalk posture. Equally apposite, *Naked Girl Perched on a Chair* was hung above a roped-off Regency chair while *Benefits Supervisor Resting* matched up to the sweaty post-coital huddle of Sir Peter Lely's *Nymphs by a Fountain*, the picture equivalent of one of the Earl of Rochester's odes to sluttishness.

Having decided, just this once, to attend the private view in mid-December Lucian turned up so "psychosomatically early," he said, that he was stopped at the ticket desk. Once people started arriving he stood watchfully, checking reactions. "Kitaj was in such a bad way; he said something very impressive: 'I don't think I'll find anyone to put up with my bullshit.' He greets me differently when other people are there: American Jewish version of *Bonjour Monsieur Courbet*: a grasping of the shoulders and brush of manly cheek. Doesn't do that when he's alone." That done Kitaj went and sat on a bench—ostentatiously, some thought, hugging his undoubted misery. Mike Andrews had hoped to be there but wasn't up to it having undergone a devastating cancer operation a few months previously. (After visiting him Lucian remarked, "I always think it's bad to let someone see you're upset.") However, some days later he and June did get to Dulwich and he wrote: "I'm full of admiration for the work and for you. There is no incompatibility between the paintings in the show at Dulwich. It's a true master class."[13] The gallery was busy, Lucian heard. "It was the first time they had a queue." An effusive postcard came from Howard Hodgkin.

*I think your painting of the benefits supervisor is one of your most
marvellous; though much more Ingres than Rubens + like all great
painting (to some extent) both classical and romantic.*[14]

Determined to get to the opening do, Leigh had left his bed,
put on a suit and, escorted by Nicola and Sue, arrived late looking
ghostly, one wrist bandaged to cover where the drips were inserted.
Lucian had visited him in hospital, had given Sue £50 to buy flowers
and, on being told that he "had a violent reaction to antibiotics," had
arranged for paid treatment whereupon Leigh tried boasting that he
was in a Swiss clinic. After Christmas he learnt the true state of affairs.
"I didn't know about the AIDS until four days before he died. He
wanted it known that he was fed up with the art world and was going
to go to Papua New Guinea 'to help the natives.' Leigh's family were
coming over, not knowing either." They arrived on 22 December and
Leigh was at the airport to meet them. Fading shortly after that, he
mumbled into his oxygen mask: "My mother's *not* Eva Perón." These
were, Lucian reported, his very last words. "Marvellous. He left a
note saying he didn't want God or his middle name mentioned. And
I was to pay for the body to go to Australia to be buried with his
mother. She died six months before he did." He died on New Year's
Day 1995 at three o'clock in the morning.

Four hours later Lucian phoned Sue, reminding her that she was
due to sit for him; he had rung the hospital and when she arrived at
Holland Park, panting up the stairs, there was little to say. "He looked
very shocked and shed a couple of tears which he tried to hide from
me by hovering in the corner of the kitchen."[15]

It emerged that Leigh had nicked two small paintings, one of
Angus Cook and another, of Katy McEwen, that Freud had kept
despite considering it a failure. Nicola told Bella and Bella told Lucian
about the Katy picture and it emerged that Nicola had already given
it to Leigh's father as a keepsake to take back with him to Australia.
There was a last-minute dash to Heathrow to retrieve it from his
luggage.

Leigh had become iconic. A three-day memorial exhibition staged
at the Fine Art Society in Bond Street in late January included two
of the sleeping heads fresh from the studio—they were getting to be
regarded as prescient—also Leigh's mash-up image of Hitler. He had

been wary of Lucian finding out about it but in the event Lucian was intrigued, or so he said to me before seeing it. "A marvellous thing Big Sue has got which she didn't want to show me. I gave him paint rags cut into strips for a portrait of Hitler, which he gave to Sue. He thought I'd be very shocked. But I'm longing to see it. Done with love and I guess he used paint for the moustache. He was a terrific stitcher.

"It was an extraordinary tenacious talent."

Lucian admired Nicola. "Her 'wicked tongue' as she calls it is so good. At Leigh's funeral—not that I went there—everyone was being funereal and anecdotal and Nicola goes over to Sue and says, 'You know, when I think about it, I didn't really like Leigh in the end.' And Sue said, 'But why? Why? Why?' 'For having a friend like you,' she said. Good isn't it?"

What proved to be the final head of Leigh—*Last Portrait of Leigh* (1995)—remained summarily curtailed, whited breath still drying on the lips, and *Girl Sitting in the Attic Doorway* (1995) too became commemorative. Nicola poised at ceiling height like a trapeze artiste kicking her heels was now elevated to chief mourner, tearful on a dark threshold. Originally Freud had thought of making this an eight-footer with Kai aloft, but as he was too big for the hatch he then thought of having him below entering the studio and Nicola installed above, but that risked making it a problem picture. So it became Nicola alone. "Certainly it was quite interesting up there," she remembered. "As he was painting it Leigh started to die. I was thinking about Leigh in hospital. And then the certainty: thinking 'Hope I can get through sitting and get there in time.'"[16] Lucian worried about straining his neck as he worked, hour after hour. The tilted point of view made the painting a Tiepolo re-enactment in W11, with Nicola playing studio nymph: not a dimpling Rococo nude but properly naked with her misery showing through.

"I've done things I find more difficult in recent years. I want to make people think again. It's only biological squeamishness I want to use. Make it right."

During the summer of 1995 Jean-Louis Prat of the Fondation Maeght, at Saint-Paul-de-Vence, staged "Bacon–Freud Expressions," an exhibition whereby, he explained, Freud's work was shown to be "different and complementary" to that of Bacon. "Francis Bacon died a short time ago and Lucian Freud continues, with his work, to main-

tain the high and mighty dialogue that they have pursued together."
This was no reconciliation; and even as an exercise in compare-and-
contrast the "dialogue" was only possible because one of them was
dead. Bacon's photo-spawned reality didn't complement Freud's
optical reality. On the contrary it avoided it. In terms of expression
it was cyclorama versus depth of field; in terms of attitude it pitted
Bacon's remark that Freud's painting had become "realistic without
being real" against Freud's rather more sympathetic "Francis was just
someone with curious tastes trying to be happy." The inclusion of
Benefits Supervisor Resting and Big Sue's decision to go to see how it
looked there on the Côte d'Azur gave those whose visit happened to
coincide the chance to see if she matched up to her image. But hav-
ing also spent time on the beach she returned to London sunburnt
enough for Lucian to leave off painting and start on *Woman with an
Arm Tattoo* (1996), an etching of flesh brimming over the sundress,
nose squashed askew, stridency reduced to a snore. Sue's pushiness (as
he saw it) annoyed him but it also provoked him into making the most
of her. He too went off for three days to take a look at the Maeght
exhibition. The painting—*Sleeping by the Lion Carpet* (1996) it was to
be—would have to wait.

In May 1995 Lord Goodman died, shortly after the publication
of his autobiography *Tell Them I'm On My Way*. Lucian had liked his
geniality. "This nice and fond man. I went sometimes to the hospital
and it was really sad. Lost a leg and didn't tell. An old friend of his—
Lord Kissin—was quite often there: the kind of man that if you saw
you'd have to apologise for; once at dinner he and Harold Lever were
talking about someone and Goodman said, 'I wish I could be as mod-
est as that.'"

Then, in July, Michael Andrews died. His funeral was held in St.
Mary's Battersea beside the Thames and as the mourners left Henri-
etta Moraes hailed them, standing waist high in a barge with drinks
to hand. Lucian attended neither service nor wake, but a few weeks
later and primarily out of consideration for Jane Willoughby he did
go up to Glenartney to see the ashes buried. The spot chosen lay in
the heart of the scene of Andrews' great panoramic painting *A View
from Uamh Mhor*, a view encompassing the estate where since the
mid-seventies he, June and Mel had spent their summer holidays.
Wearing borrowed ghillie's tweeds, Lucian came close to blending in

with a congregation of friends and neighbours in Glenartney church but, detained there, he kept twisting his head like a hawk on a perch while people spoke or sang. His discomfiture was close to panic. "I found it very harrowing, the ceremony." Afterwards, led by choristers from Edinburgh clad in red cassocks and white surplices, everyone trailed up a hillside to the spot where, under a rowan tree, the casket was interred. The next day after breakfast some of us (Feaver and Calvocoressi families together with Lucian and a resolute Bruce Bernard, whose arthritic hip was playing up) set out on a walk heading across moorland towards the Water of Ruchill with Uamh Mhòr rising beyond. Lucian soon tired of what was becoming more than a mere stroll and, out of consideration for Bruce, seated himself on a rock and talked about Captain Oates of the fated Antarctic expedition and about his colleagues being found dead in a tent just because they wouldn't eat their horses or dogs, the fools. What a musical this would make, he and Bruce agreed: "Scott on Ice." The children ran ahead to the stream, but the elders turned back and an invigorated Lucian reeled off stretches of *The Rime of the Ancient Mariner* while demonstrating the accompanying eurythmic poses he had learnt at Dartington sixty years earlier: shinning up rigging (here an attempt on a deer fence) and acting horror-struck at the death of the albatross. As we approached the gravelled surrounds of the hunting lodge talk switched to the Saki short story about the three ghostly shooters who "in crossing the moor to their favourite snipe-shooting ground . . . were all three engulfed in a treacherous piece of bog"[17] and—same as us—walked unannounced into a drawing room. This coincided with a gripe about the demanding nature of Sonia Orwell. Time was up. "Faces are genitalia," Lucian remarked apropos Henry Moore's ineffably smooth heads and with that, plus a snappy put-down he suggested for my imminent Edinburgh Festival session with David Sylvester, he ducked into a car and was driven away to catch the London train.

That left me landed with the task of countering an agitated Sylvester who, invited to deliver his views on the so-called School of London in a public lecture relating to a British Council exhibition then showing at the Scottish National Gallery of Modern Art, had declared himself unfit to do so. Ruffled all the more by the advance billing naming him "the greatest living art critic in the world," he had phoned me a couple of days before saying that he had now realised

Bruce Bernard, Lucian Freud, William Feaver
in Glenartney after the burial of Michael Andrews' ashes

that he just couldn't bring himself to speak up about Andrews or Auerbach or Kitaj or Freud. Would I please take it on? I said no but he rumbled on with such doleful conviction that I suggested that we could maybe address the topic on stage together. And so we did, in the Book Festival marquee in Charlotte Square, with Richard Calvocoressi, Director of the Scottish National Gallery of Modern Art, in the chair.

Over dinner afterwards Sylvester declared his performance lamentable but was properly reassured and we agreed that what was after all just another contentious Festival event had gone reasonably well. However, unknown to us, Magnus Linklater of *The Times* had been in the audience taking notes and he wrote a lively account of it. Sylvester, he reported, had denied the very existence of a "School of London" (true enough); he had expressed his profound disappointment with the work of Auerbach since the sixties and as for Freud, he said, he "had applied himself to the art of painting without ever convincing me that he was a painter." His present way of painting was "a disease suffered by second-year students, one which most of them get over."

Linklater quoted me as having questioned this more or less politely. "I don't agree with absolutely everything that David Sylvester has said, but I disagree with a great deal of it." But from then onwards, he reported, argument flared. "What struck me most forcibly was how gripping it was to hear a serious exchange of ideas, with no concessions to popular taste and no distraction other than the odd bead of sweat and the occasional twitch of a jaw muscle. It went on for a good 90 minutes, and I doubt if any of those listening would have missed it for anything."[18]

A silly-season furore ensued. Brian Sewell in the *Evening Standard* elaborated on Linklater's article with such prolix glee that Sylvester felt impelled to respond with an article in the *Guardian* headlined: "David Sylvester: Why Lucian Freud is not a Real Painter." In it he repeated what he had said so repeatedly in Edinburgh: "He is a painter made, not born." He shored up this assertion with magisterial remarks.

Freud looks at things too closely. I think he tends to paint bodies with the eyes of a pathologist.[19]

Here, he observed, was a compulsive cad. "Freud is a prodigious being—original, disciplined, demonically energetic—and, as his close friend Bruce Bernard says in the Edinburgh catalogue, one who 'has sometimes, or for all I know often, behaved like a shit.' "[20]

It has been enough to make him one of the best figurative painters working anywhere now, but not enough to make him a real painter.[21]

Lucian's reaction was to recall those early days when Sylvester was an army-surplus-wearing cultural commissar in the making. "Sylv called himself Anthony Sylvestre ['Tony Sylvestre' to Dylan Thomas] and exhibited at Jack Bilbo's: paintings that looked like curdled shit. They were like Dubuffet without the buffet." What he particularly objected to now, Freud said, was Sylv accusing him of painting undifferentiated floorboards. "I did mind that." For him, always, each and every part of a painting had to be equally realised.

"I don't want to retaliate. It would be like stepping on the chalk of a blind pavement artist."[22]

"After a certain point the picture takes over"

Regardless of whether or not he was a "real painter," Freud faced increasing demand for exhibitions. With or without his approval. One outstandingly high-handed patron of the arts, Lady Sieff, told the Israel Museum in Tel Aviv that there was no reason to be impressed by his view that some of the proposed exhibits they listed were "so slight as to be inappropriate for a museum show."[1] He wanted this particular clutch of matchbox-scale drawings from 1946 destroyed. Failing that, his only sanction was to refuse permission for catalogue reproduction. Mere disapproval, he found, was not enough.

Copyright issues reflected the fact that his works were fast becoming objects of worldwide interest. He rang up one morning less than a month after the Edinburgh event with piquant news. "I had lunch yesterday with three Chinese about a show in China; two painters who were 'cultural attachés' and one—the politician—who seemed really slippery. They gave me a book about beautiful things in Tibet." Not wanting to get mired in untranslatable aesthetics he had thought of a poser with which to wow the lunch table. " 'You are only allowed to keep one of these institutions. Army or university: which?' I asked. 'I want an answer now!' The man answered: 'It depends on which one I belong to at the time!' I feel hooray about the Chinese. Always have done, ever since I was at school and addressed letters to my Uncle Karl who lived at 101 Bubbling Well Road, Shanghai. Could they come to my studio? No, I said, it would be like letting someone in during an operation.

"They admire my philosophy, they said. I haven't got one. Such ideas as I have are prejudiced; I'm motivated by impulse; I have only one principle. I told the Chinese: 'I wanted my work to disturb and agitate.' They asked about colours. I said, 'I don't use bright colours; I use colours when I want to wake them up and not send them asleep.' *Book of Tibet*: how could they give that to me? The other [presentation book] was *A Mosaic of Life in China*. You know: peasants in fields and so on."

Nothing came of this overture. A more practical one, from Abbot Hall, Kendal, in the Lake District, began with a phone call followed by a letter to me from the Director, Edward King, suggesting a show of maybe a dozen works in 1996, which was to be Visual Arts Year in the North. King was "very aware of the difficulties involved" and, he added, "it is likely the artist will be unimpressed with the concept of a 'Visual Arts Year.'" I suggested to Lucian that this could be a welcome departure. "Very well," he said. "Seeing that it's your part of the country, why not?" We arranged to meet King for lunch at the River Café. What would he look like? I guessed he'd be seriously schoolmasterly, possibly pedantic, but Lucian was prepared to bet that he'd be an officer type of the sort reported gallantly dead by Christmas 1914. Ed arrived: red-faced, beef-fed, crinkly hair, all affability and enthusiasm, the very image of a punctiliously keen lieutenant felled in the opening months of the First World War. As for Ed, his initial impression of Freud was that he had "very inquiring, lively eyes."[2]

It was decided that the exhibition should run from June to September 1996 and that, most importantly, it should include the latest work.

Nagged by the suspicion that his ability to paint on a large scale might seize up any time soon—stiff shoulder and other such complaints, real or imagined—Lucian peppered his diary with reminders of sittings: up to three a day for paintings large and small and etchings too. His arrangements were such that one painting fed into another, literally so in the case of the small head of Leigh Bowery, the miniature image of which he introduced into the background of *Bramham Children and Ducks* to serve as a reminder or afterthought intruding on the scene. Thus Leigh dozed on the far wall and the two ducks from Polly Bramham's back-garden menagerie stood each on a Bramham lap. Polly and Barney were still being home-educated which

meant that they could sit during what for most adolescents would have been a school day; being adolescents they looked dead bored, having trailed so many times all the way from Richmond to Holland Park. As for the ducks, Daffy and Speedy, they couldn't but be outlandish there, so white, so bulky, so proto-emblematic, one held like a spurned offering, the other gripped under one arm like bagpipes. Ellsworth Kelly told Lucian that he had noticed that the paint handling on each of these two young persons differed. Same with the ducks (webbed feet flexed on braced fingers). Lucian agreed, and he was jolly pleased to think it should be so. Perhaps it made him (*pace* Sylvester) a real painter. Certainly the desire to create sensational paintings, by which he meant paintings infused with feel and impact, urged him on; yet he never liked this, his final Bramham painting: too contrived, he thought. Almost simultaneously the painter-to-painter relationship died away. Comparing this to the dismissal of Tim Behrens, Bramham considered himself well out of it. "Tim was really close, that is very hard. I never was and instinctively only peered into Lu's world. I could always get back to my own. But supposing I'd been ten years younger! I'm glad I wasn't."[3]

Instinctively exclusive as it was, Lucian's world could be regarded as perennially set apart. Looking at what was shaping up to become *Pluto and the Bateman Sisters* (1996), I remarked that it was good not to have floorboards in the picture for a change. Lucian nodded: the painting was going well. "Maybe it is. Maybe it's a real relief: like having a Canaletto without water." Here, arranged like poolside nymphs basking under the overhead light—a jogged memory of that Edinburgh Titian, *Diana and Actaeon*—were Nicola (her lower half only) and her sister Christine, a makeup artist whose idea it was to sit in a sliding pose, legs twisted sideways on the draped mattress immediately above where Pluto lay half asleep. With Pluto "things are understood," Lucian said. "Plute's in the foreground. Like me, not them. She has no relation to them except to do with being in my place." Blended in with the putty-coloured sheeting Pluto nestled against the low step formed by the mattress edge. ("The step is very important; I don't want the persons to be more important than the corner of the picture.") Pluto, characteristically, stabilised the scene, so much so that she could well be dreaming of the women above her. Nicola, being only half there, took a semi-detached view of the arrange-

ment. "I don't mind being cut off at the waist," she said. "Everyone will still recognise me!" Lucian saw her as a sympathetic character. "She's pretty compassionate." Away from the studio her way of life was a throwback, he liked to suppose, to rough old Paddington days. "Things went badly when she and her sister sat as they wanted a minicab not taxis: taxis thought they were whores and would dump her a hundred yards away from the flat (Leigh's flat it had been) as it was on a rough estate and the taxi drivers said they were used to being on the street. Nicola married a tattooist, tough, got on badly and they went to marriage guidance together. It worked, amazingly."

"I think the more I know them—the sitters—I won't say it makes it easier but it makes it more potential. I have to refer less to the things that happen to be there and I'm in a stronger position to choose what I want to use. I'm always trying to find out what and I always like to go on in a series because I feel I have a lot of information on which I can build . . . But sometimes the second one is much harder than the first; and sometimes a picture just comes and more or less paints itself and then you think after that you can freewheel and then it's difficult again. It's to do with the forms, very much." The two heads and ten limbs in *Pluto and the Bateman Sisters* were simply an assortment of forms; until, that is, the process of their being formed up into the painting took over. What resulted was a sense of vigil or heraldic tableau.

The need for sitters gave every late-night outing or lunchtime foray a quest aspect and there was quite a turnover in subsequent try-outs. Daughters' friends or friends of friends could be introduced, but few proved to have the necessary spark or reliability. Letters came from people who felt they needed to be painted and there were persistent approaches too from those who assumed they could commission a portrait. When it was put to him that Jimmy Page, leading rock guitarist, had the head for it Lucian's response was that some years earlier Andrew Lloyd Webber, the composer of *Cats*, had been outrageously eager to get him to paint his then wife, Sarah Brightman. "He even threatened me with theatre tickets." At the same time, despite his finances being less spectacularly insecure than ever before, occasionally and with something like bravado he did take on unsympathetic sitters. There was the arms dealer who lived in a house behind the British Embassy in Paris, stayed at the Connaught while being

painted and had been in Belsen. "That man said he saw people battling over scraps of food. 'I would never lower myself to do that,' he said. This was so odd; he can't have made it up; he was raving mad. People said that he wasn't in Belsen at all. Very intense. Certainly very nasty." On acquaintance of course even the nastiest sitter could be disarming. "Your flesh can't creep in these intimate circumstances," Lucian explained. But in this instance the dislike proved corrosive. "His wife wanted to buy the painting because she didn't want anyone else to have it."

Potential sitters spotted in bar or club or wherever were more immediately stimulating, seductively so, he would report. For example, in September 1995: "This rather amazing girl with a sore part under her nose as if she'd been up to something. It's rather exhilarating. I thought of trying to talk to her and find out her feelings. Use her as a model if I thought I'd like to change my life." Nothing came of that encounter, but others, with or without life-changing involvements, did result in paintings. At the same time, for those inured to sitting, there came what afterwards tended to become the definitive picture. *Bella*, for example, completed in 1996, was very much a salute to the daughter who had been *Baby on a Green Sofa*; thirty-five years on she was self-possessed and businesslike in black, seated on the black armchair and viewed from such a steep angle that she could have been a Lady of Shalott launched upon the streaming floorboards. "I was rather pleased with that. I quite like her almost watching: the fashion thing and being quite a Madame." He had added a section below the knees, widened the trousers ("so that it's somehow more fashionable") and accentuated her bared feet.

Nearly twenty years after he had cancelled being filmed by Tristram Powell Lucian ran into him again. (Powell's production office-cum-gallery—Peralta Pictures—was in a shop next door to Galicia, a Spanish restaurant at the far end of the Portobello Road that Lucian favoured at the time.) It occurred to him that although he had asked for the footage to be scrapped maybe it still existed. "It would be interesting to see it. I'd read the transcript and thought it so awful I said I just can't go on. Then I thought has it been destroyed? And could we get it?" The answer was probably no.[4] Failing that, "I'd like to work from you," he said, to which Powell's reaction was mild irritation at being regarded, he felt, as an inert object. But he agreed—Susanna

having suggested that he would be an agreeable person to paint being so interested in the doings of mutual friends—the sittings began and talk flowed. Gossip mainly; he wasn't the son of Anthony Powell, England's Proust, for nothing. "He's got really delicate perception," Lucian said. Sharp-eyed, observant, not entirely impressed, Tristram listened. At a late stage he had his hair trimmed and, abruptly, some curly bits behind the ears were painted out. Would he care to pose for a full-length painting? No, he said. One was enough.

For Bruce Bernard, whose photographs of Andrews, Bacon and Freud were exhibited at Peralta Pictures in the autumn of 1995 and whose *Lucian Freud* (290 plates) was published the following year, a further portrait was an accolade.[5] Resolutely he sat in rumpled pull-over and jacket, swollen hands resting on parted thighs, patently justified in considering himself an embodiment of the "fresh human feeling" that he had attributed to the artist in his amiably discursive introduction. "If his interest in the expressive potential of the human forehead distinguishes Freud from all other painters, his painting of hands and also feet is equally concentrated and revealing. When I tried to discuss this with him once, he said that if they were noticeably emphasised then they couldn't be right, although I was not accusing him of exaggerating their significance."[6] Lucian knew his Bruce and recognised that depictive favouritism was to be resisted. " 'Is that a bit you like doing?' people ask, and someone says, 'Van Dyck was good at hands.' Which seems to me to mean that that was what was wrong with the picture." He noticed too that Bruce was ailing; witness the bloated hands. "His fists are very important": four inches were added to the canvas to make space for them.

"He drinks when he's here—he just has those cans of beer—and he doesn't look well.

"Bruce likes being difficult and my not trying to overcome it, but then he's very touching about that. He said, 'I was rather worried when I said I couldn't come on Wednesday: you didn't argue with me about it.' There's a bit of that because naturally I'm inclined to be bullying; because I'm doing what I want." Freud gave him money when asked and there was a "stream of good gossip, old song lyrics and jokes," Bruce wrote. Adding, ominously, "Human life of all kinds cannot stop bringing its news, often in the revealing form of weariness, to this painter's studio."[7]

The painting took on a diagnostic air. "A result of the way Bruce lives and his digestion; but when the spots and things appear it's rather like mushroom-picking in a field: you know very well that generally they only come out there and there, so if I need something I use things which are there, or were there, or will be there, because it relates to his own particular." A lump was growing on his neck, and by rights the painting should have featured it. But no. "I would have to see it, as I often use things I see when I go further round, but here there's somehow no place for it. It would look clinical, which I always try to avoid, maybe not successfully.

"I thought Bruce's head worked awfully well, but the fact that there's a certain thing to do with one of the cheeks, that comes out more . . . It's got an expression of strain, an odd look of 'Can I keep on doing this?' I had an impossible idea of using it as a frontispiece of the big book.

"It has helped even him telling me about the doctor. It seemed to start very rapidly . . .

"I think the more I know them, I won't say it makes it easier but it makes it more potential. I have to refer less to things that happen to be there and I'm in a stronger position to choose what I want to use. I want the fact that they are physically alive to register in a specific way that I've devised."

Within months Bruce was to report on his health and future prospects as being "dire."

A dispute arose soon after the publication of *Lucian Freud* when its co-editor and designer, Derek Birdsall (who previously had designed the equally handsome 1993 Whitechapel catalogue), produced a dummy for a projected *Freud's Nudes* to which Freud took exception. Not just on the reasonable grounds that decades earlier such a book would be the sort of thing Lord Clark would have plumped for but because he had decided that some of the weaker reproductions in *Lucian Freud* could only be the consequence of poor-quality photographs having been used and that Birdsall alone (not "poor Bruce," he said) was to blame. His letter telling Birdsall so was viciously worded. "A funny thing: we used to be such good friends," Bruce lamented, citing other occasions when Lucian's exercise of copyright control became ferocious, but the injury to Birdsall was unwarranted and the hurt irreparable. It so happened that John Riddy, another friend of

Bruce's, had already become indispensable. Lucian came to regard him as the one photographer meticulous enough to do justice to each new painting. From then onwards high standards of reproduction were possible, if not always achieved. As for the *Lucian Freud*, there was to be no reprint, its eponym decided. "If the book sells out, let it become a rarity." By then he had agreed that I should begin work on what was intended to be a short book, more biographical than Bruce's and not essayish like Lawrence Gowing's. Though reluctant to assign copyright permission right away he did so, signing a scrap of paper: "Lucian Freud himself, 10 December 1995." Then by way of endorsement, I supposed, he wrote on the title page of my copy of Bruce's book: "Hope you do a bit better than this."

Lucian's life had reached the stage where distant events and former associations kept coming to mind, not so much as biographical material but as quickened memories and immediate considerations. On 14 February 1996 Caroline Blackwood died in the Mayfair Hotel, New York. She was sixty-four. Latterly there had been some contact; when, following an operation that went wrong, she was in a hotel down the road from him in Holland Park he took her flowers. "He didn't have to come and see someone out of his past," she said. Back in 1977 she had urged him to attend the memorial service for Robert Lowell, yet another of her financially dependent husbands. And more recently he had read her book about the Greenham Common women protesters against cruise missiles with what amounted to respect. ("Just on the right side of journalism. Mostly.") He thought her brief account of the macabre last years of the Duchess of Windsor reflective too. "Utterly drunk," as she was, "and careless of lives and possessions. When Caroline was dying I talked to her on the phone quite a bit. She said her mother Maureen had visited her saying, 'Say hello to husband in heaven . . .'" Rummaging through his plan chest he came upon her letters to him from his time at Goldeneye in Jamaica. "Really nice letters. I found a lot and I thought I'd throw them away. I read one and thought, I can't." Her pictures by him of her were held in a bank vault.

A few months later Freud had occasion to ask the Rector of St. Bride's Fleet Street, Canon John Oates, about the practicalities of having a faith. Religion: did it help? "It hasn't entered my life in any way. Does it help cure unhappiness?"

Behind the head of Sue Tilley, asleep in the red armchair, there arose, dreamlike, the spectacle of a lion and lioness in a tapestry landscape. Lucian had assumed that it would be easy to track down such a commonplace exotic thing. But no: big-game hunting scenes, he discovered, had become commercially extinct. Eventually however a rare survival was spotted on a jewellery stall in Portobello Road under the Westway flyover. He paid £20 for it but noticed as he peeled the readies from his back-pocket wad two or three bystanders poised to mug him. Old Paddington instincts kicked in. In a flash, he said, he whipped his belt off and wrapped it round his fist as a knuckleduster. The chancers backed off.

He reported a sniffy reaction to the big-game scene from Sue Tilley, yet it served well, the lower part immediately fed into the picture and the blue sky left until last, held back deliberately, Lucian fancying at this stage that the hummocky distant hills involved could be the fells around Kendal. "I don't know quite how high I'd have the horizon. There's a sensuality in leaving a bit to do last. The harder you concentrate the more the things that are really in your head start coming out. I had that in mind all along. The more brown and grey-brown and pinky-brown and browny-pink it got, the more I thought, 'God, when the carpet comes up all these things will start singing a bit.'" And so they did. "After a certain point the picture takes over. There's just the right degree of blue there now. You also feel that the sun's drying out everything . . ." Dryden's Africa came to mind. That masque Africa, land of tableau:

> And still for him the Lioness stalks
> And hunts her lover through the lonely walks.

"It will be clear from the border that it's carpet but I actually painted it as landscape."

Far across the floor the carpet hung as a further dimension, its outlandish surreality offsetting the surreality of that monumental body surrendered so.

"You are very conscious of the air going round people in different ways to do with their particular vitality."

Two etchings followed: *Woman with an Arm Tattoo* (a reversal of the slumped head in *Sleeping by the Lion Carpet*) and *Woman Sleeping*,

the body not weightless but chairless now and in effect embedded in the greyed plate. And that was the last of Sue. "I might do a head but I feel it's a full series and I feel that, good as she is to paint, I should make a composition with a number of people." He used to shout at her when, nodding off, her pose slipped.

So he finished with painting her. Why? "I think I've done her. Nicola yes again, maybe. I felt that I don't want to make the bulk the point. I've always thought that biology was a great help to me and perhaps even having worked with animals was a help. I thought through observation I could make something into my own that might not have been seen or noticed or noted in that way before."

Though he had told me, "I don't go there too much because it's next door to the house," Lucian became a devotee of Sally Clarke's shop and restaurant a few doors along in Kensington Church Street. Sally's particular vitality was accommodating, so much so that he would go there for breakfast before the place opened (Earl Grey and pain aux raisins, milky coffee, scrambled eggs, Ginger Pig sausages, Portuguese custard tarts) and often for lunch too—brunch at weekends—his table being the one at the back, by the rear window. One morning when he was in the shop stocking up on essentials (bagfuls of almonds, Sally Clarke nougat) a woman complained, either about him in his scruffy overcoat, disgracefully unshaven, or about Pluto. That did it. He said, "You old cow, you have no right to comment about other people. Look at yourself," and hit her on the bottom with his baguette.

Some said that Freud's Kendal exhibition was aimed at competing with, and possibly upstaging, a mighty Bacon retrospective selected by David Sylvester at the Centre Pompidou. It wasn't, and comparisons weren't invited, yet there they were, the one a grand cultural event in Paris beginning on 27 June 1996, the other more modest, opening two days earlier in a small Cumbrian town widely known only for its mint cake. Adrian Searle, in the *Guardian*, played up the contrast. "After the elephantine Bacon show, a concise survey of forty of Freud's works comes as a relief . . . They slow down the act of looking and impress one with their concentration." Unlike the Bacons in the Pompidou, slackening latterly into diagrammatic smudge, the Freuds in Abbot Hall were, Searle maintained, absorbing throughout. "He leaves us with the lesson that others are finally unknowable,

however much their presence acts upon us." Or, as Freud himself wrote by way of marginalia improving a remark of his that I quoted in my catalogue introduction: "I think of truthfulness as revealing and intrusive rather than rhyming and soothing." He went north to see the exhibition before it opened and approved the arrangement; Susanna Chancellor photographed him passing below *Girl Sitting in the Attic Doorway* vertiginously hung halfway up the stairs.

He rang to tell me how impressed he was with the Lakes. ("The Legs," it sounded like, the way he said it.) And he quite enjoyed the French-cuisine pretensions of his lakeside accommodation. "I'll certainly do a brochure for the hotel which Mr. King gave me. It said: 'Assemble in the lounge for a glass of Buck's fizz before dinner.' Susanna said: '*I'm* not going in the drawing room.' She thought it was an order."

Back home, stirring a drink suffused with headache powder, he leafed through the facsimile comments book from his 1994 show recently sent to him by the Met. "Awfully well done, don't you agree? 'Lovely works,' says a doctor. 'Singular and brave.' And 'I've come all the way from Alaska.'" As he read he brightened. News from Kendal wasn't bad either. One Saturday 570 people had been to the exhibition, which, for Kendal, pop. 25,000, was phenomenal. Attendance amounted to 26,000 altogether. One woman told me that even though her husband had died earlier that day she'd come to see it just the same.

Another day Ed King noticed a man obstructing the view of *Sleeping by the Lion Carpet* while talking noisily into his mobile phone. He asked him to please refrain, only to be told that he was in fact buying the picture; Joe Lewis was the name and he'd been speaking to Bill Acquavella who, before long, decided that the man's appetite for Freuds had become such that he refused to let him have any more. Lucian rather admired Lewis' persistence. "He's sort of small, grinning, good-natured, jolly and very very rich. Bought into Vic Chandler. Bought all off Saatchi: Acquavella sold them on to him all in one hit. He kept wanting to have some special deal: an inscription maybe, 'To Me Old Pal Joe.' He had come up through garages to property and deals in Florida, the Bahamas, Argentina, Las Vegas." Including, incidentally, a one-third stake in Christie's. He flaunted inducements such as potential trips to Russia in his yacht and he even suggested

that Lucian might care to buy into a horse he owned. Desert Prince. "He'd bought it for £50,000, he told me, and eventually it fetched £5 million. 'I'll have a leg,' I said. 'No,' he then said. He didn't want the aggro."

Midway through the run of the exhibition a brand-new painting was inserted: *Portrait on a Grey Cover* (1996) featuring Victoria Potts, a niece of Antony Gormley, the sculptor, and Dr. Michael Gormley, Lucian's doctor; she appealed to Lucian not, primarily, because she was a painter. "Victoria is rather perfect and voluptuous and very well proportioned and balanced in every way. I'd like to bring out her youth, her own particular proportions." Afterwards she alarmed him by talking of publishing her diary of the sittings. That, he felt, would have been improper, to say the least. A Chinese silk carpet from Shepherd's Bush market was laid like a giant bookmark across the bed cover as though tonguing her hip. This, Lucian thought, was an acceptable, indeed a necessary, intrusion. "It's going to have a destructive effect in the way that a real gunshot would have in a play. The carpet would fuck up the picture unless it were related. It's not very hard then to think of Chardin and think of painters where they make everything in the picture belong to them.

"It's an aspect of what I think of as truth telling. It absorbs you so that it's easier to bear it because you put a distance between yourself and it."

Ed King wanted to buy *Portrait on a Grey Cover*, valued at £780,000 (that is, a million dollars) for Abbot Hall. He raised £250,000, with Acquavella offering a £150,000 discount and £75,000 from the National Art Collections Fund; however the Heritage Lottery Fund, from which too much was half expected, declined to contribute on the grounds that the painting was insufficiently old. "A period of reflection can only be helpful," Jacob Rothschild, chairman of the HLF trustees, commented, and the painting was sold to John McEnroe, tennis champion turned art dealer, and despatched with the other new paintings to New York where Roberta Smith wrote in the *New York Times*, "These paintings take as long to look at as to paint."[8] Lucian liked that. Also included in this Acquavella show was *Self-Portrait Reflection*, the latest state of an etching that became increasingly imposing thanks to the printer's adroit interventions, wiping an inked cloth across the lower part of the plate so that skin

read as nightshirt and darkening the increasingly bitten image until it amounted to a triumph of scrutiny over shadow. Lucian was impressed and relieved. "I could do thick lines with aquatint but I don't want to get into it that deep. I've never printed anything so heavily before."

This was the face of the demanding and unyielding plaintiff whom Dan Farson (most recent book: *The Gilded Gutter Life of Francis Bacon*) spoke of, in an article he wrote for the *Daily Telegraph* to coincide with the Kendal exhibition, as "a Charming Prince of Darkness," one who, he asserted, "publicly acknowledges five children by Rose Boyt and two by Bernardine Overly [*sic*]."[9] Lucian saw no reason not to sue. "All old rubbish," he hastened to tell me in a late-night call. "It really is disgusting. I think he's sunk very low and *everything* is wrong. Nasty, sneery and something about how I wanted to get my own back on somebody. That sort of stuff." Furthermore, he added in a note for his lawyer: "The number of my children is about as relevant to this case as whether or not your mother-in-law is a practising lesbian." The article was not entirely derogatory; there was mention of Lucian having slipped him the cash after Farson had paid for lunch at Harry's Bar a few days before. "That was more than generosity, but it was typical," he wrote. No such generosity now. Farson was "one of those drunks who suddenly turned aggressive when over a certain limit," Lucian said, adding: "I rather mind being referred to as a friend. I have lived at the same address for over twenty years. Why do you imagine my 'friend' does not know my address?" He engaged Peter Carter-Ruck, deeming him to be on a par with Acquavella in that he was hard-headed: properly and agreeably so. Besides that, ever since his lawsuit against *Time* magazine fifty years before, the idea of exercising complaint had appealed to him, as did the wielding of threat and the possibility of a lucrative win. A retraction duly appeared in the *Daily Telegraph*.

As for the co-plaintiff Rose Boyt, she now came to feature as the matriarch of *The Pearce Family*, a painting, completed in 1998, which could have been designed to mock or fox Dan Farson, who did not live to see it. Rose had married Mark Pearce, widower of the writer Angela Carter, and what began as a painting of the two of them grew into a group portrait including first their baby Stella and then Alex her stepson. "Me and Mark together," Rose explained. "I

think that was my idea and then Mark was doing his teaching degree, so I thought I can perch on the arm of the armchair. Then I got pregnant and when I told him [Lucian] about being pregnant his first impulse was not congratulations, or I'll be a grandfather, but the fact that that'll really fuck up my painting. (He didn't say that.) I told him Stella will have to be in the picture and then Alex would feel left out, then, nine months after Stella, I got pregnant again: so I was making the announcement for the second time, before I gave birth to Vincent. A long time: not pregnant, pregnant 9 months then pregnant again."[10] This, to Lucian, was more than a matter of accommodation. Two successive pregnancies affected the regularity of Rose sitting and he fretted at that. "She's not very well. I long to finish it, but she was pregnant. So now I must have the baby in, also Rose's stepson, so I'll have Rose pregnant, and the baby and the stepson." With Rose at the helm, her arm round Mark's neck and her wedding ring glinting, Mark looked more supportive than assertive. Lucian had come to like him. "He's sort of nice, this man who was married to Angela Carter. I said, 'Would you like some fish?' Rose said, 'Mark doesn't really have fish.' 'Oh, is he a vegetarian?' 'No, it's to do with his childhood.' His father absolutely loathed fish, so his mother used to eat fish and make the children eat fish. Mark's got something about him; at first I just thought he was a hedgehog. Rose is probably stronger but he's pretty definite; she's pretty disciplined, much calmer, better in every way. Loves being married." Now he found (on the phone mainly) that she was good to talk to and advise him from time to time. Yet it was Mark who held the family together in the painting: Baby Stella, clamped behind a great paw of a hand larger than her head, and Alex at his knee, sporting on his T-shirt the glowering screen-printed face of Bruce Lee.

Same again was the plan when Esther and her husband, David Morrissey, began to sit. Esther saw this as a marriage portrait in prospect. "We were on a chair, I was on the arm: same pose as Rose and Mark, but we had four or five sittings only because David being an actor had to be available or was then never available." After that, with legacies in mind, Lucian decided it would be good to provide each of his children—those he favoured, that is—with (small) legacy pictures at least seven years, it was to be hoped, before he died. "No tax

liability and they have them," he said. "One each," he added, *Esther and Albie* (1995) being one such, with Esther breastfeeding her avidly snuffling firstborn.

Grandchildren interested him only insofar as he found their behaviour artless and instinctive. And only those who possessed, in his view, an inner life could qualify to sit. Ib's children, for instance, he described—appreciatively—as "relentlessly savage and attentive" and that gave them potential. Also May Cornet, Annie's daughter and his eldest granddaughter who while doing a degree in Fine Art Textiles at Goldsmith's was "awfully," he said, lost for words when he took her to the preview dinner at the Tate for Leon Kossoff's 1996 retrospective. As was he.

Though not on another occasion later that year when he found himself facing a crowd of children, nearly all unrelated to him. It happened, one November afternoon when, by invitation, he paid a visit to Cavendish School in Camden, north London, where three of the grandchildren were pupils and Ib taught maths. The headmistress suggested he might care to speak about his art to forty or so nine- to eleven-year-olds seated cross-legged in front of him in the school hall and this he did for the best part of an hour. "Please don't be inhibited," he said to them. They asked him which of his pictures he liked best and he told them he didn't really like them, as they'd cost him so much trouble. "But I hope other people can get from them what I feel I can't get." As he reported to me the next day, their enthusiasm stirred him. "All those little arms waving. A bit like the First War song: 'And if you tell them . . . Oh we'll never tell them.'[11] Real little souls. Part of my amusement was some slight difference was being made.

"I ask the people because I want to paint from them, not because they are good sitters."

Ib, resignedly glum, sat with her bare feet planted on one padded chair and her bottom on another: the slumped pose of one who was now divorced, teaching by day and with her own children to attend to yet had still agreed to commit herself to being what her father referred to as "The Ibscape" which then—with Proust on the go—became *Ib Reading*. "That one took forever: all the volumes of *Remembrance of Things Past* and one or two other books too," she said in retrospect.[12] The painting was enlarged on every side, the better to contain the plan chest with tarnished brass handles in which her

09/17/2022 11:29 AM

Cortez Public Library

(970)565-8117

cortezpl.insigniails.com/Library

Patron Barcode 1190000580xxx

Title: The lives of lucian freud
Barcode: 1190001704247
Due Date: 10/05/2022

Title: The Littlest Library : a novel / NEW
Barcode: L0001000009667
Due Date: 09/27/2022

Title: The War Librarian : NEW
Barcode: L0001000009785
Due Date: 09/27/2022

Number of Check Out: 3

1

Sunny Morning—Eight Legs (unfinished), 1976

father kept the letters, telegrams and photos that he liked to rummage through in search of pertinent items: for example, the letter from Peter Watson sent, at his request, to Halifax, Nova Scotia, in 1941 to greet him when he landed there, and the tiny head of a ferocious Barbara Skelton originally intended as a wedding present. Fifty years on such things had become distantly agreeable. Also, and more so, the "Early Works" exhibited at the Scottish National Gallery of Modern Art in the winter of 1997, mostly belonging to Jane Willoughby, among them the three-legged sandstone horse that secured his initial place at art school and the prodigiously baleful *Village Boys*. Lucian was pleased to see them elegantly catalogued and displayed. It made them look like real works, he said.

Meanwhile, by day, David Dawson posed naked with Pluto on the studio bed. He had become more than the assistant referred to sometimes as "Slave"; his role from the late 1990s onwards was to be dependable, companionable and reliable. "I just help out. I'm round there every day. I might be able to make his life a bit simpler." For Lucian such care became invaluable. "David's very fond of Pluto. He

said, 'I'd like to see as much of her as possible as she isn't going to be about too long.'" Casual employment warmed into a steady companionship. As Lucian saw it, David the young painter could have been him in Delamere days. "I don't like to take up too much of his time," he said that summer of 1997. "He was drawing recently on the towpath in Paddington where I used to live years ago and an old man came along and said, 'You know there was a young painter used to bathe here with us called Lu Freud. Used to jump in.' The old man must have been younger than me because I was always the oldest bather."

This being David's first appearance in a painting he began taking photographs to record developments. Firstly, a woman, Henrietta, posed alongside the bed, was eliminated and Pluto's role became central. For a while it seemed possible that David's jeans might feature, slipping out like a forked tongue from under the bed. Failing that, he considered maybe Susanna but opted instead for a pair of knees. "The spare legs came about out of desperation, as things quite often do in my pictures," Lucian explained after weeks of cancelled impulse. "I thought I'd have some shoes or trousers under the bed but that was an evasion. For I then realised that I had to have something organic there, something moving, and then I wanted a person under the bed, which I've used before, and which I've often sensed in pictures that I like. In my case the ease and calm of a composed picture could take some of the life out of it." Discomposure then. Planted there and casually revealed, the extra legs were like a magician's trick rumbled. "Important thing that they shouldn't look morbid," said Lucian, thinking back to Christian Morgenstern:

> *Ein Knie geht einsam durch die Welt.*
> *Es ist ein Knie, sonst nichts!*

> On earth there roams a lonely knee.
> It's just a knee, that's all!

"It's a very odd thing about what affects me. What amazes me about dreams are the casting arrangements. People I long to see. The idea of a story doesn't bother me because everything's a story. But the idea of symbolism: I hate mystification but I think that, unlike

Andy Warhol, who said, 'People go on asking me about my work, they don't realise that they are exactly as they seem; there is nothing behind them,' I want there to be *everything* behind mine. The reason I used David's legs rather than somebody else's was precisely because I don't want mystification. I thought by using his legs it would be rather like a hiccup or a stutter or a nervous repetition and therefore the legs would refer back to this. The fact that the feeling, however strong, is balanced." As David himself said, "It's a good echo of myself on the bed."

Sunshine through the blind, the yellow paint rubbed down to effect translucency, suddenly keyed the picture edge to edge. "There's something very nice about canvases being shown as canvases when they've just been done, but otherwise it's a little bit like old nudists or something: a bit funny." Though it hardly needed extra dignity or gloss bestowed upon it, *Sunny Morning—Eight Legs* (1997), as it came to be called, was fitted with non-reflective glass. ("New from Pilkington. Laminated. Looks good. Louis XV frame, very plain: weighs 18 stone.") Acquavella was delighted, he said, and hinted that the painting might go to the Chicago Art Institute with the implication that he might secure a show there.

In this, as in the other larger paintings, ambition thrived in the execution. "In the big things especially sometimes paint goes on, for me, almost all over the place and—a bit like acupuncture where you do something to the foot to change something in the neck—suddenly when I'm doing something I realise something far away no longer works in a way I wish it to. Which gives me a feeling of control when that happens. Seeing how far I can go.

"Cézanne helps a lot. Being able to do things, which I thought were undoable. It's heartening. It can be done. It *can* be done. There's nothing left without being resolved. The bathers: the one with figures under an enormous sky. I like it when they're caught in a storm. Don't make such a fuss. It's not that you want to block things out. It's the bypassing of feeling by art.

"In art you take a risk; unless you are playing, like I used to, Russian roulette with motor cars. You know: dashing across the road with your eyes shut to test your luck. In working, one of the things that makes you continue and is a stimulant is the difficulty, surely?"

Our conversations went on. "What's it like having a book about

you?" one of Ib's children asked him. "Quite interesting?" "It is, quite," he replied. "It'll be the third." He took to telling people that this was to be the first funny art book ever. He expected rapid progress day to day while acknowledging that writing, like painting, was a matter of going back over, time and again. The tapes accumulated and I posed further questions every time he phoned, early, mid-morning, mid-afternoon or late at night. I would prompt him with minutiae to get the memories uncoiling. The whole business was immersive, which made it all the more disturbing for him when he became aware of the imminent publication of a book on him by somebody called Jones, Nigel Jones, who'd previously done a biography of the novelist and *Gaslight* melodramatist Patrick Hamilton. A warning letter to the publisher, Richard Cohen, was sent from Goodman Derrick and in the ensuing spat Jones disclosed to the *Sunday Times* journalist Richard Brookes that he went to Clarke's once—known for being Freud's regular eating place in Kensington Church Street—and sat himself near the artist hoping to engage him in conversation about the weather, say, but without success. Subsequently, he continued, he experienced silent phone calls and threatening calls ("You'd better watch it") at all times of night, so much so that he changed his number and moved house. He had spoken at length to Esther (this she denied) and to Caroline Blackwood (now dead) and had tried talking to Kitty Garman, to Bella, who refused, and to Dan Farson. Besides which the "badly behaved old eccentric," hypnotic and "with tentacles everywhere" ("*Testicles*, I thought," said Lucian) had even ("blub blub") made Kennedy Fraser destroy her research material for that *Vogue* article.[13]

The *Independent on Sunday* reported on 31 August 1997 under the headline "Rumours fly as 'frightened' Freud biographer vanishes" that the book had been stopped.[14]

That morning Lucian noticed as he entered a restaurant in Holland Park Avenue for his breakfast that the place was oddly quiet. Something was up. Momentarily he thought that the literary suppression had won him respectful silence. But no: the news was that Princess Diana had just died.

Tate Retrospective and Constable in Paris

1997–2003

"Shrivel up and droop down"

Nightingale the coal man, who had lived next door in Delamere Terrace, came to mind. "Good-looking, but nearly sixty and had dyed black hair, and the children used to tease him and run away and he couldn't chase them. He'd say to me: 'Never get old, Lu: it's 'orrible. Run away!'"

Horrible too, being photographed; even by the maestro Henri Cartier-Bresson, he and his "decisive moment." The whole procedure of giving time and floor space to some stranger bent on perpetrating a trophy image was presumptuous, yet early in 1997 it was suggested that since Cartier-Bresson had no photo of Freud this oversight had to be rectified, particularly as the photographer was about to have a retrospective at the National Portrait Gallery. Better late than never, though C-B wanted it known that he was very much a former photographer who had taken to drawing. (When I asked him once who had taught him he blinked at so obvious a question and shrugged: "*Oh, Pierre et Henri.*") At eighty-eight, an older age than Pierre Bonnard and Henri Matisse had achieved, he fairly nipped up the stairs at 36 Holland Park, quicker even than Lucian and Pluto, to engage with someone who, although he could profess admiration for stretch marks on a woman, flinched in disbelief on seeing in the mirror the withering truths of chin sag and neck wrinkle, truths that around this time he considered, but decided against, having surgically expunged. The photographs were no surprise. One of them had Lucian stand-

ing, head inclined to one side, politeness tinged with deference, fresh shirt buttoned up to the chin and a crumpled paint rag tucked into his belt denoting work interrupted. Another had him seated, behind him a wall swarming with paint scrapes and the blank back of a canvas isolating a face wary of the clicked shutter. The image was tilted slightly—by chance or reflex calculation—just enough to hint at the strain of being stuck there, exposed, gripping the side of the chair with one hand. "Felt terribly uncomfortable. I think I know it was me, but I've never NEVER seen this kind of chicken. It's terribly good."

This chicken was in danger of becoming an all-too-celebrated elusive old man. When Christopher Frayling, Rector of the Royal College of Art, wrote asking if he would care to have an honorary doctorate his response was curtly surreal. "Thank you for your invitation. I certainly couldn't accept a doctorate. In declining I'd like to say I don't consider myself suitable. Like asking a fish to join an orchestra." Another such accolade was, surprisingly perhaps, acceptable. In the summer of 1997 Bella was despatched to Siegen to represent her father and pick up the Rubens Prize, awarded every five years (Bacon had received it thirty years before), and in return the Museum für Gegenwartskunst Siegen acquired paintings on permanent loan, among them *Quince on a Blue Table*, while the prize money went to the Injured Jockeys Fund. A bigger deal, the Japanese Imperiale Prize, was recommended by the former Prime Minister Edward Heath, an adviser to the organisation involved and something of a connoisseur of freeloading opportunities in the Far East. "You'll enjoy yourself," Heath assured him. "A most joyful experience with every comfort, duties very light and the pleasures enormous." Far from being even tempted by the promised (mandatory) trip to Japan and munificence all round, Lucian sat down with me and a copy of the *Financial Times* and tried working out the sterling equivalent. "Maybe I'd go for 8,000,000 yen plus a geisha girl but not just for 200,000 yen for the fortnight." At the same time he learnt that his head of John Deakin had sold for £890,000 (to Si Newhouse); only ten years earlier it had been insured for £65,000. With such escalation, he said, he hardly dared go near the studio for fear of being tempted to capitalise on discards and scraps. "One good thing about gambling: I don't let things out. There's something mildly contemptible about doing so. Periodically, especially when I'm ill, I get rid of them." That urge to

destroy whatever he judged would depress his standards, and reputation reared up whenever despondency threatened.

For one who enjoyed good health, the prospect or possibility of ailments was somehow tantalising, never more so than in 1997, the year Lucian reached seventy-five. "I don't ignore things; I want to know what's going on. That's why I went to a specialist six months ago: I thought maybe I have throat cancer. He said, 'Why?' I said, 'Because my grandfather had throat cancer and therefore I came.' 'Good reason,' he said. Arthritis he especially dreaded as he had been told as long ago as 1934 at Dartington that his acrobatic efforts might result in it. The stiff shoulder was a more immediate worry. "It was terrible for a long time; I had to have a thing made to put my palette on. I've never not used my shoulder because of it being sore. I'm not arthritic." A few months later he was, briefly, more sanguine. "The only thing I've got is my neck hurts a lot: calcium deposits, which are quite sharp." Other complaints: he insisted that there was a weakness in his left wrist, the lasting consequence of his hand smashing through a glass door panel in the Matthäikirchstrasse apartment. This he had particularly noticed in the awful cold of the North Atlantic in 1941. Unrelated to that but to his mind relevant, he remembered his left thumb becoming poisoned with paint and, to his surprise, antibiotic ointment being prescribed. As for his guts, he had a bit of a history there. "I once had pancreatitis. Had my appendix out in the sixties."

From the mid-eighties onwards Lucian's GP had been Dr. Michael Gormley, brother of the sculptor Antony Gormley. "I went to him because I thought I was getting awfully deaf and he said, 'In nine years' time you'll be completely deaf if you soldier on.' He's a decent man. Nice and undoctorlike." For his part Dr. Gormley found Freud "extraordinarily decent. Anything that interfered with his ability to work was serious: he had a lot he wanted to do and he was committed. So impressive was his single-mindedness. He was very lovely to treat: respectful and polite, well brought up. Demanding on one level— he'd ring often at home and my wife would take the call. He'd want to be seen, trivial complaints, ideally next day before the day began: 8:15 at Basil Street. I'd go in early and it would be a minor issue but he had to be seen as quickly as possible. The funniest thing was that my

receptionist thought he was a tramp off the street—his old overcoat and scarf, unshaven.

"The bottom line was that he had trivial complaints until the cancer."[1]

"I moan an awful lot," Lucian conceded. "I get very tensed up and really worried. Acupuncture didn't work. A cranial osteopath I have once a month on my neck, he does various things. Often my eyes stop working. Like windows with white soapsuds on: really frightening and it was to do with tension in my neck. He released it."

"He did see one eye doctor," Gormley confirmed. "And there wasn't a serious eye problem."[2] "I wear glasses for etching and reading but all in all I'm OK." All the same, any threat to his eyesight—a slight discoordination had been detected—sparked fear (and fury at flash photography). "As a Man is So he Sees," wrote William Blake to Dr. Trusler in 1799. "As the Eye is formed such are its Powers." Two hundred years later Freud echoed Blake. "I did a self-portrait which is no good, which I worked on for a long time, and still then was no good. Hopeless. But now I'm doing another without using my glasses, so when I look at it through my glasses it looks really free."

Talking of which, he wondered, why is it that musicians have no visual sense? "No subtle appreciator of music ever understands about painting. They seem to have their eyes closed. Slightly crazy." Whereas whatever his eye lit upon, each person or thing answered back in the sense that each monopolised attention.

"Different subjects require different treatments. If it had been a head you can change the eye. You can't change the chair." And yet chairs had their moments. "Giacometti made chairs dance; in 1960 there was a Giacometti show: a series of fourteen drawings of a chair and they, like horses, had one foot slightly forward. Very good. Getting a whole lot of air with a line is marvellous." It followed for example that *Armchair by the Fireplace* (1997) could be outstanding as a portrait of a familiar object that had already served in a number of paintings, once with a hand mirror propped on it like a detached eye and then laden with foxgloves (the flower that yields digitalis), and now needed no props or sitter. No symbolism was intended. The worn and gleaming leather, seat cracking, back dented from the many years of daily head rest, now became, as with Van Gogh's chairs—his and Gauguin's in the Yellow House in Arles—a thing of absorbed and

burnished character. "I love chairs. It's to do with who sat on it. Slight feeling of sweat."

That good a subject demanded to be revisited as an etching and so he tried doing it only to realise, with the first pull lifted from the press, that he'd failed. "A setback to my pride. I took it on Friday to the printer and it's just no good: a hundred hours gone in the bin. It being rather quiet and delineated, I somehow thought I could free-wheel from the painting into the etching. Things lead into other things then they disappear. It looked so good on the plate. But then it looked illustrative." He remembered his father taking him once to see relatives named Phillips in Hampstead. "Jews who wherever they were would be isolated. They wore skullcaps. Anyway, at dinner there was an empty chair and I thought it odd and asked my father about it and he said it was for the Messiah. 'If I knocked on the door and said I was the Messiah, would they let me sit there?' I said. And he said no."

Who to occupy the chair? For reliable availability David Dawson was now unrivalled. And there was Susanna: several vivacious little paintings of her suggested playful reaction to the pressures he imposed. There were daughters, and Ali Boyt, and grandchildren, but jobs and school made it all but impossible for them to be there for him uninterruptedly. Lucian moved on, restlessly. The more he was engaged on, the better his morale, but it was hard to tell who would prove worthwhile. "A black girl wrote to me—met at Whitechapel— and wanted to be painted." No to that, though she was to write again two years later and by virtue of persistence get taken on. "You know there's a complete misunderstanding. I paint people not because of what they're like, not exactly in spite of what they're like, but how they happen to be." Though admittedly he did thrill a little to dukes and jockeys it was easy-going acquiescence that suited him best.

"I don't want to have a type any more than I want to have any habits."

He proposed painting me a couple of times and when I demurred backed off immediately; Paul Ryan, a bar acquaintance, told me that when he asked him "Why not paint Bill?" he said "Too like Lytton Strachey."

It being popularly assumed that anyone who painted portraits was in the business of executing commissions, when Labour came to power after the May 1997 election the newly appointed Lord

Chancellor, Derry Irvine, who saw himself as a connoisseur, made overtures regarding a portrait of Prime Minister Tony Blair. Lucian fended off that idea as being no better than the overtures concerning Princess Diana and those from Andrew Lloyd Webber and the newspaper tycoon Conrad Black proposing wife portraits. And then there were the Jaggers. "Met them—him and Jerry Hall—through my friend Penelope Tree; I've got this request to paint them both. If I did I'd have to move. The idea of someone being fairly desperate for being painted yet looking at their watch: 'Time's up.' I'm also worried—I've never been to Blackpool—I haven't really done a well-known face. The idea of someone being painted: desperate for it. It's no joke." Bacon had tried doing Mick Jagger paintings in the early eighties, succeeding only in making a woozy Warhol of him.

Was Mick Jagger's too famous a face? "He looked so extreme with lines and holes, very strange and rough, but he's someone with an interesting mind, very nice manners. There's something odd about his appearance and the way he walks. His legs go on and his body follows and at first you think, 'Steady, is there something wrong?' Extraordinary legs: they look like afterthoughts but they work terribly well." This was an acquaintance worth pursuing. "When he talked about drawing, his accent changed from Cockney London and he talked straight. He has an early Warhol of Joe Dallesandro and he'd bought etchings of mine, had them in the dining room in Richmond Hill: [the playwright] Sheridan's house, you know. He said, 'Jerry's been doing a bit of shopping while I'm away.' He has his reputation for being mean: he likes that." Jerry Hall, seasoned model that she was, needed little inducement to pose. "Jerry is a great friend of Janey Longman. Very intelligent, huge head. She's having a baby and I thought that there really would be trouble but at dinner she said she'd love to sit and she said, 'I wish you'd do a pregnant picture to give to Mick.'" She told him she'd mentioned him once when staying on Mustique. "Princess Margaret who was there pulled a face, a terrible face, and sniffed: 'He used to lead Tony astray.' I've never been out with him! I didn't know him! It could have been Colin Tennant she meant." Other gossip: Mick had been in Hawaii on his world tour. "Mrs. Thatcher was there and made a beeline for him. 'I hate the Japs, don't you?' she said. He rather liked her."

The pregnant picture, a mere six inches by eight, came about

quickly. "*Eight Months Gone* I'm calling it. Seemed the most seaside postcardish. Mick didn't even know about it, it's been on her night table. For it I used glasses, which I don't use for painting normally but I didn't want to go off the canvas. 'Oh, missed!!!'—like missing the dartboard. (I've got a horror of doing miniatures.)" Indeed, the limitations of this bulging yet compacted image provoked the idea of an elaborate painting featuring mother and child. "A big picture. She's naked and nursing the baby." This was to be *Large Interior, Notting Hill*, a conflation of nurture and intellectuality plus Pluto. At the same time, in complete contrast, he drew the eminent philosopher Isaiah Berlin—who said he saw himself as "a general intellectual, by analogy to 'general domestic': will tackle anything"—pensively nodding off, his eyelids smudged: a robust drawing intended for reproduction in the *New York Review of Books*. "His appearance is to do with what's inside his head. Humanism of a rare order. Jewish upbringing, which is the opposite of athletic: an indoor life. Isaiah said, 'Are you physically aware?' 'I have to stand all the time. So, yes.'" He went on to begin a painting of him, one that could have ended up as a thinking man's portrait of the highest order, but the subject wilted. "He wasn't fighting for life. He always felt very badly about creating a major oeuvre but—very funny thing—he never seemed to be doing any work." Lucian noticed how deliberate he had become when he came for sittings. "He used to pay the taxi and put the change back in his purse. I would watch him doing it. When he went upstairs to the loo he slipped and I caught him and he blinked: he didn't seem to really notice. He was perhaps a dandy in the way he wore his clothes; he had an innate sense of style which is not to do with the clothes you wear, it's like timing in a conversation." There were two sittings a week until Berlin went into hospital. "It got better from a really bad stage the last two days I worked from him: suddenly everything went well. Then he fell ill." He died on 5 November 1997. The painting, trimmed a little and dismissed as being nothing more than a goodish start, went to the widow, Aline Berlin. "I've put 'souvenir' on the back of the painting and am going to give it to her. I'd like to work from her." This he did soon afterwards: *Aline* (2000), a stark little portrait radiating bewilderment.

Lawrence Gowing remembered that when he in his turn had painted Isaiah Berlin and they'd happened to talk about Lucian's work

his sitter had said: "I tell you what: it's the genuine article. That's the WHOLE POINT."³ The point being candour above mere exactitude and this meant a partiality for subjects free of gloss or titivation. It also meant that, on second thoughts, painting Mick Jagger was best left to Bacon and Warhol, their forte being frozen facial expression, whereas to paint Gaz, a lesser luminary of the music industry, was for Lucian a tastier challenge. The gangling Gaz, son of John Mayall (of John Mayall's Blues Breakers) was a club-scene impresario and performer with connections that went way back. "Robert Melville was in love with his mother and left her the drawing of Kitty with broderie." Gaz was up for it: an incongruous painting of a true new Soho figurehead.

"I've never worked with someone who's modelled with their face. Gaz wears his hat all the time and looks pretty marvellous, sort of aware of his appearance; he's very self-obsessed. I'm almost as interested. He's tactful and principled. Jazz people nearly always are. It's linked to very strict behaviour." A compere of live bands and disco, favouring ska, reggae, rock-steady, from 1994 Gaz ran Thursday nights at 159 Wardour Street, under the San Moritz Restaurant— which reminded Lucian of his Dean Street days—and did so with startling geniality. "He's a legend. His head is almost over life-size. He has a long head and teeth which sort of appear; one of the teeth, greener than the others, has a cap on it. Likes the idea of being depicted.

"Gaz is a sort of ham in a way. He's open fronted. Open for all. When his mother came to see the picture she was obviously a bit shaken; she was looking at it and Gaz said, 'You see, Mum, I'm at a bus stop and there are some people having a go at me and because I'm quite big they don't know whether to start something or not. That's why I'm sort of smiling and snarling.' Gaz talked with real passionate interest non-stop for an hour and a half about different hats he'd had. The thing is, he was boring and fascinating at the same time. He knows probably more about fifth-century Wales than anyone else there is." The painting failed to sell immediately. "People look at it and say he looks idiotic. *That's* the whole point."

"I wanted to smile," Gaz said, "because so many Freuds are unsmiling."

· · ·

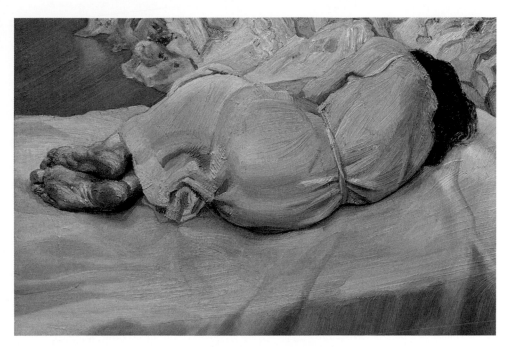

Annabel Sleeping, 1987–88

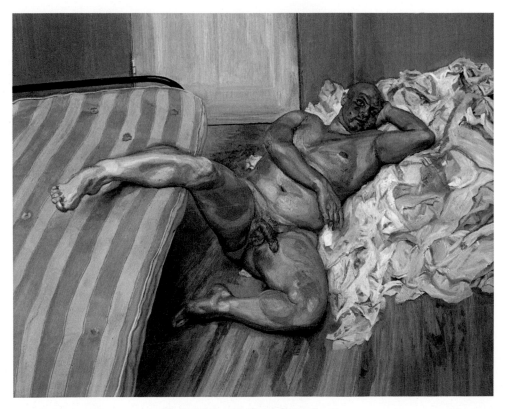

Nude with Leg Up (Leigh Bowery), 1992

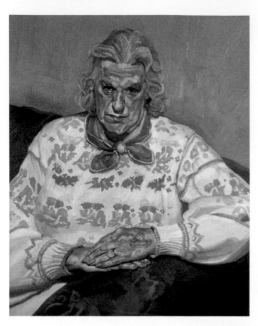

Woman in a Butterfly Jersey, 1990–91

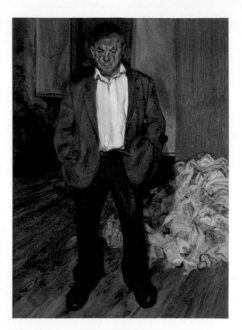

Bruce Bernard, 1992

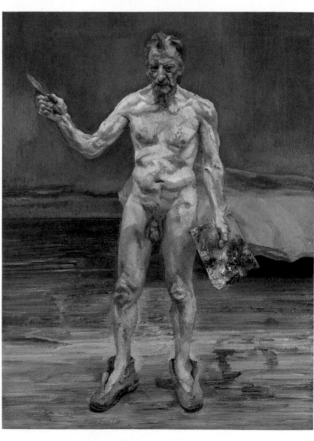

Painter Working, Reflection, 1993

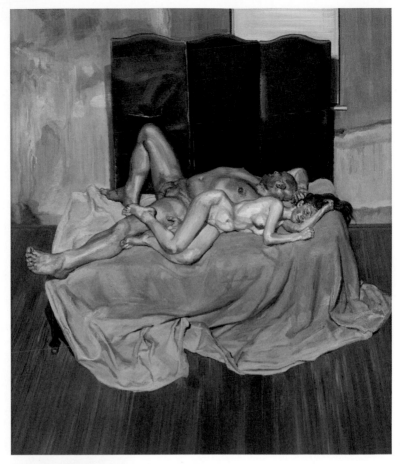

And the Bridegroom, 1993

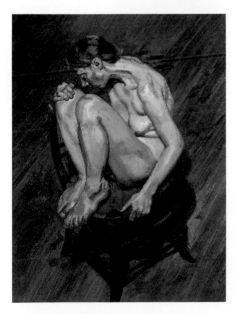

Naked Girl Perched on a Chair, 1994

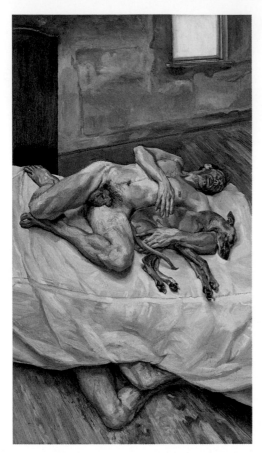

Sunny Morning—Eight Legs, 1997

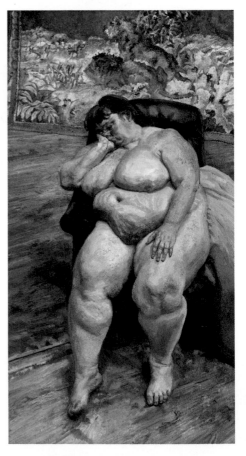

Sleeping by the Lion Carpet, 1996

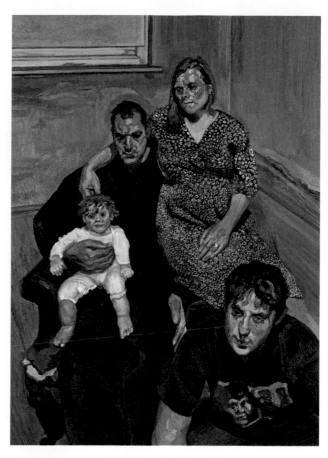

The Pearce Family, 1998

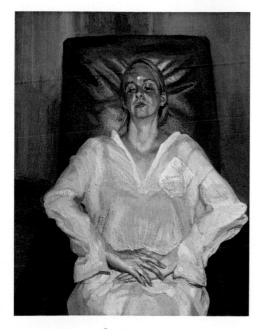

Louisa, 1998

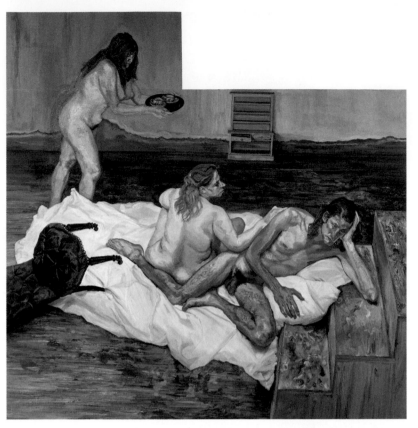

After Cézanne, 1999–2000

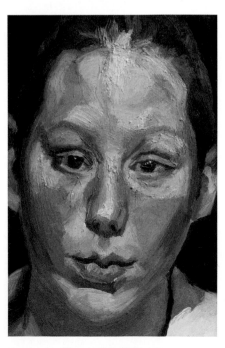

Frances Costelloe, 2002

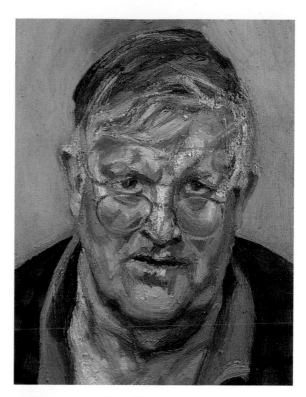

David Hockney, 2002

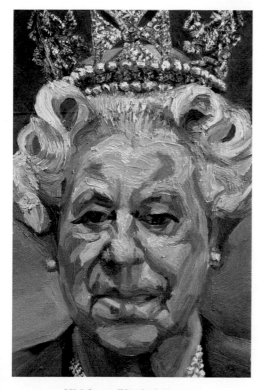

HM Queen Elizabeth II, 2001

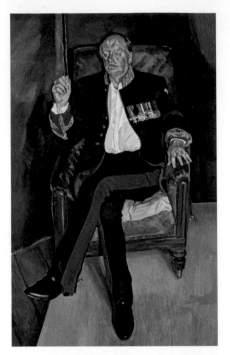

The Brigadier, 2003–04

The Painter's Garden, 2005–06

When he talked about Amy, a new girl he took up with in early 1997, Lucian pronounced himself "hopeful." As with Gaz, here was a creature from another age half a century younger than him and in her final year at Glasgow School of Art. She struck him as being "very straight and vigorous" and not overwhelmed. She made him a music tape to get him going and tagged him "frisky biscuit." The first time she came to the house she wanted to watch Channel 5, of which he was unaware. She proved restive, drank beer and smoked. "Liked going out a lot, which I don't." Indulging her he took her round to Bella's to see if she had any clothes for her. He longed to live with her, he said. Could he stay with her in Sydenham when her parents were away and she was looking after their cats? "Does she embarrass you?" I asked. "No."

A high spot of the brief relationship was a four-day trip to New York in April 1997. They went by Concorde. "It was so quick: leaving at 9 a.m. and being at the gallery at 8:30 a.m." Acquavella made social arrangements, such as parties in the Hamptons and seeing Alfred Taubman, owner of Sotheby's. "Amy was OK in company. She made me walk round New York. We went to a musical—*Chicago*—and bought Fats Waller records (*Ain't Misbehavin'*)." Joe Lewis ("the richest man in England") proposed a trip to St. Petersburg in his new yacht. Against his inclinations but showing willingness, Lucian offered to go to Glasgow for Amy's degree show. On second thoughts he asked Richard Calvocoressi, living as he did in Edinburgh, to send her a hundred red roses with a note signed Rudolph Valentino. He failed to pay for them however. An oversight attributable to the fact that he'd lost interest in her and (as happened fairly often) changed his phone number.

In Paris in 1946 he'd seen Duvivier's *La Fin du Jour* with Louis Jouvet. "About the young girl, the maid, in an old people's home—the old man in his late fifties—and the old women laugh at him so he persuades the maid that she wants to kill herself over him. And then Jouvet gets a legacy from one of the mistresses and rushes off to buy two dozen roses for the girl." For a while the attachment was hopeful, Lucian felt, but then he reported "the whole thing's up in the air." He (and she) had become too conscious of the disparity in age. Was he downcast? "No. I mean it was very short. Not *The Long Engagement*,

it was too good to be true." And in truth the relationship was spelt out in works begun and discarded. "I began a very ambitious painting, then a less ambitious one, then a tiny one . . ."

A more sustainable new sitter was Annabel Mullion who, when she first caught his attention, was twenty-five, and waitressing in one of his haunts, the Globe nightclub in Talbot Road, while aspiring to be an actress. "He used to come in most nights after work. One night, a little drunk, I asked him to paint me. A week later he took me for dinner and said he would love me to sit for him. After dinner he said he wanted to show me his studio. It was 11 o'clock and I remember this quite elderly man pole-vaulting over high railings to take a pee by someone's bins. He was old enough to be my grandfather but I felt like I was with this really cool guy. I knew of Lucian's reputation as a womaniser. I was in a serious relationship at the time and had no intention of allowing anything to happen, but I had to be on my toes. If I'd let my guard down he would have tried to get me into bed. But I never felt threatened; he wasn't lecherous."[4]

Annabel and Rattler, completed in 1998, re-enacts that classical encounter, the vying of the rough and the smooth, the bristling and the sleek, a contrast proving mutually protective: Diana and hound or a witch and her familiar spirit. The dog's pose derived, Lucian pointed out, from "the figure across the front in the Stockholm Rembrandt." (That truncated masterpiece *The Conspiracy of the Batavians* which he had seen when in Sweden decades before.) Rattler, as sprawled as any hearthrug, was ferociously splendid. "She got a dog, amazing, took it to Ireland and two customs officers looked and said, 'That'll be a dog then?' It looks bewitched, annoys Pluto: a friendly puppy wolfhound leaping like a crazy fish or something." Annabel married, had four children and once, when both she and Esther happened to be heavily pregnant at the same time, Lucian suggested that they could prom-enade with him, one on each arm. He liked her. She was enthusiasti-cally no nonsense and she had a repertoire of good Jewish jokes.

"Husband and wife. He says to her, 'In all these years you've never asked me how business is doing? Why not?' 'Well, how is it going?' 'Don't ask.'"

Relations with Susanna fluctuated, as ever. Lucian tried being philosophical about it. "OK in a way. The thing is, it's rather like those charts Gilbert de Botton sends me. Taking up with my plan

rather gave me the strength to make a break. It's impossible to be patient given my temperament followed by my age. She says rather a lot and that's rather nice; in a sense she doesn't take me seriously." She refused to be painted naked. That being so his resort was to try and catch her changeability: head tilted, eyes averted and—as with Hogarth's *Shrimp Girl*—the half-smile of an intimate fending off persistence. "I don't like having things done to me," Lucian said, frustrated that any discontinuity was generally her doing. While insisting that he had "the strength to make a break," when such breaks occurred it was he who, he felt, suffered the most. Susanna once began a sculpture of him—asleep—in wax. It looked promising, he said. "She's got that very odd thing: so immediate." Why didn't she persist? "Because people said it made her look like a 'sculptress.' She started going to art school in Florence not long ago. There she is, with this lively mind and intelligence and trying it, and she got upset. It was somehow linked to her life at the time. Won't even read, hardly."

A Conversation (1998), a snapshot of Susanna and her mother, derived from an old photo, was a substitute for immediate presence. "Two very small portraits, one smiling, the other having a drink. Very blurred, so there's terrific scope for remaking. I started it long ago. Susanna is in Italy." Her absences vexed him. "I've started a tiny thing. But it's not for want of trying to get her to sit." *Susanna* (1997), the head averted slightly. *Susanna* (2000). Had he painted her more than most, I asked? "Yes, except the self-portraits. Well, there I am. Cézanne did Madame Cézanne because she was *there*. I liked him complaining: 'All she likes is Switzerland and *confiture*.' But then he did move to Paris and arranged that she couldn't follow."

In the age of Eurostar and even, on occasion, the private jet, Lucian found he could venture abroad to Paris, say, and back again within the day. "I had a one-day holiday. Went to see Rembrandt and Van Gogh. Had an amazing time." Though he had said he would never go in the Eurotunnel he went by train with Susanna to Paris where they had lunch at Chez l'Ami Louis in the 3rd arrondissement and proceeded to the Netherlands. "Stayed in Amsterdam, hadn't been there since the sixties. The Van Gogh museum is so well done, so well hung. The Gauguin of Van Gogh working is the worst picture (but striking)." And what about the Rijksmuseum? "A tiny Rembrandt of a Jewish doctor: looks like a dwarf, marvellous; and *The*

Stadtmeister; and *The Jewish Bride*." And, obviously, *The Night Watch*? "No, not that: you realise it's a 'composition.'" He had come to feel that a painting so grand and so demonstrative had thereby lost touch somehow. "Composition" implied stagecraft—or over-calculation—where liveliness was needed. This, he argued, Rembrandt well knew.

After that excursion Susanna went off to Italy for a fortnight and their paths diverged. (The last time they were in New York together she went first class on her own, preferring the luxury of that to the narrowness and dated styling of Concorde while, given the hours saved, it was Concorde for him.) The estrangement, largely her initiative, was not permanent but it deflected Lucian for well over two years. He took to thinking of the words of Ortega y Gasset, Spanish philosopher (recommended to him by daughter Annie), "'Love is a phenomenon of attention.' A bit quotable, like Cyril Connolly."

"Dominating someone out of existence makes me rather lonely," he wrote in charcoal on a scrap of paper. "And again: I don't like having things done to me."

In the summer of 1997 Lucian set up an easel at a first-floor window in Kensington Church Street looking out over his garden into the seething leafage, the idea being to concentrate on what lay at his feet below and beyond, a feat of complexity six foot by four, with no sitter involved. He also, more tentatively, began a painting of the high wall around Holland Park proper seen from the front room of the Holland Park flat. He tried using binoculars for close examination of the leaves in the trees opposite, marked out the kerb across the road and steps in charcoal and thumbed in some foliage. It was low on the list, he said. "I wouldn't have done the [wasteground] dumps unless I was leaving. The window view was a turning away from people." People might be inserted but they were interruptions. First floor. Buddleia. He thought he might do it all through the year maybe, one season after another. There was also the image, the idea, of a fox at dusk, that he often saw, strangely large when extending itself, leaping up a wall, disappearing into the trees of the park beyond. This never came about. Instead he concentrated for three months on what started off as "the buddleias" but became *Garden, Notting Hill Gate* (1997).

"I've been thinking about doing it for ages." The attraction being that engaging with it freed him from having to depend on the punctuality and stamina of sitters. "It is actually bamboo, apple trees, no

sky; if there was sky you would have to see the neighbours' roofs."
To look down from the first-floor window into lilting greenery, to
eye the play of sunshine on serried leaves, was to engage with a com-
plexity more elaborate than any Stanley Spencer nettlescape or may-
blossom outburst and cumulatively as tumultuous as Altdorfer's *Battle
of Alexander*. "I realised that I could sustain the drama that I wanted in
the picture by—as I nearly always do—giving all the information that
I can. On the right-hand side, where those twigs were, I had things
that I could hardly see made more visible; the eye had to take it for
granted simply because they were there." This was to be a close inter-
pretation of Zola's landscape axiom: "a corner of nature seen through
a temperament."[5] He bought a cap to ward off the excessively sharp
early-morning sunlight. "A colour I've used (I asked Mike what it was,
as he used it) is Rowney's Transparent Brown. Mixed into green it's a
reddish colour. I use it on the greens and under-paint a lot with it."

By the second time he called me in to note progress it was obvious
that the entanglements of canopy and undergrowth had developed
from backdrop into lair. There were glints of wasp and butterfly in
the now familiar fronds and shoots. "It can't be said to be set fair
yet. It's going all over the place: the two and a half feet at the top
are really empty as I haven't got anything to stand on to reach it."
That was where the direct sunlight was to seep through. By August
he was reporting significant progress. "I've been working terrifically
hard, going to bed rather early, painting the buddleia; it's the most
fragile flower, changing now every day. To make it seem immediate
you've got to do a lot of work. I've got the most taxing schedule."
Every living inch needed renewed attention day by day. "The leaves
are quite a challenge, getting hold of the very mobile structure, and
ivy—variegated leaf—on the ground, which I hate; an apple tree with
a couple of apples on it: one I've changed over and over. It almost
sticks out of the canvas." There were problems with the way even the
slightest breeze exposed the underside silver of the buddleia leaves,
obliging him to go outside to straighten them. And the bamboo kept
growing. "Lots of bamboo things—very thin ones—in the rain they
shrivel up and droop down." They lanced across the picture space. "I
want the top bit of the bamboos like those religious pictures where
you see Jesus there and then he's here and then he's in front: I want
the bamboos to continue like that."

Then suddenly in early autumn the whole thing lifted. "It's whizzing. Going by leaps. Giving it so much time on my feet is very taxing for a pensioner . . . but what can I do?" The thoroughness had become liveliness. "You can't tell which bit was painted first." Its crush of growth and decay, he said, was like that bit in Camus' *L'Étranger* where the man in the condemned cell shouted at the priest: "Sure of my present life and of the death that was coming. That, no doubt, was all I had; but at least that certainty was something I could get my teeth into."[6]

The buddleia blooms darkened and shrivelled. By October there were night frosts to thin the leaves and the bamboo began to look tatty. "I wanted to use things that the light did to the garden in order to enliven my picture and make it complete. I've got butterflies in it surviving well beyond their natural span. The garden's sheltered and buddleia is a butterfly attracter, but I did notice how amazingly late they were, especially the white ones. It may last out." (This was in mid-October.) "Everything's scorched and blistered and yellow." A week later it was done. "It is changed so much, I felt, until the last three square inches, it could go terribly wrong." He was eager to see it framed.

"One always talks of surrendering to nature. There is also such a thing as surrendering to the picture. I was very conscious of where I was leading the eye, where I wanted it to go but not to rest. That is, it shouldn't have a centre; it shouldn't be like showing someone round the garden: 'This is the bit I like.' I'm giving all the information I can. I was very conscious of where I was leading the eye: where I wanted the eye to go but not to rest. That is, the eye shouldn't settle anywhere."

Called away from the seclusion of the garden painting, Lucian served as father of the bride at the marriage of Susie Boyt to Tom Astor in Farm Street Church, Mayfair, his role being to give the bride away. "I was at Susie's wedding on Saturday. A thing I never expected still goes on: I had to walk down the aisle to 'Here Comes the Bride.' I wore a dark suit. It went on to midnight but I left after the church because I felt rather worried . . . The reason I mentioned it was that when Christ says if you give something—love—to someone you get it back tenfold and if you love someone who really hates you that's

another matter. It's very odd and the same with leaves, ivy leaves, which I really hate. You get more back. It's odd to keep an even feeling about it and not make it decorative. I've got so involved." Ultimately *Garden, Notting Hill Gate* was an exhaustive account of the sheer striving abundance of nature.

Day paintings, night paintings. These kept him urgently employed and between times left him itching for action. "I did have one single sort of principle: I never wanted to be the oldest person in the nightclub. I did use to go a lot. When you've worked at night for a long time the one thing you're not is tired. I used to go to nightclubs, to bars, and ask women to dance. Sometimes they did or sometimes the man said, 'You fuck off, go back to the bar.' Not unreasonably."[7]

Inevitably in his late-night forays, scouting for sitters or whatever, Lucian fell in with members of that loose association the Young British Artists. At Green's one night he came upon a tableful of them, headed by Damien Hirst, who proceeded to ask him loudly and uninterruptedly about the means of success, deals done and prices achieved. He sat silently, uneasy at being interrogated so.[8] The others looked on him as an enviable ancient; Sarah Lucas, for one, danced with him—no talking needed—and also served, just the once, as a catwalk model for a Bella Freud fashion show at the Fridge nightspot in Brixton in September 1997. She said she felt a right nana, Freud reported, her persona being that of an unfailing provocateur. He impressed her as being quick on his feet (it was an accident, she said, when he blacked her eye) and she considered him "terribly nice."[9]

The YBAs were more a peer group than a movement. "Interested in the art world not in art," Lucian suspected, recognising in their behaviour something of the carry-on of his generation's Soho. Where he had played distinctive in fez and tartan trousers and had treated loans as proceeds, now there were the lucrative promotional skills of Damien Hirst and sundry others. As for the art, he observed, it boiled down to "What can we do to get them interested?" That was reasonably interesting in itself. As, in person, was Damien Hirst, whom he had first met in 1995 and whose room-size glass boxes reflected Bacon's formulaic cages. "I walked very late into a party somewhere with someone and Damien Hirst was dancing away and his mother was there. He said to me, 'Look, I'll introduce you to my mother but

promise me one thing: you won't say anything awful to her, will you?' Pink hair pink knickers pink everything. 'The only thing I'm really deeply envious of,' he said, 'is you being able to paint.'

"Painting is different from arranging things, which is what Damien Hirst does." He had quite liked some of Hirst's devices. "Things of his that are lively." Such as *A Thousand Years* (1990), a vitrine in which maggots feeding off a cow's head became flies destined to frizzle on a nearby Insect-O-Cutor. Such raw ingredients enacting the life cycle were live performances all right. And, come to think of it, not entirely dissimilar to the teeming seed-to-compost display of *Garden, Notting Hill Gate*.

Arriving late at a party in the Basil Street Hotel Lucian fell in with Jay Jopling, the young gallery owner whose White Cube, a famously small upstairs room in Bury Street, St. James's, served as the epicentre of what had become a rampant YBA culture. "Jopling said, tapping my ankle: 'Oh Lucian, no one likes dealers, everyone loathes them, no one's got any time for them.' So I said, 'It's your manner I don't like and I don't like being kicked,' and kicked him. Treated it as a penalty kick: just a quick below-the-kneecap. He didn't quite know what to do. (He's very insensitive.) At this point people were saying, 'Oh do come and sit down here'; they were a bit concerned." Jopling being the most conspicuously successful art dealer of the new generation, an actual kickback amounted to little more than repartee. As for Lucian, reflex action sufficed. "Then taxis to Gaz's jazz club at half past midnight."

It wasn't long before Damien Hirst was saying that he wasn't a YBA any more: he was an OAP.

By this time, Lucian felt, he could afford to be choosy about who might be permitted to get to own a Freud. "I said to Bill Acquavella, 'I'd rather say no,' when Steve Wynn wanted to buy my things. 'I prefer them in museums.' He's bought a Seurat, 30 million dollars: by ratio rather good value, I would say. I had a strange reaction to him.

"When I met him I thought he was the most repulsive person I've ever met, and also the most 'handsome' man. He had a sort of plastic wig (and you don't know whether the hair has grown out of air or head) and a terrifying plastic wife. Owns Las Vegas. 'People work for me,' he said. 'If they've got a nervous tic I let them keep it.' Bill Acqua said, 'I've got Steve Wynn in the suite next to mine. He rang me

saying, "There's no plug under the hairdryer." ' Gangsters are always spraying their hair and doing their hair. But you aren't allowed to have an electric plug under basins in case you electrocute yourself and therefore can't pay the bill." Famously, in 2006 Wynn was to put his elbow through Picasso's *La Rêve*, which he was about to sell.

"Acquavella's got a rough side. When he started bidding for the Warhol *Marilyn* Steve Wynn was under-bidder and Bill said, 'You've asked my advice but if you're going to start this it's pointless getting me to advise you. At that price I couldn't get half the money back. There are limits.' Wynn is obviously very hysterical. He said to me, 'I guess you're the best painter in Europe.'

"On the other hand it's high prices bring things into focus: by last June, he had spent with Acquavella 180 million dollars."

"What sort of present do you give that kind of guy?" Acquavella asked—rhetorically—the answer being a full set of the Zervos *Picasso* catalogue raisonné. A bit much, maybe, Lucian thought. "John Richardson says: 'I always suspect painters who have too many art books.' I agree."

Not that this inhibited Freud from buying for himself the complete Byron just because he liked a certain poem: dusty volumes to be dumped unread. He showed off his complete Watteau drawings, his complete Géricault and even a complete Fragonard that he felt elated about momentarily but then hardly looked at.

"I don't want paintings to be 'readable' but there are things going on in the room"

One pale February afternoon as I arrived at the flat Lucian let me in with barely a word then darted back into the box room to watch the racing from Haydock Park. There was an extreme close-up of the horses coming head-on, hooves thudding. "What a lovely shot. Wintry sunlight." He wasn't betting now, he said.

Splurges occurred when he felt abnormally stressed. A few months later, in the summer of '97, bets were on. "Galloping home on the straight. The excitement is like nothing else. I did a crazy thing yesterday while I was having wild bets, first time for a year. I ran a bath and all the hot water ran out which, in a minute, will be a bit warm again, so I did something amazing because I thought well, OK, unlucky in love, at least I can be lucky in gambling. So I had some rather huge bets, all of which I lost. I thought: today's Derby Day, so I backed in the first two races and lost quite big followed by two enormous ones. Then was the most difficult thing: a huge handicap with different horses of different ages and different weights and I backed two horses, which were first and second, and I had a forecast—the stakes were quite high—but the forecasts were two thousand reversed which, compared to the stakes, was very small and the first and second forecast came up and paid 104 to 1 so my £2,000 made £219,000. So with the smaller bet of the two horses—the horse that won I backed separately—I had £14,000 at 8 to 1. I was actually up after all this, after all the losings had stopped. I don't know how much, it must be £40,000. I just did it

because, I thought, since I don't drink, don't take opium, I'll have a bash."

What, I asked him, brings on the bets suddenly?

Oh, just because my life recently has been down and down and down . . .

Sex and bets isn't it?

But I'm not interested in sex. I mean I'm interested in love, that's the whole trouble; I don't mean that's what's wrong but otherwise I've never been interested in *sex.*

But surely you must have been?

Will you define it? Because I think I may not have been.

Just looking at women, say, and thinking: "I want to have her."

Oh: desire?

Well, desire and sex.

Oh, yeah, I'm not unnatural. But I thought sex was to do with doing certain things?

You mean being "creative" at it?

You know how one behaves differently with different people. I'm not at all introspective but I do notice—that's why I think I'm not interested in sex—that I haven't got "things that I want to do," I actually want to make love, I actually want to make some.

Do you always do that?

Um no. No. But then you can't love many people, you know. I'll tell you what I like very much: because I can't do courting (it makes me so nervous) I want an immediate intimate situation with a stranger who I do like. But the fact that it involves sex, obviously that's where the intimate part comes out. With someone you are already intimate with you go on making things more intimate. But unless I'm caught up with someone I would hardly notice, do you see? For example——: she's like a chicken. Free range some nights. You know you can only feel amorous if you feel happy. Reasonably happy. So if you're very unhappy the only reason that you want to go with anyone else is to try and rub your unhappiness off on them. Doesn't seem quite right, does it? I don't think that's the way to treat humans.[1]

In the spring and summer of 1997 Lucian was especially unhappy over Susanna. "Had the strength to make a break," he said, while reaching out to her in letters. It was worst when she was in Italy. "Every time you come back it makes me more unhappy," he wrote.

"She rings me rather a lot and that's rather nice. In a sense she doesn't take me seriously." Initially David Beaufort had found her oddly silent when Lucian brought her to lunch but, over time, she became voluble. "Very like Lucian in a way and that was the attraction."[2] To her, throughout, Lucian was incorrigible. And compartmented. "There were so many areas of his brain; I only got a patch of his life."[3] For his part, Lucian fancied he detected in Susanna a tendency to appease. "She's not the great-niece of Neville Chamberlain for nothing. I don't like her not telling me the truth. The smallest thing sets me off. The tiniest thing." He having phoned her four times a day in Italy and having admitted he was unreasonable, they decided not to speak on the phone for a month. "It's been torture," he told me while admitting that he was being obsessive and manic.

Bets were on again. "The thing is I want to lose money." But, as Esther pointed out, Lucian's finances now were such that losing had rather lost its appeal. "He said, 'I'm making too much money to therefore gamble it away.' He bought flats for us. Addicts can't stop; he could. At Holland Park he'd go into the box room to watch a race and we wouldn't."[4] He didn't want to be "a poor old punter," he said, but any risk of that was shrinking fast. His gambling now was borderline nostalgic for, having gone halves with Penelope Cuthbertson in an eight-year-old brown gelding, he had the invested interest of being an owner. "Miller King's been second two times and running on the 10th," he told me that afternoon in the box room. "It may win. Penelope loves it. I think it's a horse that's got possibilities. Three miles it likes, ran well in point-to-points. In four races it's nearly always gone off in front and been caught at the very end. Not broken till it was eight, so a fresh horse."

By the summer of '98 Miller King had been second four times and Lucian still had high hopes for him. "Nine years old, ideal age, one of the horses mentioned in the same breath as a horse that came third in the Cheltenham Gold Cup and not costly to keep. Four runs I've backed it. It was heavily backed favourite the last time but was ill. Bound to win sooner or later."

Luckily that summer an admirable new sitter arrived on the scene. She was Louisa Wilcock, a sixth-former who, prompted by her mother, had written to Freud with questions relating to her A-level Art coursework, the upshot being that she came up from Devon at weekends, staying Friday nights in what Lucian referred to as his "guest room." She smoked roll-ups, was nobody's victim and proved exemplary.

"She's undeveloped for her age (not boys); it's to do with her nature," Lucian told me. "She said, 'I think I'll have a look at Oxford Street.' I thought, well, lots of people there. She got a bit lost, she said, when she came back—I think it was Soho—'I didn't like it.' 'I don't like it either,' I said. She's quiet. But has an adventurous taste in food when we go out." She proved so quiet he didn't mind her being in the studio while he worked on the buddleias.

For the painting that came to be named *Louisa* (1998) she occupied the red armchair wearing a black bra, shadowy under a white shirt that, being one of Lucian's, was a bit too big for her. "This is important," he said. As were the shiny creases in the padded leather behind her head making her haloed and enthroned, a young woman determining what she wanted out of life and looking askance. Sittings were a distraction for her. Respite almost. "She is unwell and wants to become a scientist to give something back. Her mother, a graphic designer, prompted her to write to me thesis-wise. Father gone."

"Three more goes," he was saying by mid-January 1998. Then, once he saw an end in sight, he tried asking her to sit again. "I've twice mentioned it and she didn't answer. She's got mocks. And she went to Edinburgh to look at the university. And there's also King's, London." But there was more to it than that. Shortly afterwards he reported: "Louisa is in hospital, seriously ill, dangerous condition. Liver rejects. She knows a great deal about it. She is brave and extremely detached: she has had it since she was ten or eleven. Very bad scars on her feet. A lot of trouble but it's sort of controlled."

Louisa's mother now made herself available to sit ("Susanna checked up on her") and adopted the same pose except for tucking her legs up on the seat as though defying anyone to question her right to be sat there so assertively bared. The question of Louisa sitting for a further painting was raised again, this time circumspectly. "It would be a mistake for her to see her mother's picture. Not just

now. She wants to sit, but will she also sit if naked? I thought it worth broaching. Somehow I feel, when I'm painting a naked person, I've got this annoying instinct to want to do so, but really it's such a slight thing given her values. Jean said that her son—Louisa's elder brother—said, 'I don't like you sitting naked, Mum.' But it's not a worry."

Anyhow he succeeded and began a large painting of Louisa. "She's undressed but looks exactly the same. Looks quiet and triumphant." Lying across the bed, her legs dangling to the floor, she remained distinctly self-possessed, hands clasped, eyes closed. "She's going to university." Every week for three or four days he worked with shutters closed, sunlight behind, the red armchair empty and the bed stationed on the divide between the front half of the studio and the rear. After a while the canvas was extended halfway down one side to make space for the long bare feet.

Naked Portrait with Red Chair (1999) and *Large Interior, Notting Hill* (1998) proceeded simultaneously, similar in scale (where Acquavella was concerned, large paintings were always preferable to small ones for obvious reasons) and dramatically expansive. *Large Interior* was the more elaborate of the two in that three persons were involved, not just the one, and the bed used for the Louisa picture (rumpled sheet kept undisturbed from sitting to sitting) was parked below the windows as a further item. The reliable Francis Wyndham was brought in to serve as the prime sitter, one hand resting on the arm of the chapped red leather sofa, the other holding a book up to his steady gaze. Behind him, planted in the scene much like the mother and child in Giorgione's *Tempesta*, was Jerry Hall breastfeeding her baby son Gabriel.

By February 1998 what Lucian had set up to be something of a non-conversation piece was well under way. "The big picture I'm doing now, the biggest I've ever worked on, bigger than the Watteau. Jerry's naked, suckling the baby and Francis Wyndham's on the sofa reading Flaubert's letters, and Pluto at his feet with David's arm, holding her, going out of the picture. The reason I want that is to dispel any allegorical reading of it. I want a bit of life. I told Jerry and Francis to lunch together and John Richardson said, 'You're mad, you'll never see them again.' Jerry said to Francis, 'It looks like you're reading to me.'" Her view, but each being preoccupied—mutually

dissociated—the two of them came to appear separately considered. As indeed they were.

"Jerry's not going to be prominent because it's so light by the window where she is. Francis says she's his Muse there. I want her more than just against the light, when it would be like a cut-out, or like a Vuillard where you can have the picture for six months and only then find there's somebody in the room. The picture is sort of middayish with the shutters up on one window, a view through the other, the street and cars and maybe someone walking and I thought I would make the paint thick there. I've painted with a lot of white, which will change to beigeish whitish yellowish. The room looked terribly enclosed and I've opened it up so it suddenly seems a big airy place. I quite like it being flooded with light of a very different kind from *Garden, Notting Hill Gate*." Here the complexities were redoubled by the play of light both direct and reflected off people and things. "Two adults, one baby, chairs, doors, bed, windows, view: I like to do everything at once. A lot I can do on my own. Jerry's not going to be prominent that much.

"I used to always have secrets in. I still do. I don't want paintings to be 'readable' but there are things going on in the room." So small you barely notice her, as tiny as a fly on a windowpane, he put Susanna crossing Peel Street, heading away.

"Yes, it fits. Yes, it will do."

News came in January 1998 that James Kirkman was about to sell at auction *Large Interior, W11 (after Watteau)* and *The Painter's Mother Resting*: Lucie Freud elegiac in white. Predictably, since there had been talk of Kirkman inviting Nicholas Serota to select three of his Freuds as prospective bequests to the Tate, Lucian was reported by the *Daily Telegraph* to be "incandescent with rage." Tetchily apprehensive more like, for *Interior, W11* was to be his first large painting to appear at auction and Sotheby's were promoting it as a masterpiece complete with its own fat catalogue. However, on advice he felt reassured. "Acquavella says it's OK, quite a good thing. There are two things about it, a schizo feeling by Kirks: he wanted me to fail because I'd gone. And he wanted me to succeed because he'd got the stuff. Leaving all 'incandescence' out of it, I feel it odious, having the image everywhere. I've always felt there was something odious about over-advertising."

The sale was promoted to the utmost. What Kirkman had bought in 1983 for quite a price at the time went on view at Sotheby's in Bond Street, prior to a world tour, where Lucian went to see it one afternoon, itching to be angered as Jane Willoughby had told him that there appeared to be finger marks on the glass. But it looked good, so good indeed that the effusive art market commentator Godfrey Barker, writing in the *Evening Standard*, predicted that the painting, now "by general consent, Freud's noblest achievement," would fetch £2 million and, he added, "will belong to an American from Thursday unless those in authority wake up from their awesome indifference."[5] On the night of the sale, in May, he had a telephone connection to Sotheby's New York and was pleased and relieved to hear it fetch £3,578,200 ($5,832,500 million), a sum boasted by Sotheby's to be the highest price ever paid at auction for a painting by a living British artist. The new owner was one of the tycoons of personal computer software, the under-bidder being the National Gallery of Australia.

Asked some years earlier what it felt like to have a picture he did a long time ago fetching a million, Lucian had been moved to respond. "I thought about it and wrote back: 'Thinking about this question I can only say that it feels like hearing that an overbearing great-aunt I had no contact with has been eaten by cannibals.' This is worth saying I think."

Also worth saying is that cannibals are reputed to assume in terms of consumption the bigger the better. Initially Acquavella had bought each big new painting outright, but from the late 1990s he took to paying Lucian once the sale was done. The price achieved for *After Watteau* was confirmation that Freuds were gilt-edged product now, even the one of Jean nakedly defiant on the red armchair. Demand, shrewdly exploited, was not to be despised.

"People have ludicrous ideas about fame. Richard Hamilton told me fifteen years ago (when I last saw him) he was so fed up with the amount of money he was making in Germany from prints that he was advised to put up the prices. And, he said, it was no good, they still bought them." I only want to use the studio when I want it. I nearly always do want it . . .

There was now a constant shuttle between the two studios, moves determined by the diary arrangements that made it possible to keep

increasing numbers of paintings on the go in each, so much so that his output became, for him, prolific. The short and hazardous rat run in the Bentley—into Holland Park Avenue, sharp right up Campden Hill Road, left down Peel Street and right and right again into his reserved parking space—shuttled him from one preoccupation to another.

"The last few years I've been painting with such fervour I noticed today, in the big picture I'm doing, that I was using my brush for almost anything; I was amused by it because I was doing something rather delicate and I not only had the big brush but it was all silted up."

The fervour was reinforced by routine.

Usually my visits were fitted into times of day when sitters were either gone or appearing shortly. Arriving at the entrance to 36 Holland Park I would press the buzzer for Top Flat and—provided I was expected and on time—the front door would click open and I'd be awaited at the top of the stairs, Pluto to the fore. At 138 Kensington Church Street there would be a pause then a fumbling and Lucian would appear and step aside with a clenched smile, lowering his head as though ducking a joke. I would be ushered into the front room for a pause and a natter over the piled newspapers and auction catalogues before going upstairs to inspect progress.

Spring 1998: *Large Interior, Notting Hill* was still looking loosely assembled. It had been more or less presold to Mick Jagger in the expectation that what in Victorian times would have been deemed a "problem picture" would become dramatically, indeed rhythmically, contrived around Jerry Hall. But, with Francis Wyndham so focused on his book and Jerry lodged some distance behind, quirkiness threatened to bother the whole. The eye tripped over supine whippet, aloof literary figure, naked breastfeeding shrunk into keyhole vignette and, behind all that, dashes of direct sunlight spurting on to radiator and bed. The complications, exceeding those of *Large Interior, W9* twenty-five years before (Lucie Freud unaware of Jacquetta Eliot extended on the bed behind her), needed to cohere. For one thing the arms holding on to Pluto in the bottom corner had become redundant. "David's arms have to go." No problem there, but annoyance, and worse, was brewing. "Jerry has gone to Ireland for Easter." She'd missed two sessions and that, to Lucian, was desertion. David Dawson might be

prepared to sit in for her—minus baby, obviously—but he shouldn't have to be detained as a surrogate lay figure; after all, he added, David himself needed to have time for his own painting.

Continuity, generation to generation, was an emerging theme and not only in the ramifications of *Large Interior*. Besides working from several grandchildren and a third generation of whippets, Lucian took on Paul and Sam, the two sons of Alfie McLean. Since the days and months of *Two Irishmen in W11* Paul had grown up to become assertive in *Head of an Irishman* (1997), and prosperous as *Man in a Silver Suit* (1998). For these he flew in fortnightly from Belfast. "He's married to a really nice girl, doesn't want children. That's really odd. He's big and has huge thighs. Someone said to him: 'Your enemy is the pram.'"

Paul had hopes of setting up a casino in Belfast.

It irked Lucian, increasingly, that he had nowhere to show his pictures before they went to New York, and this prompted him to invite the suggestion from Nicholas Serota that he might care to exhibit at the Tate a number of new or newish paintings that hadn't been seen in London. Serota's response had been to say that he was contemplating a large Freud show in "the medium term," which Lucian took to be too far ahead. So then they lunched and it was agreed that he should have what was customarily the Rothko Room, womblike in that it had only one entrance and was, when the Rothkos hung there, suffused with sullen reds. A reclaimed Room 21 would be his from early June to late July 1998. The cul-de-sac aspect appealed in that it helped concentrate attention rather than having people just wandering through. "A showing not a show," Lucian declared. What to call it? "Lucian Freud: Some New Paintings." ("Keeps the right tone.") Costs—shipping mainly—were paid by the wealthy collector Paula Cussi and a free display guide featuring a conversation of ours from the *Observer* was produced in lieu of a formal exhibition catalogue. The twenty-two paintings and four etchings, plus the, in effect, farewell drawing of Isaiah Berlin, covered the six years since Leigh Bowery's death, a period in which Lucian achieved, by his standards, a spate of virtuosity. Witness the heads of Paul McLean, the ascendant businessman, contrasting with Gaz the entertainer, and the sorry daze of *The Painter's Son, Ali. Girl in Attic Doorway* was included but *Sleeping by the Lion Carpet* was omitted, to Serota's relief, it being, he said,

a "difficult" painting. The no doubt "easier" *Sunny Morning—Eight Legs* was shipped back from the Art Institute of Chicago.

On the Sunday night before "Some New Paintings" opened there was a viewing followed by dinner for fifty at Zafferano in Knightsbridge, run by a friend of David Dawson's, Giorgio Locatelli. Lucian wrote out the place cards and arranged judicious assortments of friends, families, associates and good connections: Susanna Chancellor, Jane Willoughby, Alfie McLean, Bruce Bernard, Diana Rawstron, Marc Balakjian, Riccardo Giaccherini and Louise Liddell, Bill Acquavella and his son Nick, David Beaufort, Jacob Rothschild, Neil MacGregor, Mick Jagger, Nick Serota, Frank and Julia Auerbach. Francis Wyndham and I were on what Lucian labelled the baby table, explaining that he thought us sympathetic to those who were recent parents: Jerry Hall, Nicola Bateman, Annabel Mullion, Rose Boyt and Esther Freud. New collectors were fed into the mix: Mr. and Mrs. Pierre Lamonde and Mr. and Mrs. Joe Lewis. "Thank you so much for including us in such an intimate evening," Jane Lewis wrote the next day. "You couldn't have done anything nicer, particularly for Joe. It was fascinating for us to meet so many people that we look at on a daily basis in our home. All of a sudden the people in those paintings became real—it was wonderful."[6]

Within a week news came that 1,000 display leaflets had gone in one day and people had to be asked to refrain from taking them away. By the time the show closed at the end of July more than 100,000 had seen it. A letter came from Nick Serota: "What a triumph."[7]

"I mustn't do anything that feels like winding down," Lucian kept insisting. Distractions were either seductive or infuriating. There was, for example, the unexpected threat from next door in Kensington Church Street, a shop with offices above. Suddenly that hot summer his privacy was violated. Shop or office employees were climbing out of a back window during their lunch breaks. "I'm having a fraught time. The flat roof next to the house: people lying on it talking into their phones. It's nine foot away from the studio. They could see me in the bedroom. Makes me feel hunted. My natural instinct was war. Liquid tar on the roof. They were nice about it and put up a notice saying not allowed to use it, but every time I stepped back there were people talking there. I worried about telling Diana Rawstron, that she might think I'd gone mad." If she couldn't deal with it, he thought,

perhaps a more drastic remedy would have to be found. Also his teeth were bothering him. "It's not that I'm afraid of the dentist, it takes a lot out of me."

Acquavella, a persuasive believer in pre-emptive healthcare, told Lucian that he would find out for him who was the best dentist in London and he submitted without demur. "The thing is I've got this infection. If I don't have anything done, they said, 'You could lose your jaw.'" The memory of his grandfather's grisly cancerous jaw remained vivid (one reason why he had avoided dentistry over the years) and the remedy, he was advised, had to be drastic. "Implant into jawbone, very strong antibiotics, cut the gums." The prospect agitated him. "Difficult to go to sleep. And to wake up. It's all in the head, not in the body. I'm working in a no-time-to-lose-ish kind of way."

The day after what he deemed "this mild mugging" he read that Henrietta Moraes had died. As with so many former girlfriends, he had been involved with her for longer than was maybe generally thought. Not only that, when crossing Holland Park Avenue to get the papers, he reported, he himself had almost died also. "A car ran me down. If I'd been well I'd have hit her—the driver—I was absolutely bashed, neck and back hurt, can't work. Every person in *The Times* obituaries this morning was younger than me; sometimes obituaries are so good. I read them all."

It was around this time that the idea arose of our doing a Constable exhibition, such as we had often talked about, one in which the portraits would take their rightful place, fitting in among the landscapes. A collaboration between the British Council, the Réunion des Musées Nationaux and the Louvre, it would be staged in the Grand Palais. Lucian was keen but wary. "Constable at the Louvre is a marvellous idea but I feel my life isn't long enough. It's just that it would be so exciting to do." Eventually he was persuaded. To exercise himself over Constable would be to take on a life's work and see an oeuvre whole. He became enthused. Over supper one evening we went through the catalogue raisonné to make a long list of ideal exhibits. Slowly working through that and other catalogues, sighing at times and tapping the page, he exclaimed at the liveliness of the portraits, especially those of children, and paused for quite a while over an early watercolour of a figure pensive beside the Stour one misty morning. "Let's have it." Could have been him, he said to himself leafing for-

wards and proceeding through the portraits and drawings and the close study of the elm trunk that had impressed him so much at Dedham in 1939. "Someone said Constable had trouble with his foregrounds . . . Dreadful, stupid thing to say." Over the following year or so we went to look at the works in the V&A, the Tate store, the Royal Academy and the British Museum. Further expeditions did not involve Lucian, but John Gage who was to write the main catalogue essay came with me to Cambridge and beyond and to Toronto to look through the largest collection of Constables in private hands. Lucian enjoyed the process of assembling works that, evading the strictures of academic Constable Studies, would bring delight. "The only way of judging it (an exhibition, a picture) is how long you remember it afterwards."

As work on this book proceeded, Lucian became concerned about how he sounded when quoted on the page. "I think the fact that a lot of the things I say have got a semi-incomprehensible side to them isn't uninteresting because it's to do with how I talk. I have to accept that." More worrying was the chronic disturbance of having his past raked over. "I'm really thinking of consistency." There was also the question of egocentricity. As Susanna observed: "Lucian didn't want to sound boastful in a book talking about himself."[8] Not only that, he had reason to be horrified at the prospect of screen versions of episodes in his life.

Love Is the Devil, a film directed by John Maybury and released in the summer of 1998, dramatised the relationship between Bacon (a pouting Derek Jacobi) and Dyer (Daniel Craig, a future James Bond) with Tilda Swinton chipping in as Muriel Belcher and several YBAs enlisted as extras for club and pub scenes. It was a bold try involving re-enactments of famous photographs of Bacon hugging his knees or strap-hanging on the Piccadilly Line but, predictably, it failed to win script approval from Bacon's devoted minder at the Marlborough, Valerie Beston. "VB was really sick when she read it," Lucian reported with a trace of relish. "Everyone is disgusting, ghastly. I thought of writing to him [Maybury]: 'It's just that we are all really queer; art is an aberration.' It isn't so much that it's cheap and vulgar. Francis is vicious. Megalomaniacal. George is a thug." Maybury, he added, had assured him that he needn't worry. "We are not including you, out of respect."

That omission was not too big a deal but when it came to the movie version of Esther's *Hideous Kinky*, also released in 1998, starring Kate Winslet as "Bernardine," his part, his very absence indeed, could not be overlooked. Novel into screenplay meant amended narrative. "They cut out things and Esther hoped I wouldn't mind," the absented father said. "I had to sign a thing that I wouldn't sue." Why? "There are remarks about people starving while I have special shoes made to cram my feet in and 'amazing waistcoats' made. I'm slagged off a bit. I don't care. They were treated very regally in Morocco." He went to a preview. "The whole audience was in tears. Only five of us." Alice Weldon could see how it touched him—"he wept when he saw it"[9]—but when asked if he was OK he explained, unconvincingly, that it was the novelty of the occasion. "It's that I just haven't seen a film for twenty-five years." At another more public showing, for fifty people, he was more composed. "Esther gave a speech. 'The feeling is so like the film,' she said. 'But bits like nappies getting stolen were left out.' I thought it sad, awfully sad, Bella and her mother. And the aggressive mystic thing was so odd: mystic ideas as though a sport and 'Allah will provide.'"

When Esther featured her father as a rather different character (who happened to wear a watch) in a subsequent book, *Peerless Flats*, he dissociated himself promptly. Was it him? "I don't wear a watch, so it's not about me."

A novel was one thing, being deniable, but the impending biography was quite another in that its cast of characters really mattered. "It's not that I don't want that side of things to appear as exposure, picking out some and mentioning others, but I was worried about how. People I've been with who haven't been painted. I'm not conscious of the rhythm of getting caught up with them. I'm really thinking of consistency. I don't want to impair it. Work out a way that is clear, not mystification, and do it rather like people who keep occasional diaries. Say he was 'not prepared to discuss this.' George Melly did three volumes of autobiography but he never mentions things to do with me and his sister." (The actress Andrée Melly, better known for having played Tony Hancock's put-upon girlfriend in *Hancock's Half Hour*.) "And then I was told, 'He did want to but you stopped him!'"

. . .

"I love starting things."

Readily impressionable, if not credulous, Lucian would tell me that someone who had written to him or met him in last night's bar seemed likely to become a sitter—reliable, punctual, sympathetic and all that—mainly because she had assured him that she happened to be a poet or sculptor or, failing that, extraordinarily keen on Balzac. This happened time and again. "Disillusioned soon enough," said Susanna.[10] But the odds were that every so often someone would prove both sympathetic and usable. In the same way as he would remind me, mock sonorously, that the duty of the art critic is "eternal vigilance," so too did he have to be on the lookout, hawkish, hovering, pouncing and taking phone numbers, whatever the circumstances. Even at Leigh Bowery's deathbed. Typically, he approached Vicken Parsons— married to Antony Gormley—by getting her phone number off Celia Paul, then lunched her and suggested working from her. "I used to be an admirer of her father's: David Tree, actor in *French without Tears*. She would sit, she said, but only with Celia." Approaches through friends of current sitters or those whose use to him was exhausted proved more effective. For example, having decided that he'd had enough of Sue Tilley as a model, he turned to an acquaintance of hers. "I nearly worked from this girl . . . [Sue] said there's this very nice pretty girl, she's longing to meet you and longing to sit for you, so we met and we got on really well, I saw her once or twice and then she said she wanted to stop working and I said, 'Look then, I'll pay, but until we start I'm really busy.' And then I did pay her for a couple of weeks and then I started with Jean, Louisa's mother, and then she slightly left my head and then I thought I must get on to her. I mean we got on really well and danced and things and then arrived this letter which I couldn't understand who it was from. Maybe I'm over-reacting, but it really shook me. She wrote, 'Dear Mr. Freud' and talked about 'discourteousness' and 'is that any way to behave?' I hadn't actually started. It's just that we went out and I did say, 'It would be nice to get to know you and what you are like and everything.' Sitters are peculiar; I talked to Jerry about it and she said, 'It's just to do with money, that's all,' and she's actually quite right.

Is it pique? ('If Sue can get painted why can't I?') If she'd said, 'I'm awfully disappointed' or 'Could I have some money?' OK. But 'Dear Mr. Freud' . . . I minded not knowing who it was from. And that terrible word 'discourteousness.'"

He had better luck towards the end of 1998. "Brand-new model: Julie. She's very nice, she looks after old people, stops them falling over. Big Sue introduced her: quiet, dumpy, pleasant and got such a feeling, and she said to Sue, 'I feel a bit funny about this' (taking her clothes off) and Sue said, 'It's nothing, once you get into it.'

"I had another letter from the other—mad—one. 'We could be of use to each other.'"

From time to time a parental role ("obligation" would be too strong a word) tied in with stirrings of pride and curiosity. In March 1998 Frank Paul ("Young Frank," to distinguish him from Frank Auerbach) had sat the scholarship exams for King's School Canterbury. He was successful and consequently on a Sunday in September Lucian went down to Canterbury to see him and the other newly enrolled scholars blessed in the cathedral by Frank's uncle, Rowan Williams, Bishop of Monmouth and future Archbishop of Canterbury, with whom Freud was on cordial terms.

"I was a bit early and as I came in those queenly people in their black gowns—the vergers—were so vicious. 'The families are over there,' they said. 'You are early.' Frank looked awfully good and got into trouble, as he's so dreamy and had mould on his gown. 'He's always reading,' his housemaster said. 'He'll be fine.'" (He was to win prizes for Academic Excellence and German and proceed to Cambridge.) The service began. "I liked some of the hymns. The sermon was completely mad but there was a feeling of treasure rather than junk in the cathedral. What interests me is not the belief but why and how (and if) it sustains them. I don't like the illness insurance-policy element." What appealed to him was the oddity of seeing a son of his being caught up in such ceremony. Sitting there he found himself philosophising to himself about progeny and other outcomes. "I just remembered a poem by Brecht: 'The Lover.' Roughly it went:

I believe the human life is fraught with folly
When I first tasted my friend's wife's delights."

So too with Robert Graves's "Why have such scores of lovely, gifted girls / Married impossible men?" (from "A Slice of Wedding Cake"). Misremembered in reverie this became: "These marvellous girls / Go with those terrible men."

Prompted by Celia, Lucian tried working from Young Frank. There were evenings when, father and son together, they watched Preston Sturges films on video, a taste for which, it was understood, they shared. Evenings passed without much said. "It's got a bit better," he reported later. "Took him to see *The Ladykillers*. I mentioned working from him and he gave a strange smile. Reserved silence. He's only awkward through being dreamy. A dandy slightly. Growing sideburns. When he comes to the house he's hunched and silent, darts around."

That other favoured son, Ali Boyt, had become a computer expert earning, Lucian learnt—boasting almost—£3,000 a week in Russia, but in 1997 he faced a charge of smuggling drugs to a friend in prison. "Ali went wrong. Talking to Rose or Isobel, they said, 'The trouble was, you used to take him up to Jane's [that is, to Glenartney], then you stopped.' The circumstances changed and it was the stopping that was the trouble. Selfishly, I didn't really think. Now forty-one." A convenient readjustment, he thought, would be to work from him, so a painting began. "Ali said, 'I thought I'd never sit for you again.' Then he said, God, he wished I'd leave him alone. He looks magnificent (only if it was an opera), but we did have a good talk. I got him a flat some years ago in Primrose Hill; he's selling that and will get a lot of money. I'm glad I'm getting on with it." But soon came a setback. "Ali has disappeared. Not got a job or anything. He sold his flat I gave him and was staying with his mother. The only news I can have is that he's reached rock bottom. But he's got a very tenacious sense of survival. He says what really suits him is a debauched life . . . In drugs, decision is not possible."

Eventually however the portrait was completed, its title, *The Painter's Son, Ali* (1998), affirming connection and, to a degree, responsibility. White drool on the lower lip made it impossible to sell, said Duncan McGuigan of the Acquavella Galleries. "Dope on the mouth," Lucian explained. "Foaming at the mouth. Head lolling, tie loosened, amiable but so out of it." The plate of a companion etching,

bitten and proofed in May 1999, was damaged en route to Marc Bal-akjian's workshop but, rather than have it cleaned up, Lucian decided to have the scratch marks preserved as fortuitous scars.

"Ali was telling me about jail and how he asked one man why he was inside and the man said, 'I was walking down a street and there was this party going on and I went in and a posh girl came up to me and said, 'You're not the type I would want at my party,' so I went home and got my meat cleaver didn't I?' Of course Ali meets extremes and, when he told me that, there was certainly a ping. I had known this before."

"I nearly always start twice"

As the tapes for this book accumulated it had become apparent to both Lucian and me that what was to have been a monograph was swelling into a biography and that raised obvious demands and concerns. In September 1998, after twenty-three years as the *Observer*'s art critic a staff cull had been imposed and suddenly I was free to concentrate more fully on the book. Rather as *Sunny Morning—Eight Legs* had come about—piecemeal until resolved—the narrative was developing momentum and, while certain figures were to come and go with due prominence, there were also legs under the bed to be acknowledged. Lucian was perturbed. He had been going around for months—for years indeed—talking about what we were engaged on as "the first funny art book ever," but the prospect was now set to alarm him.

"I hope the project as it goes more deeply won't appear like a hole. I like the idea of helping on an unauthorised biography but it's quite tricky."

He was bothered about the vexing question of recognised or unrecognised children. "Some have changed their name to Freud. When I sort of slightly got to know some of them, one of them did a thing that made it impossible to see them; then one said he didn't want to bother me but . . ." He was referring to the McAdams. Through Bella and Esther Freud, Kay McAdam's children had become known to their half-sisters and half-brothers; however their relations, if any, with their father were in his view conditional on them not attempting to oblige him to start playing father and doing any notional duty

by them, pressure that caused irritation, provoked anger at times and resulted in a determination to thwart potential claims on his estate when the time came. That this was basically unfair meant less to him than what was to him the crux of the matter: a basic lack of (mutual) understanding and connection after all those years.

When, by arrangement, I first met Paul McAdam he was sweeping a parking space outside his south London studio. Given the unlikelihood of ever catching Lucian wielding a yard broom, it was a surprise encounter, for head to toe and with every deft evasive move he was startlingly Lucian-like, though in conversation less so. Lucian was keen to hear how this meeting had gone. "He's a property developer. It's just lucky that I never started anything of him. When he had a child he wrote and said, 'I thought you'd like to know I've just had a child and it's very difficult being a father.'"

Being a mother, Paul said, was a role Kay had taken on with a will. "She was dreamy, loved being at peace with herself, very able, practical, didn't fuss, never felt deprived and wouldn't have accepted help directly, even when the electricity was cut off."[1] Her heart became enlarged and blood pressure swelled and, following her heart attack, he and his wife bought her, he said, a bungalow in Herne Bay. Shortly afterwards, in July 1998, he went there to see her and found her dead.

Lucian guessed that the McAdams would assert themselves more now that their mother was no longer there. I asked Esther how Kay McAdam had seemed to her. Was she resentful? "I couldn't tell. She was so passive. 'Would anyone like a sandwich?' she'd say; that's all. Old-fashioned homey. Not glamorous."

In the realm of the studio, in *Large Interior, Notting Hill Gate* where three elements—passivity, contemplation and nurture—seemed well set together, there developed a fault. It was a matter of control: what to do when part of the content—the glamour—started playing up.

"Hello, Villiam, how goes it?" had become the habitual greeting on the phone, but every so often, when he had dramatic news to impart, Lucian's voice quickened and there were no preliminaries. Late one night he rang excitedly, jubilantly even. "I did a rather diabolical thing, though the motive was aesthetic. The big picture is really going on very well, but Jerry put me off twice and I wrote a rather desperate letter—true, I am very demanding—that said the

situation is fucking up my life: I was being messed about. 'I need to know your intentions,' I wrote and she wrote back, 'You are blessed with very good health, you don't understand,' so I thought I must do something about it. So last night I had a letter dropped through her door by hand, a very nice letter. 'I got rather desperate,' I said, 'and you've turned into a man.' I rang Acquavella and told him, as they were perhaps going to buy it. The pleasure of doing a sex change was so exciting. Metamorphosis. It's now David. Not very different though: Baby Gabe is there. David's got Gabe."

Next morning he phoned early. "Hello, Villiam, hot newsflash: David's left holding the baby." He argued that whereas Jerry had looked like a model saddled with the baby, David looked more like a mother, as in "that Giorgione *La Tempesta* idea."

Three weeks later, in October 1998, he reported closure. The painting was completed. "David's very much in it. And a structural difference: I've lowered the door from the top, which looked more like a wall and made the top of the door go across the room behind. Makes the action more subtle and interesting and less dreamy. It's more definite that Francis [Wyndham] is outside and I'm look-ing through him into the room; like those Balzacs where you get into a house and then describe the people inside . . ." From Pluto's relaxed legs to the flopping Wyndham shoelaces and to the dimin-utive Susanna seen through the far window flitting up Peel Street, details thrive. Details had changed though. The upper half of a seated Jerry Hall had been made over into a naked David, open-mouthed, suckling a baby Gabriel still steadied by his mother's arm and hand. Lucian had asserted his right to paint whatever he jolly well wanted. I suggested to him that supermodel assumptions—the norms of the fashion shoot and cosmetic routines—rendered Jerry unaccommo-dating or too much the practised beauty to serve his purpose. He agreed. "Modelling her body: I needed time to humanise a sort of plastic glamour." He wondered what her reaction to being obliterated could be. "I imagine she'll be upset and so I put in the letter, 'I could do a head of you.' Didn't want to make it worse." Given that this was a big painting virtually presold to the Jaggers, the situation was dicey. "I thought it would be good to get the picture reproduced without a mention of her. She hasn't replied."

"Obviously Jagger went crazy," Acquavella said, and he assumed that he had a turkey on his hands. Who would want it? "How can I ever sell the thing? The first person who saw it bought it."[2]

That person could only have been intrigued and beguiled by the substitution. Here was control exercised, not patronage. "It didn't work out," the wronged Jerry later remarked. "He scratched me out."[3] Patently, no sitter could be allowed to be indispensable and, realistically, no logicality should ever obtain. A painting is as the painter does and, of course, sees fit.

A few months before the elimination of Jerry Hall from *Large Interior* Lucian agreed to be interviewed for a television film to coincide with an exhibition of Rembrandt self-portraits at the National Gallery. The questioning had stimulated him and the day before transmission he talked up what he billed as "my telly appearance tomorrow night." The BBC publicity singled out Chuck Close, painter of immense photo-fed close-ups but made no mention of Lucian; it transpired that his contribution hadn't survived the edit. He was miffed. "I'm rather like those who sue if they aren't in the book. 'Where am I?' they ask." That said, around the same time, two years ahead of the millennium, Neil MacGregor had asked him to participate in "Encounters," a project involving dozens of eminent artists of the western world, each to produce a work prompted by a National Gallery painting. Among them were Frank Auerbach, Leon Kossoff, Richard Hamilton and David Hockney and, ranging further, Cy Twombly, Jasper Johns, Bill Viola and Balthus. While most produced idiosyncratic, if not carefree, takes on Old Masters (Howard Hodgkin produced a woozily dilute version of Seurat's *Bathers at Asnières*, Kitaj a loaded usurpation of *Van Gogh's Chair*), Lucian, advised to "do anything you feel like," decided to work from NG4077, Chardin's *The Young Schoolmistress* of 1735, in which a solicitous girl gives a child— presumably her baby brother—a reading lesson. Why set himself such a task? "Never done it before, never copied. It's obvious to me that it's the one I want to do: I think I could do a lot with it." Partly, he said, because it had always struck him as being exceptionally modest and intimate, a painting upon which he could enlarge therefore and indeed from which he might well learn.

He started on what became *After Chardin (large)* in March 1999 and as he insisted on working in the gallery ("the picture's public

property so I can't take it out") was given a cupboard in which to store materials while the chief conservator, Martin Wyld, provided an easel. "I had some trouble at the beginning. I'd forgotten it, but twenty-five years ago I had a bad row with Martin Wyld as I was slagging off [Helmut] Ruhemann [the then chief restorer] and he got slightly upset." He already had a twenty-four-hour pass to the Gallery and so could work there at night bothered only by passing remarks from warders. He found it difficult settling in there even after four sessions. "I'm surveyed while I work. I felt so tensed up, not yet going properly." Unusually for him, he began with a drawing and as he proceeded, closing the gap a little between the two figures, he found things in the original that tickled his imagination, particularly the boy's cap. It reminded him of a motorcycle helmet. He reworked the docility, making the big sister exasperated and her little brother "more of a lump." Some details, he decided, were best omitted; the pointer handled by the girl for example and the words of the lesson book. True to his dislike of the allegorical he didn't bother with the neat detail of the key in the desk's keyhole but did accentuate the features that most appealed to him, notably the girl's ear ("the most beautiful ear in art"), explaining that "these things are aesthetic but they go deeper. I'm not prepared to copy *trompe l'oeil*, meaning do *trompe l'oeil tromp l'oeil*! I love the Frans Hals man and skull but the same would apply if I did that: Skull, Skull, Skull."

That reminded him. "Bruce [Bernard] is terribly ill, in amazing spirits but looking so old, sad, terribly near the end. A week ago we had breakfast in a hotel and he went out twice and left half his food, I then went round to his flat: he'd been asked to see me—and write about the picture—by the man [Richard Morphet] doing the catalogue for the National Gallery. Anything to keep Bruce busy. In his flat he now looked terribly young, with spots and hangover, but distinguished. Sadly, it's a year since his operation. It makes me solitary, if people die. Very few of my friends have died."

The next day Lucian sounded unusually tired when he rang. "Chest clogged up," he complained and that applied also to the business of starting on a painting. "I got it going—a nude—and it's gone wrong. It's just that I've overstressed a particular thing. I nearly always start twice. Very often—I've learnt a lot—it's to do with age and time.

A friend, Michael Tree, a year older than me, who's dying: I went to see him yesterday. Not much time."

One night around then when I dropped him off after dinner he paused a moment before darting as usual into the house; it was two in the morning and he'd been working until 2:45 the night before, he said, "doing Paul [McLean] II" and now, he suggested, not that I'd asked him, wasn't really the right time for seeing the little portrait of John Richardson that he had been doing by day in nine sessions, Richardson having come over from New York to give a lecture. "He sits well. He's posing. 'What's your profession?' he was asked. 'Posing.' He's quite generous and extravagant," and, by the way, he was planning to give it to him as he rather thought (typical of his insouciance concerning relative affluence) that he wouldn't be able to afford to buy it, given there were several more volumes of his life of Picasso to go. Richardson was a renewed acquaintance; he had first met him when he was with Douglas Cooper—he had disliked him then—and now had become a source of reminiscence and transatlantic gossip in late-afternoon phone calls. Richardson recommended New York for top-quality room service. 'It's the only place where you can order a thirteen-year-old boy at two in the morning and get it in an hour.' And he reminded Freud about Bacon's noted taunt: "She's left me at last. She's had all those children just to prove she's not homosexual." The portrait was a sort of souvenir, small and narrow, exuding a lofty bonhomie.

For some months the Chardin was Lucian's nocturnal preoccupation. After completing two lustrous paintings from it and starting on etchings he discovered that he had missed a detail or, rather, hadn't really noticed what he had been transcribing so intently. "After looking at it several hundred times I discovered an earring on the right-hand ear" (that is, in the reversed image of the etching) "as well as the left. This is to not know what is there until you step back and look at it as a whole." The discovery delighted him for it meant that he had been so wilful, so absorbed, that a sort of transference had occurred, from the Chardin to his efforts. "I was very affected by Mondrian's copy of a French painting copy. I like the idea of making it as good as the original, the idea of getting near, the idea that things may be superseded."

"Encounters" turned out to be a formidably incoherent celebration of the millennium, a jumble of the tenuous and the presumptuous in which the Freud Chardin stood out as a feat of faithful yet modified replication. Balthus' *A Midsummer Night's Dream*, involving a catwalk Titania laid on lightweight rocks, stirred Lucian to mock plaudit. "Dreams of sex: keeps people going."

Technically, racegoing, that unfailing stimulus, had been out of bounds for Lucian since 1983; I say technically but occasionally, in ruffian disguise, he had enjoyed evading the ban. Nonetheless it was tiresome to be listed as inadmissible. Unfairly so, he maintained. Indignant at this nonsense, in February 1999 Andrew Parker Bowles took it upon himself to write to the head of Ladbrokes, Peter George, about the matter.

> *Freud is England's greatest living artist and his pictures average around a million pounds each. I was surprised to learn that he owed this comparatively small amount.* [The disputed debt was £19,045.] *He told me that back in 1982 when he went to his local Ladbrokes and placed a bet he offered Northern Irish pounds, which the Ladbrokes clerk refused to take, although of course it was legal tender. The horse he chose then won so he deducted the money he would have won from what he owed Ladbrokes.*
>
> *He is 76, does not intend to go racing again and as a matter of principle will not pay the debt to Ladbrokes. He now bets large amounts with an Irish bookmaker (who no doubt does very well out of the arrangement).*

He was writing, he added, "as a friend of Freud who believes he should not die while on the forfeit list." And he had thought of a way to settle the matter.

> *I suspect I could persuade him to give a nominal sum of a few thousand to a charity, such as the Injured Jockeys, as he has been generous to them in the past. However he is stubborn.*[4]

Within a month John O'Reilly, commercial director at Ladbrokes, responded satisfactorily:

*We too would very much like to resolve this situation to Mr.
Freud's satisfaction . . . You may be aware that Ladbroke Racing's
annual charity is Scope, which provides facilities and care to people
with cerebral palsy . . .*[5]

Parker Bowles acted promptly on that. "He sent me a cheque for
the Injured Jockeys Fund. (A copy of which I enclose.) Lucian is happy
to open an account with you." Whereupon the matter was settled.

21 April 1999:
 *Tattersall's Committee re Lucien [sic] Freud confirm your
telephone call of today and confirm having withdrawn the report
that was made to the Jockey Club on 21 February 1983 with
reference to Lucien Freud i.e. "withdrawn from the Jockey Club
list."*[6]

"Should have been resolved long ago."
Again "Dreams of sex: keeps people going." Such dreams could
lead to luckless incidents. In August 1999, for instance, Nikki Bell
who with her husband Ben Langlands comprised the art partnership
Langlands & Bell, makers of conceptual, often quasi-architectural-
model sculpture, encountered Lucian on the pull.

*Ben and I were at a club somewhere in Regent Street. I was wearing
a hideous leg-brace made of steel and blue felt on my left leg because
I had recently severed the cruciate ligament in my knee on a trip
to India. Lucian approached me sideways, he'd been standing on
his own watching me intently for some time; I knew it was him, as
he was immaculately dressed wearing a silk cravat, and had such a
distinctive way of looking at one, with a piercing stare and rather
weird manner. I was standing next to Ben but this didn't stop him
coming up to me to ask me to dance. I said I couldn't dance and
explained it was due to the pain. He didn't want to accept this and
asked me again. It struck me that he was a man who was used to
getting what he wanted!*[7]

Lucian had remembered this as a maladroit incident that had left
him puzzled not thwarted. "She stood by me and I put my arm round
her but it went under her dress. I asked her to dance and she talked

about 'we' and said she'd broken her ankle. I was hoping to dance but, because the person I'd selected for this treat was injured, I had to talk for half an hour. Then I suddenly left. She said she was having a show at the Yale Center and I said, 'So am I. At this very moment.' I couldn't take my arm away when I started: it went in through three layers. Instead of delightful body there was gooseflesh underneath. I thought she'd be more feminine to the touch."

In the confines of the studio intimacy ruled, even with Courbet and obviously with Chardin, and it was no good aggrandising intimacy and making a charade of it. Situations might present themselves but these had to develop not designedly—or illustratively—but naturally. While that ruled out any likelihood of David Dawson posing as "Salome at the Ball," the thought remained. Would that, Lucian wondered aloud, be asking too much of him? Yet why not? It had been impulsive enough making him the alternative Jerry Hall. Yet why not? Anything could be dreamed up in the studio. Circumstances were drama enough, regardless of "meaning." He deplored "meaning." For that matter he didn't much mind, barely noticed indeed and chose not to demur when David took to snapping him entertaining visitors or even at work, clicking discreetly like a court photographer. The results did not impinge unduly. They may even have incited him to work all the more ardently beyond the scope and focus of any camera. Early in 1999 he began a second, small, garden painting in which he tried for a scurrying and unpractised look. "Sort of not drawing at all, just putting down all the time as I see it, just doing it with the fist rather than a hand. My way of trying to keep in time with nature is to keep it very loose. It's tiny."

Nature examined from the shelter of the house, a back-garden nature wild in line and bedded in darkness was a teeming motif for several etchings, the largest of which, printed in 2004, proved such a challenge for Marc Balakjian that he managed no more than one or two impressions per day. His printing skills were transformative; *Pluto Aged Twelve* (2000) took on a salutatory quality when he lightened Lucian's hand reaching in to fondle or bless the ideal whippet. "I made a little change in the hand. I got Marc to do it: rub it out a bit, as it was too black." Pluto's eye also was made to glisten with the rheum of old age. Etching echoed painting and paintings took on fresh strains of mood.

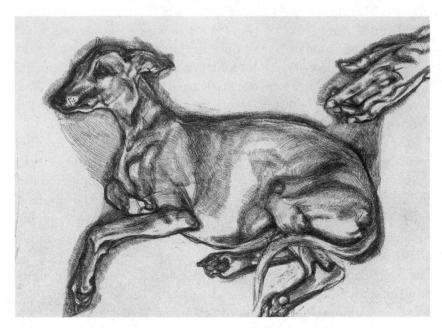

Pluto Aged Twelve, 2000

Around this time Alice, my youngest daughter, then twelve, became seriously ill and Lucian, seeing how miserable she was, reacted promptly. Late one night he rang. "A newsflash: I've got her a dog." A whippet, he knew, would hoist morale like nothing else. "It gets the scent and instinct does the rest." Jan Banyard in Dorset, doyenne of whippet breeders (Pluto was one of hers), produced Meri from the same litter as Eli who went to David Dawson. Eli was soon as practised as Pluto in being usefully asleep for painting purposes and Meri proved remedial. For Lucian the readiness of whippets, their sturdy elegance and affection, was talismanic. "What draws me to paint them is the life in them. The life they're in. The fact that the feeling, however strong, is balanced."

That could not be said of some human sitters, particularly those who proposed themselves. These, on acquaintance, were apt to turn presumptuous or, even worse, demanding and, invariably, deterioration became evident—often blatantly so—in what usually would prove to be the final painting to be accomplished of the sitter concerned.

While paintings of Julie Radford, a friend of Sue Tilley, breathed equanimity (among them *Night Portrait Face Down* (1999–2000), "The Big Bottom One," as he referred to it) and those of the McLean brothers from Ulster were formidably genial, those charged with virulence and exasperation were all the more devastating for that.

Working from Nicola-Rose O'Hara went well for a while. "Scrapped the first. Then I did the portrait very quickly, in two months." He found her disarming. "Irish Nicci. A friend of Susie's. She wrote to me saying would I consider working from her: not vain but needed petrol for her car. She's done two travel books in France and writes novels, not published. She's a bit of a lost soul but goes to dinners, parties. Sort of animated. Not a victim. Very good from a moral point of view." By her account it was her decision to stand rather than sit for him. "Standing I felt in control. I felt more like me." From her point of view their relationship was fairly soundly based. "Lucian and I established early on that we had things in common: a love of proper porridge, made with jumbo oats and sea salt and mineral water."[8]

The difference between *Head of a Naked Girl* (1999) and *Head of a Naked Girl II* (1999–2000) shortly afterwards is devastating, for what initially had seemed characterful he came to regard as pitiable. "She bites her tongue, picks spots, gets nervous rashes. Not got good health: eye operations, diabetic, various things wrong. I can see what other people wouldn't like about her. She's very nice in a sort of slightly embarrassing way—being half-Irish gentlefolk—smiling through tears and being courageous. Oh dear." *Resting on the Green Chair* (2000) caught on to all that and more: a faraway expression on the face doggedly sustained ("day and night, three days a week"), her right foot grasped with both hands and lodged in the crotch as though essaying yoga. "I was beginning to feel trapped," she later said. "At the time I thought he enjoyed keeping me captive.

"In the mornings I would sit opposite him for hours at a time while he was on the phone to his agent in New York or his biographer. We'd work, standing 30 inches apart till four in the afternoon when the light began to fade."[9]

In *Naked Portrait Standing* (1999–2000), she averted her eyes, arms crossed behind her back, presumably not best pleased. "A painting of Nicci as a tree, four foot away; it's like Constable in front of the

tree in Dedham." Constable's *Elm*, in the V&A, was the painting that he had found impossible to emulate in student days, summer of '39; but now, revisiting the idea three times bigger and in human form, he transplanted it without going so far as to represent Irish Nicci as a metamorphic Ovid nymph. "Her madness comes out in that picture." He tried an etching version of the pose, but this failed in its entirety so he had the plate sawn into three: head, torso and thighs salvaged, a tousled soul fragmented. And that was where he decided that he was finished with her. The moodiness and crying needs were excessive, he grumbled. He'd provided her with a flat; she had demanded an Aga and a sports car even. Exasperation set in. "I'm completely not charmed by Irish loopiness: it's heartless in a way. I used to be charmed but I'm not any more now. But I got a lot out of it."

Alternatively, though with less in the way of formed if not overcharged personality, several grandchildren proved suitable, and willing, to sit. Ib's younger daughter Alice Costelloe, for one, prompted him to treat her lightly. "Been painting my granddaughter, a slight thing: Ib's child with a toy on her head. She looks so beautiful and soppy." *Alice and Okie* (1999): Alice capped by her Koala Beanie bear was her idea, but happily it obliged her to keep still. "She played around. Painting her is a bit of an ordeal. But, Ib said, 'If she starts she'll finish.' To be able to say that about a child is pretty good. I was drawn to it because the pressure on Ib's family was so great. Ib's kids were at one of Rose's children's birthday party and Alice was rushing round, shoelaces undone. Why did she do that? 'I know,' she said, 'because I'm so pathetic.' So she was the one I really wanted." Alice said of her grandfather a few years later: "He kind of makes the boringest subject quite interesting."[10]

Lucian liked to think that a child's eye might somehow be all seeing; the notion, he said, was one he shared with the "tramp poet," W. H. Davies, whose poem "The Inquest," about a four-month-old baby found dead, he liked to recite:

> *One eye, that had a yellow lid,*
> *Was shut—so was the mouth that smiled;*
> *The left eye open, shining bright—*
> *It seemed a knowing little child.*

For as I looked at that one eye,
It seemed to laugh, and say with glee:
"What caused my death you'll never know—
Perhaps my mother murdered me."[11]

That reminded him. "In Delamere, when children nearly got run over, the parents almost always hit them: unfair but very natural. Like family."

On 12 January 2000, when Lucian rang with the usual "Any news?" I told him that Valerie Grove, biographer of Laurie Lee and of the Garman sisters too, had phoned me to say that Lorna Wishart had died. At that he sounded abruptly muffled and some minutes later, after digressions, he said she should have an obituary and that everyone had liked her. He was thinking far back and disregarding what Frank Auerbach had experienced when her son Michael introduced him to her in the Colony Room. She'd looked straight past him. Hers, he'd felt, was the hauteur of someone not to be bothered with lesser beings. That possessed her, seemingly, and the obstinate serenity of an ardent Catholicism.

Gashed paintings and ripped drawings accumulated in the former bedroom in the Holland Park flat. "Periodically, especially when I'm feeling ill, I get rid of them. So long as my head goes on working. That's the only important thing."

"Better plain naked"

"I'm setting up a huge picture. I've ordered the canvas: seven by five and a half." In October 1999 work began on another elaborate studio re-enactment. "It will include everything I've ever done. I'm going to do it at the flat, I think." What prompted it was a Cézanne, one of the "scabrous" (Lawrence Gowing's epithet) little paintings of the sort that had so stirred Lucian in "Cézanne: The Early Years" at the Royal Academy ten years before. Bill Acquavella had suggested that it would be better for him to buy a picture than just lose money on horses and had bought on his behalf for $1,350,000 at Christie's New York a version of *L'Après-midi à Naples*. Delivered to Kensington Church Street, it now served as a prompt. "It looks at home. So marvellously properly painted. I'm using the composition pretty roughly." He was contemplating an *After Cézanne* about seven times bigger than what had stimulated it.

Where Cézanne had picked up on the thrill of stage curtains tugged aside and frolics disclosed—seventeenth-century "amorous scenes" snitched from classical sources—Lucian addressed the practicalities underlying any such performance. As with *After Watteau* nearly twenty years before and, way back, the 1935 Dartington Eurhythmics production of *The Ancient Mariner* (with himself frozen in position having slain the albatross) those assigned roles in *After Cézanne* (2000) were, formally speaking, mute figures beached on the Holland Park studio floor. Crucially Freddy Eliot, sprawled on rumpled sheets, one elbow resting on the handy flight of steps Lucian used when tackling

the upper reaches of large paintings. What was he up to? Was he being passive-aggressive or just unaroused or maybe post-coital? No need to know precisely. He and the two women tending to his needs were simulating make-believe: it was a transaction mimed, petulance implied. "Cézanne wanted something that was neither optical nor mechanical nor intellectual."

Lucian's Cézanne, a muzzy reproduction of which—torn from the saleroom catalogue—he pinned up like a good-luck card on the paint-bedaubed studio wall, reminded him of what he had heard tell of the scenic routes of erotic literature. In Paris, in the fifties, he had come across Olympia Press publications, issued in plain green covers. "They were mostly written by very well-educated young American girls I knew through Ivy Nicholson. One of them wrote to me and I saw her for a bit. She told me that she had written some and sent them one: 'Too filthy to publish,' they said, 'even for us.' Those books, two of which I actually read, I had some difficulty in forgetting, not that I tried to. And I said to her: 'There's something I've always wondered (since in these books obviously you can't have non-stop erotic activity throughout) how do you go from one thing to another? Do you have

Freud's Cézanne, *L'Après-midi à Naples*

meals? After all, in ordinary life, even people who are very amorous still take a break. Even if they are *incredibly* amorous it's still only perhaps twelve or fourteen per cent of the time they can actually be engaged in these pursuits. How do you get people going when they are just standing in the street or sitting down or walking through a field? What happens?' She said, 'It's funny you should say that: I was looking at my own books to see what made me start off and I noticed that nearly always someone came in carrying a tray.' That's interesting, don't you think? Very detached, very funny. But I must say they *so* don't interest me, though they would if they were by a real writer. I thought *The Story of O* beautiful, I think it was by a woman." *After Cézanne* rehearsed such activities.

The female sitting on the mattress and reaching out to coax or console the discomfited male was Julie Radford, with whom Lucian drank champagne around midnight on New Year's Eve 1999 and proceeded with *Night Portrait, Face Down* while the rest of the world concerned itself more or less with greeting the new millennium. Julie fitted herself companionably into the crook of the man's leg. "A terrific waist and huge bottom and a strange confidence," said Lucian. She linked the other two. "Began with them all together. Is this too much a *composition*?" That was the worry: how to achieve a telling whole without undue contrivance. Possibilities swirled. How about setting a fire on the floor, bottom left, so as to have wisps of smoke introduced opposite to where Pluto had been—tentatively—inserted? "Earth, air, fire, water," he murmured and promptly decided against. Pluto too was deleted.

The key performer in the painting was the recumbent Freddy, seemingly inclined to assume the role of Prodigal Son. Certainly, from a Prodigal Father's point of view, rapprochement was involved. Lucian remarked that he rather wanted to gain Freddy's confidence and get to know him. "I sort of knew him before, only reseen him recently. I don't know him well at all." Freddy had been brought up a St. German and therefore very much not a Freud. "He was at Eton and in America. He's got very nice manners and is very idealistic, a dancer and potter and good with the girls. Makes mystic pottery in Spain. Hasn't had somewhere proper to live in London and so I got him a flat, a long lease. He wrote to me occasionally. 'I sort of pushed

early things out of my mind,' he said. He's very detached. He did tell me, 'I don't remember much of childhood.' Blanked it out."

Given the room-service role in a white bathrobe and carrying coffee cups on a tray was Sarah from Rochester, identified in another painting as *The Butcher's Daughter* (2000). If the Olympia Press was anything to go by she was the ubiquitous facilitator proffering refreshment and accordingly Lucian decided that an extension of the canvas was needed to take in her head and shoulders. ("So the head could come in at the end.") Without this her point of view would have been lacking. Sarah was stood there readied to bestow, completing an inverted arc of the trio's braced and slackened limbs. "It's treating people as real people, allowing them to stretch. I want the subject to finish the picture. Allow the life full swing." Not forgetting the paint itself. "When the floor went down it removed anything that had worried me: the action seemed to be the paint on the floor. The floor has paint on and thus looks extra painty."

The plan was that, if finished in time, *After Cézanne* was to be shown in "The Nude in the Twentieth Century" at the Fondation Maeght. Lucian therefore decided to have it photographed by John Riddy despite its unfinished state so that Jean-Louis Prat, who ran the Fondation, could have the image of the painting so far blown up and framed full size. "Coming Attraction: watch this space." Then at midsummer Frank Auerbach came to breakfast and impulsively, as he later admitted, suggested an alteration. Lucian agreed and rang to tell me. "We had a very interesting talk and I'm making a pretty radical change. Non-compositional. You won't guess." I didn't have to for, seconds later, he revealed his move. "Strip the servant. I think the twist inside the dress is all very fine but I want to unveil it. And I'll get John Riddy to photograph it before I do it." Thus it was that Jean-Louis Prat's "Coming Attraction" proved misleading and the painting ended up more Life Class than erotic incident. "Now she's pink and nobody else in the picture is. And she has red hair. The arm's very long: I've found Matisse sculptures have helped to do with amazingly long proportions." He paused. "It's going with a bang, so exciting to see if the [Freddy] heel sticking out meets the [Julie] body . . . And then I've got an idea to avoid it being idyllic or nudist: a sash round the waist." That didn't work. Better plain naked. "I didn't want to

make it too much a nudist colony. I'm working only to Cézanne but he had a sort of classical hint there." The extension to the canvas was a system that had been developed at the National Gallery. "They made a stretcher covered with canvas and spikes, steel rods—never had that before—and metal backing plates." He said that Louise Liddell at the framers was worried about the wooden bits. "I didn't want to argue with her. But I think they're OK, using mature pine and five or six undercoatings. I don't think it's as dangerous as extra canvas. If I put a canvas in the bedroom at the flat, the next day it's saggy."

After Cézanne was Lucian's principal concern for well over half the year, but there were also lesser, if more likeable, paintings—heads primarily—to be worked on, each demanding full attention. He was ferociously busy yet, for quick bursts of stimulus and relief, he still looked to the racing calendar. The Cheltenham Gold Cup in March 2000 proved dizzyingly memorable.

"I had a most spectacular win. At the age of seventy-seven. Won over a million. Fairly big stakes: 7:1. Colonel Andrew [Parker Bowles], who I like, knew some horses were in form, I thought it good info. Nine to two when I rang up before then seven to one favourite. So I plunged. I backed it three times: I backed it at 9:2, 5:1 and 7:1 and just before the off I wanted to find out the odds and added a bit more on. I'm going to leave off now for a while. If I hadn't been so in debt I wouldn't have bet so much. Also working so long hours." Freddy and Julie were there that afternoon. "Didn't tell them. I think that kind of thing with different economic situations would be sort of offensive. I deliberately made them lunch in the kitchen and slipped in there and watched in my telly room. I felt extremely pleased and thought *this is the life*."

It would be wrong, he ventured, to take too close (or too obvious) an interest in being so solvent. That being so he appreciated the benevolence, as he saw it, of the young woman sent by the bank every so often to go through the figures with a view to getting him to maybe move some of his idle cash into stocks and shares. The admirable thing about her, he said, was that she refrained from pressing him on the matter. "Awfully good of her, don't you agree?" Spending, he felt, had to be impulsive. The Cheltenham Gold Cup (and subsequent reverses) came and went as readily as had his venture into part-ownership. "I've sold Penelope's horse. It never won. It was second

a lot." As for being acquisitive, he continued, this was a trait to be indulged every so often, eagerly, like slaking a thirst. "I haven't bought anything, but on Saturday I bought a Frank [Auerbach] head, it's like a sculpture. I told Bruce I'd bought it and he was shocked. Last time I saw him. He didn't want to know."

Century, Bruce Bernard's massive volume of photographs of twentieth-century life, "nourishment for thought and a stimulus for the imagination," as he trusted it would prove to be, compressed year by year into 1,120 pages.[1] It had been published the previous autumn, almost too late for him to savour the praise and royalties. Now, towards the end of March and with this bestseller behind him, Bruce persisted. He photographed Lucian once again, this time for *Vanity Fair*. "Couldn't get up the stairs, he's so frail. Falls asleep." Shortly after that, and two days before he died, Lucian called in on him at home in Frederick Street, St. Pancras. "I was feeling so low at the printers (print not gone well), but there were two messages and I went on the way back. He never had good health. June [Andrews] used to knit him mittens.

"I think that Bruce didn't really like women. He was amazingly unchivalrous. 'Good in bed,' he would say. I always think—since women are finally the choosers, whatever people say—that it's not right. He talked about it like sports. I said, 'Surely it's better to have a really dodgy night or afternoon with someone who you really like than with someone you don't care about at all?' (I'm not sure I really agree with what I'm saying.) But I think there's something squalid about that attitude."

Both Lucian's paintings of Bruce Bernard (1986 and 1992) had caught a broody imagination smouldering within and they proved to be among his most sympathetic in the sense that this was a lone fig-ure doggedly sustaining a sense of fellow feeling. Bigger pictures, on the other hand, involving two sitters or more were bound to look contrived to some degree, each of them displaying relatedness and connections rather than undivided attention. Always, ever since com-pleting the *After Watteau* nearly twenty years before, there had been one large painting, sometimes two, on the go. Size mattered because it stretched him, testing his stamina. But size was also cautionary in that the pictorial equivalent of stage management was involved. In *After Cézanne* the tumbled chair and the diminutive set of shelves parked

against the back wall helped circulate attention around the picture, and that was sufficient to qualify as a small victory for contrivance.

Following on from *After Cézanne* there came, for Freddy, the more demanding role of *Freddy Standing* (2000–2). Long-haired and lanky with arms dangling, he stood in a corner of the studio as though understudying Rodin's *John the Baptist*. The window blind beside him, lowered to shoulder height, left a gap just big enough for a headless self-portrait darkly reflected. His father's raised arm had the look of a salute happening without Freddy noticing. His mother, Jacquetta Eliot, thought him a chip off the old block. "He always looked like Lucian. The way he stands is very like him."

"She's odd, really odd," Lucian commented. "I haven't really talked about Freddy to her, but she was excited when I got him a flat and wrote me an amorous letter. She is tremendously busy travelling around and doing poems and photographs; I think her life's edited as if it's all the same desperate importance." For her part Jacquetta considered herself clear-eyed. "Now I can see him when I more or less want to. I'm sure if I turned round and said, 'Yes, I want to see you all the time,' he wouldn't be available."

Alice Weldon was having a clear-out and came upon a box of letters that Lucian had left with her long ago. Would he like them back? He rang me the next day enthusing over the haul so suddenly within his grasp. "I've got it. Hundreds of letters I hadn't posted to Jacquetta, a drawing of a tree and the rest is catalogues and a huge handful of old papers. Smell of dust. And a marvellous photo of Stephen [Spender] in Wales, 1940, throwing a snowball, almost like a dance step."

On 1 April 2000, a Saturday morning, Lucian flew on Concorde to New York. Immediately on arrival—ahead of time, so to speak, and in just two hours, he boasted—he hung his "Recent Work" exhibition at Acquavella, some thirty paintings, among them *Sunny Morning— Eight Legs*, which already belonged to the Art Institute of Chicago. That, plus *Large Interior, Notting Hill* and *Garden, Notting Hill Gate*, dominated, though in terms of charged presence the most searching was the painting of Ali Boyt. A painting so forlorn that the Acquavella Galleries' Duncan McGuigan deemed it impossible to sell. Not so, as it happened. There was also the sudden Baroque of *Night Portrait, Face Down*: a headlong view of Julie Radford clinging to the mattress, tipped through tilted space as though slipping into an altered state;

better that display than the effrontery, as some Acquavella clients were likely to have regarded it, of *Naked Portrait in a Red Chair*: Jean Wilcock's ruddy-cheeked embodiment of Defiance swatting Propriety. Paintings such as that were like stubborn stains, Lucian remarked: hard to shift. "Acquavella doesn't necessarily buy them from me, for after all you want things to sell and show. 'I wish she had a fig leaf,' he said."

On the Sunday of the flying visit Acquavella laid on a trip by private plane to Chicago to check out the Art Institute and the possibility of the Tate exhibition being taken on there. A good sign was that the Director, James Wood, had *Japanese Wrestlers* hanging in his office. He assured them that it hadn't been brought out just for them to see, which left Lucian pleased but dubious. "It wasn't a 'wait in the bedroom' kind of thing but why not have it on show properly?" He was excited to see Van Gogh's *Bedroom* (such floorboard zest) and the joyfully disordered late Constable six-footer *Stoke by Nayland*. This, he decided, just had to be secured for our Grand Palais show. First thing Wednesday morning he was back in London, able to boast that he'd lost only three days' painting time.

In early May the challenging *Naked Portrait in a Red Chair* went on show at Jay Jopling's ultra-small White Cube gallery in Bury Street, St. James's. A proof of the *After Chardin* etching, straight off the press, was appended. *Naked Portrait* went to a collector in Australia who undertook to have it displayed in an Australian museum until such time as he had paid for it in full. "An American really wanted it— Pierre Lamond—who had bought six of my things, including 'The Budd' [*Garden, Notting Hill Gate*] which they thought a good picture to sell to a museum. I haven't got very many in American museums; clever placing in museums is sort of dodgy while persons who like them and buy them are important: good to have."

In mid-July, on the day of the Wimbledon men's final, I went to the studio to see how *After Cézanne* was doing. The tennis had been rained off and Lucian kept nipping into the side room in the hopes of seeing play resumed, rhythmic yet ferocious and in its way as assertive as painting. As for the painting, the nearer this preordained museum piece came to completion the more wary the touches. He said he wanted to carry on as if doing somebody else's picture. "I want to go on until there's nothing more to see."

A week or so later the picture was hauled through the skylight ("the rain came just a moment too late"), crated, lowered to street level and despatched to the framer. The hope was that it would go to François Pinault, owner of Christie's and art collector or, better still, to the National Gallery, Washington, and, possibly, the Cézanne along with it: a case of the prompt as companion piece. But this wasn't to be and instead it went to the National Gallery of Australia triggering, nine months later, a "Gallery chases $8m nudes" headline on the front page of the *Australian*.[2] "Hell to pay from the Australian government," Lucian was pleased to learn. "We had the front pages of all the major newspapers, which is something exceptional," the National Gallery's Director Brian Kennedy told me. "Nothing attracts a headline in Australia more than a considerable sum of dollars spent on a work of art."[3] There in Canberra, where the purchase of Jackson Pollock's *Blue Poles* (for Aus$1.3 million) in 1973 had established a precedent for the controversial acquisition of costly works from far overseas, *After Cézanne* was commonly taken to be a further extreme anomaly. For daft comparison *Blue Poles* was reproduced postage-stamp size on that same front page.

28

"One essay, no adjectives"

By the spring of 2000 it was high time to get going in earnest on the Tate retrospective that Nick Serota had proposed two years earlier, now scheduled for the summer of 2002. This had been on the cards since 1998. When Serota made the formal proposal he gave Lucian just three days to make up his mind about it. He accepted immediately. As did I, for although already I had been asked to be co-curator (with the Tate's Paul Moorhouse) of a Michael Andrews exhibition for 2001, at Lucian's insistent suggestion I was invited to shape and install this one too. "We both feel that you would be the best person to select the show," Serota wrote to me.[1] The new Tate in the former Bankside power station, soon to be named Tate Modern and branded "International," would be long open by 2002, while the Millbank building, diminished a little, would be known as Tate Britain. The Freud exhibition would be held there, backed into history, while Tate Modern presented the matchless duo of "Matisse Picasso." That being so, Lucian felt miffed at being classified "British," implying "non-International." He was mollified only when it was pointed out that filtered sunlight was tolerated, more or less, in the rooms assigned to him at Millbank while most of the rooms at Tate Modern to be given over to "Matisse Picasso" were sunless and wanly lit.

Nick Serota came to take a look at the current pictures and stood silent, cupping his chin. "So odd," Lucian reported, adding that maybe relations between them were affected by some slight personal concern. "Because I walked out with a secretary of his for a while.

Made it difficult." But it was Serota's manner, tight-lipped and politic, that disconcerted him. Was he being careful not to admit anything approaching overt enthusiasm for fear of committing premature endorsement? Or was enthusiasm inappropriate?

Lucian was anxious to get firm undertakings from the Tate over the selection, for he wanted my choices, he said, not theirs. And "no repetition." The recent Van Dyck exhibition at the Royal Academy had been overloaded, he reckoned: something like forty too many paintings, many of them non-Van Dycks. That said, he now suspected that insufficient space was being provided for what was to be, after all, a full retrospective and anything short of that would be a deplorable letdown. ("I've never said: 'I've never been so insulted in my life.'") Some weeks later, over lunch at the Tate with a cordial but edgy Serota, Lucian told him how we'd first met and how pleased he'd been when I told him then that I really wasn't interested in his private life. Another thing: being from an unworldly background as he put it (son of a bishop), I didn't quite grasp his economics, the fact that he just had money and used it and didn't think ahead. This book I was writing, he added, was mainly about the art. It was to be funny, he bragged.

The book had been put aside while I compiled lists of loans and set about securing them, a tortuous process of feelers, appeals and reconsiderations. About 135 works maximum, the Tate stipulated. Given that I wanted to include quite a number of small early works the potential total grew to well over 150 and that, of course, needed justifying. To Lucian this wasn't a problem, and he told Serota so. "From the very first you assured me that the Tate would give the necessary space for a full retrospective." It was no longer enough. "Simply because the selection, astringent though it is, makes it necessary to have a little more space in order to show it properly." I recognised, more readily than Lucian, that "the necessary space" was finite. But his unease extended further. While "a basic and essential selection of most of the strongest works with an Eye on Variety (and Variety of mood)" was being arrived at, the Tate line, he suspected, seemed to be that the show needed justifying if not neutralising, given its strengths. Over another lunch, this time (in the absence of Serota and Stephen Deuchar, the Director of Tate Britain) Lucian was keen to impress on the designated assistant curator, Virginia Button, that this retrospec-

tive was to be the one and only (in his lifetime) and that in stating this he was serious. Whereas, he added, the Turner Prize wasn't serious; not that he disapproved of it but he saw it as entertainment. As for the catalogue, dummies and dummy contents of which were being proffered, that, he felt, ought to be uncomplicated and therefore the Tate's proposal that "differing perspectives" be accommodated (presumably in order to placate anyone flabbergasted at nakedness) should be rejected. "One essay, no adjectives," he added. And the designer should be Robert Dalrymple, who had produced an exemplary catalogue for the show of early works in Edinburgh in 1997. "I don't want 'symposium' or 'debate' in the catalogue and I'd like to do the catalogue cover." These demands and rebukes were aggravated by the publication of the catalogue accompanying "Lucian Freud Portraits," an exhibition staged earlier that autumn at the Museum für Moderne Kunst in Frankfurt, for which the curator, Rolf Lauter, had neglected to clear copyright permissions. Worse, this catalogue was being advertised and distributed by the publisher, Hatje Cantz, as a trade book in the USA and that, Diana Rawstron pointed out, was unacceptable. So much so that remaining copies were to be pulped, Lucian insisted. "After Magna Carta the best law is that painters have their own copyright."

And now: where to tour this once-in-a-lifetime retrospective? The prime concern was to place it well in the United States. Letters were written and phone calls placed but apparently, the Tate reported, the key institutions in New York, Chicago, Philadelphia and elsewhere considered Freud insufficiently pertinent, besides which their exhibition plans were, of course, already formed well into the new century. Serota's letters to museum directors stressed that this, "the definitive Freud exhibition," would prove him "an extraordinary artist. Both his portraits and his nudes compare with some of the great masters of the past." That backward-looking line of approach proved unpersuasive at a time when prettified graffiti were shaping up to be prime desiderata on the contemporary scene. Also perhaps the recent Freuds, though expertly handled by Acquavella, were not yet quite high enough on the saleroom price index to command the attention of boards of trustees. (However, eventually Jeremy Strick, the newly appointed Director of the Museum of Contemporary Art in Los Angeles, would take it on.) As for a European showing, nowhere

suitable could be found until, happily, the Fundación "la Caixa" in Barcelona plumped for it.

The placing of Freud within the pantheon of contemporary art continued to trouble David Sylvester. During a dinner at the Ivy restaurant for Bridget Riley in June 2000, almost exactly a year before he died, he fixed me with one of his troubled looks and asked me if I was in love with Lucian. No, I said, at which he confided that Lucian had committed a monstrous act. What would that be? He had tampered with Robert Hughes' 1988 Hirshhorn catalogue introduction. This, I knew, was untrue, and told him so. Then, lowering his voice to a growl, he disclosed that he was about to have a tumour dealt with and hoped therefore to live another four years or so. Then, abruptly: "Lucian would do anything to amuse Francis." He had attached himself to Bacon like a lapdog yet was the more intelligent of the two. This he knew because he had been close to Lucian for some years. "Not a sex thing," he added. And, he continued, given the opportunity, he himself could do a Freud show and make him look like a great painter. "Better than Balthus, ultimately."[2]

A more surprisingly positive assessment came from Euan Uglow, whose lucid paintings of naked women strictly posed were apt to be cited as a corrective in comparisons with almost any Freud. Euan's wife, Maria, had been "incredibly beautiful," Lucian remarked, on learning in September 2000 that Uglow had died. He had asked him once why he never painted her. "I don't make it with models," he said, and seemed irritated with him for asking. Uglow's paintings, Lucian maintained, were best seen isolatedly. "I never get the feeling of an individual. He left everything about the people well alone, he had people sitting because he didn't have a wooden machine figure." For quite some time he had on his mantelpiece Bruce Bernard's photo of Uglow, taken a fortnight before Bruce died. I'd been surprised when Uglow, so noted for asperity, had muttered to me when we both stood looking at *Head of an Irishman* in the 1998 Tate display that it was very much like (implying just about as good as) a Velázquez.

Late November and family news triggered atavistic twinges promptly suppressed. "Susie Boyt and Tom Astor had a daughter: Mary. When I rang up and asked, 'How's the baby?' the nurse—I've always loved nurses—said, 'Lovely, blonde and smiling all the time.' Thought that was Tom. Susie is in St. John and St. Elizabeth in St.

John's Wood where I had my appendix out and drew my mother dead. It was so amazing: Saturday afternoon and all those Jews in St. John's Wood all walking along in black coats and children in black hats because there's a synagogue there. I thought, 'I'm one of those people. No!'"

That same day he asked once again if I would sit for him. "A small head, because your hair looked good the other day. After Christmas." I was non-committal, meaning unwilling, and a few days later went north for the Christmas holiday. There in Northumberland a letter arrived, postmarked 21 December, its urgency made manifest with two first-class stamps.

> *Dear William You are in no way to blame for this but the prospect of the book ever coming out makes me sick.*
>
> *Talking to you very freely about private matters (nearly everything) is different from reading them on the page.*
>
> *The one principle (Baudelaire's) I've tried to keep to without much trouble is to "behave better than the people I most despise."*
>
> *Nearly everything I've said in the book puts me well into that category.*
>
> *Here's a bit of compensation* [a cheque] *for wasting so much of your time Love Lucian*

Following a spate of phone calls over several days it was agreed that indeed the book should be shelved, at least for the time being, and that, as Lucian put it, "a novel may well appear after I'm dead." He was perturbed, panicked even, at the prospect of seeing his words trapped in print. That would have had the effect of making him appear self-obsessed. His other concern was the difficulty, not to say impossibility, of exercising influence, still less control, once he was dead.

In the new year the anxieties redoubled when he learnt that the shops and offices to one side of 138 Kensington Church Street were about to be redeveloped. "The whole thing is fairly complicated. A group of people who have a number of properties are planning to buy next door: business speculators trying to turn it into flats. I'm completely endangered. The only thing I can do is buy the house. I'll have to give them more than they can make from it: business rates £100,000 a year. They've got permission for two terraces eleven feet

away from my bedroom." Were that to happen people would be able to look down into his garden and peek through the bedroom window. "I need the garden for Pluto and I try and have a rest in the afternoon."

Seized with fury and alarm, Lucian hit out. The man behind this scheme was unspeakable. "I met him once. He's the worst. Mock gentleman. Rude to secretary." Speaking of which, even the irreproachable Diana Rawstron incurred sudden (and brief) displeasure. "Unfortunately she has fallen out with me. I hate upsetting people, unless I mean to. She is hurt and has misunderstood. I said it's important for my privacy."

One reasonable option presented itself. Gazump the developers. But the buildings were valued at £7.5 million, he learnt, and that stumped him initially. A tempting alternative was to become the neighbour from hell but that, he saw, would backfire; so, he decided, there was nothing for it but to buy outright. "They can virtually blackmail me. I'm paying out a good deal and if I get it they want to move. It's £130,000 a year rent plus shops. I have to borrow the money, otherwise I have to pay tax. It's a bit of a strain: non-stop pressure and phone calls." It took upwards of two years before he could announce the sale had gone through. "All done. I've even let one of the shops. I was relieved of this huge sum, the offices are let to these TV people and the money goes to the children. A trust was made to get it: an allowance from the rents. I don't want anything to do with it. Rose and Bella did it."

New people moved in below him at Holland Park and he wanted to see who they were. "In a sense it's better if people are there than if it's empty. My door is the only door on my floor. Don't want any neighbourliness." He was using the rooms at Kensington Church Street more and more and the flat no longer looked lived in. Indeed the famously encrusted studio was now a potential blue-plaque landmark, one to rival Bacon's at 7 Reece Mews, the contents of which, a litter of 7,000 or so items casually accumulated, were offered by John Edwards, Bacon's heir, and the Bacon Estate personified by Brian Clarke initially to the Tate and then to the Hugh Lane Gallery in Dublin where this indoor landfill was reconstituted, unveiled and declared, in the summer of 2001, a veritable shrine.

Acrimony billowed meanwhile with the launch of a lawsuit by the

Bacon Estate, the assertion being that the Marlborough had "wrong-fully exploited," not to say diddled, Bacon over the years. The dealer's riposte was that paintings had been bought outright in the expectation of making double or more on sales, that Bacon had known this and—given the indubitable devotion to him of the gallery's Miss Beston, who had handled all his affairs and concerns—he had been well served throughout. Also, obviously, he had been aware of payments to him being made through Marlborough AG, in Liechtenstein, and into his Swiss bank account. The Marlborough asked Lucian to provide a statement as one who knew Bacon, his circumstances and attitudes. He agreed to but found it troublesome. "How difficult it is to write," he told me, repeatedly, while engaged in gathering his thoughts and noting things down. "I've written quite a dense thing about Francis, mostly about money." It was no panegyric. What had to be taken into account, he felt, was "Francis's rigid belief in his own supremacy as an artist, his endless repetitions. After his inspiration had left him what had been the subject matter of his pictures became paraphernalia. Things were included in a painting because they had been in the previous one. With the urgency gone some elements in the pictures just seemed to be in the way. Like bits of gauze left inside a patient's stomach by a forgetful surgeon."[3]

The lawsuit was set to drag on until suddenly in February 2002 news came that it was all over. "Top Secret. Someone was going through tins of films he'd done and found a bit in one where Francis says: 'I'm incredibly happy, never had such a nice time as with Fischer and Lloyd.' The case is withdrawn."

John Edwards, whom Lucian had regarded as "a spiv not a vil-lain," died in Thailand the following year.

"Tells you everything"

The day the Queen declared Tate Modern open, 11 May 2000, was the day the former power station was set to exceed if not supplant the Millbank Tate Gallery, now Tate Britain, two miles upstream. Inadvertently or not the thinking behind this was doubly divisive in that the historic collection (and what in an earlier age was termed the "National School") was now circumscribed and curtailed while the role of Tate Modern was to be go-ahead and outward-looking to a wondrous degree. This made the prospect of a Freud retrospective installed at an elder and purportedly second-best Tate regrettable to some, particularly Bill Acquavella. But Lucian himself was not averse to being aligned with the historic, particularly not given that he was fixing to do a royal portrait ("I thought a little picture of the Queen"), an undertaking invested with a unique range of protocol and precedents. The possibility had been aired even before his enrolment as an OM and he had discussed the practicalities with Robert Fellowes, registrar of the OM and newly retired Private Secretary to the Queen. This was not to be a state portrait, nor, of course, would it be a Raphaelish nonsense like that New Elizabethan Annigoni portrait of the early fifties; it would be similar in size to his recent John Richardson or Aline Berlin and indeed the painting of Robert Fellowes himself, quizzically discreet.

When Fellowes reported royal approval Lucian was so pleased he produced by way of a joke a tiny image of a crowned head sporting a radiant smile. Sittings were to begin in early 2001. Could she, would

she, come to the house? Certainly not, was the answer. Given that he would be painting her entirely on the spot, without recourse to photographs or preliminary studies, a conservation studio in St. James's Palace was made available. The painting (9¼ inches by 6) would travel in a shoebox for the taxi rides there and back.

The decision that this was to be the portrait of a crowned head was "deliberately underplayed," Lucian maintained, the crown or diadem being the hard hat worn for professional reasons rather than an upgrade from a tiara such as the one donned by Ann Fleming when sitting for him in an earlier age. The crown—designed by George IV and replete with diamonds—imposed stature and burdened its wearer while invoking the Shakespearian concept of high authority brooding over the perennial obligation to act the role and yet simply Be Oneself. What to make of such a face, images of which had been circulated worldwide for half a century? The head on countless stamps, coins and banknotes, that image made flesh holding still four feet or so away from him, practically within brush reach.

A duty of the monarch is to be iconic and normally those commissioned to paint Elizabeth II kept well back, making the most of setting and costume. Mr. Freud, as she addressed him, came unusually close, as the painting demanded. When sessions turned conversational he would pause and that being so, the Queen was reported as saying, she kept silent insofar as she could. "Because when he talks he stops painting."[1]

"Don't mention how many sittings as the others only get two or three sittings," Lucian was advised. It wouldn't do to alienate the portrait trade. "Get round it by saying the Queen had been away a lot." Given the postcard size of the work in hand the Queen would have been justified in wondering at the demands made and hours spent. He tried explaining why he needed to be so deliberate. "You probably think I'm going incredibly slowly, but in fact I'm going at a hundred miles an hour, and if I go any faster, the car might overturn."[2] Towards the end of the process David Dawson was allowed to photograph the set-up: the monarch gamely seated, handbag parked beside her and Lucian inclining his head towards her, deferential yet peering. "I think," said the Queen, "it might be a little bit of history."

The canvas grew slightly. Hamish Dewar, the conservator Lucian now exclusively favoured, enlarged it by two-thirds of an inch to

accommodate more diadem. Earrings too were added, offsetting the curvature of the hair. Light from above set the jewels twinkling. With completion in sight Lucian made final modifications. "I worked on the pearls and earrings and shoulders, worked on both sides, so really it comes from a distance much more now. Looks more nervous. Worked on the neck. Not sticking the chin so much out now." The next day he reported it done. "I changed it a lot. I've made one of the shoulders very soft. Made the contour more defined."

John Riddy was summoned after the final sitting to take the photograph that would be made available to the press. Jacob Rothschild, fellow OM, recommended that because of tax implications the painting should go not to the Queen but to the Royal Collection; that said, Lucian still thought of the painting as a personal gift. "Duke Ellington gave her some music once. I like that. But mine is the first for which she's sat which has been given to her." Either way, it was truly hers and he went one Thursday morning to present it. "In the private apartments, with Canalettos of London and a Gainsborough portrait (the Duchess of Cumberland) on the walls. At first there were a lot of dogs rolling over: corgis. There was nobody else there. I saw in an anteroom a painting of Napoleon looking miserable.

" 'Where shall we look at it?' she asked. I put it on a yellow chair. She didn't say what she thought of it but seemed very pleased. 'Very nice of you to do this; I've very much enjoyed watching you mix your colours.' I likened the whole thing to a polar expedition. And I did say to her, 'If you were a professional model you'd be in demand.' " Her response, he said, was "You must excuse my hair because it's been sprayed, as we've been rehearsing the Christmas speech." How nervous it made her, she added, and his response to that was to say he had met her father once. " 'I had this photo of me and him [at the Southwold boys' camp],' I said. 'He loved those camps,' she said."

The painting went public four days before Christmas. "I'm not naive enough to think it will cause a stir. I'm pleased with the framing: it doesn't show." That he had been painting the Queen had been kept under wraps but what hadn't been anticipated was the kerfuffle of revealing it. "The papers: if only some get the picture there'll be trouble. Have to give it to the tabloids. I wanted to underplay it." But by doing so he would stimulate even more attention, I told him. Sure enough, on the day every front page carried the picture. The

Newspaper front pages showing *HM Queen Elizabeth II*

Sun spoke for most when it trumpeted, "It's a Travesty Your Majesty." Tim Spanton, the *Sun*'s "Fine Arts Correspondent" (a one-day appointment), wrote: "Art critics reacted with disbelief yesterday to the latest portrait of the Queen. They poured scorn on the oil painting by Lucian Freud—who many claim is Britain's greatest living artist."[3] Such a one was Robin Simon, editor of the *British Art Journal*, who opted for hapless simile. "It makes her look like one of her corgis who has suffered a stroke," he wrote, adding a pert reprimand. "It is a huge error for Lucian Freud. He has gone a portrait too far. The two sides of the painting are like two different portraits. He has just lost it."[4] Richard Cork, art critic of *The Times*, was more sympathetic and even made a guess at Her Majesty's state of mind. "The Queen looks self-absorbed and the conspicuous grimness of her mouth suggests that she is preoccupied with difficulties." The *Guardian*, *Independent* and *Daily Telegraph* offered such praise as could only provoke reader indignation. The *Telegraph* letters editor invited me to remonstrate with some of the more outraged, but I saw no need for that. Further afield *L'Express* summed up opinion neatly: "*peu flatteur* [hardly flat-

tering]." The oddity of the painting, its excerpted look, its mix of glitter, flesh tones and unapproachability, made it memorable and, moreover, a brisk extension of a dwindling genre. It rejigged the credibility of The Royal Portrait.

"Nearly a year it took," Freud commented. "It's got quite a number of expressions."

Inured? Contemplative? Resolute? Who could say? The image was reminiscent of the two heads in the double spread from Breasted's *Geschichte Ägyptens* and of two paintings and an etching in the mid-nineties. It wasn't so singular after all. For that matter this contemplative Queen Elizabeth wasn't so different from the 1952 head of Francis Bacon, more famous than ever once stolen (and now the image on a missing-person poster designed for display in the streets of Berlin). Lucian made a drawing of the Bacon portrait as he remembered it over dinner one evening at Moro in Exmouth Market, this face more injured than the original and—since the disappearance of the latter from the Neue Nationalgalerie—extra morose. We had got round to thinking that a WANTED poster might stir guilt or stimulate informants. Robert Dalrymple was to lay it out elegantly in several sizes for posting up in advertising kiosks and bus shelters. That settled, Lucian asked to be dropped off at the National Gallery and darted to the night door with the plate of the etching version of *After Chardin* under his arm for final on-the-spot adjustments. Work in hand was a more urgent matter than the recovery of the painting, but for campaign purposes we issued a personal plea: "Would the person who holds the painting kindly consider allowing me to show it in my exhibition at the Tate next June?" The DM30,000 reward offered for productive information attracted more media attention than the theft itself had provoked, but there was no happy outcome. Many of the 2,500 posters vanished overnight to become collectors' items.

Another head: that of Henrietta Edwards from the Royal Collection, who, in the Queen's absence, wore the diadem for several sessions, subsequently sat for a portrait in her own right, head cushioned, eyelids heavy, sleepy and drifting. Lucian was touched and impressed by her stoicism. "She has horrible cancer in the back. There's something remarkable about her. She's an expert on bronzes." Henrietta died in 2006. Six years later the painting, *Woman with Eyes Closed* (2002), was stolen from the Rotterdam Kunsthal, along with six other

pictures, among them a Monet, a Picasso and a Matisse. It was understood that the mother of one of the Romanian thieves reduced them to ashes in her kitchen stove.

By the turn of the century David Dawson was the standby sitter but others were needed, necessarily reliable for months at a stretch. Being impressionable Lucian tended to favour those who assured him that they were artistically inclined and, being impulsive, he often failed to foresee the onset of unpunctuality, or boredom setting in, or—worse—excessive attachment manifesting itself when a recruit's usefulness had run its course. His complaint about one persistent admirer was that she kept pressing him for her own professional ends with a doggedness that came close to matching his. "There's a slight element of fantasy with her projects; she was rather annoyed when I started resisting her advances."

Flora Fairbairn on the other hand was pleasingly level headed. "I saw her in Moro restaurant. Came up in the restaurant. (Maybe she's completely daft.) Three nights a week (I tried for four) I'm getting on well." She sat for upwards of eighty sessions and, in retrospect, savoured the experience. "Lucian was a very good person to be with while my mother was dying. He talked a lot of sense; he is very

Campaign for recovery of *Francis Bacon*, Berlin

black and white."[5] The Galician restaurant on the corner of Golborne and Portobello Roads was their usual place for a meal when winding down afterwards. "She likes it: we go there at night: lots of Spaniards, nice feeling. A little balcony with tables where you can eat and look down." The eventual painting, *Flora with Blue Toe Nails* (2000–1), was of the sort that Acquavella was predisposed to welcome, all fleshly harmonies and a decent size at that. Unlike *Two Brothers from Ulster*, also completed in 2001, which proved peculiarly demanding in that Alfie McLean's sons seated together (though for the most part painted separately) came across as uncommunicative, Paul very much the assertive elder and Sam more laid back: "Mentally he's very companionable. A wry humour." A table placed between them had to be painted out, making way for the four formidable thighs, and an extra panel was added for the top of Paul's head. Such ad hoc, if not wonky, accommodations worried potential buyers. What if cracks sprang, as was bound to happen? Lucian shrugged. Signs of ageing: so what?

In *Julie and Martin* (2001), another double portrait, the boyfriend's head was cut off above the eyebrows. No need for an extension there. With the fully clothed Martin vertical and naked Julie stretched horizontally, her head lodged on his hip, a telling cohesion obtained. The arrangement suited them. "She's not working: I've put them both on wages: a proper wage so they don't have to work." Julie—Big Sue's brother's ex-girlfriend—gave up her social-worker job at Lucian's urging so as to be available to sit solo more, especially at night. "I often stayed over in the studio while he went home. We didn't have an intimate relationship but we were very close."[6] "Working from Julie and Martin: they turn very slightly into monarchs when I take them out, which they prefer to me cooking. They prefer to go out to a restaurant and have a bottle of wine."

Planning for the retrospective was jolted in August 2001 when Serota wrote to tell me that thenceforward I was to be working with a Tate co-curator, the implication being that the project needed shaping up and the imposition of norms. A meeting at the studio was arranged for early September to question this. Serota arrived, sat on the edge of the bed, and engaged in preliminaries about how our respective holidays had gone, Lucian's contribution being that he loathed such occurrences but, given that the Notting Hill carnival over the bank holiday weekend drove him away for twenty-eight hours, he rather

liked staying at Badminton with David Beaufort. Then to business: clearing his throat he spoke carefully as though coaxing a reluctant witness. "Nicholas: is this my exhibition or the Tate's?" There being only one acceptable answer to that, the reassignment was abandoned and, for the second or third time, it was agreed that the catalogue should feature one essay only. Lucian had already said that "a good *Tate* catalogue" was exactly what he didn't want. "I don't want to go on hearsay. I'm suspicious of sentiments by menu. In my case it's a question of privacy; the motive is not to be bored." Serota then asked about the book. "Shelved," I said, "for the time being." Lucian brought the conversation back to the point. "We want an administrator," he said. Shortly afterwards the lively and efficient Mary Horlock took on that role. Though tentatively approached, she did not become a sitter. Lucian did succeed however in recruiting Sophie Lawrence from Tate Publishing, out of hours, and Tate Publishing, having been thwarted over catalogue content, proceeded to issue *Interpreting Freud*,[7] an essay by David Mellor bulging with detected influences and determinants, so much so that Lucian, describing it as "ghastly gush," let Serota's office know that no second printing of "this little book thing" would be allowed. "It's rubbish. Absolutely wrong. Not the 'interpretation' but the facts." For example, his father had liked Klimt. Not Grosz.

Most of the loans were now confirmed, Lucian's eye-catching handwritten letters to reluctant potential lenders proving invaluable; besides which he urged Bill Acquavella to be persuasive when some among the recent buyers failed to recognise that property rights did not entitle them to refuse to accede to the wishes of the artist, whose zeal was such that he even undertook to do a (small) head of Pierre Lamond, one of his zealous new collectors, provided he agreed to make three key paintings available to us.

Preparations for the Constable exhibition, now subtitled "Le Choix de Lucian Freud" and scheduled three months after the Tate opening, were even more complex and extended. I introduced my co-curator Olivier Meslay of the Louvre to Lucian who told him I'd shamed him into cooperating; for someone so undutiful as he, it was, he explained, something of a compulsory pleasure. Happily the collaboration between British Council and the Réunion des Musées Nationaux thrived; the Tate, the National Gallery and the Victoria

and Albert Museum were lavishly supportive and Lucian himself wrote to a number of owners, even persuading the Art Institute of Chicago to reconsider their unwillingness to lend *Stoke by Nayland*, the huge late painting so splendidly intemperate that some Constable scholars dismissed it from the canon on grounds of disordered handling and inconsistency overall.

This was to be a show of Constable reclaimed, extolled, liberated indeed. In a conversation we recorded one afternoon for the catalogue, to preface the—admirable—work of the Comité Scientifique, John Gage and Annie Lyles, Lucian extolled Constable's "completely fresh, really passionate, pictures," their overflowing quality and instinctual burrowing. ("In French painting the sentiment is completely different.")[8] *Stoke by Nayland* was to be the exhibition's finale. "It's so extreme. And gauche. Quite wild and rough. The funny things he does with scale, very often, doesn't he? Things that are completely convincing." He talked, too, about Fen Lane, the site of several paintings, such as *The Cornfield* in the National Gallery. "The way the path goes down to the gate. Constable's so marvellous at that. You think there's nothing more moving than a muddy path going down to a gate. Tells you everything." This was personal, the thrill of sudden connection taking him back to Dedham in the summer of 1939. "I used to wander down that path."

Pluto, in the corner in her basket as we talked, stirred once or twice, stood up and then slumped again. She prodded Lucian with one paw, asking to be fed. "Pluto has a bad kidney, drinks a lot, blind in one eye."

Two sleeping-dog pictures were on the go, Pluto and Eli: "one with two and one with one." Though dogs in their own right they were also, patently, dogs as surrogates. "Whereas you have to look after horses (because they don't know what's good for them), dogs you can train to think or act like you." For his part Lucian was as quick to think and act as any whippet when provoked.

Occasionally after lunch at his table in the back left-hand corner of Sally Clarke's restaurant, Lucian would take people back to the house and that could include being ushered upstairs for a look at the studio. That was the prospect when the dealer Graham Southern, with whom Lucian was friendly, arranged for Acquavella to bring Roman Abramovich to lunch with a view to interesting him in a "Big

Sue." However, the oligarch had nothing to say in English or any other language throughout the meal and Lucian too was silent. That meant no studio visit. ("I'm quite territorial. Having someone going to your house means something.") They did adjourn to the house, but only to look through books and catalogues in the downstairs room, Abramovich pointing out works he liked, some of which he owned. The upshot was that in the taxi back to the West End Acquavella sold him a Renoir, or so it was said.

"I hardly ever want to paint anyone from mere appearance."

Corot's *L'Italienne* (1870), a peasant woman, forehead, shoulder and yellow sleeve boldly lit, majestically serene, had belonged successively to Edward G. Robinson and to Stavros Niarchos who, judging her ugly, dumped the painting at auction where Lucian bought it. Here, personified, was French painting at its most radiantly deliberate. As it happened the arrival of *L'Italienne* at 138 Kensington Church Street more or less coincided with the completion of the Queen's portrait and thus served as a reminder that status, like celebrity, counted for little or nothing once the easel was in place and work under way. Moreover, those most eager to be painted were almost certain to be unsuitable. Madonna, for example, had only stopped pestering him, Lucian reported, after four goes. "Would I phone her urgently. I never did." A pity perhaps in that he didn't realise that she could be as unglamorous as the plain-clothes Leigh Bowery when not being the performer and just might have proved worthwhile. So too with the over-confident representations made to me to persuade Lucian that it would be awesome for him to do a portrait of Jimmy Page, founder and thunderous guitarist of Led Zeppelin. No go there either.

In the absence of Susanna Chancellor for upwards of two years (as she explained, she "only got a patch of his life," and had her own life to be getting on with, in Italy much of the time), two of those Lucian took up with as prime sitters moved in with him, one after the other. First came Emily Bearn, a twenty-seven-year-old journalist on the *Telegraph* who had been associated for a while with a Colditz veteran, Michael Alexander, and was subsequently involved with Alexander Chancellor, husband of Susanna. Hesitant-looking, determined nonetheless and prone to damsel-wear, Emily was, Lucian found,

"reliable and quiet." Scenting a Mills & Boon ending in prospect the *Mail on Sunday* ventured a prediction. "Perhaps this latest muse—the waif-like but elegant Miss Bearn—will be the woman to tame him in his final years."[9]

A first painting of Emily was scrapped and Lucian started again, this time, he said, on a proper footing, sallow against the ruffled greys of drapes and mattress; her grubby lilac ballet shoes positioned under the bed. Here in *Naked Portrait* (2001) and in further, smaller paintings plus an etching she had the bemused look of one who rather thought she'd just forgotten something frightfully important. For a while all was well and a further painting began, this one involving a floaty evening dress. But within weeks an alternative prospect presented itself and Lucian's flair for disingenuity kicked in with opportunism uppermost. A supermodel came his way.

"Well, I thought, of all the girls I know—all I can think of at all—only one is a model and that's Kate Moss. Bella says, 'I don't know her well, but she's reliable,' and she asked her if she was interested. ('He just wants to go for dinner with you. Don't be late.') So I took her out on Thursday, but it got very late—the boyfriend rang up once—and I thought: here's an actual person. She wrote somewhere that one person she'd like to meet is *me* as I'm so cool . . . Well, I don't know that I'm cool. She's—a mean thing to say—'over-enthusiastic.' Maybe that's the style. She goes to different countries for the weekend. But she said she'd put it—the sitting—first." She seemed robust, he said a day later, by which time he had begun to have doubts about her suitability. "I think I'll know tonight if she's OK. The idea of starting with an existing beauty and trying to do something with it isn't itself an exciting idea at all really. I was thinking about Matisse: that crazy thing that when he was sharing a studio with my friend Javier Vilato, when he got fruit for still lives he always got the stuff that had won prizes." Top models though were unlikely to be capable of sustained informality and their looks were too commercially valuable to be freely expended. "Jerry was never exactly my choice (the pregnant one was OK but I thought there was too little time to spend) and the reason I always go for what people call 'dowdy women' is that they have generous faces." Far from dowdy though she was, maybe Kate was the exception. Without any directions from him she had settled, promisingly, into "a curiously abandoned pose. Not doing that

awful thing in photographs of 'Giving My All.' She's slightly gang-
ster's moll. 'What an enormous arse Marlon Brando had,' she said. (I
agree.) 'What was he like?' 'Rather awful: only wanted one thing.' She
had a fur jacket with bare breasts. 'What a marvellous jacket,' I said.
'Got it in the Portobello Road this afternoon.' It's got writing all over
it; if I do her jacket I don't want anything to do with titillation. I'm
sure she'll be a zoo animal and see how it is."

Still residually cautious but head over heels intrigued, he asked
me the next day what I thought of her as she'd arrived just before I
left the evening before, breezing into the studio, skin glowing, cheer-
ful hellos. "Friendly, engaging, no nonsense," I'd said. She'd even
made sleek leather trousers look lively. He agreed. "Got a nice nature.
Red Indian I'd say, for some reason. Completely no side: works, has
stamina, intelligent with her body; her body rhymes well; all the pro-
portions are quite full, surprisingly so in that she is slim." Her south
London accent reminded him, he said, of Paddington days way back
and he told her how he had won respect by tattooing some of his ship-
mates in mid-Atlantic. Tickled with the idea of having him exercise
this art on her, some time later she got him to do a brace of swallows
set like inverted commas at the base of her spine. "An original Freud,"
she boasted to Bella's husband, James Fox, when he interviewed her
ten years later for *Vanity Fair*. "I wonder how much a collector would
pay for that? A few million? If it all goes horribly wrong, I could get
a skin graft and sell it."[10]

For much of the nine months, on and off, that she made herself
available Kate was pregnant with Lila Grace, her baby by Jefferson
Hack, editor of *Dazed & Confused*, the magazine from which Lucian
had learnt that she fancied him painting her. As news emerged of the
pregnancy, the *Evening Standard* asked if she was being painted from
the toes upwards and, if so, was she being shown to be pregnant?
Lucian shrugged. "I said if she was being done while pregnant then
she would be pregnant. She has cut down: twenty cigarettes a day
instead of eighty. Amazing glowing health."

Lucian's main concern, besides adapting to her burgeoning shape,
was their privacy. "I minded when someone—the boyfriend—was
waiting outside the house while she was with me. I've always hated
being watched." He found her endearing. She said that she really
couldn't understand Frank's work. Could he teach her? And she gave

him a first edition of Allen Ginsberg's *Howl* for Christmas. "Nice present," he acknowledged, though in print it failed to live up to his memory of Ginsberg reciting it forty years or so before at the Albert Hall. The performance had been astounding. "But the poem is crap." He had come to think of Kate as, yes, pleasingly racy, something of a life force even. "I like the idea of her naked with a naked baby. She's already getting so maternal. Strokes her stomach all the time." He discussed with her his stimulant of choice: Solpadeine tablets, recommended dosage of which was two at a time in water. He favoured handfuls. "You take as much as you need." The Kate Moss zest became irksome, though, once her punctuality slackened. He tried speeding up, aiming to keep pace with the pregnancy. "I've got a rhythm of three pictures: something in the morning over there, Emily in the morning over here, Kate in the evening." But then she was apt to have other plans. "She says, 'Will you come and stay at Saint-Tropez?' 'I'm going to do my best to keep you here,' I said." When she was away and he wanted to work on peripherals David sat in for her; unlike in the Jerry Hall episode, he was no substitute. "She's pretty good: physically intelligent and reacts so quickly, talks about herself like about somebody else. Cold yesterday: 'With this temperature my nipples hurt,' she said." The painting ended up, predictably, with Kate looking polished, puckish but inert. So, at Frank's suggestion ("I have an idea, it may be completely mad"), triangular sections each side of her were painted white by David Dawson so as to contain the figure and couch it better. And that was that: *Naked Portrait* (2002) went off and was sold for £3.9 million to someone in Brazil, despatched, Lucian imagined, to an equatorial heart of darkness, where oblivion seemed guaranteed. "Leave it in Brazil," he urged me, not wanting to have it turn up at the Tate. "It's a painting I don't particularly like. It didn't quite work. I remember the first night I took her out, to talk about her picture, she had two and a half bottles of champagne and it hardly showed."

As for Kate, she "loved his wicked sense of humour"; that and his disarming variations on gallantry. "When we went out—to a party or a dinner—he would hold onto my belt all night so I couldn't leave his side. He was otherworldly, Lucian: a proper old-fashioned gentleman from a different time."[11] That said, exasperation had set in when she gadded around in foreign parts or became unreliable. And then

there was the unhappiness of Emily Bearn when supplanted, a state of affairs that Lucian tried passing off as tiresome insecurity on her part. "Emily was a bit worried and I placated her. 'Kate Moss is a trouper,' I said. 'But it's no good,' she said: 'If I wasn't jealous it would mean I wouldn't care.'"

Care extended to cakes. I called round on a Sunday evening in early December to look through a sketchbook. Lucian pressed me to try two birthday cakes: one from Clarke's next door from Sally Clarke herself, the other given him by Emily, who happened not to be there. This in itself was no surprise, but there were further hints of disengagement. The next day, Lucian announced, he was due to go to a house in Ennismore Gardens owned by Noam Gottesman, a youngish financier, who had just acquired through Matthew Marks the complete etchings, a collection accumulated for Susanna over the years beginning with *Bird in a Cage* (edition of three, 1946) which he had bought from the Marlborough and given to her, thinking she'd like it, and the rest had followed. And now an enthused Matthew had installed the whole lot in a room designated the library where they hung frame to frame, floor to ceiling. Though interested in seeing what Matthew had assured him was a truly spectacular display he was not too keen on dining there afterwards. He therefore decided to eat woodcock in advance so that during the meal he could just sit there and peck.

"They asked if I wanted Emily to come too. I didn't want to be a couple. Couples wanting to be friendly with other couples: I don't know how long we'll be a couple. Though I want to at the moment . . ."

That moment passed. When Emily discovered that the *Telegraph* was about to reveal that Lucian was painting Kate Moss—and, implicitly, that she was being supplanted—she decided to strike out professionally and go to New York, also Australia. Travelling, she pointed out, was what journalists did. Lucian thought this nonsensical. It was absenteeism really. "There is no need for holidays. A fortnight's holiday is just her habit." He needed her to sit, he insisted; besides which, quite plainly, her problem was Kate. His too, it transpired. When Kate came back from New York Fashion Week he took her to dinner with Bella and Acquavella's son, Nick. "She was looking very rough and talking absolutely non-stop." So much so that he thought he might not be able to go on with her. "She says she has to sleep for

two days after being up for forty-eight hours at a stretch and she *does not* answer her phone." Days passed before she became available and paintable, by which time he had scrapped the first picture, resolving to go bigger.

That setback was annoying enough but, worse, his second etching of Emily became a disaster. "Something was wrong with the acid and it came out all shadows like something by Marie Laurencin. I spent six hours a day on it. No good. One hope, when I saw Marc [Balakjian] rubbing at it, was that it would be a noble wreck, but no. Nothing. None of the strong lines came out." Emily agreed, telling me that, rather than recognise herself in it, she imagined it to be how she could look in ten years' time when she'd hit the gin. As for Lucian, he told himself that pencil drawing was less risky and talked of doing two standing figures—himself and Emily—his hand on her breast for the Tate catalogue cover. Like a Matisse sculpture, he added, and then, tongue in cheek, produced a "jolly working drawing" of Emily's left breast cupped in her hand, an image that he suspected would fluster the Tate. How would they put it to him that sporting such an image was just not on? An agreeable alternative, I suggested, would be the newly completed painting of his granddaughter Frances Costelloe who, in an interview for the exhibition Acoustiguide, had come up with a nifty appraisal. "I think it's a picture of a teenager and that's what I am . . . It's not just what he sees, it's how he sees me I suppose."[12] Talking to me some months later she elaborated. "I was a little nervous about posing for my grandfather because I haven't really spoken to him that much and I didn't really know him that well and I thought there might be really awkward silences but it was fine: he's quite chatty."[13]

Obviously her appearance was a concern. "I think it does look quite a lot like me but I think it does make me look a bit ugly. I don't know: maybe it's just realistic." She saw the difference between portrait and reflection. "When you look in a mirror you have a special mirror pose."[14]

The special consideration in *Self-Portrait, Reflection* (2002) was that a mirror image is a surrogate view, flattened and contained. Sixty years on from the precociously self-conscious—not to say whimsical—*Man with a Feather*, this was Lucian, troubled to see himself looking so aged, standing against a wallful of paint wipings realised with facsimile spontaneity, one hand clutching the silk scarf worn like a noose

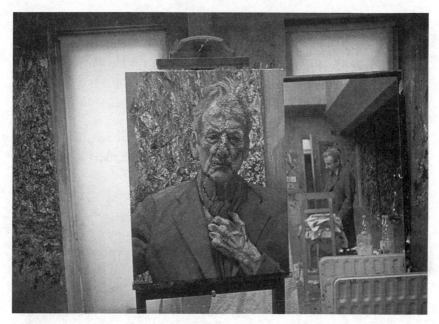

Self-Portrait—Reflection, Lucian Freud in background

to disguise the scragginess of the neck. Though not completed in time for the start of the exhibition it was inserted shortly afterwards, a latecomer staring out from the wall nearest the exit. As for the *Frances Costelloe*, it came across well on the catalogue cover and (Lucian was pleased to report) quickly found a buyer. "*Frances* has been sold to a *new* collector. 'Important to do that,' Bill Acqua says."

Meanwhile issues with the Tate blew up, notably over the precise white to be used on the walls: a faintly warmed mix. This resulted in the first rooms having to be repainted. More contentious was our determination to have some, if not most, of the roof blinds opened to admit direct (filtered) daylight. And the Tate addiction to over-explanatory labels had to be faced down. As Lucian said, "Allow them at all and they multiply like maggots." In the end it was agreed that a hand-list and the Acoustiguide could provide names and dates and clipped commentary. As for the Tate Britain Director's catalogue foreword: better without, Lucian insisted, his argument being "that a piece of chamber music had two other instruments suddenly introduced. Good, don't you think?"

One of these instruments was a salute from Frank Auerbach: "I can only put this approximately; I am not a writer," he began. Lucian, he wrote, "has no safety net of manner. Whenever his way of working threatens to become a style, he puts it aside like a blunted pencil and finds a procedure more suited to his needs." That, he concluded, was the necessary manner.

"The paintings live because their creator has been passionately attentive to their theme, and his attention has left something for us to look at. It seems a sort of miracle."[15]

Over many months during this period Jake Auerbach and I were working on our film *Lucian Freud: Portraits*, a process of conducting and assembling interviews involving, among others, Francis Wyndham, Anne Dunn, the Duke and Duchess of Devonshire, Nicola Bateman, Sue Tilley, David Hockney, David Dawson of course, Bella and Esther and the Boyt sisters. Lucian told Jake that he didn't want to be filmed as all that needed to be known was in the Tate catalogue and so we proceeded on the assumption that he would be unseen but ubiquitous.

In the course of our session with Hockney he described the routine of sitting. "He wanted you to talk so he could watch how your face moved. We talked a lot: about our lives, people we knew in common, bitchy art gossip." The painting became the measure of his concentration. "It's a duration, not a moment; not many people could look at a face for 120 hours and constantly do something with it." Often when Lucian left the room, usually to phone, Hockney would whip out a sketchbook and draw whatever caught his eye: brushes, plan chest, floorboards. Then, from memory, he did a watercolour of Lucian at work, lunging at the canvas under a bright-blue patch of skylight-framed sky. He had noticed that Lucian only looked foxed when he needed something precise. Cerulean blue, say, for the shirt. The portrait proceeded through spring and summer and by July it was just about finished except for the specs. And then, Lucian added, there was just the one more touch to be implanted. "That he's talking."

Hockney's verdict on the painting was cannily oblique. "It's not me; it's an account of looking at me by a very intelligent and skilled painter. That's what a Cézanne portrait is—an account of looking." He wanted to buy it, but Bill Acquavella made it clear that he wanted to keep it for himself. "Technical thing," Lucian explained: "The

paintings are mine until he sells them; but then this one he didn't sell." That, he argued, meant that Hockney's resentment was Acquavella's business not his.

"Hockney has an innate kind of decency. I like him. A megalomaniac, but all artists are. Even me."

Having caught Hockney's eagerly speculative look, Lucian submitted, reluctantly, to sitting for him, the idea being that David Dawson and he should be seated together for one of his portraits of serially red-faced twosomes. Hockney's Freud proved fidgety and grievously wizened. Dawson on the other hand was, as ever, cooperative. And though it was undeniably more arduous, sitting for Lucian had become routine, not least because, as he put it, he had "no other relationship to get in the way."[16] His availability had made him indispensable. That being so, and partly to pass the time, he took to taking photographs at odd moments, mostly impromptu. "There's some good magic or something about the way he photographs," Lucian said. Where Bruce Bernard had been anxious not to irritate his idol, David clicked freely. One morning, for instance, he anticipated Lucian's ostensible surprise on re-entering the studio to find David's

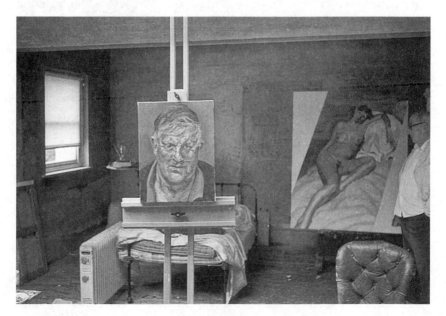

David Hockney, 2002

camera pointed at him while Hockney sat waiting, ashtray to hand, matching his talkative expression to that already caught in the painting on the easel beside him.

Wanting to look at the painting for a while before taking it to the Tate, Lucian put it on the bedroom mantelpiece, between an Auerbach nude and Bacon's *Two Figures* ("The Buggers"). "I shut the shutters from the garden just in case of a robber because of having it in the house."

"I don't want to retire. I want to paint myself to death."

One morning Lucian passed Eduardo Paolozzi, only two years his junior and now huge and stricken, being wheeled down Holland Park Avenue by one of his devotees. "My God. I nearly turned back but didn't because I thought the girl would worry, and then if he went 'Ooohghurr' at me, what then? I felt uneasy about it." He couldn't but think how the decrepitude of others reflected on him. When in April 2002 the death of Baron Thyssen (*Man in a Chair*) was reported, he remarked that Heini had been a year older than him and that set him thinking, not for the first time, that his days were numbered. "My father had a stroke at eighty-three. I think that's when Susanna said, 'I'll have one.' I said to her, 'I've got such an awful banging in my head,' and she said: 'It's silly talking like this, you've got ten or fifteen years.'" That failed to reassure him. His teeth were giving him trouble again and he was advised to have implants fitted. "Boring in the Lister Clinic, shunted into a tunnel, ultrasound X-rays: seemed like hours, but about twenty-five minutes and kept wanting to tickle my nose. Tomorrow to the dentist and then a long session on the 17th." That being the day of the Tate dinner, dentistry became his excuse for not attending. "Not very gentle; £600 a time; the alternative is horrible. I go into a trance. I had to sign a paper saying I won't sue if I die on Monday. Could be dead by Tuesday."

Lucian was advised—principally by Bella, his usual consultant on medical and dietary fads—to take homeopathic remedies, assortments of which accumulated, also specially prescribed foodstuffs. These, he was assured, would make him feel like the common man. Not that he wanted to feel that way. "They don't do very much, the common men.

"It's not courage I lack, but feeling doomed."

Ever since I'd first known him Lucian had liked to talk about the lack of "a positionable God." He used to ask me, hesitantly, what my father (who had happened to become a bishop round about the time Lucian and I first met) really thought about death and the purported afterlife. Certain beliefs, he liked to think, were helpful possibly, though not for him; for at least beliefs, like superstitions, could maybe help fend off ill health. Self-confessed hypochondriac that he was, he tended to react peevishly to any untoward symptom; everyday frustrations were then intolerable and when this resulted, for example, in putting the phone down on Jane Willoughby (bad manners: quickly regretted) he would cast around for those to blame. Difficulties with the Tate thus became overblown, above all the failure to secure a suitable museum showing for the exhibition in America. This rankled.

"I've had Duncan McGuigan shouting down the phone that the Tate is useless and a decent American curator would do the definitive retrospective in good venues." Infuriated, he counter-complained that McGuigan wasn't contacting lenders when asked, to which McGuigan replied that as a curator I had no commercial sense. "That's the good thing about him," Lucian retorted. Or so he told me.

Failure to apply pressure to secure loans was inconsiderate to say the least, especially where Mrs. Kravis was involved: Marie-Josée Kravis (soon to become President of MoMA) who, in May 2002, bought *Freddy Standing*. This upset Lucian, who told Bill Acquavella that he didn't care where the paintings went but he had been rather hoping that this one might go to the Tate even if only for the show. " 'Bill bullied me into selling it,' I thought I'd tell her when she didn't want to lend it to the tour. I did say it was on condition and Bill is very professional." So it was arranged that she should call on Lucian one afternoon with a view to straightening things out. "I talked to Mrs. Kravis. Very intense," he reported. "She has collected all her life and had lots of Bacons, she said, which she got rid of because she got tired of them and she has a metal necklace with diamonds, which Mr. Kravis adds to whenever he makes another billion, which is every few weeks. She sent a strange letter by hand; in it she said she'll never be the same again. 'And now back to the mundane business of *business*.' It was slightly spooky. If there were a Madame Tussaud's for billionaires

she'd be in it. She's a bit sad: having lots of houses in different places, you can't even say why. I couldn't ever imagine it being a pleasure. I like the idea of hideouts but the real point is privacy.

"She agreed, though, to lend."

A young Australian art critic, Sebastian Smee, had written about a show of Freud etchings at the Rex Irwin Gallery in Sydney and Lucian had been impressed by the straightforward clarity of what he had said. "Lucian Freud's etchings have a unique way of paying attention to their subjects."[17] When, a year or so later, Smee came to London they met and got on well. "I feel," he later wrote, "as if I can't talk about what it was like as a 29-year-old joker from Oz to be suddenly getting to know him."[18] Shortly before the Tate exhibition opened, Smee published an article in the *Sunday Telegraph* in which Lucian talked to him about facing up to his retrospective. "I've gone out of my way not to give it any thought, because I don't want it to interfere with my real work." He went on to say that he felt a bit self-conscious about the whole affair and emphasised that his pictures were what counted, nothing else.[19]

By way of distraction plus exercise of privilege Lucian arranged to go with me early on the Sunday morning of the Golden Jubilee weekend to see how the latest royal portrait looked in "Treasures of the Royal Collection," a gala display staged to show off the newly enlarged Queen's Gallery in Buckingham Palace.

There had been a classical concert in the palace grounds the night before and the streets were still closed off with *Zadok the Priest* booming from loudspeakers in the Mall as I locked my bike and at 8:30, bang on time, Lucian approached from the stables end of Buckingham Palace Road. Finding no bell to ring at the new gallery entrance we approached a policeman on duty at a side gate and Lucian, furtive and unshaven in frazzled overcoat and paint-spattered trousers, asked to be admitted. The policeman was polite but unimpressed. "Kerry Bishop, Visitor Services, expects us," I put in. "Your name, Sir?" "Lucian Freud," Lucian murmured. "Sir?" "Lucian FREUD." "Well, Mr. Freud, if you'll just wait by the door I'll make enquiries." As we retreated to the squat Doric portico the policeman hurried after us to suggest that maybe if we went off for a cup of coffee . . . but then a woman appeared and nudged his elbow. "It's all right," she panted. "I'm here but I'll have to go through the palace to let you in."

Once inside and left to ourselves we wandered around for a while before seeking out the *HM Queen Elizabeth II*. Lucian fancied that a truly remarkable bust of Henry VIII as a seven-year-old was somewhere there. Did I know it? We went past the big Van Dyck (Charles I, so small in real life, he murmured, even tinier than Hitler, probably) and Frith's *Ramsgate Sands*: such a parade of cut-out types, none of them touching one another, not even the pickpockets. Whereas the great Landseer near by—*Eos*, Prince Albert's black greyhound, posed next to an equally glossy top hat—was, surely, truly felt. From there it was no distance to the picture we had come to see, hung beside a large label saying how long it had taken to do and a wispy study of emblematic bits and bobs labelled "A gift to Prince Philip." Lucian wondered aloud if, possibly, a rehang could be effected. "It can bear the scarlet wall but it's next to a Graham Sutherland. I wish it was next to the Monet." That being the dazzlingly abrupt *Study of Rocks: Creuse*, bequeathed by the Queen Mother (recently deceased) to HM the Queen. Then, scouting around, we sighted at last Guido Mazzoni's polychrome bust of the piggy-eyed infant Henry VIII. "Hooray!" Lucian cried. "How amazingly malevolent." Somehow it reminded him, he said, of "The Inquest" by W. H. Davies: "*And I could see that child's one eye / Which seemed to laugh.*"

Descending to basement level in search of our minder we found ourselves in a realm of yellowed corridors. Where next? Lucian pushed open a door marked Private, only to disturb a squad of footmen busy donning scarlet livery. There were four of them, one with blonded hair and a Germanic accent. We wanted to be let out, Lucian explained, so they ushered us upstairs smartish, our escort reappeared and we were released into the empty and now silent streets. An hour later Lucian rang. Would I not agree that our early-morning adventure had been Alice in Wonderlandish? "Did you realise the queer footman was the queer butler who was there when I painted her?"

"Very doomish"

Installation at the Tate began the day after our Queen's Gallery outing. Starting with the grey remembered mountains and boxed windfalls of *Apples in Wales* (1939), themes and preoccupations were to show up, room by room, not nudging but, I planned, implicit. For example, I'd decided to put the two forlorn little paintings of Lorna Wishart on either side of *Dead Heron*, forming a votive triptych. Similarly, the lugubrious portrait of John Deakin was to go between hard-boiled scarface Ted (*A Man and his Daughter*) and, doubly defensive, *Michael Andrews and June*. The exhibition would be one long pursuit, compelling at every turn. Or so I hoped.

Lucian looked in on the Thursday, ostensibly just to deliver the self-portrait though his intention, he said, had been to come with Frank early on to arrange the layout. He was surprised therefore to see that this had all been done. "Pleasantly surprised. Terribly good. Grand rooms. I think you've really done it well . . ."

I arranged for Frank and Julia Auerbach to come in, along with Lucian, on the following Sunday to see how it looked. As they entered the galleries, Frank said he was going to walk straight through and say what he thought. His one suggestion was to switch around the Big Sue–dominated room so that the dense bamboos and buddleia of *Garden, Notting Hill Gate* would have more impact. He then left saying it was a landmark exhibition. Whereupon Lucian asked for what he made sound like a personal favour. "One thing, Villiam, would you mind? The painting of my mother, that tiny one: would you perhaps

put it next to *Reflection (Self-Portrait)* or the mirror-in-the-window one?" Easily done and they went well together. "Oh, thanks awfully," he said.

With that he went home only to find a journalist hoping for a word with him. "I was so angry I couldn't get the key into the door." A photograph had appeared in the *Sunday Times* of him and Emily outside Clarke's, cue for enquiries. That struck him as tantamount to persecution. Yet at the same time he was pleased to hear that public interest in the forthcoming show had become phenomenal. Catalogue sales were exceeding Tate predictions so enormously that a reprint had to be ordered well ahead of the preview. That was manageable, but the notion of holding an exclusive preview for "sixty or so" friends, daughters and the like on the Sunday before the official opening, with a dinner afterwards at Locanda Locatelli, proved troublesome, so much were the invitees outnumbered by all those who felt over-looked, not to say excluded. Come the Sunday evening and, arriving early as was his habit, with David Dawson and Emily Bearn he found Anne Dunn and Francis Wyndham, also David Hockney, waiting on the Tate steps, fortuitously representative of three phases of his paint-ing life. They entered together and Anne's immediate response in a letter to me a few days later was how vivid the works were. "Stunning and wonderful to see in natural light. I was particularly struck by the colour. When I see his work in New York at Acquavella the colour seems flattened out and the work loses its glow and subtlety, as alas so often happens in New York, one gets the feel of a 'commercial hang.' The installation of the exhibition is masterly . . ."[1] For many of us moving onwards through the exhibition that evening there was an overwhelming sense of déjà vu reversed as past sitters took in their ever-present portrait selves. Later, at Locanda Locatelli, generations mingled and gossip thrived, Devonshires and Rothschilds, Bindy Lambton, Jane Willoughby, Leigh Bowery connections (Nicola Bate-man, rigged out in scarlet and white flounces), Henrietta Edwards from the Royal Collection, connections founded on and perpetuated by the works of art. After the dinner Lucian was so relieved, euphoric even, that he perched himself on Nicola Bateman's knee and, precari-ously enthroned, thanked me.

The press view the next day was crowded and the subsequent reviews were for the most part celebratory. While the archly prurient

Brian Sewell took it upon himself to tackle "the intellectual problem of relating penis and testicles" in the *Evening Standard*, the *Guardian* and *Independent* reported the exhibition as front-page news. Gratifyingly *Newsnight Review* appreciated the absence of labels, as did Tom Lubbock in the *Independent*: "Despite the Tate's addiction to interpretative verbiage, and despite all the biography lodged in Freud's work, bursting to be spelled out, there is not a label or caption in sight. It is pictures, 60 years of them, all through."[2] Adrian Searle concluded his *Guardian* review with a flourish: "Freud's last self-portrait is a grim, wonderful, extreme, unforgettable, unforgiving painting. What a show."[3]

That said, there were others for whom Freud was irredeemably parochially foreign. Peter Schjeldahl, in the *New Yorker*, argued that only the English could grasp the work of "an English grandee."[4] Some time before what could be termed this Yankee-doodle verdict appeared, Lucian was persuaded by Geordie Greig, editor of the egregiously grandee-friendly *Tatler*, that it would be good to see one or two of the newest paintings reproduced exclusively in its pages. When I questioned this, Lucian explained that the women who take the *Tatler* don't have jobs as a rule and so, with little or nothing to do all day, were likely to consider going to the Tate. Several David Dawson photographs also appeared in the *Tatler* and following that Matthew Marks suggested making prints available in limited editions. Again Lucian approved. Though these informal images, amounting to a dossier, exposed aspects of his privacy, the photographer was well intentioned and answerable to him besides.

When Emily asked him if he'd be OK with her going to the preview at the Tate, bearing in mind that "dreadful" photographs had been taken of her in the past and that she might run into the paparazzi, he shrugged. It was up to her. As it turned out she proved a not elusive prey, drifting into frame. That, Lucian considered, seemed to be artlessness unmasked.

More than 6,000 people paid to get into the exhibition over the first weekend and subsequently at least 1,000 a day. Lucian wasn't bothered about the attendance figures; he just wanted to hear that the rooms were crowded. "It's full," he was told and that was enough. He had no great desire to see for himself but did agree to take a look one afternoon with his venture-capitalist sitter Pierre Lamond. ("He's

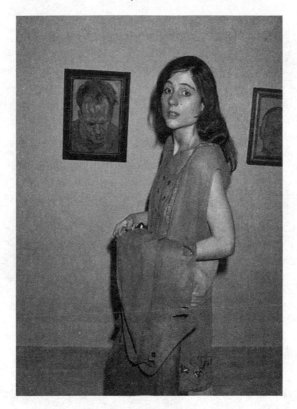

Emily Bearn at Tate Britain's
Lucian Freud exhibition

interesting. He was in France when war broke out, a child in hiding, family mostly murdered. He's Jewish, not that I'd have known.") As it turned out the visit was an ordeal. "Ill at ease. A bit embarrassing: one or two people came up to me." One minute he was there, Lamond said, and then he was gone. "He just ran off."[5]

Work resumed on the small portrait head that Lucian had agreed to do provided Lamond lent certain key paintings to the Tate, a businesslike agreement that worked out well enough. Unlike the business of painting Kate Moss, for with her there was the risk of late-night flashlights and the two of them caught on the doorstep.

"At 2:30 three paparazzi jumped out when I left the house with Kate. They followed us taking photographs, I tried to run one over." That sort of scuffle could be rewarding. Not so the trite misreporting and, worse, the efforts of some to become famous at his expense.

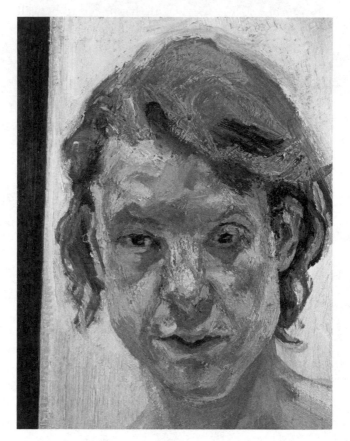

Head of a Naked Girl, 1991–2000

He baulked at Sue Tilley being referred to repeatedly as "a favourite model" of his. ("Enough of her, don't you agree?") He did concede however that every so often the misguided approaches of the gutter press had a guileless quality: "Message from the *Sun*: they want me to paint 'Miss T,' sculpture or drawing or painting, whatever I want. 'What's in it for me?' I asked. 'Her. She's absolutely willing to do anything.'"

Then there were the passionate avowals. "Wild letters: 'Dear Mr. Freud I admire your work with all my heart I'd love to meet you, in Pakistan, in July. Is there the remotest possibility you can call or write? I'd get to wherever you are. Miss——'"

One afternoon that August my wife happened to be walking past a call box on the only road through a landscape of rock, peat bog and lochan in northernmost North Uist in the Outer Hebrides when the phone rang. The voice on the line was familiar. "Is Villiam there?" Lucian explained that he had been trying North Uist numbers—there weren't many to choose from—and had had several interesting conversations. He wanted to know if I'd seen an article in the *Sunday Times* by Nicci (Nicola) Rose O'Hara, his former sitter, whose *Naked Portrait Standing* happened to be about to serve as a frontispiece for our Constable show in Paris, now imminent.

The article was a mix of plaint and gush. "When a friend of mine said her dad was a painter I'm afraid I hadn't heard of Lucian Freud . . . She asked if I'd like to meet him." What followed went swimmingly. ("Neither of us drank tap water and both had a passion for T. S. Eliot's *Waste Land* and Rimbaud.") So, despite forewarnings ("I was surprised how little he asked about me"), sittings began and a relationship developed. Rewards were proffered. "At this time he gave me three etchings and a small picture. I felt dizzy with gratitude. He didn't pay me to work for him. They would be a sort of payment in kind." But then, suddenly and unaccountably in her view, the sessions ceased. "'The new picture's not going forward,' he said." When she sought to collect her three etchings and a painting the brush-off was abrupt. "Petulant Lucian slammed down the phone. David, jubilant, said, 'We've decided you can't have your pictures.'"[6]

A riposte came from Esther in a letter to the *Sunday Times* the following week. "Although my father was fully aware and not particularly displeased at being persuaded to buy your correspondent Nicola-Rose O'Hara a BMW sports car and a flat in North Kensington, as well as providing holiday money, a generous allowance and severance pay, he was still surprised at finding himself stabbed in the kidneys with a self-pitying penknife."[7]

"Ib came round and said, 'I see things have changed.'" Certainly *Portrait Head* of Emily Bearn took on a resigned if not dismissive look: rigid neck tendons and a lacklustre air. That was the end of it, an estrangement that prompted Lucian to go to her house and bang on the door ineffectually. For it transpired she was back with Alexander Chancellor, by whom, contentedly, she had a baby. She turned up with her father for the closing drinks at the Tate, a quiet

affair—champagne and no speeches—where Lucian was notably sub-dued. Not in reaction to her being there but because, he explained afterwards, he saw on the walls so many people no longer alive. "I felt demoralised. I felt odd: all those people I had known and it was only the third time I had been to see the show." Also it vexed him that the Tate wouldn't remain open for extra hours in the last week. The final attendance figure was 195,517: more than any other living artist had then achieved. And *Girl with a White Dog* was the Tate's bestselling postcard for 2002.

When the Caixa Barcelona curators, Imma Casas and Isabel Salgado, came to London to meet Lucian they asked what had first inspired him to become an artist. He told them that he had kept say-ing he was a painter so in the end he had to be, so as to prove him-self right.

The Constable installation in Paris took three weeks to complete, with dramatic moments such as the arrival by night of *The Haywain* surrounded by zooming squads of police outriders. Banners around the Grand Palais gave equal prominence to Constable and Freud, leading people to assume that "Le Choix de Lucian Freud" meant that he had determined everything. He had been with me to look at works in the London museums but not further afield and the hang, in suites of rooms inconveniently spread over two floors, didn't concern him. But, as we had always agreed when picturing the ideal Constable show, the portraits belonged among the landscapes, inhabited them indeed. Besides that, we wanted to demonstrate Constable's emotional pull. Shuffling chronology, I aligned intimacies and spectaculars so that by the end, I hoped, exhilaration flared and foreboding struck: clouds riding high over the Avon valley, drifts of rain darkening the Brigh-ton sea front and Constable's farewell painting—"broken hearted," he said—of his son Charley as a callow little midshipman about to set off for India. (Charley, who never saw his father again, was to become defender of the oeuvre against the posthumous epidemic of fake Con-stables.) Then finally the Chicago *Stoke by Nayland*—tousled, hefty, crammed with familiar elements, from plough to church tower—proclaimed the fact that to Constable everything conspires and (as Lucian often said) "everything is a self-portrait."

Many reviewers assumed that the positioning of *Naked Portrait Standing* (Nicola-Rose O'Hara in startling proximity) beside Con-

stable's *Study for the Trunk of an Elm Tree* as a joint frontispiece to the exhibition could only be Freud putting himself forward as Constable's equal. That wasn't so. Sixty-three years on from the summer day in Dedham when Freud had attempted to paint a bark-perfect tree trunk he and Constable were now standing side by side in Paris, not duellists but confrères, painter and painter.

Matthew Marks reported that Jasper Johns and Ellsworth Kelly had expressed jealousy when he showed them the Constable catalogue, wondering why he had been given this treat of a task but admiring him for what he'd accomplished: an exhibition that, in Paris of all places, proved this most English of artists enlivening and feisty besides. At the opening ceremony, performed by Jack Straw the Foreign Secretary and his French counterpart Justin de Villeneuve taking a break from their pre-Iraq War parleys, I spotted the aged Henri Cartier-Bresson standing to one side as we approached *The Leaping Horse* and asked him if he'd care to be introduced. He blinked. "*Mais, Bill,*" he said. "*Moi, je suis anarchiste!*"

Shortly afterwards in Barcelona, where the Tate exhibition shrank by twenty paintings, Ib Boyt (whom I had invited to be her father's representative at the private view) said she thought it looked even better than in London. Certainly it picked up pace. But throughout the installation period Lucian, on the phone most mornings, had been sounding troubled. When I wrote a couple of weeks later to Isabel Salgado, it was to confirm that most definitely he wasn't going to be coming to Barcelona. "Lucian is more cheerful now that he has been printing a big new etching of Eli but his health problem is quite serious. He says he doesn't know what dying feels like, but he thinks that if he did know he would recognise how he feels when his head goes dead like it does at present."[8]

His health had become a serious worry. Given an irregular heartbeat, the prospect of maybe having a pacemaker installed, the possibility of having had a slight stroke—and the fact that he was about to turn eighty and likely to lose his driving licence—for some weeks that autumn Lucian thought he was about to die.

Heart thing: really stress. Symptoms. So I've had lots of tests.
Feeling terribly ill and wrought up. It's lowering: not working.
And emotional stress . . . thoughts to do with the past, like people

do in really bad films. This thing in my chest is like a really bad opera. Really boring.[9]

This provoked obsessive sifting through the plan chest, a shredding of letters and smashing of tapes. Anything, he thought, that could be "potential ammunition against me and, to some degree, my children."[10]

Events, it so happened, agitated him even more. One evening, when his granddaughter Frances was sitting for another picture, there had come from downstairs sounds of a break-in. She'd thought it a lark, she and her granddad going downstairs, Lucian brandishing a sort of pitchfork. By Lucian's account this was not the first time he had faced an intruder. "Somebody came into the bedroom; I saw a man swinging his body across the window; I was so angry I had a pitchfork there and was going to get him and stopped myself. So I shouted, "Jack, get my gun!" and there was a noise and a crash and he managed to climb away and everything was covered with blood. It was someone on drugs. If I'd used the pitchfork . . . there's that old saying: 'In a murder the victim is always guilty.'" After that he kept a spade handy by his bed.

Nightmarish threats could be guarded against. Worse, being insidious, were those that involved authentication or (to put it another way) the elimination of substandard works or outright fakes. Where once there had been just the infuriating business of Johnny Craxton flogging off graphic bits and bobs, now there was misattribution, innocent or otherwise, with serious money involved. One large drawing sent to him by its new owner, who wanted it signed and thereby authenticated, was left facing the wall in the Holland Park kitchen for well over a year with Lucian's note on the back: "I want this destroyed." There it remained, condemned yet to the relief of Diana Rawstron, who pitied the poor owner, still intact until, eventually, Lucian conceded that he had been hasty. ("When I was ill I wrote that.") The owner was given an etching and the drawing survived. "So it became," as Lucian put it, "a fake drawing that actually isn't."

"When I read, 'Life is ruined by delay' (one of those French writers around 1810) I realised I'd been thinking of this for a while, so I got on with it."

By late November and with his birthday imminent, Lucian was

eager to secure fresh sitters and resume connections. "Kate Moss came last night; she looked very good with big breasts and small waist. Paparazzi followed us and I jumped out of the car and a man—Spanish—came up to me shouting, 'I've not got my camera.' I tried to stop them taking Kate and he said, 'She doesn't mind.' I said, 'She does,' he said, 'She doesn't.' And I didn't want to go on with this schoolboy argument. Turned out he wanted me to sign something for his best friend. Said that his best friend liked my paintings in Barcelona and that the pavement is public."

The assumption that doorstep encounters triggered press coverage was never shaken off; yet it did prove possible to conduct a working life, day and night, without attracting undue attention. Sophie Lawrence, who worked for Tate Publishing, agreed to sit for what became *Portrait on a White Cover* (2002–3). A night painting, it proceeded without untoward complications, the only interruption being her honeymoon in late November. ("Sophie, who's nice, is not going away until I've finished the picture.") Lucian thought her odd in that she insisted on getting dressed before they ate. She, on the other hand, told me that he'd said she could go out with him to get the papers just in her dressing gown.

Someone eager to sit (often a bad sign) was Marilyn, a Swiss-Ghanaian lawyer who had written confidently proposing herself as an attractive person. Lucian, finding her "very nice and high-spirited," was stirred by the prospect of working from someone ample and dark skinned. "Skin tones strangely violet and she has eczema: mulatto patches. Swiss of course, so her hair's not that elaborate. OK so far. But it might get tricky." Her husband had rung her as she arrived for the first session. "He didn't realise that I'm an old man. Can't get to the door quick enough to be a threat." Marilyn proved good at holding an expression, open mouthed on demand and quiveringly eager. She was provocative, not least in her boast that she charged him as much per sitting as she would charge as a lawyer. Lucian didn't resent this ("Because it's taking up her time") but he did think it a bit rich that she, this *Naked Solicitor*, should equate the passive with the professional. He became bored with her. "With Marilyn I don't talk." She didn't seem to understand her role or, rather, like others before her she mistook the processes of depiction, the persistence and concentration involved, for amity and more. Wendy, Diana Rawstron's

assistant, went in a taxi to Marilyn's house in south London with the bold-faced etching *Solicitor's Head*, as a gift in lieu of a pay-off only to be met with such weeping and wailing that she dumped it and fled.

David's Eli having proved more reliable than any human in that he slept often and well, a painting and an etching were begun. "I'm really fully engaged. When Eli wasn't in the best of moods I started on David. I'm very much working on the big etching. An awful lot of lines: Eli's lying on my coat." Puppyish still and embedded like a heraldic emblem, *Eli* emerged in November 2002 from the acid bath at the London Print Studio in the Harrow Road. As he no longer trusted Marc Balakjian to do the dipping, Lucian made out that David Dawson would be responsible though in fact Paul Dewis of the Print Workshop undertook it. Proofs were run off and it was decided that part of the seething expanse on which Eli lay would have to be reworked for in its first state, Lucian remarked, it looked horribly like a horrible Paul Klee.

Marc Balakjian began printing the edition (of forty-six) the following week. The initial price of an *Eli* was $36,000, increasing with demand, and as usual Lucian insisted on getting full payment (£408,000) right away from Matthew Marks as the publisher; he also counted on whatever he happened to make from selling artist's proofs to other dealers. Cash for the wad in his back pocket: ready money, tangible money, with which to feel free: as much as £16,000, that being, he reckoned, as much as he could carry without sporting conspicuous bulges about his person. Having readies to hand reminded him of old borrowing habits: knowing that what he liked to regard as surety for the time being others had tended to take to be an outright sale. There was no question but that he sold Matthew Marks the Freud–Schuster Book of 1939–40: both Lucian and Matthew Marks had seen the sketchbook as a fount of cash potential, initially as a museum purchase. "He's attempting to sell them in one go. Not individually. In the end it's up to him." There were no takers for the sketchbook as a whole so the 170 or so drawings were disassembled, framed (double-sided many of them) and exhibited in New York in early 2003, subsequently in London at the Timothy Taylor gallery. Lucian professed himself astonished at the amount that was being asked per drawing. But hadn't he been paid a million? Cheap at the price, he told me.

First proof of the etching *After Constable* emerging, London Print Workshop

"They've got such a strong atmosphere. A million? I could do with money. I haven't sold anything for four months."

We decided to publish an English edition of the conversation we'd had, translated into French, for the Constable catalogue and Lucian offered to produce an *After Constable's Elm* etching to pay for it. He scrapped a first plate and started again on a bigger one, sixteen inches by ten, the idea now being to use this for the book cover. The translation of the image absorbed him for weeks. "I got up at five so I can do odd things to it: the light has got to be delicate and the mysteriousness of the trunk and the blackbird." There was, he thought, a premonitory aspect to it, a sense of early-morning solitude.

"Feeling awfully ill a lot of the time. Very doomish. Taking Solpadeine—which I do need—aspirin and cod liver oil."

In mid-December a morale-boosting day trip to Paris was laid on by John Morton Morris, gallery owner and husband of Sally Clarke, who offered to fly Lucian and three others to Paris—thirty-five minutes from Luton airport—to see the Constable exhibition. "A friend," he explained, "has lent me a safe small jet." He decided to take David, Andrew Parker Bowles and Kate Moss (who in the event couldn't

come as she had her Christmas shopping to do) and arranged for
Pierre Rosenberg, recently retired Director of the Louvre, to meet
them at the Grand Palais ("I can then see how well I've hung the
exhibition") and to have lunch afterwards at Chez l'Ami Louis. The
exhibition exhilarated him. "Taken round by quite a nice man, thin
face, bad breath. We knew it would be good. But what was interesting
was that the things look completely different in Paris." After lunch
they went through "Manet/Velázquez" at the Musée d'Orsay, but
Lucian, for one, had seen enough by then: his head being "so full of
Constable" he didn't really take it in. What had excited him so much
in the morning was a sense of affinity. "All the painters I like best were
alive then, all except Rembrandt and Hals. Ingres was working; Corot
was working—he ended up a Rembrandt in a way—Géricault was
working; Courbet was working." Our exhibition had proved to be, he
said, "more of a game. It was a good idea and it was didactic: showing
Constable how he should be shown." He added, "And I did it. With
you doing most of it."

Shortly after *Lucian Freud on John Constable* was published, Kitaj
wrote to me about it: as usual in red ink on yellow ledger paper.

> *It was very thoughtful of you to send me the lovely Constable
> Book. Becoming Lucian's Boswell is far more noble than crabbed
> reviewing! I hear you're sitting for Frank. He's my favourite
> living painter. I live with a dozen of his pictures every day. They
> grow day by day.*
>
> *Best to you, affection to AR* [Andrea Rose] *and LF and
> love to FA.*
>
> *Ps The School of London closed in 1997!*[11]

Kitaj, now resident in Los Angeles, hadn't attended the opening
gala staged by the Museum of Contemporary Art in February. He
was, he had told me, a recluse these days. Forty years earlier, maybe,
he would have been right in there. But now, no: the Saturday-night
event was superabundantly bizarre (not unlike one of Kitaj's orgiastic
tableaux), as was some of the attendant coverage.

"It was the teeth, the horsey English chompers, that signalled the
arrival of an alien culture in downtown Los Angeles. They belonged,
respectively, to William Feaver, curator of the new Lucian Freud ret-

rospective at the Museum of Contemporary Art, and David Dawson, Freud's assistant and occasional model . . ."[12]

That day Lucian had phoned yet again at 3 a.m. ("Oh is that the time?") complaining of incapacity. "I can't work." Then, "How goes it?"

In terms of numbers, and bravado, it went swimmingly. Eight thousand people attended the preview and for subscribers to the gala night ("*Be the first to see six decades of work by Britain's greatest living painter*") there was razzle-dazzle aplenty. Having reported guests "a bit unsteadied by Freud's penetrating eye," though failing to mention the indoor icebergs flowing with vodka, the *LA Times* marvelled at the excess. "From the fan-dancing women wearing python costumes to the multi-media display that projected David Hockney's image around the walls, MoCA's gala celebrating the opening of the Lucian Freud retrospective was—to say the least—memorable."[13]

Entertainment was provided in mid-meal by Leonard Nimoy—*Star Trek*'s Mr. Spock—and his wife reading from Shakespeare and once the salads had been cleared away Hockney too stepped up to deliver a jovial homily. "I'm just here as an artist's model. I sat for Lucian for about 120 hours. I always assumed I didn't stay there long enough." Walking the mile or so to Lucian's studio of a morning in order to sit he'd seen plants and trees burst into leaf and birds singing. This, he explained, was something "you Los Angeles people" never experience. "They call it spring."

The West Coast reviews of the exhibition were mixed, some biting, some wide-eyed. In the *Jewish Journal of Greater Los Angeles* Tom Telcholz raised the question "Is Lucian Freud Hot?," his response being: "What makes Freud's paintings so enthralling and so relevant to our lives here in paradise is the drama just below the surface, a battle between who we strive to be and who we become, between our parents and ourselves, between our minds and our bodies, between life and death . . . Freud's paintings dare us to ask: Is this all there is?"[14]

"A fine painter with a very narrow repertoire—and a tendency to manipulate the audience to dubious effect," wrote Christopher Knight in the *LA Times* while conceding allure to a limited degree. "Sometimes it does have the capacity to beguile."[15] Kenneth Baker of the *San Francisco Chronicle* was one of the unbeguiled. "Freud's good, but not that good." There were aspects to the work that he felt he had

to warn against. "Manipulation of a viewer is what every great artist accomplishes, but it's got to be achieved with care . . . You can go a certain distance with an artist like Freud, but not all the way."[16]

Back in London, and well before this inanely equivocal verdict was arrived at, Jake Auerbach and I had decided that, since Lucian himself wouldn't go so far as to appear in the documentary we wanted to make about him, we would go the distance with those who had sat for him. In session after session over two years—from April 2002 onwards—we filmed every variety of sitter, ranging from the aged Duke of Devonshire and the Duchess ("To be married to Lucian: it'd be a killer") to daughters and granddaughters, fellow painters (David Hockney, Celia Paul) and old acquaintances-cum-sitters such as Francis Wyndham, all of whom had come to know him not necessarily intimately but certainly well.[17]

I myself began sitting for Frank Auerbach on the third Monday in February 2003 and was to continue doing so indefinitely, painting after painting, two hours every Monday evening, 6 till 8. "Are you Franking tonight?" Lucian would ask, and there were no longer suggestions that I might care to do so for him. I was reminded that, ten years earlier, when I asked what he would do if he ever became incapable of painting he said that he would hope to sit for Frank.

As our film interviews progressed it became obvious that several of those involved, daughters especially, were inclined to speak as if being asked to contribute to forthcoming obituaries. It was apparent too that many of the ramifications of Lucian's life weren't even going to get to the digital equivalent of the cutting-room floor. For example, beyond our scope (there being no painting of him) was Frank Paul. He wasn't a success as a sitter, his father found, though he tried him a number of times: too unpunctual or casually unavailable. Their encounters were apt to be awkward. What to say? And, given the many incidents and connections feeding the fame that blew into the gossip columns, what account should be given of the life and notoriety beyond the studio?

One event connected with Young Frank struck Lucian as worth witnessing maybe. "I've been invited to Young Frank's uncle's inauguration at Canterbury. He's modest and really impressive. I may go." The enthronement of Rowan Williams as Archbishop was to take place in Canterbury Cathedral on 27 February 2003. Lucian was "in

two minds about it until the last minute," Celia remembered, and then decided against. Lucian and Rowan "remained distantly respectful friends."[18] At the same time Frank applied to Cambridge to read Russian and having won a place at Peterhouse went off to spend a gap year in Russia and the next thing Lucian heard was that he'd run into trouble there. "Poor little Frank's been robbed: his glasses, passport, credit cards, everything. He was held up in the street. Basically, he's OK. It's only just happened. Didn't want to come back at all. He's very affected by how people are to him." Later on Frank lodged for a while with his uncle and aunt at Lambeth Palace.

In March 2003 Lucian, along with a comedian and a film director, accepted (uncharacteristically for him) an honorary degree from Glasgow University. "Big men came down from Glasgow to do it. They suggested doing it in the studio—obviously hopeless—so it was the Senate House. They mumbled over me and put me in a huge silk gown and gave me scrolls and books. The comedian was that man Stanley Baxter, possibly queer, has a wife and dog, lives in Highgate. And the man who made *Kes* [Kenneth Loach] and his wife."

Accolades were all very well but what Lucian became increasingly anxious to have was show space in London for some if not all his new paintings before Acquavella shipped them away. The Dulwich Picture Gallery had been ideal, being both public and distinguished. And then there was the Tate. How about the Wallace Collection, I suggested, and in mid-April we decided to reconnoitre there one lunchtime. But when I came to pick him up it was obvious something was wrong. Face grey, specs broken. I got him a glass of water, he sat down, winced, offered me a slab of apricot crumble and told me that Susanna had brought him antibiotics but, for all the good they did him, his head hurt and his backbone felt, he said, "like that pastry stuff." "Filou?" "No: Clarke's crumble." Pluto, slumped in her basket, eyes blued, barely stirred.

"The bad part is I can't breathe. At three in the morning I have to sit in a chair. David's been staying here and I had an Australian nurse, in uniform, on Saturday night. Rose got lots of information: it's all right with the lung and heart and I got a home X-ray to see how bad my chest is. Making a slow and painful recovery."

Pluto it was who died, to Lucian's bewilderment and plain distress. His daughter Annabel tried commiserating. "I put my hand on

his shoulder. 'Sorry about Pluto,' I said and he burst into tears."[19] Some days later, having arranged once again to go and look at the Wallace Collection, he phoned. "Afraid I can't come in the morning. Burying Pluto's ashes in the garden. Under the bamboo, I think, about twelve feet from the house. A little box with the ashes (David collected it early this morning). I'd like them in the garden and very very quiet somehow seems right and proper." Then it struck him that there was no way of knowing that these were the true ashes. "Maybe there's a pile of ashes at the vet's and they put a spoon in. But—that thing people say—'It's the thought that counts.'" Every phone call that weekend was despondent.

"I put the ashes on Friday into the garden; I thought I'd do some drawings of where it went; Susanna shovelled a deep hole and I put the ashes in. They started blowing about. You read these stories about that happening. Very organic it seemed. Greatly distressed. It's funny, I've never been to a funeral before this one."

Monday came. "Felt rotten yesterday. I noticed quite small things get me down. A barman called Pat at Wilton's, they said come to his leaving party after forty years and he will open oysters for you. There were *no* oysters, just petits fours. Fraudulently horrible: a few bits of oyster wrapped in bacon. After *forty years*. Ghastly. I feel low. I think it's just the remains of the antibiotics." A couple of days later he admitted to feeling better. "The black phlegm is getting yellow. Rose and Esther have been reading a bit; Rose read *Middlemarch* and Esther read *Decline and Fall*. And I talk to Susanna. Did twenty minutes' work last night. It's so odd not being able to get out. Solpadeine gives me a bit of a pick-up when I work, but not with this. Last week I thought I might go off with Pluto." But then all of a sudden he felt better. "It's amazing; I'd forgotten what it was like to feel all right. I'd had these marvellous soups Rose has been sending." Helpful though sustained soup and *Middlemarch* may well have been, a day or two later gloom resumed. "Rotten again. Saw Frank last night. He cooked for me 'invalid food': chicken and vegetables, really good."

A few days later, after breakfast at Clarke's—croissant, tea and yoghurt—we found that David had arrived at the house and Eli had settled into Pluto's basket.

Outside, just visible through the French window, there was a patch of disturbed earth where the ashes had gone. Jane Willoughby

was to have brought a stone slab as a marker, but instead Lucian had simply written PLUTO on a bit of wood and planted this on the spot. He then decided that a painting would be a better reminder since the name washed off almost overnight. *The Painter's Garden* resulted, also a print version, undertaken with Pluto in mind ("in it there'll be the unobtrusive knowledge of it rather than the mark") and destined to be his largest etching. He laboured over the plate for months, through one summer and into the next, making Pluto's board a footnote half buried in drifting leaves.

The Painter Surprised, Final Years

2003–11

"Trying to do what I can't do"

Painter's Garden in several versions was subject enough to preoccupy him at a time of health worries and a narrowing future but, anxious to busy himself ever more, Lucian set himself a subject that promised to be even more demanding: a seven-foot head-to-toecap painting of Andrew Parker Bowles—"Colonel Andrew" aka *The Brigadier*. He wanted it to be generous in scale and resplendently characterful, a tall effort, floor to ceiling almost ("I've got some acrobatic steps"), testing stamina and reach, a grand portrait in line with tradition, assertively so. "Trying to do what I can't do." Though prompted by James Tissot's deuced handsome *Colonel Burnaby* in the National Portrait Gallery languidly extending a red-striped dress uniform leg, the overriding intention was to summon up a reminder of great British military images of a vainglorious past such as Joshua Reynolds' bluff *Lord Heathfield* brandishing the key to Gibraltar. That said, in terms of affability, *The Brigadier* (2003–4) was to be akin to Hogarth's *Captain Coram*, much the same size and similarly unbuttoned. It was, as Michael Kimmelman commented in the *New York Times* when the painting went on show at Acquavella, "deeply, provocatively unfashionable."[1]

The Duke of Edinburgh had advised Parker Bowles against sitting. "'What on earth do you want to go and do that for?' he said." Retired from active service he adopted a resolute pose. It was an honorific assignment, an act of friendship.

Lucian regarded Parker Bowles as staunch, downright and potentially good in a scrap. "Makes his living from racing." That in itself would have been commendation enough. What else? "I've known Andrew quite a long time and I would have thought he got more considerate. Got the bad reputation unfairly. His advice is good: manly or more military. I think he had a sort of army attitude towards women and wives. This has changed. He's got metal knees and doesn't get about that much."

Within weeks it was apparent that the painting was going great guns, helped along by David sitting in when Parker Bowles was out of town. "David sat early on wearing the medals. Colonel Andrew's upper half is in place, medals and linen on belly. Unbuttoned and shirt loose so as not to make it formal and official." When Parker Bowles complained about the stomach bulge being a bit much Lucian promptly added a stroke or two to the distended dress shirt. Every detail proved telling: medal twinkle, forehead shine, red stripe pulsating down the trouser leg, spurred footwear buffed to perfection. ("Using lamp black, which I don't normally use.") Over the months it became clear that this was to be a triumph of individuality over genre. "It's what's inside their head that's so important to me." But the strain of balancing on the set of steps that enabled him to deal with the upper reaches took its toll. "Worked hard on Colonel Andrew this morning then I felt awfully ill in the park, by the Serpentine, with Susanna in the car. Sat seeing people doing exercises."

There were diversions. Wednesday 18 June: "Colonel Andrew is sitting from 8 to 10 then I'm hopping on a train to Parigi at 3:30 from Waterloo. Acquavella is there in Paris, seeing some things, dining with Phipps—very nice couple—who took me racing at Belmont outside New York. Bristol Hotel then flying back on Thursday. Private plane of course: how else? Then dining with the American Ambassador in Regent's Park: Bill Acqua is always asking me to do things. The reason I'm going to Paris is I want to be very obliging because I can then tell him about the Wallace. I thought Paris might be quite a good place to tell him."

Lucian was worried. What if Acquavella reckoned the Wallace Collection not prominent enough to be of use? Had he not heard of it? "Even if he does object I'm going to do it. The last three

things haven't sold for months—*Buddleia, Emily, Eli*—I really don't know why."

For the first time in what seemed like ages he began working again at the flat. "It was like a dead man's house going in. I'm starting Freddy [Eliot] and Ruth his girlfriend." No good. There was a desultory feel to the place, the sitters seemed uncommitted and the painting was soon abandoned. At the same time he had too many works on the go back in the house on Kensington Church Street. "It gets blocked up." Each picture in progress had its appointed dais, bed, chair or mattress to be positioned for every sitting besides which creases in the sheets had to be preserved from one session to the next. A more serious (tacit) concern was thematic blockage: a repetitive straining after effect. *The Brigadier* was well set but *David and Eli* (2003–4), in which the pair of them were sprawled on a bed beside a shock of untended leaves stuck in a trellised jardinière, looked like becoming a lavish remix of *Interior in Paddington* (1951), plus slap-up reconfiguration of *Sunny Morning—Eight Legs*. Its deep gaping perspective and air of come-what-may smacked of virtuosity. Towards the end David had been sitting every night for a week. "It's exhausting."[2]

The idea of a painting of Bella and her then assistant Cozette McCreery—"the Irish Woman"—derived from Titian's *Danae* belonging to the Museo Capodimonte in Naples and shown in the National Gallery's Titian exhibition in early 2003, thereby prompting Lucian to re-enact it. Cozette would be Danae (or, moreover, Victorine Meurent, Manet's *Modern Olympia*, which he happened to have admired in the Musée d'Orsay two months before) and Bella would be the attendant servant. Once again Lucian was eager to clear away story and symbol, stripping back to studio-tableau mode. This took several sessions to establish. "Third sitting of Bella and friend Cozette: she's naked, Bella not." Bella then dropped out, leaving Cozette to sit for fifteen hours a week over nine months, punctuality being the first requirement. When she was late once he threatened to throw the picture out of the window.

Danae showered with gold coins by Zeus her father became a possibly disengaged or resentful Cozette lying back with cherries spilt against her thigh and silvery feathers spewing gently from a pillow. Lucian thought *Irish Girl on a Bed* would be a good plain title and I

suggested *Irishwoman on a Bed* would be even more so. The legs, he later felt, weren't up to much and the absence of Bella left something to be desired. But anyway off it went to New York where Acquavella hung it prominently over one of the gallery fireplaces and in due course sold it. Afterwards Lucian complained he'd had no opportunity to rework the legs. They'd been "botched," he said.

"People ask about putting 'everything' into pictures. I put in what I use. Only that."

In September 2003 Jake Auerbach and I decided to do our interview with Andrew Parker Bowles for *Lucian Freud: Portraits* at Kensington Church Street. There he would be, still seated on his dais at the end of a morning sitting, but Lucian of course would not be filmed. Casually during a break I asked Parker Bowles what was his favourite film. "Maybe *North by Northwest*." That led me to bring up Hitchcock's fleeting appearances in practically every movie he made: man in crowd, man gawping, man walking dog. Filming resumed and just as Parker Bowles was starting to say which four pictures he would particularly like to own Lucian entered the room brandishing a postcard he proposed sending to a critic who had written dismissively about some drawings of his. "Dear John, You're a cunt. Lucian." Could this get through the post? "Only if you're a doctor," I said. "Well, I've got a Glasgow doctorship." Then, saying he needed something from a cupboard, with sudden intent he picked his way past the camera, Parker Bowles looking on in gratifying amazement as Jake secured the final shot.

A far cry from the Knightsbridge Barracks and many years after his spell of early-morning gallops in Hyde Park on mounts made available by Andrew Parker Bowles, Lucian came to hear of a not-too-distant riding establishment for special-needs children and young adults where there were horses he might be allowed to paint. The Wormwood Scrubs Pony Centre was run by Mary-Joy Langdon, formerly of the East Sussex Fire Brigade (where she had served as Britain's first female firefighter) but, since 2001, known as Sister Mary-Joy of the Congregation of the Infant Jesus Sisters.

Lucian nosed around the paddocks and stable yard for several days looking for a horse that would suit him. "It's very nice there. Sister Mary set it up on her own. The horses are ones that are thrown out

and ill-treated, there's a thoroughbred there, and Shetland ponies, riding lessons for the impaired, very imaginative."

His first choice was Releef, a grey gelding. He painted him head and shoulders, nostrils and halter to the fore, nodding acquaintance only. He then deliberated for several days before choosing his next horse, Sioux, and deciding to paint her sideways on, favouring the hindquarters. Sioux and he took to one another; their rapport sustained by her willingness to stand still, his knowledgeable touch, his cajolements and his readiness with the carrots from his overcoat pockets. "Quite extreme. Sideways on but only the bottom, stomach and beginning of the legs. Lovely markings. I've never before done a picture that size in a very free way, grooming with the paint."

Shortly after he started, winter set in. "It's sort of indoors—the door and top part and plastic roof—then a drop of rain hit the mare and she jumped. I've never done anything so big and sketchy." Standing there for hours in the cold was an ordeal. "The bending down in the dark and trying to pick out the right colour in the very dark basket. Horrible strip lighting. I've got a little electric heater."

Standing foursquare and fetlock-deep in a litter of chopped straw, her markings mapped, Sioux the *Skewbald Mare* was extraordinarily tactile in the sense that any horse lover, student of form or child rider could see how the pelt, muscle and bone would feel when prodded and stroked.

"This morning it started warm at the stable. Sister Mary brought a cup of tea and sat in the hay with me. I realise why she establishes such amazingly intimate relations with horses: if you're celibate and very emotional and full of feeling, it happens. The horse drinks the tea with her: I've never seen, with all my horse life, such intimacy, such friendship. Says she's never had a relationship with a horse like that. A horse named Sioux. There's a filly called Shadow, which is ordinary *Black Beauty* stuff."

Months later, in January 2005, Lucian had a brief ride on Sioux. "She's such a lovely shape. Being bareback—lot of corduroy—you get the feel."

I suggested he might paint Sister Mary-Joy and Sioux together. "I'd rather put David [Dawson] in. She might not want to: to do with being a nun and modesty, but when David stands there I feel I'd so like

to do him. David had five ponies when he was growing up in Scotland; he's got a good eye, as though rubbing it down or feeling for it. Sister Mary would probably do mostly her feeling of time-on-earth."

"Having a good eye" was near enough but not necessarily quite good enough. "David Beaufort has got a really good eye and he likes paintings, but let's just say if he's in a town he wouldn't always go to the museum, if you see what I mean."

In terms of painting, Lucian maintained, the good eye was venturesome as well as perceptive. In other words, "the need to be as audacious as I can possibly be," as he emphasised to the writer Martin Gayford who, having unexpectedly ceased being the *Sunday Telegraph* art critic, volunteered to sit for him.

From late 2003 until the late spring of 2004, Gayford served his turn as witness and static subject matter. ("'You are here,' he says firmly, 'to help it.'")[3] Neck and neck with Sioux, figuratively speaking, over those winter months, Gayford went on to publish, in 2010, a pleasing record of the sessions week by week up to and including the disappointment he felt at the painting not bearing his name. On this Lucian would not budge. "I only name family or painters." *Man with a Blue Scarf* (2003–4) it was to be, followed by an etching, an attitudinised *Portrait Head* (2005).

Anonymity was a condition of service, off-putting to attention-seekers and an indication of the primacy of painting over sitter. Some who fancied the idea of being immortalised failed to grasp this key requirement. "You are here to help it." Those who thought sitting a pastime were soon disabused. And those—the nameless ones—who couldn't be bothered to be punctual were of no use to him ever. "Hasn't worked. She doesn't understand being on time. Sat six hours. Then she was late. Twenty minutes late. I was rather angry and she said, 'I'm always late.' I said, 'That's no good: it's my time.' But people who are late are always late. I'm generally early. Never do anything unless it's on time." That was the end of her. Others who suggested themselves, or were otherwise recruited, included Verity Brown, "a girl now in charge of me at MOMART" (the art handlers), also Nicola Chambers, a third-year student at Camberwell School of Art who had the potentially irritating idea of recycling his used rags into pictures of her own. "A quarter Jamaican as her father is half Jamaican. Really good. Lovely altogether. When she first came, I said, 'Take off your

clothes and lie there'—on the rags—and she said she wouldn't, so I said, 'OK then, a portrait.'"

One Sunday morning in the new year an etching of Nicola was taken to be bitten at the London Print Workshop. We watched as, after touching in one or two marks, the printer Paul Dewis laid the plate in the acid but after less than fifteen minutes noticed that the wax had started flaking and promptly retrieved it, while Lucian stood by remarking to David and me that he hadn't enough life left to waste on failures. That said, Paul rinsed and dried the plate, inked it, placed it, flipped the blanket, laid the paper and ran it through the press and there emerged the quarter-Jamaican image, blemished yet viable maybe. Three more pulls: one too dark, another blotched, and then one—on off-white paper—that worked. Maybe an edition of ten could be managed. In the end, thanks to Paul's vigilance and Marc Balakjian's expertise, *Girl with Fuzzy Hair* (2004), hair filling out like a feat of imagination, was produced in the standard edition of forty-six.

Not long after that I had an early-morning call—"Have I woken you?"—in which without even acknowledging my grunt Lucian delivered a tirade about Matthew Marks and how he hadn't been available to be rebuked. Calls were not returned. "'He's not in New York,' the gallery said. 'He's busy.' I was pestering him, which I loathe, so I can't go on with it. He employs thirty people, so he can't be poor, and he's fastidious, which I like, but the business has changed. For fourteen years he was immaculate in his behaviour. Then this. Lunch today was arranged but I'm going to finish it. So we won't have lunch because I've decided to

Girl with Fuzzy Hair, 2004

end the arrangement, I'll tell him." When Marks turned up at the house, as arranged, his reaction to being laid off was spectacular, Lucian reported afterwards. "He broke down, dropped to the floor and started sobbing. You were right: that drawings show, the Welsh sketchbook, did badly; he said none sold [untrue] and that it nearly ruined his whole gallery. After that I thought he'd walk out but I asked if he'd like lunch and he got up, said yes and then it was like before. He just talked."

According to Lucian it was as though nothing had happened; and since he now had "no debts and children taken care of," he could afford to do without that print-business relationship. "I'm going to lie low now with the prints. When I did them with Matthew it was my only certain income when I had debts but as I've got a bit of money—no debts—I don't need to sell prints now. They can wait. I'll go on etching and just put them away." So he said while arranging that thenceforward the publisher would be Acquavella, to whom the prints were a sideline: affordable for young people such as his children's friends who might then go on to be serious buyers. Lucian continued to enjoy the ready cash his APs generated. Just as the gambling, he liked to think, had taught him "not to pay too much attention to money," so too with these. "Besides," he added, "I try and avoid sterling income."

Lunch at Clarke's with Roz Savill, Director of the Wallace, so that I could introduce her to him. They got on well and he came away saying that she had the bloom of a Normandy milkmaid. Following that he informed me that he'd had a "very exciting" postcard from her. Though he didn't like her saying that she'd be "honoured" to sit but that she "really didn't want to show her genitalia.

"I don't think of genitals as special."

He wrote back to her and, agitated at getting no immediate reply, asked me to intervene. "Could you phone her again? I was worried that the letter had gone astray. I wrote and David took it round by hand. 'Would you consider lying naked on a bed for me starting in April; it could go on for a very long time. At night. Of course I would pay you.' The reason I sent it by hand was that I thought if a secretary opened it, it might be more embarrassing."

Roz Savill told me, years later, what had transpired. "I was sitting

in the development office and we were talking and saying how strange it is to be a sitter and have no ownership of the painting. So when this note arrived I immediately assumed someone was playing a practical joke." However, at the time one of her trustees checked with me as to whether or not this was a serious proposal and if it was then perhaps they might be able to acquire this prospective painting at a discount. I thought not. Lucian had gone off the idea and on second thoughts had modified his original proposal. "I was going to do a head of that nice Wallace woman. Soft features."

He wasn't going to appear at the Wallace Collection opening, of course, but he paid due attention to the guest list and was particularly keen to have the man at the Holland Park vegetable shop invited, also his doctors—his "team of doctors," as he designated them. Visitor numbers counted. "As this will almost certainly be my last show I'd like it to be seen." I reminded him that he always said that. "No, but each time it could be more accurate . . .

"Went to the National Gallery last night. Saw the El Grecos. Didn't get much out of them. Look as though they were done in the thirties. I noticed a picture I used to love, the *Woman in Fur Coat*, was nothing like as it was. And the Inquisitor's head doesn't fit the rest of him. I expected to be more moved. Also, I grew up with the Phaidon *El Greco* and even made a special cover with potato cuts. Paint ages like we do."

Ageing brought out the cantankerous, or furiously self-defensive, in him. A quarrel blew up with Louise Liddell at Riccardo's, the framers. He said that she was impossible, and that Wiggins (a firm owned by John Morton Morris) would substitute. Louise had been told she couldn't keep paintings at the shop over the weekend in case of accidents. "Louise had the frames for *Albie* and *The Brigadier* and wouldn't let me have them. She was furious. 'How dare you, it's like being stabbed. I've never damaged a Freud in twenty-five years.' And she left this note saying she'd smashed the glass on a very big picture and 'on a personal level I thank you for your support in the past . . . you're a difficult unreasonable shit.' It's boring the thing of starting with new framers. Got no quarrel with her but I can't be having it. I've been to Wiggins': the new frames are good. You can get degrees in framing now, you know. Frameology.

"The self-portrait is almost finished. I've never worked so

intensely on a very small picture: Giacometti said that since the sub-ject [in a self-portrait] is always available you just go on and on."

10 March 2004, to Frank Auerbach:

> *Dear Frank,*
> *Thank you for helping me in the clearest and severest way. I often think that I have detached Judgement regarding conviction (Truth-telling) and Quality in my work—but you are certainly able to detect the Pur-blindness and Self deception that often weakens it. Love Lucian*

The main thing was to keep looking, signs of ageing the haunt-ing concern. As for those who came and sat, they of course had their needs as well as having to be talkable to. Some, the dilatory and the garrulous, were promptly dismissed, as were those who didn't respond to a tentative pass being made and who—if embarrassment resulted—were likely to be put in a taxi with £350 for their trouble. One girl, "a voluptuous nude," as Lucian described her, who had proposed herself by letter and proved wholly unsuitable in a single meeting ("She gave me the extremely strange feeling that there was nothing there"), two days later killed herself.

Martin Gayford mentioned this in "Freud Laid Bare," an article for the *Daily Telegraph* about being painted. Lucian bridled at that. "Gayford, he's awfully decent but uh huh, I thought: he's picked on the girl killing herself, not considering these are private things. And again, I'd prefer him to say he wasn't sitting. It's too early. I don't want my privacy disturbed . . ."[4]

Once the editing of his documentary *Lucian Freud: Portraits* was completed, Jake Auerbach was anxious for Lucian to take a look at it. Lucian, naturally, was in no hurry. "I don't want to ask to see it. The later the better. It doesn't suit me ideally." When Jake did get him to see it Lucian was on the phone within the hour. "Tell Jake I'm very pleased and happy he's done it." He then proceeded to deliver appraisals of many of the contributors. "Louise is ridiculous. She goes on and on about me being 'dishy.' Anne [Dunn] is embarrassing in the best possible way. I rang Francis [Wyndham] and told him how good

he was. He was very pleased. Celia [Paul] is so good and the involvement so clear. Big Sue is a bore and is insistent. Nicola [Bateman] was very different: I was a friend for her and have strong affection and concern. The film treats her as same as Big Sue who I never asked out." And he saw nothing funny in her telling people that he did pictures of dogs because dogs didn't need paying.

"I do like the film, tell Jake, because the good part is so good: Francis [Wyndham] and Debo and Andrew Devonshire. Shortening it could make it a bit like a thriller. Any facts relating to art are interesting but when it gets to asking 'what blood group?' it's outside the realms of art or art history."

Three months later we had a first screening at the National Gallery. Seated with the Auerbachs in a middle row of the auditorium, Lucian sporting a crushed panama hat put on a show of near anonymity. He was pleased, he admitted, at how good the pictures looked, enormous on the big screen. "I thought I'd better phone Jake and tell him I like it. It was an ordeal sitting there."

Following extended negotiations with the BBC, the film was broadcast, uncut, on BBC1 in June and the reviews were positive ("fascinating," "mesmerising," "intoxicating") with A. N. Wilson going so far as to describe it as "one of the most gripping TV programmes I can recall . . . Art is a means, perhaps the only means, of telling the deepest truth in life . . . An extraordinarily uplifting experience."[5]

As for those who had taken part in the film, most approved, though several were disconcerted to find my questions had been edited out, which tended to make them seem unduly emphatic. Thus Rose Boyt, speaking for the favoured siblings, said how appreciative they were that their father related so well to them now. "So cosy, the idea that what he really likes is children and grandchildren. To me that's just good news." To Lucian such sentiments were fanciful, or so he maintained. "Susie asked me about whether making the film altered my attitude to families. Isn't she odd?"

"Portrait of the Forgotten Children," a headline in the *Sunday Times* for 18 April, seized attention the day the exhibition ended. The Forgotten were the McAdams, with Jane McAdam speaking out: "Pissing him off might have some effect." She talked of setting records straight. "For me now it's about standing up to be counted. I didn't ask to be born." Hers was a story of paternal absence, laced

with casuistry ("I would say that Lucian lived with us because he lived in Paddington and so did we"). Dad was a non-starter. "Mum said that he never hugged us, never picked us up when we were children. She said he would just look at us. Very intently."

Lucian's reaction was to shrug at what was by then long ago. "Jane had notes from her mother, from me, saying 'See you Thursday' as though that was terrible. I must say I have held out. Anyway, they are middle-aged now." That, he felt, his indignation flowing more freely by the minute, meant that all concerned should just get over it.

"I would only ever go round to have a 'short time,' as they say; I had a degree of goodwill to them but they did it because of this show surely? I wish them well and Lucy [McAdam] has threatened before, that she's not in *Who's Who*. If they want to feel overlooked they will."

The article also said: "Both credit him with financial generosity."

"They've done nothing vindictive; there's a sort of misunderstanding. Jane says: 'All I ask: when you get ill, that I'll be allowed to see you.' Obviously they've got an idea that it would be shaming for me. But Lucy did send a nice letter saying take no notice."

That same day Andrew Graham-Dixon in the *Sunday Telegraph* weighed into the Wallace Collection array with remarkable assurance. "Seen collectively Freud's etched nudes distantly recall pictures of the inmates of concentration camps, huddled together, naked." He detected ineptitude. "Many of these paintings seem indecisive and weak, to the point of being outright botches. In particular *Irishwoman on a Bed*, a boneless nude smearily painted, should never have left the studio. But Freud has earned the right to paint some failures . . ." How so shambolic a dauber had earned that right he didn't say.[6]

"Had a general check-up yesterday. He said I was well apart from the chest. Blood pressure, pulse, heart OK."

The exhibition had attracted as many as 1,500 people a day, adding up altogether to double the annual visitor numbers, and this, Lucian argued, boded well for the retrospective I was to select for the Museo Correr in Venice to coincide with the 2005 Biennale. At the Wallace Collection private view Acquavella denied knowing anything about this, but to Lucian's relief he agreed to it on the spot. "Bill Acqua approves of Venice: it's one of the places that he's heard of. It will be after my funeral."

Acquavella made his plane available for Lucian to go to Paris for

the night to see "Picasso Ingres" and he also offered to send the plane to bring him to see his show in New York. He decided against. "If I do come, it's a bit tarty . . . I'm not sure. I've only ever been for two days and I've enjoyed that." That, as Acquavella was to fondly recall, was the occasion Lucian flew in at his invitation for a Long Island weekend, arriving with a twenty-year-old blonde and, for luggage, a shirt in a carrier bag.

At Lucian's urging I went to New York in late April to install the exhibition. "Don't let Bill Acqua interfere with the hang. Strict instructions," he said, a stipulation that, predictably, had little effect. David Dawson arrived two days after me, as his photographs were to be shown in the upper room of the gallery; he had been told to phone Matthew Marks and say that in future Acquavella would handle all print sales, for Lucian was still fuming over what he liked to think was Matthew's misbehaviour.

"Matthew gave mc £6,000 a print from a print edition of forty-six. That makes £276,000, which is less than I'd get for a small painting. Bill Acqua wants to lower the price, he told me, and David Beaufort wants half of each edition. I wrote this letter saying that he'd stopped being interested and he became queeny, rude, unreliable. How ghastly he is: the way he walks, trotting along."

Over dinner after the opening Acquavella told me that he was prepared to back a catalogue raisonné and would I undertake it, maybe collaborating with Catherine Lampert? Knowing that Lucian regarded so conclusive a publication as an untimely tombstone I said I'd think about it. When, a fortnight later, during another session at the London Print Workshop, where an etching of a pregnant woman was proving unviable, I produced a blue scarf that Kim the receptionist at Acquavella, a dog lover and ardent knitter, had entrusted to me to deliver to Lucian he fed it round his neck and pronounced it wearable. "Perhaps as a shroud." That reminded him: there'd been the funeral of Andrew Devonshire the day before and the late Duke had been reported as insisting how important it was to keep busy always. "I must hold on until . . ." Holding on: "That's what I do too," Lucian added. A catalogue raisonné would imply completed oeuvre and authority offloaded. The thing to do, Diana Rawstron argued, was to set up a trust or tax-deductible fund to cover the costs and get a good academic publisher to take it on. "He didn't need much pressure

to agree as, on reflection, it wasn't sensible to associate with a commercial dealer." A few months on and Lucian's misgivings took over. "I want to close it down. I mean down and out. I've been going off it for a while. It's more and more depressing." I reminded him that we'd had a River Café lunch thirteen years back to celebrate my not doing a catalogue then. "That's it, tell her [Catherine Lampert] that and let's have a lunch to celebrate." The suspicion was that his objections were to do with works he would have preferred not to have been by him, even if they really were. "He can't not authenticate them," Diana Rawstron said. "That poor man and that drawing which he wrote on the back: 'Destroy This.'"[7]

It wasn't, and in this instance an accommodation was reached. But the instinct to deny or prevent, to engage the formidable Peter Carter-Ruck in legal reactions, persisted. Anything that threatened his privacy or that could be thought to involve exploitation by others had to be swatted. One day he asked, casually, if I'd had a postcard from Martin Gayford. Yes, I said: he was wanting to write an essay for the Venice catalogue. "Essay? Fucking hell, why? All that food I bought him: I shouldn't have bothered. It would be chat. OK, but not in the catalogue."

"The fact that people don't know me doesn't mean that I'm interesting," he had said on the phone a week or two before to Michael Kimmelman.[8]

Acquavella said there were up to 650 visitors a day in his gallery, a phenomenal number. But there was counter-reaction, Lucian heard. "Violent abuse in the *New York Post*. Bill Acqua didn't want to show it to me. Bloated drivel: 'Inflated man who's bribed the critics.'"

A week later Lucian announced that for all its retro airs (or perhaps partly because it so ebulliently cut across the ruts of art history) *The Brigadier* had found a buyer. "Some collector of Baroque pictures, a fund-holder, American. 'Cozette and the Cherries' [*Irishwoman on a Bed*] hasn't sold because, perhaps, it's more Surrealist than most." Alfie McLean had wanted to buy *The Brigadier*. "But Bill said it would be better for it not to be in Northern Ireland but where it would be seen." To which his response was that the same could be said of Texas; and anyway it would be one of the latest paintings in the Venice show for which I was busy selecting and coaxing loans. "Why not the Queen?" I said. "Good idea," he said.

"It's a stimulating thought that this may be my last picture"

Through that spring and summer Lucian cast around compulsively for suitable sitters, the problem being that the ones who fancied the role were those most likely to have questionable reasons for doing so. The "crafty devil," as one whom he did paint referred to him later, was gentleman enough to offer consolatory lunch the next day to those he decided weren't worthwhile. But even the slightest acquaintance was liable to spark press attention and late-night doorstep encounters. Verity Brown, for example, who sat only twice a week and without further involvement, was hounded across London. "Verity has been chased to her Brixton flat. They pursued her from the Wolseley (I won't go there any more), came back here, waited till after midnight then followed her. She made one mistake: one man found out which flat, rang the doorbell and she said hello. 'It's the *Mail on Sunday*,' the man said. I rang Geordie Greig—he's the only journalist I know—about what to do and he said she, Verity, could be an ingénue and phone the police and tell them a man's pestering her. But if you phone the police they just come round and say, 'Will you make me a cup of tea?' and then move in. They can't harm me, but Verity's upset."

Some proved eager for celebrity. "A new girl, a sort of student, said, when I said, 'Will you take your clothes off?'—sounding like a gynaecologist—'Do you mind if I keep my boots on?' Amazing pointy boots." Two sessions with her were more than enough. "Thought I wouldn't go on with the new girl. Only had two goes. It just wasn't right. I felt I was in a queue. She started squeezing out a tube of paint

and I sort of said, 'I'd rather you didn't,' and she said, 'What's so special?' Five nights ago I was with her in a restaurant and she said, 'It's a bit embarrassing: three of the people in here I'm having affairs with.' I thought, 'She's a good sort,' but then we were in a taxi and suddenly there were flashlights all round and following, taking photographs, and I thought: 'You bitch.' She said, 'It's quite exciting. Like being in a shipwreck.' Pulling my coat over my head I fell over the house steps."

Others lacked the preferred physique. "A girl wrote from Staffordshire. Too skimpy. Nice but skimpy." And then there were the dramatists. Late one night he alerted me to an article to appear the next day in the *Sunday Times*: "An Evening with Lucian Freud" by Laura-Jane Foley, originally published in *Oxford Student* and promoted now to wider circulation. "She was quite nice. Said she was Christian and wouldn't take her clothes off." Lucian's précis over the phone was quite cordial. "Talks about my driving dangerously. What cheek: I might say I haven't had a conviction for twenty-five years." She reported him as saying to her: "I'm looking for a suitable model for a nude at the moment actually . . . I need to get on with them as we'll be spending so much time together," adding: "He smiled and glanced me up and down." She was to write a play: *An Evening with Lucian Freud*, staged briefly in 2016.[1] Already that summer *Sketching Lucian*, a play by Alison Trower, had been put on at the Café Royal Edinburgh, annoying Lucian, from what he heard of it, because there it was. "I think they shouldn't use living people in this way; I'd mind much more if they reproduce anything. Diana [Rawstron] has stopped that. I asked what it was like. 'Drivel,' she said."

Then there was Alexi. She was a sitter who stayed. Alexandra Williams-Wynn, an ex-assistant to "visual artist" Mark Quinn and a sculpture student at the Royal Academy Schools. "Worked in meat, brought a dead porpoise home from Wales once and it stank the RA out. Kept it in a cupboard." She had been a friend of Bruce Bernard and when she wrote admiringly to Lucian he invited her to lunch, took to her, asked her to sit and a relationship ensued. David Dawson saw immediately what this was. "Verity he can work on without her there, she's good but just a sitter. Unlike Alexi, who is a muse."[2] Alexi settled in. "The speed with which I entered his life and began sitting for him was, I think, very characteristic of him—highly impul-

sive, urgent, impatient towards anything beyond his life in the studio.
I wasn't taking it seriously at first."[3] Frank Auerbach was impressed
with her. "She looks after him, he paints her and is enraptured."[4] He
felt all the better for her, he told himself. "The doctor said I was the
fittest eighty-one-year-old he had ever seen. I have to say that I'd have
thought my life is reasonably healthy. Standing all the time." He now
employed a cranial chiropractor as well as an osteopath. It was four
months since he had been told he might have suffered a slight epilep-
tic fit. "Fizzle in the brain," David said. "Twelve years ago he had a
brain scan: hopeless as he struggled in the tunnel."[5]

Wednesday 27 October 2004: another session at the London
Print Workshop. This time a tired-looking Alexi in jeans and trainers
accompanied him and at first pull the etching—of Alexi—came out
disjointed. Lucian stood over it, paused, then rejected it. (They later
tried cutting the plate in half: it still didn't work.) Then, brightening,
he took to talking about a new picture, currently his preoccupation.
It had a number of things going on in it, including paint rags again.
Going well now and very different. Would I care to take a look?

Back at the flat he climbed the stairs more deliberately than usual,
pausing to say he'd been feeling fragile. He was abandoning the nude
he'd been working on after introducing his painting arm on the left-
hand side, paused in the act. Had it enlarged, but thought it better to
press on now with the latest, the set-up of which looked singularly
contrived: self-portrait with Alexi naked, squatting on the floor and
clinging to "Her Master's Leg." ("Good title, wouldn't you agree?") I
thought of the make-believe of *After Cézanne* but said nothing. This
seemed so patently a follow-through. "Courbet's studio," Lucian
murmured. Yes but . . . Was that it?

A fortnight or so later he made tea for me, sat himself on a kitchen
stool and before showing me how much further the painting had
progressed talked about Alexi, how her landowner father had said to
her, aged nine, and her twin sister, "Go and get some rabbits," and
how she had gone out with a shotgun and shot seventeen or more for
a dinner he was giving. As for the sculptures she'd been fashioning
from meat, he really didn't want to know. For her part she'd been
disconcerted by the *Mail on Sunday* naming her as the latest muse.

Muse or impediment? Alexi clamping herself to him, eyes closed
in ostensible rapture, appeared to be resisting the painting's claim on

the painter's attention regardless of the fact that a mirror faced the two of them and that the mirror image from which Lucian was working compressed the studio space and distanced them both. Behind them were drapes and rags tumbled along the skirting, also the impressive spread of waste paint wiped on to the studio wall and now rendered into facsimile incoherence.

Forty years on from the mirror laid on the floor for the downwards-peering Narcissus pose of his *Reflection with Two Children (Self-Portrait)*, Lucian was now having to take several steps between Alexi and the easel, going back and forth, carrying detail in his head then setting it down detail on detail, scraping off those touches that failed and became mere dabs on the wall behind. Set at a wonky angle, its seat bristling with brushes, the stool served as a marker or stand-in for the painter at his furthest from Alexi. "The stool has changed quite a bit. The stool's crucial." Lucian wondered whether or not to show himself brush in hand; a palette knife would be better, he thought, but that would make a streak of light and there was already one such streak along the top of the stool, so he left himself standing empty-handed sizing up the scene. The complications excited him. "Got up at half past four with the sole intention of doing the handle on the easel. Last night I felt rough but at 4:30 I felt really well. The trousers have definitely improved."

Two days later: "It's changed a lot, something slightly rhymed has gone. It looks really dramatic so that my looking slightly down is more obvious. I repainted her head, strengthened my head. Not with Alexi being there: she needs a lot of sleep." The painter's top-lit fore-head now merged with the neurons of muddied paint, and accordingly the painting looked to be something of a finale. "It's got a funny feeling, looks as if it were done long ago. Not the idiom: it's to do with distance and things. I've never done one entirely in the mirror apart from self-portraits. It's like doing it on another planet. It's a stimulating thought that this may be my last picture."

The title, he decided, was to be mock-Augustan: *The Painter Surprised by a Naked Admirer*. "Good don't you think?"

Frank Auerbach suggested calling it "A Quiet Night In." Lucian laughed. "It's very good but, if you used it, it would be like those people who go around in T-shirts that say, 'I'm a Loser.'"

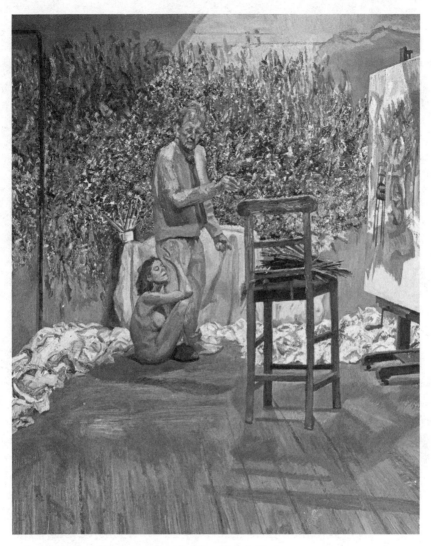

The Painter Surprised by a Naked Admirer, 2004–05

"Watch out for the feminist movement," Alexi added.

"Do you think, um, we could possibly try and show the new picture?" Lucian wanted to have it seen in London before it went off to Venice then New York and thereafter wherever Acquavella succeeded in placing it. I suggested the National Portrait Gallery. "I've never had anything to do with them at the NPG." That was easily rem-

edied. I took Sandy Nairne, the NPG's Director, to the flat to meet him and have a look at the potential exhibit. His verdict, as we left, was "a good painting, but odd." I agreed but was more positive about it, seeing it as very much an old man's painting, a deliberately uneasy, consciously unsteady, studio tableau.

Assuming that the London NPG was as staid an institution as its Washington counterpart, Bill Acquavella argued that Tate Modern would serve better. Lucian brushed that aside. "He just doesn't understand Europe. I don't care about fashion. I just want it shown. Tate Modern is wrong on every level. EVERY level.

"I had an oily letter from that dealer Thomas Gibson. I told Acqua and he said, 'I bet you say that about me. Writing oily letters.' I said, 'I don't because you are illiterate.' He deals direct, doesn't write things down."

As it happened Lucian had just been to see "Beyond Caravaggio" at the National Gallery and failed to be moved by the many expanses of lustrous panache. "They are composed in such an awkward way. I've never been alive to it. The drama's a bit wearisome. Interesting, but you feel he's telling lies. The usual hand pointed out at us. Telling a story, but what about *this*? he sort of says. I've never been alive to it. [Frans] Hals portraits you believe in. There's lots of fearsome stuff in Caravaggio. But not true." While we talked in the kitchen one mouse after another nipped out and scurried for cover. Lucian eyed them evenly. "Can't put down poison because of the dogs."

A whippet had been bought ("They are very cheap aren't they?") for Alexi from Jan Banyard, who lived not far from Lulworth Cove in Dorset. "Alexi is reading Egyptian books for some two-syllable name for him. Went down to that cove, Lulworth, marvellous shape, arch, rock, I will put into the picture." Podegoss the whippet pup— Goss for short—was brought back from Dorset at the end of January, was kept downstairs in the basement by the laundry room, took to whining and within days was passed over to Alexi's brother for training, never to return. David had complained to me that Eli wasn't being allowed to go to the house because the puppy didn't like him. This applied to him too, he felt. "It's awful. I don't know what I'm doing and I don't feel welcome. Lucian can be cruel."[6]

· · ·

Friday 28 January 2005: "Terribly weary. I've got to have my teeth out, the rest of them. Lungs aren't OK, so it's not good to have an operation and then just have mince and porridge. The girl at the dentist's who talks about this said to me, 'I've noticed people like you who don't want anything done, their lives go downhill.' The alternative is to feel rough for a month and I don't want to waste that time. I haven't got that sort of time. In Paddington they had 'em all out. I told Alexi about the teeth but I don't know if she understood really; after all even if I was twenty-five years younger I'd still be much older than her.

"'Old people becoming sex maniacs': who said that? People change. 'Dirty bastard' becomes 'Hey, he can still do it.'"

He had asked Alexi to ask Lucy, her twin sister, if she might care to sit. "'She's a bit nervous about a frontal view,' she said. Alexi doesn't care." No go for the two of them, so Alexi posed solo in the bedroom, legs akimbo. "I've started the nude on the bed and Bill [Acqua] was going on: 'Lucian, will you leave the *Origin of the World* alone!'" That February the painting of Tim Behrens, fully clad, as *Red-Haired Man on a Chair* (1963) fetched £3.7 million at Christie's. "Bill is very pleased, said he shouldn't be my dealer as his prices are too low." Also in that sale was the Kate Moss painting, back from Brazil. Lucian was so uneasy about it he had been prepared to badmouth it, indirectly. "Would you say when they ring up that it's a painting I don't particularly like? It didn't quite work. But I'd like it to go for a decent amount." In the event it made £3.5 million. "Kate was pleased. She likes a large sum."

Restless, he went with David Dawson down to Dorset once more to see Jan Banyard, her whippets and Lulworth Cove. "I want to see that cliff shape again. I feel it will help my portrait of Alexi." Second time round though the stratifications weren't all that impressive. "I got very exhausted walking up the hill at Lulworth. And it didn't look as good as I thought. It was a long journey and I got tired, even though I wasn't driving."

"My balls hurt. Don't know why: haven't been exercised."

"The way life goes"

On 12 April 2005 Lucian swallowed a camera to detect a bowel problem on the advice of Alexi's doctor, not of his preferred GP, Dr. Gormley, who was away at the time. "Australian nurse, pretty, coaxed it down." First thing the next day he went to the National Portrait Gallery to see *Painter Surprised* installed and two days later he was in the London Clinic. "Horrible. Got to have more things done tomorrow. My liver malfunction makes other things not work." David phoned to say that Lucian was at home but so doped up he couldn't remember what had happened and that there was a small lump at the head of the pancreas duct blocking it. "He's thinking he's got cancer. There's this horrible wait. Alexi is too young and has only known him six months; she doesn't know how his brain works. Rose is talking to the doctors. She just says to him she's coming with him. He's having lunch though with David Beaufort today."[1]

I'd been to Milan to check the Venice catalogue designs and as soon as I was back Lucian rang. "Any news flashes?" Would I come round? Alexi opened the door warily, gave me some bean soup from Clarke's and left once Lucian had appeared. Masses of flowers clumped around the feet of Rodin's Balzac scented the room. Lucian agreed the catalogue cover (*Double Portrait*, Susanna and Joshua), touched his stomach and said, "Polyps: that's the word." He'd have to have an operation or pills. In the bedroom he showed me the painting of Alexi—head realised, sheets insubstantial still—then launched into

his fears. Heartbeat irregular: sometimes, at "certain moments," it seemed to stop altogether, Alexi had told him.

The next day he was back in the London Clinic and there he remained, on pethidine to blunt the pain. A surgeons' conference was being held. "It looks bad."

Tuesday 26 April: David phoned from a taxi saying that it wasn't cancer or anything sinister, but the endoscopy had gone awry and that was now the trouble: pancreatic inflammation. Lucian butted in. "Two icy doctors—surgeons—are going to leave me alone they say. I'm longing to get back to the painting." He wasn't seeing anyone except daughters, perhaps, David reported, and Alexi had been persuaded to go home. "Bill Acquavella has been good. When he learnt that it wasn't cancer he said, 'Dammmmn!' Very American."

Jane Willoughby called me, unaware that Lucian was being kept in hospital. "Lucian never accepts his age," she said. "He should know that there are days when there are things that are going to be too much."

Shortly after that Lucian himself phoned, anxious to talk about his condition. "Doctors don't do the ifs and buts, but it's amazing how primitive medicine still is compared to the complexity of the body. I don't know quite what's real and what isn't. It's a sort of horrible painful stomach, like a tidal wave. Emotional and unpleasant. They are trying various things." He particularly objected to the apparatus involved. "The drip is in me. Last night, the whole night, this five-foot-square nurse with no nails kept trying to hook up the drip, clambering on the bed, and I had to do the thing, as she has no nails. One mistake I've made is complaining too much and everything I complain about they give me something for and it's too much I think." "Anything you need?" "Stomach pump."

When I saw him that weekend, an early-morning visit, he was in a little room featuring a pot plant in the far corner. He was propped up in bed, pressing hand to forehead. I'd brought the remaining colour proofs for the Venice catalogue for him to look through and at that he brightened momentarily. Then, grunting at the Italian designer's taste for catchy details, he pulled up his legs and turned on his side. On the wall opposite a towel had been draped over a sun-kissed view of the Grand Canal. "Can't be looking at it. I just want to be patched

up and go home and do a few more paintings." He cleared his throat. "Villiam, I'm feeling a bit rough and I would like the light out."

May day: Lucian phoned at 7 a.m. "Have I woken you?" It was a muggy morning. He was now in a better room with some fresh air, a bathroom and two pictures. One of them, a Mediterranean regatta blue on blue, was left uncovered because he could look at the bathroom door instead. Rose, he told me, was going to bring soup with all the fat scooped off. And he wrote to Frank, a hand-delivered note:

My dear Frank you really are a marvellous friend. When you came with all the drawing materials my future opened wide and I feel very Hopeful and clearheaded. I feel very workish with much love Lucian[2]

Monday evening: I called in once more on my way to sit for Frank. Lucian was in a chair by the window. "They take me off the drip at eight. I feel weak through lack of food but brighter generally, sometimes I even draw. Frank brought me these marvellous drawing materials. For a moment I put my glasses on and then put them off again. Thought I'd done a brilliant last drawing. But it wasn't. On we go. I hate it in hospital. I hate having the room cleaned when I'm in it, when I'm chained up." Then he coughed and lowered his voice. "Villiam, you don't see—seriously—any recent signs of madness? Something that I wouldn't be aware of? I always think I'm quite instinctive. Someone I hardly know behaved *incomprehensively*. There are only two explanations: it's simply a side I hadn't come across, or I'm over-aware. Someone I hardly know. Emotional things." The phone went so I got up to go. He edged across the room. "Hullo, John." It was John Richardson. "Yes, it's been pretty bad."

It transpired that "emotional things" was short for what had occurred when a woman, a schoolteacher who had written to him and excited his interest, had been slipped in (David's doing) to see him and had spent three hours at his bedside. Lucian had to have a secret—private—life going on, said David. "Alexi won't take it well. Why should she? No one knows except Rose, who had to be told. The stuff about madness was to do with the woman who came the other night, she said she was depressed and Lucian couldn't be having that, so he tore up her card with her address and phone number on.

Ripped it up. He ate some chicken soup. Second attempt at drawing. Mucked up the first."[3]

Wednesday 4 May: "How are you? Any news? I'm feeling better. Should be out on Thursday."

And so he was. "Emotional greeting in the street from Sally Clarke. I was sitting down while they filled a tub of ice cream. Had mussels, delicious. I was ill over lobster: perhaps better not eat that. I can't manage things I ate before. No animal fats."

David suggested having Alexi in to sit a couple of evenings a week. It would help. "I see what you mean," was all Lucian would say to that. "He likes having young girls in tow to take to the Wolseley. Makes him look good."[4] As for David himself, his instinct was to stay because Lucian had no one to look after him and he had chronic panics in the night. Panic over future prospects shortening and the dreadfulness of things becoming uncontrollable.

Sunday afternoon a week later: Lucian shuffled to the cupboard to get a cup and gave me some lukewarm tea from the pot saying that doing right by the children was bothering him. He had already set about providing those he favoured with a small painting each; grandchildren came in handy as sitters for ready heirlooms. But there was also the whole estate at his disposal. "This is the first time I have had money really. I want the children to be able to have some." Those, of course, with whom he was familiar.

His new bank, Hoare's (the world's fourth oldest), was, he assured me, very good. "They said, 'You have to invest in equities,' and I said, 'I don't want anything that might distract me from form and colour, which having stocks and shares would do.' So the girl they sent said, 'Good,' and I get my money on deposit for 4.5 per cent, which is good enough, surely? I have plenty, where in the past I usually had nothing. My banker, Amanda, suddenly advised me in a more formal way and said, 'I want to be in touch.' She's got the bit of money I have and quite a high position at Hoare's. When I ring her up it's like ringing up to ask for Gordon Selfridge. Must be good."

Sheltered behind the disingenuity was a lively interest in fortunes made. Lucian liked to have large liquid assets in his current account, Diana Rawstron commented, but he had a good deal of money on the money market as well. "It's just that he likes to be able to pay out any cheque without a fuss."

The painting of Alexi was still under way in the bedroom with Bacon's "The Buggers" hanging there parallel to it. I suggested that the sheets in the one were affecting the similarly rumpled sheets in the other. He agreed and fidgeted. "Had a bad night. Alexi's picture near by, looking at me." He fretted. "I just don't know: wrong place, wrong room, not well enough to read. Pills? Got some harmless ones from Bill Acqua. Had quite a difficult week over Alexi: telling her I wanted to be alone. Went all right but these things are hard to explain. I just know it's right for me. I've got her a flat/studio. It's impulse. I've got to be alone; if you're unfit you want to be alone; I don't like anyone doing anything for me." Alexi kept wanting to do things, he complained, and she had been phoning Diana Rawstron and Rose. "Couldn't get the message." Emily Bearn on the other hand was on peaceable terms with him these days. She sent him a photograph of her newborn baby. "I was so overwhelmed by her," she wrote, and Lucian was touched. "Only a few lines; you could call it closure." He wouldn't talk to Susanna; she was in Italy, he guessed.

The third week in May and the time had come to do something about the mice. A fluffed-up black and white cat was nosing round sniffing at a food bowl and snapping at a fly. Lucian decided that he wanted to get that fly too; the cat lost interest but he folded a newspaper and hit out ineffectually. A friend of Bella's had lent the cat, but he hated having it in the house, mewing and staring so, whereas dogs knew their place. When David went to Paris for a night he left Eli with Lucian. "We were OK. He's quite used to being here. I'd like a dog. I'd like one if I'd had it for quite a long time already."

While I was upstairs looking at the newly completed painting of Alexi (*Naked Portrait*, 2004–5) the cat's owner came and, to Lucian's relief, that was the end of the cat residency. "Cats, unlike dogs, take no notice, don't respond, aren't interesting. Didn't mind the mice: they are something to look at. Dogs aren't interested in mice. Hated the way the cat stretched its claws and insisted on being around all the time wanting attention." The phone went and there was a brief exchange and he turned to me as I got up to go. "They say I should have radiography. What does this mean?" He saw me out. "Get Bill [Acquavella] to invite Diana to the dinner in Venice; Acqua thinks she's an employee but she's a sort of friend really—not that I've spo-

ken to her recently—and she is *good*, always so good with Carter-Ruck."

He had just received *Lucian Freud 1996–2005*, the sequel to Bruce Bernard's 1996 volume, to look through and relish. "What a lot I've done. Very nice, all in all. I'm pleased with it." The final plates were 98, *Painter Surprised*, and 99, *Naked Portrait*—the one I'd just been looking at upstairs. Ten paintings or etchings per year, a remarkable output by his standards. Sebastian Smee had written the introduction. "What he wrote was original and a good style," Lucian said.

The Venice exhibition was to run from 11 June to the end of October. Would he come? "I'm older, it's further and they are my things. So no." He missed some spectacular feats of handling, for installation on two upper floors of the Correr at the far end of St. Mark's Square involved uniquely Venetian methods, the pictures being brought in by barge, precariously unloaded and spectacularly manhandled. The most cumbersome ones, *Evening in the Studio* and *The Brigadier*, needed a dozen men each to run them, literally, up wide flights of steps to the *piano nobile*, any loss of momentum being potentially calamitous. All eighty paintings, interspersed with etchings, were distributed into a series of rooms opening off a long corridor so that from *Girl with Roses* onwards, processional altogether, they paraded persistence and finality, *Painter Surprised* being a valedictory Prospero. "The way life goes," Lucian remarked, not that he felt passive about that. "I'm working round the clock."

Early on the opening day Bill Acquavella walked through the exhibition, phone clamped to his ear, telling Lucian where pictures had been placed. It was more recital than commentary. "I'm now going into the next room, Lucian: *The Queen, Frances, The Brigadier, Man with a Blue Scarf*." He was about to add himself to the list of sitters, the plan being that, following the Basel art fair, he would stay in London for a fortnight, sitting daily, and would return for further stints if needed. Lucian found him pleasingly cooperative. "He's very intense and a good sitter, can come at 8:30 on to 2 and not move once. Done thirteen days so far. It's been on the cards for a while." One morning he turned up wearing not the usual soft blue shirt but a similar one and Lucian had to explain that this was unacceptable as even the slightest difference of tinge affected the face.

Evenings without sitters meant that David began taking Lucian out to openings and dinners, some of which—often events involving the YBAs (Young British Artists) generation—he found bewildering. A revamped Soho puzzled him; he was also nervous, not knowing what affliction might strike and when and where. "Last night I went with David to a Jay Jopling party at the Raymond Revuebar. This morning there was blood on a towel. Haemorrhage. Depressing." David explained what had happened: he had been taking extra Solpadeine in the morning to wake himself up before Acquavella arrived. And there were prolonged nosebleeds. He told David that the blood might be a girl's but that was bluff, probably. Should he tell Dr. Gorm? He thought not, particularly after a midsummer-night incident restored his morale a bit.

Tuesday 28 June: "A scrape. I didn't stay in my house last night; I stayed with a huge girl I'm going to paint. Locked myself out, put the keys in my pocket and they were the wrong ones. So I went back with her. Lives down the road—a small bed and two people in it—so I'm a bit weary. She's a schoolteacher (English and swimming, I think), really big and very very nice. Intelligent. Sensible. How to paint her? It means opening up Holland Park again. Kai is going to open the bathroom at Holland Park out a bit so I can be standing in the doorway and using the view from the window. The view is so good I very much want to do it, but there's no question of my doing anything she doesn't want. She's amazingly strong. Came to see me when I was ill. I thought of beginning rather small, as she's so big. For a teacher she doesn't seem inhibited or conventional. A very good nature."

Predictably, and almost immediately, the affair was no go. "The swimmer? I gave up. So I think I'm meeting some girls this week. Colonel Andrew has some ideas and this evening, at Esther's, there was a woman and her dog. But she just wasn't right: intelligent in a knowing rather than an animal way."

A week after that Lucian was on the phone at dawn. He sounded sleepy. "What's the time? I had a dream. Dreamt I was going to get married." Who to? "Don't know really. Rather complicated. Something about the bridge of my nose."

Thursday 14 July: "I'm starting on an etching tonight of Dr. Gorm. The idea was to please him (he wants something to leave to his children) and an etching is the best way to do it because things should

go through Bill and I don't want things underhand. He's not like his brother: he's spectacular looking, not embarrassing."

Michael Gormley had asked Lucian if he could do him a portrait of some sort. "It would be for my family and a conclusion. (I knew he was getting old and ill.)" "I'd be thrilled," Lucian replied. The arrangement was that he would come and sit at the end of the day for two hours. "I'd go to the pub opposite and have fish and chips before. I found it very relaxing, didn't want to talk. He'd utter the odd word—'Oh no!' or 'I don't think so,' then 'Yes.' Talking his way through. I was praying silence." There were tea breaks and nibbles, bottles of claret and occasionally Bollinger, which Lucian didn't drink, explaining, to Gormley's tacit approval, that he didn't care to, "except perhaps half a glass of claret before going to bed normally."

"In this seventy hours I was contemplative, reading *Madame Bovary* and *Moses and Monotheism*. I did nod off." There was no call to associate the elderly man scratching away at the etching plate with the make-believe Moses reimagined by Dr. Freud as a Dynastic Egyptian nor any reason to compare the artist to the wretched Madame Bovary. Yet certain traits, relating to ambition, devotion and ruthlessness, occurred to this sitter. As he sat, eyes down, Gormley was both patient and examiner, passive as regards progress on the etching plate, perceptive in other respects. He recognised the strengths that compelled or propelled. "Lucian was one of those wonderful people who owned his self. His selfishness. He had an addictive personality. Addictive people love *intensity*; it's the nature of the personality, ruling everything. He was fastidious. Interesting that he disliked his brother [Clement]; he'd say, 'He's no good.' It's interesting who he cared about.

"The ability to love deeply is not always easy for an artist. Because behind addiction is vulnerability or damage numbed out by drugs, gambling, sex. They also get in the way of love fully. That aspect saddened me."[5]

David Beaufort, who had known Lucian longer than most, offered no such diagnosis. He was blunt. "Lucian was spoilt. He never looked after himself."[6] But then, where his mother had humoured him, picking up after him, he had honoured her. He was appreciative. And he liked it when Bella tried cutting his hair rather than just have the barber come. "She's good at it, and tried to smooth it down."

The portrait of Bill Acquavella, as yet unfinished, was placed on the easel for me to see. There he was: close enough for a word in his ear, looking less businesslike than in weekday life, the geniality wearing thin maybe, given that he was unable to determine the outcome of this particular deal. It struck me as an uncannily good account of the narrowed eyes.

A fortnight later Lucian phoned, sounding agitated. "Bill Acqua left on Sunday, I think upset by his portrait. Didn't say goodbye or anything." What had happened? What crisis? "It couldn't be business worries. I only finished it on Sunday. Frank's seeing it tomorrow." Obviously he was rattled: twelve years' worth of good relations and swelling income suddenly collapsed. "I've never bothered about such things, I don't really need him, I'm lucky to be able to work, nothing else matters much. This is the only thing I've had trouble with him about.

"When I was quite young I wanted people to see things; now I like Frank and I like you to see them. But Bill Acqua: he talked about money *non-stop* for two hours. I was surprised because I thought him sophisticated. It's something to do with the price. I don't think he knew why he got upset." Could it be, I wondered, that he hoped you would give it to him? "He said, 'Looschian, you're charging too much. I'll swap it for a Picasso and some money but if you die then you'll have to pay double tax on things.' My price was based on him, and the last picture. I can't pretend it's not disturbing. He was shouting about money. I always ask David Beaufort how much. And prices relate to each other. I charged for 'Alexi' 2.4 and I asked 1.8 for 'Bill.'"

It didn't take long for Acquavella to reconcile himself to the way he'd been made to look and four months later he was back in London to sit for an etching. "Bill is OK about the picture now. Altered the nose to make it better." What to call it? "Looschian, I'll leave that to you," he said. And so it became, quite simply, *New Yorker in a Blue Shirt* (2005). There he was. Perpetuated. All in all, over six weeks of sittings of up to six hours at a time, he had enjoyed being worked over.

"Acquavella said that the number of [potential] commissions he'd got from showing people my portrait of him was amazing. One reason for doing them—portraits—is money and the other would be to meet someone." Doing portraits of well-to-do sitters was of course a fairly sure way of achieving a sale and such sitters could be presump-

tuous. Witness David Hockney's vexation over his failure to acquire Lucian's portrait of him only because Acquavella had bagged it for himself. For Lucian too (and Ingres before him) there was the itch to possess. Given his lust for Auerbachs, plus the Constable portrait of Laura Moubray that he came to own, Corot's *L'Italienne*, Degas bronzes, Rodin's *Camille Claudel*, not to mention the stretch of carpet from the Prince Regent's Carlton House, he could not deny ("I'm a bit crazy: old age") his sporadic passion for buying things. He tried explaining this:

> *Collecting is an illness.*
>
> *A) I'm not claiming not to be ill.*
>
> *B) My thing is I like things in the room where I live to thicken my life and give me ideas. I rate privacy enormously but paintings, hooray!*
>
> *C) Collectors investing are keen on money with interest rates. Even at school I used to buy or borrow pictures. I like to have them round me but I wouldn't mind if I came back one day and they weren't there.*
>
> *Collecting is a game.*

"I don't want to slow down
in this late evening of my days"

Lucian Freud 1996–2005, the single-decade sequel to Bruce Bernard's *Lucian Freud*, represented an extraordinary flow of accomplishment. As Sebastian Smee put it in his introductory essay, "The longer you look over the last decade of Freud's work the more you are struck by the absence of any set formula. No discernible 'late style.'" Later one could look back and detect among, for example, the virtuoso bedspreads (such glistening quilts) indications of the preoccupations of old age: recap and recall. Not "late style" but habitual persistence. It was obvious, when seeing freshness diminished, virtuosity dwindling into slog, that each new work up to and including *The Painter Surprised* was (or, rather, had been) potentially final. At the time this uneasy take on the reflected image of the artist centre stage, halted amid his preoccupations, was both epilogue and holding operation.

"I don't want to slow down in this late evening of my days."

"More like tea-time," I suggested.

"OK: high tea-time of my days."

Monday 10 October 2005: arriving at 5 p.m. precisely—punctuality being key—I rang the bell repeatedly but it wasn't until 5:10 that the door was opened by Susanna Chancellor carrying an ashtray and explaining that she and Lucian had been talking upstairs and hadn't heard. Lucian had begun a small head of her but as she was spending half her time in Tuscany progress was halting.

David Beaufort said, "Susanna was very like Lucian in a way and that was the attraction."[1] A degree of detachment was essential and,

as she saw it, Lucian's conduct was to be humoured at times, maybe, but not revered. Susanna: "When Lucian was on show he would tell the most monstrous non-truths. He sat through lunches on top form. He was an entertainer."[2]

Susanna left and I sat sipping weak tea while Lucian nibbled almonds, dipping them into honey, and Chinese lettuce, wiped leaf by leaf in mayonnaise. "Would you like some? I get these blank moments: not forgetting names, more not knowing what day or place it is. And Susanna's being so severe." (She was keeping him indoors.) "I'm a bit weary. Had a very bad nosebleed: to do with eating a lot of aspirin. Had to go to Harley Street and have my nose done up. Top nose man."

I'd been asked to see how *Eli and David* (2006) was coming along: David seated bare-chested in an armchair, his head turned just enough for him not to see what Lucian was doing and Eli draped across his lap. It seemed obvious that what with the brightness and encroaching black, a forearm dramatically foreshortened and Eli playing almost dead, Lucian was out to picture something like a Caravaggio. "Beyond Caravaggio?" I ventured. "Hah!" he responded. Yes: a cult pose defrocked, truly a lay Pietà.

Christmas approached. "Lucian seems in better health; is the horse painting done?" Acquavella asked, and told me that he would be happy to lend his portrait to the V&A. I had suggested another museum showing for new work next spring and the V&A had agreed to accommodate a dozen or so Freuds and Auerbachs at one end of the Constable galleries, celebrating mutuality and (with Constables beyond) a reflective affinity.

On Christmas Eve Lucian went, as was his habit, to dinner with the Auerbachs in Finsbury Park. ("Superb fish dish cooked by Frank, sort of bouillabaisse.") Family Christmas lunch was at Rose's, in Islington, for a dozen or so. His habitual Christmas Day phone call ("Any news flashes?") came with the annual disclaimer. No revelry for him. "I was just there, that's all."

David Dawson's end-of-year view was that the fact that Lucian was now talking to Susanna was helpful, she being "a proper woman, not one of these neurotics."[3] He'd seen Alexi again occasionally. And a new girl, Sabina Donnelly, was on the scene. "She's a friend of Freddy Eliot. She's good. She does some dancing and I think she's going to

art school. Quite mercenary." David explained this precipitate optimism. "Lucian regrets he split up with Alexi and is sorry for her, but that's because she fell in love with him."[4]

He was paying Sabina handsomely and for a while he didn't resent her demands, as above all he wanted a new leading sitter. ("Posh girls get the flats," David added. "Others don't.")[5] It wasn't long though before he suffered a deserved rebuff and with that his enthusiasm wilted. "She has been difficult," he complained. By "difficult" he meant uncooperative. "He pounced," David explained. "She said: 'Don't do that.' And that upset him."[6] Sittings ceased and she turned to David for advice. "What to do? Go to Paris or New York or stay around?" While David told her not to hang around, Lucian only told me that he had finished with the painting. "I thought I'd let you know that I decided to scrap the nude. The girl was coming tonight but I'm not going to go on. I thought about it a lot today." At the same time he had a further painting of Alexi to reconsider for over and above any emotional worries was fear of painting entrapment. "The second painting of Alexi *isn't* somehow. No surprise: I just thought that it's ANOTHER painting, not an idea so much. I saw one possible girl yesterday but she was too keen. Over-keen. Not very much there, not just mentally: she approached David in the street and had a boyfriend with hair in places on his face and she was eager to a degree and that made me wonder. She said 'we' (she and her bearded friend). I hate that. I quite like the idea of her on a long lead, but not opinions *shared*."

The quest for fresh sitters continued, primarily now to feed self-confidence ("I'll go to the Wolseley and find someone") rather than simply to meet studio needs. "Since I'm old—very old—it's a bit 'Look who's there, still there' kind of thing. Like in a Vuillard you almost don't see the person." This persistence worried David. "If he goes off to Moro at eleven o'clock to look for girls I can't relax."[7]

In lieu of recruits there was still *The Painter's Garden* to be addressed. Being mostly evergreen the view from the back porch could be worked from throughout the year using the decking as studio space. Drifts of dead leaves now obscured Pluto's grave marker. Marc Balakjian told Lucian that the large *Painter's Garden* print that preceded the painting was the most difficult he had ever handled; he had done ten impressions for the edition in one day and none were

any good. That said, *Girl with Frizzy Hair* had been even more of a challenge surely? Lucian agreed. "Yes, that was. Almost nothing there, but actually that was what made it so interesting. Made it almost like a drypoint, the failure of the etch bath." As for the garden plate and print, its complexity had come to reflect a wilderness of place and mind, nature teeming away outside, its entanglements untouched by chainsaw or secateurs.

"Why is it that a painting is always better, more to look at, than, say, an etching? It must be the paint."

Depression set in. "I'm not just fatigued, I feel in a dangerous state." It may have been that Lucian had a minor stroke in the new year. Certainly he felt bemused. He and David had been rummaging through the plan chest and the back room at the flat having a good clear-out and this relieved him. He could remember everything to do with painting, he said, but not other things. I put it to him every so often that he really shouldn't be taking Solpadeine and he usually agreed. "Gorm says no too." He had come off the Aricept (for Alzheimer's) as it made him shaky and he was having nightmares. A brain scan (Esther's suggestion) showed that he hadn't got Alzheimer's but his brain had shrunk, his short-term memory had almost completely gone and he was vague about arrangements of every kind. He talked of having photographed Hitler when actually it was a snapshot of the future George VI attending the Southwold youth camp in the mid-thirties.

David complained about the demands, relieved only when Susanna was around. He had to do everything from administering the drugs to dealing with moths in the basement and all else involved in keeping Lucian going. "It's a slight madness but the same person, the drugs have calmed him. He was manic: he's just more of what he is. Panics more. Bed by 10:30, drug and sleeping pill. But there's no new painting on the go.

"He does this thing in the mornings: says he couldn't remember who he was. 'Who am I?'"[8]

After fifty years of dangerous driving he was finally disqualified. Conveniently, there was a switch in the boot of the Bentley, which cut out the battery so that it didn't run down when the car wasn't regularly used, and Lucian, David knew, was unaware of this. "I switch it off and he can't then drive."[9]

Diaries now listed the necessary reminders: phone calls to be made plus hospital, dental, masseur and cranial osteopath appointments. Lucian consulted this but regarded implementation as rather beyond him. The urologist at Chelsea & Westminster gave him options when all he wanted, he told me, was staying power. "He points out what's prostate cancer. There are 'certain bits' that just don't work. I have to piss into a tube. I'm not bothered about these things: the only thing that bothers me is if I don't feel well. Teeth: not going to bother to get them redone. It's entirely to do with the brain. I feel anxious and hunted. At least I know that. Whereas a lunatic would be saying, 'The world thinks I'm mad, but I think the *world*'s mad . . . Damn, I'm outnumbered.' I'm anxious and low. But not when I'm working. Anything to do with radical decisions is a bit of a boost."

And still he telephoned ("Hello, Villiam, how goes it?"), often three times a day. "I see I have to phone. Maybe it's lunacy. Was I supposed to ring you? I get these blank moments. Not forgetting names, more not knowing what day or place it is. Standing makes me tired."

An Ingres exhibition was staged at the Louvre from February to May 2006, and Lucian was easily persuaded that he shouldn't miss it.

"I don't leave London, I don't go away, but I must say the one thing that would make me is Ingres. I always like the ones over the top: *Jupiter and Thetis*, the imploring nymph. Bill Acqua (private plane) has gone but you can get there on the train very easily can't you?"

David couldn't manage Lucian to Paris on his own, so I met them at Waterloo one April morning to catch the 7:30 Eurostar, Lucian fumbling with the tickets while having to take his overcoat off to go through security and handling a big bunch of house keys. Over a full breakfast, sausages and all, he looked out at the back windows of south London. "You can see the toothbrushes even." As we went through the North Downs he talked about Graham Sutherland and their disquieting visit once to Maidstone Prison; nearing the coast, he looked out for the K. Clark castle at Saltwood, now guarding the approach to the Channel tunnel, and was startled at how soon after that we were zipping through Picardy, he remarking how the villages set in open fields, each with its squat church tower, were so typically Corot. By now Solpadeines were obviously needed. David brought out a sheet of them and gave him just one, prompting Lucian to explain that he was cutting down on them; however, throughout the day whenever

he flagged he asked for more. Perking up as we approached the Gare du Nord, he admired the trackside graffiti, the loopier the better as the railway cuttings closed in. "So stylish," he insisted, and in the taxi onwards through the 2ème he recalled the unfailing thrill of arrival in post-war days. Even now, Paris seemed welcoming in pale spring sunshine. In the Louvre courtyard he phoned Susanna to tell her he was there; it being a Tuesday the Louvre was closed to the public but Olivier Meslay's assistant met us and, apologising for Olivier's absence (he was in Japan), escorted us in.

Lucian Freud in Paris to see the Ingres show

The dim lighting bothered Lucian at first but the works absorbed him: the steady hand and limpid cohesion. He inspected testy M. Bertin the editor, nodded at the resplendent self-satisfaction of Mme Moitessier in both poses, standing and seated, and was particularly taken with the aplomb of *The Virgin Adoring the Host*, with the ghastly moment of *Paolo et Francesca* (lovers discovered, her book falling to the floor), and with the lofty indifference of bare-chested Jupiter, so unaccommodating to the comely Thetis stroking his beard.

After about an hour and a half of swerving from room to room Lucian began murmuring, repeatedly, "It's like ten minutes." In the Café Louvre he ordered prawns and the second most expensive wine, the waiter duly complimenting him on his choice; then it was back to the Gare du Nord only to find that the train had been cancelled. Suddenly, with plans awry, he looked stricken. Somewhere in south London a building beside the track had collapsed and any trains that did run were to go no further than Ashford. David tried phoning Kai Boyt to arrange for a car to pick us up there but failed to get through; eventually, though, the queue did begin to move and once we were through the checkpoint there was the first-class lounge for refuge and Lucian, exhausted, sank into a chair. The train that eventually left for London was packed—no first class now—and by the time we reached Waterloo there was no more talk of Ingres or, for that matter, the delights of Paris.

Earlier in the day Lucian had kept listing the paintings he had under way and then, going round the exhibition ("I always liked Ingres"), he had taken to wondering aloud how old Ingres would have been at whatever point we were. Died at eighty-six. And he, at eighty-four, was not far short of that.

Failings were beginning to show, he saw. He hadn't been to the flat (Holland Park) since he was ill and that was eight months back; and just the other day he had found himself completely disorientated. "Rushed out in the morning three days ago. 'Esther 7' it said in my diary. I decided I was meeting her near Fleet Street and went to the City and couldn't find the place—got to Piccadilly—and everything was irrational. But not when I'm working. So it's just part of my brain. The brain is a muscle and one has to train it."

A few weeks later, while I was installing the V&A display of recent Auerbachs and Freuds, David brought Lucian in to see how it was

going. They'd been to Dr. Gormley. "I feel fragile," Lucian said—his now habitual preamble—and peered around paying more attention to the Auerbachs than to his own works and then nipping ahead to look closely at the Constable oil sketches. "Constable's more like life than Turner, and the little people in Constable's paintings are all portraits," he explained to the critic Richard Cork who had come in for a prearranged chat to be published in *The Times*. He found Lucian unforthcoming and Frank expansive.[10]

The hang was proving difficult: too many pictures all on an end wall. Lucian suggested giving an inch or two more breathing space to the Acquavella portrait, then drifted off again, looked politely at the Turners and was happy to see that I had put his etching of Constable's elm alongside the original. As we left, a young woman from the hanging team, girdled with hammers and screwdrivers, approached him to say what a privilege it was to be hanging the pictures. "I was a painting student and it means so much." Walking with Lucian towards the exit along a medieval stained-glass corridor I said something about how good it was to see in the V&A a fully laden carpenter's belt slung around a waist and went off to unlock my bike but then, suddenly alert, he stopped me. "Villiam, I wonder if you could mention to that girl about a phone number?" I jibbed at that and David told him to go back and get it himself, which he did, though it transpired that Mark Evans, the V&A curator, was the one who did the asking. "She said what a privilege and I told her that all she has to do is be prompt." Early the next morning, when we met at the side entrance, Lucian was jubilant. "As you know, I never go anywhere, but I did have a feeling of excitement when she [the hanging girl] came up. I thought I'd start soon. Something about the nervousness: it's stimulating." Certainly Ria Kirby was happy to sit and began right away, he reported a day or two later. "The new girl from the V&A, she's very nice, good in every way. She was going for a week to Greece with her parents and brother and she'd put it off, she said. She's from a different social background. Something brand-newish about her but she's so sensible, loves working at the V&A and was at Camberwell, painting where painting was discouraged. I'm very pleased. No hint of showing me her work, always a quarter of an hour early and since I'm always longing to start that's good too." She posed right away to appreciable effect. "Lying on the bed she's tragic."

Jeremy King, restaurateur of the Wolseley in Piccadilly, famously courteous and self-possessed, began to sit too and, shortly after beginning with him, Lucian enlisted, on the recommendation of Andrew Parker Bowles, a neighbour who proved equally reliable and sympathetic. "Pat Doherty, Irish billionaire, interesting and a lively mind. Red face. Small. Shakes your hand as though just before a fight. In the end what people *look* like doesn't count, it's what they have in them." The Doherty portrait was the first he did without Acquavella being involved in the sale; David did the negotiations. "He's good at that, and Acquavella's taking ten per cent. Is that fair?"

The new sitters worked well and the diary remained not too full, yet Lucian's stamina ebbed. He became used to sampling distractions, so much so that by July 2007 he was even contemplating a foreign holiday, not immediately but in due course perhaps. "I said to Susanna I'd like to come to Italy for a few days. Next year, if I'm still here. I could use Bill's plane, I thought. I felt fine on that. (He's coming here for me to finish the etching.)"

Exhibitions in prospect were to be savoured: "The Painter's Etchings" at the Museum of Modern Art in late 2007 and a touring show, proceeding from Dublin to the Louisiana Museum of Modern Art near Copenhagen and to The Hague, was assembled piecemeal by Catherine Lampert around this time. One proposal, though, sparked indignation. The Kunsthistorisches Museum in Vienna put it to him that, being a Freud, Lucian would, or indeed should, show there. "They wrote and said, 'Glad you've forgiven us and are on good terms with Germany again.' Fucking hell, I thought. My grandfather wrote something about the Nazis: 'I can never thank them enough for making it possible to come and live in England.' That's what I feel too. If you go into the history of Germany the Nazi part is a very important part. Anti-Semitism is their history, right through, and the idea is: 'We want to celebrate you as a Viennese.'

"A symbolic gesture: that's how it would appear. 'The thing is,' they said, 'we didn't know you were concerned with Judaism.' No, I'm not. My great-aunts, when the Nazis put them into the concentration camp, were in their sixties. One went to the head of the camp and said: 'We aren't ordinary persons that have been roped in, because we are half-sisters of a very great man. Could you put us to death right away?' So they did. It's not secret. My father told me that; he

liked them [the aunts] and the thing is the Austrians were more anti-Semitic than the Germans. Jews weren't allowed to walk on paths. My grandfather was walking with some of his children and a man shouted, 'Filthy Jew. Get off, filthy Jew,' and what do you think my grandfather did? He bent down and picked up a stone. That was all. Interesting. Sort of aggressive."[11]

Saturday 22 July 2006: Lucian was reluctant to show me the painting of Ria but ushered me into the front half of the studio where, since the canvas had been extended to accommodate the feet, there was more blank than the last time I'd seen it several weeks before. The small head of Susanna hadn't got much further either. Dominant in the daily routine, the two pictures were now evidence of inactivity setting in.

"The only thing that matters is to be completely reliable. Ria's very good. I needed a day-girl. Such a shape, surprising: very thin without being skinny, she's got breasts and that sort of thing, fitted into a long narrow cupboard. I told her I did tattoos. 'I want you to do a tattoo!' she said. So I started one. 'I'd like another on my shoulder,' she said. There's an artichoke flower." One weekend he took her to stay with David Beaufort at Badminton. "Ria swam a lot: a marvellous sight. Diving in without making the slightest noise. I was asleep a lot of the time but I watched her. Amazing turns in the water. Ria is most strong and sensible: unusual mixture." She talked about preferring her V&A job—carpentry, handling exhibits—to the work she had been assigned to: "curating" at the Bethnal Green Museum of Childhood. That too struck him as impressive.

"To me anyone wanting to sit is rather surprising. A new girl, very singular and very nice, is coming today at five. (I'm slightly worried as Ria is coming at eight.) Rather extraordinary how I found her: Esther said, 'I think I've found this model. She's interested in writing.' If you met her you would say, 'I want to see her, not the picture.' Seems remarkably modest in a way. 'Week after next I'm going to have the curse,' she said. In a sympathetic way, I was quite worried."

"I'm secretive. I like to think that no one knows what I'm thinking or feeling. There are things that, as it were, *think* one, would you not say?"

Sunday 17 September 2006: Ria made tea on the morning the etching of Bill Acquavella was to be bitten while we waited for Lucian

to finish a session with Jeremy King. When he emerged we drove off in David's new Cherokee Jeep to the print workshop in the Harrow Road where, immediately, he fished out a roll of Solpadeine. I asked him how many Lucian was taking. "Four a day." As usual we watched, strictly nonchalant, while the plate was prepared, laid in the sink and eventually fished out. The first pulls were promising—that keen-eyed Acquavella look proved well registered—and so with the plate wrapped in a white cloth we went off for prawns and mussels at the Cow, a pub turned oyster bar in Westbourne Park Road. There, suddenly, Lucian lost focus. "Where am I?"

Back at the house and adequately confident again he showed me the Ria painting—more glistening bedspread than hitherto—saying, not for the first time, that it could well be completed in a fortnight. Then he went off upstairs to sleep, leaving David and me to talk about what was to be done, some time in the future, with unfinished works. Obvious failures were kicked or slashed (the painting of Sabina was a recent casualty), but some of those left off at an early stage could be regarded as spurts preserved. These, I suggested, should be put away in a cupboard and forgotten about, at least for the time being.

Obviously Lucian wasn't working much. "Three and a half to four hours is my max," he admitted, and even that, according to David, was unusual. "Ria arrives, they drink, they go out to the Wolseley and that's it." Lucian liked to have Ria there and, because she was there, the painting became distinctly over-stippled. He worked at it as though just putting in the hours.

Ria had been living in a squat in the East End, but shortly before Christmas Lucian announced that, since he had "a bit of money" she was now living near by and would certainly go on with him, he thought. Maybe an etching next? He paid Ria £100 a night for sitting and £300,000 for the lease of her flat. There was no hanky-panky, David said firmly. "Ria? She'd never dream of it. Never entered her head. To her he was an old man." It even seemed that he was going slow deliberately, wanting to avoid bringing the connection to an end. Ria was unwilling to proceed with another picture; she had told Lucian that she wanted a Saturday night off. "Because I want to marry some time and have children." "But Saturday night," Lucian protested, "is for married men to go out and find blondes."

"Having been pleased with the head, and left it alone, I'm going

to rework it. I don't want to leave the 'best' bit because that might look as if I liked it. The radiator, top left, will go in; I'm interested to see what it looks like." I remarked how substantial the painting now was and Lucian brightened. "Will you phone Bill Acqua and tell him?" His "Recent Works" show had just opened in New York and Acquavella reported that 380 people came in the first day, students were taking notes and saying that this was exactly how they were told not to work. That made them rebels, as all students should be. "I thought how nice to have people sitting drawing in the gallery."

An invitation, more a command, had arrived for an OM luncheon at Buckingham Palace. "When?" I asked. "Next May." "That's optimistic," I said.

Annie Freud, distressed at having become, once again, on non-speaking terms with her father, rang me asking if I could maybe intervene. "Probably nothing to be done; it's just that I don't hear from him. Last time was a year ago: a message a bit before last Christmas, a nice message, not unfriendly. There's no point of issue; it's just this worry that I won't see him again." Living as she did at quite a distance from London in a house he had bought her, she was isolated from him. "Just never seeing him again makes me feel incredibly sad and it preoccupies me. I'm very much aware of—what's the word?—'restraint.' In a way I want him to be interested in *me* in an ordinary way."[12]

She phoned again some days later: "Just to say, I went to see Dad and he was delightful and funny and himself. He knew everything. He was painting a small head of Susanna. Sometimes I ask him to show me what he's painting and sometimes it's better not to ask him. I know him so well."[13]

"I have an idea which is that I've left a lot of things unsaid in order to have ideas in painting."

New Year's Day, 2007: "I talked to Harold Pinter yesterday. He's one of the most famous writers there is: Eskimos have heard of him, and I arranged something, but he said it'll have to be a date in the future; his secretary rang up 'my secretary': he doesn't know how I work. 'He will come on Feb 17th.' But that's no good. I suppose it's silly, but I'm too old, I'd like to see the *possibility* of the end of them

(pictures completed). I suggested it but I think I'll say I can't, which sounds a bit cuntish so I'll see. He's practical, being an actor. I want his goodwill."

A couple of sessions were arranged. "He came in a car with a Slovak driver. Found it hard to get up the stairs, so I helped him." That helping hand could have scuppered them both. "The physiotherapist says it's not so good to stand either, but I can't paint if I can't move."

The sitter then cancelled. "I had a tragic message from Pinter: 'I can't give you any more time to sit.'" He died the following year. Barely begun, charcoal plus dabs, the portrait proved tantalisingly apposite: truculent disposition, brusque façade, bursting to give voice.

Coincidentally I asked Lucian whether he could still concentrate as he used to. "I think it's to do with what matters, and what I'm thinking about, and what I steer by. And—odd that you should say this because I thought about it yesterday—I thought I'd rather not go completely absent-minded, because small things to do with working really worry me and I want to get back and change them and adjust them, and then I forget what it is I wanted to change."

"I'm not an object"

A note to Frank Auerbach, 3 February 2007:

> *Dear Frank Sorry to have made a mess-up. I really wanted to talk to you and, having thought I was the one reliable person—apart from you—I now don't know where I am. Love Lucian*

"Frank came round last Saturday and rang the bell and rang it and then had to leave because Lucian didn't hear," David Dawson explained. "He wakes up and because he hasn't had the results that minute he thinks he's doomed and I completely believe him for an hour or two. I forget that he's always been like this, but now he's eighty-four it's more to the point."[1]

Given that Lucian's stamina was now ebbing away diversions became routine, as for instance in June 2007 when he was flown to Basel in the Acquavella plane for a preview of the art fair where the painting of the tall and elegant Jeremy King ("odd doing an over-life-size portrait of an over-life-size person") was shown and sold. Basel didn't detain him: after a brief look at the Cézannes in the nearby Fondation Beyeler it was home in time for tea. Another day soon after that he sat in on the colour-proofing for *Lucian Freud*, my selection of works from over seventy years, primarily an art book.[2] The long-drawn-out process prompted coughs and sighs, also protests that such and such a painting wasn't by him because it was owned by, or a portrait of, someone to whom he had taken a dislike. Late that sultry

afternoon he and the rest of us failed to notice that the transparency of *After Cézanne* was one that had been taken when the maidservant had not yet lost her clothing; consequently the painting was reproduced in a vanished state.[3]

Such an oversight would have been uncharacteristic of Lucian in the past. Now it was symptomatic. As also were his ever more testy reactions to what he took to be slights. When, for instance, Nick Serota phoned him hoping to clinch the loan of *Two Figures* (aka "The Buggers") for the Tate's Bacon show the following year and happened to say "so pleased you've agreed to lend," Lucian was so incensed at what he regarded as a presumption that despite the fact that earlier he had responded to the request with a casual "Why not?" he now decided to despatch a "You're a fucking liar" postcard. Serota wasn't to know that the painting had come to belong to Jane Willoughby while remaining in Lucian's bedroom for the duration. "She's so good at lending," Lucian pointed out. "And not lending when I say not."

Undiplomatic (and often unsent) postcards were fighting talk, better than festering distress and muddle, forgetfulness especially. Over breakfast at Sally Clarke's one morning he suffered a sort of blackout. "Something in the brain went empty," David reported. "Two minutes later couldn't remember a single thing about it."[4]

"Considering that I'm completely selfish and only do what I want to do, what am I doing forgetting what I want to do? That's the worrying thing."

Memory might lapse but reflex reactions kicked in as normal, strikingly so when flash photography occurred as part of every biennial Order of Merit luncheon at Buckingham Palace. In 2005 he had sat in the front row next to Lady Thatcher with nothing to say to her—or she to him—so he'd moved away without attracting comment. In 2007 however—front row again but between diva Joan Sutherland and architect Norman Foster—he made himself conspicuous as the only person present touchy enough to attempt to ward off the momentary blinding light. "He had his face in his left hand," the Press Association reported. "Flashes too bright." Naturally he flinched. Was this, the *Daily Mirror* wanted to know, a deliberate snub? In 2009 he was again the only OM to present himself in profile,

this time in the back row, three along from Jacob Rothschild. Every time, from his point of view, this was too sticky an occasion. Immediately after lunch, he told me, he'd asked to be shown the way out and a flunkey escorted him downstairs to a back door where, "do you know, there was a taxi waiting, a good taxi driver, tactful, knew all about it and took me home."

In any social setting Lucian was liable now to ask where he was and what he was there for; he would greet people warmly without knowing who they were, friend or foe. At a Courtauld Institute reception one evening he spied James Kirkman, his aggrieved former dealer, and asked him cheerily how he was.[5]

Working hours were dwindling, particularly the evening sessions, and eventually after sitting four nights running without him doing a stroke Ria Kirby became frustrated. Through spring and summer and now into the autumn of 2007 there had been, as Lucian admitted, little more to do on the painting of her ("needs a foot and a bit of radiator"), yet instead, night after night, it was off to the Wolseley for them. Finally she said that she would continue only until Christmas. To Lucian this was tantamount to a threat. He couldn't risk losing a sitter before he had finished with him or her. And so it happened that in late October, at long last, *Ria, Naked Portrait* (2007) went on show, briefly, at Tate Modern, aligned—boxed in rather—for glib comparison with a formulaic Balthus and a showy Christian Schad.

Lacking the energy to seek out fresh sitters Lucian fell to thinking that people he already knew might serve. Could he, should he, work from Sister Mary-Joy, say? She was too preoccupied. But Sally Clarke, neighbour, friend and sustainer, he did approach and she was happy to cooperate. "She's so good, patient and tactful. I feel a bit like a girlfriend." Sally Clarke remembered "how charming, polite and lovely he was." Sitting was "a most special" unique and privileged experience: "there is an enormous sense of kindness and thoughtfulness which envelops the person in front of him."[6]

"I like to think I can work from anyone." That was fanciful. (He had almost come to accept that the over-eager were apt to be liabilities.) Yet there were those who could be expected to both sit and buy. Another neighbour, builder turned property developer Pat Doherty—*Donegal Man*—was one such; rumpled and astute, his shrewdness and cordiality proved so reliably agreeable that two paint-

ings and an etching resulted. And then, distance no obstacle, Mark Fisch, also in property and a trustee of the Metropolitan Museum besides, came from New York every other week from 2007 to 2008. Once, for Lucian's delectation, he flew in with a small Rembrandt he owned: *Abraham Serving the Three Angels*. This went down well. "Lucian cares about his Jewish roots, it seems, and likes talking about Jewishness," David Dawson observed. Fisch had no great interest in art, he added. "It's got to be a guaranteed Old Master and guaranteed not in World War II [that is, of untainted provenance]. His Rembrandt is about the only one in private hands. That's his interest. And that Lucian's a Jew."[7]

"He has a neutral look," Lucian said.

The obituary pages, riffled through most mornings, brought sharp reminders. When Jacquetta Eliot's eldest son, Jago, died suddenly in April 2006 Lucian's reaction had been to turn to her and be patient with her in her grief, hugging her to him night after night. On the other hand he reacted with little more than a shrug when, in October 2007, news came that Kitaj had killed himself, aged seventy-four: not quite old enough to qualify as one of those who as he put it

Lucian Freud and Pat Doherty looking at first pull of *Donegal Man*

"made it new in extreme old age," his suicide being the culmination of illnesses and despair aggravated, seemingly, by a lifelong sense of predestined occasion. For him, dying one week short of his seventy-fifth birthday, the idea of ultimate greatness achieved in an artist's old age had turned desperate. In his pamphlet *Sandra Two*, he had written, "Every good artist is both a revisionist and a pioneer and if one of those two impulses ain't there, God help that artist."[8] Lucian thought this well meant but simplistic. For years his unfinished painting of Kitaj, tight-faced, eyes narrowed, had been stuck among the canvases stashed for disposal in the hallway at Holland Park. He had caught something of that Fine Artist persona, second nature to Kitaj: dogged assertion crossed with grievous vulnerability.

Defiantly, against the odds, a large (and soon enlarged) painting was begun of David and Eli companionable as ever on the studio floor and in effect readdressing *Sunny Morning—Eight Legs*, this time with fewer legs. "I will alert you when there's something to see." Then he went quiet. In mid-November I found myself sitting next to him after a dinner at Bentley's restaurant following a private view of paintings by Keith Tyson, a youngish artist of whom he had been unaware but to whom he was now introduced. He yawned enormously and peered around. "Villiam, why are we here?"

Gaps, setbacks and occasional excursions interrupted what remained of studio routine. Crucially it was arranged that in mid-December Lucian would once again go by Acquavella jet to New York, this time for the opening of "The Painter's Etchings" at the Museum of Modern Art. "Out on Monday, back on Wednesday," he emphasised. "Not too long." This would be a pleasing, if sixty years belated, riposte to a snarky remark from Alfred Barr in 1948. "That man who was in charge of the Museum of Modern Art said to me: 'You're certainly one of the best technical people working now.' In other words 'Fuck off!'" And now in the catalogue Glenn Lowry, the Director of MoMA, gave Lucian a Barr-like accolade, pronouncing him "a resolutely singular figure" while being "among the foremost artists working today."[9] The exhibition's curator, Starr Figura, offset that with a cogent essay in which she wrote of Lucian "overturning expectations and dispensing with narrative supports."[10]

Arrangements for the three-day there-and-back became complicated. "Susanna's not coming, no. Things are quite careful. She won't

go on a private plane: too sensible for that or Concorde." However, at Lucian's suggestion Dr. and Mrs. Gormley hitched a ride as their bucket-shop airline booking for a trip to New York had fallen through. It wasn't just that he felt he could do with a medic to hand. "Doctors don't earn very much do they? He had trouble with his ticket so it was a good idea for him to come too." Acquavella booked him into the Carlyle Hotel on 57th and Madison, a suite booked under the usual false name with an adjoining room for David, who anticipated Lucian wandering naked into corridors to the distress of fellow guests. But he didn't. "It went smoothly. I was flying under water while Lucian was calm. Acquavella helped: never left his side, looked after him throughout and he appeared at the pre-party and all were satisfied."[11]

When a month or so later I went to give a lecture at MoMA I saw, for the first time, the recent portraits aligned as a trio: *The Painter's Doctor*, *Donegal Man* and *The New Yorker*, the latter being Bill Acquavella, seen also as *New Yorker in a Blue Shirt*, patently shrewd not to say downright quizzical as he watched Lucian at work on him. The next day I called on him in his office, finding him in the process of selling an untypically good Vlaminck. He complained about Lucian's dwindling output. "Can't deal in him while there is this lack."[12] Two paintings had failed to sell at auction the previous week. There was no possibility of another show in New York in the near future.

In January 2008 David arranged another trip to Paris by Eurostar, this time to see Courbet at the Grand Palais, an exhibition more powerful throughout than even the Louvre's great Ingres show had been. Telling me about it the day after, Lucian was vague about the speedier than ever journey there and back but the paintings, he agreed, were astounding. "So humorous. I was amazed. That crazy one of him standing in front of the sea. Completely Surrealist. (I stand all the time too, of course. I can hardly walk.)" He checked through his diary ("the book") to tell me what little, beyond those marvellous Courbets, had been affecting him. A new sitter, Perienne Christian, a recent student at the Prince's Drawing School, was sitting three nights a week, cheerful, keen, happy, so far, to accompany him to the Wolseley. Good all round. "Undressed she has curves and bulk perhaps you would not notice." I asked how his self-portrait was coming along. "Self-portrait?" He bristled. "Remind me. I'm sitting by my book so I can tell you what I'm doing. Mark. Alexi . . ." Alexi Williams-Wynn

was back but wouldn't be around for long, I gathered, given her pressing, hence to his mind restrictive, devotion. He seemed occupied once more; however, when I looked in one afternoon to see what had come to be called *Portrait of the Hound* (Eli and David sprawled on a mattress) it was still barely begun. David had written the title on the wall to make sure of that at least. There was a hint of balladry to it, we agreed. "And that's his voice," David added.

David had been sitting every day for six weeks but Lucian was listless again, seemingly incurious. Frank remarked how difficult talking to him had become.[13] Rather than converse he had taken to lobbing questions. "Who?" "What?" "Remind me." Yet he could still manage spurts of concentration on the work in hand. "He has control to that degree," David said. I asked him what had prompted Lucian to phone me that day. "Because your name was in the book; it's all down to the book listing what he must do."[14]

Out in the slipstream world of the art market, though, Freuds were doing well. In May 2008 *Benefits Supervisor Sleeping* went to Roman Abramovich for £17.2 million ($33.6 million) at Christie's in New York, setting a briefly held world record for a living artist at auction. The following month *Naked Portrait with Reflection* (Rose Boyt on the sofa with the painter's legs mirrored behind) fetched £12 million, also at Christie's. This was just months before the 2008 financial crisis took effect, concerning which Lucian professed to feel as detached as any other seasoned gambler. When one afternoon we talked about non-doms leaving Britain rather than pay tax he turned pensive. "How strange they are," he said. "And what a strange preoccupation, money."

In July the indefatigably self-confessional artist Tracey Emin threw one of her birthday parties. Among the many jamming the kitchen of her elegant Spitalfields weaver's house was Ivor Braka, a dealer whom Lucian had always liked for his expertise, his wealth of gossip and his artfully dishevelled appearance. ("He doesn't have a hair-do: he has a hair-undo," he once observed.) With him was Jerry Hall. And suddenly, as though implanted from on high, Lucian and David appeared, there because Tracey, David's friend from Royal College days, had approached them at the Wolseley a few nights before and urged them to come. David looked keen, Lucian querulous. "Where are we?" he asked me. Noticing Ivor and Jerry opposite

him, across a table laden with popeyed sardine heads poking through stargazy pie crusts, he twitched and muttered: "What IS this place? WHY are we here?" Time to butt through the crowd and out into the street. Back to the Wolseley for them.

Later that summer he was advised to have titanium screws inserted into his lower jaw. Though this involved more than five hours under local anaesthetic, he said afterwards that he thought it had taken no time at all. It was possible that he had had a number of small strokes over the preceding months; certainly his concentration wavered. David's responsibilities had now deepened to such an extent that he became exasperated at times with those who sought to advise and ordain. There was, he said, competition among the daughters over who had most recently lunched with Dad; yet meanwhile he, David, was "stuck with the tedium and worry."[15] Slowly, *Portrait of the Hound* took shape, David's sprawl firming up. As with *Ria, Naked Portrait*, areas of particular concern (knees, neck) were hardening into excrescences. It seemed that accretion was being taken to represent, and justify, time spent.

"Are you working?" I asked.

"Never stop! Not quite."

David phoned one afternoon while exercising Eli in Kensington Gardens. He sounded numb. "Eighteen hours a day: it's too much. I buy sleeping pills and I lock up and leave and then I wake him up every morning, sit in the morning and have supper in the evening. He's depressed. Doesn't know anything. The last three and a half weeks he has got steadily worse. He drinks every night, two glasses of wine then he's relaxed and happy and phones Susanna." The cancer detected some time before had not been eliminated. It was in the lymph glands and spreading. There was nothing to be done about it and David couldn't tell whether or not Lucian was aware of this. "He's still the same person: doesn't do things unless he wants to. Luckily the venom hasn't come out of him yet."[16]

"I think about avoiding death, keeping it at bay," Lucian had said to me not long before. "I think there's death after death."

In the autumn "Lucian Freud: Early Works, 1940–58" was staged at Hazlitt Holland-Hibbert (a gallery round the corner from Christie's, backed by John Morton Morris) with David involved in the selection and Catherine Lampert adding catalogue commentary.

Intentionally or not it indicated the unlikelihood of there being any further shows of new work. On a Sunday morning, three days before it opened, David brought Lucian, with Jane Willoughby, to take a look. Lucian had little to say, standing awkwardly and then turning on his heel, hands jammed in overcoat pockets. The paintings, drawings and sketchbook pages, displayed just around the corner from Christie's and classifiable (in auction-house parlance) as Pre-Modern British, looked lively but circumscribed, hailing from another age. A dinner was held at the Royal Academy after the opening and he was more animated there, sitting with Susanna and older cronies, also—a first—his nephew Matthew Freud, son of Clement. His recent and current sitters, Sally Clarke, Pat Doherty, Jeremy King and Perienne Christian, were, of course, among the guests, their very presence reasserting the possibility of paintings to come.

Three weeks later Lucian was filmed for *Channel 4 News* looking at Titian's *Diana and Actaeon* and talking to Nicholas Penny, the National Gallery's Director, about saving for the nation this crucial painting and its companion piece *Diana and Callisto*, on offer from the Duke of Sutherland for £100 million the pair. He appeared tentative, as usual when caught on camera, edited down to just a few remarks. Yet what he felt—that lingering thrill—was palpable. "When something's really convincing I don't think about how they were done. I never think like that. Because when colours work I think of the colour of life rather than 'coloured.'" Here was wonder tinged with incredulity. "With really convincing pictures the thing they have in common is how *could* they have been painted?"[17] To him such pictures seemed replete. Brimming somehow. As did Ingres' representation of Thetis enticing Jupiter, gazing up at him and grasping his beard between thumb and forefinger, the set-up that he himself had mimicked rather in *The Painter Surprised*. Such "really convincing" pictures (among which I wouldn't necessarily include *The Painter Surprised*) are operatic in the fullest and deepest sense.

The many Auerbachs that Lucian now owned were incitements, he maintained. "I would be disconcerted if I tried to paint like he does," he said to me around this time. "It's to do with training, imagination and temperament. He puts down so much in one go. I'd love to work like that. I wouldn't though."

Progress on *Portrait of the Hound* slowed from fitful to minimal.

"It's really not got far," David reported. "Working this morning: three brushstrokes on my shin. He's so lost."[18] This wasn't simply down to loss of stamina. The painting had become something to be getting on with, as in an exercise yard. There were business matters too. Shortly before Lucian's eighty-sixth birthday in December 2008 Diana Rawstron spent "three Freud days" setting up a non-profitmaking Lucian Freud Archive with herself and David Dawson in charge, the plan being to avoid children and grandchildren having to be consulted over picture copyright permissions and so on in future years. The birthday was celebrated with Frank and Julia Auerbach coming to dinner at the house in Kensington Church Street. All evening Lucian sat holding Susanna's hand.

Five months later, on 14 April 2009, Clement Freud died. Few of the obituaries failed to mention that he hadn't been on speaking terms with his ultimately more famous brother. Which irritated the latter. It was fine for him to rubbish Cle but not for others less entitled to do so. "How did he die?" he asked me with studied unconcern. "Why did he die? Heart attack or stroke presumably? Death in the night." David took this to be calculated understatement. "What he says and how he feels are not the same thing. Ever."[19] Lucian's last words to me about Clement, brother on brother, were consummately laconic: "We never got on. He's dead now. Always was, actually."

By this time preparations were well advanced for "Lucian Freud: L'Atelier" at the Pompidou Centre, a venture designed to serve as evidence that the artist was alive and working in time-honoured fashion. Unlike the previous Freud show there in 1988, it was to be more programmatic than retrospective, identifying the artist as one who, within the confines of a traditional studio, followed on from Ingres and Courbet. It promised to rival and even outdo in impact the Bacon shows at the Grand Palais in 1971 and at the Pompidou in 1996.

Noon on 12 September: I arrived, by appointment, rang the bell and waited for quite some time before there was a thumping of feet down the stairs and Lucian rattled the door open, dipping his head in greeting. He had been working, he explained, evidence of which being fresh streaks of paint on his apron, but little progress had been made. *Portrait of the Hound* still hadn't begun to feature Eli. Ever the habitual whippet, Eli slumped on the mattress with outstretched legs, seemingly resigned to spending the rest of the day there. Lucian lin-

gered in the other half of the room as though unconcerned. David reminded him that the foot doctor was coming at four. "Hooray!" he responded listlessly. "Hooray!"

It was apparent he had little or no idea of what to do when David wasn't there. He hadn't the concentration for reading, not even the newspapers now, and he would complain that his leg hurt whenever David suggested a walk. Distractions were needed and these tended to revolve around reminiscence. At a Sotheby's lunch on 1 December I was seated next to Lucian. Jane Willoughby, on his other side, was characteristically saying little so, stuck for something viable to talk about, I remarked that Johnny Craxton had died about a fortnight before. "About time too," he said.

One afternoon a few weeks later Lucian slowly lowered *Portrait of the Hound* on the easel until, it being a dark afternoon, the fading daylight lay evenly across it. "Is that right?" David's face and kneecaps were still focal points in the nest of rumpled bed linen; Eli was edging in but not yet substantially so. Again the question arose: was there to be more Eli? Lucian said yes, but David, all too aware that things were idling, pointed out a head of Sally Clarke, the etching plate so gouged and scratched that he had fixed it and left it at that: shadow crusted with chalk marks. Obviously all works were being put on hold. Perienne Christian was still engaged and turning up to sit. "She doesn't seem fazed by not doing much," David said. "At least she's not in love with him. She is so unlike all the rest. So much younger."[20]

As I left, Lucian, slumped in a chair, raised both fists like a boxer resignedly acknowledging victory. "He's claustrophic," David said as he saw me to the door. "Does nothing but go out in the evenings. Which he likes."[21] Though the occasional excursion did please him: private plane, for instance, to Amsterdam (flight arranged by Jay Jopling) and a visit to the Rijksmuseum closed for renovation at the time but the Director, Taco Dibbits, was there to show him Rembrandts. David photographed him in the conservation studios with an unframed Van Gogh self-portrait, steadying it by pinching one corner between finger and thumb.

And then, just ahead of the spring season, there was the inauguration of "Lucian Freud: L'Atelier" at the Pompidou in March 2010, a formidable social occasion: jammed external escalators buzzing with the exasperation of those held back while diplomats and other such

guests were ushered ahead. What a contrast between this and the indifference shown at the soirée twenty-two years before when many of these same works were exhibited there on a lower—lesser—floor. A bewildered Lucian in a fine new suit was jostled through the rooms encircled by dignitaries and photographers. Approaching him in the hubbub his teenage granddaughter Lucy Costelloe said hullo but, bemused as he was, he failed to recognise her.

This time, commencing with *The Painter's Room* (1944)—that boulevardier's retreat adorned with zebra head—the exhibits were sorted into themes and phases, more regulatory than necessary for works so individually urgent, and culminating in the paintings of Leigh Bowery, aggrandised yet vulnerable, and "Big Sue" Tilley, while those stemming from or, rather, invoking and connecting with Titian, Watteau, Constable and Cézanne were passed off as, essentially, tribute acts. Self-portraits had a room to themselves.

The intention, clearly, had been to stage something approaching a re-enactment of Courbet's *The Painter's Studio: A Real Allegory*; in this instance it amounted to a multiplex tableau. To this end at both start and finish there were rooms of introductory and valedictory films and photographs of the artist and his milieu.

Six months before the opening David mentioned that he had made a film for use in the exhibition: "OK as a preliminary. Four minutes or so of me and Lucian in the studio." The Pompidou had bought 3,000 DVDs of this for sale. He called it *Inside Job* and it showed Lucian making a brief and irresolute stab at working on *Portrait of the Hound*. The full DVD, at twenty-eight minutes, also featured John Richardson reminiscing with Lucian about goings-on in wartime London, that madly busy bar in the basement of the Ritz being what most readily came to mind. A further film, screened at the exit, was *Small Gestures in Bare Rooms*, directed by Tim Meara, featuring David, the caretaker as it were, approaching 36 Holland Park in reverent mood, rain dribbling across his windscreen, and entering the deserted studio with Eli at his heel snuffling dust, there to gaze on paint-encrusted walls and ever-dripping tap. Cut to Lucian traipsing bewilderedly along the Regent's canal towpath with a kestrel perched on his wrist. Quite why was all too obvious.

After the opening Acquavella threw a dinner for sixty-five at the opulently appointed hotel Le Meurice in the Rue de Rivoli. Lucian

was seated between Jane Willoughby and David Dawson to ensure that there would be no call on him to chat. The next day Acquavella flew them and others to Madrid where in the Prado, it had been proposed, a number of paintings might be installed. (This was cancelled shortly afterwards, on account of the Spanish financial crisis, but an appended bid from the Kunsthistorisches Museum for these paintings, and more, to be shown in Vienna did go ahead in 2013, the museum authorities considering redundant Lucian's resolve never to exhibit in the land of his murdered great-aunts.)

That morning in the Prado David photographed Lucian with Acquavella at his side, hands in pockets both of them, paying their respects to *Las Meninas*. Lunch followed and after that the flight back to London. "By Saturday he could just about remember where he was," David reported. "But really it was horrendous. He had no idea about anything."

Yet he had responded to *Las Meninas*, perhaps even more strongly than when he had first seen it, in 1953. "He was always alert where it came to art," Celia Paul observed. "Looking through the catalogue of his exhibition at the Pompidou Centre he was displeased at the juxtaposition there of his self-portrait next to a Bonnard self-portrait. 'Ugh! What's that horrible thing?' (pointing to the Bonnard). I think it may have seemed a bit 'holy' to him compared to his own uncompromising self-portrait. He was hurt that more people hadn't written to him about his Paris exhibition. I think that he wasn't aware how few letters people write in this age of emails."[22] Just over a quarter of a million people, around 3,000 a day, saw the Pompidou show.

Coincidentally *Small Gestures in Bare Rooms* swelled in scale and pretension for, hoping to complete an extended film to coincide with Freud's ninetieth birthday the following year, Meara proceeded to stage symbolical tableaux: *Sunny Morning—Eight Legs* with a dancer (Australian ballerina Amy Hollingsworth) positioned under the bed and *Evening in the Studio* with Nicola Bateman in person discovered, Penelope-like, embroidering again (as in *Evening in the Studio*) the nuptial bedspread for herself and Leigh Bowery.

The Painter's Room was revisited too in skeletal form: a framework the same dimensions as the room in Holland Park and garnished with paint rags. "Originally we were going to get Michael Clark to do a piece," David explained. "But we got rid of him and got an anony-

mous dancer [Amy Hollingsworth] and the bed, which we got across from Holland Park." To complete the tableau a zebra (named Lulu) was hired and brought from somewhere in Shropshire to the film studio in Acton, west London. "It was an exciting opportunity to meet a zebra," Meara later explained. So Lucian was brought along to witness and involve himself a little.[23] "We got a film of it, fifteen minutes," David said. "Wanted a shot with the zebra, but it was moving its head, the rein was tight, slipping, and Lucian fell. The zebra pulled him over. Horrendously shocking and I rang the Cromwell Hospital. They did X-rays: there's nothing broken. Bruising and groin strain. Physio came and he's got a Zimmer frame. Stayed in bed for five days and then I told him he had to get going again."

Kate Moss dropped in bearing flowers and cuddled up to him in bed. "He pulled back the covers and went, 'I've been keeping it warm for you.'"[24]

"Lucian allows anything these days," David reported. "Loves publicity. He's dozy but OK though, in that the scans showed him to

Kate Moss and Lucian Freud in bed

be OK. Of course, the cancer will come back. But he's more robust. Slightly."[25]

"He moans, but more to his children and Susanna. I say, 'There's nothing wrong with you,' so he doesn't go on about it to me. I was with him yesterday afternoon, he was lying in bed chin-wagging then Susanna called and immediately it was talk about 'nervous tummies.'"[26] Lucian agreed that he was, and always had been, a committed hypochondriac. "I'm a terrible fuss-maker about the slightest thing." Which made David all the more indispensable. As Frank Auerbach said, "David now thinks of himself as Lucian's other half."[27] That summer David took Lucian with him to the farm he now owned in mid-Wales (formerly his parents' place), anticipating an enlivening stay for a day or two. But as soon as they arrived there Lucian phoned Susanna and then turned to him and demanded, "Can I get a taxi round here?" He had to go home immediately and so after an hour's rest—Lucian comatose on a bed while he dozed ("Susanna makes these crises") on the sunny hillside—David drove him straight back to London.

More successfully, there was a midsummer-day trip to Corsica by private plane with John Morton Morris, the object being to see several Titian portraits of men, assembled at one of the provincial *grands musées* of France, the Fesch Museum in Ajaccio. Two paintings came from the Louvre; one belonged to the Fesch and one to Morton Morris. It was Lucian's idea to go, prompted by Morton Morris, and David saw it as a purposeful joy ride. "He has some energy and it filled the time, a year exactly since the alarm over the cancer and the treatment, so it is amazing to that extent."[28] But when, soon after that, he took Lucian to see John Richardson's "Picasso: The Mediterranean Years" at the Gagosian Gallery in Britannia Street near King's Cross, piquant though it was, it barely registered. "He didn't respond at all. He's OK. Not crazy, but blank." Easier alternatives were afternoon excursions: being driven around by David or Susanna to once familiar places, to an unaltered St. John's Wood Terrace, to the blandly reconstructed Delamere Terrace (sixties council flats, the high wall between canal and street now vanished) and past the plum-coloured bulk of St. Mary Magdalene church to the site of Clarendon Crescent, now grassed over.

Mid-morning, 25 July 2010: Lucian opened the door, beaming,

and led me upstairs to the studio where David gathered his clothes and, once dressed, adjusted the easel to the best height for viewing *Portrait of the Hound*. Eli was still little more than wisps of white and russet. After well over two years on the go the image of David was getting to look overstretched; as for the painting of Perienne Christian in the night-pictures half of the studio, it appeared to have stalled. Lucian sat sipping water. "Frank sends his love," I told him. He looked puzzled. Then he said, "I was fond of him." We looked through drawings from a sketchbook, dating them for cataloguing and exhibiting in two years' time. I suggested 1982 (probably) for one of them. Lucian brightened. "I like two as a number," he said. "Always have. Eight too." So 1982 it was.

Day-to-day arrangements were improvised then settled upon for the time being. By the autumn Susanna was coming in late at night three nights a week. "Well, he's not miserable," she told me. "He says he wants to go on living, though he has a real low minute, around five or six o'clock. He can't keep up. The infuriating thing is that when he's resting he'd normally think about what he's painting, what he's doing, but now [resting] upstairs in the bedroom, now he can't."[29]

I remembered Lucian saying to me once that in the event of his being incapable of painting any further he would sit for Frank (as I'd been doing every Monday evening since 2003) and thereby make himself useful. I couldn't see him doing that. After all, he'd been a pretty useless sitter for David Hockney. Susanna suggested, unconvincingly, that maybe he should or could sit for David Dawson as he had once for her. "I was doing sculpture and he sat for me in the bath. Didn't last."[30]

Frank and Julia Auerbach had Lucian to dinner as usual on Christmas Eve and in the absence of David, who had gone off to a family Christmas in New Zealand, Susie Boyt arranged for Lucian to be delivered by chauffeured car to the Auerbachs' accompanied by Frances Costelloe for whom that would be an odd evening out as most favoured granddaughter. The stew Frank cooked wasn't, he admitted, an unqualified success. "Too many vegetables and Lucian ate nothing. However, he mainly eats nougat now."[31] That and cheese sprinkled with salt. Or salt only.

On 11 January 2011, Kitty (Garman/Godley) died. I half expected

Lucian to mention this (there were several obituaries) but nothing
was said. Annie Freud called me one evening after seeing him. "His
power—expression—has gone," she said. Towards the end of January
he came to the opening of a Celia Paul show at the Marlborough.
Seeing him standing cagey yet benign in overcoat and muffler, among
strangers mostly, Jacob Rothschild assured me that Lucian was on
such good form that he was going to produce an etching—or possibly
a painting—to go with a display of Chardins he was putting on the
following year at Waddesdon Manor. "Unlikely," I said. "How long
does he work each day?" "A few minutes at most."

Saturday 5 February: breakfast at Sally Clarke's: out-of-hours
entry via the side door. Saturday being a day off for Geordie Greig
(then editor of the *Evening Standard*), he phoned David from the
street, as was his habit when, as he said, he "happened to be passing."
"You don't mind him coming round do you?" David asked moments
before Greig appeared. Obviously I didn't: only Nicky Haslam,
socialite and interior designer, could match Geordie for current and
vintage gossip to which Lucian could still contribute, albeit fitfully.
("Gossip," Lucian had told me once, "is only interesting because it's
often all there is about anyone.") Walking back to the house half an
hour later David remarked that Lucian's conversation was now "all
on the Joan Collins level." The actress and former starlet was a regu-
lar at the Wolseley, so much so that Lucian invited her to join him
at table one evening. "She kept pestering and Lucian kept grabbing
her knees and arm, which she loved," David said. There had been
a fruitless encounter on the canal bank in Paddington, she revealed
afterwards in the *Spectator* Diary. That would have been around 1950.
"He invited me to his studio for a cup of tea. He told me his name was
Lucian and asked if he could sketch me."[32]

By March the cancer had recurred and the question now was
whether to continue with treatments or opt for palliative care. It
was decided that Lucian should go into hospital for the removal of
a growth in his bladder and prostate with an epidural, not a riskier
anaesthetic. "I think we should give him another go," David said.
"There's another year in him, which gives him time to finish the big
picture."[33] There was also his National Portrait Gallery exhibition
in prospect, scheduled for early 2012, and though that had begun to

look like becoming the memorial show he did enjoy the anticipation and reading about it (and himself) in the papers.

"It was only an epidural but Lucian kept freaking out," David told me afterwards. "He pulls all the tubes out. He gets aggressive, acts like a baby, jumping and shouting out. The nurse was there all night with him. Can't have an operation but, in theory, the process was to be repeated in four months' time." Mark Pearce, Rose's husband, was with him that morning, sitting by the bed.

A week later an ominous quiet set in. "Lucian's in bed, hasn't shown any signs of stirring and he isn't eating. Nothing since scrambled eggs three days ago. The daughters come round and are obsessed with reading to him." A sensible thing to do in that it relieved the reader of the strain of making conversation and, being read to, the patient could doze. Better poetry and *Middlemarch* than faltering bedside chat. Susanna spent nights with him and tried to get him to eat, tempting him as and when with cup of tea and tiny cake. "He has a mouthful and then chews and then stops, chews and spits it on to the plate. That's what he did at the Wolseley: chew, spit and place a bit of cabbage on top." Three days on and he rallied a little. "Starting to eat," David reported. "Suddenly he's been talking a bit. The cancer's mutated. He'll have to repeat the scrape. He did ask this morning: 'Am I working on something?' "[34]

In theory, given months rather than just weeks to live, painting was a possibility; or, rather, a theoretical necessity, as Michael Gormley stressed. "The bottom line was that he had trivial complaints until the cancer. There wasn't a serious eye problem. In his view anything that interfered with his work was serious."[35] Mid-April and, according to David, Lucian got going again, briefly. "This morning he mixed colours—he selected them and lingered over the tubes and put it on the canvas—twenty minutes at it and he was focused. The trouble is once he's in the habit of not working what is there to get him going?" They went to see Watteau drawings at the Royal Academy. "It was hopeless. Five minutes." But he did paint a little the following morning. "He worked on Eli. A bit of white on the nose and it looks like Eli's cocked his ear up now: a real addition. Lucian's about listening not just looking."[36]

A few days later, on 7 May, a Saturday morning, I waited in the studio until Lucian appeared, unshaven, sat with a thump, cocked one

leg over the chair arm, changed his mind, got up and went to pee, came back into the room and suddenly, urgently, said that he liked to get drawings back to destroy them.

Thursday 30 June: David on the phone: "Downhill, on morphine. He's in a dream world really, has been for two weeks. Just moves around the house. He's had no food for two weeks, though he has picked up on drinking. He's like a little bird. Susanna does weekday nights. (We've tried nurses but he doesn't like people being in the house.) It's been family family all the time during the day. He's very, very confused. Doesn't know how to make sentences. But Jane [Willoughby] has been in and he said, 'Hello Jane. I'm fashionably thin.' He has spells of being manic, walking up and down. I can't persuade him to do anything. He's all pointed and hollow. Yellow and there's anguish underneath. The daughters keep reading him poetry."[37] Their voices, the rhythms, stood a chance of sinking in; their attention was, individually and collectively, the best possible solace.

Later there were to be accounts of Lucian speaking confidently, lovingly, apologetically even, to those admitted to the bedroom. According to Lucy McAdam Freud, who hadn't seen him for fifteen years, he stroked her cheek and cuddled her, telling her he was "a very selfish person."[38] Her brother David took the opportunity to sketch him—he later exhibited a number of deathbed watercolours—while their sister Jane proceeded to sculpt a two-faced head. "All of the McAdam children are artists," the *Daily Mail* reported.[39]

Probably Lucian was unaware of any graphic objectification undertaken at his bedside. "His brain is there and he frowns but he can't do words," David said on 16 July. "He's trying to look at death." Susanna had gone off to Italy. Drug doses were doubled. "He tries to get up and collapses. Talks a bit but has nothing to say. He holds hands and can look at you but that's about all."[40]

When I arrived the next morning it was to find the house tidied, partially cleared and preternaturally quiet. A nurse was sitting outside the bedroom. Jane Willoughby had arrived a few minutes before me and settled with a book just inside the door. Lucian had been restless all night. Head sunk into the pillow, mouth open, soft breathing, he was heavily asleep, his solitude watched over.

Anne Dunn rang from France. Francis Wyndham had told her Lucian was poorly and she wanted to know more. "I can't imagine

him not being here." She had last seen him, she told me, at her eightieth birthday party a year or so back and was shocked that he didn't recognise her. Her great-niece was with her and she, being a little girl, was told not to touch him. "I'm not an object," he'd protested.[41]

"He's a little bit less," David reported the following Wednesday. "Big gaps in the breathing. I think he'll die at four tomorrow morning: that's when people do. He's gone already really. Been asleep for two or three days. I sit and hold his hand and tell him things. I'll put in another couple of hours then I'll go home and go to bed. There'll be nothing to do."[42]

Thursday 21 July: David phoned. "Lucian passed off in the night. Died peacefully, just stopped breathing. Mark [Pearce] and Kai [Boyt] were with him." Not Rose: her feeling was that had she been there, close beside him, he would have felt hindered somehow.

"When I die I want nobody there," he had often said.

The undertakers were due to come at nine o'clock and there would be no press release until he'd been taken away. As it happened, though, the body was removed from the house five minutes before that and my phone rang: the first of many quick calls from news desks for confirmation and comment.

Afterword

The headlines that appeared in following days ranged from disproportionate ("Colossus of art world 'lived to paint'": *Daily Telegraph*) to the more measured "Lucian Freud, Figurative Painter Who Redefined Portraiture, is Dead at 88" (*New York Times*) in which I was quoted as saying: "Freud has generated a life's worth of genuinely new painting that sits obstinately across the path of those lesser painters who get by on less. He always pressed to extremes, carrying on further than one would think necessary and rarely letting anything go before it became disconcerting."[1]

Regardless of the provision made by Sigmund Freud that his ashes and those of his widow and descendants were to be preserved in Golders Green crematorium,[2] and disregarding Lucian's throwaway wish to be rolled in a blanket and dumped in the canal, Rose, on behalf of her siblings, had bought a burial plot in Highgate Cemetery, primarily for their father but also, at a later date, for Suzy their mother.

It was thought—Rose's initiative—that the funeral on 27 July would be best conducted by the Archbishop of Canterbury, Rowan Williams. He was touched, he said. "I being the only priest she's come across. It was a difficult assignment as to what was appropriate." No vestments, he decided, and he used the Book of Common Prayer. "Just family."[3] That included the McAdams, who one after another had become by deed poll McAdam Freuds, and Francis Eliot, now a qualified whirling dervish practising in Hebden Bridge. Virtually all friends and associates were excluded. "Most of us aren't expected or

even wanted," Diana Rawstron said, exceptions being, of course, Jane Willoughby and David Dawson.[4] Also Sister Mary-Joy who was asked to bring along Sioux the gelding mare. David, Mark, Kai and Ali, assisted by professional pallbearers, shouldered the lead-lined coffin from chapel to grave.

Rowan Williams' sister-in-law, Celia Paul, regarded the funeral as something of a healing ceremony. "Rowan's moving sermon stressed how one doesn't 'own' anybody. I think many people feel posses-sive when someone they love dies, and in Lucian's case, because of the intensity of the attention he gave people, most particularly so. It worked better for the family, made them feel better for themselves. That was good. Rowan talked about Redemption."[5]

"I remember saying at the funeral that Lucian would always bring life to a situation," Rowan Williams commented. "His works do that: something charged."[6] Suddenly, silently, during the burial, Esther remembered, a fox appeared.

"Everything is autobiographical. And everything is a portrait."

Six months later, in February 2012, a memorial gathering at the opening of the National Portrait Gallery's "Lucian Freud Portraits" was an occasion for speeches by, among others, Ali Boyt and Nick Serota and an opportunity for many of Lucian's diverse associates to mingle for the first time. Those present but also represented on the gallery walls saw themselves already recruited into that peculiar after-life existence conferred on all in the Freud oeuvre.

"The one thing more important than the person in the painting is the picture."

The dispersal of Freud's collection was a prime concern. His Corot (*L'Italienne*) went to the National Gallery under the Accep-tance in Lieu scheme. His Auerbachs (forty or so altogether) were distributed around museums and galleries in Britain. The residue of the studio clearances, including sketchbooks and "countless" letters (to him), went to the National Portrait Gallery. The house in Ken-sington Church Street went to David Dawson, who reroofed it and cleared the wilderness behind.

Freud's wealth at death was £95,917,859. Probate was granted on 27 April 2012 leaving a £42 million estate to be distributed among his heirs. His executors, Diana Rawstron and Rose Boyt (Pearce), the latter having been nominated thirty years before ("She's so sensible,"

Lucian used to say), were made responsible for fulfilling his wishes. A secret trust had been established authorising them to distribute the legacies in strictest confidence, the beneficiaries being those Freud favoured and with whom he associated. An action brought by Paul McAdam Freud to invalidate the will of May 2006 was dismissed by the High Court in 2014. Had it succeeded, the estate would have been declared intestate and therefore liable to be exposed to demands from diverse claimants of "uncertain paternity."[7]

On what the Highgate Cemetery lists as "Memorial ID 73743429" the epitaph reads:

<div align="center">

LUCIAN
FREUD

Painter

Berlin 1922
London 2011

Beloved Father and
Grandfather

</div>

Inscriptions such as this address the living while circumscribing not to say objectifying the deceased. The elderly Freud's reaction to a child (Anne Dunn's great-niece) when in all innocence she reached out and touched him qualifies as a definitive response: "I'm not an object," he said. Whereas, of course, a picture essentially is just that.

The painter's task is to convince, Freud told his Norwich School of Art students in 1964 when instructing them to produce naked self-portraits. "Try and make it the most revealing, telling and believable object. Tell people you've been alive."

"The only thing that's interesting about art present or past is quality. The whole mystery of art is why good things are good."

As for himself, he repeatedly said: "I've had a marvellous time."

Anything to add?

"I've always liked lipstick on the teeth."

NOTES

1 "THE POINT IS THE FOREHEAD"

1. *Vogue*, "50 Years in Vogue," Golden Jubilee issue, 15 October 1966.
2. Jacquetta Eliot, conversation with the author, 30 June 2000.
3. Ibid.
4. Ibid.
5. Ibid.
6. Ibid.
7. Ibid., 5 July 2000.
8. Ibid.
9. Ibid.
10. Mary Rose Beaumont, conversation with the author, 20 February 2014.
11. Ibid.
12. Ibid.
13. Ibid.
14. Andrew Cavendish, Duke of Devonshire, interviewed by the author in *Lucian Freud: Portraits* (2004), film directed by Jake Auerbach, produced by Jake Auerbach and William Feaver.
15. Ibid.
16. This may have been a novel. Her only published book was the memoir, *Henrietta* (London: Hamish Hamilton, 1994).
17. Dr. Paul Brass, conversation with the author, 24 April 2005.
18. Alice Weldon, conversation with the author, 19 March 2014.
19. Giorgio de Chirico, "Statues, Furniture and Generals," in *Hebdomeros* (Cambridge, Mass.: Exact Change, 1992), p. 246.
20. Stanley Spencer, Spencer papers, Tate Archives: Tate 733.3.1.
21. Esther Freud, *Sunday Telegraph*, 29 January 2012.

2 "I CUT SUCH A LOT DOWN THEN"

1. William Feaver, "Stranded Dinosaurs," *London Magazine*, July/August 1971.
2. Leland Wallin, "The Evolution of Philip Pearlstein Part II," *Art International*, September 1979, p. 58.

3. David Sylvester, *Britain Today*, June 1950.
4. Spencer papers, Tate Archives.
5. Ibid.
6. Ibid.
7. Sigmund Freud, "The Uncanny" (1919), in *An Infinite Neurosis and Other Works*, vol. XVII of *The Standard Edition of the Complete Psychological Works of Sigmund Freud* (London: Hogarth Press, 1953–74), pp. 219–20.
8. Jacquetta Eliot, conversation with the author, 30 June 2000.
9. Ibid.
10. Frank Auerbach, conversation with the author.
11. Jacquetta Eliot, conversation with the author, 5 July 2000.
12. Ibid.
13. Ibid.
14. Ibid., 30 June 2000.
15. Ibid.
16. Ibid.
17. Ibid.
18. Ibid.

3 "PICTURES HAVEN'T GOT TO DO WITH REASON"

1. Frank Auerbach, conversation with the author.
2. James Kirkman, conversation with the author, 21 November 2019.
3. James Kirkman, letter to the author, 15 December 1999.
4. Ibid.
5. Marina Vaizey, *Financial Times*, 18 October 1972.
6. William Feaver, *Newcastle Journal*, 25 November 1972.
7. William Feaver, "New Realism," *London Magazine*, February 1973.
8. Ibid.
9. Sigmund Freud, "A Childhood Recollection from *Dichtung und Wahrheit*" (1917), in *An Infinite Neurosis and Other Works*, vol. XVII of *The Standard Edition of the Complete Psychological Works of Sigmund Freud* (London: Hogarth Press, 1953–74).
10. Jacquetta Eliot, conversation with the author, 30 June 2000.
11. Daniel Farson, *The Gilded Gutter Life of Francis Bacon* (London: Century, 1993), p. 190.
12. *Parkinson*, BBC Television, 7 October 1972.
13. Geoffrey Grigson, in Stephen Spender (ed.), *W. H. Auden: A Tribute* (London: Weidenfeld & Nicolson, 1975), p. 25.

4 "THE PORTRAITS ARE ALL PERSONAL AND THE NUDES ESPECIALLY DEMAND IT"

1. Anne Dunn, conversation with the author, 16 April 2000.
2. John Russell, introduction to *Lucian Freud* (London: Hayward Gallery, 1974), p. 5.
3. Quoted in ibid., p. 13.
4. John Russell, *Sunday Times*, 27 January 1974.
5. Ibid.
6. Kenneth Clark, *Edvard Munch 1863–1944* (London: Arts Council, 1974), pp. 7, 8.
7. Robert Melville, *New Statesman*, 1 February 1974.
8. Paul Overy, *The Times*, 20 January 1974.
9. William Feaver, "Lucian Freud: The Analytical Eye," *Sunday Times Magazine*, 3 February 1974, p. 57.
10. David Sylvester, *Interviews with Francis Bacon* (London: Thames & Hudson, 1973), p. 78.

5 "I DON'T USE THINGS UNLESS THEY ARE OF USE TO ME"

1. Jacquetta Eliot, conversation with the author, 30 June 2000.
2. Ibid.
3. Ibid., 22 July 2002.
4. Anne Dunn, letter to the author, 18 January 2012.
5. LF, letter to Jacquetta Eliot, private collection.
6. Ibid.
7. Jacquetta Eliot, conversation with the author, 30 June 2000.
8. Ibid., 5 July 2000.
9. Ibid., 30 June 2000.
10. Ibid., 5 July 2000.
11. Ibid.
12. Ibid.
13. Edmond L. A. H. de Goncourt and Jules A. H. de Goncourt, *Pages from the Goncourt Journal*, ed. Robert Baldick (London: Oxford University Press, 1962), p. 324.
14. Alice Weldon, conversation with the author, 14 January 2014.
15. Ibid.
16. Ibid.
17. Tony Eyton, letter to the author, 4 December 2004.
18. Brian Sayers, letter to the author, 17 February 2012.

19. Ibid.
20. Ibid.
21. Ibid.
22. LF, panel discussion with David Sylvester, William Coldstream, and Euan Uglow at the Slade School, 1974 (Lynda Morris transcript).
23. Ibid.
24. Ibid.
25. Anne Dunn, letter to the author, 16 April 2000.
26. Frank Auerbach, conversation with the author.
27. Alberto Giacometti, "Le Rideau brun" (1922).
28. Esther Freud, conversation with the author, 2 October 1999.
29. Alice Weldon, conversation with the author, 14 January 2014.
30. Ibid.
31. Annie Freud, conversation with the author, 9 April 2013.
32. Alice Weldon, conversation with the author, 14 January 2014.
33. June Andrews, conversation with the author, 2 February 1999.

6 "THINGS NEVER LOOK AS BAD AS THEY DO UNDER A SKYLIGHT"

1. Andrew Forge, introduction to *British Painting '74* (London: Arts Council/Lund Humphries, 1974), p. 16.
2. Norbert Lynton, "Painting: Situation and Extensions," in *Arte Inglese Oggi*, exhibition catalogue (British Council/Commune di Milano, 1976), p. 16.
3. Frank Auerbach, conversation with the author.
4. Wolf Dorian, *Kai aus der Kiste* (Berlin: Franz Schneider Verlag, 1927).
5. Frank Auerbach, conversation with the author.
6. LF and Frank Auerbach, letters, n.d., private collection.
7. Colin Wiggins, *Frank Auerbach and the National Gallery: Working after the Masters* (London: National Gallery, 1995), unpaginated.
8. Bruce Bernard, introduction to Bruce Bernard and Derek Birdsall, *Lucian Freud* (London: Jonathan Cape, 1996), p. 16.
9. Frank Auerbach, conversation with the author.
10. Frank Auerbach, letter to the author, 16 January 1998.
11. Frank Auerbach, conversation with the author.
12. June Andrews, conversation with the author, 20 January 1999.
13. Ibid.
14. Esther Freud, conversation with the author, 2 October 1999.
15. John McEwen, conversation with the author, 23 October 1998.

16. June Andrews, conversation with the author, 10 February 1999.

17. Moira Kelly, conversation with the author, 7 August 2013.

7 "I DON'T WANT A PAINTING TO APPEAR
AS A DEVICE OF SOME SORT"

1. Robert Lowell, "Mermaid," in his *Dolphin* (New York: Farrar, Straus & Giroux, 1973).

2. Philip Larkin, remark to Robert Conquest re 1997 Booker Prize dinner, quoted in Andrew Motion, *Philip Larkin* (New York: Farrar Straus Giroux, 1993), p. 464.

3. *Vogue*, November 1974, p. 158.

4. T. S. Eliot, "Preludes," IV.

5. For John Singer Sargent's celebrated remark see Evan Charteris, *John Sargent* (New York: Charles Scribner's Sons, 1927), p. 157.

6. Ambroise Vollard, *Cézanne* (New York/London: Dover Publications, 1985).

7. Alberto Giacometti, "Entretien avec Jean Clay," in his *Écrits* (Paris: Hermann, 2007), p. 311.

8. Lawrence Gowing, conversation with the author, 14 November 1983.

9. June Andrews, conversation with the author, 14 May 2001.

10. David Sylvester, *Interviews with Francis Bacon* (London: Thames & Hudson, 1975).

11. R. B. Kitaj, *The Human Clay* (London: Arts Council of Great Britain, 1976), p. 7.

12. Ibid.

13. Ibid.

14. R. B. Kitaj, conversation with the author, 12 May 1994.

15. Frank Auerbach, quoted in Lawrence Gowing, *Eight Figurative Painters* (New Haven: Yale Center for British Art, 1981), p. 26.

16. R. B. Kitaj, letter to the author, August 2003.

17. Celia Paul, conversation with the author, November 2012.

18. Frank Auerbach, conversation with the author, October 2012.

8 "I DON'T THINK PAINTINGS HAVE COME ABOUT EMOTIONALLY"

1. LF, interview with the author, *Observer*, 17 May 1998, pp. 18–23.

2. *The Journal of Eugène Delacroix* (London: Phaidon, 1951), pp. 387–8.

3. Harriet Vyner, quoted in "Lucian Freud: the man behind the legend," interviews by Chloe Fox, *Vogue*, February 2012, p. 133.

4. Ibid.
5. Quoted in Mark Vernon, *The Philosophy of Friendship* (London: Palgrave Macmillan, 2005), p. 30.
6. John Dryden, preface to *The Rival Ladies* (1664).
7. June Andrews, conversation with the author, 14 March 1998.
8. Angus Cook, "The Following," published as "Quanto segue," in *Lucian Freud* (London: British Council/Milan: Mondadori, 1991), p. 16.

9 "THE ONE THING MORE IMPORTANT THAN THE PERSON
IN THE PAINTING IS THE PICTURE"

1. William Feaver, *Observer* Review, 19 February 1978.
2. John McEwen, *Spectator*, 11 March 1978.
3. Lawrence Gowing, introduction to his *Eight Figurative Painters* (New Haven: Yale Center for British Art, 1981), p. 16.
4. Ibid.
5. James Kirkman, conversation with the author, 25 November 2014.
6. Anne Dunn, conversation with the author, 16 April 2000.
7. Ibid.
8. Celia Paul, interviewed by the author in *Lucian Freud: Portraits* (2004), film directed by Jake Auerbach, produced by Jake Auerbach and William Feaver.
9. Patrick George, quoted by Celia Paul in *The Last Art Film* (2012), directed by Jake Auerbach.
10. Celia Paul, in ibid.
11. Anne Dunn, conversation with the author.
12. Celia Paul, in *The Last Art Film*.
13. Frank Auerbach, conversation with the author.
14. Rose Boyt, in *Lucian Freud: Portraits*.
15. Ibid.
16. Ibid.
17. Frank Auerbach, conversation with the author.
18. Rose Boyt, conversation with the author, 12 October 2018; and see Rose Boyt essay in the catalogue for *In the Studio* (London: Ordovas, 2019).
19. Bella Freud, in *Lucian Freud: Portraits*.
20. Ibid.
21. Ibid.
22. Esther Freud, conversation with the author, 15 September 1999.

23. *In Tearing Haste: Letters between Deborah Devonshire and Patrick Leigh Fermor*, ed. Charlotte Mosley (London: John Murray, 2008), pp. 195–6.

24. Anne Dunn, conversation with the author, 12 February 2013.

25. Anne Dunn, letter to the author, January 2013.

26. Ibid.

10 "IT WAS QUITE AN URGENT SITUATION"

1. Introduction to Christos Joachimedes, Norman Rosenthal and Nicholas Serota (eds.), *A New Spirit in Painting* (London: Royal Academy, 1981), p. 13.

2. H. G. Wells, *The Invisible Man* (London: C. A. Pearson, 1897), Chapter 23.

3. C. Day Lewis, "The Sitting," in *The Complete Poems* (London: Sinclair-Stevenson, 1992).

4. Lawrence Gowing, notes to his Serpentine Gallery exhibition catalogue *Lawrence Gowing* (London: Arts Council of Great Britain, 1983), p. 54.

5. Ibid.

6. Lawrence Gowing, *Lucian Freud* (London: Thames & Hudson, 1982), p. 7.

7. Ibid., p. 189.

8. Ibid., p. 5.

9. Lawrence Gowing, letter to Angela Dyer, 24 January 1984.

10. LF, letter to Angela Dyer, n.d. ("Monday night").

11. Quoted in Henry Porter, "Lucian the Elusive," *Sunday Times*, 10 October 1982, p. 37.

12. Guy Harte, quoted in ibid.

13. Marina Vaizey, *Sunday Times*, 17 October 1982.

11 "SUCH AN INTIMATE GRANDEUR"

1. Celia Paul, letter to the author, 3 December 2003.

2. Judy Adam, conversation with the author, 27 January 2015.

3. Celia Paul, conversation with the author, 10 December 2003.

4. Annie Freud, conversation with the author, 9 April 2013.

5. Celia Paul, letter to the author, 26 November 2007.

6. Celia Paul, letter to the author, 2013.

7. "The Man Who Couldn't Cry" by Loudon Wainwright III, 1973: "His

ex-wife died of stretch marks, his ex-employer went broke." There was a cover version by Johnny Cash.

8. Terence Mullaly, *Daily Telegraph*, 16 November 1983, p. 13.
9. Richard Cork, *Evening Standard*, 10 November 1983.
10. Tim Hilton, *Observer*, 27 November 1983.

12 "I GAVE £5,000, A HUGELY HANDSOME SUM, TO GET THEM BACK"

1. Lawrence Gowing, "Human Stuff," *London Review of Books*, 2 February 1984.
2. Christopher Bramham, letter to the author, 15 August 1993.
3. LF, letter to Christopher Bramham, 16 November 1983.
4. Christopher Bramham, conversation with the author, 15 August 1993.
5. R. B. Kitaj, conversation with the author, 12 May 1994.
6. Ibid.
7. David Plante, conversation with the author, 12 May 2014.
8. Richard Morphet, *The Hard-Won Image* (London: Tate Gallery, 1984), p. 46.
9. Sophie de Stempel, conversation with the author, 14 June 2002.
10. Sophie de Stempel, quoted in "Lucian Freud: the man behind the legend," interviews by Chloe Fox, *Vogue*, February 2012.
11. Jacquetta Eliot, quoted in ibid., and conversation with the author, 13 November 2007.
12. Andrew Parker Bowles, conversation with the author, 17 September 2003.
13. James Kirkman, conversation with the author, 25 November 2014.
14. Christopher Hull Gallery, Fulham, press release, February 1984.
15. Frank Auerbach, conversation with the author.
16. John Russell, *Sunday Times*, 22 January 1967.
17. Ian Collins, *John Craxton* (Farnham: Lund Humphries, 2011), p. 132.
18. Anne Dunn, letter to the author, 14 April 2000.
19. Oswell Blakeston, *Arts Review*, May 1984.

13 "IT WAS A DIRECT JUMP FROM PAINTINGS TO ETCHINGS"

1. Lord Goodman, *London Review of Books*, 13–18 July 1985.
2. Ibid.
3. W. H. Auden, dedication to Stephen Spender in *The Orators* (London: Faber & Faber, 1932).

4. Nick Garland, letter to the author, 17 March 2000.
5. Lucian Freud, introduction to *Annabel's*, linocuts by Nicholas Garland (London: Mark Birley, 1985).

14 "I WANT PORTRAITURE WHICH PORTRAYS THEM,
NOT HERE'S ANOTHER OF MINE"

1. Édouard Manet, letter to Antonin Proust, May 1880, in *Manet by Himself*, ed. Juliet Wilson-Bareau (London: Macdonald, 1991), p. 246.
2. That is, in September 1985.
3. William Feaver, *Observer*, 21 June 1987.
4. Frank Auerbach, conversation with the author.
5. LF quoted in Robert Hughes, introduction to his *Lucian Freud: Paintings* (London: British Council, 1987).

15 "WHAT DO I ASK OF A PAINTING? I ASK IT
TO ASTONISH, DISTURB, SEDUCE, CONVINCE"

1. Alan Bowness, Report to British Council Visual Arts Committee, 1986, British Council archives.
2. Bill Rubin, British Council archives.
3. Diane Waldman, British Council archives.
4. Alan Bowness, foreword to *Francis Bacon* (London: Tate Gallery, 1985), p. 7.
5. Angus Cook in *Lucian Freud* (London: British Council/Milan: Mondadori, 1991), mss. p. 4.
6. Celia Paul, letter to the author, 12 November 1999.
7. William Feaver, "A Reasonable Definition of Love," *Architectural Digest*, July 1987, p. 34.
8. Celia Paul, Tate Acoustiguide (London: Tate Britain, 2002).
9. Frank Auerbach, conversation with the author.
10. Celia Paul, letter to the author, 12 April 2014.
11. Hirshhorn/British Council press release, 1987.
12. Paul Richard, *Washington Post*, 15 September 1987.
13. Jack Flam, "The Real Lucian Freud," *Wall Street Journal*, 11 November 1987.
14. Robert Taylor, *Boston Globe*, 15 November 1987.
15. Robert Hughes, *Lucian Freud: Paintings* (London: British Council, 1987).
16. John Russell, *New York Times*, 27 September 1987.

17. Ibid.
18. Ibid.
19. Andrea Rose, British Council exhibition report, January 1988.
20. Ibid.

16 "MY WORLD IS FAIRLY FLOORBOARDISH"

1. William Feaver, presenter and interviewer in *Lucian Freud*, BBC Review, 1988.
2. Jake Auerbach, conversation with the author.
3. William Holmes, *The Times*, 21 May 1988.
4. Sarah Kent, *Time Out*, 21 May 1988.
5. Quoted in Daniel Farson, *The Gilded Gutter Life of Francis Bacon* (London: Century, 1993), p. 239.
6. LF, remark to the author in 1998.
7. Colin Gleadell, *Art Monthly*, November 1987.
8. Michael Andrews, letter to the author, 20 July 1988.
9. Robert Hughes, "Francis Bacon: Horrible!," *Guardian*, 30 August 2008.
10. Professor Dieter Honisch report to Stiftung Preusschische Kulturbesitz, 6 June 1988.
11. "The Lion and Albert," in Marriott Edgar, *Albert, 'Arold and Others* (London: Francis, Day & Hunter, 1930).
12. Chris Bramham, letter to the author, 14 December 2014.
13. Lawrence Gowing, *Early Cézanne* (London: Royal Academy, 1988), p. 124.
14. Quoted in Celia Lyttelton, "Freudian Associations," *Art Review*, June 2002, p. 38.
15. Angus Cook, reprinted as "Seeing Things" in *Lucian Freud: Recent Drawings and Etchings* (New York: Matthew Marks Gallery, 1993).
16. Ibid.
17. Sophie de Stempel, conversation with the author, 26 May 2017.
18. Arthur Rimbaud, "Once if My Memory Serves Me Well," *A Season in Hell* (1873).

17 "IN A CONSPIRATORIAL WAY SHE KEPT ALL MY DRAWINGS"

1. Esther Freud, conversation with the author, 26 February 2016.
2. Annabel Freud, conversation with the author, 14 February 2014.
3. Susie Boyt, interviewed by the author in *Lucian Freud: Portraits* (2004), film directed by Jake Auerbach, produced by Jake Auerbach and William Feaver.

4. Robert Hughes, "On Lucian Freud," in his *Lucian Freud: Paintings* (London: British Council, 1987), p. 13.

5. Victor Chandler, interviewed by Will Buckley, *Observer*, 15 June 2008.

6. Chris Bramham, letter to the author, 23 January 2014.

7. Ibid.

8. Ibid., 10 December 2014.

9. LF, letter to Chris Bramham, 26 June 1988.

10. Chris Bramham, letter to the author, 23 January 2014.

11. Ibid.

12. LF, letter to Chris Bramham, 1 March 1990.

13. Chris Bramham, *Modern Painters*, vol. 6, no. 3, Autumn 1993.

14. Chris Bramham, letter to the author, 10 December 2014.

15. Barney Bramham, *Modern Painters*, vol. 6, no. 3, Autumn 1993.

16. Frederick Drimmer, *Very Special People: The Struggles, Loves and Triumphs of Human Oddities* (New York: Amjon Publishers, 1973).

17. Chris Bramham, letter to the author, 10 December 2014.

18. Jan Banyard, email to the author, 29 April 2004.

19. Angus Cook, "The Following," published as "Quanto segue" in *Lucian Freud* (London: British Council/Milan: Mondadori, 1991).

20. Walt Whitman, "A Song of Myself" (no. 32), in *Leaves of Grass* (1855).

21. Mrs. Piozzi, *Anecdotes of the Late Samuel Johnson* (London: Cadell, 1786).

22. Bella Freud, quoted in "Lucian Freud: the man behind the legend," interviews by Chloe Fox, *Vogue*, February 2012, p. 133.

23. Stephen Freud, conversation with the author, 2008.

24. Allan Ramsay to Lady Bute, 1741 (*Infant Son of the Artist*, National Galleries of Scotland).

25. What W. B. Yeats actually said in a letter to Olivia Shakespear in 1927 was: "Only two topics can be of the least interest to a serious and studious mind—sex and the dead."

26. LF, annotation to MS Introduction to catalogue, *Lucian Freud* (British Council catalogue, 1992).

27. Esther Freud, conversation with the author, 26 February 2016.

28. Hilaire Belloc, "Lord Henry Chase."

29. Jane McAdam, letter to the author, 22 November 2000.

30. Paul McAdam, conversation with the author, 4 December 2000.

31. Jane McAdam, letter to the author, 22 November 2000.

18 "NOTHING TENTATIVE"

1. LF, letter to Chris Bramham, 15 October 1990.

2. Judy Adam, conversation with the author, 27 January 2015.

3. Sue Tilley, *Leigh Bowery: The Life and Times of an Icon* (London: Hodder & Stoughton, 1997), p. 216.
4. Leigh Bowery, conversation with the author, 27 July 1993.
5. Ibid.
6. Tilley, *Leigh Bowery*, p. 140.
7. Leigh Bowery, conversation with the author, 27 July 1993.
8. Ibid.
9. Ibid.
10. Bruce Bernard, conversation with the author, 6 February 1992.
11. "Lucian Freud in conversation with Sebastian Smee," in *Freud at Work: Photographs by Bruce Bernard and David Dawson* (London: Jonathan Cape, 2006), p. 30.
12. Leigh Bowery, conversation with the author, 27 July 1993.
13. Nicola Bateman, conversation with the author, 29 July 1993.
14. Nicola Bateman, interviewed by the author in *Lucian Freud: Portraits* (2004), film directed by Jake Auerbach, produced by Jake Auerbach and William Feaver.
15. Lucian Freud, interviewed by Leigh Bowery in *Lovely Jobly*, reprinted in the *Independent*, 11 January 1992.
16. David Dawson, conversation with the author, 2003.
17. LF, quoted by Angus Cook, "The Following," published as "Quanto segue" in *Lucian Freud* (London: British Council/Milan: Mondadori, 1991), p. 21.
18. Ibid., p. 22.
19. Frank Auerbach, conversation with the author.
20. Ibid.
21. Ibid.

19 "SHOWS I DO ARE PUNCTUATIONS"

1. James Kirkman, letter to the author, 15 December 1999.
2. Tate Gallery, press release on acquisition of *Standing by Rags*, 1990.
3. James Kirkman, letter to the author, 15 December 1999.
4. James Kirkman, conversation with the author, 25 November 2014.
5. Ibid.
6. Ibid.
7. Frank Auerbach, conversation with the author.
8. James Kirkman, conversation with the author, 25 November 2014.
9. James Kirkman, letter to the author, 15 December 1999.
10. Lucian Freud interviewed by William Feaver, BBC's *Third Ear*, produced by Judith Bumpus, recorded 10 December 1991.

11. Ibid.

12. Ibid.; Chris Bramham, letter to the author, 15 December 2014.

13. Oliver Bernard, *Cock Sparrow: A True Chronicle* (London: Jonathan Cape, 1936), p. 161.

14. Gilbert de Botton, letter to LF, 13 February 1995.

15. Ib Boyt, interviewed by the author in *Lucian Freud: Portraits* (2004), film directed by Jake Auerbach, produced by Jake Auerbach and William Feaver.

16. Chris Bramham, letter to the author, 15 December 2014.

17. Stuart Jeffries, "Talent in the Raw," *Guardian*, 10 June 2002.

18. Ib Boyt, in *Lucian Freud: Portraits*.

19. Matthew Marks as reported by LF.

20. William Feaver, "Beyond Feeling," in *Lucian Freud* (Sydney: British Council/Art Gallery of New South Wales, 1992), p. 9.

21. Elwyn Lynn, *Australian*, 14 November 1992, review section, p. 10.

20 "TRYING TO MAKE SOMETHING THAT'S NEVER BEEN SEEN BEFORE"

1. James Kirkman, conversation with the author, 25 November 2014.

2. Ibid.

3. Peter Aspden, *Financial Times*, 30 September 2011.

4. Ibid.

5. Bill Acquavella, interview, *Vanity Fair*, February 2012.

6. Ibid.

7. Lucian Freud, interview with William Feaver, "The Artist out of his Cage," *Observer*, 6 December 1992, pp. 45–7 and transcript.

8. A. E. Housman, *A Shropshire Lad* (London: Kegan Paul, 1896), XII.

9. Nicola Bateman, interviewed by the author in *Lucian Freud: Portraits* (2004), film directed by Jake Auerbach, produced by Jake Auerbach and William Feaver.

10. Sue Tilley, *Leigh Bowery: The Life and Times of an Icon* (London: Hodder & Stoughton, 1997), p. 93.

11. Leigh Bowery, conversation with the author, 27 July 1993.

12. Ibid.

21 "I CAN NEVER SAY THAT IT'S FINISHED"

1. Francis Wyndham, conversation with the author, 20 July 1993.

2. Ibid.

3. Ibid.

4. Francis Wyndham, interviewed by the author in *Lucian Freud: Portraits* (2004), film directed by Jake Auerbach, produced by Jake Auerbach and William Feaver.

5. Francis Wyndham, conversation with the author, 20 July 1993.

6. Ibid.

7. Francis Wyndham, in *Lucian Freud: Portraits*.

8. Ibid.

9. James Lord, *New Criterion*, vol. 2, December 1983, p. 258.

10. *Modern Painters*, vol. 7, no. 3, Autumn 1994.

11. Shakespeare, *King Lear*, Act 3, scene 4.

12. Kennedy Fraser, *Vogue* (US), November 1993.

13. Martin Filler, "The Naked and the Id," *Vanity Fair*, November 1993.

14. John McEwen, "On the Couch with Freud," *Sunday Telegraph*, 5 September 1993.

15. Ibid.

16. Bruce Bernard, *Independent on Sunday*, 5 September 1993.

17. Andrew Graham-Dixon, *Independent*, 4 September 1993.

18. Tim Hilton, *Independent on Sunday*, 19 September 1993.

19. Waldemar Januszczak, *Sunday Times*, 12 September 1993.

20. LF is referring to Paul Johnson's article, "Portrait of the artist who loathes mankind," *Daily Mail*, 11 September 1993.

21. Sue Tilley, in *Lucian Freud: Portraits*.

22. Ibid.

23. Lucian Freud, "Pin-up" interview by William Feaver, *Observer*, Life, 17 May 1998.

24. John Donne, "Elegy IX."

25. Sue Tilley, in *Lucian Freud: Portraits*.

26. Sue Tilley, conversation with the author, 16 April 2012.

27. *Baltimore Sun*, 30 September 1993.

22 "BRITAIN HAD TAKEN ME IN"

1. Isaiah Berlin, letter to Edward Adean, 4 May 1993, *Affirming: Letters 1975–1997* (London: Chatto & Windus, 2015).

2. John Ezard, *Guardian*, 15 March 1994.

3. R. B. Kitaj, letter to the author, 18 July 1994.

4. LF, letter to Sandy Wilson, 2 July 1994.

5. R. B. Kitaj, conversation with the author, 12 May 1994.

6. Ibid.

7. Ibid.

8. Ibid.

9. Jonathan Swift, *Gulliver's Travels*, in *The Works of Dr. Jonathan Swift*, vol. 2 (London, 1766), pp. 107–8.

10. Leigh Bowery in Ginny Dougary, "Soon to be Revealed as a Man," *Independent*, 19 September 1991.

11. Nicola Bateman, interviewed by the author in *Lucian Freud: Portraits* (2004), film directed by Jake Auerbach, produced by Jake Auerbach and William Feaver.

12. Ibid.

13. Michael Andrews, letter to LF, n.d. 1994.

14. Howard Hodgkin, postcard to LF, 25 January 1995.

15. Sue Tilley, *Leigh Bowery: The Life and Times of an Icon* (London: Hodder & Stoughton, 1997), p. 284.

16. Nicola Bateman, conversation with the author, 29 July 1993.

17. Saki, "The Open Window" (1914).

18. Magnus Linklater, "Throwing a Pot of Paint at the Artist," *The Times*, 22 August 1995.

19. David Sylvester, "Recanting? No way, Brian," *Guardian*, 25 August 1995.

20. Bruce Bernard, *From London*, quoted by Brian Sewell in *Evening Standard*, 23 August 1995.

21. Sylvester, "Recanting? No way, Brian."

22. See also William Feaver, *The Lives of Lucian Freud: Youth 1922–1968* (London: Bloomsbury, 2019), p. 196.

23 "AFTER A CERTAIN POINT THE PICTURE TAKES OVER"

1. Lady Seiff, as reported by LF.

2. David Whetstone, *Newcastle Journal*, 29 June 1996.

3. Chris Bramham, letter to the author, 8 March 2017.

4. In fact the footage—fifty minutes of it—came to light after Freud's death and was eventually consigned to the National Portrait Gallery archive.

5. Bruce Bernard and Derek Birdsall, *Lucian Freud* (London: Jonathan Cape, 1996).

6. Ibid., p. 16.

7. Ibid., p. 21.

8. *New York Times*, 25 October 1996.

9. *Daily Telegraph*, 22 June 1996.

10. Rose Boyt, interviewed by the author in *Lucian Freud: Portraits* (2004),

film directed by Jake Auerbach, produced by Jake Auerbach and William Feaver.

11. The song resounding over the massed crosses at the end of *Oh! What a Lovely War* (1969), directed by Richard Attenborough.

12. Ib Boyt, in *Lucian Freud: Portraits*.

13. Richard Brooks, *Observer*, 31 August 1997.

14. Ros Wynne-Jones and Jojo Moyes, "Rumours fly as 'frightened' Freud biographer vanishes," *Independent on Sunday*, 31 August 1997. Nigel Jones went on to become, briefly, deputy editor of *History Today* and to write a life of Rupert Brooke.

24 "SHRIVEL UP AND DROOP DOWN"

1. Private information, 9 June 2016.

2. Ibid.

3. Lawrence Gowing, conversation with the author, 1984.

4. Annabel Mullion (Baring), quoted in "Lucian Freud: the man behind the legend," interviews by Chloe Fox, *Vogue*, February 2012.

5. In Émile Zola, *Mes haines: causeries littéraires et artistiques* (1866) (Paris: G. Charpentier, 1879).

6. In Albert Camus, *The Outsider*, trans. Stuart Gilbert (1946) (London: Penguin, 1973).

7. LF quoted in Sebastian Smee, *Freud at Work: Photographs by Bruce Bernard and David Dawson* (London: Jonathan Cape, 2006), pp. 27–8.

8. Gregor Muir, conversation with the author, November 2016.

9. Sarah Lucas, conversation with the author, 29 November 2014.

25 "I DON'T WANT PAINTINGS TO BE 'READABLE' BUT THERE ARE THINGS GOING ON IN THE ROOM"

1. LF, conversation with the author, 9 June 1997.

2. David Beaufort, conversation with the author, 7 November 2012.

3. Susanna Chancellor, conversation with the author, 9 October 2016.

4. Esther Freud, conversation with the author, 15 November 1998.

5. Godfrey Barker, *Evening Standard*, 11 May 1998.

6. Jane Lewis, letter to LF, 28 June 1998.

7. Nicholas Serota, letter to LF, July 1998.

8. Susanna Chancellor, conversation with the author, 9 October 2016.

9. Alice Weldon, conversation with the author, 9 March 2014.

10. Susanna Chancellor, conversation with the author, 9 October 2016.

26 "I NEARLY ALWAYS START TWICE"

1. Paul McAdam, conversation with the author, 4 December 2000.
2. Mark Guiducci, *Vogue* (US), February 2015.
3. Richard Eden, "Jerry Hall is Shocked," *Daily Telegraph*, 19 September 2010.
4. Andrew Parker Bowles, letter to Peter George, 27 February 1999.
5. John O'Reilly, letter to Andrew Parker Bowles, 19 April 1999.
6. Letter in private collection.
7. Nikki Bell, letter to the author, 6 July 2015.
8. Nicola-Rose O'Hara, interview in the *Sunday Times*, 11 August 2002.
9. Ibid.
10. Alice Costelloe, interviewed by the author in *Lucian Freud: Portraits* (2004), film directed by Jake Auerbach, produced by Jake Auerbach and William Feaver.
11. W. H. Davies, "The Inquest" (1916).

27 "BETTER PLAIN NAKED"

1. Bruce Bernard and Terence McNamee, *Century: One Hundred Years of Human Progress, Regression, Suffering and Hope, 1899–1999* (London: Phaidon Press, 1999), p. 7.
2. *Australian*, 18 April 2001.
3. Brian Kennedy, letter to the author, 5 November 2001.

28 "ONE ESSAY, NO ADJECTIVES"

1. Nicholas Serota, letter to the author, 14 October 1999.
2. David Sylvester, conversation with the author, 7 June 2000.
3. LF, handwritten note, private collection, 2001.

29 "TELLS YOU EVERYTHING"

1. Anon, private source.
2. LF, interview with Sebastian Smee, *Sunday Telegraph*, 19 May 2002.
3. Tim Spanton, "One looks like one of one's corgis chewing a wasp," *Sun*, 21 December 2001, pp. 32–3.
4. Quoted in ibid.
5. Quoted in Luke Leitch, "Freud's models take a turn," *Evening Standard*, 20 June 2002.

6. Christie's catalogue, November 2014.

7. David Alan Mellor, *Interpreting Freud* (London: Tate Publishing, 2002).

8. *Constable: Le Choix de Lucian Freud* (Paris: Réunion des Musées Nationaux, 2002), p. 26; English edition, *Freud on Constable* (London: British Council, 2003), p. 27.

9. Amanda Perthen, *Mail on Sunday*, 1 July 2001.

10. James Fox, "The Riddle of Kate Moss," *Vanity Fair*, December 2012.

11. Kate Moss, quoted in "Lucian Freud: the man behind the legend," interviews by Chloe Fox, *Vogue*, February 2012.

12. Frances Costelloe, Tate Acoustiguide (London: Tate Modern, 2002).

13. Frances Costelloe, interviewed by the author in *Lucian Freud: Portraits* (2004), film directed by Jake Auerbach, produced by Jake Auerbach and William Feaver.

14. Ibid.

15. Frank Auerbach, "On Lucian Freud," preface to William Feaver, *Lucian Freud* (London: Tate Publishing, 2002).

16. David Dawson, in *Lucian Freud: Portraits*.

17. Sebastian Smee, "Master of Reinvention," *Sydney Morning Herald*, 15 July 2000.

18. Sebastian Smee, email to the author, 27 July 2011.

19. Sebastian Smee, "I Intend to Paint Myself to Death," *Sunday Telegraph*, 19 May 2002.

30 "VERY DOOMISH"

1. Anne Dunn, letter to the author, 18 June 2002.

2. Tom Lubbock, *Independent Review*, 21 June 2002.

3. Adrian Searle, "The Eye that Devours," *Guardian*, 18 June 2002.

4. Peter Schjeldhal, "Naked Punch," *New Yorker*, 8 July 2002, pp. 72–4.

5. Pierre Lamond, conversation with the author, September 2002.

6. Nicola-Rose O'Hara, "Lucian's Captive," *Sunday Times* News Review, 11 August 2002.

7. Esther Freud, letter to the *Sunday Times*, 18 August 2002.

8. William Feaver, letter to Isabel Salgado, 8 November 2002.

9. LF, letter to the author, 14 October 2002.

10. Ibid.

11. R. B. Kitaj, letter to the author, June 2003.

12. Brendan Bernhard, "Private Faces in Public Places: Hanging Lucian Freud," *LA Weekly*, 28 February 2003.

13. Gina Piccalo, *Los Angeles Times*, 11 February 2003.

14. Tom Telcholz, "Is Lucian Freud Hot?," *Jewish Journal of Greater Los Angeles*, 28 February 2003.
15. Christopher Knight, *Los Angeles Times*, 11 February 2003.
16. Kenneth Baker, *San Francisco Chronicle*, 13 February 2003.
17. *Lucian Freud Portraits* (2004), film directed by Jake Auerbach, produced by Jake Auerbach and William Feaver.
18. Celia Paul, letter to the author, 26 November 2017.
19. Annabel Freud, conversation with the author, 14 February 2014.

31 "TRYING TO DO WHAT I CAN'T DO"

1. Michael Kimmelman, "Lucian Freud from the Stable to the Gallery," *New York Times*, 4 May 2004.
2. David Dawson, conversation with the author, May 2004.
3. Martin Gayford, *Man with a Blue Scarf: On Sitting for a Portrait by Lucian Freud* (London: Thames & Hudson, 2012), p. 108.
4. Martin Gayford, "Freud Laid Bare," *Daily Telegraph*, 13 March 2004.
5. A. N. Wilson, *Evening Standard*, 11 June 2004.
6. Andrew Graham-Dixon, "Sympathy for the Vulnerable," *Sunday Telegraph*, 18 April 2004.
7. Diana Rawstron, conversation with the author, 19 October 2004.
8. Kimmelman, "Lucian Freud from the Stable to the Gallery."

32 "IT'S A STIMULATING THOUGHT THAT THIS MAY BE MY LAST PICTURE"

1. Laura-Jane Foley, "An Evening with Lucian Freud," *Sunday Times*, 24 October 2004; Charlotte Edwards, "Girls that turn down Lucian Freud are not timid, believe me," *Evening Standard*, 15 August 2016.
2. David Dawson, conversation with the author, 14 March 2004.
3. Alexandra ("Alexi") Williams-Wynn, conversation with the author, July 2005.
4. Frank Auerbach, conversation with the author, 2004.
5. David Dawson, conversation with the author, April 2004.
6. Ibid., 16 February 2005.

33 "THE WAY LIFE GOES"

1. David Dawson, conversation with the author, 16 April 2005.
2. LF, letter to Frank Auerbach, 2 May 2005.

3. David Dawson, conversation with the author, 5 May 2005.
4. Ibid., 6 May 2005.
5. Michael Gormley, conversation with the author, 9 June 2016.
6. David Beaufort, conversation with the author, 7 November 2012.

34 "I DON'T WANT TO SLOW DOWN
IN THIS LATE EVENING OF MY DAYS"

1. David Beaufort, conversation with the author, 20 January 2014.
2. Susanna Chancellor, conversation with the author, 9 October 2016.
3. David Dawson, telephone conversations with the author.
4. Ibid.
5. Ibid.
6. Ibid.
7. Ibid.
8. Ibid.
9. Ibid.
10. Richard Cork, *The Times*, 3 May 2006.
11. *Lucian Freud* was staged at the Kunsthistorisches Museum, Vienna, 8 October 2013–6 January 2014.
12. Annie Freud, conversation with the author, 14 November 2006.
13. Ibid., 29 December 2006.

35 "I'M NOT AN OBJECT"

1. David Dawson, conversation with the author, 6 February 2007.
2. William Feaver, *Lucian Freud* (New York: Rizzoli, 2007).
3. Ibid., illustration 318.
4. David Dawson, conversation with the author, 14 January 2008.
5. James Kirkman, conversation with the author, 25 November 2014.
6. Memoir by Sally Clarke, "Lucian Freud Remembered," in British Council exhibition catalogue, *Lucian Freud: Corpos e Rostos—Drawings & Paintings by Lucian Freud with Photographs by David Dawson* (São Paulo: Museu de Arte de São Paulo, 2013).
7. David Dawson, conversation with the author, 2007.
8. R. B. Kitaj, *Sandra Two* (London: Marlborough Fine Art, 1996), pp. 7, 9.
9. Quoted in Starr Figura, *Lucian Freud: The Painter's Etchings* (New York: Museum of Modern Art, 2007), p. 7.
10. Ibid., p. 24.

11. David Dawson, conversation with the author, 17 December 2007.
12. Bill Acquavella, conversation with the author, 28 February 2008.
13. Frank Auerbach, conversation with the author, January 2008.
14. David Dawson, conversation with the author, 3 March 2008.
15. Ibid., 7 March 2008.
16. Ibid., 4 September 2008.
17. Nick Glass report, *Channel 4 News*, 28 October 2008.
18. David Dawson, conversation with the author, 14 September 2008.
19. Ibid., 7 October 2008.
20. Ibid.
21. Ibid.
22. Celia Paul, letter to the author, 26 November 2017.
23. Tim Meara, quoted in Cath Clarke, "Lucian Freud's Feathered Friend," *Guardian*, 16 June 2010.
24. Kate Moss, quoted in "Lucian Freud: the man behind the legend," interviews by Chloe Fox, *Vogue*, February 2012.
25. David Dawson, conversation with the author, 22 June 2010.
26. Ibid.
27. Frank Auerbach, conversation with the author, June 2010.
28. David Dawson, conversation with the author, 22 June 2010.
29. Susanna Chancellor, conversation with the author, 10 December 2010.
30. Ibid.
31. Frank Auerbach, conversation with the author, 3 January 2011.
32. Joan Collins, *Spectator* Diary, 24 July 2010.
33. David Dawson, conversation with the author, 4 March 2011.
34. Ibid., 12 March 2011.
35. Michael Gormley, conversation with the author, 9 June 2016.
36. David Dawson, conversation with the author, 12 April 2011.
37. Ibid., 30 June 2011.
38. Lucy McAdam Freud, quoted in Alexis Parr, *Daily Mail*, 30 July 2014. See also Rosie Millard, "Portrait of the forgotten children," *Sunday Times*, 11 April 2004, and Rebecca Hardy, "I'm one of Lucian's freudian slips," *Daily Mail*, 5 October 2006.
39. *Daily Mail*, 23 July 2011.
40. David Dawson, conversation with the author, 16 July 2011.
41. Anne Dunn, conversation with the author, 17 July 2011.
42. Ibid., 20 July 2011.

AFTERWORD

1. Obituary by William Grimes, *New York Times*, 22 July 2011.
2. New Year 2014: vandals smashed the antique Greek urn that served as a memorial; it had been given to Sigmund Freud by Princess Marie Bonaparte.
3. Rowan Williams, conversation with the author, 8 March 2016.
4. Diana Rawstron, conversation with the author, 23 July 2011.
5. Celia Paul, letter to the author, 26 November 2017.
6. Rowan Williams, conversation with the author, 8 March 2016.
7. Alison Boshoff, "Feuding Freuds," *Daily Mail*, 9 June 2014.

BIBLIOGRAPHY

PRIMARY SOURCES

Author's recorded interviews and conversations with Freud, 1973 to 2011
Author's extensive conversations with, among many others, Frank Auerbach, Bruce Bernard, Christopher Bramham, David Dawson, Anne Dunn, Jacquetta Eliot, Annie Freud, Esther Freud, James Kirkman, Alice Weldon, Francis Wyndham
Lucian Freud, statement in *The Artist's Eye* (London: National Gallery, 1987)

PUBLISHED INTERVIEWS WITH LUCIAN FREUD BY THE AUTHOR

"Lucian Freud: The Analytical Eye," *Sunday Times* Magazine, 3 February 1974
"The Artist Out of his Cage," *Observer* Review, 6 December 1992
"The Naked Eye," *Observer* Life, 23 June 1996
"Seeing Through the Skin," *Guardian* Weekend, 18 May 2002
Lucian Freud on John Constable: A Conversation with William Feaver (London: British Council, 2003)
"Conversation," February 2007, in Feaver, *Lucian Freud* (New York: Rizzoli, 2007)

SECONDARY SOURCES

Exhibition catalogues (within the artist's lifetime and including significant group shows)
John Russell, Introduction, *Lucian Freud* (London: Hayward Gallery, 1974, touring to Bristol, Birmingham and Leeds)
R. B. Kitaj, Introduction, *The Human Clay* (London: Arts Council/Hayward Gallery, 1976)
Seiji Oshima, *"Where is the girl's face?"* (Tokyo: Nishimura Gallery, 1979)
Lawrence Gowing, Introduction, *Eight Figurative Painters* (New Haven: Yale Center for British Art, 1981)

Christos Joachimides, Norman Rosenthal and Nicholas Serota, *A New Spirit in Painting* (London: Royal Academy, 1981)

William Feaver, *As of Now*, featuring Michael Andrews, Frank Auerbach and Freud (Liverpool: Walker Art Gallery; Dublin: Douglas Hyde Gallery, 1983)

The Proper Study: Contemporary Figurative Paintings from Britain (Delhi, British Council/Lalit Kala Akademi, 1984)

Robert Hughes, Introduction, *Lucian Freud* (Washington DC: British Council/Hirshhorn Museum, touring to London, Hayward Gallery, Paris, Centre Pompidou, Berlin, Neue Nationalgalerie, 1988)

Angus Cook, Introduction, *Lucian Freud* (Rome: Palazzo Ruspoli; Liverpool: Tate Gallery, 1991–2)

William Feaver, Introduction, *Lucian Freud* (Tokyo: Tochigi, Nishinomiya; Sydney: Art Gallery of New South Wales; Perth: Art Gallery of Western Australia, 1992–3)

Catherine Lampert, Introduction, *Lucian Freud Recent Paintings* (London: Whitechapel Art Gallery; New York: Metropolitan Museum; Madrid: Centro di Reina Sofia, 1993–4)

Caroline Blackwood et al., *Lucian Freud Early Works* (New York: Robert Miller Gallery, 1994)

William Feaver, Introduction, *Lucian Freud* (Kendal, Cumbria: Abbot Hall Art Gallery, 1996)

Esther Freud, "Ode to Pluto," in *Lucian Freud: Etchings* (New York: Matthew Marks, 2000)

William Feaver, *Lucian Freud* (London: Tate Britain, 2002, touring to Fundacio la Caixa, Barcelona and Museum of Contemporary Art Los Angeles)

William Feaver, *Lucian Freud* (Venice: Museo Correr, 2005)

Catherine Lampert: *Lucian Freud* (Dublin: Irish Museum of Modern Art, 2007)

Starr Figura, Introduction, *Lucian Freud: The Painter's Etchings* (New York: Museum of Modern Art, 2008)

Lucian Freud: L'Atelier (Paris: Centre Pompidou, 2010)

Sarah Howgate, *Lucian Freud Portraits* (London: National Portrait Gallery, 2012)

William Feaver, *Lucian Freud Drawings* (London: Blain Southern; New York, Acquavella, 2012)

Sabine Haag and Jasper Sharp, *Lucian Freud* (Vienna: Kunsthistorisches Museum, 2013)

Martin Gayford, *Lucian Freud* (London: Phaidon 2018)

David Dawson, *Monumental* (New York: Acquavella, 2019)

Rose Boyt, *In the Studio* (London: Ordovas, 2019)

Christina Kennedy and Nathan O'Donnell (eds), *Life Above Everything: Lucian Freud and Jack Yeats* (Dublin: Irish Museum of Modern Art, 2019)

Monographs

Lawrence Gowing, *Lucian Freud* (London: Thames & Hudson, 1982)

Craig Hartley, *The Etchings of Lucian Freud 1946–1995* (London: Marlborough Graphics, 1995)

Bruce Bernard and Derek Birdsall, *Lucian Freud* (London: Jonathan Cape, 1996)

Sebastian Smee, *Lucian Freud 1996–2005* (London: Jonathan Cape, 2005)

Sebastian Smee, *Lucian Freud* (Cologne: Taschen, 2007)

William Feaver, *Lucian Freud* (New York: Rizzoli, 2007)

Sebastian Smee and Richard Calvocoressi, *Freud on Paper* (London: Jonathan Cape, 2010)

Articles

William Feaver, "Stranded Dinosaurs," *London Magazine*, July–August 1970

William Feaver, "New Realists," *London Magazine*, February 1973

John Gruen, "Relentlessly Personal Vision of Lucian Freud," *Artnews* (New York), April 1977

William Feaver, "Artist's Dialogue: Lucian Freud: A Reasonable Definition of Love," *Architectural Digest* (New York), July 1987

Leigh Bowery, "Art and Love," *Independent* magazine, 11 January 1992

Film, television and radio

Tristram Powell (director), footage interview for an unrealised film on Freud (London: National Portrait Gallery, Freud Archive, 1977)

Jake Auerbach (producer), *Omnibus: Lucian Freud*, BBC1, 1988

Judith Bumpus (producer), *Lucian Freud in Conversation with William Feaver*, Third Ear, BBC Radio 3 (recorded 10 December 1991)

Jake Auerbach, *Lucian Freud Portraits*, Jake Auerbach Films Ltd, London, 2004 (interviews conducted by the author as co-producer, with many of Freud's sitters)

Randall Wright (producer), *Lucian Freud: A Painted Life*, BBC2, 2012

Photography books

Bruce Bernard and David Dawson, *Freud at Work* (London: Jonathan Cape, 2006)

David Dawson, *A Portrait of Lucian Freud* (London: Jonathan Cape, 2014)

Books (including several for which Freud had an idiosyncratic enthusiasm)

J. H. Breasted: *Geschichte Ägyptens* (Vienna: Phaidon, 1936)

François-René de Chateaubriand: *Memoirs from Beyond the Tomb* (London: Penguin, 1972)

Clement Freud, *Freud Ego* (London: BBC Books, 2001)

Esther Freud, *Hideous Kinky* (London: Hamish Hamilton, 1992)

Martin Gayford, *Man with a Blue Scarf* (London: Thames & Hudson, 2010)

Martin Gayford, *Modernists & Mavericks* (London: Thames & Hudson, 2018)

Geordie Greig, *Breakfast with Lucian: A Portrait of the Artist* (London: Jonathan Cape, 2013)

Phoebe Hoban, *Lucian Freud: Eyes Wide Open* (New York: Houghton Mifflin Harcourt, 2014)

A. E. Housman: *Selected Prose* (Cambridge University Press, 1961)

Ivana Lowell, *"Why Not Say What Happened?"* (London: Bloomsbury, 2010)

A. A. Milne: *Toad of Toad Hall* (London: Methuen 1929)

Henrietta Moraes, *Henrietta* (London: Hamish Hamilton, 1994)

Celia Paul, *Self-Portrait* (London: Jonathan Cape, 2019)

Michael Peppiatt, *Francis Bacon: Anatomy of an Enigma* (London: Weidenfeld & Nicolson, 1996)

John Richardson, *Sacred Monsters, Sacred Masters* (London: Jonathan Cape, 2001)

Brian Robertson, John Russell and Lord Snowdon, *Private View* (London: Thomas Nelson, 1965)

Nancy Schoenberger, *Dangerous Muse: The Life of Lady Caroline Blackwood* (Cambridge, Mass.: Da Capo Press, 2002)

Sebastian Smee, *The Art of Rivalry* (New York: Penguin, 2016)

Stephen Spender, *New Selected Journals 1939–1995*, ed. Lara Feigel and John Sutherland with Natasha Spender (London: Faber & Faber, 2012)

David Sylvester: *Interviews with Francis Bacon* (London: Thames & Hudson, 1975)

David Sylvester: *Looking Back at Francis Bacon* (London: Thames & Hudson, 2000)

Sue Tilley, *Leigh Bowery: The Life and Times of an Icon* (London: Hodder & Stoughton, 1997)

ACKNOWLEDGEMENTS

Gratitude first and foremost to Lucian Freud, whose love of anecdote and vivid recall kept me listening for decades, and to Frank Auerbach, for whom I began sitting weekly in 2003 and who has provided insight, reminders and corroboration. Special thanks also to Bruce Bernard (who introduced me to Freud in the first place), and to Christopher Bramham, Anne Dunn, Jacquetta Eliot, Annie Freud, Esther Freud and Alice Weldon.

Acknowledgements also to those who, variously and over several decades, advised, informed, enabled and encouraged me:

Judy Adam, Anne Ambler, June Andrews, Melanie Andrews, Michael Andrews, James Astor, Jake Auerbach, Kate Austin, Marc Balakjian, J. G. Ballard, Jan Banyard, Oliver Barker, Nicola Bateman, David Batterham, Emily Bearn, David, Duke of Beaufort, Mary Rose Beaumont, Julian Bell, Nicci Bell, Derek Birdsall, Leigh Bowery, Mark Boxer, Alex Boyt, Ib Boyt, Ivor Braka, Ruth Bramham, Dr. Paul Brass, Judith Bumpus, Richard Calvocoressi, Jeffery Camp, Robin Campbell, Patrick Caulfield, Robin Cembalest, Susanna Chancellor, Perienne Christian, Jane Clark, Sally Clarke, Bill Coldstream, Robert Coward, John Craxton, Caroline Cuthbert, Robert Dalrymple, Terry Danziger-Miles, William Darby, Michael Davie, Roy Davis, Jim Demetrion, Andrew Dempsey, Stephen Deuchar, Andrew Cavendish, 11th Duke of Devonshire, Deborah Cavendish, Duchess of Devonshire, Hamish Dewar, Harry Diamond, Pat Doherty, Robert Dukes, Angela Dyer, Freddy Eliot, Jacquetta Eliot, Tracey Emin, Mark Evans, Father Henry Everett, Tony Eyton, Oliver Fairclough, Alice Feaver, Dorothy Feaver, Emily Feaver, Starr Figura, Robert Flynn Johnson, Jackie Ford, Philip French, Annabel Freud, Bella Freud, Esther Freud, Stephen Freud, John Gage, Nick Garland, Martin Gayford, Patrick George, Riccardo Giaccherini, Kitty Godley, Catherine Goodman, Dr. Michael Gormley, Noam Gottesman, Lawrence Gowing, Penelope (Cuthbertson) Guinness, Maggie Hambling, Michael Hamburger, Richard Hamilton, Felicity Hellaby, David Hockney, Howard Hodgkin, Sarah Holgate, Richard Hollis, Mary Horlock, John Hubbard, Robert Hughes, Evelyn Joll, Jay Jopling, Danny Katz, Moira Kelly, Brian Kennedy, Rolfe Kentish, Peggy Kilbourn, Edward King, Jeremy King, R. B. Kitaj, Leon Kossoff, Fred Lambton,

Catherine Lampert, Cecily Langdale, Sophie Lawrence, John Lessore, Joe Lewis, Louise Liddell, Bill Lieberman, Magnus Linklater, Janey Longman, Honey Luard, Sarah Lucas, Matthew Marks, Jane McAdam Freud, Paul McAdam Freud, John McCracken, John McEwen, Alfie McLean, Paul McLean, Robert McPherson, Mel Merians, Daniel Miller, Brian Mills, Chris Moore, Harry Moore-Gwyn, Mike Moritz, Richard Morphet, Lynda Morris, Rebecca Morse, Richard Mosse, Sandy Nairne, Victoria Newhouse, Tim Nicholson, Cavan O'Brien, Pilar Ordovas, Sonia Orwell, Francis Outred, Eduardo Paolozzi, Andrew Parker Bowles, Geoffrey Parton, Celia Paul, Susanna Pollen, Tristram Powell, Marcus Price, Matthew Pritchard, John Richardson, John Riddy, Alan Ross, Eric de Rothschild, Jacob Rothschild, Paul Rousseau, John Russell, Roz Saville, Brian Sayers, Karsten Schubert, Colin Self, Sir Nicholas Serota, Michael Sheldon, Sebastian Smee, David Somerset, 11th Duke of Beaufort, Graham Southern, Unity Spender, Nikos Stangos, Sophie de Stempel, George Stephenson, Timothy Stevens, Mercedes Stoutzker, Jeremy Strick, Hugh Stubbs, Katherine Stubbs, Christine Styrnau, Alan Sykes, David Sylvester, Bob Tanner, Tommy Tannock, Tim Taylor, Rupert Thomas, Sue Tilley, Joe Tilson, Ruthven Todd, Vitek Tracz, Euan Uglow, Gabriele Ullstein, Virginia Verran, John Virtue, Alister Warman, Brian Webb, Alice Weldon, Hugo Williams, Paul Williams, Rowan Williams, Alexi Williams-Wynn, Nick Willing, Lady Jane Willoughby, Colin (Sandy) Wilson, John Wonnacott and Francis Wyndham.

The following have kindly given me permission to quote from letters and documents: Lucian Freud Archives, Tate Archives and the National Portrait Gallery archives.

I am also indebted to Freud's successive dealers, James Kirkman and William Acquavella, to Freud's daughter, Rose Pearce, to his assistant David Dawson and to his lawyer Diana Rawstron (who together administer the Lucian Freud Archive).

My deepest thanks to my literary agent Deborah Rogers, of Rogers, Coleridge and White, whose advocacy for the book extended over many years until her untimely death in 2014, since when at RCW Zoe Waldie has been a most excellent prompt and minder.

At Bloomsbury Alexandra Pringle has been the ideal publisher: imaginative, patient and exhilaratingly involved; my editor Bill Swainson guided and amended with irresistible authority; Peter James (copy editor) and Catherine Best (proofreader) were most considerately efficient and managing editor Lauren Whybrow saw this second volume through in difficult times with phenomenal patience and a light touch. And further thanks to Angelique Tran Van Sang, Allegra Le Fanu, Phil Beresford, David Atkin-

son (compiler of the processional index) and to Hetty Touquet and Genista Tate-Alexander.

At Knopf in New York Shelley Wanger has coordinated publication with her renowned efficiency and flair.

*

To Andrea Rose for her patience, knowledge and ever reliable advice, my ultimate gratitude and love.

INDEX

ILLUSTRATION CREDITS

Freud's Cézanne, *L'Après-midi à Naples* © William Feaver

Newspaper front pages showing *HM Queen Elizabeth II* © William Feaver

Campaign for recovery of *Francis Bacon*, Berlin © William Feaver

Self-Portrait—Reflection, Lucian Freud in background © William Feaver

David Hockney by Lucian Freud © William Feaver

Emily Bearn at Tate Britain's Lucian Freud exhibition © David Bearn / Getty Images

Head of a Naked Girl, 1999–2000 by Lucian Freud © The Lucian Freud Archive / Bridgeman Images

First proof of the etching *After Constable* emerging, London Print Workshop © William Feaver

Girl with Fuzzy Hair, 2004 by Lucian Freud © The Lucian Freud Archive / Bridgeman Images

The Painter Surprised by a Naked Admirer, 2004–05 by Lucian Freud © The Lucian Freud Archive / Bridgeman Images

Lucian Freud in Paris to see the Ingres show © William Feaver

Lucian Freud and Pat Doherty looking at first pull of *Donegal Man* © William Feaver

With Kate in Bed © David Dawson / Bridgeman Images

COLOUR PLATE SECTIONS

First plate section

Wasteground with Houses, Paddington, 1970–72 (oil on canvas, 167.5 x 101.5 cm), Freud, Lucian (1922–2011) / Private Collection / © The Lucian Freud Archive / Bridgeman Images

Small Naked Portrait, 1973–74 (oil on canvas, 22 x 27 cm), Freud, Lucian (1922–2011) / Ashmolean Museum, University of Oxford, UK / © The Lucian Freud Archive / Bridgeman Images

Last Portrait, 1974–75 (oil on canvas, 61 x 61 cm), Freud, Lucian (1922–2011) / Museo Thyssen-Bornemisza, Madrid, Spain / © The Lucian Freud Archive / Bridgeman Images

Large Interior, London W.9., 1973 (oil on canvas, 91.5 x 91.5 cm), Freud, Lucian (1922–2011) / © The Devonshire Collections, Chatsworth / © The Lucian Freud Archive / Reproduced by permission of Chatsworth Settlement Trustees / Bridgeman Images

Painter's Mother II, 1972 (oil on canvas, 17.8 x 14 cm), Freud, Lucian (1922–2011) / Private Collection / © The Lucian Freud Archive / Bridgeman Images

Ali, 1974 (oil on canvas, 71.1 x 71.1 cm), Freud, Lucian (1922–2011) / Private Collection / © The Lucian Freud Archive / Bridgeman Images

Frank Auerbach, 1975–76 (oil on canvas, 40 x 26.5 cm), Freud, Lucian (1922–2011) / Private Collection / © The Lucian Freud Archive / Bridgeman Images

Guy and Speck, 1980–81 (oil on canvas, 76.2 x 71.1 cm), Freud, Lucian (1922–2011) / Private Collection / © The Lucian Freud Archive / Bridgeman Images

Naked Man with His Friend, 1978–80 (oil on canvas, 90.2 x 105.5 cm), Freud, Lucian (1922–2011) / Private Collection / © The Lucian Freud Archive / Bridgeman Images

Two Plants, 1977–80 (oil on canvas, 149.9 x 120 cm), Freud, Lucian (1922–2011) / Tate, UK / © The Lucian Freud Archive / Bridgeman Images

Annie and Alice, 1975 (oil on canvas, 22.5 x 27 cm), Freud, Lucian (1922–2011) / Private Collection / © The Lucian Freud Archive / Bridgeman Images

Large Interior W11 (after Watteau), 1981–83 (oil on canvas, 186 x 198 cm), Freud, Lucian (1922–2011) / Private Collection / © The Lucian Freud Archive / Bridgeman Images

Two Irishmen in W11, 1984–85 (oil on canvas, 172.7 x 141.6 cm), Freud, Lucian (1922–2011) / Private Collection / © The Lucian Freud Archive / Bridgeman Images

Double Portrait, 1985–86 (oil on canvas, 78.8 x 88.9 cm), Freud, Lucian (1922–2011) / Private Collection / © The Lucian Freud Archive / Bridgeman Images

Painter and Model, 1986–87 (oil on canvas, 159.6 x 120 cm), Freud, Lucian (1922–2011) / Private Collection / © The Lucian Freud Archive / Bridgeman Images

Second plate section

Annabel Sleeping, 1987–88 (oil on canvas, 56 x 38.8 cm), Freud, Lucian (1922–2011) / Private Collection / © The Lucian Freud Archive / Bridgeman Images

Nude with Leg Up (Leigh Bowery), 1992 (oil on canvas), Freud, Lucian (1922–2011) / Private Collection / © The Lucian Freud Archive / Bridgeman Images

Woman in a Butterfly Jersey, 1990–91 (oil on canvas, 100.3 x 81.3 cm), Freud, Lucian (1922–2011) / Private Collection / © The Lucian Freud Archive / Bridgeman Images

Bruce Bernard, 1992 (oil on canvas, 111.8 x 83.8 cm), Freud, Lucian (1922–2011) / Private Collection / © The Lucian Freud Archive / Bridgeman Images

Painter Working, Reflection, 1993 (oil on canvas, 101.2 x 81.7 cm), Freud, Lucian (1922–2011) / Private Collection / © The Lucian Freud Archive / Bridgeman Images

And the Bridegroom, 1993 (oil on canvas, 232 x 196 cm), Freud, Lucian (1922–2011) / Private Collection / © The Lucian Freud Archive / Bridgeman Images

Naked Girl Perched on a Chair, 1994 (oil on canvas, 120 x 76 cm), Freud, Lucian (1922–2011) / Private Collection / © The Lucian Freud Archive / Bridgeman Images

Sunny Morning—Eight Legs (unfinished), 1996 (not completed until 1997; oil on canvas), Freud, Lucian (1922–2011) / Private Collection / © The Lucian Freud Archive / Bridgeman Images

Sleeping by the Lion Carpet, 1996 (oil on canvas, 228 x 121 cm), Freud, Lucian